A SHORT HISTORY OF THE MIDDLE AGES

ASHORT HISTORY OF THE MIDDLE AGES

BARBARA H. ROSENWEIN FIFTH EDITION

UNIVERSITY OF TORONTO PRESS

Toronto Buffalo London

Copyright © University of Toronto Press 2018

utorontopress.com

All rights reserved. The use of any part of this publication reproduced, transmitted in any form or by any means, electronic, mechanical, photocopying, recording, or otherwise, or stored in a retrieval system, without prior written consent of the publisher—or in the case of photocopying, a licence from Access Copyright (the Canadian Copyright Licensing Agency) 320-56 Wellesley Street West, Toronto, Ontario, M5S 2S3—is an infringement of the copyright law.

Library and Archives Canada Cataloguing in Publication

Rosenwein, Barbara H., author

A short history of the Middle Ages / Barbara H. Rosenwein. — Fifth edition.

Includes bibliographical references and index.

Issued in print and electronic formats.

ISBN 978-1-4426-3623-1 (hardcover).—ISBN 978-1-4426-3622-4 (softcover).— ISBN 978-1-4426-3625-5 (HTML).—ISBN 978-1-4426-3624-8 (PDF)

1. Middle Ages. 2. Europe—History—476-1492. I. Title.

D117.R67 2018

940.1

C2018-900013-9

C2018-900014-7

We welcome comments and suggestions regarding any aspect of our publications—please feel free to contact us at news@utphighereducation.com or visit our Internet site at www.utorontopress.com.

North America

5201 Dufferin Street

North York, Ontario, Canada, M3H 5T8

UK, Ireland, and continental Europe

NBN International

Estover Road, Plymouth, PL6 7PY, UK

2250 Military Road

Tonawanda, New York, USA, 14150

ORDERS PHONE: 44 (0) 1752 202301 ORDERS FAX: 44 (0) 1752 202333

ORDERS E-MAIL: enquiries@nbninternational.com

ORDERS PHONE: 1-800-565-9523

ORDERS FAX: 1-800-221-9985

ORDERS E-MAIL: utpbooks@utpress.utoronto.ca

Every effort has been made to contact copyright holders; in the event of an error or omission, please notify the publisher.

The University of Toronto Press acknowledges the financial support for its publishing activities of the Government of Canada through the Canada Book Fund.

Printed in Canada.

Funded by the Financé par le Canad'ä Government gouvernement of Canada du Canada

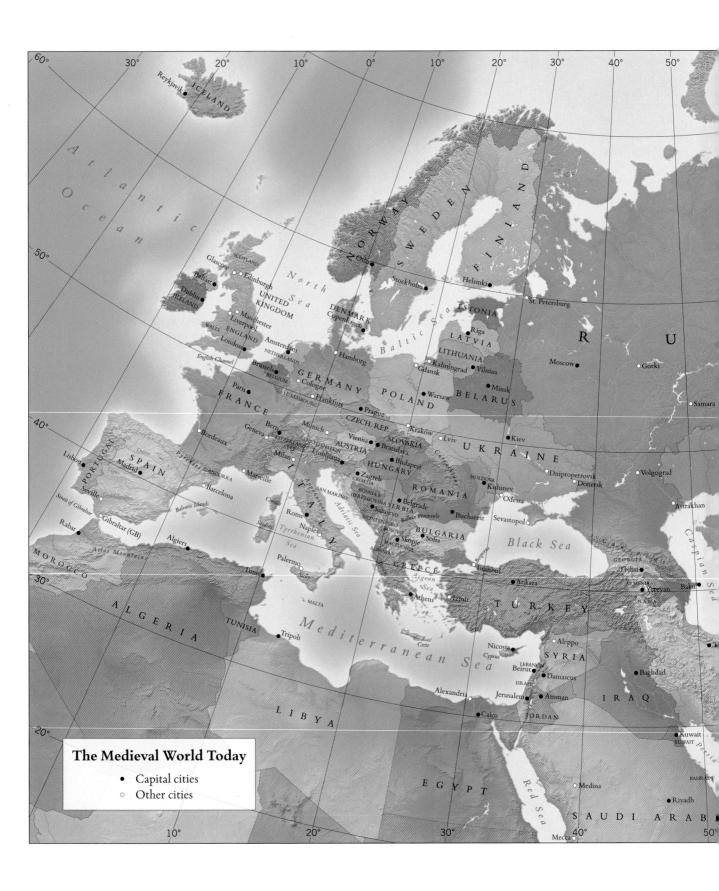

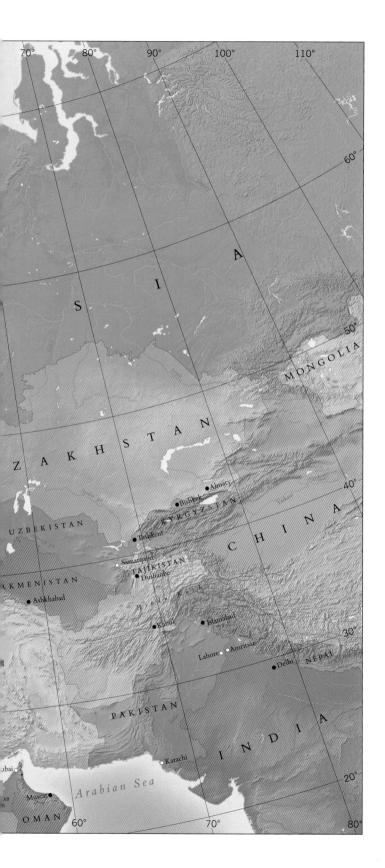

The union of the Roman empire was dissolved; its genius was humbled in the dust; and armies of unknown barbarians, issuing from the frozen regions of the North, had established their victorious reign over the fairest provinces of Europe and Africa.

Edward Gibbon, *The Decline and Fall of the Roman Empire*

It may very well happen that what seems for one group a period of decline may seem to another the birth of a new advance.

Edward Hallett Carr, What Is History?

CONTENTS

List of Maps • x

Index • 349

List of Plates • xi List of Genealogies • xiv List of Figures • xiv Abbreviations, Date Conventions, Website • xv Acknowledgments • xvii Prelude: The Roman World Transformed (c.300–c.600) • 1 CHAPTER ONE Part I: Three Cultures from One CHAPTER TWO The Emergence of Sibling Cultures (c.600-c.750) • 41 MATERIAL CULTURE: FORGING MEDIEVAL SWORDS • 74 CHAPTER THREE Creating New Identities (c.750-c.900) • 81 CHAPTER FOUR Political Communities Reordered (c.900-c.1050) • 113 MATERIAL CULTURE: THE MAKING OF AN ILLUMINATED MANUSCRIPT • 152 Part II: Diverging Paths New Configurations (*c*. 1050–*c*. 1150) • 161 CHAPTER FIVE Institutionalizing Aspirations (c.1150–c.1250) • CHAPTER SIX CHAPTER SEVEN Tensions and Reconciliations (c.1250–c.1350) • MATERIAL CULTURE: THE DEVELOPMENT OF ISLAMIC CERAMICS • 294 CHAPTER EIGHT Catastrophe and Creativity (c.1350-c.1500) • 301 Sources • 345

MAPS

	The Medieval World Today • vi
I.I	The Roman Empire, c.300 • 2
1.2	The Capital Cities of the Empire • 4
1.3	Christian Populations at the End of the 3rd cent. • 7
1.4	Wijster • 22
1.5	The Huns and the Visigoths, c.375-450 • 24
1.6	The Former Western Empire, c.500 • 25
1.7	Tours, <i>c</i> .600 • 27
1.8	Europe, the Eastern Roman Empire, and Persia, c.600 • 34
2.1	Persian Expansion, 602–622 • 42
2.2	The Byzantine Empire, c.700 • 43
2.3	The Islamic World to 750 • 50
2.4	Western Europe, c.750 • 59
2.5	Lombard Italy, c.750 • 71
3.1	The Byzantine and Bulgarian Empires, c.920 • 83
3.2	The Avar Khaganate, 7th–8th cent. • 84
3.3	The Islamic World, c.800 • 89
3.4	Europe, <i>c</i> .814 • 96
3.5a	Partition of 843 (Treaty of Verdun) • 102
	Partition of 870 (Treaty of Meerssen) • 102
3.5C	Partition of 880 • 102
3.6	Northern Emporia in the Carolingian Age • 104
4. I	Constantinople, c. 1100 • 114
4.2	The Byzantine Empire during the Reign of Basil II, 976–1025 • 118
4.3	Kievan Rus', c. 1050 • 120
4.4	Fragmentation of the Islamic World, c. 1000 • 123
4.5	Viking, Muslim, and Hungarian Invasions, 9th and 10th cent. • 131
4.6	Europe, <i>c</i> . 1050 • 141
4.7	Ottonian Empire, c.1000 • 144
5.1	The Byzantine and Seljuk Empires, c. 1090 • 162
5.2	The Almoravid Empire, c.1115 • 169
5.3	Byzantium, 12th cent. • 171
5.4	Tours c.600 vs. Tours c.1100 • 172
5.5	Western Europe, <i>c</i> .1100 • 174
5.6	The First Crusade and Early Crusader States • 182
5.7	The Norman Invasion of England, 1066–1100 • 185
5.8	The Iberian Peninsula, c.1140 • 187
6.1	Saladin's Empire, c.1200 • 211
6.2	The Almohad Empire, c.1172 • 212
6.2	The Latin Empire and Byzantine Successor States 1204–6 1250 • 219

- 6.4 The Angevin and Capetian Realms in the Late 12th cent. 218
- 6.5 Spain and Portugal, c.1275 220
- 6.6 Italy and Southern Germany in the Age of Frederick Barbarossa 224
- 6.7 France, c.1230 245
- 6.8 German Settlement in the Baltic Sea Region, 12th to 14th cent. 246
- 7.1 The Mongol Empire, *c*.1260–1350 252
- 7.2 The Mamluk Sultanate 256
- 7.3a, b European and Eurasian Trade Routes, c.1300 258
- 7.4 Piacenza, Late 13th cent. 262
- 7.5 Western Europe, c. 1300 269
- 7.6 East Central Europe, *c*. 1300 273
- 7.7 The Village of Toury, 14th and 15th cent. 292
- 8.1 Eurasia c. 1400 302
- 8.2 The First Phase of the Hundred Years' War, 1337–1360 312
- 8.3 English and Burgundian Hegemony in France, c. 1430 314
- 8.4 The Duchy of Burgundy, 1363–1477 315
- 8.5 Western Europe, *c*. 1450 319
- 8.6 Long-Distance Sea Voyages of the 15th cent. 340

PLATES

- 1.1 Mars and Venus, Pompeii (1st cent.) 12
- 1.2 Hercules in the Garden of the Hesperides, Oplontis (c.10-1 BCE) 13
- 1.3 Harbor Scene (late 1st cent. BCE) 14
- 1.4 Euhodus Sarcophagus (c. 161–170) 16
- 1.5 Venus and Two Nymphs, Britain (2nd or early 3rd cent.) 17
- 1.6 Tombstone, near Carthage (2nd cent.?) 18
- 1.7 Embracing Tetrarchs (c.300) 19
- 1.8 Base of the Hippodrome Obelisk (c. 390) 20
- 1.9 Orant Fresco (second half of 4th cent.) 21
- 1.10 Sarcophagus of Junius Bassus (359) 22
- 1.11 Reliquary of Theuderic (late 7th cent.) 29
- 1.12 San Vitale, Ravenna, Apse Mosaics (mid-6th cent.) 32
- 2.1 Cross at Hagia Sophia (orig. mosaic 6th cent.; redone 768/769) 48
- 2.2 Page from an Early Qur'an (568–645) 51
- 2.3 Damascus Great Mosque Mosaic (706) 55
- 2.4 Great Square-Headed Brooch (early 6th cent.) 66
- 2.5 Saint Luke, Lindisfarne Gospels (first third of 8th cent.?) 67
- 2.6 Carpet Page, Lindisfarne Gospels (first third of 8th cent.?) 68
- 2.7 First Text Page, Gospel of Saint Luke, Lindisfarne Gospels (first third of 8th cent.?) 69

```
The Altar of Ratchis (737–744) • 72
     The Cividale Tempietto (8th cent.?) •
MATERIAL CULTURE: FORGING MEDIEVAL SWORDS
2.10 The Sigurd Portal, Hylestad Stave Church, Norway (12th–13th cent.) •
2.11 Ulfberht Sword (9th cent.) • 76
2.12 The Utrecht Psalter (first half of 9th cent.)
     Christ on the Cross amid Saints (9th–early 10th cent.) • 86
     Gregory of Nazianzus Preaches on the Plague of Hail, Gregory's Homilies
     (c.880) • 87
     Water Pitcher in the Shape of an Eagle (796–797) •
3.3
     Chest or Cenotaph Panel (second half of 8th cent.) •
     Great Mosque, Córdoba (785–787) • 97
3.5
     Sacramentary of Saint-Germain-des-Prés (early 9th cent.) •
     Andromeda (840s?) •
                            108
3.7
     Psalter Page (second quarter of 9th cent.)
3.8
     Saint John (second half of 9th cent.) • 110
     Emperor Basil II (1018) •
4.I
     Golden Jug (985–998) • 122
4.2
     The mihrab of al-Azhar Mosque (969/973) • 124
4.3
     Fatimid Cemetery at Aswan (11th cent.)
     Oseberg Ship (834) • 132
4.5
     The Raising of Lazarus, Egbert Codex (985–990) •
4.6
     Christ Asleep, Hitda Gospels (c. 1000–c. 1020)
4.7
     Saint Luke, Gospel Book of Otto III (998–1001) • 149
MATERIAL CULTURE: THE MAKING OF AN ILLUMINATED MANUSCRIPT
     Hamburg Bible (1255) • 153
4.10 Miniature of Saint Dunstan (12th cent.) • 154
     Codex Aureus (870) • 155
     Isfahan Mosque Courtyard (11th–12th cent.) •
5.1
     Isfahan Mosque North Dome (1088) •
     Great Mosque Minaret at Siirt (1128/1129?)
5.3
     Great Mosque at Diyarbakir (1179/1180?)
5.4
     Almería Silk (first half of 12th cent.) •
5.5
     Durham Cathedral, Interior (1093–1133) •
                                                193
5.6
     Sant Tomàs de Fluvià, The Last Supper, Painted Vault (early 12th cent.) •
     Cathedral Complex, Pisa (11th–12th cent.) • 196
5.8
     Saint-Lazare of Autun, Nave (1120–1146) • 197
5.10 Autun, Cockfight (12th cent.) • 198
     Carthusian Diurnal from Lyon (12th cent.) • 200
5.12 Sénanque Monastery Church, Interior (c.1160) •
5.13 Jael, Humility, and Judith (c.1140) • 202
     Frontispiece for the Book of Songs (1217–1219) •
```

```
6.2
    Funerary Madrasa Complex of Nur al-Din at Damascus (1167–1168) •
     Minaret at Rabat (c. 1199)
6.3
    Bust of Frederick Barbarossa (1165)
6.4
     Notre Dame of Paris, Exterior (begun 1163)
6.5
     Notre Dame of Paris, Interior (begun 1163) • 236
6.6
     San Francesco at Assisi (Upper Church; completed by 1253) •
6.7
     Bamberg Cathedral, Tympanum of "The Princes' Door," (c.1230–1235) •
6.8
     Great Mongol Shahnama, "The Death of Alexander" (1330s) • 255
7.I
     Funerary Complex of Mamluk Emirs Salar and Sanjar al-Jawli, Cairo
7.2
     (1302-1304) • 257
    Jews in an English Exchequer Tax Receipt Roll (1233) •
7.3
7.4
     Chalice (c.1300) • 277
     A Shrine Madonna from the Rhineland (c. 1300) • 278
7.5
    Page from a Book of Hours, Northern France or Flanders
     (early 14th cent.) • 280
     Tomb and Effigy of Robert d'Artois (1317) •
7.7
    The Motet Le premier jor de mai (c.1280) • 283
7.8
7.9 Page from Giovanni d'Andrea, Summa on Engagements and Marriages and
     Lecture on the Tree of Consanguinity and Affinity (c.1315) • 286
7.10 Sepulcher of Giovanni d'Andrea, Bologna (1348) • 287
7.11 Giotto, Scrovegni Chapel, Padua (1304–1306) • 288
7.12 Giotto, Lamentation of Christ, Scrovegni Chapel (1304–1306) •
MATERIAL CULTURE: THE DEVELOPMENT OF ISLAMIC CERAMICS
    Great Mosque mihrab, Kairouan, Tunisia (862–863) • 295
7.14 Rooster Ewer, Kashan, Iran (1200–1220)
7.15 Bowl, Samarqand, Uzbekistan (c.1420–1450) • 297
8.1
     Costanzo da Ferrara, Portrait Medallion of Mehmed II (1470s) • 305
     Ushak Medallion Carpet, Anatolia (third quarter of 15th cent.) • 306
8.2
    Building Complex, Edirne (1484–1488) •
8.3
    Corpses Confront the Living (c.1441) • 310
8.4
8.5
    Donatello, Judith and Holofernes (c.1420–1430) •
    Piero di Cosimo, Venus, Cupid, and Mars (c.1495–1505) • 328
8.6
8.7
    Filippo Brunelleschi, Florence Cathedral Dome (1418–1436) •
8.8
    Leonardo da Vinci, The Last Supper (1494–1497) • 331
    Jacopo de' Barbari, Bird's-Eye View of Venice (1500) •
```

8.10 History of Alexander the Great, Tapestry (c.1459)
8.11 Rogier van der Weyden, Columba Altarpiece (1450s)
8.12 Jan van Eyck, Portrait of Jan de Leeuw (1436)
337

GENEALOGIES

- 2.1 Muhammad's Relatives and Successors to 750 56
- 2.2 The Merovingians 62
- 3.1 The Abbasids 90
- 3.2 The Carolingians 101
- 4.1 Alfred and His Progeny 142
- 4.2 The Ottonians 145
- 5.1 The Great Seljuk Sultans 164
- 5.2 The Comnenian Dynasty 171
- 5.3 The Salian Kings and Emperors 178
- 5.4 The Norman Kings of England 185
- 5.5 The Capetian Kings of France 189
- 6.1 The Angevin Kings of England 216
- 6.2 Rulers of Germany and Sicily 223
- 7.1 The Mongol Khans 253
- 7.2 Henry III and His Progeny 266
- 7.3 Louis IX and His Progeny 267
- Kings of France and England and the Dukes of Burgundy during the Hundred Years' War
 313
- 8.2 Yorkist and Lancastrian (Tudor) Kings 316

FIGURES

- I.I San Vitale, Ravenna, Reconstructed Original Ground Plan, 6th cent. 30
- 2.1 Late Antique Ephesus 45
- 2.2 Yeavering, Northumberland, Anglo-Saxon Royal Estate, 7th cent. 60
- 3.1 Mosque Plan (Cairo, Ibn Tulum Mosque, built 876–879) 95
- 5.1 Saint-Germain of Auxerre (12th cent.) 192
- 5.2 A Model Romanesque Church: Saint-Lazare of Autun 195
- 5.3 Plan of Fountains Abbey (founded 1132) 199
- 6.1 Elements of a Gothic Church 234
- 7.1 Single Notes and Values of Franconian Notation 284

ABBREVIATIONS, DATE CONVENTIONS, WEBSITE

ABBREVIATIONS

- c. circa. Used to indicate that dates or other numbers are approximate.
- cent. century
 - d. date of death
- emp. emperor
 - fl. flourished. This is given when even approximate birth and death dates are unknown.
 - pl. plural form of a word
 - r. dates of reign
- sing. singular form of a word

DATE CONVENTIONS

All dates are CE/AD unless otherwise noted (the two systems are interchangeable). The dates of popes are not preceded by r. because popes took their papal names upon accession to office, and the dates after those names apply only to their papacies.

The symbol / between dates indicates uncertainty: e.g., Boethius (d.524/526) means that he died some time between 524 and 526.

WEBSITE

http://www.utphistorymatters.com = The website for this book, which has practice shortanswer and discussion questions (with sample answers provided), as well as maps, figures, and genealogies.

ACKNOWLEDGMENTS

I would like to thank all the readers, many anonymous, who made suggestions for improving earlier editions of *A Short History of the Middle Ages*. While I hope I will be forgiven for not naming everyone—a full list of names would begin to sound like a roll call of medievalists, both American and European—I want to single out two who were of special help for this edition: Dionysios Stathakopoulos and Julia Bray. Both sent me enormously helpful and often annotated bibliographies (on Byzantium and the Islamic world, respectively) for each chapter. I am indebted as always to Riccardo Cristiani for his help with and advice on every part and phase of this entire book. In addition, he prepared the inserts on Material Culture. Erik Goosmann was an exceptionally learned, creative, and willing cartographer. I thank as well Esther Cohen, who alerted me to some new interpretations; Albrecht Diem, who shared with me his classroom experiences with the book; Judith Earnshaw, editor extraordinaire; Natalie Fingerhut; and Matthew Jubb at Em Dash Design.

Finally, I thank my family, and I dedicate this book to my granddaughters Sophie and Natalie.

NOTE FOR THE FIFTH EDITION

Here students and teachers will find a much-enhanced map and artistic program and considerable expansion of the treatment of the Islamic and Byzantine worlds. To counter the tendency of textbook readers to imagine that everything therein is a "fact," I have singled out in each chapter at least one issue on which historians explicitly differ. The proponents of the various sides of those controversies are listed in the end-of-chapter Further Reading offerings, which have also been updated to take into account the most important new contributions.

ONE

PRELUDE: THE ROMAN WORLD TRANSFORMED (c.300-c.600)

At the beginning of the third century, the Roman Empire wrapped around the Mediterranean Sea like a scarf. (See Map 1.1.) Thinner on the North African coast, it bulked large as it enveloped what is today Spain, England, Wales, France, and Belgium, and then evened out along the southern coast of the Danube River, following that river eastward, taking in most of what is today called the Balkans (southwestern Europe, including Greece), crossing the Hellespont and engulfing in its sweep the territory of present-day Turkey, much of Syria, and all of modern Lebanon, Israel, and Egypt. All the regions but Italy comprised what the Romans called the "provinces."

This was the Roman Empire whose "decline and fall" was famously proclaimed by the eighteenth-century historian Edward Gibbon. Many historians today still think that judgment to be correct: consider the title of Bryan Ward-Perkins' book The Fall of Rome: And the End of Civilization. (For all modern author references, see Further Reading at the end of each chapter.) But many other historians follow Peter Brown in stressing the vitality of what he called "Late Antiquity." It is true that the old elites of the cities, especially of Rome itself, largely regretted the changes taking place around them c.250-350. They were witnessing the end of their political, military, religious, economic, and cultural leadership. That role was passing to the provincials (the Romans living outside of Italy) for whom this was in many ways a heady period, a long-postponed coming of age. They did not regret that Emperor Diocletian (r.284–305) divided the Roman Empire into four parts, each ruled by a different man. Called the Tetrarchy, the partition was tacit recognition of the importance of the provinces. But even the provinces eventually lost their centrality, as people still farther afield (whom the Romans called "barbarians") moved into the Roman Empire ϵ .400–500. The barbarians, in turn, were glad to be the heirs of the Romans even as they contributed to the Empire's transformation.

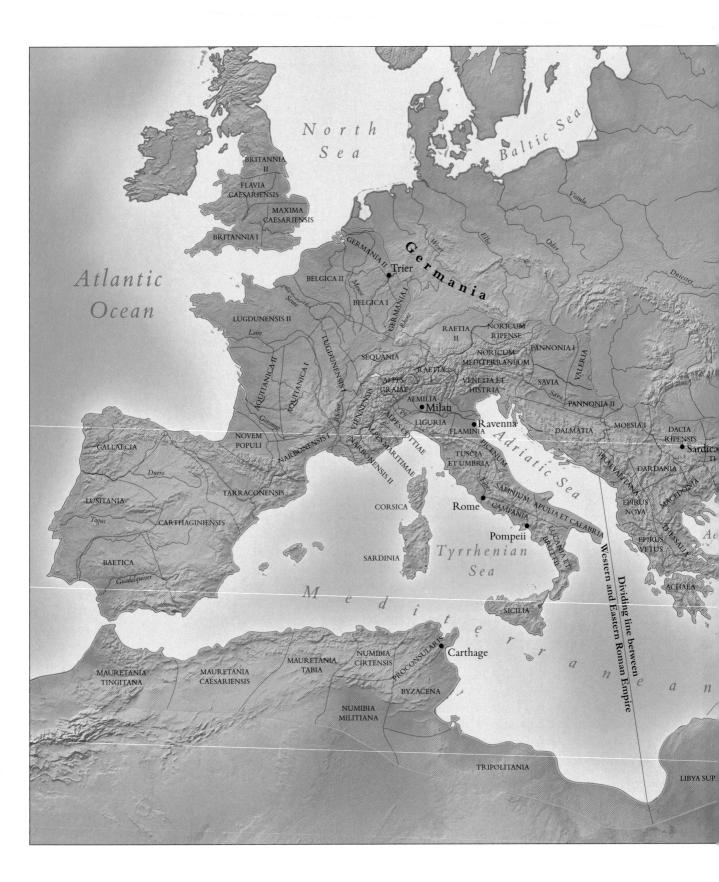

Empire, *c*.300 Caspian Sea SCYTHIA Black Sea DIOSPONTUS PAPHLAGONIA ESIA II HAEMIMONTUS ARMENIA MINOR Sasanid Empire Byzantium • Chalcedon of the Persians Nicomedia CAPPADOCIA MESOPOTAMIA GALATIA OSRHOENE SYRIA COELE Antioch LYCIA ET PAMPHYLIA Palmyra CYPRUS Damascus Jerusalem ... ETA ET ENAICA PALAESTINA ARABIA II Alexandria Legend LIBYA INFERIOR TRIPOLITANIA Roman province AEGYPTUS HERCULIA $500\ km$ 300 mi THEBAIS

Map 1.1 The Roman

THE PROVINCIALIZATION OF THE EMPIRE (c.250-c.350)

The Roman Empire was too large to be ruled by one man in one place, except in peacetime. This became clear during the so-called crisis of the third century, when two different groups from two different directions bore down on the frontiers of the Empire. From the north, beyond the Rhine and Danube Rivers, came the people the Romans dubbed barbarians; from the east came the Persians. To contend with these attacks, the Roman government responded with wide-ranging reforms that brought new prominence to the provinces.

Above all, the government expanded the army, setting up new crack mobile troops while reinforcing the standing army. Soldier-workers set up new fortifications, cities ringed themselves with walls, farms gained lookout towers and fences. It was not easy to find enough recruits to man this newly expanded defensive system. Before the crisis, the Roman legions had been largely self-perpetuating. The legionaries, drawn mainly from local provincial families, had settled permanently along the borders and raised the sons who would make up the next generation of recruits. Now, however, this supply was dwindling: the birthrate was declining, and c.252–267 an epidemic of smallpox ravaged the population further. Recruits would have to come from farther away, from Germania (the region beyond the northern borders of the Empire) and elsewhere. In fact, long before this time, Germanic warriors had been regular members of Roman army units; they had done their stints and gone home. But in the third century the Roman government began a new policy: it settled Germanic and other barbarian groups within the Empire, giving them land in return for military service.

The primacy of the provinces was further enhanced by the need to feed and supply the army. To meet its demand for ready money, the Roman government debased the currency, increasing the proportion of inferior metals to silver. While helpful in the short term, this policy produced severe inflation. Strapped for cash, the state increased taxes and used its power to requisition goods and services. To clothe the troops, it confiscated uniforms; to arm them it set up factories staffed by artisans who were required to produce a regular quota of weapons (spears, short swords, shields) for the state. Food for the army had to be produced and delivered; here too the state depended on the labor of growers, bakers, and haulers. New taxes assessed on both land and individual "heads" were collected.

Map 1.2 The Capital Cities of the Empire

The wealth and labor of the Empire moved inexorably toward the provinces, to the hot spots where armies were clashing.

The whole Empire, organized for war, became militarized. In about the middle of the third century, Emperor Gallienus (r.253–268) forbade the senatorial aristocracy—the old Roman elite—to lead the army; tougher men from the ranks were promoted to command positions instead. It was no wonder that those men also became the emperors. They brought new provincial tastes and sensibilities to the very heart of the Empire, as we shall see.

Diocletian, a provincial from Dalmatia (today Croatia), brought the crisis under control, and Constantine (r.306–337), from Moesia (today Serbia and Bulgaria), brought it to an end. For administrative purposes, Diocletian divided the Empire into four parts, later reduced to two. Although the emperors who ruled these divisions were supposed to confer on all matters (and even be the best of friends, as Plate 1.7 on p. 19 suggests), the administrative division was a harbinger of things to come, when the eastern and western halves of the Empire would go their separate ways. Meanwhile, the wars over imperial succession ceased with the establishment of Constantine's dynasty, and political stability put an end to the border wars.

A New Religion

The empire of Constantine was meant to be the Roman Empire restored. Yet it was nothing like the old Roman Empire. Constantine's rule marks the end of the classical era and the beginning of Late Antiquity, a period transformed by the culture and religion of the provinces.

The province of Palestine—to the Romans of Italy a most dismal backwater—had been in fact a hotbed of creative religious and social ideas around the beginning of the first millennium. Chafing under Roman domination, experimenting with new notions of morality and new ethical lifestyles, the Jews of Palestine gave birth to religious groups of breathtaking originality. One coalesced around Jesus. After his death, under the impetus of the Jew-turned-Christian Paul (d.c.67), a new and radical brand of monotheism in Jesus' name was actively preached to Gentiles (non-Jews), not only in Palestine, but also beyond. Its core belief was that men and women were saved—redeemed and accorded eternal life in heaven—by their faith in Jesus Christ.

At first Christianity was of nearly perfect indifference to elite Romans, who were devoted to the gods who had served them so well over years of conquest and prosperity. Nor did it attract many of the lower classes, who were still firmly rooted in old local religious traditions. The Romans had never insisted that the provincials whom they conquered give up their beliefs; they simply added official Roman gods into local pantheons. For most people, both rich and poor, the rich texture of religious life at the local level was both comfortable and satisfying. In dreams, they encountered their personal gods, who served them as guardians and friends. At home, they found their household gods, evoking

family ancestors. Outside, on the street, they visited temples and monuments to local gods, reminders of home-town pride. Here and there could be seen monuments to the "divine emperor," put up by rich town benefactors. Everyone engaged in the festivals of the public cults, whose ceremonies gave rhythm to the year. Paganism was thus at one and the same time personal, familial, local, and imperial.

But Christianity had its attractions, too. Romans and other city-dwellers of the middle class could never hope to become part of the educated upper crust. Christianity gave them dignity by substituting "the elect" for the elite. Education, long and expensive, was the ticket into Roman high society. Christians had their own solid, less expensive knowledge. It was the key to an even "higher" society—the one in Heaven.

In the provinces, Christianity attracted men and women who had never been given the chance to feel truly Roman. (Citizenship was not granted to all provincials until 212.) The new religion was confident, hopeful, and universal. As the Empire settled into an era of peaceful complacency in the second century, its hinterlands opened up to the influence of the center, and vice versa. Men and women whose horizons in earlier times would have stretched no farther than their village now took to the roads as traders—or confronted a new cosmopolitanism right at their doorsteps. Uprooted from old traditions, they found comfort in small assemblies—churches—where they were welcomed as equals and where God was the same, no matter what region the members of the church hailed from.

The Romans persecuted Christians, but at first only locally, sporadically, and above all in times of crisis. At such moments, the Romans feared that the gods were venting their wrath on the Empire because Christians would not carry out the proper sacrifices. True, the Jews also refused to honor the Roman gods, but the Romans could usually tolerate—just barely—Jewish practices as part of their particular cultural identity. Christians, however, claimed their God not only for themselves but for all. Major official government persecutions of Christians began in the 250s, with the third-century crisis.

By 304, on the eve of the promulgation of Diocletian's last great persecutory edict, perhaps only 10 per cent of the population was Christian. (See Map 1.3.) But despite their tiny number, the Christians were well organized. Gathered into "churches" (from the Greek word, ekklesia, meaning "assembly"), they formed a two-tiered institution. At the bottom were the people (the "laity," from the Greek laikos, meaning "of the people"). Above them were the clergy (from the Greek word kleros, meaning "lot," or "inheritance," and referring to Deut. 18:2, where the Levitical priests have no inheritance but "the Lord himself"). In turn, the clergy were supervised by a regional bishop (in Greek episkopos, "overseer"), assisted by his "presbyters" (from the Greek presbyteroi, "elders," the priests who served with the bishops), deacons, and lesser servitors. Some bishops—those of Alexandria, Antioch, Carthage, Jerusalem, and Rome, whose bishop was later called the "pope"—were more important than others. No religion was better prepared for official recognition.

This it received in 313, in the so-called Edict of Milan. Emperors Licinius and Constantine declared toleration for all the religions in the Empire "so that whatever divinity is enthroned in heaven may be gracious and favorable to us." In fact, the Edict

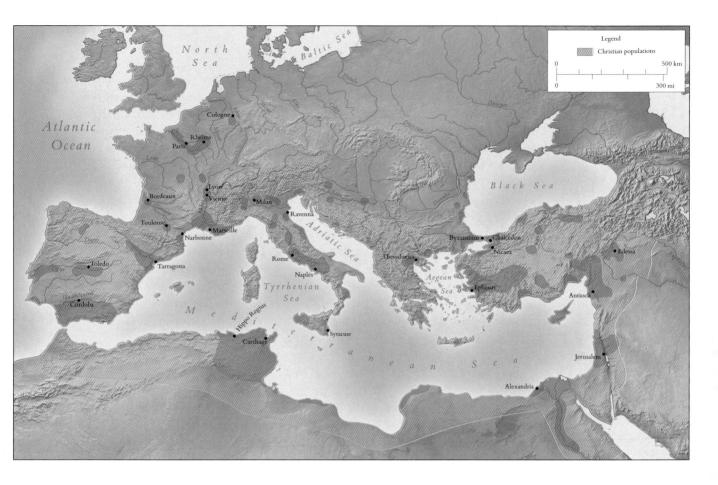

Map 1.3 Christian Populations at the End of the 3rd cent.

helped Christians above all: they had been the ones persecuted, and now, in addition to enjoying the toleration declared in the Edict, they regained their property. Constantine was the chief force behind the Edict: it was issued just after his triumphant battle at the Milvian Bridge against his rival emperor Maxentius in 312, a victory that he attributed to the God of the Christians. Constantine seems to have converted to Christianity; he certainly favored it, building and endowing church buildings, making sure that property was restored to churches that had been stripped during the persecutions, and giving priests special privileges. Under him, the ancient Greek city of Byzantium became a new Christian city, residence of emperors, and named for the emperor himself: Constantinople. The bishop of Constantinople became a patriarch, a "superbishop," equal to the bishops of Antioch and Alexandria, although not as important as the bishop of Rome. In one of the crowning measures of his career, Constantine called and then presided over the first ecumenical (universal) church council, the Council of Nicaea, in 325. There the assembled bishops hammered out some of the canon law and doctrines of the Christian church.

After Constantine, it was simply a matter of time before most people considered it both good and expedient to convert. Though several emperors espoused "heretical"—unacceptable—forms of Christianity, and one (Julian, the "Apostate") professed paganism, the die had been cast. In a series of laws starting in 380 with the Edict of Thessalonica

and continuing throughout his reign, Emperor Theodosius I (r.379–395) declared that the form of Christianity determined at the Council of Nicaea applied to all Romans, and he outlawed all the old public and private cults. Christianity was now the official religion of the Roman Empire. In some places, Christian mobs took to smashing local pagan temples. In these ways—via law, coercion, and conviction—a fragile religion hailing from one of the most backward of the provinces triumphed everywhere in the Roman world.

But "Christianity" was not simply one thing. In North Africa, Donatists—who considered themselves purer than other Christians because they had not backpedaled during the period of persecutions—fought bitterly with Catholics all through the fourth century, willingly killing and dying to prevent priests and bishops from resuming their offices if they had handed over their Bibles, church furnishings, and other emblems of their faith to Roman authorities to escape death. As paganism gave way, Christian disagreements came to the fore: what was the nature of God? where were God and the sacred to be found? how did God relate to humanity? In the fourth and fifth centuries, Christians fought with each other ever more vehemently over doctrine and over the location of the holy.

Doctrine

The so-called Church Fathers were the victors in the battles over doctrine. Already in Constantine's day, Saint Athanasius (c.295-373)—then secretary to the bishop of Alexandria, later bishop there himself—had led the challenge against the beliefs of the Christians next door. He called them "Arians," rather than Christians, after the priest Arius (250–336), another Alexandrian and a competing focus of local loyalties. Athanasius promoted his views at the Council of Nicaea (325) and won. It is because of this that he is considered the orthodox catholic "Father," while Arius is the "heretic." For both Athanasius and Arius, God was triune, that is, three persons in one: the Father, the Son, and the Holy Spirit. Their debate was about the nature of these persons. For the Arians, the Father was pure Godhead while the Son (Christ) was created. Christ was, therefore, flesh though not quite flesh, neither purely human nor purely divine, but mediating between the two. To Athanasius and the assembled bishops at Nicaea, this was heresy—the wrong "choice" (the root meaning of the Greek term *hairesis*)—and a damnable faith. The Council of Nicaea wrote the party line: "We believe in one God, the Father almighty,... And in one Lord Jesus Christ, the Son of God, begotten from the Father,... begotten not made, of one substance [homousios] with the Father." Arius was condemned and banished. His doctrine, however, persisted. It was the brand of Christianity that Ulfila (311-c.382), a Gothic bishop with Roman connections, preached to the Goths beyond the borders of the Empire, at the same time translating the Bible into the Gothic language.

Arianism was only the tip of the iceberg. Indeed, the period 350–450 might be called the "era of competing doctrines." Already the Council of Nicaea worried not only about Arians, who thought Christ to have a different substance from the Father, but also about groups (later called Monophysites or Miaphysites) who held that the "flesh" that God

assumed as Christ was nevertheless entirely divine. Thus, the Nicene Creed went on to declare that Jesus Christ, "because of us men and because of our salvation came down and became incarnate,"—that is, became *human* flesh.³ Despite that decision, ratified by later councils, especially one held at Chalcedon (451), Monophysite belief in the divinity of Christ's flesh nourished the Armenian, Coptic (Egyptian), and Ethiopian Christian churches.

Even Augustine (354–430), eventually the bishop of Hippo, a saint, and the most influential Western churchman of his day (and for many centuries thereafter), flirted in his youth with yet another variant of Christianity, Manichaeism. The Manichees, armed with a revelation from Mani, "apostle of Jesus Christ," believed in two cosmic principles, one godly, spiritual, and light; the other evil, material, and dark. For the Manichees, Jesus' human nature was not real; its materiality and suffering were only apparent. Human beings were mired in the material world, but they might liberate themselves from its shackles by fasting, renouncing sex, disdaining all forms of property, and clinging to the special knowledge brought to mankind by Christ's apostles. "The fasting that the saints fast," noted one Manichaean text, makes the soul "holy, cleansed, purified, and washed from the adulteration of the darkness that is mixed in with it." Other believers, too weak to be saints, showed their support of their pure brethren "by their faith and their alms." They had the hope of being reborn in new bodies and eventually becoming one of the saints.

Pelagius (from Britain, d. after 418) was also interested in what human beings could do to achieve salvation. Pelagius thought that conversion bleached out sins, and thereafter people could follow God by their own will. But just as Augustine repudiated the Manichees for their dualism, which made God only one of two cosmic powers, so he rejected Pelagianism for its woeful misreading of human nature. In Augustine's view, human beings were capable of nothing good without God's grace working through them: "Come, Lord, act upon us and rouse us up and call us back! Fire us, clutch us, let your sweet fragrance grow upon us!" 5

Like arguments over sports teams today, these disputes were more than small talk: they identified people's loyalties. They also brought God down to earth. God had debased himself to take on human flesh. It was critical to know how he had done so and what that meant for the rest of humanity.

For these huge questions, Augustine wrote most of the definitive answers for the West, though they were certainly modified and reworked over the centuries. In the City of God, a huge and sprawling work, he defined two cities: the earthly one in which our feet are planted, in which we are born, learn to read, marry, get old, and die; and the heavenly one, on which our hearts and minds are fixed. The first, the "City of Man," is impermanent, subject to fire, war, famine, and sickness; the second, the "City of God," is the opposite. Only there is true, eternal happiness to be found. Yet the first, however imperfect, is where the institutions of society—local churches, schools, governments—make possible the attainment of the second. Thus "if anyone accepts the present life in such a spirit that he uses it with the end in view of [the City of God],... such a man may without absurdity be called happy, even now." In Augustine's hands, the old fixtures of the ancient world were reused and reoriented for a new Christian society.

The Sources of God's Grace

The City of Man was fortunate. There God had instituted his church. Christ had said to Peter, the foremost of his twelve apostles (his "messengers"):

Thou art Peter [*Petros*, or "rock" in Greek]; and upon this rock I will build my church, and the gates of hell shall not prevail against it. And I will give to thee the keys of the kingdom of heaven. And whatsoever thou shalt bind upon earth, it shall be bound also in heaven; and whatsoever thou shalt loose on earth, it shall be loosed also in heaven. (Matt. 16:18–19)

Although variously interpreted (above all by the popes at Rome, who took it to mean that, as the successors of Saint Peter, the first bishop of Rome, they held the keys), no one doubted that this declaration confirmed that the all-important powers of binding (imposing penance on) and loosing (forgiving) sinners were in the hands of Christ's earthly heirs, the priests and bishops. In the Mass, the central liturgy of the earthly church, the bread and wine on the altar became the body and blood of Christ, the "Eucharist." Through the Mass the faithful were joined to one another; to the souls of the dead, who were remembered in the liturgy; and to Christ himself.

The importance of the Mass was made clear in the very architecture and decoration of Christian churches. In the sixth-century church of San Vitale in Ravenna, an apse (a semicircular niche) forms a brilliant marble and mosaic halo around the altar. Above the altar, a half dome presents an image of heaven, while just beneath the heavens, on either side of three lofty windows, are full-length figures of the emperor (on the left) and empress (on the right) along with their retinues. They are bringing offerings for the altar. (See Plate I.12 and further discussion on pp. 31–33). In this way, imperial power was associated with the Eucharist and the Mass.

The Eucharist was one potent source of God's grace. There were others. Above all, there were certain people so beloved by God, so infused with his grace, that they were both models of virtue and powerful wonder-workers. These were the saints. In the early church, the saints had largely been the martyrs, who died for their faith. But Christian martyrdom ended with Constantine. The new saints of the fourth and fifth centuries had to find ways to be martyrs even while alive. Like Saint Symeon Stylites (c.390–459), they climbed tall pillars and stood there for decades; or, like Saint Antony (250–356), they entered tombs to fight, heroically and successfully, with the demons (whose reality was as little questioned as the existence of neutrons is today). They were the "athletes of Christ," greatly admired by the surrounding community. Purged of sin by their ascetic rigors—giving up their possessions, fasting, praying, not sleeping, not engaging in sex—holy men and women offered compelling role models. Twelve-year-old Asella, born into Roman high society, was inspired by such models to remain a virgin: she shut herself off from the world in a tiny cell where, as her admirer Saint Jerome put it, "fasting was her pleasure and hunger her refreshment." This sounds a bit like Manichaeism, and the similarities are

certainly real. But Jerome also spoke admiringly of Asella's devotion to martyrs' shrines, very much part of the material world and yet, in orthodox Christianity, godly as well.

Beyond offering models of Christian virtue, the saints interceded with God on behalf of their neighbors and acted as social peace-keepers. Saint Athanasius told the story of Saint Antony: after years of solitude and asceticism the saint emerged

as if from some shrine, initiated into the mysteries and filled with God.... When he saw the crowd [awaiting him], he was not disturbed, nor did he rejoice to be greeted by so many people. Rather, he was wholly balanced, as if he were being navigated by the Word [of God] and existing in his natural state. Therefore, through Antony the Lord healed many of the suffering bodies of those present, and others he cleansed of demons. He gave Antony grace in speaking, and thus he comforted many who were grieved and reconciled into friendship others who were quarreling.⁸

Healer of illnesses, mediator of disputes, worker of wonders, Antony's power was spiritual, physical, and judicial combined.

But who was in charge of such power; who had the right to control it? Bishop Athanasius of Alexandria laid claim to Antony's legacy by writing about it. Yet writing was only one way to appropriate and harness the power of the saints. When holy men and women died, their power lived on in their relics (whatever they left behind: their bones, hair, clothes, sometimes even the dust near their tombs). Pious people knew this very well. They wanted access to these "special dead." Rich and influential Romans got their own holy monopolies simply by moving saintly bones home with them. Plate 1.9 on p. 21 shows the wall of just such a house, decorated with the image of an orant (a praying figure), perhaps a martyr-saint, and two kneeling women. Above them, hidden and yet tantalizingly present behind a grate, were the precious remains of martyrs.

Men like Saint Ambrose (339–397), bishop of Milan, tried to make clergymen, not pious laypeople, the overseers of relics. Ambrose had the newly discovered relics of Saints Gervasius and Protasius moved from their original resting place into his newly built cathedral and buried under the altar, the focus of communal worship. In this way, he allied himself, his successors, and the whole Christian community of Milan with the power of those saints. But laypeople continued to find private ways to keep precious bits of the saints near to them, wearing them in rings, lockets, purses, and belt buckles.

Art from the Provinces to the Center

Just as Christianity came from the periphery to transform the center, so too did provincial artistic traditions. Classical Roman art, nicely exemplified by paintings on the walls of ancient Roman villas (Plates 1.1, 1.2, and 1.3), was characterized by light and shadow, a sense of atmosphere—of earth, sky, air, light—and a feeling of movement, even in the midst of calm. Figures—sometimes lithe, sometimes stocky, always "plastic,"

suggesting volume and real weight on the ground—interacted, touching one another or talking, and caring little or nothing about the viewer.

Plate 1.1 pictures an event well known to Romans from their myths. A handsome man lifts the veil that covers a beautiful woman, exposing her naked body to their mutual delight. A winged boy, a quiver strapped around his shoulder and an arrow in his hand, hovers nearby, while another boy, below the couple, plays with a man's helmet. Any Roman would know from the "iconography"—the symbolic meaning of the elements—that the man is the god Mars, the woman the goddess Venus, and the two boys are their sons, the winged one Cupid. Venus was married to Vulcan, but she and Mars carried on a passionate love affair until Vulcan caught them in a net as they were embracing and displayed them, to their shame, to all the other gods. The

artist has chosen to depict a happy moment before their capture. Even though the story is illustrated for the pleasure of its viewers, the figures act as if no one is looking at them. They are self-absorbed, glimpsed as if through a window onto their private world.

That world was recognizably natural, much like the one the viewers lived in. In Plate 1.2 an orchard is the focus. A large tree dominates the scene, with an imposing figure, naked except for a lion skin. It's Hercules on one of his final labors: to gather the golden apples that will bring life after death. The golden scarf on the tree announces its sacredness. Two of the golden apples are already on a rock just visible at the lower right. Although this labor required Hercules to kill numerous opponents and, in the most common variant, to hold up the world on his shoulders in the place of Atlas, the artist shows none of that: his emphasis is on the natural world, here interpreted as both tranquil and grand.

Roman artists were also interested in busy, everyday life. Plate 1.3 is one panel of an extensive fresco painted in a corridor of the Villa Farnesina, located in a suburb of Rome. It features lithe figures painted with rapid brushstrokes and engaged in various activities. Some (on the far left) fill water jugs at a fountain. Others ready their fishing nets. Still others pass by a two-story villa delineated by interlocking blocks. Behind, connected by a bridge across the water, are the faint outlines of a building that may be a temple. The Villa Farnesina itself was too far from Rome's working port for this to represent its local

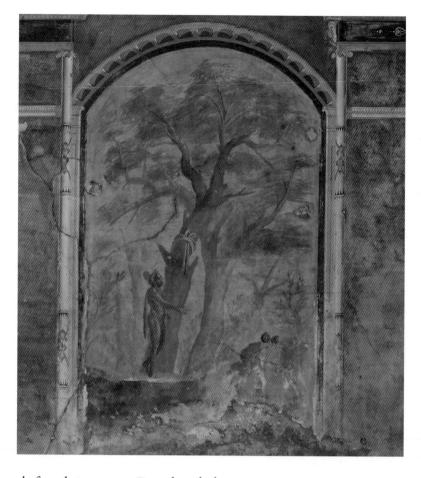

Plate 1.1 (facing page) Mars and Venus, Pompeii (1st cent.). Venus, goddess of love and beauty, and Mars, god of war, are utterly absorbed in both themselves and one another as they adorn the wall of a private house at Pompeii.

Plate 1.2 Hercules in the Garden of the Hesperides, Oplontis (c.10–1 BCE).
Decorating one panel in the caldarium (hot tub room) of a villa at Oplontis (near Pompeii), this landscape features a hazy blue sky and trees that stretch into the distance. The artist of this painting created the illusion of space, air, and light directly on the flat surface of a wall.

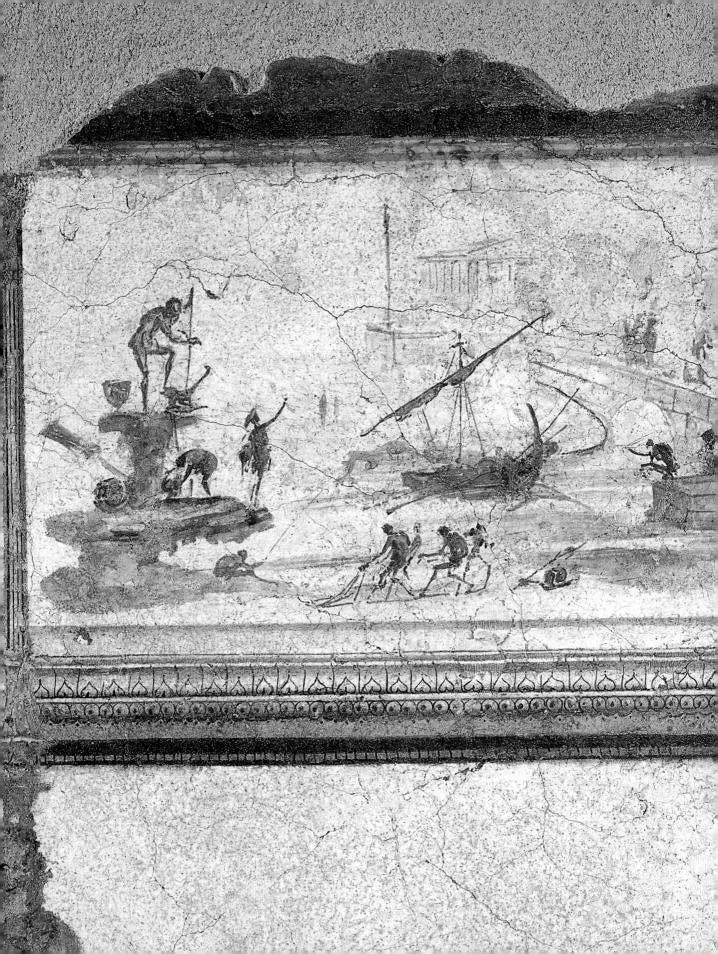

Plate 1.3 (previous page)
Harbor Scene (late 1st cent.
BCE). One of many painted
panels in a long corridor at the
Villa Farnesina, the scene seems
to evoke the outside world even
as it idealizes it.

Plate 1.4 Euhodus Sarcophagus (c.161–170). The sculptors have used a trick of perspective—carving the figures at different depths—to make some literally stand out and others recede.

Note the veiled woman at the right: she is the spirit of Alcestis, returned from the dead.

landscape. But the likely owner, the Roman statesman and architect Agrippa, had in fact built a bridge over the Tiber and thus was personally involved in the very fabric of the city as depicted here.

Roman sculptors, like painters, were also interested in movement and three-dimensionality. They showed figures turning and interacting with one another, and they created space by playing on the optical illusion of "perspective," where some elements seem to recede while others—smaller, less precisely delineated—come to the fore. Consider a marble sarcophagus carved for Euhodus and his wife, Metilia Acte, both of whom were prestigious office-holders at Ostia (near Rome). Here the sculpture tells the story of Alcestis, a virtuous wife who volunteered to die in place of her young husband, King Admetus. After her death, the god Apollo persuaded the Fates to let her return to the world, and Hercules brought her back as a spirit. The sarcophagus's sculptors made Alcestis's death the central focus: she reclines on a long couch, while Admetus reaches toward her as if to embrace her one last time. To give the scene extra meaning and poignancy, the carvers have given Alcestis the face of Metilia Acte, while Admetus has the face of the old Euhodus. Like Mars and Venus in Plate 1.1, the sarcophagus shows two people utterly absorbed in one another. But the sarcophagus goes further, suggesting that the bond between the husband and wife will endure even beyond the grave.

Yet even in the classical period other artistic values and conventions existed in the Roman Empire—in the provinces. For many years these provincial styles had been tamped down, though not extinguished, by the juggernaut of Roman political and cultural hegemony. But in the third century, with the new importance of the provinces, regional traditions re-emerged. As provincial military men became the new heroes and emperors, artistic tastes changed as well. The center—Rome, Italy, Constantinople—began to borrow its artistic styles from the periphery.

To understand some of these regional traditions, consider the sculpted depiction of Venus from the north of Britain in Plate 1.5 and a tombstone from the region of Carthage—Tunis, Tunisia today—in Plate 1.6. Both of these were made under the shadow of Roman imperial rule. Yet they are little like Roman works of art. Above all, the artists who made these pieces valued clear hierarchies and decorative elements divorced from

natural forms. The Venus from Britain is the center of attention not only because she is right in the middle of the relief but also because she looms over the two other women; she is too tall even to stand up straight. Although clearly based on a classical model, she was created by an artist in love with decoration. The "landscape" on this relief consists of wavy lines; a tree has become a series of diagonal sticks converging on a vertical. The figures do not interact; they look out—beyond one another and even beyond the viewer. All of this gives the relief an otherworldly feel, as if Venus existed in a place that transcended the here and now of the natural world.

The same emphasis on transcendence explains the horizontal zones of the limestone tombstone in Plate 1.6, which announce a hierarchy. In the center of the top zone is a god. In the middle tier are people busying themselves with religious ceremonies. At the bottom, the lowest rung, three people are praying. The proper order of the cosmos, not the natural order, is the focus. The tombstone sculptors flattened their figures, varying them by cutting lines for folds, hands, and eyes. Any sense of movement here comes from the incised patterns, not from the rigidly frontal figures, who do not interact at all. Unlike the Venus and Mars fresco, this tombstone is no window onto a private world; unlike the Euhodus sarcophagus, it betrays no emotions. Rather, it teaches and preaches to those who look at it.

Plate 1.5 Venus and Two Nymphs, Britain (2nd or early 3rd cent.). This relief was originally made to decorate the front of a water tank that stood before the headquarters of the Roman fort at High Rochester (today in Northumberland). This was an outpost of the Roman army, a fort on the road to Scotland. Compare the depiction of Venus here with that of Venus in Plate 1.1 to see the very different notions of the human body and of beauty that co-existed in the Roman Empire.

Plate 1.6 Tombstone, near Carthage (2nd cent.?). The stiff, frontal figures on this relief show the sculptors' delight in order, hierarchy, and decoration.

Plate 1.7 (facing page) Embracing Tetrarchs (c.300). Nearly two feet high, this imperial pair was accompanied by another nearly identical couple, both placed at the mid-point of two separate porphyry columns.

There may be something to the idea that such works of art were "inferior" to Roman products—but not much. The artists who made them had their own values and were not particularly interested in classical conventions. In the third century, even artists at the heart of the empire—at Rome, at Constantinople—adopted the provincial styles. Those conventions spoke best to new needs and interests. The "new" official style is nicely illustrated by the depiction of two emperors in Plate 1.7. Carved out of expensive, "imperial" porphyry stone, it was meant to telegraph amity and authority, not tell a story. When Diocletian divided the empire into four administrative districts, each ruled by a "Tetrarch" (ruler of a quarter), their unity was broadcast in a profusion of just such sculpted images. The two in Plate 1.7 are nearly identical; gone is the impulse (so evident in the Euhodus sarcophagus) to individualize. The sculptor is interested only in the gesture of embrace and the image of power, symbolized by the orbs both men hold in their left hands. Despite their friendliness, they do not look at each other but stare out, even beyond the viewer. Decorative elements—the details of their military garb, the leaves of their laurel wreaths—provide the only relief from the somber message here.

While the Tetrarchs were depicted as equals, other monuments of the fourth century telegraphed hierarchy. Consider a marble base made at Constantinople c.390 to support a gigantic ancient obelisk, transported at great cost from Egypt and set up with considerable difficulty at the

Hippodrome, the great sports arena. (For the location of the Hippodrome, see Map 4.1 on p. 114.) The four-sided base depicts the games and races that took place in the stadium. The side shown in Plate 1.8 is decisively divided into two tiers. At the top are the imperial family and other dignitaries, all formal, frontal, staring straight ahead. Directly in the center is the imperial group, higher than all others. Beneath, in the lower tier, are bearded, hairy-coated barbarians, bringing humble offerings to those on high. The two levels are divided by a decorative frame, a rough indication of the "sky boxes" inhabited by the emperor and his retinue. The folds of the drapery are graceful but stylized. The hairstyles are caps. The ensemble is meant to preach eternal truths: the highness of imperial power and its transcendence of time and place.

Although this style of art was not initially Christian, it was quickly adopted by Christians. It was suited to a religion that saw only fleeting value in the City of Man, sought to transcend the world, and had a message to preach. A good example is the fourth-century wall painting decorating a small confessio—a place where martyrs or their

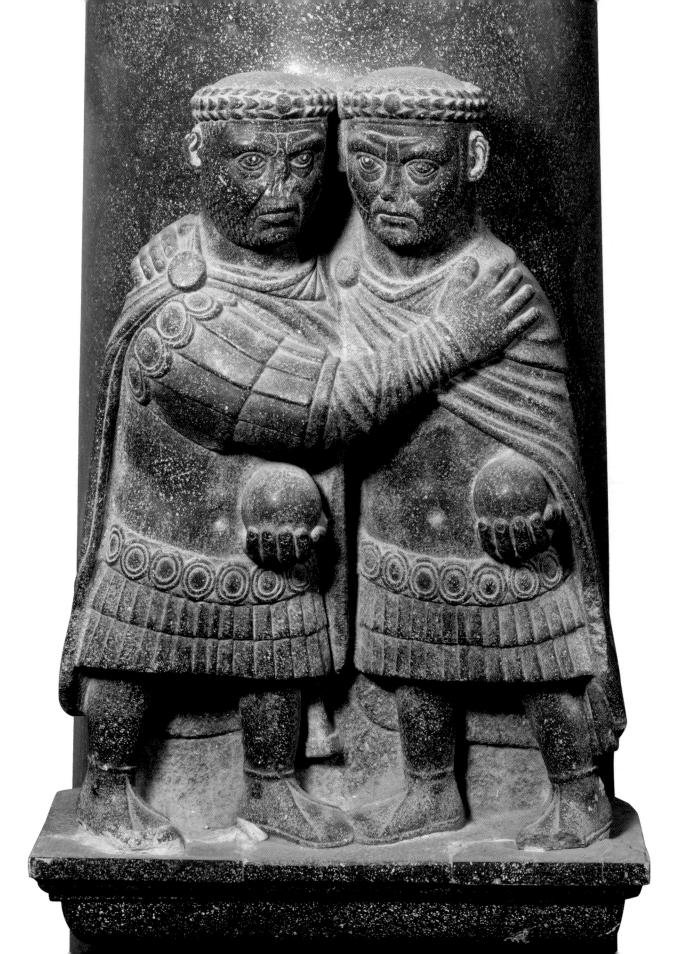

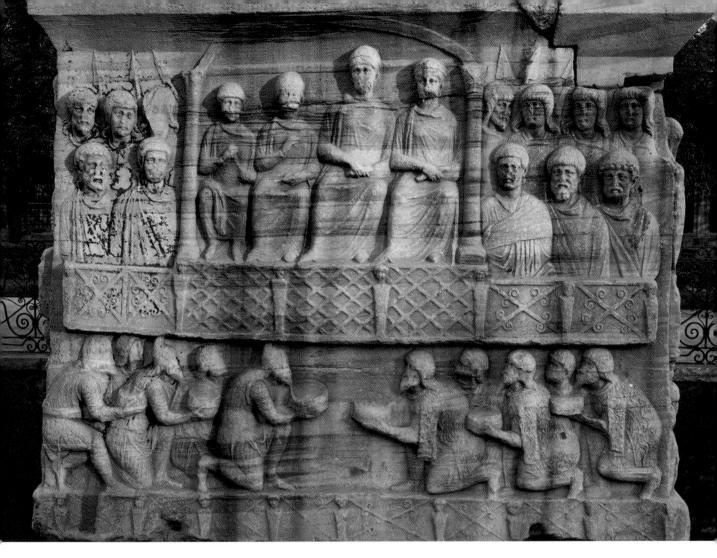

Plate 1.8 Base of the Hippodrome Obelisk (c.390). This carving, placed right in the middle of the most imperial part of Constantinople, was inspired more by the conventions of the Carthage tombstone (Plate 1.6) than by the traditional classical forms of the Euhodus sarcophagus (Plate 1.4).

relics were buried. (See Plate 1.9, also discussed earlier on p. 11.) The wall, originally in an alcove on the landing of a private house in Rome, is today beneath a church dedicated to two martyr-saints, John and Paul. Much like the figures on the tombstone in Plate 1.6, the painting immediately communicates a spiritual hierarchy. Whoever the standing orant might represent (there are conflicting interpretations), it is clear that he dominates the scene while two figures in postures of humility touch his feet. The curtains that frame the scene may symbolize a place of eternal rest. Certainly, the fresco, like the tombstone, marked a burial site, since behind the grill above the orant were the remains of a martyr or martyrs. Like the figures on the tombstone, those in the fresco have no weight, exist in no landscape, and interact with no one. We shall continue to see the influence of this transcendent style throughout the Middle Ages.

Nevertheless, around the very same time as this fresco was produced, classical artistic styles were making a brief comeback even in a Christian context. Sometimes called the "renaissance of the late fourth and early fifth centuries," this was the first of many recurring infusions of the classical spirit in medieval art. Consider the sarcophagus of Junius

Bassus, carved in 359 (Plate 1.10). Look at just the bottom central panel, which depicts a man on a horse-like donkey. Two young men greet him, one peeking out from behind an oak tree, the other laying down a cloak. The rider's garment drapes convincingly around his body, which has weight, volume, and plasticity. There is a sense of depth and lively human interaction, just as there was in the Euhodus sarcophagus (Plate 1.4). But this is a Christian coffin, and the rider is Christ, entering Jerusalem.

THE BARBARIANS

The classicizing style exemplified by Junius Bassus's coffin did not long survive the sack of Rome by the Visigoths in 410. The sack was a stunning blow. Like a married couple in a bitter divorce, both Romans and Goths had once wooed one another; they then became mutually and comfortably dependent; eventually they fell into betrayal and strife. Nor was the Visigothic experience unique. The Franks, too, had been

recruited into the Roman army, some of their members settling peacefully within the imperial borders. The Burgundian experience was similar.

The Romans called all these peoples "barbarians," though, borrowing a term from the Gauls, they designated those beyond the Rhine as "Germani"—Germans. Historians today tend to differentiate these peoples linguistically: "Germanic peoples" are those who spoke Germanic languages. Whatever name we give them (they certainly had no collective name for themselves), these peoples were not nomads (as an earlier generation of historians believed) but rather accustomed to a settled existence. Archaeologists have found evidence in northern Europe of some of their hamlets, built and inhabited for centuries before any Germanic groups entered the Empire. A settlement near Wijster, near the North Sea (today in the Netherlands; see p. 22), is a good example of one such community. Inhabited largely between c.150 and c.400, it consisted of well over fifty large rectangular wooden houses—these were partitioned so that they could be shared by humans and animals—and many smaller out-buildings, some of which were used as barns or workrooms, others as dwellings. Palisades—fences made of wooden stakes—marked off its streets and lanes. The people who lived at Wijster cultivated grains and raised cattle. They also raised horses, as we know from the fact that they frequently buried their horses

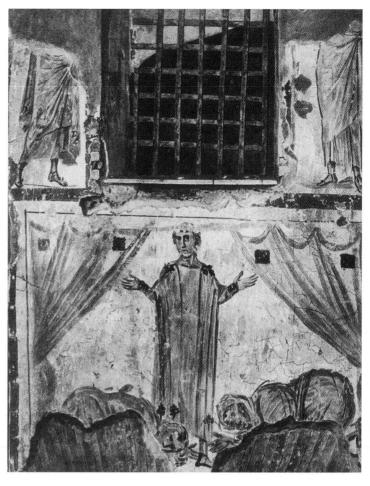

Plate 1.9 Orant Fresco (second half of 4th cent.). In a private house located in a posh neighborhood in Rome, an imposing figure commands the lower wall of a small room serving as a confessio, which contained the remains of martyrs. At the time, the house functioned as a titulus, or community church. We see here the sorts of lay devotional initiatives—a confessio in a private house—that Bishop Ambrose hoped to end.

Plate 1.10 Sarcophagus of Junius Bassus (359). The figures of this relief are carved nearly in the round, and in that sense they are even more "classical" in inspiration than the Euhodus sarcophagus (Plate 1.4). However, the tight compartments in which the figures gesture and interact betray the fourth-century obsession with order. Although the figures could have almost been lifted from any classical sculpture, they are here involved in an entirely Christian story. Reading the scenes from left to right, they portray: (top) Abraham and Isaac: Peter's arrest: Christ enthroned between Saints Peter and Paul, his feet resting on the scarf of Heaven; Christ's arrest; the judgment of Pilate; (bottom) Job sitting on the dunghill, comforted by friends; Adam and Eve; Christ's triumphal entry into Jerusalem; Daniel (clothed by a later, prudish carver, but originally naked) in the lion's den; the arrest of Saint Paul.

Map 1.4 Wijster

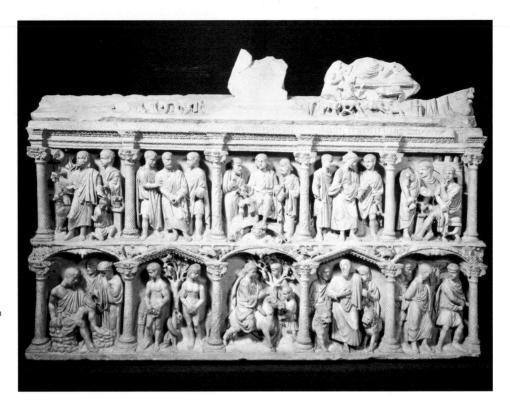

in carefully dug rectangular pits. Some were craftsmen, like the carpenters who built the houses, the ironworkers who made the tools, and the cobbler who made a shoe found on the site. Some were craftswomen, like the spinners and weavers who used the spindle-whorls and loom-weights that were found there.

The disparate sizes of its houses suggest that the community at Wijster was hardly egalitarian. The cemetery there made the same point, since, while most of the graves contained no goods at all, a very few were richly furnished with weapons, necklaces, and jewelry. It seems that the wealthy few also had access to Roman products: archaeologists have unearthed a couple of Roman coins, bits of Roman glass, and numerous fragments of provincial Roman pottery. But even the rich at Wijster were probably not very powerful: it is very likely that here, as elsewhere in the Germanic world, kings leading military retinues lorded it over the community, commanding labor services and a percentage of its agricultural production.

How did the better-off inhabitants of Wijster get their Roman dinnerware? They probably produced surplus enough to trade for other goods. All along the Empire's border, Germanic traders bartered with Roman provincials. No physical trait distinguished buyers from sellers. But barbarians and Romans had numerous *ethnic* differences—differences created by preferences and customs surrounding food, language, clothing, hairstyle, behaviors, and all the other elements that go into a sense of identity. Germanic ethnicities were often in flux as tribes came together and broke apart (and Roman ethnic identity also changed; for example, some began to sport Germanic clothing).

Consider the Goths. Their "ethnogenesis"—the ethnicities that came into being and changed over time—made them not one people but many. If it is true that a group called the "Goths" (Gutones) can be found in the first century in what is today northwestern Poland, that does not mean that they much resembled those "Goths" who, in the third century, organized and dominated a confederation of steppe peoples and forest dwellers of mixed origins north of the Black Sea (today Ukraine). The second set of Goths was a splinter of the first; by the time they got to the Black Sea, they had joined with many other groups. In short, the Goths were multiethnic.

Taking advantage—and soon becoming a part—of the crisis of the third century, the Black Sea Goths invaded and plundered the nearby provinces of the Roman Empire. The Romans responded at first with annual payments to buy peace, but before long they stopped, preferring confrontation. Around 250, Gothic and other raiders and pirates plundered parts of the Balkans and Anatolia (today Turkey). It took many years of bitter fighting for Roman armies, reinforced by Gothic and other mercenaries, to stop these raids. Afterwards, once again transformed, the Goths emerged in what historians have for convenience called two different groups: eastern (Ostrogoths), again north of the Black Sea, and western (Visigoths), in what is today Romania. By the mid-330s the Visigoths were allies of the Empire and fighting in their armies. Some rose to the position of army leaders. By the end of the fourth century, many Roman army units were made up of whole tribes—Goths or Franks, for example—fighting as "federates" for the Roman government under their own chiefs.

This was the marriage.

It fell apart, however, in the later fourth century, when first the Visigoths and soon other barbarian groups demanded entry into the Empire. They were fleeing the Huns, a nomadic people from the semi-arid, grass-covered plains (the "steppeland") of west-central Asia. After invading the Black Sea region in 376, the Huns moved west into what is today Romania, uprooting the Gothic groups living there and driving some to treat with the Romans and enter the Empire.

Barbarians had long been settled within the imperial borders as army recruits. But in this case the numbers were unprecedented: tens of thousands, perhaps even up to 200,000. The Romans were overwhelmed, unprepared, and resentful. They mistreated the refugees woefully, and in 378 a group of Visigoths and other barbarians rebelled, killing Emperor Valens (r.364–378) at the battle of Adrianople. The defeat meant more than the death of an emperor; it badly weakened the Roman army. Because the emperors needed soldiers and the Visigoths needed food and a place to settle, various arrangements were tried: treaties making the Visigoths federates; promises of pay and reward. None worked for long. Led by Alaric (d.410), an army of Visigoths set out to avenge their wrongs and to find land. Map 1.5 traces their long trek across Europe. Their sack of Rome in 410 inspired Augustine to write the *City of God*, but the Visigoths did not remain long in Italy. Joined by many other barbarian groups as well as Roman slaves taking advantage of the mayhem, they settled in southern Gaul by 418 and by 484 had taken most of Spain as well. The impact of the Visigoths on the Roman Empire was so decisive that some historians have taken the

date 378 to mark the end of the Roman Empire, while others have chosen the date 410. (Other historians, to be sure, have disagreed with both dates!)

Meanwhile, beginning late in 406 and perhaps also impelled by the Huns, other barbarian groups—among them Vandals and Sueves—entered the Empire by crossing the Rhine River. They first moved into Gaul, then into Spain. The Vandals crossed into North Africa; the Sueves remained in Spain, though the Visigoths conquered most of their kingdom in the course of the sixth century. When, after the death in 453 of the powerful Hunnic leader Attila, the empire that he had created along the Danubian frontier collapsed, still other groups—Ostrogoths, Rugi, Gepids—moved into the Roman Empire. Each arrived with a "deal" from the Roman government; each hoped to work for Rome and reap its rewards. In 476 the last Roman emperor in the West, Romulus Augustulus (r.475-476), was deposed by Odoacer (433-493), a barbarian (from one of the lesser tribes, the Sciri) leading Roman troops. Odoacer promptly had himself declared king of Italy and, in a bid to "unite" the Empire, sent Romulus's imperial insignia to Emperor Zeno (r.474-491), ruler of the eastern half of the Roman Empire. But Zeno, in turn, authorized Theodoric, king of the Ostrogoths, to attack Odoacer in 489. Four years later, Theodoric's conquest of Italy was complete. Not much later the Franks, long used to fighting for the Romans, conquered Gaul under Clovis (r.481/482–511), a Roman official and king of the Franks, by defeating a provincial governor of Gaul and several barbarian rivals. Meanwhile, other barbarian groups set up their own kingdoms.

Around the year 500 the former Roman Empire was no longer like a scarf flung around the Mediterranean; it was a mosaic. (See Map 1.6.) Northwest Africa was now the Vandal kingdom, Spain the Visigothic kingdom, Gaul the kingdom of the Franks, and Italy the kingdom of the Ostrogoths. The Anglo-Saxons occupied southeastern Britain; the Burgundians formed a kingdom centered in what is today Switzerland. Only the eastern half of the Empire—the long end of the scarf—remained intact.

Map 1.5 The Huns and the Visigoths, *c*.375–450

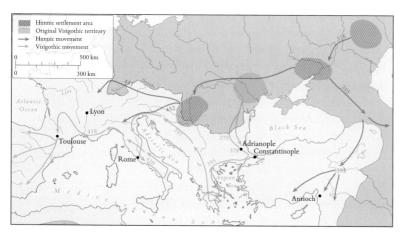

THE NEW ORDER

What was new about the "new order" of the sixth century was less the rise of barbarian kingdoms than it was, in the West, the decay of the cities balanced by the liveliness of the countryside, the increased dominance of the rich, and the quiet domestication of Christianity. In the East, the Roman Empire continued, made an ill-fated bid to expand, and finally retrenched as an autonomous entity: the Byzantine Empire.

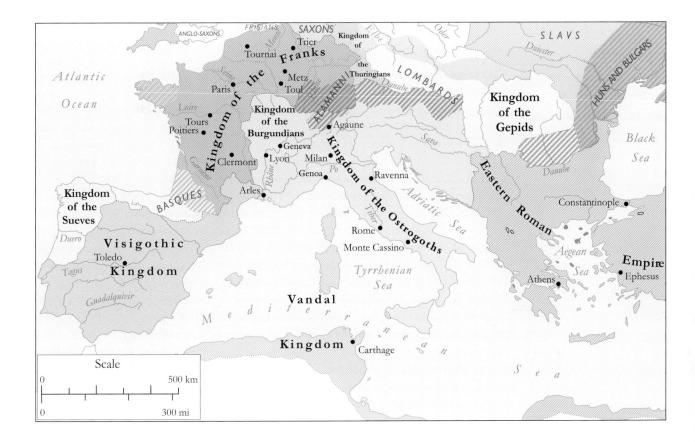

The Ruralization of the West

Map 1.6 The Former Western Empire, c.500

Where the barbarians settled, they did so with only tiny ripples of discontent from articulate Roman elites. How was that possible? Walter Goffart argues that taxes on Roman estates were shared between barbarian kings and their soldiers, with the allotments for the soldiers granted to their heirs as well. In this way, nothing upset traditional Roman property arrangements. Other historians—Matthew Innes is a good example—maintain that the barbarians were settled as "guests" directly on land of Roman property owners. In that case, barbarian kings, influenced by their Roman advisors, managed to defuse outright conflict. In either scenario, the end result was that elite "Romans" and "barbarians" gradually came to belong to the same community of free landowners.

But before this merging could take place, the great barrier to assimilation between Romans and barbarians—divergent religious beliefs—had to be overcome. Recall that Ulfila had preached Arianism to the Goths, and many of the other barbarian groups adopted this brand of Christianity as well. Clovis, king of the Franks, may have been the first Germanic king to choose the Roman version (though, if so, the king of Burgundy was close behind). Clovis had flirted with Arianism early on, but he soon converted to the Catholic Christianity of his Gallic neighbors. Bishop Avitus of Vienne welcomed this move with open arms: "Your faith is our victory."

In other respects as well, the new rulers adopted Roman institutions, issuing laws that drew on Roman imperial precedents like *The Theodosian Code* (see below, p. 30), on regulations governing rural life found in Roman provincial law codes, and possibly on tribal customary law as well. *The Visigothic Code* was drawn up during the course of the fifth through seventh centuries. *The Burgundian Code* was issued in 517 by Sigismund, king of the Burgundians (r.516–524). A Frankish law code was compiled under King Clovis, fusing provincial Roman and Germanic procedures into a single whole.

Written in Latin, these laws revealed their Roman inspiration even in their language. Barbarian kings, some well-educated themselves, depended on classically trained advisors to write up their letters and laws. In Italy, in particular, an outstanding group of Roman administrators, judges, and officers served the Ostrogothic king Theodoric the Great (r.493–526). They included the learned Boethius (d.524/526), who wrote the tranquil Consolation of Philosophy as he awaited execution for treason, and the encyclopedic Cassiodorus (490–583), who wrote letters on behalf of Theodoric in the guise of a pious lawgiver. "As it is my desire, when petitioned, to give a lawful consent, so I do not like the laws to be cheated through my favors, especially in that area where I believe reverence for God to be concerned," Cassiodorus wrote (in Theodoric's name) to Jews at Genoa, allowing them, in accordance with Roman law and reverence for God, to add a roof to their synagogue, but nothing more. Since the fourth century, Romans had become used to barbarian leaders; in the sixth, there was nothing very strange in having them as kings.

Far stranger was the disappearance of the urban middle class. The new taxes of the fourth century had much to do with this. The town councilors—the *curiales*, traditional leaders and spokesmen for the cities—had been used to collecting the taxes for their communities, making up any shortfalls, and reaping the rewards of prestige for doing so. In the fourth century, new land and head taxes impoverished the *curiales*, while very rich landowners—out in the countryside, surrounded by their bodyguards and slaves—simply did not bother to pay. Now the tax burdens fell on poorer people. Pressed to pay taxes they could not afford, families escaped to the great estates of the rich, giving up their free status in return for land and protection. By the seventh century, the rich had won; the barbarian kings no longer bothered to collect general taxes.

The cities, most of them walled since the time of the crisis of the third century, were no longer thriving or populous, though they remained political and religious centers. Tours (in Gaul), for example, protected its episcopal complex with a wall built c.400. (See Map 1.7.) But few people apart from the bishop and his entourage actually lived within those walls any longer. At the same time, in a cemetery that the Romans had carefully sited outside the city, a new church rose over the tomb of the local saint, Martin. This served as a magnet for the people of the surrounding countryside and even farther away. A baptistery was constructed nearby, to baptize the infants of pilgrims and others who came to the tomb hoping for a miracle. Sometimes people stayed for years. Gregory, bishop of Tours (r.573–594), our chief source for the history of Gaul in the sixth century, described Monegundis, a very pious woman:

[she] left her husband, her family, her whole house, and went, full of faith, to the basilica of the holy bishop Martin. [After curing a sick girl on her way, she] arrived at the basilica of St Martin, and there, on her knees in front of the tomb, she gave thanks to God for being able to see the holy tomb with her own eyes. She settled herself in a small room [nearby] in which she gave herself every day to prayer, fasts and vigils."

With people like Monegundis flocking to the tomb, it is no wonder that archaeologists have found evidence of semi-permanent habitations right at the cemetery.

The shift from urban to rural settlements brought with it a new localism. The active long-distance trade of the Mediterranean slowed down, and although it did not stop, it penetrated very little beyond the coast. Consider the fate of pottery, a cheap necessity in the ancient world. In the sixth century, fine mass-produced African red pottery adorned even the humblest tables along the

Mediterranean Sea coast. Inland, however, most people had to make do with local hand-made wares, as regional networks of exchange eroded long-distance connections.

For some—the rich—the new disconnection of the rural landscape from the wider world hardly mattered. Bishop Gregory of Tours, who wrote about Monegundis, reported that greedy bishops sent an armed force against Bishop Victor right in the midst of his birthday celebration: "The attackers ripped his clothes, struck down servants and took away vessels and all the utensils of the feast, leaving the bishop grossly insulted." Clearly Bishop Victor was used to living well. Indeed, bishops were among the rich; many rose to their episcopal status in their twilight years, after they had married and had sired children to inherit their estates. (Their wives continued to live with them but—or so it was expected—not to sleep with them.) Great lay landlords, kings, queens, warriors, and courtiers controlled and monopolized most of the rest of the wealth of the West, now based largely on land.

Monasteries, too, were becoming important corporate landowners. In the sixth century, many monks lived in communities just far enough away from the centers of power to be holy, yet near enough to be important. Monks were not quite laity (since they devoted their entire life to religion), yet not quite clergy (since they were only rarely ordained), but something in between and increasingly admired. It is often said that Saint Antony was the "first monk," and though this may not be strictly true, it is not far off the mark. Like Antony, monks lived a life of daily martyrdom, giving up their wealth, family ties, and worldly offices. Like Antony, who eventually gave up the solitary life, monks lived in communities. Some communities were of men only, some of women, some of both

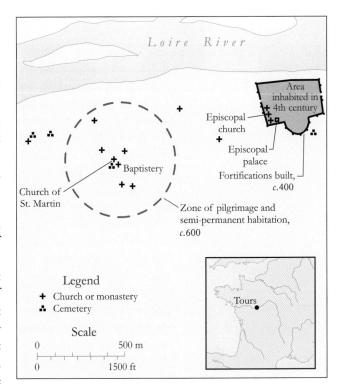

Map 1.7 Tours, c.600

(in separate quarters). Whatever the sort, monks lived in obedience to a "rule" that gave them a stable and orderly way of life.

The rule might be unwritten, as it was at Saint-Maurice d'Agaune, a monastic community set up in 515 by Sigismund on the eve of his accession to the Burgundian throne. The monks at Agaune, divided into groups that went to the church in relay, carried out a grueling regime of non-stop prayer every day. Built outside the Burgundian capital of Geneva, high on a cliff that was held to be the site of the heroic martyrdom of a Christian Roman legion, this monastery tapped into a holy landscape and linked it to Sigismund and his episcopal advisors.

Other rules were written. Caesarius, bishop of Arles (r.502–542) wrote one for his sister, the "abbess" (head) of a monastery of women. He wrote another for his nephew, the "abbot" of a male monastery. In Italy, Saint Benedict (d.c.550/560) wrote the most famous of the monastic rules at some time between 530 and 560. With its adoption, much later, by the Carolingian kings of the ninth century, it became the monastic norm in the West. Unlike the rule of Agaune, where prayer was paramount, the Benedictine Rule divided the day into discrete periods of prayer, reading, and labor. Nevertheless, the core of its program, as at Agaune, was the "liturgy"—not just the Mass, but also an elaborate round of formal worship that took place seven times a day and once at night. At these specific times, the monks chanted—that is sang—the "Offices," most of which consisted of the psalms, a group of 150 poems in the Old Testament:

During wintertime ... first this verse is to be said three times: "Lord, you will open my lips, and my mouth will proclaim your praise." To that should be added Psalm 3 and the Gloria [a short hymn of praise]. After that, Psalm 94 with an antiphon [a sort of chorus], or at least chanted. Then an Ambrosian hymn [written by Saint Ambrose of Milan] should follow, and then six psalms with antiphons. 13

By the end of each week the monks would have completed all 150 psalms.

Benedict's monastery, Monte Cassino, was in the shadow of the city of Rome, far enough to be an "escape" from society but near enough to link it to the papacy. Pope Gregory the Great (590–604), arguably responsible for making the papacy the greatest power in Italy, took the time to write a biography of Benedict and praise his Rule. Monks may have renounced wealth and power individually, but monasteries became partners of the wealthy and powerful and benefited from their largess. The monks were seen as models of virtue, and their prayers were thought to reach God's ear. It was crucial to ally with them.

Little by little the Christian religion was domesticated to meet the needs of the new order, even as it shaped that order to fit its demands. Monegundis was not afraid to go to the cemetery outside of Tours. There were no demons there; they had been driven far away by the power of Saint Martin. Just as Benedict's monasteries had become perfectly acceptable alternatives to the old avenues of male prestige—armies and schools—so Monegundis's little cell became home to a group of pious women who found their vocation in the

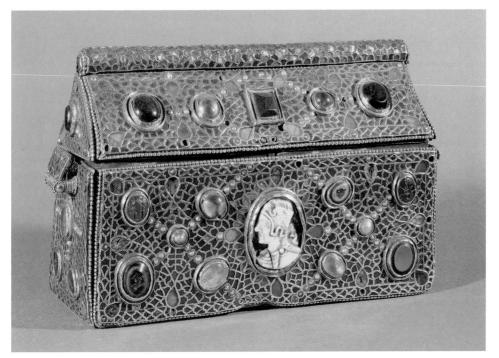

Plate 1.11 Reliquary of Theuderic (late 7th cent.). A small box shaped like a miniature sarcophagus and made of cloisonné enamel (bits of enamel framed by metal) richly adorned with semi-precious stones, this reliquary is inscribed on the back, "Theuderic the priest had this made in honor of Saint Maurice." Paying for the creation of a reliquary—suitable housing for the remains of the saints—was itself an act of piety.

religious life rather than marriage. When Monegundis was about to die, they acted to perpetuate the community she had founded, begging her "to bless some oil and salt that we can give to the sick who ask for a blessing." She did so, and they "preserved [it] with great care." ¹⁴ No doubt they kept the oil in a precious container, just as the monastery of Saint-Maurice d'Agaune kept some of its saintly relics in a gorgeous reliquary studded with garnets, glass gems, and a cameo (Plate 1.11). Relics like Monegundis's oil or Saint Martin's tomb brought the sacred into the countryside and into the texture of everyday life.

Retrenchment in the East

After 476 there was a "new order" in the East as well as the West, but initially the changes were less obvious. For one thing, there was still an emperor with considerable authority. The towns continued to thrive, and the best of the small-town educated elite went off to Constantinople, where they found good jobs as administrators, civil servants, and financial advisors. While barbarian kings in the West were giving in to the rich and eliminating general taxes altogether, the eastern emperors were collecting state revenues more efficiently than ever. Emperor Justinian (r.527–565) had the money to wage major wars—though failing to revive the Roman Empire of the first centuries—even as he rebuilt Hagia Sophia ("Holy Wisdom"), the great church of Constantinople, when it burned down. Ten thousand workers covered its domed ceiling with gold and used 40,000 pounds of silver for its decoration. When a terrible plague hit the whole Mediterranean region and beyond in the 540s, Justinian (after whom historians have named the plague) paid to dispose of

Figure 1.1 San Vitale, Ravenna, Reconstructed Original Ground Plan, 6th cent.

the rotting corpses piled up along the shore of Constantinople. He hired workers to build stretchers, carry out the bodies, and deposit the remains in burial pits. (Pope Gregory the Great had a more spiritual response to a later wave of the same plague: he called for "tears of penitence" rather than grave diggers. ¹⁵)

Nevertheless, the eastern Roman Empire was not the old Roman Empire writ small. When the Visigoths sacked Rome, the eastern emperor Theodosius II (r.408–450) did not send an army; he built walls around Constantinople instead. When the roads fell into disrepair, Justinian let many of them decay. When the Slavs pressed on the Roman frontier in the Balkans, Justinian let them enter. The Plague of Justinian, which continued to attack sporadically until the mid-eighth century, led to manpower and revenue shortages.

In the fifth and sixth centuries, the Eastern half of the Empire reorganized itself. For the first time, emperors issued compendia of Roman laws. *The Theodosian Code*, which gathered together imperial "constitutions" (general laws) alongside "rescripts" (rulings on individual cases), was published in 438. Western barbarian law codes of the sixth century attempted to match this achievement, but they were overshadowed by the great legal initiatives of Justinian, which included an imperial law code known as the *Codex Justinianus* (529, revised in 534), and the *Digest* (533), an orderly compilation of Roman juridical thought from the pre-imperial period onward. From then on the laws of the eastern Roman Empire were largely (though not wholly) fixed, though Justinian's books were soon eclipsed by short summaries in Greek, while in the West they had little impact until the twelfth century.

Above all, the emperor in the East took on the image of concentrated power associated with the ceremony and pomp of the Persian "king of kings," combining it with an exalted role in the Christian church. San Vitale at Ravenna offers a dazzling example. It was built by successive bishops of Ravenna: Ecclesius, Victor, and Archbishop Maximianus.

Constructed in the unusual form of an octagon (see Figure 1.1), San Vitale is topped by a lofty dome and glows with marble and mosaics. Its main apse—directly behind the altar—seamlessly merges heaven and earth, church and state. Plate 1.12 conveys an idea of the whole as the viewer (perhaps a priest entering to celebrate the Eucharist, or others entering the church in liturgical procession at one of the building's many doors) might have seen it. The plate shows the central half dome of the apse: beneath a youthful Christ, flanked by angels and sitting on a blue orb, run the Four Rivers of Paradise. Lilies and roses bloom on the rocky ground. The two angels flanking Christ look away from him, attending to the two men at their sides. These are, on the viewer's right, Bishop Ecclesius, who offers Christ a model of the very church of San Vitale; and on the left, Saint Vitalis (after whom the church is named), who accepts the crown of martyrdom from Christ.

Three large windows below this heavenly scene light the apse. On either side are mosaic panels depicting (on the viewer's left) Emperor Justinian and (on the right) Empress Theodora. Justinian, the central and largest figure in his panel, has a halo and wears a crown. He holds a large golden paten—the bowl that contains the bread of the Eucharist—and offers it in the direction of both Christ above him and the altar, which would have been below. To his left is a bishop carrying a gem-studded gold cross; the name MAXIMIANUS is boldly outlined above his head. Both the name and the face of Maximianus were added to the mosaic after it was first made. Maximianus was Justianian's appointee at Ravenna, and he here found a way to permanently associate himself with the imperial majesty. Behind Maximianus are other churchmen bringing more precious objects to the altar. On Justinian's right-hand side are members of his court: aristocrats and soldiers. It is no accident that the total number of people led by Justianian is twelve (or possibly thirteen), like the apostles of Jesus.

Facing the emperor's panel is a similar one for the empress. She, too, has a halo, and her garment (the same sort of purple *chlamys* that Justinian wears) has at the hem an image of the three Magi offering gifts to the Christ Child. Like them, Theodora is making an offering: she holds out to Christ (above her) and to the altar (below) a gold chalice, the vessel for the wine of the Eucharist. To her left are a group of splendidly dressed women, representing her retinue. To her right are two men of high rank.

The entire complex—reading it from the viewer's right to left—depicts a circle of gift-giving and mutual generosity: Theodora offers a chalice to Christ and the altar, Ecclesius gives a church to Christ, Christ presents a crown to Vitalis, and finally Emperor Justinian completes the circle by offering the paten back to Christ and the altar on which Christ's sacrifice is celebrated.

What were Justinian and Theodora doing in Ravenna? Hadn't the Ostrogoths conquered Italy in the fifth century, making Ravenna the seat of their royal government? The answer is that Justinian reconquered Italy as part of his bid to recapture the glory and territory of the old Roman Empire. His armies quickly took North Africa from the Vandals in 534. They added a strip of southeastern Spain in 552 and went on to wrench—but only with great difficulty—Italy from the Ostrogoths. Only the first enterprise was fairly successful; Eastern Roman rule lasted in North Africa for another century. The last venture, however,

Following pages:

Plate 1.12 San Vitale, Ravenna, Apse Mosaics (mid-6th cent.). The warm colors of the apse mosaics—especially greens and golds—emphasize the rich abundance of the offerings brought to the altar by emperor and empress, a theme mirrored by the intersecting cornucopias that frame the image of Christ and his companions in heaven.

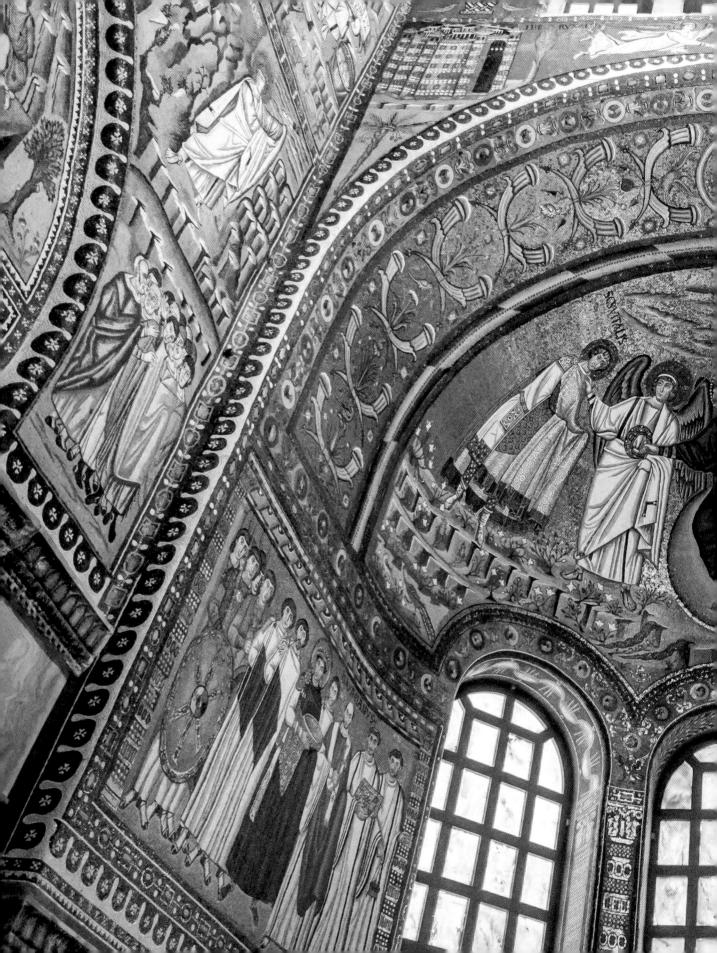

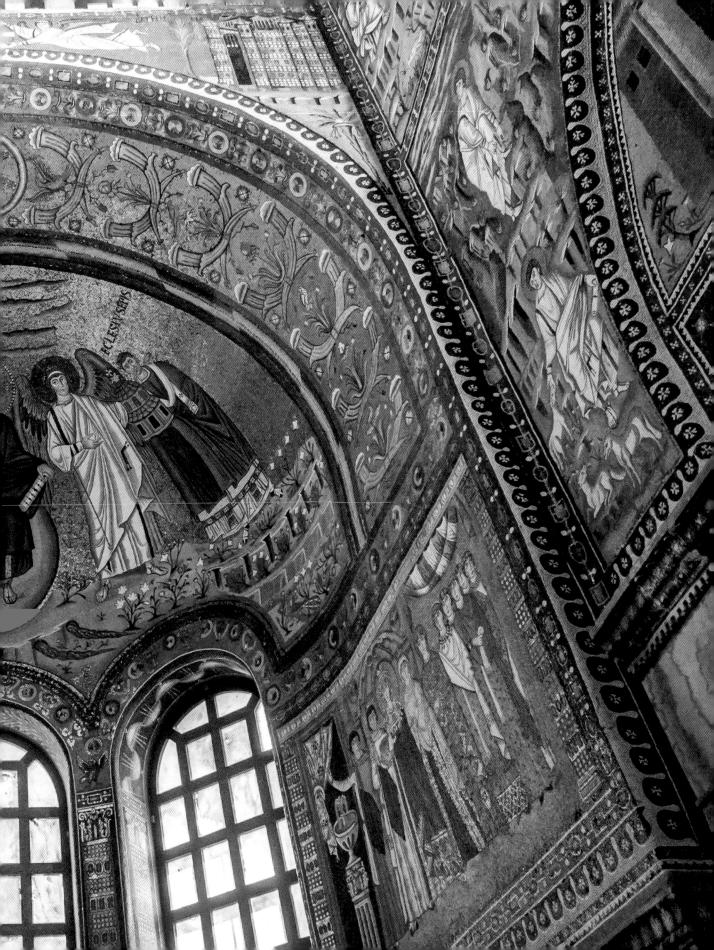

Map 1.8 Europe, the Eastern Roman Empire, and Persia, *c.*600

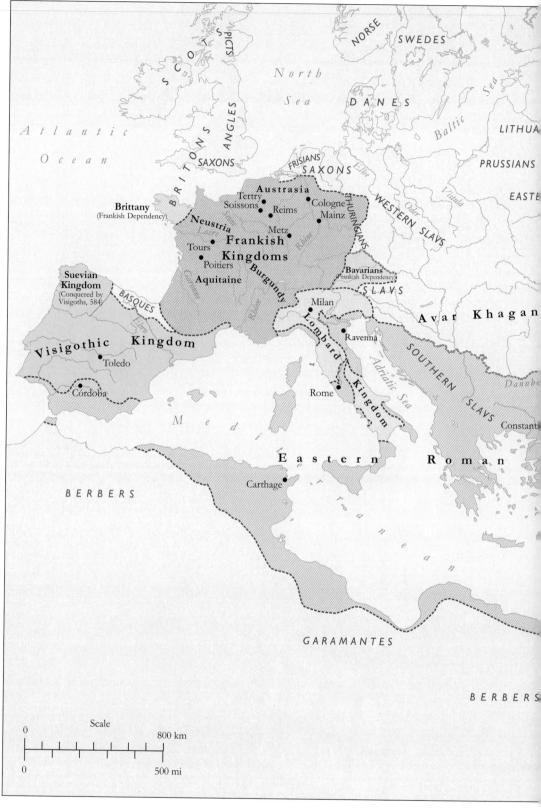

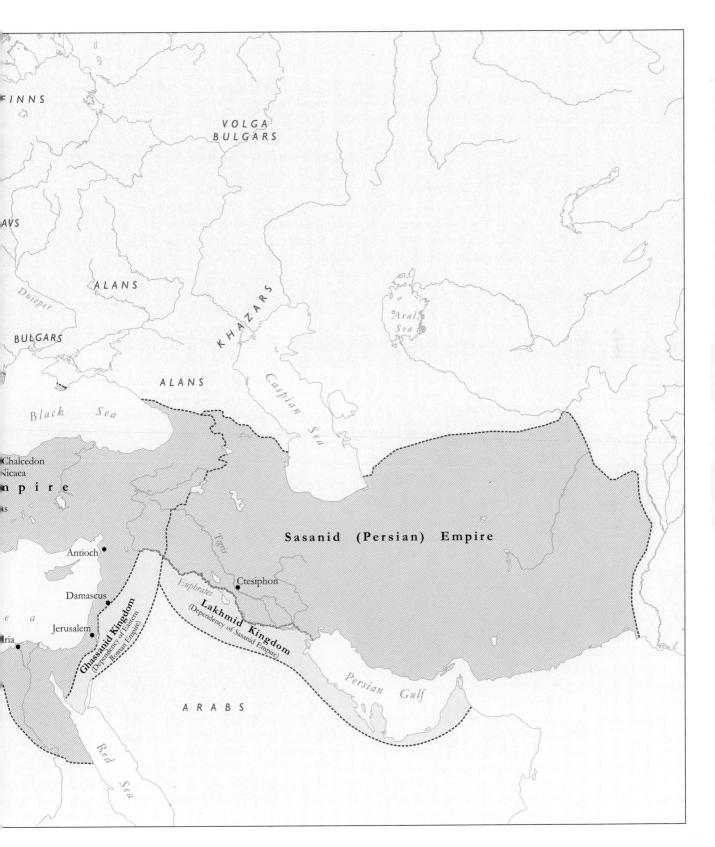

was nearly a disaster. The long war in Italy, which began in 535 and ended only in 553, devastated the country. Soon the Lombards, Germanic warriors employed by Justinian to help take Italy, returned to Italy on their own behalf. By 572 they were masters of part of northern Italy and, further south, of Spoleto and Benevento. Only an hour-glass-shaped strip of land running from Ravenna to Rome remained to the "Romans" of the East (See Map 1.8.)

For the Eastern Roman Empire, the western undertaking was a sideshow. The Empire's real focus was on the Sasanid Empire of the Persians. The two "super-powers" confronted one another with wary forays throughout the sixth century. They thought that to the winner would come the spoils. Little did they imagine that the real winner would be a new and unheard-of group: the Muslims.

* * * * *

The crisis of the third century demoted the old Roman elites, bringing new groups to the fore. Among these were the Christians, who insisted on one God and one way to understand and worship him. Made the official religion of the Empire under Theodosius, Christianity redefined the location of the holy: no longer was it in private households or city temples but in the precious relics of the saints and the Eucharist; in those who ministered on behalf of the church on earth (the priests, bishops, and emperors); and in those who led lives of ascetic heroism (the monks).

Politically the Empire, once a vast conglomeration of conquered provinces, was in turn largely conquered by its periphery. In spite of themselves, the Romans had tacitly to acknowledge and exploit the interdependence between the center and the hinterlands. They invited the barbarians in, but then declined to recognize the needs of their guests. That repudiation came too late. The barbarians were part of the Empire, and in the western half they took it over. In the next century, they would show how much they had learned from their former hosts.

CHAPTER ONE: ESSENTIAL DATES

- 306-337 Reign of Emperor Constantine
 - 313 Edict of Milan; toleration of all religions in Empire
 - 325 Council of Nicaea; laws and doctrines of Christianity declared
 - 378 Battle of Adrianople; Emperor Valens killed by Visigoths
 - 380 Edict of Thessalonica; Christianity becomes the official religion of the Roman Empire
 - 410 Visigoths sack Rome
 - 476 Deposition of Romulus Augustulus, last Roman emperor in the West
- 590-604 Pope Gregory the Great

NOTES

- I The Edict of Milan, in Reading the Middle Ages: Sources from Europe, Byzantium, and the Islamic World, 3rd ed., ed. Barbara H. Rosenwein (Toronto: University of Toronto Press, 2018), p. 3.
- 2 The Nicene Creed, in Reading the Middle Ages, p. 11.
- 3 Ibid.
- 4 Manichaean Texts, in Reading the Middle Ages, p. 10-11.
- 5 The Confessions of Saint Augustine 8.4, trans. Rex Warner (New York: Mentor, 1963), p. 166.
- 6 Augustine, City of God, in Reading the Middle Ages, p. 20.
- 7 Jerome, Letter 24 (To Marcella), in Reading the Middle Ages, p. 29.
- 8 Athanasius, Life of St. Antony of Egypt, in Reading the Middle Ages, p. 34.
- 9 Avitus of Vienne, Letter to Clovis, in Reading the Middle Ages, p. 43.
- 10 Cassiodorus, Variae (State Papers), in Reading the Middle Ages, p. 41.
- II Gregory of Tours, The Life of Monegundis, in Reading the Middle Ages, p. 40.
- 12 Gregory of Tours, Histories, in Reading the Middle Ages, p. 52.
- 13 The Benedictine Rule, in Reading the Middle Ages, p. 24.
- 14 Gregory of Tours, The Life of Monegundis, in Reading the Middle Ages, p. 40.
- 15 Gregory the Great, Letter to Bishop Dominic of Carthage, in Reading the Middle Ages, p. 7.

FURTHER READING

Brown, Peter. "Enjoying the Saints in Late Antiquity." *Early Medieval Europe* 9, no. 1 (2000): 1–24. Burrus, Virginia, ed. *Late Ancient Christianity*. Minneapolis: Fortress Press, 2010.

Deliyannis, Deborah Mauskopf. *Ravenna in Late Antiquity*. Cambridge: Cambridge University Press, 2010.

- Demacopoulos, George E. *Gregory the Great: Ascetic, Pastor, and First Man of Rome.* Notre Dame: University of Notre Dame Press, 2015.
- Fleming, Robin. Britain after Rome: The Fall and Rise, 400 to 1070. London: Penguin, 2010.
- Goffart, Walter. "The Technique of Barbarian Settlement in the Fifth Century: A Personal, Streamlined Account with Ten Additional Comments." *Journal of Late Antiquity* 3, no. 1 (2010): 65–98.
- Heather, Peter. *Empires and Barbarians: Migrations, Development and the Birth of Europe*. London: Macmillan, 2009.
- Heinzelmann, Martin. *Gregory of Tours: History and Society in the Sixth Century*. Trans. Christopher Carroll. Cambridge: Cambridge University Press, 2001.
- Innes, Matthew. "Land, Freedom and the Making of the Medieval West." *Transactions of the Royal Historical Society* 16 (2006): 39–74.
- Johnson, Scott Fitzegerald, ed. *The Oxford Handbook of Late Antiquity*. Oxford: Oxford University Press, 2012.
- Little, Lester K., ed. *Plague and the End of Antiquity: The Pandemic of 541–750*. Cambridge: Cambridge University Press, 2007.
- Mitchell, Stephen. A History of the Later Roman Empire. 2nd ed. Chichester: Wiley Blackwell, 2015.
- O'Donnell, James J. Pagans: The End of Traditional Religion and the Rise of Christianity. New York: HarperCollins, 2015.
- Potter, David. Theodora: Actress, Empress, Saint. Oxford: Oxford University Press, 2015.
- Scott, Sarah, and Jane Webster, eds. *Roman Imperialism and Provincial Art*. Cambridge: Cambridge University Press, 2003.
- Tuck, Steven L. A History of Roman Art. Chichester: Wiley Blackwell, 2014.
- Ward-Perkins, Bryan. The Fall of Rome: And the End of Civilization. Oxford: Oxford University Press, 2005.

To test your knowledge of this chapter, please go to www.utphistorymatters.com for Study Questions.

PART I THREE CULTURES FROM ONE

TWO

THE EMERGENCE OF SIBLING CULTURES

(c.600-c.750)

The rise of Islam in the Arabic world and its triumph over territories that for centuries had been dominated by either Rome or Persia is the first astonishing fact of the seventh and eighth centuries. The second is the persistence of the Roman Empire both politically, in what historians call the "Byzantine Empire," and culturally, in the Islamic world and Europe. By 750 three distinct and nearly separate civilizations—Byzantine, European, and Islamic—crystallized in and around the territory of the old Roman Empire. They professed different values, struggled with different problems, adapted to different standards of living. Yet all three bore the marks of common parentage—or, at least, of common adoption. They were sibling heirs of Rome.

SAVING BYZANTIUM

In the seventh century, the eastern Roman Empire was so transformed that by convention historians call it something new, the "Byzantine Empire," from the old Greek name for Constantinople: Byzantium. (Often the word "Byzantium" alone is used to refer to this empire as well.) War, first with the Sasanid Persians, then with the Arabs, was the major transforming agent. Gone was the ambitious imperial reach of Justinian; by 700, Byzantium had lost all its rich territories in North Africa and its tiny Spanish outpost as well. (See Map 2.2.) True, it held on tenuously to bits and pieces of Italy and Greece. But in the main it had become a medium-sized state, in the same location but about two-thirds the size of Turkey today. Yet, if small, it was also tough.

Sources of Resiliency

Byzantium survived the onslaughts of outsiders by preserving its capital city, which was well protected by high, thick, and far-flung walls that embraced farmland and pasture as well as the city proper. Within, the emperor (still calling himself the Roman emperor) and his officials serenely continued to collect the traditional Roman land taxes from the provinces left to them. This allowed the state to pay regular salaries to its soldiers, sailors, and court officials. The navy, well supplied with ships, patrolled the Mediterranean Sea. It was proud of its prestigious weapon, Greek fire—a mixture of crude oil and resin, heated and projected via a tube over the water, where it burned, engulfing enemy ships with its flames. The armies of the empire, formerly posted as frontier guards, were pulled back in the face of the Arab invaders and set up as large regional defensive units within the empire itself. Called strategiai (literally, "commands of a general"), they were led by strategoi (generals), appointed by the emperors. Officials were posted throughout the empire to provide food and weapons to the army. They were authorized to collect foodstuffs as taxes in kind and to purchase materials for the army in the name of the state. Protected by fortresses, the strategiai managed to stave off Arab conquest. Well trained and equipped, Byzantium's troops served as reliable defenders of their newly compact state.

Invasions and Their Consequences

The Sasanid Empire of Persia, its capital at Ctesiphon, its ruler styled king of kings, was as venerable as the Roman Empire—and as ambitious. (See Map 2.1.) King Chosroes II (r.590–628), not unlike Justinian a half-century before him, dreamed of recreating past glories. In his case the inspiration was the ancient empire of Xerxes and Darius, which had sprawled from a lick of land just west of Libya to a great swathe of territory ending

Map 2.1 Persian Expansion, 602–622

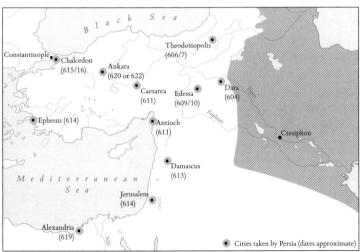

near the Indus River. When Byzantine Emperor Maurice was deposed by Phocas in 602, Chosroes took advantage of the ensuing political chaos to invade Byzantine territory. By 604 he had captured Dara and soon other cities nearby; he took Theodosiopolis in Byzantine Armenia in 606/607, Damascus by 613, Jerusalem by 614, and Alexandria by 619. By mid-621 the whole of Egypt was in his hands.

When Emperor Heraclius (r.610–641) went on the offensive, the Persians, in alliance with Avars and Slavs, attacked Constantinople itself. A chronicler of the event attributed their defeat to the city's protector, the Virgin Mary, whose image was displayed on all the city gates: "After

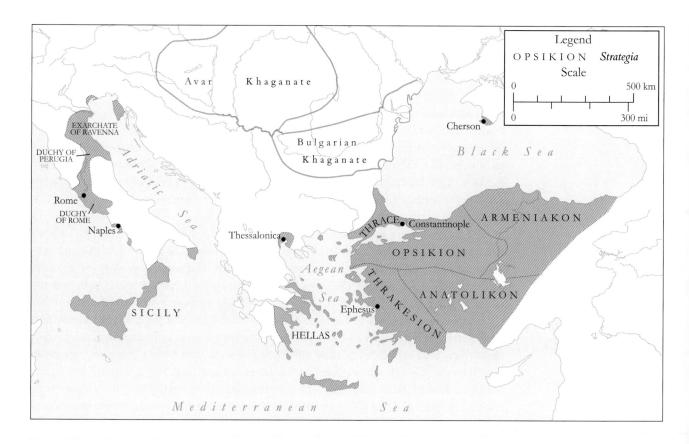

approaching the church of our Lady the Mother of God and the Holy Reliquary, the enemy were completely unable to damage any of the things there, since God showed favor, at the intercession of his undefiled Mother." Harder facts were at work as well: Heraclius's canny deployment of his army and use of diplomacy saved the city. By 630 all territories taken by the Persians were back in Byzantine hands. On a map, it would seem that nothing much had happened; in fact, the cities fought over were depopulated and ruined, and both Sasanid and Byzantine troops and revenues were exhausted.

Although the Persians were pushed back, the Slavs—farmers and stock-breeders in the main—moved into the Balkans, sometimes accompanied by the Avars, multi-ethnic horseback warriors and pastoralists. It took another half-century for the Bulgars, a Turkic-speaking nomadic group, to become a threat, but in the 670s they began moving into what is today Bulgaria, defeating the Byzantine army in 680 and again in 681. By 700 very little of the Balkan Peninsula was Byzantine. (See Map 2.2.) The place where once the two halves of the Roman Empire had met was now a wedge—created by Bulgars, Avars, and Slavs—that separated East from West.

An even more dramatic obliteration of the old geography took place when attacks by Arab Muslims in the century after 630 ended in the conquest of Sasanid Persia and the further shrinking of Byzantium. We shall soon see how and why the Arabs poured out of Arabia. But first we need to know what the shrunken Byzantium was like.

Map 2.2 The Byzantine Empire, *c.*700

Decline of Urban Centers

The city-based Greco-Roman culture on which the Byzantine Empire was originally constructed had long been gradually giving way. Invasions and raids hastened this development. Many urban centers, once bustling nodes of trade and administration, disappeared or reinvented themselves. Some became fortresses; others were abandoned; still others remained as skeletal administrative centers. The public activities of marketplaces, theaters, and town squares yielded to the pious pursuits of churchgoers or the private affairs of the family.

The story of Ephesus (for its location see Map 2.2) is unique only in its details. Ephesus had once been an opulent commercial and industrial center. Turned to rubble by an earthquake near the end of the third century, it rebuilt itself on a grand scale during the course of the fourth and especially the fifth centuries. Imagine it in about 500. (See Figure 2.1, concentrating on the labels in red.) It had two main centers, both fitting comfortably within the old walls that had been constructed in the Hellenistic period. The most important center was the Embolos, a grand avenue paved with marble. Extending the length of more than two football fields, the Embolos began at its west end on a market square and the Library of Celsus, while it opened out on its east end onto the so-called State Agora, only bits of which were restored after the earthquake. All along the Embolos's length were statues, monumental fountains, and arcades. Along its north side were the Baths of Varius and other public buildings. Flanking its south were poor living quarters built over the rubble of once-elegant "terrace houses." There was no question about the religious affiliation of this sector of the city: the Embolos was well Christianized by numerous crosses etched onto the marble slabs of its fountains and paving stones. Small churches were scattered about the vicinity.

The second center of Ephesus around 500 was to the northwest, nearer the harbor. Here numerous old temples and cultural centers were now being reused for homes, baths, and churches. Richly furnished houses were erected in the Harbor Baths, while a chapel was built in the Byzantine palace and a church was constructed in the stadium. Above all, there was the new Church of St. Mary, the seat of the bishopric, which had been built into the southern flank of an old temple (the Olympieion) next to the bishop's palace and the baptistery.

In short, Ephesus around 500 suggests the comfortable integration of Christian and old Roman institutions. Baths expressed the traditional Roman value of cleanliness; temples were turned into churches; a chapel nestled in the shadow of the old stadium. Grand fountains and heroic statues continued to be built along the Embolos by proud city benefactors.

But the events of the sixth and seventh centuries transformed the city. The Persian wars disrupted Ephesus's trade and threatened its prosperity. Repeated visitations of the Plague of Justinian took their grim demographic toll. The residences along the length of the Embolos were destroyed in 614, as the result of the Persian invasions and perhaps an earthquake as well. Arab attacks on Ephesus began in 654–655.

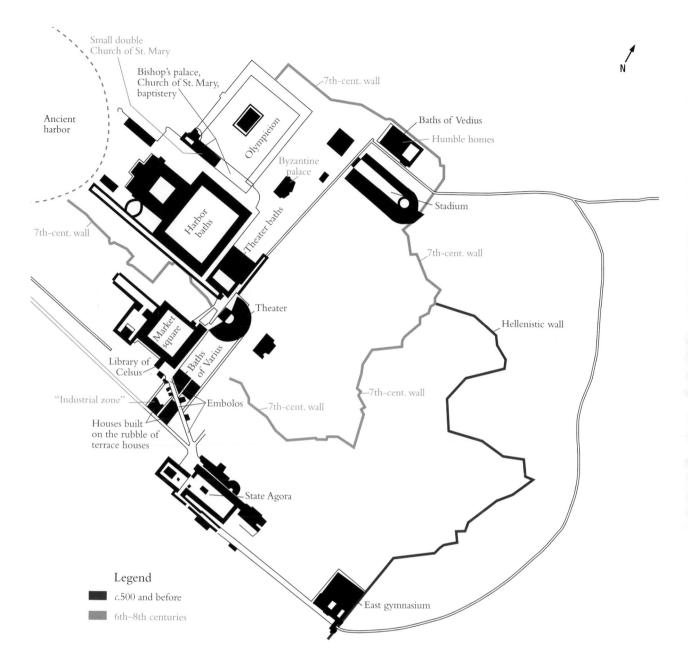

In the face of these disasters, the face of Ephesus changed. (Consider Figure 2.1 again, now focusing on the elements in green.) As if tightening its belt, the city put up new walls to enclose the harbor area. The Embolos lost its centrality. Its southern flank became an "industrial zone," with mills and stone-cutting and ceramic factories, while other workshops were built on the edge of where the terrace houses had once stood. No doubt this location protected the harbor from both noise and pollution. A road south of the Embolos became the workaday thoroughfare, while the "Byzantine palace," closely protected by the seventh-century walls, became the new center of administration.

Figure 2.1 Late Antique Ephesus

Yet the new walls did not stave off disaster and decay. The Baths of Vedius were destroyed—though some families made their homes in the rubble until the roof collapsed, probably at the end of the sixth century. The Church of St. Mary itself was partially destroyed—perhaps in the early seventh century—and rebuilt as two separate smaller churches within the original space. Finally, in the wake of Arab attacks, the bishop abandoned his palace by the harbor and moved to a church about a mile and a half outside of the city.

The fate of Ephesus—much reduced in size but nevertheless still a center of production and habitation—was echoed in many cities circling the eastern Mediterranean in Syria, Palestine, and Egypt. Elsewhere, the urban centers of the Byzantine Empire became little more than fortresses in the course of the seventh and eighth centuries. Constantinople itself was spared this fate only in part. As with other cities, its population shrank, and formerly inhabited areas right within the walls were abandoned or turned into farms. As the capital of both church and state, however, Constantinople boasted an extraordinarily thriving imperial and ecclesiastical upper class. It also retained some trade and industry. Even in the darkest days of the seventh-century wars, it had taverns, brothels, merchants, and a money economy. Its factories continued to manufacture fine silk textiles. Although Byzantium's economic life became increasingly rural in the seventh and eighth centuries, institutions vital to urban growth remained at Constantinople, ensuring a revival of commercial activity once the wars ended.

Ruralization

With the decline of cities came the rise of the countryside. Agriculture had all along been the backbone of the Byzantine economy. Apart from large landowners—the state, the church, and a few wealthy individuals—most Byzantines were free or semi-free peasant farmers. In the interior of Anatolia, on the great plateau that extends from the Mediterranean to the Black Sea, peasants must often have had to abandon their farms when Arab raiders came. Some may have joined the pastoralists of the region, ready to drive their flocks to safety. Elsewhere (and, in times of peace, on the Anatolian plains as well), peasants worked small plots (sometimes rented, sometimes owned outright), herding animals, cultivating grains, and tending orchards.

These peasants were subject as never before to imperial rule. With the disappearance of the traditional town councilors—the *curiales*—cities and their rural hinterlands were now controlled directly by the reigning imperial governor and the local "notables"—a new elite consisting of the bishop and big land owners favored by the emperor. Freed from the old buffers that separated it from commoners, the state adopted a thoroughgoing agenda of "family values," narrowing the grounds for divorce, setting new punishments for marital infidelity, and prohibiting abortions. Legislation gave mothers greater power over their offspring and made widows the legal guardians of their minor children. Education was still important, but now for many pious Christians, reading the ancient classics took second

place to studying the Psalter, the book of 150 psalms in the Old Testament thought to have been written by King David.

New family values coexisted with old community practices. A church council that met at Constantinople in 691/692 (the so-called Quinisext) forbade, among other things, dancing on the first day of March, wearing comic masks at festivals, and cross-dressing in masquerade: "Moreover we drive away from the life of Christians the dances given in the names of those falsely called gods by the Greeks whether of men or women, and which are performed after an ancient and un-Christian fashion; decreeing that no man from this time forth shall be dressed as a woman, nor any woman in the garb suitable to men."³

Iconoclasm

Other popular practices centered on the saints. As in the West, so too in the East, saints' relics were housed in precious containers. Some were kept in churches, often under the altar; others were preserved at home by pious Christians. Many reliquaries were decorated with precious stones and metals and often, too, with images of saints, Christ, and his mother, Mary. Around 680, these images took on new importance in the Byzantine world. A cult of images became as important there as the cult of saints. The argument on their behalf was straightforward: the sacred could best be grasped by human beings when made visible and palpable. Stories circulated of saintly images that spoke; it became common for worshipers to bow down to sacred portraits. Images became more than representations of divine beings; they became—like relics, like reliquaries—containers of the holy.

These new ideas responded to the crises of the day. In the late seventh century, as we have seen, Byzantium was confronted by plagues, earthquakes, and (above all) wars. How could this happen to God's Chosen People (as the Byzantines thought of themselves)? The answer was clear: God was angry with them for their sins. What recourse did they have but to seek new avenues to access divine favor? While still depending on relics to protect and fortify them, many Byzantines sought the aid of holy images as well. Monks were especially enthusiastic patrons of these powerful works of art.

Soon there was a backlash against these new-fangled ideas. Emperor Leo III the Isaurian (r.717–741) agreed that the crises were God's punishment for the sins of the Byzantines. But he thought that their chief sin was idolatry—their cult of images. In 726, after a terrifying volcanic eruption in the middle of the Aegean Sea, Leo seems to have denounced sacred portraits publicly. Historians used to report that Leo had his soldiers tear down a great golden icon of Christ at the Chalke, the gateway to the imperial palace, and replace it with a cross. Newer research (by Leslie Brubaker, for example) notes that no contemporary sources record this incident. Most likely it was a legend invented much later. Nevertheless, around 726, or perhaps a bit before, Leo erected a cross in front of the imperial palace. It affirmed not only the Cross's salvific place in the lives of all Christians but also its unwavering role in imperial victories. This may be taken to signify the beginning of the "iconoclastic" (anti-icon or, literally, icon-breaking) period. In 730, Leo required

Plate 2.1 Cross at Hagia Sophia (orig. mosaic 6th cent.; redone 768/769). In this section of a mosaic just off the gallery at Hagia Sophia, the original mosaicist depicted a holy figure in a medallion. Beneath the image was an inscription identifying the saint. During the iconoclastic period, the figure and inscription were hacked out. The saint was replaced by a gold cross with flared arm tips; it was surrounded by a rainbow of colored tesserae (the bits of glass or stone used in mosaics) to make the cross seem to glow. Below the cross can be clearly seen the rectangular space in which the original inscription was replaced by tesserae to match the background color.

the pope at Rome and the patriarch of Constantinople to subscribe to a new policy: to remove sacred images, or at least to marginalize them, if they inspired the wrong kind of devotion.

Leo was the harbinger of a new religious current. There had always been churchmen who objected to compassing the divine in the limiting form of a material image, but they had been in the minority. By the end of Leo's reign, a majority was inspired to criticize images. At the Synod of 754, a meeting of over 300 bishops and Emperor Constantine V (r.741–775) held in Constantinople, sacred images were banned outright. Its decrees made clear how material representations threatened, according to iconoclasts, to befoul the purity of the divine. Christ himself had declared he should be represented through the bread and wine—and in no other way. As for the saints, they (in the words of the Synod)

live on eternally with God, although they have died. If anyone thinks to call them back again to life by a dead art, discovered by the heathen, he makes himself guilty of blasphemy.... It is not permitted to Christians ... to insult the saints, who shine in so great glory, by common dead matter.⁴

Above all, iconoclastic churchmen worried about losing control over the sacred. Unlike relics, images could be reproduced infinitely and without clerical authorization. Their cultivation at monas-

teries threatened to encroach on clerical authority. Banning icons had multiple purposes.

However vehement they may have been, the iconoclasts seem rarely to have wiped out already-existing icons—though later propagandists on the iconophile (icon-loving) side accused them of great damage. One example of obliteration, however, certainly remains from Hagia Sophia. A room used by the patriarch—located just off the southwest corner of the gallery—was originally covered with mosaics, including medallions with images of saints. During the iconoclastic period, the images were cut out and replaced by crosses. (See Plate 2.1.) Elsewhere, new churches were decorated with crosses from the start, while artists of the iconoclastic period were commissioned to depict (depending on the use of the building) ornaments, trees, birds, hunting, horse races, and other non-sacred motifs. The iconoclasts thought that they thereby ensured God's favor—that, once again, the Byzantines were God's "Chosen People."

Ultimately, however, iconoclasm was an utter failure, though the ban on icons lasted until 787 and was revived, in modified form, between 815 and 843. Not only did the iconoclastic movement come to an end, but during the eighth century the position of those who supported icons, already argued at the Quinisext Council, would be elaborated at great length in learned treatises. The idea that icons held the "real presence" of the divine marked a watershed between the early Christian and the medieval Byzantine state.

THE RISE OF THE "BEST COMMUNITY": ISLAM

Like the Byzantines, the Muslims thought of themselves as God's people. In the Qur'an, the "recitation" of God's words, Muslims are "the best community ever raised up for mankind ... having faith in God" (3:110). The community's common purpose is "submission to God," the literal meaning of "Islam." The Muslim (a word that derives from "Islam") is "one who submits." Under the leadership of Muhammad (c.570–632) in Arabia, Islam created a new world power in less than a century.

The Shaping of Islam

"One community" was a revolutionary notion for the disparate peoples of Arabia (today Saudi Arabia), who converted to Islam in the course of the early seventh century. Pre-Islamic Arabia lay between the two great empires of the day—Persia and Byzantium—and felt the cross-currents as well as the magnetic pull of their economies and cultures. Its land supported Bedouins: nomads (the word "arab" is derived from the most prestigious of these, the camel-herders) and semi-nomads. But by far the majority of the population was neither; it was sedentary. To the southwest, where rain was adequate, farmers worked the soil. Elsewhere people settled at oases, where they raised date palms for their highly prized fruit; some of these communities were prosperous enough to support merchants and artisans. Both the nomads and the settled population were organized as tribes—communities whose members considered themselves related through a common ancestor.

Herding goats, sheep, or camels, the nomads and semi-nomads lived in small groups, largely making do with the products (leather, milk, meat) of their animals, and raiding one another for booty—including women. "Manliness" was the chief Bedouin virtue; it meant not sexual prowess (though polygyny—having more than one wife at a time—was practiced), but rather bravery, generosity, and a keen sense of honor.

By the time of Muhammad, the prophet of Islam, the Arabs had a well-developed literary as well as oral culture. Poetry was much honored (and remains so to this day); multipurpose, the ode alone (there were many other forms of poetry) could praise, mock, lament, and wax nostalgic about love. Most poets were "publicists" for their tribe, advertising its virtues. But a few were appreciated even beyond Arabia.

Islam began as a religion of the sedentary, but it soon found support and military strength among the nomads. The movement began at Mecca, a commercial center and the launching pad of caravans organized to sell Bedouin products—mainly leather goods and raisins—to the more urbanized areas at the Syrian border. (See Map 2.3.) Mecca was also a holy place. Its shrine, the Ka'ba, was rimmed with the images of hundreds of gods. Within its sacred precincts, where war and violence were prohibited, pilgrims bartered and traded.

Muhammad, born in this commercial and religious center, was orphaned as a child and came under the guardianship of his uncle, a leader of the Quraysh tribe that dominated Mecca and controlled access to the Ka'ba. Muhammad became a trader, married, had

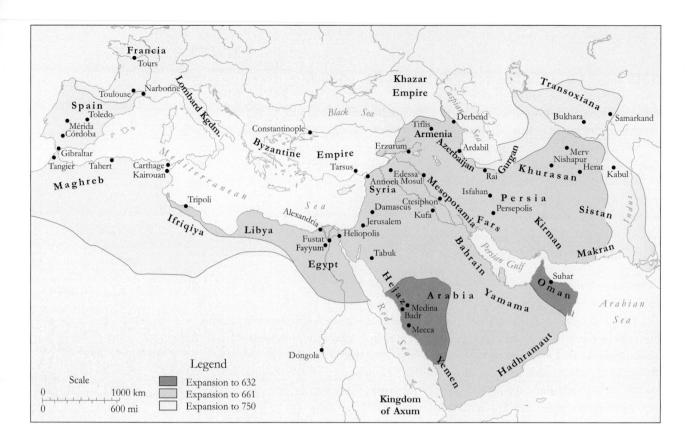

Map 2.3 The Islamic World to 750

children, and seemed comfortable and happy. But he sought something more: he would sometimes leave home, escaping to a nearby mountain to pray.

"In the Name of God the Compassionate the Caring / Recite in the name of your lord who created— / From an embryo created the human / Recite your lord is all-giving." Thus began a sequence of searing words and visions that, beginning around 610 (as tradition has it), came to Muhammad during his retreats. The key word was God, one God (the Arabic word for God is Allah). The key command was to "recite." Muhammad obeyed, and later his recitations of God's word were written down on scraps of parchment and elsewhere by Muhammad's companions. Once arranged—a process that was certainly completed by the mid-seventh century—they became the Qur'an, the holy book of Islam. (See Plate 2.2.) The Qur'an is understood to be God's revelation as told to Muhammad by the angel Gabriel, and then recited in turn by Muhammad to others. Its first chapter—or sura—is the fatihah, or Opening:

In the name of God
the Compassionate the Caring
Praise be to God
lord sustainer of the worlds
the Compassionate the Caring
master of the day of reckoning

To you we turn to worship and to you we turn in time of need Guide us along the road straight the road of those to whom you are giving not those with anger upon them not those who have lost the way.⁶

The Qur'an continues with a far longer sura, followed by others (114 in all) of gradually decreasing length. For Muslims, the Qur'an covers the gamut of human experience—the sum total of history, prophecy, and the legal and moral code by which men and women should live—as well as the life to come.

Banning infanticide, Islam gave girls and women new dignity. It allowed for polygyny, but this was limited to four wives at one time, all to be treated equally. It mandated dowries and offered some female inheritance rights. At first women even prayed with men, though that practice ended in the eighth century. The nuclear family (newly emphasized, as was happening around the same time at Byzantium as well; see p. 46) became more important than the tribe. In Islam, there are three essential social facts: the individual, God, and the *ummah*,

the community of the faithful. There are no intermediaries between the divine and human realms, no priests, Eucharist, or relics.

A community of believers coalesced around Muhammad as God's prophet. They adhered to a strict monotheism, prepared for the final Day of Judgment, and carried out the tasks that their piety demanded—daily prayers, charity, periods of fasting, and so on. Later these were institutionalized as the "five pillars" of Islam. The early believers' idea of the righteous life included living in the world, marrying, and having children. For them, virtue meant mindfulness of God in all things. They could take moderate—though not excessive—pleasure in God's bounty. Their notions of righteousness did not call for asceticism.

At Mecca, where Quraysh tribal interests were bound up with the Ka'ba and its many gods, Muhammad's message was unwelcome. But it was greeted with enthusiasm at Medina, an oasis about 200 miles to the northeast of Mecca. Feuding tribes there invited Muhammad to join them and arbitrate their disputes. He agreed, and in 622 he made the *Hijra*, or flight from Mecca to Medina. There he became not only a religious but also a secular leader. This joining of the political and religious spheres set the pattern for Islamic government thereafter. After Muhammad's death, the year of the *Hijra*, 622, became the year 1 of the Islamic calendar, marking the establishment of the Islamic era.

Muhammad consolidated his leadership by asserting hegemony over three important groups: the Jews, the Meccans, and the nomads. At Medina itself, he took control by ousting and sometimes killing his main competitors, the Jewish clans of the city.

Plate 2.2 Page from an Early Qur'an (568-645). The parchment used for this Qur'an page has been radiocarbon dated to 568-645. Its precocity calls into question the traditional dating of Muhammad's revelations as well as when and how they were organized into an official text. Tradition gives the role of organization to Caliph Uthman (r.644-656), who had an authorized text prepared by a committee and issued c.650. These fragments (and other similar finds) suggest an earlier date and variant compilations of the Qur'an.

Reading from right to left and top to bottom, we see the end of sura 19 ("Maryam") and the beginning of sura 20 ("Ta Ha"). The verses of each sura are marked by little clusters of dots, and the division between the two suras is indicated by a decorative design in red ink.

Against the Meccans he fought a series of battles; the battle of Badr (624), waged against a Meccan caravan, marked the first Islamic military victory. After several other campaigns, Muhammad triumphed and took over Mecca in 630, offering leniency to most of its inhabitants, who in turn converted to Islam. Meanwhile, Muhammad allied himself with numerous nomadic groups, adding their contingents to his army. Warfare was thus integrated into the new religion as a part of the duty of Muslims to strive in the ways of God; *jihad*, often translated as "holy war," in fact means "striving." Through a combination of military might, conversion, and negotiation, Muhammad united many, though by no means all, Arabic tribes under his leadership by the time of his death in 632.

Out of Arabia

"Strive, O Prophet," says the Qur'an, "against the unbelievers and the hypocrites, and deal with them firmly. Their final abode is Hell; And what a wretched destination" (9:73). Cutting across tribal allegiances, the Islamic *ummah* was itself a formidable "supertribe" dedicated to victory over the enemies of God. After Muhammad's death, armies of Muslims led by caliphs—a title that at first seems to have derived from *khalifat Allah*, "deputy of God," but that later came to mean "deputy of the Apostle of God, Muhammad"—moved into Sasanid and Byzantine territory, toppling or crippling the once-great ancient empires. (See Map 2.3.) Islamic armies captured the Persian capital, Ctesiphon, in 637 and continued eastward to take Persepolis in 648, Nishapur in 651, and then, beyond Persia, to conquer Kabul in 664 and Samarqand in 710. To the west, they picked off, one by one, the great Mediterranean cities of the Byzantine Empire: Antioch and Damascus in 635, Alexandria in 642, Carthage in 697. By the beginning of the eighth century, Islamic warriors held sway from Spain to India.

What explains their astonishing triumph? Above all, they were formidable fighters, and their enemies were relatively weak. The Persian and Byzantine Empires had exhausted one another after years of fighting. Nor were their populations particularly loyal; some—Jews and Christians in Persia; Monophysite (or Miaphysite) Christians in Syria and Egypt—even welcomed the invaders. Despite some harsh measures, as when the Muslim conqueror of Egypt "destroyed the houses of the Alexandrians who had fled" before his army, the Christians were largely proved right. The Muslims made no attempt to convert them, imposing a tax on them instead. Then, too, the Muslims sometimes conquered through diplomacy rather than battle. In Spain, for example, they treated with a local leader, Theodemir (or Tudmir), offering him and his men protection—the promise that "[they will not] be separated from their women and children. They will not be coerced in matters of religion"—in return for loyalty and taxes.

Although Arabic culture was only partly city-based, Muhammad himself was attached to Mecca and Medina, and the Muslims almost immediately fostered urban life in the regions that they conquered. In Syria and Palestine, most of the soldiers settled within existing coastal cities; their leaders, however, built palaces and hunting lodges in the

countryside. Everywhere else the invaders created large permanent camps of their own, remaining separate from the indigenous populations. Some of these camps were eventually abandoned, but others—such as those at Baghdad and Cairo—became centers of new and thriving urban agglomerations.

The caliphate was well organized. Regional governors appointed by the caliphs worked with lower-level local officials to collect taxes, maintain law and order, and provision the military. Consider the administration of Egypt, for which we have a relatively large number of documents. Papyrus sheets, preserved for centuries beneath the ground (thanks to Egypt's dry climate), reveal a thriving bureaucracy. The Egyptian governor (the amir) sent out orders to local pagarchs (officials) who in turn ordered underlings to help them collect taxes, regulate water use (of utmost importance in this largely agricultural society), and settle claims. Numerous scribes dutifully wrote letters and instructions, for even though most transactions were oral, the written word was highly valued. Sails, nails, woolen cloth, and Egyptian wheat—formerly exported to feed the people at Constantinople—were requisitioned for the army and navy. The Egyptian tax system, too, required the movement not only of money but of vast amounts of goods in kind: grapes, oil, beans, barley. The pagarchs were evidently very much at the beck and call of the amir. As one of them wrote to an underling: "The amir ... wrote to me with what he has calculated for me, of the amount in coin of the people of the province [and] of their taxes in kind. So pay this to him and ... hurry to me the amount in money." 10

Thus, men and women who had been living along the Mediterranean—in Syria, Palestine, North Africa, and Spain—went back to work and play much as they had done before the invasions. In return for a heavy tax, Christians and Jews could worship in their traditional ways. Safe in Muslim-controlled Damascus, Saint John of Damascus (d.749) was able to thunder against iconoclasm as he would never have been allowed to do in iconoclastic Byzantium. Another Christian, al-Akhtal (c.640–710), found employment at the court of Caliph 'Abd al-Malik (r.685–705), where he poured forth verses of praise:

So let him in his victory
long delight!
He who wades into the deep of battle,
auspicious his augury,
The Caliph of God
through whom men pray for rain."

Maps of the Islamic conquest divide the world into Muslims and Christians. But the "Islamic world" was only slightly Islamic; Muslims constituted a minority of the population. Then, even as their religion came to predominate, they were themselves absorbed, at least to some degree, into the cultures that they had conquered.

The Culture of the Umayyads

Dissension, triumph, and disappointment followed the naming of Muhammad's successors. The caliphs were not chosen from the old tribal elites but rather from a new inner circle of men close to Muhammad. The first two caliphs, Abu-Bakr and Umar, ruled without serious opposition. They were the fathers of two of Muhammad's wives. But the third caliph, Uthman, husband of two of Muhammad's daughters and great-grandson of the Quraysh leader Umayyah, aroused resentment. (See Genealogy 2.1.) His family had come late to Islam, and some of its members had once even persecuted Muhammad. The opponents of the Umayyads supported Ali, the husband of Muhammad's daughter Fatimah. After a group of discontented soldiers murdered Uthman, civil war broke out between the Umayyads and Ali's faction. It ended when Ali was killed in 661 by one of his own erstwhile supporters. Thereafter, the caliphate remained in Umayyad hands until 750.

Yet the *Shi'ah*, the supporters of Ali, did not forget their leader. They became the "Shi'ites," faithful to Ali's dynasty, mourning his martyrdom, shunning the "mainstream" caliphs of the other Muslims ("Sunni" Muslims, as they were later called), awaiting the arrival of the true leader—the *imam*—who would spring from the house of Ali.

Meanwhile, the Umayyads made Damascus, previously a minor Byzantine city, into their capital. Here they adopted many of the institutions of the culture that they had conquered, issuing coins like those of the Byzantines (in the east they used coins based on Persian models), and employing former Byzantine officials as administrators. Caliph 'Abd al-Malik (who, as we have seen, won high praise from the poet al-Akhtal) turned Jerusalem—already sacred to Jews and Christians—into an Islamic holy city as well. His successor, al-Walid I (r.705–715) built major mosques (places of worship for Muslims) at Damascus, Medina, and Jerusalem. The one at Damascus retains most of its original elements; Plate 2.3 demonstrates how effortlessly Byzantine motifs were absorbed—yet also transformed—in their new Islamic context. Cityscapes and floral motifs drawn from Byzantine traditions were combined to depict an idealized world created by the triumph of Islam.

Arabic, the language of the Qur'an, became the official tongue of the Islamic world. As translators rendered important Greek and other texts into this newly imperial language, it proved to be both flexible and capacious. Around this time, Muslim scholars began to compile pious narratives about the Prophet's sayings, or *hadith*. A new literate class—composed mainly of the old Persian and Syrian elite, now converted to Islam and schooled in Arabic—created new forms of prose and poetry. A commercial revolution in China helped to vivify commerce in the Islamic world. At hand was a cultural flowering in a land of prosperity.

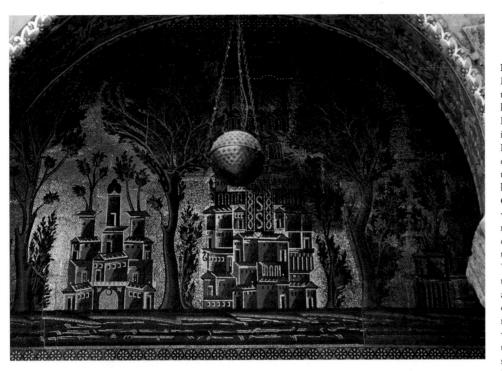

THE MAKING OF WESTERN EUROPE

No reasonable person in the year 750 would have predicted that, of the three heirs of the Roman Empire, Western Europe would, by 1500, be well on its way to dominating the world. While Byzantium cut back, reorganized, and forged ahead, while Islam spread its language and rule over a territory that stretched nearly twice the length of the United States today, Western Europe remained an impoverished backwater. Fragmented politically and linguistically, its cities (left over from Roman antiquity) mere shells, its tools primitive, its infrastructure—what was left of Roman roads, schools, and bridges—collapsing, Europe lacked identity and cohesion. That these and other strengths did indeed eventually develop over a long period of time is a tribute in part to the survival of some Roman traditions and institutions and in part to the inventive ways in which people adapted those institutions and made up new ones to meet their needs and desires.

Impoverishment and Its Variations

Taking in the whole of Western Europe around this time means dwelling long on its variety. Dominating the scene was Gaul, now taken over by the Franks; we may call it Francia. To its south were Spain (ruled first by the Visigoths, and then, after ϵ .715, by the Muslims) and Italy (divided between the pope, the Byzantines, and the Lombards). To the north, joined to, rather than separated from, the Continent by the lick of water

Plate 2.3 Damascus Great Mosque Mosaic (706). It is likely that Byzantine artisans were hired to cover the mosque at Damascus with mosaics both inside and out. Even if not from Byzantium, the mosaicists drew on Byzantine artistic traditions that were still recognizably based on classical Roman motifs. Compare this detail of the western portico of the Damascus mosque, which shows two cities separated by trees, with the harbor scene in Plate 1.3. We see here buildings similar to the depiction of the villa at Villa Farnesina, composed of blocks, topped by slanting roofs, and pierced by numerous windows. The way in which the trees work to divide the scene in the Damascus portico is also Romano-Byzantine. But in another way, the mosaicists rejected that ancient inheritance, imposing a different—an Islamic-ideal: they depicted no human being or animal. To be sure, we should not expect that Mars would seduce Venus here (recall Plate 1.1)! But more remarkably, no living being whatsoever paraded on this or any mosque's walls. In what ways might this ideal have affected Byzantium itself?

Following pages:

Genealogy 2.1 Muhammad's Relatives and Successors to 750

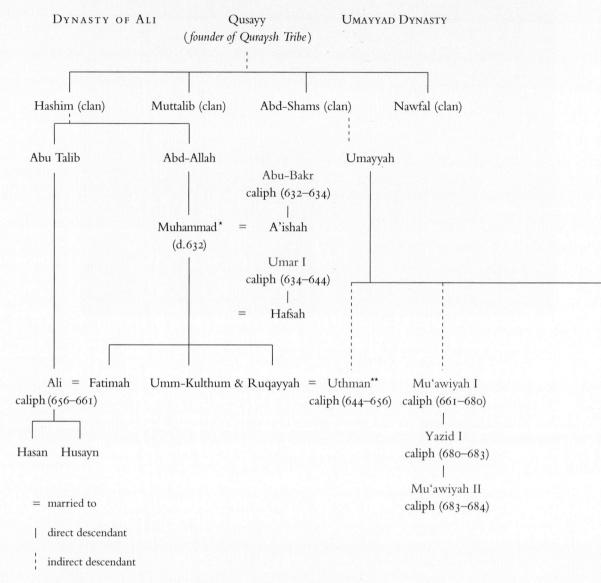

^{*} Muhammad was married to both A'ishah and Hafsah, as well as others

^{**} Uthman was married to two of Muhammad's daughters, Umm-Kulthum and Ruqayyah

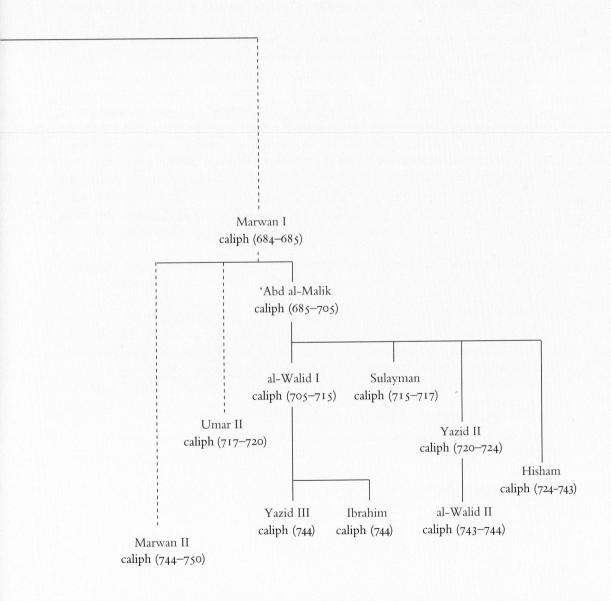

called the English Channel, the British Isles were home to a plethora of tiny kingdoms, about three quarters of which were native ("Celtic") and the last quarter Germanic ("Anglo-Saxons").

There were clear differences between the Romanized south—Spain, Italy, southern Francia—and the north. (See Map 2.4.) Travelers going from Anglo-Saxon England to Rome would have noticed them. There were many such travelers: some, like the churchman Benedict Biscop, were voluntary pilgrims; others were slaves on forced march. Making their way across England, voyagers such as these would pass fenced wooden farmsteads much like the ones at Wijster (see pp. 21–22). Even royal estates were made of wood, however impressive in size they must have been. Figure 2.2 on p. 60 shows an artist's recreation of Yeavering (England) based on archaeological excavations there. Built within a landscape dominated by a great twin-peaked hill, it was occupied—and used as a burial site—for millennia without having any special regional status. In the early seventh century, however, it became a major royal estate center that included a great hall, a theater (a feature clearly drawing on Roman precedents), and a large enclosure probably used for keeping animals but also serviceable for defense. The estate belonged to the king of the northern Anglo-Saxon kingdom of Bernicia, who probably stayed there once or twice a year, hunting in the nearby woods, feasting in the great hall, and calling his chief men together in the theater. Right at the narrow point of this wedge-shaped wooden edifice was a small platform marked by a high post; the best guess is that from this acoustically well-placed spot the king greeted foreign dignitaries and declared his judgments and decisions. Even in the absence of the king, officials might have used the theater in this way to carry out business in his name.

More typical farmsteads consisted of a relatively large house, outbuildings, and perhaps a sunken house, its floor below the level of the soil, its damp atmosphere suitable for weaving. Ordinarily built in clusters of four or five, such family farmsteads made up tiny hamlets. Peasants planted their fields with barley (used to make a thick and nourishing ale) as well as oats, wheat, rye, beans, and flax. Two kinds of plows were used. One was heavy: it had a coulter and moldboard, often tipped with iron, to cut through and turn over heavy soils. The other was a light "scratch plow," suitable for making narrow furrows in light soils. Because the first plow was hard to turn, the fields it produced tended to be long and rectangular in shape. The lighter plow was more agile: it was used to cut the soil in one direction and then at right angles to that, producing a square field. There were many animals on these farms: cattle, sheep, horses, pigs, and dogs. In some cases, the peasants who worked the land and tended the animals were relatively independent, owing little to anyone outside their village. In other instances, regional lords—often kings commanded a share of the peasants' produce and, occasionally, labor services. But all was not pastoral or agricultural in England: here and there, and especially toward the south, were commercial settlements—real emporia.

Crossing the Channel, travelers would enter northern Francia, also dotted with emporia (such as Quentovic and Dorestad) but additionally boasting old Roman cities, now mainly religious centers. Paris, for example, was largely an agglomeration of churches: Montmartre, Saint-Laurent, Saint-Martin-des-Champs—perhaps thirty-five churches

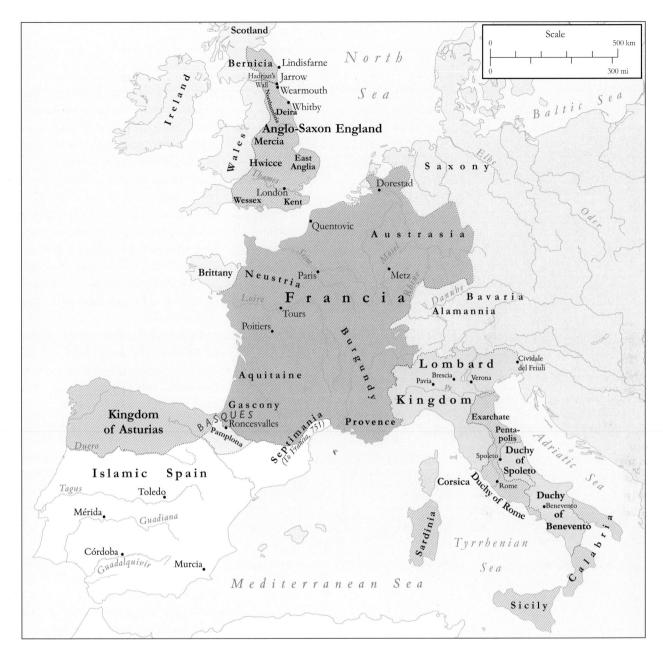

were jammed into an otherwise nearly abandoned city. In the countryside around Paris, peasant families, each with its own plot, tended lands and vineyards that were generally owned by aristocrats. Moving eastward, our voyagers would pass through thick forests and land more often used as pasture for animals than for cereal cultivation. Along the Mosel River they would find villages with fields, meadows, woods, and water courses, a few supplied with mills and churches. Some of the peasants in these villages would be tenants or slaves of a lord; others would be independent farmers who owned all or part of the land that they cultivated.

Map 2.4 Western Europe, ϵ .750

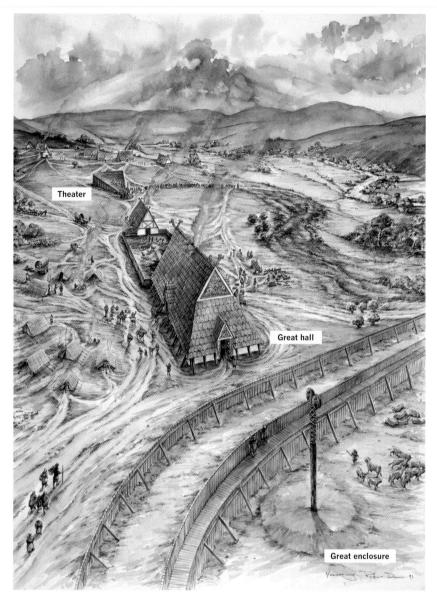

Figure 2.2 Yeavering, Northumberland, Anglo-Saxon Royal Estate, 7th cent.

Near the Mediterranean, by contrast, the terrain still had an urban feel. Here the great hulks of Roman cities, with their stone amphitheaters, baths, and walls, dominated the landscape even though, as at Byzantium, their populations were much diminished. Peasants, settled in small hamlets scattered throughout the countryside, cultivated their own plots of land. In Italy, many of these peasants were real landowners; aristocratic landlords were less important there than in Francia. The soil of this region was lighter than in the north, easily worked with scratch plows to produce the barley and rye (in northern Italy) and wheat (elsewhere) that were the staples—along with meat and fish—of the peasant diet.

By 700, there was little left of the old long-distance Mediterranean commerce of the ancient Roman world. Nevertheless, although this was an impoverished society, it was not without wealth or lively patterns of exchange. In the first place, money was still minted—increasingly in silver rather than gold. The change of metal was due in part to a shortage of gold in Europe. But it was also a nod to the importance of small-scale

commercial transactions—sales of surplus wine from a vineyard, say, for which small coins were the most practical. In the second place, North Sea merchant-sailors—carrying, for example, ceramic plates and glass vessels—had begun to link together through commerce northern Francia, the east coast of England, Scandinavia, and the Baltic Sea. Brisk trade gave rise to new emporia and revivified older Roman cities along the coasts. In the third place, a gift economy—that is, an economy of give and take—flourished. Booty was seized, tribute demanded, harvests hoarded, and coins struck, all to be redistributed to friends, followers, dependents, and the church. Kings and other rich and powerful men and women amassed gold, silver, ornaments, and jewelry in their treasuries and grain in their

storehouses to give out in ceremonies that marked their power and added to their prestige. Even the rents that peasants paid to their lords, mainly in kind, were often couched as "gifts."

Politics and Culture

If variations were plentiful in even so basic a matter as material and farming conditions, the differences were magnified by political and cultural conditions. We need now to take Europe kingdom by kingdom.

FRANCIA

Francia comes first because it was the major player, a real political entity that dominated what is today France, Belgium, the Netherlands, Luxembourg, and much of Germany. In the seventh century, it was divided into three related kingdoms—Neustria, Austrasia, and Burgundy—each of which included parts of a fourth, southern region, Aquitaine. By 700, however, the political distinctions between them were melting, and Francia was becoming one kingdom.

The line of Clovis—the Merovingians—ruled these kingdoms. (See Genealogy 2.2.) The dynasty owed its longevity to biological good fortune and excellent political sense: it allied itself with the major lay aristocrats and ecclesiastical authorities of Gaul—men and women of high status, enormous wealth, and marked local power. To that alliance, the kings brought their own sources of power: a skeletal Roman administrative apparatus, family properties, appropriated lands once belonging to the Roman state, and the profits and prestige of leadership in war.

The royal court—which moved with the kings as they traveled from one place to another, as they had no capital city—was the focus of political life. Here gathered talented young men; they were aristocrats on the rise and many of them later became bishops. The most important courtiers had official positions: there were, for example, the referendary and the cupbearer. Highest of all was the "mayor of the palace," who controlled access to the king and brokered deals with aristocratic factions.

Queens were an important part of the court as well. One of them, Balthild (d.680), had once been among the unwilling travelers from England. Purchased there as a slave by the mayor of the palace of Neustria, she parlayed her beauty into marriage with the king himself. (Merovingian kings often married slaves or women captured in war. By avoiding wives with powerful kindred, they staved off challenges to their royal authority.) Balthild's biographer praised her for ministering to all the men at court. When her husband, King Clovis II, died in 657, Balthild served as regent for her minor sons, acting, in effect, as king during this time. Meanwhile, she gave generously to churches and monasteries. In an era before formal canonization processes, Balthild was nevertheless deemed a saint: "Without

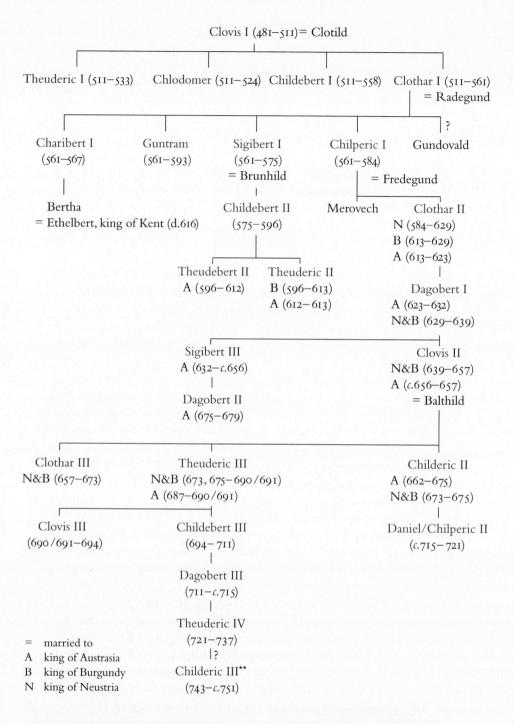

- * Many of the Merovingian kings had more than one wife. The children listed (selected as only the most important of the fathers' progeny) are those of the king but not necessarily of the wife named here.
- ** The parentage of Childeric III is not clear. His father may equally well have been Daniel/Chilperic II as Theuderic IV.

Genealogy 2.2 (facing page) The Merovingians*

doubt this holy soul was gloriously received by a chorus of angels," was the dramatic way in which her hagiographer ended his account of her life. 12

Just as a king's power radiated outward from his court, so too did aristocrats command their own lordly centers. Like kings, they had many "homes" at one time, scattered throughout Francia. Tending to their estates, honing their skills in the hunt, aristocratic men regularly led armed retinues to war. They proved their worth in the regular taking of booty and rewarded their faithful followers afterwards at generous banquets.

And they bedded down. The bed—or rather procreation—was the focus of marriage, the key to the survival of aristocratic families and the transmission of their property and power. Though churchmen had many ideas about the value of marriage, they had nothing to do with the ceremony; no one married in a church. Rather, marriage was a family affair, and often a very expensive one. There was more than one form of marriage: in the most formal, the husband-to-be gave his future bride a handsome dowry of clothes, bedding, livestock, and land. Then, after the marriage was consummated, he gave his wife a morning gift of furniture and perhaps the keys to the house. Very rich men often had, in addition to their wife, one or more "concubines" at the same time. These enjoyed a less formal type of marriage, receiving a morning gift but no dowry.

The wife's role was above all to maintain the family. A woman passed from one family (that of her birth) to the next (that of her marriage) by parental fiat. When they married, women left the legal protection of their father for that of their husband. Did women have any freedom of action? Yes. For one thing, they had considerable control over their dowries. Some participated in family land transactions: sales, donations, exchanges, and the like. Upon the death of their husbands, widows received a portion of the household property. Although inheritances generally went from fathers to sons, many fathers left bequests to their daughters, who could then dispose of their property more or less as they liked. In 632, for example, the nun Burgundofara, who had never married, drew up a will giving to her monastery the land, slaves, vineyards, pastures, and forests that she had received from her two brothers and her father. In the same will, she gave other property near Paris to her brothers and sister.

Burgundofara's generous piety was extraordinary only in degree. The world of kings, queens, and aristocrats intersected with that of the church. The arrival (c.590) on the Continent of the fierce Irish monastic reformer Saint Columbanus (543–615) marked a new level of association between the two. Columbanus's brand of monasticism, which stressed exile, devotion, and discipline, made a powerful impact on Merovingian aristocrats. They flocked to the monasteries that he established in both Francia and Italy, and they founded new ones on their own lands in the countryside. In Francia alone there was an explosion of monasteries: between the years 600 and 700, an astonishing 320 new houses were established, most of them outside of the cities. Some of the new monks and nuns were grown men and women; others were young children, given to a monastery by their parents. This latter practice, called oblation, was well accepted and even considered essential for the spiritual well-being of both children and their families.

The Irish monks introduced aristocrats on the Continent to a deepened religious devotion. Those who did not actively join or patronize a monastery still read—or listened to others read—books preaching penance, and they chanted the psalms. Irish and Anglo-Saxon clerics cultivated private penance; using books called "penitentials," they reminded people of their possible sins and assigned penances, usually fasting on bread and water for a certain length of time. The *Penitential of Finnian*, for example, assigns six years of fasting, three of them on bread and water and the last three abstaining from wine and meat, to "any cleric or woman who practices magic [and has] led astray anyone by their magic." ¹³

Deepened piety did not, in this case, lead to the persecution of others—something that (as we shall see) happened in later centuries. In particular, where Jews were settled in Western Europe—along the Mediterranean coast and inland, in Burgundy, for example—they remained integrated into every aspect of secular life. They used Hebrew in worship, but otherwise they spoke the same languages as Christians and used Latin in their legal documents. Their children were often given the same names as Christians (and Christians often took biblical names, such as Solomon); they dressed as everyone else dressed; and they engaged in the same occupations. Many Jews planted and tended vineyards, in part because of the importance of wine in synagogue services, in part because the surplus could easily be sold. Some were rich landowners, with slaves and dependent peasants working for them; others were independent peasants of modest means. While some Jews lived in the few cities that remained, most, like their Christian neighbors, lived on the land.

THE BRITISH ISLES

Celtic groups from the north and west had often attacked Roman Britain. When the last of the Roman garrisons left Britain c.410, new immigrants—Saxon and other Germanic groups—arrived piecemeal. They came as families, in boats that held about forty persons, to settle and farm along Britain's east coast. Irish immigrants gradually settled in the west. Elsewhere—in what is today the north and west of England, Scotland, and Ireland—Celtic kingdoms survived.

Where the Germanic tribes settled, their tastes, expectations, styles, and religious practices affected the indigenous British population, and vice versa. In the eighth century, the monk-historian Bede portrayed this amalgamated culture as utterly pagan: Anglo-Saxon England was, in his words, "a barbarous, fierce, and unbelieving nation." He But the story that archaeology tells is more nuanced: holy sites dedicated to the saints remained magnets for pilgrimage, burial, and settlement. Most, perhaps all, of the British Isles remained Christian. Wales was already Christian when, in the course of the fifth century, missionaries converted Ireland and Scotland. (Saint Patrick, apostle to the Irish, is only the most famous of these.) However, in contrast to Bede's vision of a highly organized church led by the pope, post-Roman Britain's Christianity was decentralized and local. The same was true in the Celtic kingdoms—Wales, Ireland, and Scotland—which supported relatively non-hierarchical church organizations. Rural monasteries normally served as the

seats of bishoprics as well as centers of population and settlement. Abbots and abbesses, often members of powerful families, enjoyed considerable power and prestige.

At the end of the sixth century the Roman form of Christianity arrived to compete with the diverse forms already flourishing in the British Isles. In 597 missionaries sent by Pope Gregory the Great, led by Augustine (not the fifth-century bishop of Hippo!), arrived at the court of King Ethelbert of Kent (d.616). According to Bede, Ethelbert was a pagan. Yet he was married to a Christian Frankish princess, and he welcomed the missionaries kindly: "At the king's command they sat down and preached the word of life to himself and all his officials and companions there present." While he refused to convert because "[I cannot] forsake those beliefs which I and the whole people of the Angles have held so long," the king did give the missionaries housing and material support.¹⁵

Above all, the king let them preach. This was key: Augustine had in mind more than the conversion of a king: he wanted to set up an English church on the Roman model, with ties to the pope and a clear hierarchy. Successful in his work of evangelization, he divided England into territorial units (dioceses) headed by an archbishop and bishops. Augustine himself became the first archbishop of Canterbury. There he constructed the model English ecclesiastical complex: a cathedral, a monastery, and a school to train young clerics.

There was nothing easy or quick about the conversion of England to the Roman brand of Christianity. The old and the new Christian traditions clashed over matters as large as the organization of the church and as seemingly small as the date of Easter. Everyone agreed that they could not be saved unless they observed the day of Christ's Resurrection properly and on the right date. But what was the right date? Each side was wedded to its own view. A turning point came at the Synod of Whitby, organized in 664 by the Northumbrian king Oswy to decide between the Roman and Irish dates. When Oswy became convinced that Rome spoke with the very voice of Saint Peter, the heavenly doorkeeper, he opted for the Roman calculation of the date and embraced the Roman church as a whole.

The pull of Rome—the symbol, in the new view, of the Christian religion itself—was almost physical. In the wake of Whitby, Benedict Biscop, a Northumbrian aristocratturned-abbot and founder of two important English monasteries, Wearmouth and Jarrow, made numerous arduous trips to Rome. He brought back books, saints' relics, liturgical vestments, and even a cantor to teach his monks the proper melodies in a time before written musical notation existed. A century later, the Anglo-Saxon monk Wynfrith changed his name to the more Roman-sounding Boniface (672/675–754) after he went to Rome to get a commission from Pope Gregory II (715–731) to preach the Word to people living east of the Rhine. Though they were already Christian, their brand of Christianity was not Roman enough for Saint Boniface.

As Roman culture confronted Anglo-Saxon forms, the results were particularly eclectic. This is best seen in the visual arts. The Anglo-Saxons, like other barbarian (and, indeed, Celtic) tribes, had artistic traditions particularly well suited to adorning flat surfaces. Belt buckles, helmet nose-pieces, brooches, and other sorts of jewelry of the rich were embellished with semi-precious stones and enlivened with decorative patterns, often made up of animal parts or intertwining snakes (see Plate 2.4). When Benedict Biscop (and others like

Plate 2.4 Great Square-Headed Brooch (early 6th cent.). This brooch—one of many found in the graves of wealthy women in Anglo-Saxon England and elsewhere in the North and Baltic Sea regions—was heavy and imposing. Made of silver gilt and niello (a black metallic alloy), it measures over five inches long. A framed panel adorned with scrolls and stylized animals forms the top, while the foot is decorated with many face masks: there is one on each of the side lobes, and a larger one in the middle of the diamond. Two more are at the top and bottom of the bow (the center clip).

him) returned to England with books from Rome, they challenged scribes and artists there to combine traditions. The imported books contained not only texts but also illustrations that relied, at least distantly, on ancient Roman artistic traditions (see Plates 1.1–1.4). English artists soon combined their native decorative impulses with the classical interest in human forms. The result was perfectly suited to flat pages. Consider the Lindisfarne Gospels, which were probably made at the monastery of Lindisfarne in the first third of the eighth century. (The Gospels are the four canonical accounts of Christ's life and death in the New Testament.) The artist of this

sumptuous book was clearly uniting Anglo-Saxon, Irish, and Roman artistic traditions when he introduced each Gospel with three full-page illustrations: first, a portrait of the "author" (the evangelist); then an entirely ornamental "carpet" page; finally, the beginning words of the Gospel text. Plates 2.5 to 2.7 illustrate the sequence for the

Gospel of Luke. The figure of Luke (see Plate 2.5), though clearly human, floats in space. His "throne" is a square of ribbons, his drapery a series of looping lines. The artist captures the essence of an otherworldly saint without the distraction of three-dimensionality. The carpet page (see Plate 2.6), with its geometrical and animal forms, has some of the features of the Great Square-Headed brooch as well as Irish interlace patterns. It is more than decorative,

however: the design clearly evokes a cross. The next page (see Plate 2.7) begins with a great letter, Q (for the first word, "quoniam"), as richly decorated as the cross of the carpet page; gradually, in the course of the next few words, the ornamentation diminishes. In this way, after the fanfare of author and carpet pages, the reader is ushered into the Gospel text itself.

Just as the Anglo-Saxons held on to their artistic styles, so too did they retain their language. In England, the vernacular—the language of the people, as opposed to Latin—was quickly turned into a written language and used in every aspect of English life, from government to entertainment. If you look closely at Plate 2.7 you will see tiny words written in the spaces between the large Latin words of the text: these are in Anglo-Saxon (or Old English). Even Bede praised the common speech of the people, telling the story of Caedmon, a simple monk who dreamed a song in Anglo-Saxon about God's creation. Bede himself provided only a Latin translation of the poem in his *Ecclesiastical History*, but Anglo-Saxon versions were soon available. Indeed, two manuscripts of Bede's work from the eighth century still survive today with Caedmon's hymn in both Latin and Anglo-Saxon.

THE SOUTH: SPAIN AND ITALY

The mix of cultures characteristic of England was doubly the case in Spain and Italy. In Spain, especially in the south and east, some Roman cities had continued to flourish after the Visigothic invasions. Merchants from Byzantium regularly visited Mérida, and the sixth-century bishops there constructed lavish churches and set up a system of regular food distribution. Under King Leovigild (r.569–586), all of Spain came under Visigothic control.

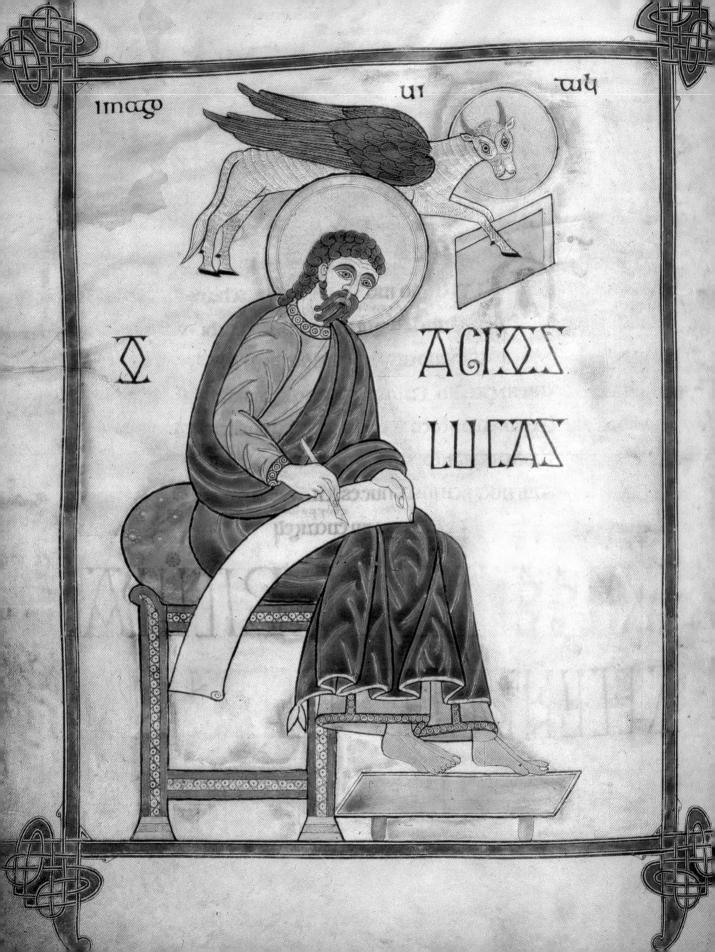

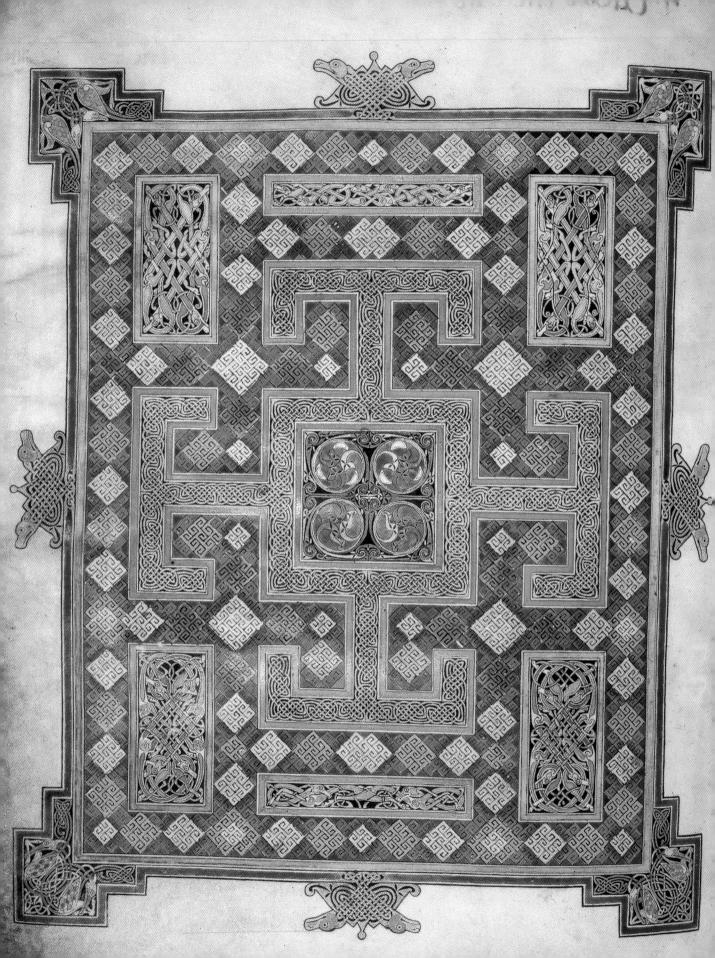

on grands utulus 7 mabit enantehum OLIDE Cunnenso MULLINE SEPTION SEPTION SE

Previous pages:

Plate 2.5 Saint Luke, Lindisfarne Gospels (first third of 8th cent.?). Inspired by Late Roman traditions, the artist—who was also the scribe of this book—introduced the Gospel of Luke with an author's portrait. The winged calf perched on Luke's halo is his symbol.

Plate 2.6 Carpet Page, Lindisfarne Gospels (first third of 8th cent.?). Anglo-Saxon and Celtic artistic ornamental traditions lie behind this elaborate cross, which follows Luke's portrait in Plate 2.5 and faces (as here) the first text page, depicted in Plate 2.7.

Plate 2.7 First Text Page, Gospel of Saint Luke, Lindisfarne Gospels (first third of 8th cent.?). The third page in the Luke Gospel sequence begins the text itself: "Quoniam quidem multi conati sunt ordinare narrationem," "Since many have undertaken to put in narrative order...." Under his son Reccared (r.586–601), the monarchy converted from Arian to Catholic Christianity. This event (587) cemented the ties between the king and the Hispano-Roman population, which included the great landowners and leading bishops. Two years later, at the Third Council of Toledo, most of the Arian bishops followed their king by announcing their conversion to Catholicism, and the assembled churchmen enacted decrees for a united church in Spain, starting with the provision "that the statutes of the Councils and the decrees of the Roman Pontiffs be maintained." Here, as in England a few decades later, Rome and the papacy had become the linchpins of the Christian religion.

The Roman inheritance in Spain was clear not only in the dominance of the Hispano-Roman aristocracy and the adoption of its form of Christianity but also in the legal and intellectual culture that prevailed there. Nowhere else in Europe were church councils so regular or royal legislation so frequent. Nowhere else were the traditions of classical learning so highly regarded. Only in seventh-century Spain could a man like Isidore of Seville (c.560–636) draw on centuries of Latin learning to write the encyclopedic *Etymologies*, in which the essence of things was explained by their linguistic roots. His book was wildly popular.

Unlike the Merovingians the Visigothic kings were not able to establish a stable dynasty. The minority of a king's son almost always sparked revolts by rival families, and the child's deposition was often accompanied by wholesale slaughter of his father's followers and confiscation of their lands. Even so, the kings were able to control their realm from the top more effectively than most barbarian kings because of their partnership with the Spanish church. While the king gave the churchmen free rein to set up their own hierarchy (with the bishop of Toledo at the top) and to meet regularly at synods to regulate and reform the church, the bishops in turn supported the king. They even anointed him, daubing him with holy oil in a ritual that paralleled the ordination of priests and echoed the anointment of kings in the Old Testament. While the bishops in this way made the king's cause their own, their lay counterparts, the great landowners, helped supply the king with troops.

It was precisely the centralization of the Visigothic kingdom that proved its undoing. In 711, a small Islamic raiding party killed the Visigothic king and thereby dealt the whole state a decisive blow. Between 712 and 715, as we have seen, armies led by Arabs took over the peninsula through a combination of war and diplomacy.

The conquest of Spain was less Arab or Islamic than Berber. The generals who led the invasion of Spain were Arabs, to be sure, but the rank-and-file fighters were Berbers from North Africa. While the Berbers were converts to Islam, they did not speak Arabic. The Arabs considered them crude mountainfolk, only imperfectly Muslim. Perhaps a million people settled in Spain in the wake of the invasions, the Arabs taking the better lands in the south, the Berbers getting less rich properties in the center and north. Most of the conquered population consisted of Christians, along with a sprinkling of Jews. A thin ribbon of Christian states—Asturias, Pamplona, and so on—survived in the north. There was thus a great variety of religions on the Iberian Peninsula. (See Map 2.4 on p. 59.) The history of Spain would for many centuries thereafter be one of both acculturation and war.

Unlike Visigothic Spain, Lombard Italy presented no united front. In the center of the peninsula was a swathe of territory claimed by the Byzantines (the Exarchate) and dominated on its southwestern end by the papacy, always hostile to the Lombard kings in the north. To Rome's east and south were the dukes of Benevento and Spoleto. Although theoretically the Lombard king's officers, in fact they were virtually independent rulers. Although many Lombards were Catholics, others, including important kings and dukes, were Arians. The "official" religion varied with the ruler in power. Rather than signal a major political event, then, the conversion of the Lombards to Catholic Christianity occurred gradually, ending only in the late seventh century. Partly as a result of this slow development, the Lombard kings, unlike the Visigoths, Franks, or even Anglo-Saxons, never enlisted the wholehearted support of any particular group of churchmen.

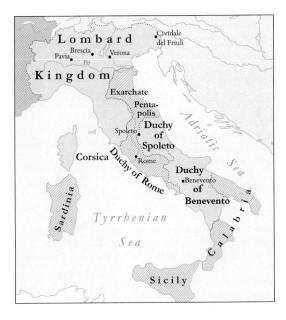

Map 2.5 Lombard Italy, c.750

Yet the Lombard kings did not lack advantages. They controlled extensive estates, and they made use of the Roman institutions that survived in Italy. The kings made the cities their administrative bases, assigning dukes to rule from them and setting up one, Pavia, as their capital. Recalling emperors like Constantine and Justinian, the kings built churches and monasteries at Pavia, maintained city walls, and issued law codes.

When the Lombards settled in Italy, they found the artifacts and lingering traditions of Rome's city-based culture. The newcomers tried to preserve these to some degree, as at Brescia and Verona, where they maintained some Roman roads. On the other hand, cities taken over by the Lombards were no longer commercially active, even though the urban centers of Byzantine Italy (the narrow strip running from Ravenna to Rome) were still alive with trade. The Lombards also allowed Roman houses and apartment blocks to crumble, their places taken by burial plots, vegetable gardens, and, more ambitiously, new churches and monasteries.

The influence of both classical Roman and "barbarian" or at least "provincial" artistic sensibilities in Lombard Italy is clear in two monuments from the period: the altar of King Ratchis (r.744–749) from the church of San Giovanni at Cividale del Friuli and carved figures in Cividale's Tempietto (i.e., small temple). Both probably date from the eighth century (though the Tempietto's date may be later), and both involve religious themes. At first glance, they seem very different. The altar (Plate 2.8) is made of slabs of marble carved in very low relief. The sculptors, here depicting the theme of the Three Magi bringing gifts to the Christ Child, showed no interest in the volume and weight of ordinary human bodies. Nevertheless, considering that most Lombard art was purely decorative, the figures on the altar may be seen as a real concession to Roman traditions.

The Tempietto (Plate 2.9), located right next to San Giovanni in Cividale, is in a rather different style. Unlike the Mary of the Ratchis Altar, the women here have weight and volume. When they were originally made, they were part of an array of such female saints all along the Tempietto's walls. One turns toward another (see the two figures flanking

Plate 2.8 The Altar of Ratchis (737-744). Like the provincial artists of the Roman Empire (see Plates 1.5 and 1.6 on pp. 17-18), the sculptors of this marble slab—one end of a four-sided carved altar—were interested in pattern and transcendence. The three magi advance toward Mother and Child in lock step, their short tunics forming identical triangles, the folds of their clothing turned into incised lines. Mary, mother of God, and the Christ Child look outward, beyond the viewer, interacting with no one. The otherworldly character of the relief is stressed by the landscape—three "half daisy-wheels" rising from a decorative border—and an angel hovering above. A tiny Joseph, husband of Mary, hovers mid-air behind her throne. Originally the altar was studded with gems and brightly painted in blues, yellows, and reds; traces of polychrome remain. An opening in the back panel of the altar allowed worshipers to view the relics within. A dedicatory inscription running along the top border of the entire altar declares that it was King Ratchis's gift to San Giovanni (Saint John).

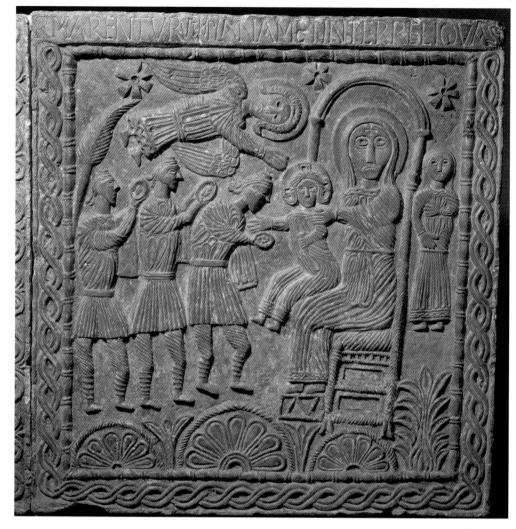

the open space, the lunette). Yet even in the case of these Tempietto carvings, the artists' interest in design and decoration is clear: above and below the saints are decorative borders with flowers that recall the "daisy-wheels" of the Altar of Ratchis (Plate 2.8), and their robes fall into folds created by incised lines.

Cividale was not the only Lombard center to boast significant artistic activity. The monastery of San Salvatore at Brescia, for example, also built in the eighth century, was comparably decorated. The importance of both classical and Roman provincial styles in Lombard Italy suggests that the elites there welcomed artists not only from Europe but also from the Byzantine and Islamic worlds. This should not be surprising: Byzantium ran through the middle of Italy, while the Umayyad caliphs, not far from Sicily and Southern Italy, were themselves enthralled with Romano-Byzantine traditions, as we saw in the case of their mosque at Damascus (Plate 2.3).

Emboldened by their achievements in the north, the Lombard kings tried to make some headway against the independent dukes of southern Italy. But that threatened to

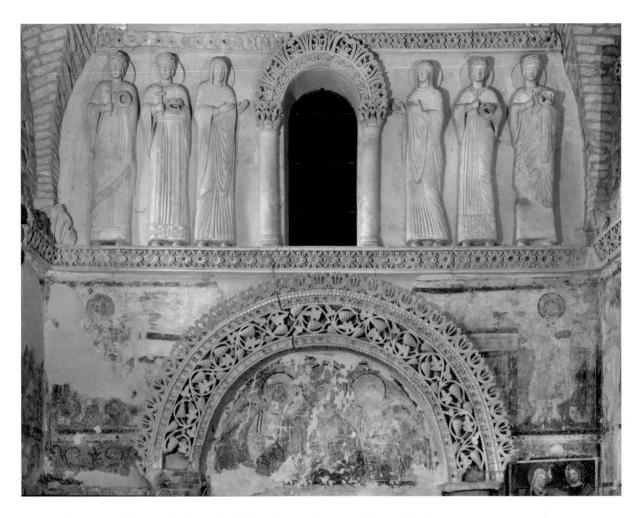

surround Rome with a unified Lombard kingdom. The pope, fearing for his own position, called on the Franks for help.

THE POPE: A MAN IN THE MIDDLE

By the end of the sixth century, the pope's position was ambiguous. As bishop of Rome, he wielded real secular power within the city as well as a measure of spiritual leadership farther afield. Yet in other ways he was subordinate to Byzantium. Pope Gregory the Great (590–604), whom we have already met a number of times, laid the foundations for the papacy's later spiritual and temporal ascendancy. During Gregory's tenure, the pope became the greatest landowner in Italy; he organized Rome's defense and paid for its army; he heard court cases, made treaties, and provided welfare services. The missionary expedition he sent to England was only a small part of his involvement in the rest of Europe. A prolific author of spiritual works, Gregory digested and simplified the ideas of Church Fathers such as Saint Augustine, making them accessible to a wider audience. In his *Moralia in Job*, he set forth a model of biblical exegesis that was widely imitated for centuries. His

Plate 2.9 The Cividale Tempietto (8th cent.?). These stucco figures stand above the main entrance of the small church of Santa Maria in Valle, originally an oratory for the church of San Giovanni.

MATERIAL CULTURE: FORGING MEDIEVAL SWORDS

The medieval sword was more than a weapon on which the warrior's life depended. It had magical, sacred, even moral significance. Usually expensive, it was available only to richer men and often handed down over generations. Medieval epic poetry sometimes made swords their very focus. Consider the story of Sigurd (or Siegfried) in the *Volsunga Saga*. His father's sword, Gram (in epic tales the hero's sword had names; e.g., Excalibur, Durendal), broke in two, but the swordsmith Regin forged the two halves together, making Gram better than ever. Now unbreakable, it made possible Sigurd's slaying of the treasure-guarding dragon, Fafnir.

A carved wooden panel, originally part of a twelfth-century (or perhaps early thirteenthcentury) church portal in Norway, shows how Gram was forged (see Plate 2.10).

The carvings seem to display a "pattern-welded" blade, an early technique in which twisted strips of natural steel (iron with heterogeneous carbon content) and wrought iron (iron low in carbon) were welded together on a forge fire at a temperature of no less than 2100° F/1150°C. The result was a distinctive serpentine pattern on the blade surface and the unique attributes of durability and resistance to fracture. The sword in the carvings also shows a "fuller," a groove that runs along almost the entire length of the blade to make the sword lighter.

Temperature control was key during the forging process. The lower roundel in Plate 2.10 shows an assistant (or perhaps Sigurd) manning two bellows. These blowing devices—generally made of wood and leather—provided constant air flow into the forge to keep the fire going. The swordsmith needed to reach top forging temperatures of c.2400–2500° F/1315–1370° C. Moreover, the swordsmith used heat-control techniques (and not

just mechanical ones, like hammering) to modify the distribution of carbon inside the blade. He repeatedly quenched and then tempered the blade. Quenching had to be performed when the blade was cherry red (at a minimum temperature of 1375° F/745° C) by rapidly immersing it in cool water (or sometimes brine or oil) to improve its hardness, while tempering called for the blade to be reheated at lower temperatures (300° to 1200° F/150° to 650° C) to relieve brittleness.

Swords were much on the minds of ninthcentury Carolingian kings, who were constantly waging war. While the Norwegian portal romanticized the making of the blade, in the ninth century whole workshops were dedicated to the task, often employing slaves to operate both forge and bellows. Some produced very fine blades, like the shop that made swords boasting on their fuller the name Vlfberht or Ulfberht along with one or two crosses in various positions (e.g., +Vlfberht+; +Vlfberh+t). They were exceptionally popular: their remains have been found in more than twenty different European countries. Scholars have long debated the identity of Ulfberht. Some (like Ewart Oakeshott) think that he was the sword maker, a Frankish blacksmith operating in the lower or middle Rhine area (Germany). Other scholars (such as Anne Stalsberg) believe he was the master, or supervisor, of a local sword-blade workshop where illiterate slaves did the actual forging. If so, this may explain the many variants of the Ulfberht signatures. In one case (see Plate 2.11)—one of the oldest extant Ulfberht blades—the "wrong" spelling +Vlfbeht+ (with the "r" missing) has been attributed to imitation or even to a forgery to make the sword more valuable. But it is even more likely that it was the simple mistake of an illiterate smith.

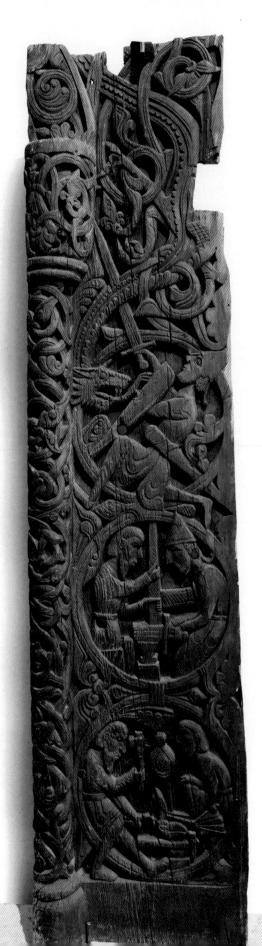

Plate 2.10 The Sigurd Portal, Hylestad Stave Church, Norway (12th–13th cent.). Shown here is the right-hand column of the portal, which reads from bottom to top. At the bottom, Gram is being forged. In the middle roundel, Sigurd (with the helmet) tests the sword, while in the top roundel he slays the dragon Fafnir. A Carolingian Psalter illustration sheds light on the final step in the production of a sword: sharpening the blade. Plate 2.12 shows two techniques. On the right, the side where the psalmist himself stands inspired by a winged angel above, members of the army of the righteous sharpen a sword on a hand-operated rotary grindstone. That was the most up-to-date method, and this drawing is the first we have of it. On the left, the enemy army, the "wicked," as the psalmist puts it, uses an "old-fashioned" whetstone. The artist seems to be saying that virtue and advanced technology go hand-in-hand.

The invention of the blast furnace, a new technology for smelting iron ores, allowed for transformations in the production of weaponry, and—in particular—made all-steel swords a reality. Scholars now seem to agree that prototypes of this kind of shaft furnace were probably introduced earlier than c.1350 (the traditional date). It was in use at some point between the eleventh and thirteenth century in central Swabia (southwest Germany). However, from the late fourteenth century, it heralded an "industrial revolution." The transition from the traditional direct process smelting furnace—the small, low-shaft bloomery that could operate at c.1470–1650° F/800–900° Cto the blast furnace occurred when shafts were pitched higher and made larger, and air was blasted into the furnace with water-powered bellows.

Plate 2.11 Ulfberht Sword (9th cent.). This sword was found in the Rhine, near Mannheim, in 1960.

The furnace temperature could now go far above 2100° F/1150° C (the melting point of cast iron), and even up to the melting point of pure iron (2795°F/1535° C). This method produced massive quantities of liquid cast iron (or "pig iron"): a single blast furnace could yield up to nine tons of iron from a single "charge"—the load of iron ore and charcoal fed into the top of the furnace. The high carbon content (up to 3-4 per cent) in the liquid cast iron was then reduced in a refining furnace to obtain high quality wrought iron and/or natural steel. With these sweeping, "proto-industrial" improvements, medieval weaponry could include steel plate armor, wrought iron bombards (cannons that hurled stones) and handguns, and cast iron cannons, eventually giving way to modern warfare.

FURTHER READING

Peirce, Ian. Swords of the Viking Age, Introduction by Ewart Oakeshott. Woodbridge: Boydell Press, 2002.

Stalsberg, Anne. "The identity of Vlfberht and how the swords with his signature were spread in Europe." In *Tverrfaglige perspektiver*, ed. Marianne Nitter and Einar Solheim Pedersen, 21–36. Stavanger: University of Stavanger, 2009.

Williams, Alan. The Sword and the Crucible. A History of the Metallurgy of European Swords up to the 16th Century. Leiden: Brill, 2012.

Plate 2.12 (facing page) The Utrecht Psalter (first half of 9th cent.). This drawing of the two techniques of blade-sharpening depicts a passage in Psalm 64 (Douay 63):1–4, "Preserve my life from dread of the enemy, hide me from the secret plots of the wicked, from the scheming of evildoers, who whet their tongues like swords, who aim bitter words like arrows, shooting from ambush at the blameless."

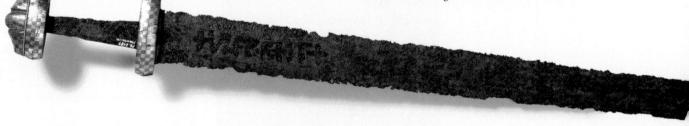

DSOSOMEUS
ADTIDITUCIUIÇILO SI
TIUITIMTEANIMAMEA
QUAMMULTIPLICITER
TIBICAROMEA;

THERADESERTATION
ULATININAQUOSA
SICINSCOAPPARUITIBI
UTUIDEREMUIRTUTEM
TUAMETGLORIATUAM

TUAMEICIORIATUAM; GMMELIORESTMISERICOR DIATUASUPERUITAS: LABIAMEALAUDABITE: S ICBENEDICAMTEINUITA MEA-ETINNOMINETUO LEUABOMANUSMEAS:

S ICUTADIPETTINGUIDI MEREPLEATURANIMA MEA: ETLABIAEX SULTATI OMISLAUDABITOS MEÚ:

S IMEMORÉULTUISUPER STRATUMMEULMMATU TIMISMEDITABORINTE QUIAFUISTIADIUTORMS

ETINUFLAMENTOALARÚ TUARUMEXSULTABO ADHAESITANIMAMEA POSITE MESUSCEPITOEX TERATUA:

Triutroinuanuquae sierumtanimamea introibtininferiora terrae tradenturin manuscladiipartes uulriumerunt;

R EXUFROLAFIABITINDÓ.
LAUDABUNTOMSQUILU
RANTINFO QUIAOBSTRUC
TÜFÓSLOQUENTIÚINIQUA

E XAUDIOSORATI ONIMMEAMCUMDE PRECOR ATIMOREINI

PSALOCUS
MICIERIPEANIMAMIA
PROTEXISTIMEACONUEN
TUMALICNANTIUM

AMULTITUDIMEOPERAN TIUMIMIQUITATEM: QUIAEXACUERUMTUTÇIA handbook for clerics, *Pastoral Care*, went hand-in-hand with his practical church reforms in Italy, where he tried to impose regular episcopal elections and enforce clerical celibacy.

At the same time, even Gregory was only one of many bishops in the Byzantine Empire. For a long time the emperor's views on dogma, discipline, and church administration largely prevailed at Rome. However, this authority began to unravel in the seventh century. In 691/692, the Quinisext council did not just ban dancing on the first day of March (see p. 48), but in fact drew up 102 rules of discipline for both churchmen and laity. Emperor Justinian II (r.685–695; 705–711) convened the council with the hope that the pope would attend, but Pope Sergius I (687–701) did not, nor would he agree to the canons produced by the council. He objected in particular to two, one permitting priests to have wives if their marriages had occurred before ordination and the other prohibiting fasting on Saturdays in Lent (which the Roman church required). Outraged by Sergius's refusal, Justinian tried to arrest the pope, but the imperial army in Italy (theoretically under the emperor's command) came to the pontiff's aid instead. Justinian's arresting officer was reduced to cowering under the pope's bed. Clearly Constantinople's influence and authority over Rome had become tenuous. Sheer distance as well as diminishing imperial power in Italy meant that the popes had in effect become the leaders of non-Lombard Italy.

The gap between Byzantium and the papacy widened in the early eighth century, when Emperor Leo III tried to increase the taxes on papal property to pay for his wars against the Arabs. Gregory II, the pope who later commissioned Saint Boniface's evangelical work (see above, p. 65), responded by leading a general tax revolt. Meanwhile, Leo's fierce policy of iconoclasm collided with the pope's tolerance of images. For Gregory, holy images could and should be venerated, though not worshiped. Increasing friction with Byzantium meant that when the pope felt threatened by the Lombard kings, as he did in the mid-eighth century, he looked elsewhere for support. Pope Stephen II (752–757) appealed to the Franks—not to the Merovingians, who had just lost the throne, but to Pippin III, the king who had taken the royal crown. Pippin listened to the pope's entreaties and marched into Italy with an army to fight the Lombards. The new Frankish/papal alliance would change the map of Europe in the coming decades.

* * * * *

The "fall" of the Roman Empire meant the rise of its heirs. In the East, the Muslims swept out of Arabia—and promptly set up a Roman-style government where they conquered. The bit that they did not take—the part ruled from Constantinople—still considered itself the Roman Empire. In the West, impoverished kingdoms looked to the city of Rome for religion, culture, and inspiration. However much East and West, Christian and Muslim, would come to deviate from and hate one another, they could not change the fact of shared parentage.

CHAPTER TWO: ESSENTIAL DATES

- 622 Hijra; Muhammad's migration from Mecca to Medina
- 624 Battle of Badr; first Islamic military victory
- 632 Death of Muhammad the Prophet
- 661-750 Umayyad caliphate
 - 664 Synod of Whitby; Roman form of Christianity adopted in England
- 711-715 Conquest of Spain by Islamic-led armies
- 726–787, 815–843 Iconoclasm at Byzantium

NOTES

- I For "Greek fire," see "Reading through Looking," in *Reading the Middle Ages: Sources from Europe, Byzantium, and the Islamic World*, 3rd ed., ed. Barbara H. Rosenwein (Toronto: University of Toronto Press, 2018), pp. X–XII.
- 2 The Easter Chronicle, in Reading the Middle Ages, p. 59.
- 3 The Quinisext Council, Canon 62, in Reading the Middle Ages, p. 61.
- 4 The Synod of 754, in Reading the Middle Ages, pp. 64–65.
- 5 Qur'an Sura 96 ("The Embryo"), in Reading the Middle Ages, p. 68.
- 6 Qur'an Sura 1, in Reading the Middle Ages, p. 67.
- 7 The five pillars are: 1) the zakat, a tax to be used for charity; 2) Ramadan, a month of fasting to mark the battle of Badr (624); 3) the hajj, an annual pilgrimage to Mecca to be made at least once in a believer's lifetime; and 4) the salat, formal worship at least three times a day (later increased to five), including 5) the shahadah, or profession of faith: "There is no god but God, and Muhammad is His prophet."
- 8 John of Nikiu, Chronicle, in Reading the Middle Ages, p. 73.
- 9 The Treaty of Tudmir, in Reading the Middle Ages, p. 79.
- 10 Letters to 'Abd Allah b. As' ad, in Reading the Middle Ages, p. 80.
- II Al-Akhtal, The Tribe Has Departed, in Reading the Middle Ages, p. 83.
- 12 The Life of Queen Balthild, in Reading the Middle Ages, p. 91.
- 13 Penitential of Finnian, in Reading the Middle Ages, p. 87.
- 14 Bede, The Ecclesiastical History of the English People, in Reading the Middle Ages, p. 96.
- 15 Ibid., p. 97.
- 16 The Third Council of Toledo, in Reading the Middle Ages, p. 46.

FURTHER READING

- Al-Azmeh, Aziz. The Emergence of Islam in Late Antiquity: Allah and His People. Cambridge: Cambridge University Press, 2014.
- Brown, Peter. The Ransom of the Soul: Afterlife and Wealth in Early Western Christianity. Cambridge, MA: Harvard University Press, 2015.
- Brubaker, Leslie, and John Haldon. *Byzantium in the Iconoclast Era c. 680–850: A History*. Cambridge: Cambridge University Press, 2011.
- Donner, Fred M. Muhammad and the Believers: At the Origins of Islam. Cambridge, MA: Harvard University Press, 2010.
- Eger, A. Asa. The Islamic-Byzantine Frontier: Interaction and Exchange among Muslim and Christian Communities. London: I.B. Tauris, 2015.
- Evans, Helen C. with Brandie Ratliff. Byzantium and Islam: Age of Transition, 7th–9th Century. New Haven, CT: Yale University Press, 2012.
- Fleming, Robin. Britain after Rome: The Fall and Rise, 400 to 1070. London: Penguin, 2010.
- Fox, Yaniv. Power and Religion in Merovingian Gaul: Columbian Monasticism and the Frankish Elites. Cambridge: Cambridge University Press, 2014.
- Haldon, John. The Empire That Would Not Die: The Paradox of Eastern Roman Survival, 640–740. Cambridge, MA: Harvard University Press, 2016.
- Hoyland, Robert G. In God's Path: The Arab Conquests and the Creation of an Islamic Empire. Oxford: Oxford University Press, 2015.
- Kaegi, Walter E. Muslim Expansion and Byzantine Collapse in North Africa. Cambridge: Cambridge University Press, 2015.
- Meens, Rob. Penance in Medieval Europe, 600-1200. Cambridge: Cambridge University Press, 2014.
- Reimitz, Helmut. *History, Frankish Identity and the Framing of Western Ethnicity, 550–850.* Cambridge: Cambridge University Press, 2015.
- Reynolds, Gabriel Said, ed. The Qur'an in Its Historical Context. Abingdon: Routledge, 2008.
- Robinson, Chase F. 'Abd al-Malik. Oxford: Oxford University Press, 2005.
- Stathakopoulos, Dionysios. A Short History of the Byzantine Empire. London: I.B. Tauris, 2014.
- Stevens, Susan T., and Jonathan P. Conant, eds. *North Africa under Byzantium and Early Islam*. Washington, DC: Dumbarton Oaks, 2016.
- Storr, Jim. King Arthur's Wars: The Anglo-Saxon Conquest of England. Solihull, UK: Helion & Company, 2016.
- Wagner, Walter. Opening the Qur'an: Introducing Islam's Holy Book. South Bend, IN: University of Notre Dame Press, 2008.
- Wickham, Chris. *The Inheritance of Rome: Illuminating the Dark Ages, 400–1000*. New York: Viking, 2009.

To test your knowledge of this chapter, please go to www.utphistorymatters.com for Study Questions.

THREE

CREATING NEW IDENTITIES (c.750-c.900)

In the second half of the eighth century the periodic outbreaks of the Plague of Justinian, which had devastated half of the globe for two centuries, came to an end. In their wake came a gradual but undeniable upswing in population, land cultivation, and general prosperity. At Byzantium an empress took the throne, in the Islamic world the Abbasids displaced the Umayyads, while in Francia the Carolingians deposed the Merovingians. New institutions of war and peace, learning, and culture developed, giving each culture—Byzantine, Islamic, and European—its own characteristic identity (though with some telling similarities).

BYZANTIUM: FROM TURNING WITHIN TO CAUTIOUS EXPANSION

In 750 Byzantium was a state with its back to the world: its iconoclasm isolated it from other Christians; its *strategiai* focused its military operations on internal defense; and its abandonment of classical learning set it apart from its past. By 900, all this had changed. Byzantium was iconophile (icon-loving), aggressive, and cultured.

New Icons, New Armies, New Territories

Within Byzantium, iconoclasm sowed dissension. In the face of persecution and humiliation, men and women continued to venerate icons, even in the very bedrooms of the imperial palace. The tide turned in 780 when Leo IV died and his widow, Irene, became head of the Byzantine state as regent for her son Constantine VI, and sole ruler 797–802 after her son was deposed. Long a secret iconophile, Irene immediately moved to replace important iconoclast bishops. Then she called a council at Nicaea in 787, the first there

since the famous one of 325. The meeting went as planned, and the assembled bishops condemned iconoclasm. But iconoclastic fervor still lingered, and a partial ban on icons was put into effect between 815 and 843.

At first the end of iconoclasm displeased the old guard in the army, but soon a new generation was in charge. Already before Irene's rule, Byzantium's territorial *strategiai* had been reformed. That system had given too much power to a few *strategoi*, who dominated their regions and often rebelled against imperial power. In the eighth century, the emperors began to divide the imperial army into smaller regional units (and led by less powerful *strategoi*). Drawing the recruits for each unit from its immediate neighborhood, they made the nearby rural communities pay for the equipment of soldiers unable to foot the bill. By the early ninth century, each local army and its district both were given the name *thema* (pl. *themata*): theme. Rooted in the rural landscape, the theme's very organization made clear how fully the once city-based Roman East had become agricultural. Indeed, the eighth-century landowner Philaretos was considered a saint because he gave away or lost most of his extensive lands, "so that he was left with no more than one yoke of oxen and one horse and one ass and one cow with its calf and one slave and one slave-girl." Soon he gave those away as well.

One key element of the newly reformed army was not, however, grounded in the countryside: the *tagmata* (sing. *tagma*). Created by Emperor Constantine V (r.741–775), they consisted of two new mobile regiments of heavy cavalry. At first deployed largely around Constantinople itself to shore up the emperors, the *tagmata* were eventually used in cautious frontier battles. Under the ninth- and tenth-century emperors, they helped Byzantium to expand.

In Greece, where Slavs had settled, the emperors made inroads by trying to impose their rule and taxes. To the north, in the Balkans, the emperors used military force against the Bulgars, sometimes successfully. But when Emperor Nicephorus I (r.802–811) attempted in 810 to take Sardica (today Sofia, Bulgaria), which had long been outside Byzantine control, his soldiers mutinied. To secure at least his northern border, Nicephorus uprooted thousands of families from Anatolia and elsewhere, sending them to settle and serve as soldiers in the Balkans and offering them new lands and fiscal privileges.

A year later, still keen to knock out Bulgarian power in the region, Nicephorus marshaled a huge army. Escorted by the luminaries of his court, he plundered the Bulgarian capital, Pliska, and then coolly made his way west. But the Bulgarians blockaded his army as it passed through a narrow river valley, fell on the imperial party, and killed the emperor. The toll on the fleeing soldiers and courtiers was immense, and Theophanes the Confessor said that the Bulgarian ruler, Krum (r.803–814), covered Nicephorus's skull with silver and turned it into a ceremonial drinking cup. But Theophanes, who detested both Nicephorus (because of his iconoclastic policies) and the Bulgars, may well have made up the story. In the end, Byzantine territory north- and westward swelled mightily, as a comparison of Map 3.1 with Map 2.2 on p. 43 makes clear.

Another glance at the two maps reveals a second area of modest expansion, this time on Byzantium's eastern front. In the course of the ninth century the Byzantines worked

Map 3.1 The Byzantine and Bulgarian Empires, c.920

out a strategy of skirmish warfare in Anatolia. When Muslim raiding parties attacked, the strategoi evacuated the population, burned the crops, and, while sending out a few troops to harass the invaders, largely waited out the raid within their local fortifications. But by 860, the threat of invasion was largely over (though the menace of Muslim navies-on Sicily and southern Italy, for example—remained very real). In 900, Emperor Leo VI (r.886-912) was confident enough to go on the offensive, sending the tagmata in the direction of Tarsus. The raid was a success, and in its wake at least one princely family in Armenia broke off its alliance with the Arabs, entered imperial service, and ceded its principality to Byzantium. Reorganized as the theme of Mesopotamia, it was the first of a series of new themes that Leo created in an area that had been largely a no-man's-land between the Islamic and Byzantine worlds.

The rise of the tagmata eventually had the unanticipated consequence of downgrading the themata. The soldiers of the themes did the "grunt work"—the inglorious job of skirmish warfare—without much honor or (probably) extra pay. The tagmata were the professionals, gradually taking over most of the fighting, especially as the need to defend the interior of Anatolia receded. By the same token, the troops of the themes became increasingly inactive, and the strategoi, whose original job had been to lead the themes, gradually also became regional governors. These were new men, not drawn from the traditional elites. They formed a military aristocracy that mirrored (as we shall see) the rise of a similar class in Europe and the Islamic world.

Christianity and the Rise of East Central Europe

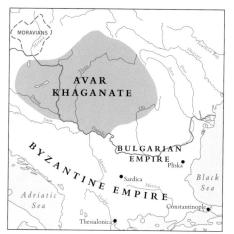

Map 3.2 The Avar Khaganate, 7th–8th cent.

To the north of Byzantium was a huge swathe of territory stretching to the Baltic Sea. Once states coalesced there, it would become East Central Europe. But while such polities (in this case under the aegis of Germanic leaders) were forming in Europe's west, the east-central region remained in flux as new groups, mainly of Slavic and Turkic origins, entered, created ephemeral political entities, and then disappeared. The Slavs made up the majority of these immigrants. As farmers rather than warriors (on the whole), however, they were normally subject to others. Chief among these were the Avars, Turkic-speaking warrior nomads who created a great empire on the Pannonian Plain. (See Map 3.2.) But the Avars were wiped out by the Franks in 796 (see below, p. 99).

Thereafter, East Central Europe took shape like a carpet unrolled from south to north; Lithuania was the last to become a fairly permanent state (see p. 274), Bulgaria the first. Christianization went hand-in-hand with state

formation; in the ninth century Byzantines (following Orthodox Christianity) and Franks (who preached the Roman Catholic brand of Christianity) competed to take advantage of the new political stability in the region. For these proselytizers, spreading the Gospel had not only spiritual but also political advantages: it was a way to bring border regions under their respective spheres of influence. For the fledgling East Central European states, conversion to Christianity meant new institutions to buttress the ruling classes, recognition by one or another of the prestigious heirs of Rome, and enhanced economic and military opportunities.

The process of Christianization began in Moravia and Bulgaria. In Moravia, Duke Ratislav (r.846-870) made a bid for autonomy from Frankish hegemony by calling on Byzantium for missionaries. The imperial court was ready. Two brothers, Constantine (later called Cyril) and Methodius, set out in 863 armed with translations of the Gospels and liturgical texts. Born in Thessalonica, they well knew about the Slavic languages, which had been purely oral. Constantine devised an alphabet using Greek letters to represent the sounds of one Slavic dialect (the "Glagolitic" alphabet). He then added Greek words and grammar where the Slavic lacked Christian vocabulary and suitable expressions. The resulting language, later called Old Church Slavonic, was an effective tool for conversion: "What man can tell all the parables / Denouncing nations without their own books / And who do not preach in an intelligible tongue? / ... Whoever accepts these letters, / To him Christ speaks wisdom," reads the prologue to Constantine-Cyril's translation of the Gospels.2 However much Byzantium valued the Greek language, and however keen it was to control all matters from Constantinople, it was nevertheless willing at times to work with different regional linguistic and cultural traditions. The Roman church, by contrast, was more rigid, insisting that the Gospels and liturgy be in Latin. In the end, however, Moravia opted for Rome.

But the Byzantine brand of Christianity prevailed in Bulgaria, Serbia, and later (see Chapter 4) Russia. We have seen how hostile the relations between the Bulgar ruler and the Byzantine emperors were. Yet c.864, Khan Boris (r.852-889) not only converted to Christianity under Byzantine auspices but also adopted the name of the Byzantine emperor of the time, Michael III (r.842-867), becoming Boris-Michael. How did Bulgaria end up in the Byzantine camp? To answer this question, consider the position of the Bulgar khan. Leader of warrior nomads, he claimed heaven's mandate; but as ruler of a state that embraced a large Christian population of Greek-speaking former Byzantines, he was obliged to take on the trappings of a Byzantine ruler as well: he employed Greeks to administer his state, used Greek officials in his writing-office, authenticated his documents with Byzantine-style seals, and adopted Byzantine court ceremonies.³ In addition, in the course of the ninth century, Bulgar contact with Byzantines increased as a result of Greek refugees fleeing—and war-prisoners being forced—into the Bulgar state. The religion of these newcomers began to "rub off" on the ruling classes. Finally, as questions Boris-Michael put to the pope in 866 suggest, the pagan religion of the Bulgars involved practices rather than dogma. It was therefore possible (though hardly easy) to convert by exchanging one sort of act with another: "When you used to go into battle," the pope wrote, "you indicated that you carried the tail of a horse as your military emblem, and you ask what you should carry now in its place. What else, of course, but the sign of the cross?" 4 By writing to the pope, Boris made clear that he had no intention of becoming subservient to Byzantium. Similarly, he arranged for an archbishop independent of Constantinople to live near him at Pliska, his capital city.

Cultural Flowering at Byzantium

The creation of the Glagolitic alphabet in the mid-ninth century was one of many scholarly and educational initiatives taking place in the Byzantine Empire in the ninth century. Constantinople had always had schools, books, and teachers dedicated above all to training civil servants. But in the eighth century the number of bureaucrats was dwindling, schools were decaying, and books, painstakingly written out on papyrus, were disintegrating. Ninth-century confidence reversed this trend, while fiscal stability and surplus wealth in the treasury greased the wheels. So did competition with the rulers and elites of the Islamic world, who supported the translations of hundreds of classical Greek texts into Arabic. Emperor Theophilus (r.829–842) opened a public school in the palace headed by Leo the Mathematician, a master of geometry, mechanics, medicine, and philosophy. Controversies over iconoclasm sent churchmen scurrying to the writings of the Church Fathers to find passages that supported their cause. With the end of iconoclasm, the monasteries, staunch defenders of icons, garnered renewed prestige and gained new recruits. Because their abbots insisted that they read Christian texts, the monks had to get new manuscripts in a hurry. Practical need gave impetus to the creation of a new kind of script: minuscule. This was made up of lower-case letters, written in cursive, the letters strung together. It

Plate 3.1 Christ on the Cross amid Saints (9th—early 10th cent.). Today this is the front cover of a liturgical book, joined to a matching portrayal of Mary, Mother of God, serving as the back cover. Perhaps originally the two together formed an icon diptych, with Mary, like Christ, standing within a cross, her arms raised in prayer, while roundels originally holding images of saints surround her.

was faster and easier to write than the formal capital uncial letters that had previously been used. Words were newly separated by spaces, making them easier to read. Papyrus was no longer easily available from Egypt, so the new manuscripts were made out of parchment—animal skins scraped and treated to create a good writing surface. (See The Making of an Illuminated Manuscript on pp. 152–55.) Far more expensive than papyrus, parchment was nevertheless much more durable, making possible books' preservation over the long haul.

A general cultural revival was clearly under way by the middle of the century. As a young man, Photius, later patriarch of Constantinople (r.858–867; 877–886), had already read hundreds of books, including works of history, literature, and philosophy. As patriarch, he gathered a circle of scholars around him; wrote sermons, homilies, and theological treatises; and tutored Emperor Leo VI. He taught Constantine-Cyril, the future missionary to the Slavs, who was already a brilliant student in his home town, Thessalonica.

The new importance of classical Greek texts helped inspire an artistic revival. Even during the somber years of iconoclasm, artistic activity did not entirely end at Byzantium. But the new exuberance and sheer numbers of mosaics, manuscript illuminations, ivories, and enamels after 870 suggest a new era. Sometimes called the Macedonian Renaissance,

after the ninth- and tenth-century imperial dynasty that fostered it, the new movement found its models in both the hierarchical style that was so important during the pre-iconoclastic period (see Plate 1.12 on pp. 32–33) and the natural, plastic style of classical art and its revivals (see Plates 1.2, 1.3, and 1.10 on pp. 13, 14–15, and 22).

Thus, both styles harked back to the past. In Plate 3.1, Christ is entirely flat and perpendicular except for his bent head. Images of the saints and angels appear in roundels. Made of cloisonné enamel and outlined with strung pearls, the figures are complex and glowing. Their richness is set off by the simplicity of the silver-gilt flat surface of the plaque and its frame, which is made of cut glass and beads of gold and pearl. No one looks at anyone else; the figures are totally isolated from one another. The artist is far more interested in patterns and color than in delineating bodies. At the same time, the very weightlessness of Christ and the others stresses a permanent, transcendental reality, so that the event of Christ's crucifixion is as triumphant as Justinian's procession in Plate 1.12 (pp. 32–33).

In Plate 3.2, however, a very different—and more classical—artistic spirit is in play. Painted in a manuscript of homilies (sermons) given by a revered figure of the Byzantine church, the figures gesture and interact, and they exist in a landscape beneath a hail-filled sky.

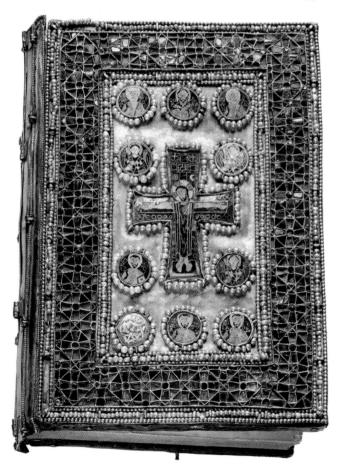

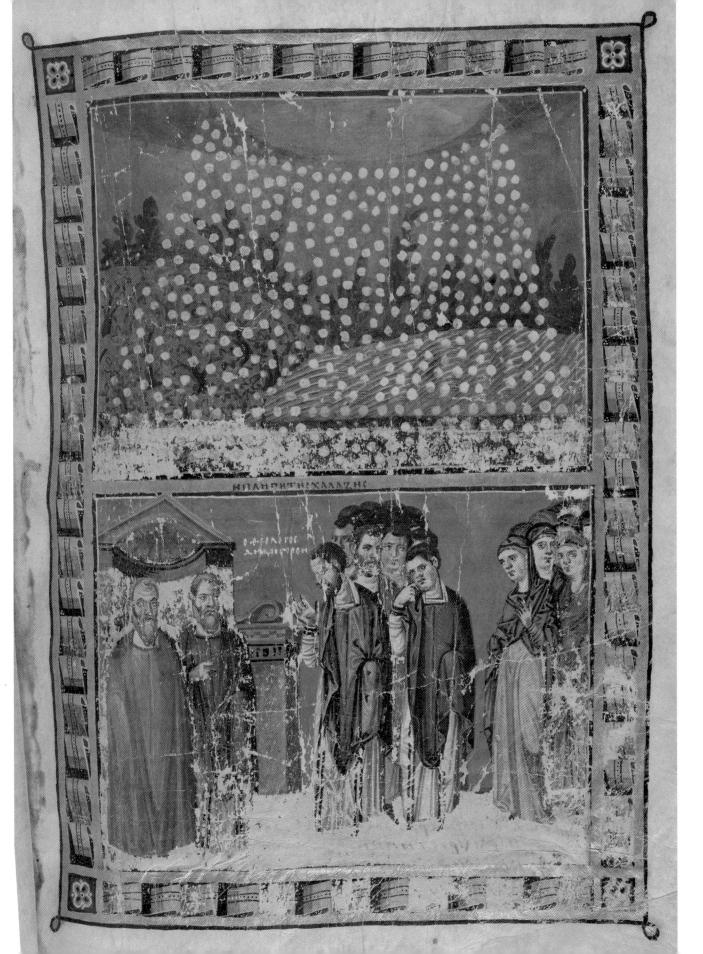

Plate 3.2 (previous page)

Gregory of Nazianzus Preaches on the Plague of Hail, Gregory's Homilies (c.880). There is a human-interest story behind this miniature, which illustrates Gregory's Homily 16: "On the plague of hail and his father's silence." There had been a hailstorm in 373 that ruined the harvests in Nazianzus, a small town in the province of Cappadocia. Gregory's father, who as local bishop should have delivered the sermon, was too depressed by the events to do so. Gregory preached in his stead. In the miniature, the hail falls from the sky, a rare instance of the portrayal of a real natural disaster. Below are three groups: on the left are Gregory and his father, in the middle are menvillagers, no doubt-and to their right are women. Gregory's father hides his hands beneath his cloak to show that he cannot preach; Gregory gestures with his right hand to indicate that he is speaking. The central man gestures that the people demand an official response to the disaster; the other people indicate their sorrow. In the homily Gregory admits the horror of the event, attributes it to God's just chastisement of sinners, and counsels weeping, prayer, and confession.

All have roundness and weight; they turn and interact. It is true that the hail is depicted as a polka-dotted veil, and the picture's frame is made of decorative curls of ribbon. But it is in just this way that the Byzantines melded classical traditions to their overriding need to represent transcendence.

Not surprisingly, the same period saw the revival of monumental architecture. Emperor Theophilus was known for the splendid palace that he commissioned on the outskirts of Constantinople, and Basil I was famous as a builder of churches. Rich men from the court and church imitated imperial tastes, constructing palaces, churches, and monasteries of their own.

THE SHIFT TO THE EAST IN THE ISLAMIC WORLD

Just as at Byzantium the imperial court determined both culture and policies, so too in the Islamic world of the ninth century were the caliph and his court the center of power. The Abbasids, who ousted the Umayyad caliphs in 750, moved their capital city to Iraq (part of the former Persia) and stepped into the shoes of the Sasanid king of kings, the "shadow of God on earth." Yet much of their time was spent less in imposing their will than in conciliating different interest groups.

The Abbasid Reconfiguration

Years of Roman rule had made Byzantium relatively homogeneous. Nothing was less true of the Islamic world, made up of regions wildly diverse in geography, language, and political, religious, and social traditions. Each tribe, family, and region had its own expectations and desires for a place in the sun. The Umayyads paid little heed. Their power base was Syria, formerly a part of Byzantium. There they rewarded their hard-core followers and took the lion's share of conquered land for themselves. They expected every other region to send its taxes to their coffers at Damascus. This annoyed regional leaders, even though they probably managed to keep most of the taxes that they raised. Moreover, with no claims to the religious functions of an *imam*, the Umayyads could never gain the adherence of the followers of Ali. Soon still other groups began to complain. Where was the equality of believers preached in the Qur'an? The Umayyads privileged an elite; Arabs who had expected a fair division of the spoils were disappointed. So too were non-Arabs who converted to Islam: they discovered that they had still to pay the old taxes of their non-believing days.

The discontents festered, and two main centers of resistance emerged: Khurasan (today eastern Iran) and Iraq. (See Map 3.3.) Both had been part of the Persian Empire; the rebellion represented the convergence of old Persian and newly "Persianized" Arab factions. In the 740s this defiant coalition at Khurasan decided to support the Abbasid family. This was

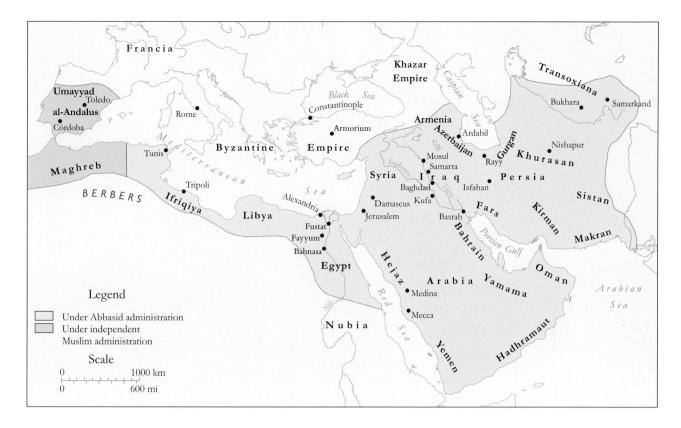

an extended kin group with deep-rooted claims to the caliphate, tracing its lineage back to the very uncle who had cared for the orphaned Muhammad. With militant supporters, considerable money, and the backing of a powerful propaganda organization, the Abbasids organized an army in Khurasan and, marching undefeated into Iraq, picked up more support there. In 750 the last Umayyad caliph, Marwan II, abandoned by almost everyone and on the run in Egypt, was killed in a short battle. Al-Saffah was then solemnly named the first Abbasid caliph.

The new dynasty seemed to signal a revolution. Most importantly, the Abbasids recognized the crucial centrality of Iraq and built their capital cities there: Baghdad became the capital in 762, Samarra in the 830s in the aftermath of a bitter civil war. The Abbasids took the title of *imam* and even, at one point, wore the green color of the Shi'ites.

Yet, as they became entrenched, the Abbasids in turn created their own elite, under whom other groups chafed. In the eighth century most of their provincial governors, for example, came from the Abbasid family itself. When building Baghdad, Caliph al-Mansur (r.754–775) allotted important tracts of real estate to his Khurasan military leaders. In the course of time, as Baghdad prospered and land prices rose, the Khurasani came to constitute a new, exclusive, and jealous elite. At the same time as they favored these groups, the Abbasids succeeded in centralizing their control even more fully than the Umayyads had done. This is clearest in the area of taxation. The Umayyads had demanded in vain that all taxes come to them. But the Abbasid caliph al-Mu'tasim (r.833–842) was able to control and direct provincial revenues to his court in Iraq. (For the Abbasids, see Genealogy 3.1).

Map 3.3 The Islamic World, c.800

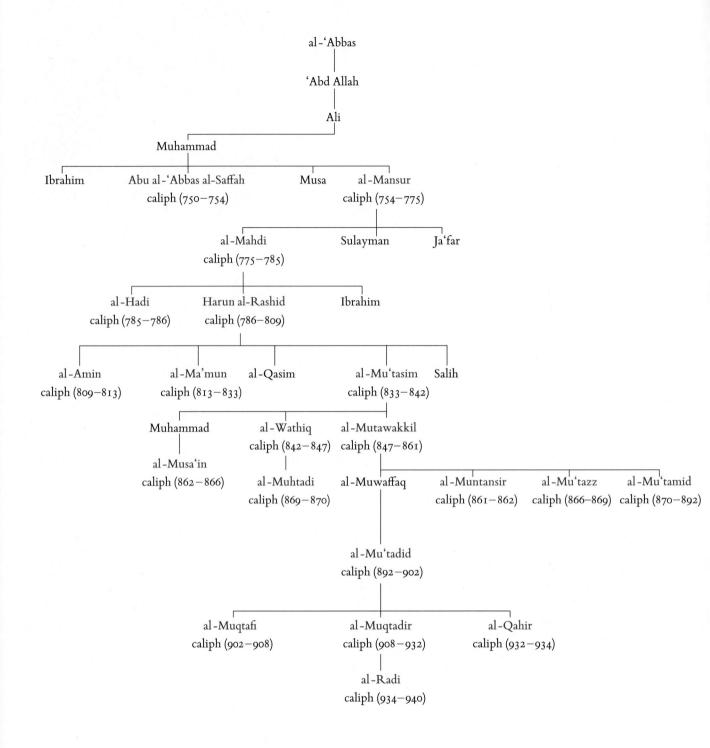

* Abbasid caliphs continued at Baghdad—with however, only nominal power—until 1258. Thereafter, a branch of the family in Cairo held the caliphate until the sixteenth century.

Control, however, was uneven. Until the beginning of the tenth century, the Abbasid caliphs generally could count on ruling Iraq (their "headquarters"), Syria, Khurasan, and Egypt. But they never had the Iberian Peninsula; they lost Ifriqiya (today Tunisia) by about 800; and they never controlled the Berbers in the soft underbelly of North Africa. In the course of the tenth century, they would lose effective control even in their heartlands. That, however, was in the future (see Chapter 4).

Whatever control the Abbasids had depended largely on their armies. Unlike the Byzantines, the Abbasids did not need soldiers to stave off external enemies or to expand outwards. (The Byzantine strategy of skirmish warfare worked largely because the caliphs led raids to display their prowess, not to take territory. The serious naval wars that took Sicily from Byzantium were launched from Ifriqiya, independent of the caliphs.) Rather, the Abbasids needed troops to collect taxes in areas already conquered but weakly controlled.

Well into the ninth century the caliphs' troops were paid, but not mustered, by them. Generals recruited their own troops from their home districts,

tribes, families, and clients. When the generals were loyal to the caliphs, this military system worked well. In the dark days of civil war, however, when two brothers fought over the caliphate (811–819), no one controlled the armies. After al-Ma'mun (r.813–833) won this civil war, he had no reliable army to back him up. His brother and successor, al-Mu'tasim, found the solution in a new-style, private army. He bought and trained his own slaves, many of them Turks and thus unrelated to other tribal groups. These men were given governorships as well as military posts. They were the reason that al-Mu'tasim was able to collect provincial taxes so effectively. He could not foresee that in time the Turks would come to constitute a new elite, one that would eventually help to overpower the caliphate itself.

Under the Abbasids, the Islamic world became wealthy. The Mediterranean region had always been a great trade corridor; in the ninth century, Baghdad, at the crossroads of East and West, drew that trade into a wider network that included India, China, and the Khazar Empire to its north. Eclectic, open to numerous traditions of arts and crafts, the Abbasid world was cosmopolitan. Dining off ornate plates and bowls, pouring their water from richly decorated pitchers, the Islamic upper and middle classes could boast splendid tableware (see Plate 3.3). Their clothes, made of richly woven fabrics, were luxurious. Wall-hangings and rugs adorned their homes, and elaborately carved censers spread their perfume. Luxury followed them even into the graveyard. (See Plate 3.4.)

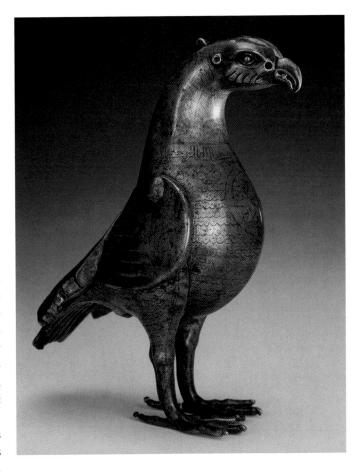

Genealogy 3.1 (facing page) The Abbasids*

Plate 3.3 Water Pitcher in the Shape of an Eagle (796–797). At one time this brass eagle had a handle and was no doubt used as a water pitcher by a well-to-do Syrian or Iraqi family. Inlaid with silver and copper, most of which has disappeared, it includes the name of the craftsman who made it (Suleiman) along with a blessing and the date of its manufacture.

Plate 3.4 Chest or Cenotaph Panel (second half of 8th cent.). This inlaid wood panel, found in a cemetery near Fustat (Old Cairo), brings together numerous different traditions. Marquetry, which uses thousands of pieces of tiny bone and woods of different shades to create an intricate design, was a skill practiced by the Coptic Christians in Egypt. The wings at the top of the columns and holding up the central wheel drew on a Sasanid Persian motif. The geometric pattern was pre-Islamic. In the center of the wheel is a late classical vine scroll. The sequence of arches is Romano-Byzantine. Perhaps this remarkable piece may be connected to a military garrison established in the vicinity in the mid-eighth century.

New Forms of Literature

With revenues from commerce and (above all) taxes from agriculture in their coffers, the Abbasid caliphs paid their armies, salaried their officials (drawn from the many talented men—but, in this relentlessly male-dominated society, not women—in the Persian, Arab, Christian, and Jewish population), and presided over a cultural revival that, as we have seen, inspired a similar one at Constantinople.

In the ninth century, most spectacularly under caliphs Harun al-Rashid and al-Ma'mun, literature, science, law, and other forms of scholarship flourished. Books of all sorts were relatively cheap (and therefore accessible) in the Islamic world because they were written on paper. The caliphs launched scientific studies via a massive translation effort that brought the philosophical, medical, mathematical, and astrological treatises of the Indian and Greek worlds into Islamic culture. They encouraged poetry of every sort.

Thus after Caliph al-Mu'tasim conquered the Byzantine city of Amorium (838), he paid the poet Abu Tammam handsomely for a long poem that praised both the victory and the victors:

A victory of victories, so sublime prose cannot speak nor verse can utter it;
A victory at which Heaven threw wide its gates, which Earth put on new dress to celebrate:
O battle of Amorium, for which our hopes returned engorged with milk and honey.
The Muslims hast thou fixed in the ascendant, pagans and pagandom fixed in decline!

It is obvious why such laudatory poetry, beautifully and cleverly written, should be cultivated under the Abbasids. But other kinds of poetry were equally prized: those celebrating wine and love, for example, were appreciated as *adab*, a literature (both in verse and prose) of refinement. (*Adab* means "good manners.")

Shoring up the regime with astrological predictions; winning theological debates with the pointed weapons of Aristotle's logical and scientific works; understanding the theories of bridge-building, irrigation, and land-surveying with Euclid's geometry—these were just some of the reasons why scholars in the Islamic world labored over translations and created original scientific works. Their intellectual pyrotechnics won general support. Patrons of scientific writing included the caliphs, their wives, courtiers, generals, and ordinary people with practical interests. Al-Khwarizmi (d.c.850), author of a book on algebra (a term derived from al-jabr, a word in its title), explained all its practical uses. Even handier was his treatise on the Indian method of calculation—Indian numerals are what we call Arabic numerals—and the use of the zero, essential (to give just one example) for distinguishing 100 from 1.

How should one live to be pleasing to God? This was the major question that inspired the treatises on *hadith* (traditions about the Prophet) that began to appear in the Abbasid period. Each *hadith* began with the chain of oral transmitters (the most recent listed first) that told a story about Muhammad; there then followed the story itself. Thus, for example, in the compilation of *hadith* by al-Bukhari (810–870) on the issue of fasting during Ramadan (the yearly period of fasting from sunrise to sunset), he took up the question of the distracted "faster who eats and drinks from forgetfulness":

'Abdan related to us [saying], Yazid b. Zurai' informed us, saying, Hisham related to us, saying: Ibn Sirin related to us from Abu Huraira, from the Prophet—upon

whom be blessing and peace—that he said: "If anyone forgets and eats or drinks, let him complete his fast, for it was Allah who caused him thus to eat or drink."

Here 'Abdan was the most recent witness to a saying of the Prophet, with Abu Huraira the closest to the source. A well-known "Companion" of the Prophet Muhammad, Abu Huraira was named as the ultimate authority for thousands of *hadith*.

Even the Qur'an did not escape scholarly scrutiny. While some interpreters read it literally as the word of God and thus part of God, others viewed it as something (like humankind) created by God and therefore separate from Him. For Caliph al-Ma'mun, taking the Qur'an literally undermined the caliph's religious authority. Somewhat like the Byzantine emperor Leo III (see pp. 47–48), whose iconoclastic policies were designed to separate divinity from its representations, al-Ma'mun determined to make God greater than the Qur'an. In 833 he instituted the Mihna, or Inquisition, demanding that the literalists profess the Qur'an's createdness. But al-Ma'mun died before he could punish those who refused, and his immediate successors were relatively ineffective in pursuing the project. The scholars on the other side—the literalists and those who looked to the hadith—carried the day, and in 848 Caliph al-Mutawakkil (r.847–861) ended the Mihna, emphatically reversing the caliphate's position on the matter. Sunni Islam thus defined itself against the views of a caliph who, by asserting great power, lost much. The caliphs ceased to be the source of religious doctrine; that role went to the scholars, the ulama. It was around this time that the title "caliph" came to be associated with the phrase "deputy of the Prophet of God" rather than the "deputy of God." The designation reflected the caliphate's decreasing political as well as religious authority (see Chapter 4).

Al-Andalus: A Society in the Middle

Taking advantage of the caliphs' waning prestige was the ruler of al-Andalus (Islamic Spain). In the mid-eighth century Abd al-Rahman I, an Umayyad prince on the run from the Abbasids, managed to gather an army, make his way to Iberia, and defeat the provincial governor at Córdoba. In 756 he proclaimed himself "emir" (commander) of al-Andalus. His dynasty governed al-Andalus for two and a half centuries. In 929, emboldened by his growing power and the depletion of caliphal power at Baghdad, Abd al-Rahman III (r.912–961) took the title caliph. Nevertheless, like the Abbasid caliphs, the Umayyad rulers of Spain headed a state poised to break into its regional constituents.

Al-Andalus under the emirs was hardly Muslim and even less Arab. As the caliphs came to rely on Turks, so the emirs relied on a professional standing army of non-Arabs, the *al-khurs*, the "silent ones"—men who could not speak Arabic. They lived among a largely Christian—and partly Jewish—population; even by 900, only about 25 per cent of the people in al-Andalus were Muslim. This had its benefits for the regime, which taxed Christians and Jews heavily. Although, like Western European rulers, they did not have the land tax that the Byzantine emperors and caliphs could impose, the emirs did

draw some of their revenue from Muslims, especially around their capital at Córdoba. (See Map 3.4 on p. 96.)

Money allowed the emirs to pay salaries to their civil servants and to preside over a cultural efflorescence that reflected the region's unique ethnic and religious mix. The Great Mosque in Córdoba is a good example. Begun under Abd al-Rahman I and expanded by his successors, its square form was much like other early mosques. (See Figure 3.1). Yet it drew on the design of the Roman aqueduct at Mérida for its rows of columns connected by double arches. (See Plate 3.5 on p. 97.) For the shape of the arches, however, it borrowed a form—the "Visigothic" horseshoe arch—from the Christians.

The cultural "mix" went beyond architectural forms. Some Muslim men took Christian wives, and religious practices seem to have melded a bit. In fact, the Christians who lived in al-Andalus were called "Mozarabs"—"would-be Arabs"—by Christians elsewhere. It is likely that Christians and Muslims on the whole got along fairly well. Christians dressed like Muslims, worked side-by-side with them in government posts, and used Arabic in many aspects of their life. In the mid-ninth century, there were in the region of Córdoba alone at least four churches and nine monasteries. No doubt there were synagogues as well, but our sources for Jewish life in Islamic Iberia are very fragmentary until the tenth century, when at least a few high-ranking Jews burst onto the public stage.

To the north of al-Andalus, beyond the Duero River, were tiny Christian principalities. Their spokesmen donned the mantle of the Visigoths, claiming to be the legitimate rulers of Spain. A chronicler from the ninth century celebrated their triumphs as God-given: "Alfonso was elected king by all the people, receiving the royal sceptre with

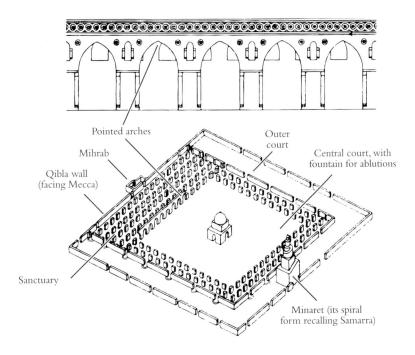

Figure 3.1 Mosque Plan (Cairo, Ibn Tulum Mosque, built 876–879)

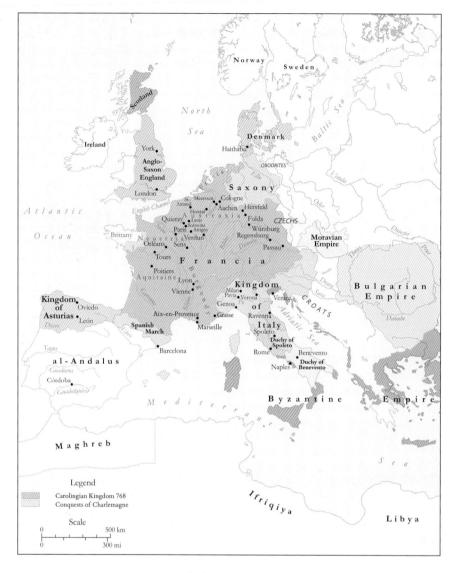

Map 3.4 Europe, c.814 Plate 3.5 (facing page) Great Mosque, Córdoba (785-787). The Great Mosque of Córdoba gave monumental identity to the new Umayyad rulers in al-Andalus. Note the two tiers of arches, the first set on pre-Islamic columns despoiled from Roman and Visigothic buildings, the second springing from high piers. With their alternating red and white stones and repeated pattern, the arches suggest lively arcades leading from west to east, but the overall effect is tranquil.

divine grace. He always crushed the audacity of his enemies.... Killing all the Arabs with the sword, he led the Christians back with him to his country."7 The hero here was Alfonso I (r.739-757), whose kingdom of Asturias partook in the general demographic and economic growth of the period. Alfonso and his successors built churches. encouraged monastic foundations, collected relics, patronized literary efforts, and welcomed Mozarabs from the south. As they did so, they looked to Christian models still farther north-to Francia, where Charlemagne and his heirs ruled as kings "by grace of God."

AN EMPIRE IN SPITE OF ITSELF

Between Byzantium and the Islamic world was Francia. While the first two were politically centralized, subject to sophisticated tax systems, and served by salaried armies and officials, Francia inher-

ited the centralizing traditions of the Roman Empire without its order and efficiency. Francia's kings could not collect a land tax, the backbone of the old Roman and the more recent Byzantine and Islamic fiscal systems. There were no salaried officials or soldiers in Francia. Yet the new dynasty of kings there, the Carolingians, managed to muster armies, expand their kingdom, encourage a revival of scholarship and learning, command the respect of emperors and caliphs, and forge an identity for themselves as leaders of the Christian people. Their successes bore striking resemblance to contemporary achievements at Constantinople and Baghdad. How was this possible? The answer is at least threefold: the Carolingians took advantage of the same gentle economic upturn that seems to have taken place generally; they exploited to the full the institutions of Roman culture and political life that remained to them; and at the same time, they were willing to experiment with new institutions and take advantage of unexpected opportunities.

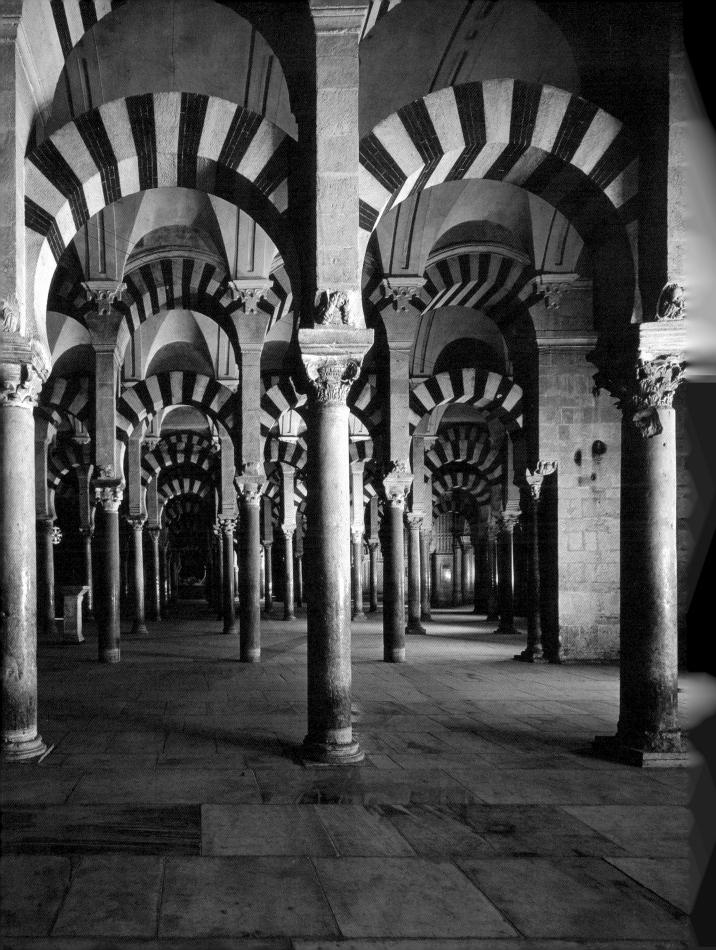

The Making of the Carolingians

The Carolingian take-over was a "palace coup." After a battle (at Tertry, in 687) between Neustrian and Austrasian noble factions, one powerful family with vast estates in Austrasia came to monopolize the high office of mayor for the Merovingian kings in both places. In the first half of the eighth century these mayors took over much of the power and most of the responsibilities of the kings.

Charles Martel (mayor 714–741) gave the name Carolingian (from *Carolus*, Latin for Charles) to the dynasty. In 732 he won a battle near Poitiers against an army led by the Muslim governor of al-Andalus, ending further raids. But Charles had other enemies: he spent most of his time fighting vigorously against regional Frankish aristocrats intent on carving out independent lordships for themselves. Playing powerful factions against one another, rewarding supporters, defeating enemies, and dominating whole regions by controlling monasteries and bishoprics that served as focal points for both religious piety and land donations, the Carolingians created a tight network of supporters.

Moreover, they chose their allies well, reaching beyond Francia to the popes and to Anglo-Saxon churchmen, who (as we have seen) were closely tied to Rome. When the Anglo-Saxon missionary Boniface (d.754) wanted to preach in Frisia (today the Netherlands) and Germany, the Carolingians readily supported him as a prelude to their own conquests. Although many of the areas where Boniface missionized had long been Christian, their practices were local rather than tied to Rome. By contrast, Boniface's newly appointed bishops were loyal to Rome and the Carolingians, not to regional aristocracies. They knew that their power came from papal and royal fiat rather than from local power centers.

Men like Boniface opened the way to a more direct alliance between the Carolingians and the pope. Historians used to think that Pippin III (d.768), the son of Charles Martel, obtained approval from Pope Zacharias (741–752) to depose the reigning Merovingian king. Recent research by Rosamond McKitterick suggests that such an early liaison between the pope and the Carolingians was manufactured by later writers. But it is certain that after Pippin took the throne in 751, Pope Stephen II (752–757) traveled to Francia. He anointed Pippin, blessed him, and begged him to send an army against the encircling Lombards: "Hasten, hasten, I urge and protest by the living and true God, hasten and assist! ... Do not suffer this Roman city to perish in which the Lord laid my body [i.e., the body of Saint Peter, with whom the pope identified himself] and which he commended to me and established as the foundation of the faith. Free it and its Roman people, your brothers, and in no way permit it to be invaded by the people of the Lombards."

In the so-called Donation of Pippin (756), the new king forced the Lombards to give some cities back to the pope. The arrangement recognized that the papacy was now the ruler in central Italy of a territory that had once belonged to Byzantium. Before the 750s, the papacy had been part of the Byzantine Empire; by the middle of that decade, it had become part of the West. It was probably soon thereafter that members of the papal chancery (writing office) forged a document, the *Donation of Constantine*, which had the

fourth-century Emperor Constantine declare that he was handing the western half of the Roman Empire to Pope Sylvester.

The chronicler of Charles Martel had already tied his hero's victories to Christ. The Carolingian partnership with Rome and Romanizing churchmen added to the dynasty's Christian aura. Anointment—daubing the kings with holy oil—provided the finishing touch. It reminded contemporaries of David, king of the Israelites: "Then Samuel took the horn of oil and anointed him in the midst of his brethren; and the spirit of the Lord came upon David from that day forward" (I Sam. [or Vulgate I Kings] 16:13).

Charlemagne

The most famous Carolingian king was Charles (r.768–814), called "the Great" ("le Magne" in Old French). Large, tough, wily, and devout, he was everyone's model king. Einhard (d.840), his courtier and scholar, saw him as a Roman emperor: he patterned his *Life of Charlemagne* on the *Lives of the Caesars*, written in the second century by the Roman biographer Suetonius. Alcuin (d.804), also the king's courtier and an even more famous scholar, emphasized Charlemagne's religious side, nicknaming him "David," the putative author of the psalms, victor over the giant Goliath, and king of Israel. Empress Irene at Constantinople saw Charlemagne as a suitable husband for herself (though the arrangement eventually fell through).

Charlemagne's fame was largely achieved through warfare. While the Byzantine and Islamic rulers clung tightly to what they had, Charlemagne waged wars of plunder and conquest. He invaded Italy, seizing the Lombard crown and annexing northern Italy in 774. He moved his armies northward, fighting the Saxons for more than thirty years, forcibly converting them to Christianity, and annexing their territory. To the southeast, he sent his forces against the Avars, capturing their strongholds, forcing them to submit to his overlordship, and making off with cartloads of plunder. His expedition to al-Andalus gained Charlemagne a band of territory north of the Ebro River, a buffer between Francia and the Islamic world called the "Spanish March." Even his failures were the stuff of myth: a Basque attack on Charlemagne's army as it returned from Spain became the core of the epic poem *The Song of Roland*.

Ventures like these depended on a good army. Charlemagne's was led by his *fideles*, faithful aristocrats, and manned by free men, many the "vassals" (clients) of the aristocrats. The king had the *bannum*, the ban, which was the right to call his subjects to arms (and, more generally, to command, prohibit, punish, and collect fines when his ban was not obeyed). Soldiers provided their own equipment; the richest went to war on horseback, the poorest had to have at least a lance, shield, and bow. There was no standing army; men had to be mobilized for each expedition. No *tagmata* or Turkish soldier-slaves were to be found here! Yet, while the empire was expanding, it was a very successful system; men were glad to go off to war when they could expect to return enriched with booty.

Genealogy 3.2 (facing page) The Carolingians* By 800, Charlemagne's kingdom stretched 800 miles from east to west, even more from north to south when Italy is counted. (See Map 3.4 on p. 96.) On its eastern edge was a strip of "buffer regions" extending from the Baltic to the Adriatic; they were under Carolingian overlordship. Such hegemony was reminiscent of an empire, and Charlemagne began to act according to the model of Roman emperors, sponsoring building programs to symbolize his authority, standardizing weights and measures, and acting as a patron of intellectual and artistic enterprises. He built a capital "city"—a palace complex, in fact—at Aachen, complete with a chapel patterned on San Vitale, the church built by Justinian at Ravenna (see pp. 31–33). So keen was Charlemagne on Byzantine models that he had columns, mosaics, and marbles from Rome and Ravenna carted up north to use in his own buildings.

Further drawing on imperial traditions, Charlemagne issued laws in the form of "capitularies," summaries of decisions made at assemblies held with the chief men of the realm. He appointed regional governors, called "counts," to carry out his laws, muster his armies, and collect his taxes. Chosen from Charlemagne's aristocratic supporters, they were compensated for their work by temporary grants of land rather than with salaries. This was not Roman; but Charlemagne lacked the fiscal apparatus of the Roman emperors (and of his contemporary Byzantine emperors and Islamic caliphs), so he made land substitute for money. To discourage corruption, he appointed officials called *missi dominici* ("those sent out by the lord king") to oversee the counts on the king's behalf. The *missi*—abbots, bishops, and counts, aristocrats all—traveled in pairs across Francia. They were to look into the affairs—large and small—of the church and laity.

In this way, Charlemagne set up institutions meant to echo those of the Roman Empire. It was a brilliant move on the part of Pope Leo III (795–816) to harness the king's imperial pretensions to papal ambitions. In 799, accused of adultery and perjury by a hostile faction at Rome, Leo narrowly escaped blinding and having his tongue cut out. Fleeing northward to seek Charlemagne's protection, he returned home under escort, the king close behind. Charlemagne arrived in late November 800 to an imperial welcome orchestrated by Leo. On Christmas Day of that year, Leo put an imperial crown on Charlemagne's head, and the clergy and nobles who were present acclaimed the king "Augustus," the title of the first Roman emperor. In one stroke the pope managed to exalt the king of the Franks, downgrade Irene at Byzantium, and enjoy the role of "emperor maker" himself.

About twenty years later, when Einhard wrote about this coronation, he said that the imperial titles at first so displeased Charlemagne "that he stated that, if he had known in advance of the pope's plan, he would not have entered the church that day, even though it was a great feast day." In fact, Charlemagne continued to use the title "king" for about a year; then he adopted a new one that was both long and revealing: "Charles, the most serene Augustus, crowned by God, great and peaceful emperor who governs the Roman Empire and who is, by the mercy of God, king of the Franks and the Lombards." According to this title, Charlemagne was not the Roman emperor crowned by the pope but rather God's emperor, who governed the Roman Empire along with his many other duties.

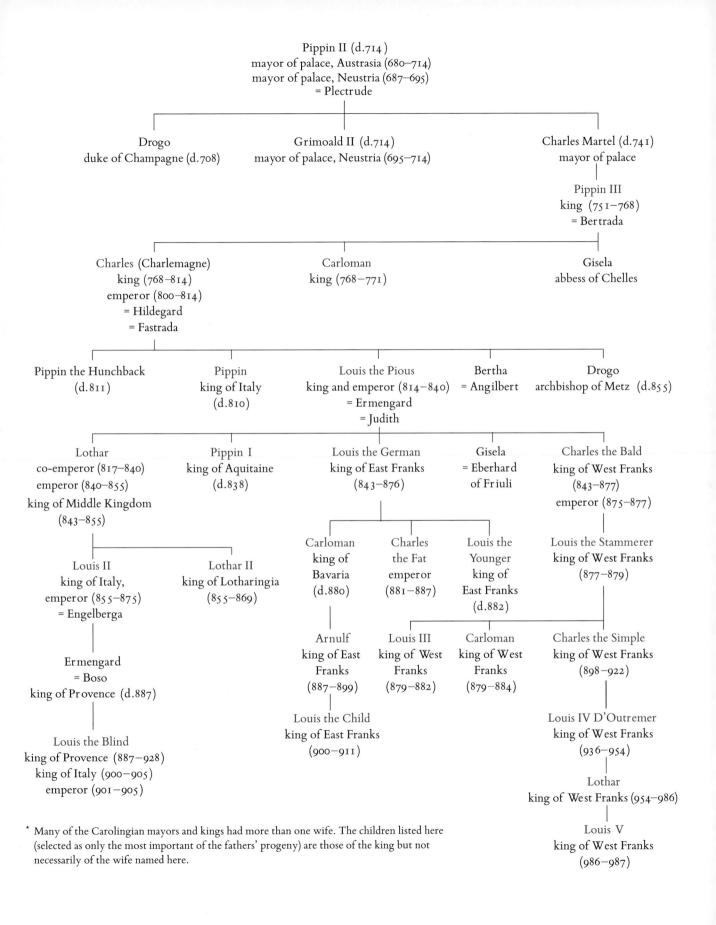

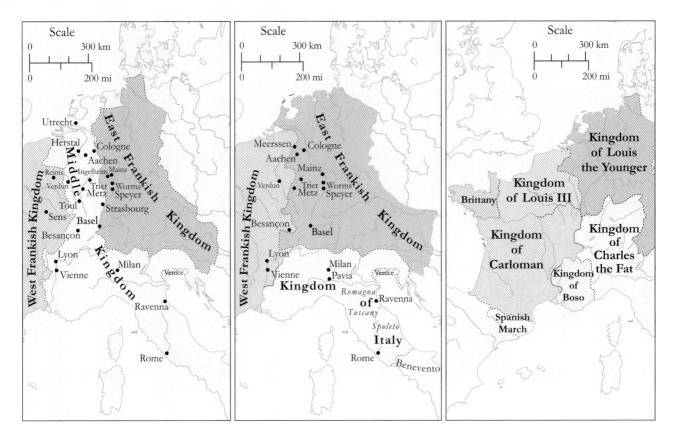

Map 3.5a Partition of 843 (Treaty of Verdun)

Map 3.5b Partition of 870 (Treaty of Meerssen)

Map 3.5c Partition of 880

Charlemagne's Heirs

When Charlemagne died, only one of his sons remained alive: Louis, nicknamed "the Pious." (See Genealogy 3.2.) Emperor he was (from 814 to 840), but over an empire that was a conglomeration of territories with little unity. He had to contend with the revolts of his sons, the depredations of outside invaders, the regional interests of counts and bishops, and above all an enormous variety of languages, laws, customs, and traditions, all of which tended to pull his empire apart. He contended with gusto, his chief unifying tool being Christianity. Calling on the help of the monastic reformer Benedict of Aniane (d.821), Louis imposed the Benedictine Rule on all the monasteries in Francia. Monks and abbots served as his chief advisors. Louis's imperial model was Theodosius I, who had made Christianity the official religion of the Roman Empire (see pp. 7–8). Organizing inquests by the missi, Louis looked into allegations of exploitation of the poor, standardized the procedures of his chancery, and put all Frankish bishops and monasteries under his control.

Charlemagne had employed his sons as "sub-kings," but Louis politicized his family still more. Early in his reign he had his wife crowned empress; named his first-born son, Lothar, emperor and co-ruler; and had his other sons, Pippin and Louis (later called "the German"), agree to be sub-kings under their older brother. It was neatly planned. But when Louis's first wife died he married Judith, daughter of a relatively obscure kindred (the Welfs) that stemmed from the Saxon and Bavarian nobility and would later become enormously powerful. In 823 she and Louis had a son, Charles (later "the Bald"), and this upset the earlier division of the empire. A family feud turned into bitter civil war as brothers fought one another and their father for titles and kingdoms. In 833 matters came to a head when Louis, effectively taken prisoner by Lothar, was forced to do public penance. Lothar expected the ritual to get his father off the throne for life. But Louis played one son against the other and made a swift comeback. The episode showed how Carolingian rulers could portray themselves as accountable to God and yet, in that very act of subservience, make themselves even more sacred and authoritative in the eyes of their subjects.

After Louis's death, a period of war and uncertainty (840–843) among the three remaining brothers (Pippin had died in 838) ended with the Treaty of Verdun (843). (See Map 3.5a.) The empire was divided into three parts, an arrangement that would roughly define the future political contours of Western Europe. The western third, bequeathed to Charles the Bald (r.843–877), would eventually become France, and the eastern third, given to Louis the German (r.843–876), would become Germany. The "Middle Kingdom," which became Lothar's portion (r. as co-emperor 817–840; as emperor 840–855), had a different fate: parts of it were absorbed by France and Germany, while the rest eventually coalesced into the modern states of Belgium, the Netherlands, and Luxembourg—the so-called Benelux countries—as well as Switzerland and Italy. All this was far in the future. As the brothers had their own children, new divisions were tried: one in 870 (the Treaty of Meerssen), for example, and another in 880. (See Maps 3.5b and 3.5c.) After the death of Emperor Charles the Fat (888), various kings and lesser rulers, many of them non-Carolingians, came to the fore in the irrevocably splintered empire.

Dynastic problems contributed to the breakup of the Carolingian Empire. So did invasions by outsiders—Vikings, Muslims, and, starting in 899, Magyars (Hungarians)—which harassed the Frankish Kingdom throughout the ninth century. These certainly weakened the kings: without a standing army, they were unable to respond to lightning raids, and what regional defense there was fell into the hands of local leaders, such as counts. A monk at Paris named Abbo, an eyewitness to Viking attacks there, wrote a poem in praise of the defenders of his city: "Among all the warriors, there were two most outstanding / For their valor: one was a count, the other an abbot." ¹⁰

The Carolingians lost prestige and money as they paid out tribute to stave off further attacks. Above all, the Carolingian Empire atomized because linguistic and other differences between regions—and familial and other ties within regions—were simply too strong to be overcome by directives from a central court. Even today a unified Europe is only a distant ideal. Anyway, as we shall see, fragmentation had its own strengths and possibilities.

The Wealth of a Local Economy

The Carolingian economy was based on plunder, trade, and agriculture. After the Carolingians could push no further and the raids of Charlemagne's day came to an end,

Map 3.6 Northern Emporia in the Carolingian Age

trade and land became the chief resources of the kingdom. To the north, in Viking trading stations such as Haithabu (see Map 3.6), archaeologists have found Carolingian glass and pots alongside Islamic coins and cloth, showing that the Carolingian economy meshed with that of the Abbasid caliphate. Silver from the Islamic world probably came north from the Caspian Sea, up the Volga River to the Baltic Sea. There the coins were melted down and the silver traded to the Carolingians in return for wine, jugs, glasses, and other manufactured goods. The Carolingians turned the silver into coins of their own, to be used throughout the

empire for small-scale local trade. Baltic Sea emporia such as Haithabu supplemented those—Quentovic and Dorestad, for example—that served the North Sea trade.

Nevertheless, the backbone of the Carolingian economy was land. A few written records, called *polyptyques*, document the output of the Carolingian great estates—"villae," as they were called in Latin, "manors," as we term them. On the far-flung and widely scattered manors of rich landowners—churches, monasteries, kings, and aristocrats—a major reorganization and rationalization was taking place. The most enterprising landlords instituted a three-field rather than a two-field cultivation system. It meant that two-thirds of the land rather than one-half was sown with crops each year, yielding a tidy surplus.

Consider Lambesc, near Aix-en-Provence, one of the many manors belonging to the cathedral of Saint Mary of Marseille. It was not a compact farm but rather a conglomeration of essential parts, with its lands, woods, meadows, and vineyards scattered about the countryside. All were worked by peasant families, some legally free, some unfree, each settled on its own holding—here called a *colonica*; elsewhere often called a *mansus*, or "manse"—usually including a house, a garden, small bits of several fields, and so on. The peasants farmed the land that belonged to them and paid yearly dues to their lord—in this case the Church of Saint Mary, which, in its *polyptyque*, kept careful track of what was owed:

[There is a] holding [colonica] at Nemphas. Martinus, colonus. Wife Dominica. Bertemarus, an adult son. Desideria, an adult daughter. It pays the tax: 1 pig, 1 suckling [pig]; 2 fattened hens; 10 chickens; 40 eggs. Savarildis, an adult woman. Olisirga, a daughter 10 years old. Rica, a daughter 9 years old. The same of the same o

Martinus and his family apparently did not work the *demesne*—the land, woods, meadows, and vineyards directly held by Saint Mary—but they paid a yearly tax of animals and animal produce. Other tenants farmed the demesne, as at Nidis, in the region of Grasse, where Bernarius owed daily service and also paid a penny (1 *denarius*) in yearly dues. On many manors women were required to feed the lord's chickens or busy themselves in the *gynecaeum*, the women's workshop, where they made and dyed cloth and sewed garments.

Clearly the labor was onerous and the accounting system complex and unwieldy; but manors organized on the model of Saint Mary made a profit. Like the Church of Saint Mary and other lords, the Carolingian kings benefited from their own extensive manors.

Nevertheless, farming did not return great surpluses, and as the lands belonging to the king were divided up in the wake of the partitioning of the empire, Carolingian dependence on manors scattered throughout their kingdom proved to be a source of weakness.

The Carolingian Renaissance

With the profits from their manors, some monasteries and churches invested in books. These were not made of paper—a product that, although already used in the Islamic world, did not reach the West until the eleventh century—but rather of parchment: animal skins soaked, scraped, and cut into sheets (see The Making of an Illuminated Manuscript on pp. 152-55). Nor were Carolingian books printed, since the printing press was not invented until around 1450. Rather, books were written by hand; they were "manuscripts" from manus = hand and scriptus = written. This was taxing work, and scribes often shared in the production of just one manuscript, working together in scribal workshops (scriptoria; sing. scriptorium). Consider the monastery of Saint-Amand (today in northern France), which made books both for its own use and for the needs of many other institutions: its scriptorium produced Gospels, works of the Church Fathers, grammars, and above all liturgical books for the Mass and other church services.

Plate 3.6 on p. 106 shows a page from a Sacramentary (a liturgical book) that was produced at Saint-Amand for the Parisian monastery of Saint-Germain-des-Prés (where Abbo, above p. 103, wrote about the Viking attacks). For the most part, Saint-Amand provided only the texts of Mass chants. But in one instance the scribe added some "dots and dashes" above the word Exaudi (Hear!). They illustrate one early form of musical notation. These "notes" did not indicate pitches to the monks who sang the melodies. Nor did they suggest rhythms. They simply reminded the monks of the melody associated with one chant beginning with the word Exaudi.

The development of written music was a response to royal policy. Before the Carolingians came to power, the music at churches and monasteries had been determined by local oral traditions. But the special relationship that the Carolingians had with Rome included importing Roman chant melodies to Francia. This reform—the imposition of the so-called Gregorian chant—posed great practical difficulties. It meant that every monk and priest had to learn a year's worth of Roman music; but how? A few cantors were imported from Rome, but without a system of notation, it was easy to forget new tunes. The monks of Saint-Amand were part of a revolution in musical technology.

The same Sacramentary reveals another key development of the era: the use of minuscule writing. As at Byzantium, and around the same time, the Carolingians experimented with letterforms that were quick to write and easy to read. "Caroline minuscule" lasted into the eleventh century, when it gave way to a more angular script, today called "Gothic." But the Carolingian letter forms were rediscovered in the fifteenth century—by scholars who thought that they represented ancient Roman writing!—and they became the model for modern lower-case printed fonts.

The Carolingian court was behind much of this activity. Most of the centers of learning, scholarship, and book production began under men and women who at one time or another were part of the royal court. Alcuin, perhaps the most famous of the Carolingian intellectuals, was "imported" by Charlemagne from England—where, as we have seen (p. 65), monastic scholarship flourished—to head up the king's palace school. Chief advisor to Charlemagne and tutor to the entire royal family, Alcuin eventually became abbot of Saint-Martin of Tours, grooming a new generation of teachers. More unusual but equally telling was the experience of Gisela, Charlemagne's sister. She too was a key royal advisor, the one who alerted the others at home about Charlemagne's imperial coronation at Rome in 800. She was also abbess of Chelles, near Paris, a center of manuscript production in its own right. Chelles had a library, and its nuns were well educated. They wrote learned letters and composed a history (the "Prior Metz Annals") that treated the rise of the Carolingians as a tale of struggle between brothers, sons, and fathers eased by the wise counsel of mothers, aunts, and sisters.

Women and the poor made up the largely invisible half of the Carolingian Renaissance. But without doubt some were part of it. One of Charlemagne's capitularies ordered that the cathedrals and monasteries of his kingdom should teach reading and writing to all who could learn. There were enough complaints (by rich people) about upstart peasants who found a place at court that we may be sure that some talented sons of the poor were getting an education. A few churchmen expressed the hope that schools for "children" would be established even in small villages and hamlets. Were they thinking of girls as well as boys? Certainly the noblewoman Dhuoda proves that education was available even to laywomen. We would never know about her had she not worried enough about her absent son to write a Handbook for Her Son full of advice. It is clear in this deeply felt moral text that Dhuoda was drawing on an excellent education: she obviously knew the Bible, writings of the Church Fathers, Gregory the Great, and "moderns," like Alcuin. Her Latin was fluent and sophisticated. And she understood the value of the written word:

My great concern, my son William, is to offer you helpful words. My burning, watchful heart especially desires that you may have in this little volume what I have longed to be written down for you, about how you were born through God's grace. 12

The original manuscript of Dhuoda's text is not extant. Had it survived, it would no doubt have looked like other "practical texts" of the time: the "folios" (pages) would have been written in Caroline minuscule, each carefully designed to set off the poetry— Dhuoda's own and quotes from others—from the prose; the titles of each chapter (there are nearly a hundred, each very short) would have been enlivened with delicately colored capital letters. The manuscript would probably not have been illuminated (illustrated); fancy books were generally made for royalty, for prestigious ceremonial occasions, or for books that were especially esteemed, such as the Gospels.

There were, however, many such lavish productions. In fact, Carolingian art and architecture mark a turning point. For all its richness, Merovingian culture had not stressed Plate 3.6 (facing page) Sacramentary of Saint-Germain-des-Prés (early 9th cent.). The scribe of this list of incipits (the "first words") of Mass chants provided a musical reminder of one (seven lines from the bottom, on the left) by adding neumes above the first words, "Exaudi Domine," "Hear, O Lord."

Plate 3.7 Andromeda (840s?). In this notebook-sized (about 9 × 8 inch) Carolingian manuscript, probably made at Aachen or Metz, an artist painted nearly forty miniatures of the constellations named in a poem by Aratos.

artistic expression, though some of the monasteries inspired by Saint Columbanus produced a few illuminated manuscripts. By contrast, the Carolingians, admirers and imitators of Christian Rome, vigorously promoted a vast, eclectic, and ideologically motivated program of artistic work. They were reviving the Roman Empire. We have already seen how Charlemagne brought the very marble of Rome and Ravenna home to Aachen to build his new palace complex. A similar impulse inspired Carolingian art.

As with texts, so with pictures: the Carolingians revered and imitated the past while building on and changing it. Their manuscript illuminations were inspired by a vast repertory of models: from the British Isles (where, as we have seen, a rich synthesis of decorative and representational styles had a long tradition), from late-antique Italy (which yielded its models in old manuscripts), and from Byzantium (which may have inadver-

tently provided some artists, fleeing iconoclasm, as well as manuscripts).

In Plate 3.7, a beautiful woman, nearly naked, stands with her arms outstretched, bound at their wrists by chains. Small stars are scattered over her body. She is the galaxy Andromeda. In Greek mythology she was the daughter of Cepheus and Cassiopeia, king and queen of Aethiopia. When Cassiopeia boasted that Andromeda was more beautiful than even the daughters of the sea god, that god took his revenge on Aethiopia and forced Cepheus to sacrifice his daughter by stripping off her clothes and chaining her to a rock. She was saved by the hero Perseus, who married her, and after her death Athena turned her into a constellation in the northern sky. The Carolingian artist took his inspiration not only from the text he (or she) was illustrating—the *Phainomena* by the classical Greek poet Aratos (fl. 3rd cent. BCE) in the later Latin version by Germanicus Caesar (fl. 1st cent. CE)—but also from the ancient classical models. Compare Andromeda to Venus in Plate 1.1. Both women have weight and flesh; both are absorbed in their own story and care nothing about hierarchy, ideology, or a world beyond their own.

An entirely different tradition lies behind the grand letters on the opening page of a Psalter (Plate 3.8). Painted around the same time as Plate 3.7, the only "classical" element here is the Latin language. Rather, the page owes much to the decorative style of the British Isles. "Beatus vir," ("Blessed is the man"), the first words of the first psalm, are here given luminous treatment with the use of gold leaf and a restrained palette. The page is then framed with designs of the same colors, with interlaced birds and dragon heads at the corners.

In Plate 3.9, combining the two traditions in a startlingly original manner, an artist at Saint-Amand created a classically inspired scene framed by columns sporting the stylized birds and interlace designs of the Insular style—the style of the British Isles. Much as in an ancient Roman wall painting, the figure the evangelist John—has volume and weight. He seems to live in a world of his own, separate from the viewer. But unlike an ancient wall painting, his world does not evoke an illusionistic atmosphere (as, for example, at Oplontis [see Plate 1.2 on pp. 14-15]) but rather is composed of three well-defined zones:

at the bottom, earth of brushy brown; in the middle, a huge swathe of blue broken by ornamental trees; above, clouds of bright yellow and orange. The figure, too, has an unclassical twist, its pleated drapery giving it a somewhat frenetic urgency. By mixing various styles, the artist found a new mode of expressing the transcendent.

In this portrait, Saint John seems to be caught in the act of listening to a voice dictating what he is to write down. The artist is almost telling us a story about John. But the narrative impulse is given its fullest expression in the Utrecht Psalter, a Carolingian manuscript commissioned by Archbishop Ebbo of Reims and executed at a nearly monastery. Not only does it contain all 150 psalms and 16 other songs known as canticles, but it accompanies each poem with drawings that bring it to life. In Plate 2.12 (above, p. 77), the illustration for Psalm 64 (Douay 63), lively figures render the words of the first four verses literally:

Preserve my life from dread of the enemy, / hide me from the secret plots of the wicked, from the scheming of evildoers, / who whet their tongues like swords, who aim bitter words like arrows, / shooting from ambush at the blameless.

In the middle is the psalmist standing on a mountain and holding forth. An angel above him stretches almost on tip-toe, bending over in order to hold a protective cloth over psalmist's head. Beneath them are the members of God's army, getting ready to do

Plate 3.8 Psalter Page (second quarter of 9th cent.). In this sumptuous manuscript dedicated to King Louis the German (r.843-876) the artist (a monk at the monastery of Saint Omer, today in northern France) drew on the decorative, abstract traditions of the British Isles. Nevertheless, following the principle of "less is more," he pared down the colors and the "busyness" of his model, as a quick comparison with Plate 2.7, p. 69, illustrates.

battle. On the left is the enemy, the "scheming evildoers": one soldier whets a sword, while another is about to shoot an arrow. But, as the discussion of this plate on p. 76 points out, the wicked army has the outdated equipment; it is no surprise that a later line in the psalm predicts the enemy's defeat.

It may plausibly be said that the various artistic styles elaborated during the Carolingian Renaissance—fed by classical, decorative, abstract traditions but combined in new and original ways—formed the basis of all subsequent Western art.

Plate 3.9 Saint John (second half of 9th cent.). Neither classically naturalistic nor entirely decorative in inspiration, this painting of the evangelist Saint John evokes a heavenly reality that is only vaguely anchored in earthly things. The book that John is writing (note the ink horn in his left hand) gives the opening line of his Gospel: "In principio erat verbum" ("In the beginning was the Word").

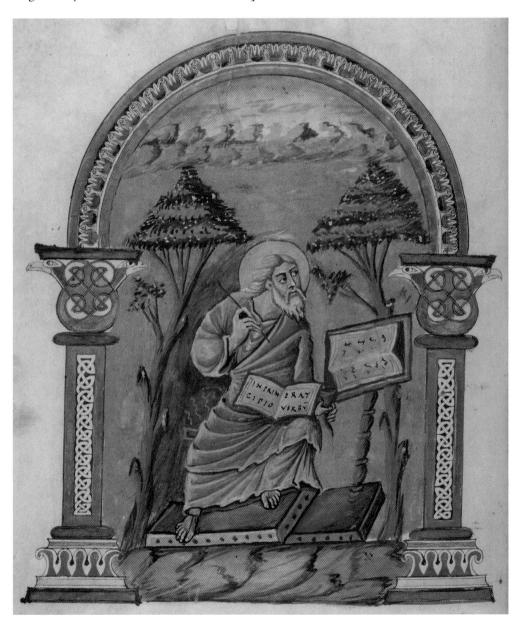

CHAPTER THREE: ESSENTIAL DATES

- 750 Abbasid caliphate begins
- 751 Pippin III (the first Carolingian king) elevated to kingship
- 762 Baghdad founded as the Abbasid capital city
- 768-814 Reign of Charlemagne (Charles the Great)
 - 800 Charlemagne crowned emperor
 - 843 End of iconoclasm in Byzantine Empire
 - 843 Treaty of Verdun; Carolingian Empire divided
 - c.864 Bulgarian Khan Boris-Michael converts to Christianity

NOTES

- I The Life of Saint Philaretos, in Reading the Middle Ages: Sources from Europe, Byzantium, and the Islamic World, 3rd ed., ed. Barbara H. Rosenwein (Toronto: University of Toronto Press, 2018), p. 108.
- 2 Constantine-Cyril, Prologue to the Gospel, in Reading the Middle Ages, pp. 162-63.
- 3 For one of Boris-Michael's seals, see "Reading through Looking," in Reading the Middle Ages, p. II.
- 4 Pope Nicholas I, Letter to Answer the Bulgarians' Questions, in Reading the Middle Ages, p. 167.
- 5 Abu Tammam, The sword gives truer tidings, in Reading the Middle Ages, p. 125.
- 6 Al-Bukhari, On Fasting, in Reading the Middle Ages, p. 151.
- 7 The Chronicle of Alfonso III, in Reading the Middle Ages, p. 135.
- 8 Pope Stephen II, Letters to King Pippin III, in Reading the Middle Ages, p. 158.
- 9 Einhard, Life of Charlemagne, in Reading the Middle Ages, p. 123.
- 10 Abbo of Saint-Germain-des-Prés, Battles of the City of Paris, in Reading the Middle Ages, p. 139.
- 11 Polyptyque of the Church of Saint Mary of Marseille, in Reading the Middle Ages, p. 106.
- 12 Dhuoda, Handbook for Her Son, in Reading the Middle Ages, p. 129.

FURTHER READING

- Bennison, Amira K. *The Great Caliphs: The Golden Age of the 'Abbasid Empire*. New Haven, CT, and London: Yale University Press, 2009.
- Benson, Bobrick. *The Caliph's Splendor: Islam and the West in the Golden Age of Baghdad*. New York: Simon and Schuster, 2012.
- Berend, Nora, ed. Christianization and the Rise of Christian Monarchy: Scandinavia, Central Europe and Rus' c.900–1200. Cambridge: Cambridge University Press, 2007.
- Betti, Maddalena. *The Making of Christian Moravia (858–882): Papal Power and Political Reality*. Leiden: Brill, 2014.
- Cameron, Averil. Byzantine Christianity: A Very Brief History. London: SPCK, 2017.

- Cooperson, Michael. Al-Ma'mun. Oxford: Oneworld, 2005.
- Costambeys, Marios, Matthew Innes, and Simon MacLean. *The Carolingian World*. Cambridge: Cambridge University Press, 2011.
- Davis, Jennifer R. Charlemagne's Practice of Empire. Cambridge: Cambridge University Press, 2015.
- DeJong, Mayke. The Penitential State: Authority and Atonement in the Ages of Louis the Pious, 814–840. Cambridge: Cambridge University Press, 2009.
- Faulkner, Thomas. Law and Authority in the Early Middle Ages: The Frankish leges in the Carolingian Period. Cambridge: Cambridge University Press, 2016.
- Fried, Johannes. *The Middle Ages*. Trans. Peter Lewis. Cambridge, MA: Harvard University Press, 2015.
- Goldberg, Eric J. Struggle for Empire: Kingship and Conflict under Louis the German, 817–876. Ithaca, NY: Cornell University Press, 2006.
- Hallaq, Wael B. *The Origins and Evolution of Islamic Law*. Cambridge: Cambridge University Press, 2005.
- Heather, Peter. The Restoration of Rome: Barbarian Popes & Imperial Pretenders. London: Macmillan, 2014. Herrin, Judith. Women in Purple: Rulers of Medieval Byzantium. Princeton, NJ: Princeton University Press, 2002.
- Levy, Kenneth. Gregorian Chant and the Carolingians. Princeton, NJ: Princeton University Press, 1998.
- McCormick, Michael. Origins of the European Economy: Communications and Commerce, AD 300–900. Cambridge: Cambridge University Press, 2001.
- McKitterick, Rosamond. "The Illusion of Royal Power in the Carolingian Annals." *English Historical Review* 115, no. 460 (2000): 1–20.
- ———. Charlemagne: The Formation of a European Identity. Cambridge: Cambridge University Press, 2008.
- Phelan, Owen Michael. The Formation of Christian Europe: The Carolingians, Baptism, and the Imperium Christianum. Oxford: Oxford University Press, 2014.
- Turner, John P. Inquisition in Early Islam: The Competition for Political and Religious Authority in the Abbasid Empire. London: I.B. Tauris, 2013.
- Verhulst, Adriaan. The Carolingian Economy. Cambridge: Cambridge University Press, 2002.
- Wormald, Patrick, and Janet L. Nelson, eds. *Lay Intellectuals in the Carolingian World*. Cambridge: Cambridge University Press, 2011.

To test your knowledge of this chapter, please go to www.utphistorymatters.com for Study Questions.

FOUR

POLITICAL COMMUNITIES REORDERED

(c.900-c.1050)

The large-scale centralized governments of the ninth century dissolved in the tenth. The fission was least noticeable at Byzantium, where, although important landowning families emerged as brokers of patronage and power, the primacy of the emperor was never effectively challenged. In the Islamic world, however, new dynastic groups established themselves as regional rulers. In Western Europe, Carolingian kings ceased to control land and men, while new political entities—some extremely local and weak, others quite strong and unified—emerged in their wake.

BYZANTIUM: THE STRENGTHS AND LIMITS OF CENTRALIZATION

By 1025 the Byzantine Empire once again touched the Danube and Euphrates Rivers. Its emperors maintained the traditional cultural importance of Constantinople by carefully orchestrating the radiating power of the imperial court. At the same time, however, powerful men in both town and countryside gobbled up land and dominated the peasantry, challenging the dominance of the center.

The Imperial Court

The Great Palace of Constantinople, a sprawling building complex begun under Constantine, was expanded and beautified under his successors. (See Map 4.1.) Far more than the symbolic emplacement of imperial power, it was the central command post of the empire. Servants, slaves, and grooms; top courtiers and learned clergymen; cousins,

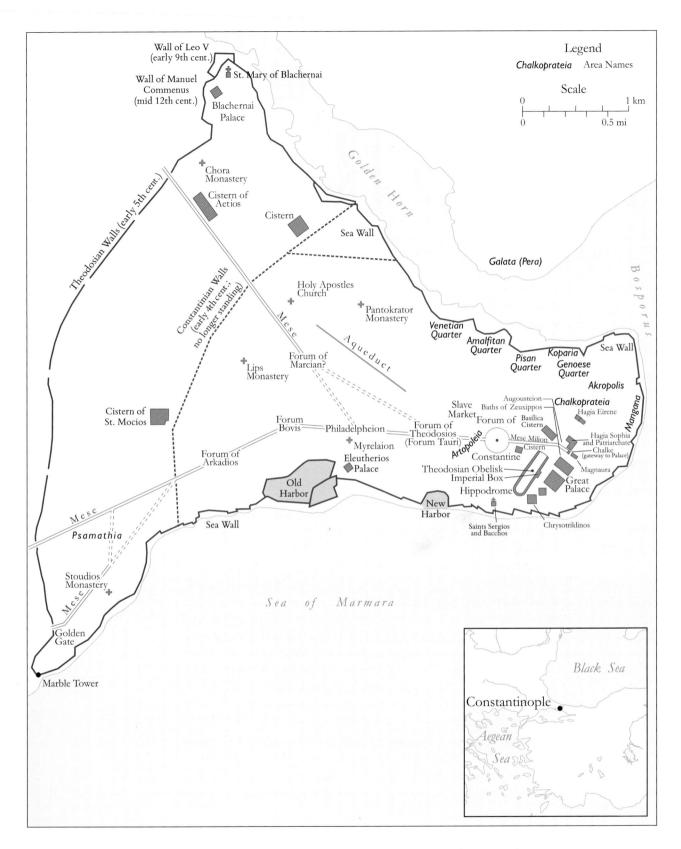

Map 4.1 (facing page) Constantinople, c. 1100

siblings, and hangers-on of the emperor and empress lived within its walls. Other courtiers—civil servants, officials, scholars, military men, advisers, and other dependents—lived as near to the palace as they could manage. They were "on call" at every hour. The emperor had only to give short notice and all assembled for impromptu but nevertheless highly choreographed ceremonies. These were in themselves instruments of power; the emperors manipulated courtly formalities to indicate new favorites or to signal displeasure.

The court was mainly a male preserve, but there were powerful women at the Great Palace as well. Consider Zoe (d. 1050), the daughter of Constantine VIII. Contemporaries acknowledged her right to rule through her imperial blood, and through her marriages, she "made" her husbands into legitimate emperors. She and her sister even ruled jointly for one year (1042). But their biographer, Michael Psellus, a courtier who observed them with a jaundiced eye, was happy only when Zoe married: "The country needed a man's supervision—a man at once strong-handed and very experienced in government, one who not only understood the present situation, but also any mistakes that had been made in the past, with their probable results."1

There was also a "third gender" at the Great Palace: eunuchs—men who had been castrated, normally as children, and raised to be teachers, doctors, or guardians of the women at court. Their status began to rise in the tenth century. Originally foreigners, they were increasingly recruited from the educated upper classes in the Byzantine Empire itself, even from the imperial families. In addition to their duties in the women's quarter of the palace, some of them accompanied the emperor during his most sacred and vulnerable moments—when he removed his crown; when he participated in religious ceremonies; even when he dreamed, at night. They hovered by his throne, like the angels flanking Christ in the apse of San Vitale (Plate 1.12 on pp. 32-33). No one, it was thought, was as faithful, trustworthy, or spiritually pure as a eunuch.

The imperial court assiduously cultivated the image of perfect, stable, eternal order. The emperor wore the finest silks, decorated with gold. In artistic representations, he was the largest figure. Sometimes he was shown seated on a high throne with admiring officials beneath him. At other times he stood, as in Plate 4.1, which depicts Emperor Basil II (r.976–1025), broad of shoulder and well-armed, as figures grovel beneath his feet, and Christ, helped by an archangel, places a crown on his head.

This sort of image of Basil—as Christian emperor—has led historians such as Paul Magdalino to emphasize the Orthodox identity of Byzantium. Other historians, impressed by the fact that the Byzantines spoke and wrote in Greek, see Byzantine culture as a distant heir of Hellenism. Still others—Anthony Kaldellis is one—emphasize continuities with Roman political forms. All of these identities (and a few others besides) are surveyed in Averil Cameron's recent book (see Further Reading, p. 157), which argues against seeking a single Byzantine identity. She prefers to find it in constant dialogue with its own many traditions and those of the other cultures—Persian, Slavic, European, Islamic—with whose histories it was a part.

A Wide Embrace and Its Tensions

The artist who painted the image of Basil at the start of a Psalter was imagining him as a sort of King David, the presumed author of the psalms. Like the biblical slayer of Goliath, Basil liked to present himself as a giant-slayer: a tireless warrior. Certainly his epitaph reads that way:

nobody saw my spear at rest,... but I kept vigilant through the whole span of my life ... marching bravely to the West, and as far as the very frontiers of the East.2

Ruling longer than any other Byzantine emperor, Basil built on the achievements of his predecessors. Nicephorus II Phocas (r.963-969) and John I Tzimisces (r.969-976) pushed the Byzantine frontiers north to the Danube (taking half of the Bulgarian Empire), east beyond the Euphrates, and south to Antioch, Crete, and Cyprus (see Map 4.2). Basil thus inherited a fairly secure empire except for the threat from Rus' further to the north. This he defanged through a diplomatic and religious alliance, as we shall see (p. 119). (Rus' is used for the polity; Rus, without the apostrophe, for the peoples.)

But if his borders were secure, Basil's position was not. It was challenged by powerful landowning families from whose ranks his two predecessors had come. Members of the provincial elite—military and government officers, bishops, abbots, and others—benefitted from a general quickening of the economy and the rise of new urban centers. They took advantage of their ascendency, buying land from still impoverished peasants as yet untouched by the economic upswing. No wonder they were called *dynatoi* (sing. *dynatos*), "powerful men." Already, some forty years before Basil came to the throne, Emperor Romanus I Lecapenus (r.920-944) had bewailed in his Novel (New Law) of 934 the "intrusion" of the rich

into a village or hamlet for the sake of a sale, gift, or inheritance.... For the domination of these persons has increased the great hardship of the poor ... [and] will cause no little harm to the commonwealth unless the present legislation puts an end to it first.3

The dynatoi made military men their clients (even if they were not themselves military men) and, as in the case of Nicephorus Phocas and John Tzimisces, sometimes seized the imperial throne itself.

Basil had two main political goals: to stifle the rebellions of the dynatoi, and to swell the borders of his empire. When the powerful Phocas and Scleros families of Anatolia, along with much of the Byzantine army, rebelled against him in 987, he created his own personal Varangian Guard, made up of troops from Rus'. Once victorious, Basil moved to enervate the dynatoi as a group. He reinforced the provisions of Romanus's Novel and

Plate 4.1 (facing page)

Emperor Basil II (1018). Commissioned by Basil II to celebrate his final victory over the Bulgarians in 1018, this picture, painted on shiny gold leaf, shows the emperor triumphant over cowering Bulgarians. Beneath his armor, Basil wears a long-sleeved purple tunic trimmed with gold. Medallions of saints flank his sides, much as they surround the cross of Christ in Plate 3.1 (p. 86). Two archangels hover above. Gabriel, on the left, gives Basil a lance, while Michael, on the right, transmits to him the crown offered by Christ. The emperor grasps a sword in one hand, while in the other he holds a staff that touches the neck of one of the semi-prone figures beneath his feet.

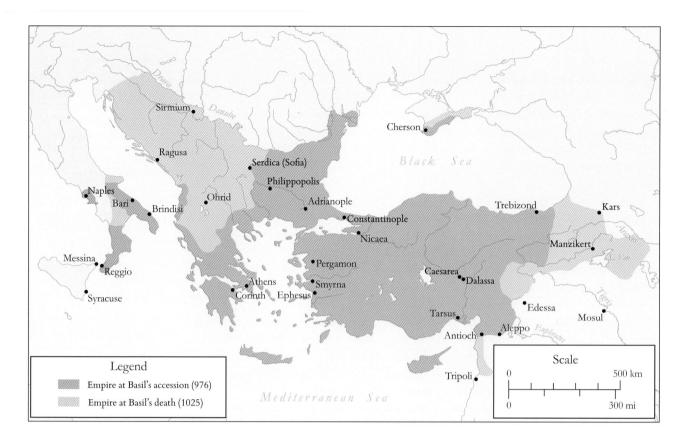

Map 4.2 The Byzantine Empire during the Reign of Basil II, 976–1025

others like it by threatening to confiscate and destroy the villas of those who transgressed the rules. He changed the system of taxation so that the burden fell on large landowners rather than on the peasants. He relieved the peasants and others of local military duty in the themes by asking for money payments instead. This allowed him to shower wealth on the Varangian Guard and other mercenary troops.

At the same time, Basil launched attacks beyond his borders: south to Syria and beyond; east all the way to Georgia and Armenia; southwest to southern Italy; and west to the Balkans, where he conquered the whole of the Bulgarian empire and reached the Adriatic coast. Basil's victory over the Bulgarians, celebrated on the psalter page shown in Plate 4.1, used to be considered his defining feat, and in the fourteenth century he was given the epithet "Bulgar-Slayer." But historians such as Michael Angold see Basil as an autocrat, ruling by whim and undermining hallowed Byzantine traditions. He never married or groomed a successor, which is one reason why Zoe and her sister could take the imperial throne after his death.

By the time of Basil's death in 1025, the Byzantine Empire was no longer the tight fist centered on Anatolia that it had been in the dark days of the eighth century. On the contrary, it was an open hand: sprawling, multi-ethnic, and multilingual. (See Map 4.2.) To the east it embraced Armenians, Syrians, and Arabs; to the north it included Slavs and Bulgarians (by now themselves Slavic speaking) as well as Pechenegs, a Turkic group that had served as allies of Bulgaria; to the west, in the Byzantine toe of Italy, it included

Lombards, Italians, and Greeks. There must have been Muslims right in the middle of Constantinople: a mosque there, built in the eighth century, was restored and reopened in the eleventh century. The Rus Varangian Guard served as the empire's elite troops, and by the mid-eleventh century, Byzantine mercenaries included "Franks" (mainly from Normandy), Arabs, and Bulgarians as well. In spite of ingrained prejudices, Byzantine princesses had occasionally been married to foreigners before the tenth century, but in Basil's reign this happened to a sister of the emperor himself.

All this openness went only so far, however. Toward the middle of the eleventh century, the Jews of Constantinople were expelled and resettled in a walled quarter in Pera, on the other side of the Golden Horn (see Map 4.1 on p. 114). Even though they did not expel Jews so dramatically, many other Byzantine cities forbade Jews from mixing with Christians. Around the same time, the rights of Jews as "Roman citizens" were denied; henceforth, in law at least, they had only servile status. The Jewish religion was condemned as a heresy.

Ethnic diversity and the emergence of the dynatoi were responsible for regional political movements that threatened centralized imperial control. In southern Italy, where the Byzantines ruled through an official called a catapan, Norman mercenaries hired themselves out to Lombard rebels, Muslim emirs, and others with local interests. In the second half of the eleventh century, the Normans began their own conquest of the region. On Byzantium's eastern flank, dynatoi families rose to high positions in government. The Dalasseni family was fairly typical of this group. Its founder, who took the family name from Dalassa, a city near Caesarea in Anatolia, was an army leader and governor of Antioch at the end of the tenth century. One of his sons, Theophylact, became governor of "Iberia"—not Spain but rather a theme on the very eastern edge of the empire. Another, Constantine, inherited his father's position at Antioch. With estates scattered throughout Anatolia and a network of connections to other powerful families, the Dalasseni sometimes defied the emperor and even coordinated rebellions against him. From the end of the tenth century, imperial control had to contend with the decentralizing forces of provincial dynatoi such as these. But the emperors were not dethroned, and Basil II triumphed over the families that challenged his reign to emerge even stronger than before.

The Formation of Rus'

Basil must have needed troops very badly to have married his sister to Vladimir (r.980–1015), ruler of Rus', in return for the Varangian Guard and Vladimir's conversion to Christianity. Known as Vikings in the West, the Rus originally came from Scandinavia. Well before the ninth century they had traveled eastward, to the regions of Lake Ladoga and Lake Ilmen (see Map 4.3 on p. 120). Mainly interested in trapping animals for furs and capturing people as slaves, they took advantage of river networks and other trade routes that led as far south as Iraq and as far west as Austria, exchanging their human and animal cargos for silks and silver. Other long-distance traders in the region were the Khazars, a Turkic-speaking people, whose powerful state, straddling the Black and Caspian Seas, dominated

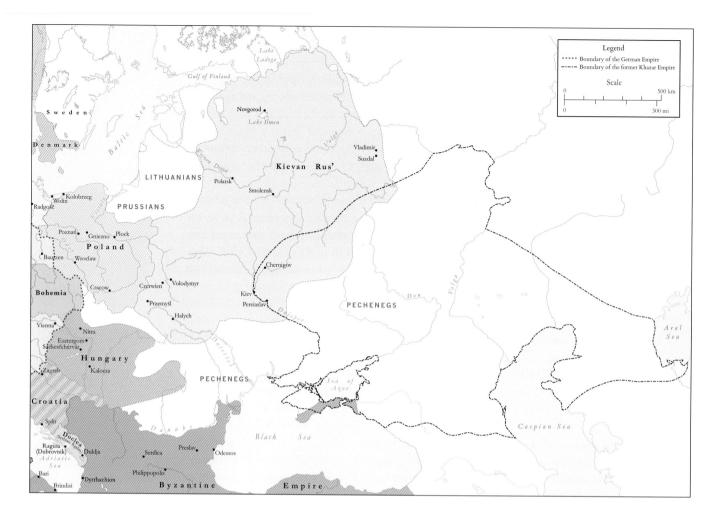

Map 4.3 Kievan Rus', c. 1050

part of the silk road in the ninth century. The Khazars were ruled by a khagan (meaning khan of khans), much like the Avars, and, like other nomads of the Eurasian steppes, they were tempted and courted by the religions of neighboring states. Unusually, their elites opted for Judaism. The Rus were influenced enough by Khazar culture to adopt the title of khagan for the ruler of their own fledgling ninth-century state at Novgorod, the first Rus polity, but they did not embrace Judaism.

Soon northern Rus' had an affiliate in the south—in the region of Kiev. This was very close to the Khazars, to whom it is likely that the Kievan Rus at first paid tribute. While on occasion attacking both Khazars and Byzantines, Rus rulers saw their greatest advantage in good relations with the Byzantines, who wanted their fine furs, wax, honey, and—especially—slaves. In the course of the tenth century, with the blessing of the Byzantines, the Rus brought the Khazar Empire to its knees.

Nurtured through trade and military agreements, good relations between Rus' and Byzantium were sealed through religious conversion. In the mid-tenth century, quite a few Christians lived in Rus'. But the official conversion of the Rus to Christianity came under Vladimir. Ruler of Rus' by force of conquest (though from a princely family), Vladimir

was anxious to court the elites of both Novgorod and Kiev. He did so through wars with surrounding peoples that brought him and his troops plunder and tribute. Strengthening his position still further, in 988 he adopted the Byzantine form of Christianity, took the name "Basil" in honor of Emperor Basil II, and married Anna, the emperor's sister. Christianization of the general population seems to have followed quickly. In any event, the *Russian Primary Chronicle*, a twelfth-century text based in part on earlier materials, reported that under Vladimir's son Yaroslav the Wise (r.1019–1054), "the Christian faith was fruitful and multiplied, while the number of monks increased, and new monasteries came into being." 4

Vladimir's conversion was part of a larger process of state formation and Christianization taking place around the year 1000. In Scandinavia and the new states of East Central Europe, as we shall see, the process resulted in Catholic kingships rather than the Orthodox principality that Rus' became. Given its geographic location, it was anyone's guess how Rus' would go: it might have converted to the Roman form of Christianity of its western neighbors. Or it might have turned to Judaism under the influence of the Khazars. Or, indeed, it might have adopted Islam, given that the Volga Bulgars had converted to Islam in the early tenth century. It is likely that Vladimir chose the Byzantine form of Christianity because of the prestige of the empire under Basil.

That momentary decision, it used to be argued, left lasting consequences: Rus', ancestor of Russia, became the heir of Byzantium and its many tensions with the West. Recently, however, some historians—Christian Raffensperger is one—have stressed the many interrelationships between Rus' and Europe. All shared the Christian religion, albeit in different forms; all were interconnected via traders and trade routes; and all were literally bound together through marriages. In that last sense, in particular, women were the bearers of cultural integration as they moved from one court to another.

DIVISION AND DEVELOPMENT IN THE ISLAMIC WORLD

While at Byzantium the forces of decentralization were relatively feeble, they carried the day in the Islamic world. Where once the caliph at Baghdad or Samarra could boast collecting taxes from Kabul (today in Afghanistan) to Benghazi (today in Libya), in the eleventh century a bewildering profusion of regional groups and dynasties divided the Islamic world. Yet this was in general a period of prosperity and intellectual blossoming.

The Emergence of Regional Powers

The Muslim conquest had not eliminated, but rather papered over, local powers and regional affiliations. While the Umayyad and Abbasid caliphates remained strong, they imposed their rule through their governors and army. But when the caliphate became

weak, as it did in the tenth and eleventh centuries, old and new regional interests came to the fore.

A glance at a map of the Islamic world c. 1000 (Map 4.4) shows, from east to west, the main new groups that emerged: the Samanids, Buyids, Hamdanids, Fatimids, and Zirids. But the map hides the many territories dominated by smaller independent rulers. North of the Fatimid Caliphate, al-Andalus had a parallel history. Its Umayyad ruler took the title of caliph in 929, but in the eleventh century he too was unable to stave off political fragmentation.

The key cause of the weakness of the Abbasid caliphate was lack of revenue. When landowners, governors, or recalcitrant military leaders in the various regions of the Islamic world refused to pay taxes into the treasury, the caliphs had to rely on the rich farmland of Iraq, long a stable source of income. But a deadly revolt lasting from 869 to 883 by the Zanj—black slaves from sub-Saharan Africa who had been put to work to turn marshes into farmland—devastated the Iraqi economy. Although the revolt was put down and the head of its leader was "displayed on a spear mounted in front of [the winning general] on a barge," there was no chance for the caliphate to recover. In the tenth century the Qaramita (sometimes called "Carmathians"), a sect of Shi'ites based in Arabia, found Iraq

easy prey. The result was decisive: the caliphs could not pay their troops. New men—military leaders with their own armies and titles like "commander of commanders"—took the reins of power. They preserved the Abbasid line, but they reduced the caliph's political authority to nothing.

The new rulers represented groups that had long awaited their ascendency. The Buyids, for example, belonged to ancient warrior tribes from the mountains of Iran. Even in the tenth century, most were relatively new converts to Islam. Bolstered by long-festering local discontent, one of them became "commander of commanders" in 945. Thereafter, the Buyids, with help from their own Turkish mercenaries, dominated the region south of the Caspian Sea, including Baghdad. For a time they presided over a glittering culture that supported (and was in turn celebrated by) scholars, poets, artists, and craftsman. Small wonder that the inscription decorating the golden jug in Plate 4.2 praises Emir Samsam al-Dawla (r.985–998) as "the image of the full moon at night, the first gleam of sun on the horizon of the morning."6 Yet already in al-Dawla's day, other local men were challenging Buyid rule in a political process—the progressive regionalization and fragmentation of power—echoed elsewhere in the Islamic world and in

Plate 4.2 Golden Jug (985–998). Four ribbons of angular kufic script praise the emir, probably the jug's owner. Complementing them are two large bands of interlaced medallions; those on the neck enclose what are probably griffons, while those on the body boast birds, perhaps peacocks.

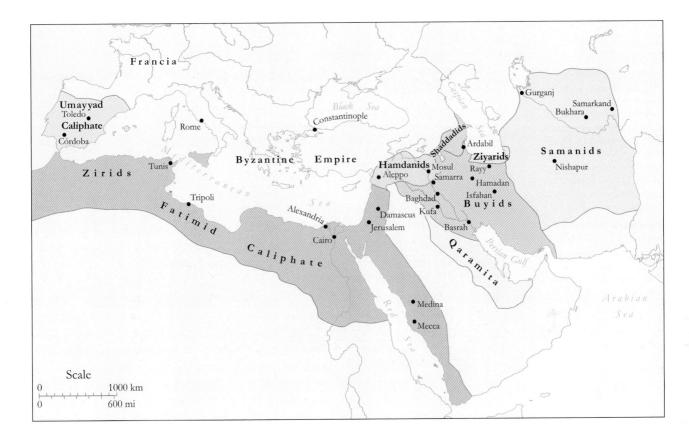

The most important of the new regional rulers were the Fatimids. They, like the Qaramita (and, increasingly in the course of time, the Buyids), were Shi'ites, taking their name from Muhammad's daughter Fatimah, wife of Ali. The Fatimids professed a particular form of Shi'ism called Isma'ilism. The Fatimid leader claimed not only to be the true imam, descendant of Ali, but also the mahdi, the "divinely guided" messiah, come to bring justice on earth. Because of this, the Fatimids were proclaimed "caliphs" by their followers—the true "successors" of the Prophet. Allying with the Berbers in North Africa, by 910 the Fatimids had established themselves as rulers in what is today Tunisia and Libya. Within a half-century they had moved eastward (largely abandoning the Maghreb to the Zirids), to rule Egypt, southern Syria, and the western edge of the Arabian Peninsula. They cultivated contacts far beyond their borders: across the Mediterranean to Europe and Byzantium and beyond, to India and China. Jewish traders often served as the human links among these regions, as did Islamic religious scholars, who financed their many voyages to noted centers of learning by acting as merchants or mercantile agents. A flourishing textile industry kept Egypt's economy buoyant: farmers produced flax (not only for Egypt but for Tunisia and Sicily as well); industrial laborers turned the flax into linen; tailors cut and sewed garments; and traders exported the products of each phase or sold them at home. Public and private investment in both the agricultural and industrial side of this product guaranteed its success.

Map 4.4 Fragmentation of the Islamic World, *c*.1000

Plate 4.3 The mihrab of al-Azhar Mosque, Cairo (969/973). Two marble columns taken from older buildings frame the mihrab, which is decorated with carved stucco. As befits the purpose of the mihrab, the inscription quotes the Qur'an on prayer and the relationship between man and God.

Wealthy and cosmopolitan, the Fatimids created a new capital city, Cairo, filling it with palaces, libraries, shops, pavilions, gardens, private houses, and mosques. The al-Azhar mosque was built right after they conquered Egypt as a major gathering place and school. In its original form, it had a five-aisle prayer hall and a courtyard probably surrounded by arcades. Built in brick, its walls were covered with stucco carved with vegetal forms outlined by bands of Qur'anic inscriptions. The decoration was probably painted in bright colors. The *mihrab* (the niche pointing in the direction of Mecca) at al-Azhar was topped by a dome. (See Plate 4.3.) But the building had no minaret, following the Shi'ite practice of calling the congregation to prayer from the mosque door or roof.

The Shi'ites also emphasized commemoration of the dead (though Sunni Muslims often did so as well); a Fatimid cemetery at Aswan (see Plate 4.4) is filled with mudbrick tombs and mausolea (buildings for burials), each one originally containing one or more tombstones. Muhammad had prohibited ostentatious burials, but this ban was skirted as long as the tombs were open to the elements. That explains the many windows in the mausolea at Aswan.

The Fatimids achieved the height of their power before the mid-eleventh century. But during the rule of al-Mustansir (1036–1094), economic and climatic woes, factional fighting within the army, and a rebellion by Turkish troops weakened the regime, and by the 1070s, the Fatimid caliphate had lost most of Syria and North Africa to other rulers.

The Umayyad rulers at Córdoba experienced a similar rise and fall. Abd al-Rahman III (r.912–961) took the title caliph in 929 to rival the Fatimids and to assume the luster of the ruler of Baghdad. "He bore [signs of] piety on his forehead and religious and secular authority upon his right hand," wrote a court poet of the new caliph.⁷ An active military man backed by an army made up mainly of Slavic slaves, Abd al-Rahman defeated his rivals and imposed his rule on all of al-Andalus. Under the new caliph and his immediate successors, Islamic Iberia became a powerful centralized state. Even so, regional elites sought to carve out their own polities. Between 1009 and 1031 bitter civil war undid the dynasty's power. After 1031, al-Andalus was split into small emirates called *taifas*, ruled by local strongmen.

Thus, in the Islamic world, far more decisively than at Byzantium, newly powerful regional rulers came to the fore. Nor did the fragmentation of power end at the regional level. To pay their armies, Islamic rulers often resorted to granting their commanders *iqta*—lands and villages—from which the *iqta*-holder was expected to gather revenues and pay their troops. As we shall see, this was a bit like the Western European institution of the fief. It meant that even minor commanders could act as local governors, tax-collectors, and military leaders. But there was a major difference between this institution and the system of fiefs and vassals in the West: while vassals were generally tied to one region and one lord, the troops under Islamic local commanders were often foreigners and former slaves, unconnected to any particular place and easily wooed by rival commanders.

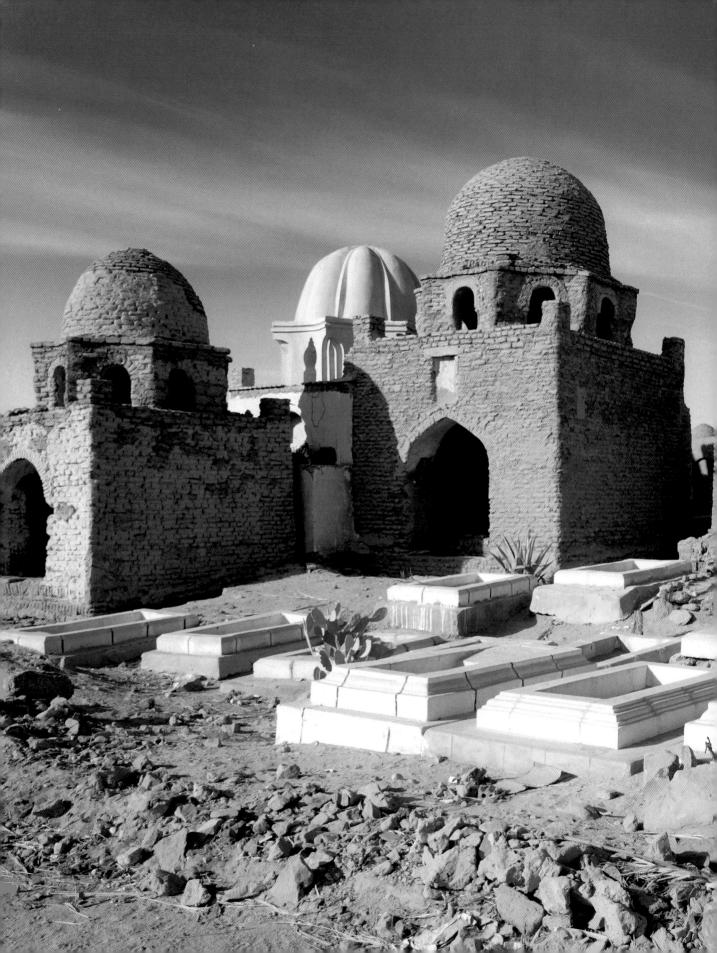

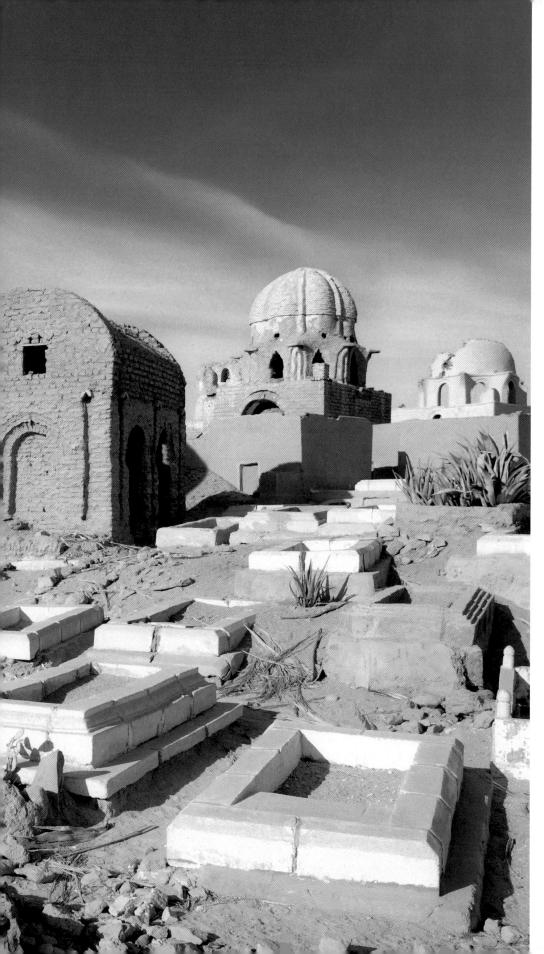

Plate 4.4 Fatimid Cemetery at Aswan (11th cent.). Outside of Cairo, an exuberant architectural imagination held sway. In this cemetery at Aswan, a series of mausolea with cubic bases topped by domes are particularly inventive in composing the zone that bridges dome and base: note here the octagonal structures with wing-like projections.

Cultural Unity, Religious Polarization

The emergence of local strongmen meant not the end of Arab court culture but a multiplicity of courts, each attempting to out-do one another in brilliant artistic, scientific, theological, and literary productions. We have already seen what the Fatimids achieved in Egypt. Even more impressive was the Umayyad court at Córdoba, the wealthiest and showiest city of the West. It boasted seventy public libraries in addition to the caliph's private library of perhaps 400,000 books. The Córdoban Great Mosque was a center for scholars from the rest of the Islamic world (the caliphs paid their salaries), while nearly thirty free schools were set up throughout the city.

Córdoba was noteworthy not only because of the brilliance of its intellectual life but also because of the role women played in it. Elsewhere in the Islamic world there were certainly a few unusual women associated with cultural and scholarly life. But at Córdoba this was a general phenomenon: women were not only doctors, teachers, and librarians but also worked as copyists for the many books widely in demand.

Male scholars were, however, everywhere the norm. They moved easily from court to court. The Fatimid scholar-merchants are barely known, but Ibn Sina (980–1037), who began his career serving the ruler at Bukhara in Central Asia, is famous. In the West, his name was Latinized as Avicenna. From Bukhara he traveled westward to Gurganj, Rayy, and Hamadan before ending up for thirteen years at the court of Isfahan in Iran. Sometimes in favor and sometimes decidedly not so (he was even briefly imprisoned), he nevertheless managed to study and practice medicine and to write numerous books on the natural sciences and philosophy. His pioneering systematization of Aristotle laid the foundations of future philosophical thought in the field of logic.

Despite its political disunity, then, the Islamic world of the tenth and eleventh centuries remained in many ways an integrated culture. This was partly due to the model of intellectual life fostered by the Abbasids, which even in decline was copied by the new regional rulers. It was also due to the common Arabic language, the glue that bound the astronomer at Córdoba to the merchant at Cairo.

Writing in Arabic, Islamic authors could count on a large reading public. Manuscripts were churned out quickly via a well-honed division of labor: scribes, illustrators, page cutters, and book-binders specialized in each task. Children were sent to school to learn the Qur'an; listening, reciting, reading, and writing were taught in elementary schools along with good manners and religious obligations. Although a conservative like al-Qabisi (d.1012) warned that "[a girl] being taught letter-writing or poetry is a cause for fear," he also insisted that parents send their children to school to learn "vocalization, spelling, good handwriting, [and] good reading." He even admitted that learning about "famous men and of chivalrous knights" might be acceptable.8

Educated in similar texts across the whole Islamic world, speaking a common language, Muslims could easily communicate, and this facilitated open networks of trade. With no national barriers to commerce and few regulations, merchants regularly moved from one region to another. Consider paper. The sheets manufactured in Baghdad and Damascus

were in demand across the entire Islamic world and beyond. Though scorned in Byzantium, paper was appreciated in peripheral regions of the Empire such as Armenia and Georgia. Indeed, Islamic merchants dealt in far-flung, various, and sometimes exotic goods. From England came tin, while salt, ivory, and gold were imported from Timbuktu in west-central Africa. From Russia came amber, gold, and copper; slaves were wrested from sub-Saharan Africa, the Eurasian steppes, and Slavic regions. Arab merchants set up permanent headquarters in China and South-East Asia, where traders brought wares from the Islamic world: flax and linen from Egypt (as we have seen), pearls from the Persian Gulf, ceramics from Iraq. Much of this trade was financed by enterprising government officials and other elites, whose investments in land at home paid off handsomely.

Although Muslims dominated these trade networks, other groups were involved in commerce as well. Thanks to the abundance of paper for everyday transactions, we know a good deal about one Jewish community living at Fustat, about two miles south of Cairo. It observed the then-common custom of depositing for eventual ritual burial all worn-out papers containing the name of God. For good measure, the Jews in this community included everything written in Hebrew letters: legal documents, fragments of sacred works, marriage contracts, doctors' prescriptions, and so on. By chance, the materials that they left in their *geniza* (depository) at Fustat were preserved rather than buried. They reveal a cosmopolitan, middle-class society. Many were traders, for Fustat was the center of a vast and predominately Jewish trade network that stretched from al-Andalus to India.

The Tustari brothers, Jewish merchants from southern Iran, offer a telling example. By the early eleventh century, the brothers had established a flourishing business in Egypt. Informal family networks offered them many of the same advantages as branch offices: friends and family in Iran shipped the Tustaris's fine textiles to sell in Egypt, while they exported Egyptian fabrics back to Iran.

Only Islam itself, ironically, pulled Islamic culture apart. In the tenth century the split between the Sunnis and Shi'ites widened to a chasm. At Baghdad, al-Mufid (d.1022) and others turned Shi'ism into a partisan ideology that insisted on publicly cursing the first two caliphs, turning the tombs of Ali and his family into objects of veneration, and creating an Alid caliph. Small wonder that the Abbasid caliphs soon became ardent spokesmen for Sunni Islam, which developed in turn its own public symbols. Many of the new dynasties—the Fatimids and the Qaramita especially—took advantage of the newly polarized faith to bolster their power.

THE WEST: FRAGMENTATION AND RESILIENCE

Fragmentation was the watchword in Western Europe in many parts of the shattered Carolingian Empire. Historians speak of "France," "Germany," and "Italy" in this period as a shorthand for designating broad geographical areas (as will be the case in this book). But there were no national states, only regions with more or less clear borders and rulers

Map 4.5 (facing page) Viking, Muslim, and Hungarian Invasions, 9th and 10th cent.

with more or less authority. In some places—in parts of "France," for example—regions as small as a few square miles were under the control of different lords who acted, in effect, as independent rulers. Yet this same period saw consolidated European kingdoms beginning to emerge. To the north were England, Scotland, and two relatively unified Scandinavian states—Denmark and Norway; toward the east Bohemia, Poland, and Hungary. In the center of Europe, a powerful royal dynasty from Saxony, the Ottonians, came to rule an empire stretching from the North Sea to Rome.

The Last Invaders of the West

Three groups invaded Western Europe during the ninth and tenth centuries: the Vikings, the Muslims, and the Magyars (called Hungarians by the rest of Europe). (See Map 4.5.) In the short run, they wreaked havoc on land and people. In the long run, they were absorbed into the European population and became constituents of a newly prosperous and aggressive European civilization.

VIKINGS

Around the same time as they made forays eastward toward Novgorod, some Scandinavians were traveling to western shores. Their peregrinations were largely the result of the competition for power and wealth by kings and chieftains back home. In Egil's Saga, the core of which was composed in the Viking age though it was given written form only in the thirteenth century, King Harald Fairhair gave the chieftains "the options of entering his service or leaving the country, or a third choice of suffering hardship or paying with their lives." Egil's family eventually fled to Iceland.

Wealth was obtained through plunder and gifts. The most precious and sought-after gifts were beautifully crafted and decorated jewelry made of gold and silver; weapons, too, well forged and ornamented, were highly prized (see Material Culture: Forging Medieval Swords, pp. 74-77). Chieftains fed their warrior followers' hunger for gifts by controlling nearby agricultural production, indigenous crafts, and long-distance trade. Some left home to fight for foreign kings; for example, Egil and his brother worked for English King Æthelstan (r.924–939) and shared in the fruits of his victories. Others raided under Viking leaders. This was the background to the "Viking invasions of Europe." Traveling in long, narrow, and shallow ships powered by wind and sails (see Plate 4.5 on pp. 132-33), the Vikings sailed down the coasts and rivers of France, England, Scotland, and Ireland, terrorizing not only the inhabitants but also the armies mustered to fight them: "Many a time an army was assembled to oppose them, but as soon as they were to join battle, always for some cause it was agreed to disperse, and always in the end [the Vikings] had the victory," wrote a chronicler in southern England. 10

Some Vikings, like Egil's family, crossed the Atlantic, making themselves at home in Iceland or continuing on to Greenland or, in about 1000, touching on the coast of the North

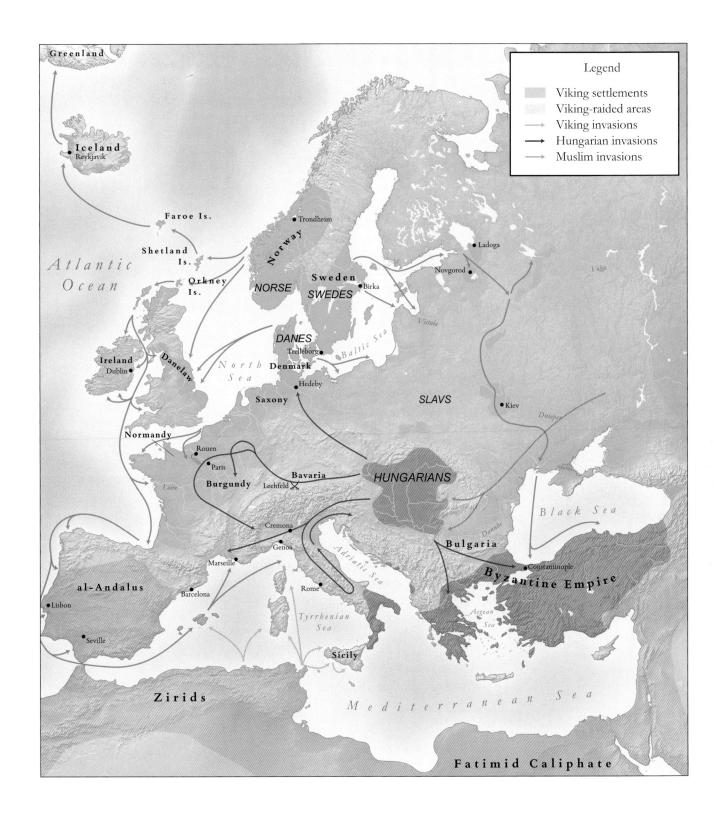

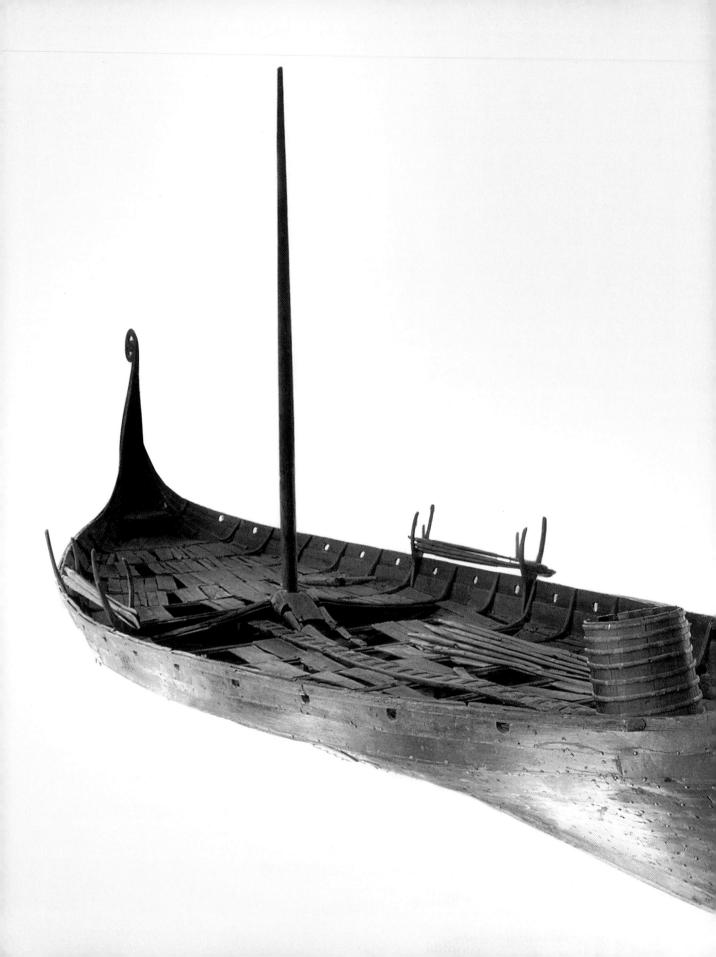

Plate 4.5 Oseberg Ship (834). This large ceremonial ship was found buried in a grave mound near the Oslo fjord in 1904. Within were the skeletons of two women, one more than eighty years old, the other in her early fifties. They were accompanied by high-quality artifacts, delicate foods (such as fruits, berries, and walnuts), and many animals and birds. Wooden carvings, including those of the ship's prow and sternpost, attest to the intricacy and finesse of Viking workmanship, characterized by interlaced animal motifs. Compare this interlace with the more abstract forms of the Lindisfarne Gospels in Plates 2.5, 2.6, and 2.7.

American mainland. While the elites came largely for booty, lesser men, eager for land, traveled with their wives and children to live after conquests in Ireland, Scotland, England, and Normandy (giving their name to the region: Norman = Northman, or Viking).

In Ireland, where their settlements were in the east and south, the newcomers added their own claims to rule an island already fragmented among several competing dynasties. In Scotland, however, in the face of Norse settlements in the north and west, the natives drew together under kings who allied themselves with churchmen and other powerful local leaders. Cináed mac Ailpín (Kenneth I MacAlpin) (d.858) established a hereditary dynasty of kings that ruled over two hitherto independent native peoples. By c.900, the separate identities were gone, and most people in Alba, the nucleus of the future Scotland, shared a common sense of being Scottish.

England underwent a similar process of unification. Initially divided into small competing kingdoms, it was weak prey in the face of invasion. By the end of the ninth century, the Vikings were plowing fields in northeastern England and living in accordance with their own laws, giving the region the name Danelaw. In Wessex, the southernmost English kingdom, King Alfred the Great (r.871–899) bought time and peace by paying tribute to the invaders with the income from a new tax, later called the Danegeld. (It eventually became the basis of a relatively lucrative taxation system in England.) In 878 he led a series of raids against the Vikings settled in his kingdom, inspired the previously cowed Anglo-Saxons to follow him, and camped outside the Viking stronghold until their leaders surrendered and accepted baptism. Soon the Vikings left Wessex.

Thereafter the pressure of invasion eased somewhat as Alfred reorganized his army, set up strongholds of his own (called *burhs*), and created a fleet of ships—a real navy. An uneasy stability was achieved, with the Vikings dominating the east of England and Alfred and his successors gaining control over most of the rest. Even so, the impact of the Vikings on the formation of Anglo-Saxon England has recently been downplayed, and Alfred's role has been somewhat minimized by historians such as George Molyneaux, who sees the real unification of England taking place via the administrative structures put into place in the second half of the tenth century.

On the Continent, the invaders were absorbed above all in Normandy, where in 911 their leader Rollo converted to Christianity and received Normandy as a duchy from the Frankish king Charles the Simple. Although many of the Normans adopted sedentary ways, some of their descendants in the early eleventh century ventured to the Mediterranean, where they established themselves as rulers of petty principalities in southern Italy. From there, in 1061, the Normans began the conquest of Sicily.

MUSLIMS

Sicily, once Byzantine, was the rich and fertile plum of the conquests achieved by the Muslim invaders of the ninth and tenth centuries. That they took the island attests to the power of a new Muslim navy developed by the dynasty that preceded the Fatimids

in Ifriqiya. Briefly held by the Fatimids, by mid-century Sicily was under the control of independent Islamic princes, and Muslim immigrants were swelling the population.

Elsewhere the Muslim presence in Western Europe was more ephemeral. In the first half of the tenth century, Muslim raiders pillaged southern France, northern Italy, and the Alpine passes. But these were quick expeditions, largely attacks on churches and monasteries. Some Muslims established themselves at La Garde-Freinet, in Provence, becoming landowners in the region and lords of Christian serfs. They even hired themselves out as occasional fighters for the wars that local Christian aristocrats were waging against one another. But they made the mistake of capturing for ransom the holiest man of his era, Abbot Majolus of Cluny (c.906–994). Outraged, the local aristocracy finally came together and ousted the Muslims from their midst.

MAGYARS (HUNGARIANS)

By contrast, the Magyars remained. "Magyar" was and remains their name for themselves, though the rest of Europe called them "Hungarians," from the Slavonic for "Onogurs," a people already settled in the Danube basin in the eighth and ninth centuries. Originally nomads who raised (and rode) horses, the Magyars spoke a language unrelated to any other in Europe (except Finnish). Known as effective warriors, they were employed by Arnulf, king of the East Franks (r.887–899), when he fought the Moravians and by the Byzantine emperor Leo VI (r.886–912) during his struggle against the Bulgars. In 894, taking advantage of their position, the Hungarians, as we may now call them, conquered much of the Danube basin for themselves.

From there, for over fifty years, they raided into Germany, Italy, and even southern France. At the same time, however, the Hungarians worked for various western rulers. Until 937 they spared Bavaria, for example, because they were allies of its duke. Gradually they made the transition from nomads to farmers, and their polity coalesced into the Kingdom of Hungary. This is no doubt a major reason for the end of their attacks. At the time, however, the cessation of their raids was widely credited to the German king Otto I (r.936-973), who won a major victory over a Hungarian marauding party at the battle of Lechfeld in 955.

Public Power and Private Relationships

The invasions left new political arrangements in their wake. Unlike the Byzantines and Muslims, European rulers had no mercenaries and no salaried officials. They commanded others by ensuring personal loyalty. The Carolingian kings had had their fideles—their faithful men. Tenth-century rulers were even more dependent on ties of dependency: they needed their "men" (homines), their "vassals" (vassalli). Whatever the term, all were armed retainers who fought for a lord. Sometimes these subordinates held land from their lord, either as a reward for their military service or as an inheritance for which services were due. The term for such an estate, fief (feodum), gave historians the word "feudalism" to describe the social and economic system created by the relationships among lords, vassals, and fiefs. During the last forty years or so, however, the term has provoked great controversy. Some historians argue that it has been used in too many different and contradictory ways to mean anything at all. Was it a mode of exploiting the land that involved lords and serfs? A condition of anarchy and lawlessness? Or a political system of ordered gradations of power, from the king on down? Historians have used all of these definitions. Another area of contention is the date for the emergence of feudal institutions. At the beginning of the 1970s, the French historian Georges Duby assigned an early date: around the year 1000. His view prevailed for two decades, but in the 1990s it was forcefully challenged by Dominique Barthélemy, who argued that the major transformation took place in the twelfth century. In this book the word feudalism is avoided, but the institutions that historians associate with that term cannot be ignored. Their origins (where they took hold) are to be found in the break-up of the Carolingian order—the tenth and eleventh centuries.

LORDS AND VASSALS

The key to tenth- and eleventh-century society was personal dependency. This took many forms. Of the three traditional "orders" recognized by writers in the ninth through eleventh centuries—those who pray (the *oratores*), those who fight (the *bellatores*), and those who work (the *laboratores*)—the top two were free. The pray-ers (the monks) and the fighters (the nobles and their lower-class counterparts, the knights) participated in prestigious kinds of subordination, whether as vassals, lords, or both. Indeed, they were usually both: a typical warrior was lord of several vassals and the vassal of another lord. Monasteries normally had vassals to fight for them, while their abbots in turn were vassals of a king or other lord. At the low end of the social scale, poor vassals looked to their lords to feed, clothe, house, and arm them. At the upper end, vassals looked to their lords to enrich them with still more fiefs.

Some women were vassals, and some were lords (or, rather, "ladies," the female version). Many upper-class laywomen participated in the society of warriors and monks as wives and mothers of vassals and lords and as landowners in their own right. Others entered convents and became *oratores* themselves. Through its abbess or a man standing in for her, a convent was itself often the "lord" of vassals.

Vassalage was voluntary and public. The personal fidelity that the Carolingian kings required of the Frankish elites became more general, as all lords wanted the same assurance. Over time a ceremony of deference came increasingly to mark the occasion: a man kneeled and placed his hands together (in a position we associate with prayer) within the hands of another who stood: this was the act of homage. It generally included an oath: "I promise to be your man." The vassal-to-be then rose and promised "fealty"—fidelity, trust, and service—which he swore with his hand on relics or a Bible. Then the vassal and the lord kissed. In an age when many people could not read, a public moment such as this represented a visual and verbal contract, binding the vassal and lord together with

mutual obligations to help each other. On the other hand, these obligations were rarely spelled out, and a lord with many vassals, or a vassal with many lords, needed to satisfy numerous conflicting claims. "I am a loser only because of my loyalty to you," Hugh of Lusignan told his lord, William of Aquitaine, after his expectations for reward were continually disappointed."

LORDS AND PEASANTS

At the lowest end of the social scale were those who worked: the peasants. In many regions of Europe, as power fell into the hands of local rulers, the distinction between "free" and "unfree" peasants began to blur; many peasants simply became "serfs," dependents of lords. This was a heavy dependency, without prestige or honor. It was hereditary rather than voluntary: no serf did homage or fealty to his lord; no serf and lord kissed each other.

Indeed, the upper classes barely noticed the peasants—except as sources of labor and revenue. In the tenth century, the three-field system became more prevalent, and the heavy moldboard plows that could turn wet, clayey northern soils came into wider use. Such plows could not work around fences, and they were hard to turn: thus was produced the characteristic "look" of medieval agriculture—long, furrowed strips in broad, open fields. Peasants knew very well which strips were "theirs" and which belonged to their neighbors. A team of oxen was normally used to pull the plow, but horses (more efficient than oxen) were sometimes substituted. The result was surplus food and a better standard of living for nearly everyone.

In search of still greater profits, some lords lightened the dues and services of peasants temporarily to allow them to open up new lands by draining marshes and cutting down forests. Other lords converted dues and labor services into money payments, providing themselves with ready cash. Peasants, too, benefited from these rents because their payments were fixed despite inflation. As the prices of agricultural products went up, peasants became small-scale entrepreneurs, selling their chickens and eggs at local markets and reaping a profit.

In the eleventh century, and increasingly so in the twelfth, peasant settlements gained boundaries and focus: they became real villages. The parish church often formed the center, next to which was the cemetery. Then, normally crowded right onto the cemetery itself, were the houses, barns, animals, and tools of the living peasants. Boundary markers—sometimes simple stones, at other times real fortifications—announced not only the physical limit of the village but also its sense of community. This derived from very practical concerns: peasants needed to share oxen or horses to pull their plows; they were all dependent on the village craftsmen to fix their wheels or shoe their horses.

Variety was the hallmark of peasant society. In Saxony and other parts of Germany free peasants prevailed. In France and England most were serfs. In Italy peasants ranged from small independent landowners to leaseholders; most were both, owning a parcel in one place and leasing another nearby.

Where the power of kings was weak, peasant obligations became part of a larger system of local rule. As landlords consolidated their power over their manors, they collected not only dues and services but also fees for the use of their flour mills, bake houses, and breweries. In some regions—parts of France and in Catalonia, for example—some lords built castles and exercised the power of the "ban": the right to collect taxes, hear court cases, levy fines, and muster men for defense. These lords were "castellans."

WARRIORS AND BISHOPS

Although the developments described here did not occur everywhere simultaneously (and in some places hardly at all), in the end the social, political, and cultural life of the West came to be dominated by landowners who styled themselves both military men and regional leaders. These men and their armed retainers shared a common lifestyle, living together, eating in the lord's great hall, listening to bards sing of military exploits, hunting for recreation, competing with one another in military games. They fought in groups as well—as cavalry. In the month of May, when the grasses were high enough for their horses to forage, the war season began. To be sure, there were powerful vassals who lived on their own fiefs and hardly ever saw their lord—except for perhaps forty days out of the year, when they owed him military service. But they themselves were lords of knightly vassals who were not married and who lived and ate and hunted with them.

The marriage bed, so important to the medieval aristocracy from the start, now took on new meaning. In the seventh and eighth centuries, aristocratic families had thought of themselves as large and loosely organized kin groups. They were not tied to any particular estate, for they had numerous estates, scattered all about. With wealth enough to go around, the rich practiced partible inheritance, giving land (though not in equal amounts) to all of their sons and daughters. The Carolingians "politicized" these family relations. As some men were elevated to positions of dazzling power, they took the opportunity to pick and choose their "family members," narrowing the family circle. They also became more conscious of their male line, favoring sons over daughters. In the eleventh century, family definitions tightened even further. The claims of one son, often the eldest, overrode all else; to him went the family inheritance. (This is called "primogeniture"; but there were regions in which the youngest son was privileged, and there were also areas in which more equitable inheritance practices continued in place.) The heir in the new system traced his lineage only through the male line, backward through his father and forward through his own eldest son.

What happened to the other sons? Some of them became knights, others monks. Nor should we forget that many became bishops. In many ways, the interests of bishops and lay nobles were similar: bishops were men of property, lords of vassals, and faithful to patrons, such as kings, who often were the ones to appoint them to their posts. In some places, bishops wielded the powers of a count or duke. Some bishops ruled cities. Nevertheless, bishops were also "pastors," spiritual leaders charged with shepherding their flock, which

included the laity, priests, and monks in their diocese (a district that gained clear definition in the eleventh century).

As episcopal power expanded and was clarified in the course of the tenth and eleventh centuries, some bishops in southern France, joined by the upper crust of the aristocracy, sought to control the behavior of the lesser knights through a movement called the "Peace of God." They were not satisfied with the current practices of peace-making, in which enemies, pressured by their peers, negotiated an end to—or at least a cessation of hostilities. (Behind the negotiation was the threat of an ordeal—for instance a trial by battle whose outcome was in the hands of God—if the two sides did not come to terms.) This system of arbitration was not always satisfactory. Hugh of Lusignan, a discontented vassal, complained that his lord "[did not] broker a good agreement." The Peace movement began in 989 and grew apace, its forum the regional church council, where bishops galvanized popular opinion, attracting both grand aristocrats and peasants to their gatherings. There, drawing upon bits and pieces of defunct Carolingian legislation, the bishops declared the Peace, and knights took oaths to observe it. At Bourges a particularly enthusiastic archbishop took the oath himself: "I Aimon ... will wholeheartedly attack those who steal ecclesiastical property, those who provoke pillage, those who oppress monks, nuns, and clerics."12 In the Truce of God, which by the 1040s was declared alongside the Peace, warfare between armed men was prohibited from Lent to Easter, while at other times of the year it was forbidden on Sunday (because that was the Lord's Day), on Saturday (because that was a reminder of Holy Saturday), on Friday (because it symbolized Good Friday), and on Thursday (because it stood for Holy Thursday).

To the bishops who promulgated the Peace, warriors fell conceptually into two groups: the sinful ones who broke the Peace, and the righteous ones who upheld church law. Although the Peace and Truce were taken up by powerful lay rulers, eager to sanctify their own warfare and control that of others, the major initiative for the movement came from churchmen eager to draw clear boundaries between the realms of the sacred and the profane.

CITIES AND MERCHANTS

These clerics were, in part, reacting to new developments in the secular realm: the growing importance of urban institutions and professions. Though much of Europe was rural, there were important exceptions. Italy was one place where urban life, though dramatically reduced in size and population, persisted. In Italy, the power structure still reflected, if feebly, the political organization of ancient Rome. Whereas in northern France great lords built their castles in the countryside, in Italy they often constructed their family seats within the walls of cities. From these perches the nobles, both lay and religious, dominated the *contado*, the rural area around the city.

In Italy, most peasants were renters, paying cash to urban landowners. Peasants depended on city markets to sell their surplus goods; their customers included bishops,

Map 4.6 (facing page) Europe, *c*.1050

nobles, and middle-class shopkeepers, artisans, and merchants. At Milan, for example, the merchants were prosperous enough to own houses in both the city center and the *contado*.

Rome, although exceptional in size, was in some ways a typical Italian city. Large and powerful families built their castles within its walls and controlled the churches and monasteries in the vicinity. The population depended on local producers for their food, and merchants brought their wares to sell within its walls. Yet Rome was special apart from its size: it was the "see"—the seat—of the pope, the most important bishop in the West. In the tenth and early eleventh centuries, the papacy did not control the church, but it had great prestige, and powerful families at Rome fought to place one of their sons at its head.

Outside Italy cities were less prevalent. Yet even so we can see the rise of a new mercantile class. This was true less in the heartland of the old Carolingian Empire than on its fringes. In the north, England, northern Germany, Denmark, and the Low Countries bathed in a sea of silver coins; commercial centers such as Haithabu reached their grandest extent in the mid-tenth century. Here merchants bought and sold slaves, honey, furs, wax, and pirates' plunder. Haithabu was a city of wood, but a very rich one indeed.

In the south of Europe, beyond the Pyrenees, Catalonia was equally commercialized, but in a different way. It imitated the Islamic world of al-Andalus (which was, in effect, in its backyard). The counts of Barcelona minted gold coins just like those at Córdoba. The villagers around Barcelona soon got used to selling their wares for money, and some of them became prosperous. They married into the aristocracy, moved to Barcelona to become city leaders, and lent money to ransom prisoners of the many wars waged to their south.

Kingship in an Age of Fragmentation

In such a world, what did kings do? At the least, they stood for tradition, serving as symbols of legitimacy. At the most, they united kingdoms and maintained a measure of law and order. (See Map 4.6.)

NORTHERN KINGDOMS

King Alfred of England was a king of the second sort. In the face of the Viking invasions, he developed new mechanisms of royal government, creating institutions that became the foundation of strong English kingship. We have already seen his military reforms: the system of *burhs* and the creation of a navy. Alfred was interested in religious and intellectual reforms as well. These were closely linked in his mind: the causes of England's troubles (in his view) were the sins of its people, brought on by their ignorance. Alfred intended to educate "all free-born men." He brought scholars to his court and embarked on an ambitious program to translate key religious works from Latin into Anglo-Saxon (or Old English). This was the vernacular, the spoken language of the people. Indeed, Anglo-Saxon was used in England not only for literature but for official administrative purposes as well:

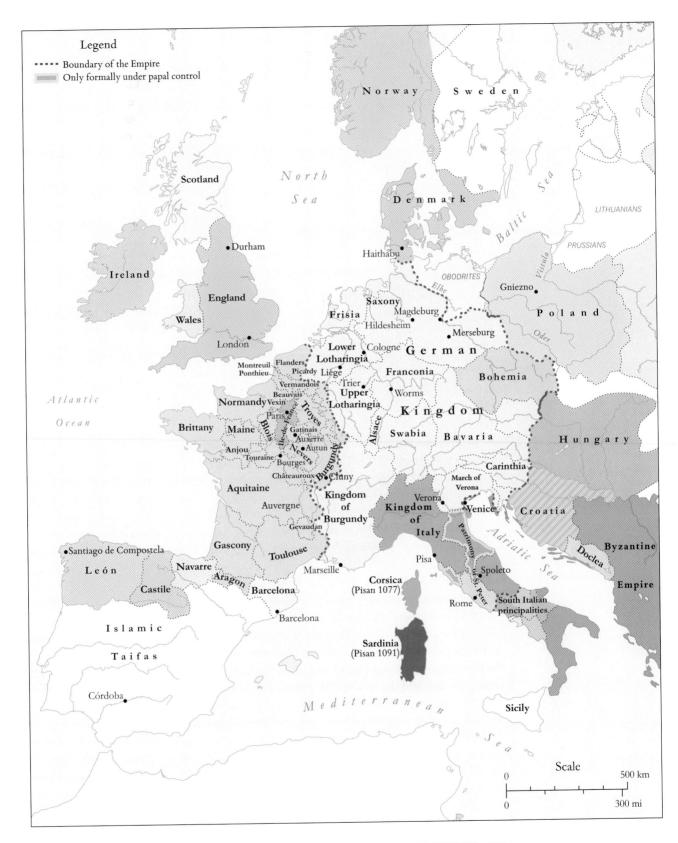

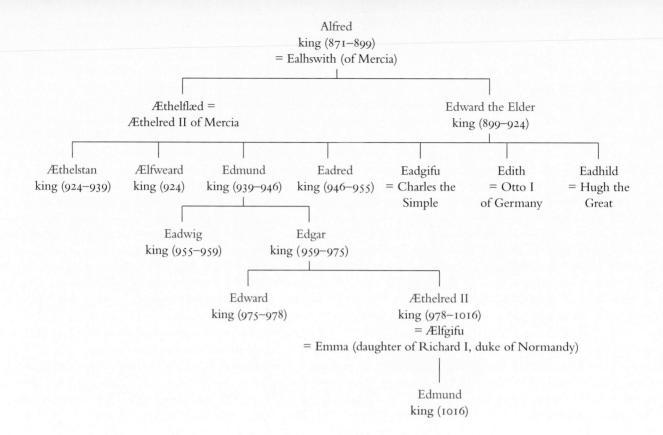

Genealogy 4.1 Alfred and His Progeny

for example, for royal "writs" that kings and queens directed to their officials and for law codes such as the one that Æthelred II the Unready (r.978–1016) issued in 1008.13 England was not alone in its esteem of the vernacular: in Ireland, too, the vernacular language was a written one. But the British Isles were unusual by the standards of Continental Europe, where Latin alone was the language of scholarship and writing.

As Alfred harried the Danes who were pushing south and westward, he gained recognition as king of all the English not under Viking rule. His law code, issued in the late 880s or early 890s, was the first by an English king since 695. Unlike earlier codes, which had been drawn up for each separate kingdom, Alfred's contained laws from and for all the English kingdoms in common. The king's inspiration was the Mosaic law of the Bible. Alfred believed that God had made a new covenant with the victors over the Vikings; as leader of his people, Alfred, like the Old Testament patriarch Moses, issued a law for all.

His successors, beneficiaries of that covenant, rolled back the Viking rule in England. (See Genealogy 4.1.) Many Vikings fled back to Scandinavia, but others remained. Converted to Christianity, their great men joined Anglo-Saxons to attend the English king at court. The whole kingdom was divided into districts called "shires" and "hundreds," and in each shire, the king's reeve—the sheriff—oversaw royal administration.

Alfred's grandson Æthelstan (r.924–939) took advantage of all the institutions that early medieval kingship offered. The first king of all the Anglo-Saxon kingdoms, he was crowned in a new ritual created by the archbishop of Canterbury to emphasize harmony and unity. When Æthelstan toured his realm (as he did constantly), he was accompanied by a varied and impressive retinue: bishops, nobles, thegns (the English equivalent of high-status vassals), scholars, foreign dignitaries, and servants. Well known as an effective military leader who extended his realm northwards, he received oaths of loyalty from the rulers of other parts of Britain. Churchmen attended him at court, and he in turn chose bishops and other churchmen, often drawing on the priests in his household. Like Alfred, he issued laws and expected local authorities—the ealdormen and sheriffs to carry them out.14

From the point of view of control, however, Æthelstan had nowhere near the power over England that, say, Basil II had over Byzantium at about the same time. The dynatoi might sometimes chafe at the emperor's directives and rebel, but the emperor had his Varangian Guard to put them down and an experienced, professional civil service to do his bidding. The king of England depended less on force and bureaucracy than on consensus. The great landowners adhered to the king because they found it in their interest to do so. When they ceased to do so, the kingdom easily fragmented, becoming prey to civil war. Disunity was exacerbated by new attacks from the Vikings. One Danish king, Cnut (or Canute), even became king of England for a time (r.1016–1035). Yet under Cnut, English kingship did not change much. He kept intact much of the administrative, ecclesiastical, and military apparatus already established. By Cnut's time, much of Scandinavia had been Christianized, and its traditions had largely merged with those of the rest of Europe.

In fact, two European-style kingdoms—Denmark and Norway—developed in Scandinavia around the year 1000, and Sweden followed thereafter. In effect, the Vikings took home with them not only Europe's plundered wealth but also its prestigious religion, with all its implications for royal power and state-building. (Consider how closely King Alfred linked God to royal authority, morality, and territorial expansion.) The impetus for conversion in Scandinavia came from two directions. From the south, missionaries such as the Frankish monk Ansgar (d.865) came to preach Christianity, while bishops in the north of Germany imposed what claims they could over the Scandinavian church. From within Scandinavia itself, kings found it worth their while to ally with the Christian world to enhance their own position.

Danish King Harald Bluetooth (r.c.958–c.986), much like Khan Boris-Michael of Bulgaria a century before (see p. 85), proclaimed his conversion through an artifact. Boris-Michael had used seals—items prestigious for their association with Byzantine imperial government. Before converting to Christianity, Harald buried his father in a mound prestigious precisely for its non-Christian, pagan connotations. About a decade later, when he became Christian, he added a giant runestone to the burial place of his father, whose body he moved from the mound into a new church he built for the occasion. The runestone, which included an image of Christ, announced that Harald had "won for himself all of Denmark and Norway and made the Danes Christian." Thus graphically turning a pagan site into a Christian one, Harald announced himself the ruler of a state that extended into what is today southern Sweden and parts of Norway. His successors turned their sights further outward, culminating in the conquest of England and Norway, but this grand empire ended with the death of Cnut in 1035.

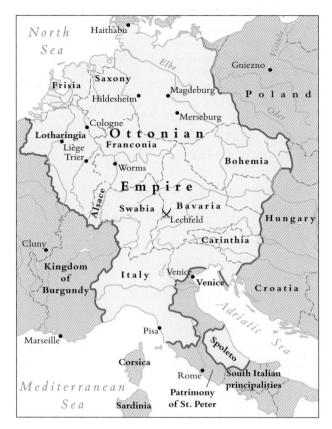

Map 4.7 Ottonian Empire, *c*.1000

The processes of conversion and the development of kingship in Norway are less easily traceable because there are few sources from the time. It is clear, however, that at the beginning of the eleventh century the baptism of Olav Haraldsson allowed him to ally with the English king ousted by the Danes. It also let Olav tie himself to his own men through the bonds of godparenthood. Building on the successes of Olav in opposing Danish King Cnut's hegemony in Norway, Magnus the Good (r.1035–1047) harnessed the Christian institutions already in place.

The story of Sweden was similar to that of Denmark and Norway, but delayed until the twelfth century. Before then, Sweden was divided among many competing rulers, most of them professing Christianity.

GERMANY

Just below Denmark was Germany. There the king was as effective and powerful as his English counterpart—and additionally worked with a much wider palette of territories, institutions, and possibilities. It is true that at first Germany seemed ready to disintegrate into duchies: five

emerged in the late Carolingian period, each held by a military leader who exercised quasiroyal powers. But, in the face of their own quarrels and the threats of outside invaders, the dukes needed and wanted a strong king. With the death in 911 of the last Carolingian king in Germany, Louis the Child, they crowned one of themselves. Then, as attacks by the Hungarians increased, the dukes gave the royal title to their most powerful member, the duke of Saxony, Henry I (r.919–936), who proceeded to set up fortifications and reorganize his army, crowning his efforts with a major defeat of the Hungarians in 933.

Henry's son Otto I (r.936–973) defeated rival family members, rebellious dukes, and Slavic and Hungarian armies soon after coming to the throne. Through astute marriage alliances and appointments, he was eventually able to get his family members to head up all the duchies. In 951, Otto marched into Italy and took the Lombard crown. That gave him control, at least theoretically, of much of northern Italy (see Map 4.7). Soon (in 962) he received the imperial crown that recognized his far-flung power. Both to himself and to contemporaries he recalled the greatness of Charlemagne. Meanwhile, Otto's victory at Lechfeld in 955 (see p. 135) ended the Hungarian threat. In the same year, Otto defeated a Slavic group, the Obodrites, just east of the Elbe River and set up fortifications and bishoprics in the no-man's-land between the Elbe and the Oder Rivers.

Victories such as these brought tribute, plum positions to disburse, and lands to give away, ensuring Otto a following among the great men of the realm. His successors, Otto II (r.961–983), Otto III (r.983–1002)—hence the dynastic name "Ottonians"—and Henry II

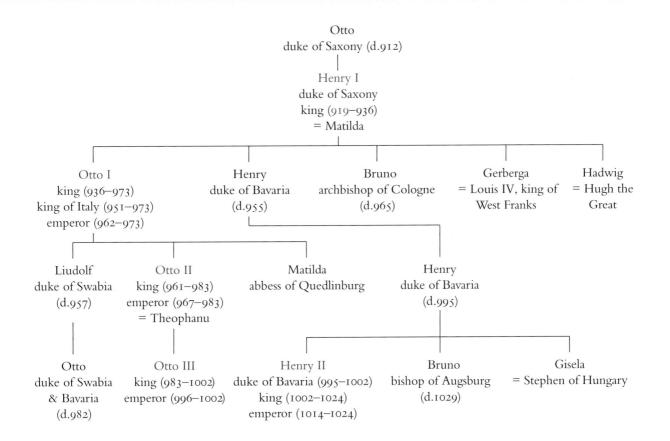

(r.1002–1024), built on his achievements. (See Genealogy 4.2.) Granted power by the magnates, they gave back in turn: they distributed land and appointed their aristocratic supporters to duchies, counties, and bishoprics. Royal power was tempered by hereditary claims and plenty of lobbying by influential men at court and at the great assemblies that met with the king to hammer out policies. The role of kings in filling bishoprics and archbishoprics was particularly important to them because, unlike counties and duchies, those positions could not be inherited. Otto I created a ribbon of new bishoprics along his eastern border, endowing them with extensive lands and subjecting the local peasantry to episcopal overlordship. Throughout Germany bishops had the right to collect revenues and call men to arms.

Bishops and archbishops constituted the backbone of Ottonian rule. Once he had chosen the bishop (usually with the consent of the clergy of the cathedral over which the bishop was to preside), the king usually received a gift—a token of episcopal support—in return. Then the king "invested" the new prelate in his post by participating in the ceremony that installed him into office. Archbishop Bruno of Cologne is a good—if extreme—example of the symbiotic relations between church and state in the German realm. An ally of the king (as were almost all the bishops), he was also Otto I's brother. Right after he was invested as archbishop in 953, he was appointed by Otto to be duke of Lotharingia and to put down a local rebellion. Later Bruno's biographer, Ruotger, strove mightily to justify Bruno's role as a warrior-bishop:

Genealogy 4.2 The Ottonians

Some people ignorant of divine will may object: why did a bishop assume public office and the dangers of war when he had undertaken only the care of souls? If they understand any sane matter, the result itself will easily satisfy them, when they see a great and very unaccustomed (especially in their homelands) gift of peace spread far and wide through this guardian and teacher of a faithful people.... Nor was governing this world new or unusual for rectors of the holy Church, previous examples of which, if someone needs them, are at hand.¹⁶

Ruotger was right: there were other examples near at hand, for the German kings found their most loyal administrators among their bishops. Consider the bishop of Liège; he held the rights and exercised the duties of several counts, had his own mints, and hunted and fished in a grand private forest granted to him in 1006.

Bruno was not only duke of Lotharingia, pastor of his flock at Cologne, and head (as archbishop of Cologne) of the bishops of his duchy. He was also a serious scholar. "There was nearly no type of liberal study in Greek or Latin," wrote the admiring Ruotger, "that escaped the vitality of his genius." Bruno's interest in learning was part of a larger movement. With wealth coming in from their eastern tributaries, Italy, and the silver mines of Saxony (discovered in the time of Otto I), the Ottonians presided over a bril-

liant intellectual and artistic efflorescence. As in the Islamic world, much of this was dispersed; in Germany, the centers of culture included the royal court, the great cathedral schools, and women's convents.

The most talented young men crowded the schools at the episcopal courts of Trier, Cologne, Magdeburg, Worms, and Hildesheim. Honing their Latin, they studied classical authors such as Cicero and Horace as well as Scripture, while their episcopal teachers wrote histories, saints' lives, and works on canon law. One such was the Decretum (1008/1012) by Burchard, bishop of Worms. This widely influential collection—much like the compilations of hadith produced about a century before in the Islamic world—winnowed out the least authoritative canons and systematized the contradictory ones. The men at the cathedral schools were largely in training to become courtiers, administrators, and bishops themselves.

Plate 4.6 The Raising of Lazarus, Egbert Codex (985–990). This miniature is one of fifty-one illustrations in a Pericopes, a book of readings arranged for the liturgical year. The story of the Raising of Lazarus, which is recounted in John II:I–45, is read during the week before Easter. Of the many elements of this story, the artist chose a few important moments, arranging them into a unified scene.

Churchmen such as Egbert, archbishop of Trier (r.977–993), appreciated art as well as scholarship. Plate 4.6, an illustration of the Raising of Lazarus, from the Egbert Codex (named for its patron), is a good example of what is called the "Ottonian style." Drawing above all on the art of the late antique "renaissance" (see p. 20 and Plate 1.10), the Egbert Codex artists nevertheless achieved an effect all their own. Utterly unafraid of open space, which was rendered in otherworldly pastel colors, they focused on the figures, who gestured like actors on a stage. In Plate 4.6 the apostles are on the left-hand side, their arms raised and hands wide open with wonder at Christ. He has just raised the dead Lazarus from the tomb, and one of the Jews, on the right, holds his nose. Two women-Mary and Martha, the sisters of Lazarus—fall at Christ's feet, completing the dramatic tableau.

At around the same time, in convents that provided them with comfortable private apartments, noblewomen were writing books and supporting other artists and scholars. Plate 4.7 is from a manuscript made at Cologne between c.1000 and c.1020 for Abbess Hitda of Meschede. It draws on Byzantine and Carolingian models as well as the palette of the Egbert Codex to produce a calm Christ, asleep during a wild storm on the Sea of Galilee that ruffles the sails of the ship and seems to toss it into sheer air. The marriage of Otto II to a Byzantine princess, Theophanu, helps account for the Byzantine influence.

Among the most active patrons of the arts were the Ottonian kings themselves. In a Gospel book made for Otto III—a work fit for royal consumption—the full achievement of Ottonian culture is made clear. Plate 4.8 shows one of twenty-nine full-page miniatures in this manuscript, whose binding alone—set with countless gems around a Byzantine carved ivory—was worth a fortune. The figure of the evangelist Luke emerges from a pure gold-leaf background, while the purple of his dress and the columns that frame him recall imperial majesty. At the same time, Luke is clearly of another world, and his Gospels have here become a theological vision.

FRANCE

By contrast with the English and German kings, those in France had a hard time coping with invasions. Unlike Alfred's dynasty, which started small and built slowly, the French kings had half an empire to defend. Unlike the Ottonians, who asserted their military prowess in decisive battles such as the one at Lechfeld, the French kings generally had to let local men both take the brunt of the attacks and reap the prestige and authority that came with military leadership. Nor did the French kings have the advantage of Germany's tributaries, silver mines, or Italian connections. Much like the Abbasid caliphs at Baghdad, the kings of France saw their power wane. During most of the tenth century, Carolingian kings alternated on the throne with kings from a family that would later be called the "Capetians." At the end of that century the most powerful men of the realm, seeking to stave off civil war, elected Hugh Capet (r.987-996) as their king. The Carolingians were displaced, and the Capetians continued on the throne until the fourteenth century. (See Genealogy 5.5 on p. 189.)

Following pages:

Plate 4.7 Christ Asleep, Hitda Gospels (c. 1000–c. 1020). The moral of the story (which is told in Matt. 8:23-26) is right in the picture: as the apostles look anxiously toward the mast to save them from the stormy sea, one (in the exact center) turns to rouse the sleeping Christ, the real Savior. The prow of this ship, in the shape of a beast, echoes the prow of Viking vessels.

Plate 4.8 Saint Luke, Gospel Book of Otto III (998-1001). St. Luke is like Atlas holding up the world, but in this case the "world" consists of Luke's symbol, the ox, surrounded by Old Testament prophets, each of whom is accompanied by an angel (King David, at the very top, is flanked by two angels). The artist was no doubt thinking of Heb. 12:1 where Paul says that prophets are a "cloud of witnesses over our head." He also recalled Rev. 4:2-3, where Christ will be seated on a "throne set in heaven" with "a rainbow round about the throne." Here, Luke sits in the place of Christ.

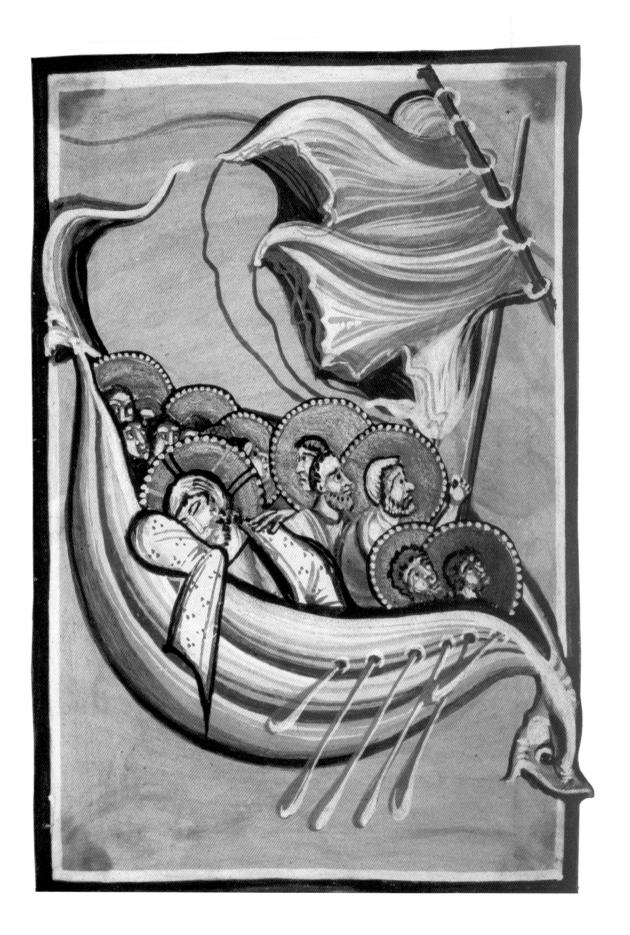

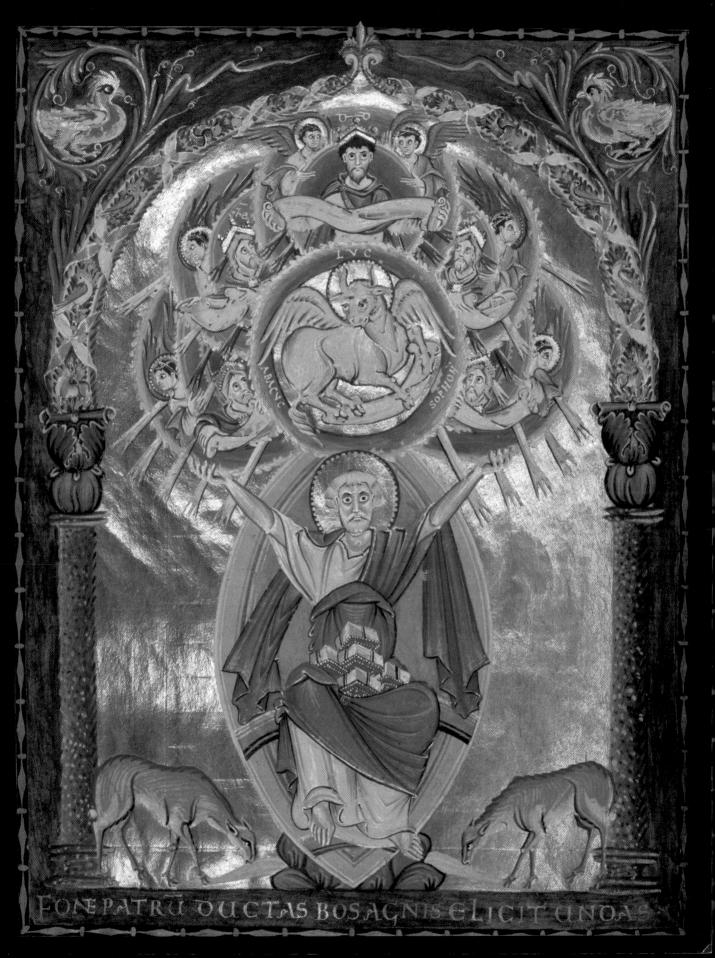

The Capetians' scattered but substantial estates lay in the north of France, in the region around Paris. Here the kings had their vassals and their castles. This "Ile-de-France" (which was all there was to "France" in the period; see Map 4.6 on p. 141) was indeed an "island,"—an île—surrounded by independent castellans. In the sense that he, too, had little more military power than other castellans, Hugh Capet and his eleventh-century successors were similar to local strongmen. But the Capetian kings had the prestige of their office. Anointed with holy oil, they represented the idea of unity and God-given rule inherited from Charlemagne. Most of the counts and dukes—at least those in the north of France—swore homage and fealty to the king, a gesture, however weak, of personal support. Unlike the German kings, the French could rely on vassalage to bind the great men of the realm to them.

New States in East Central Europe

Around the same time as Moravia and Bulgaria lost their independence to the Magyars and the Byzantines (respectively), three new polities—Bohemia, Poland, and Hungary—emerged in East Central Europe. In many ways, they formed an interconnected bloc, as their ruling houses intermarried with one another and with the great families of the Empire—the looming power to the west. Bohemia and Poland both were largely Slavic-speaking; linguistically Hungary was odd man out, but in almost every other way it was typical of the fledgling states in the region.

BOHEMIA AND POLAND

While the five German duchies were subsumed by the Ottonian state, Bohemia in effect became a separate duchy of the Ottonian Empire. (See Map 4.7 on p. 144.) Already Christianized, largely under the aegis of German bishops, Bohemia was unified in the course of the tenth century. (One of its early rulers was Wenceslas—the carol's "Good King Wenceslas"—who was to become a national saint after his assassination.) Its princes were supposed to be vassals of the emperor in Germany. Thus, when Bretislav I (d.1055) tried in 1038 to expand into what was by then Poland, laying waste the land all the way to Gniezno and kidnapping the body of the revered Saint Adalbert, Emperor Henry III (d.1056) declared war, forcing Bretislav to give up the captured territory and hostages. Although left to its own affairs internally, Bohemia was thereafter semi-dependent on the Empire.

What was this "Poland" of such interest to Bretislav and Henry? Like the Dane Harald Bluetooth, and around the same time, the ruler of the region that would become Poland, Mieszko I (r.c.960–992), became Christian. In 990/991 he put his realm under the protection of the pope, tying it closely to the power of Saint Peter. Mieszko built a network of defensive structures manned by knights, subjected the surrounding countryside to his rule, and expanded his realm in all directions. Mieszko's son Boleslaw the Brave (or, in

Polish, Chrobry) (r.992–1025), "with fox-like cunning" (as a hostile German observer put it), continued his father's expansion, for a short time even becoming duke of Bohemia. Boheve all, Boleslaw made the Christian religion a centerpiece of his rule when Gniezno was declared an archbishopric. It was probably around that time that Boleslaw declared his alliance with Christ on a coin: on one side he portrayed himself as a sort of Roman emperor, while on the other he displayed a cross. Soon the Polish rulers could count on a string of bishoprics—and the bishops who presided in them. A dynastic crisis in the 1030s gave Bretislav his opening, but, as we have seen, that was quickly ended by the German emperor. Poland persisted, although somewhat reduced in size.

HUNGARY

Polytheists at the time of their entry into the West, most Magyars were peasants, initially specializing in herding but soon busy cultivating vineyards, orchards, and grains. Above them was a warrior class, and above the warriors were the elites, whose richly furnished graves reveal the importance of weapons, jewelry, and horses to this society. Originally organized into tribes led by dukes, by the mid-tenth century the Hungarians recognized one ruling house—that of Prince Géza (r.972–997).

Like the ambitious kings of Scandinavia, Géza was determined to give his power new ballast via baptism. His son, Stephen I (r.997–1038), consolidated the change to Christianity: he built churches and monasteries, and required everyone to attend church on Sundays. Establishing his authority as sole ruler, Stephen had himself crowned king in the year 1000 (or possibly 1001). Around the same time, "governing our monarchy by the will of God and emulating both ancient and modern caesars [emperors]," he issued a code of law that brought his kingdom into step with other European powers.²⁰

* * * * *

Political fragmentation did not mean chaos. It simply betokened a new order. At Byzantium, in any event, even the most centrifugal forces were focused on the center; the real trouble for Basil II, for example, came from *dynatoi* who wanted to be emperors, not from people who wanted to be independent regional rulers. In the Islamic world fragmentation largely meant replication, as courts patterned on or competitive with the Abbasid model were set up by Fatimid caliphs and other rulers. In Europe, the rise of local rulers was accompanied by the widespread adoption of forms of personal dependency—vassalage, serfdom—that could be (and were) manipulated even by kings, such as the Capetians, who seemed to have lost the most from the dispersal of power. Another institution that they could count on was the church. No wonder that in Rus', Scandinavia, and East Central Europe, state formation and Christianization went hand in hand. The *real* fragmentation was among the former heirs of the Roman Empire. They did not speak the same language, they were increasingly estranged by their religions, and they knew almost nothing about one another. In the next centuries, the gaps would only widen.

MATERIAL CULTURE: THE MAKING OF AN ILLUMINATED MANUSCRIPT

Before the use of paper became widespread in the West in the fourteenth century, European books were made of parchment, the product of animal skins. The most common parchment was made from goats and sheep, while calfskin was considered the finest sort (commonly known as vellum, from the Latin *vitulinum*, i.e., "of a calf"). All parchments were produced through an elaborate process by a *percamenarius*, a parchmenter.

To begin, the parchmenter cleaned the skin in fresh, running water—generally a river—for a day or two. Then he (almost never she) soaked it for many days in vats filled with a thick mixture of lime and water. Lime, composed mainly of calcium carbonate, helped to de-hair the skin, which the parchmenter then scraped off by means of a long, concave knife. Once meticulously and thoroughly de-haired, the skin was rinsed in fresh water. Still wet, it was stretched on a wooden frame for the second stage of the process. Now the parchmenter scraped both sides of the skin (known as the flesh and hair sides) with a *lunellum*, a special, half-moon-shaped knife that reduced the risk of scratches while smoothing and thinning the skin (Plate 4.9).

Even while he was scraping, the parchmenter was constantly stretching the skin by expertly tightening the pegs of the wooden frame. The parchment stretched even more as it dried. After the parchmenter did a final scraping and smoothing of the dried skin, it was removed from the frame, rolled up, and sold. Between the fifth and the twelfth centuries, the entire production of books was monopolized—almost exclusively—by monks. By the thirteenth century, some commercial manuscript makers opened shops in urban centers.

In a model book-production schedule, monks first cut the parchment to the desired size of the

book that was to be made, folding the rectangular sheet in half to obtain two pages (a bifolium), each page (folium in Latin) with a recto and a verso (technical terms for the two sides of one page). They put together several folded sheets to form a quire (or gathering). The sheets in a quire were assembled so that two facing pages presented the same side of the parchment: two facing flesh sides followed by two facing hair sides. At this point, the scribes—monks charged with copying textsfurther prepared each folium by rubbing it with a pumice stone, a procedure that made the surface receptive to inks and paints. The scribes then had to "rule" the pages—make the lines that would keep their writing even and straight—by joining up prick marks made through a closed quire along a measured grid. Then the scribes "drew" barely visible lines with a tool that had a hard metal point; by the twelfth century this was commonly made of lead and was called a plummet marker. Later, ruling was done also in ink or in pigment.

With everything set, the scribe was ready to write. He or she (for there were many female monasteries, and women, too, were trained as scribes) wrote the text with a quill pen made from a wing feather—usually a goose or a swan feather (penna in Latin, a word that has been passed down for centuries!). In their free hand, scribes held a knife (see Plate 4.10), which they used for several operations: to cut the parchment, keep the pages firm while writing, erase errors (which occurred quite frequently), and sharpen the quill pen itself. Because the writing was done by hand, the resulting book is called a manuscript (from the Latin manus, hand and scriptus, written).

If the manuscript was to be "illuminated"—illustrated—production continued with the

participation of illuminators. Illustrations might be as simple as an ornamental letter or as elaborate as a full page, as in Plate 4.10. The illuminator first made a sketch, then began to apply gold leaf. But gold was very expensive and therefore used in only the most extravagant of books. Alternatives included tin leaf or even "poorer" natural substances such as saffron. The "gold" was applied to selected letters or figures, using gesso, in most cases, as a ground. Next, illuminators painted the rest of their sketch. Paints were made with coloring agents (pigments)

zabulon una. Eta talem guingento क्षा चार है m parem etod obtained from vegetables, animals, and minerals and bound with glair (made from egg white), gum and/or glue, and water. Additives such as salt, stale urine, honey, and ear wax were also used to alter the shade and the consistency of the paints. Red and blue, followed by green, were the most common colors used in medieval manuscripts.

The final production stage was carried out by bookbinders. In monastic scriptoria, binding could be performed by any monk who knew the techniques. Later, when books were produced by commercial workshops, lay professionals or stationers became widespread. The binder's job was to put together a stack of loose quires in the correct order (according to the progressive folio numeration) and to sew them onto bands or thongs across the spine of the book. Two wooden boards served as front and back covers and were often covered with leather and reinforced with corner metal pieces. Luxury binding was typically reserved for whole Bibles or the four Gospels. Some bejeweled bindings remain today, attesting to the full artistry of medieval book-making (see Plate 4.11).

FURTHER READING

Clemens, Raymond and Timothy Graham. *Introduction to Manuscript Studies*. Ithaca: Cornell University Press,

De Hamel, Christopher. Medieval Craftsmen. Scribes and Illuminators. London: British Museum Press, 1992.

Plate 4.9 Hamburg Bible (1255). In this decorated initial letter (D for Daniel) of a Bible made at Hamburg's Cathedral canonry, a monk—possibly Saint Jerome (note the halo)—buys parchments from a lay craftsman. The parchmenter's wooden frame and scraping tool, the *lunellum*, are depicted in the lower half, between the two standing figures.

Plate 4.10 Miniature of Saint Dunstan (12th cent.). In this full-page miniature made between c.1170-c.1180 at the Benedictine cathedral priory of Holy Trinity or Christ Church, Canterbury, Saint Dunstan (d.988), former archbishop of Canterbury, is shown copying Smaragdus of Saint-Mihiel's Commentary on the Rule of Saint Benedict. The lavish image, embellished with gold leaf, shows the saint in full episcopal attire. With a quill pen in his right hand, a knife in his left, and a handy inkwell below, he writes by following the pale-gray lines that were drawn with a plummet.

Plate 4.11 (facing page)
Codex Aureus (870). This
so-called Golden book
of Gospels received royal
treatment with a bejeweled
upper cover. It was most likely
produced at the monastery
of Saint-Denis, near Paris,
by artists patronized by
Emperor Charles the Bald,
Charlemagne's grandson. At
the center, Christ in Majesty
is surrounded by the four
evangelists and scenes from
the life of Christ.

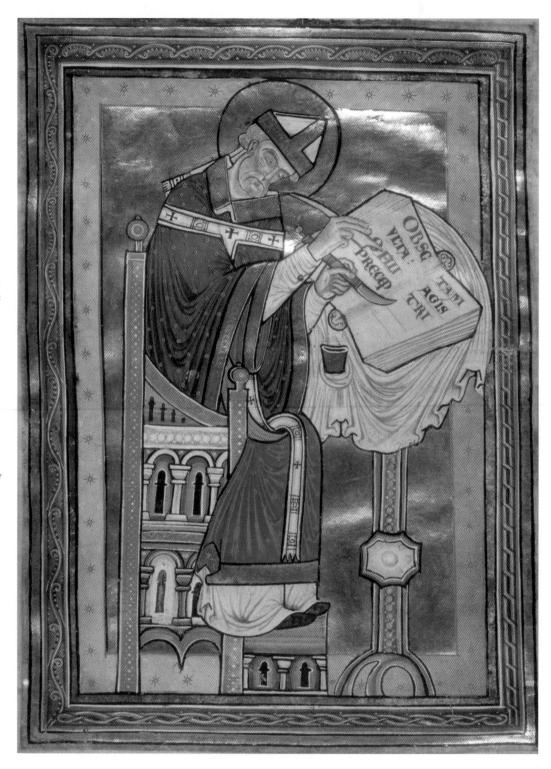

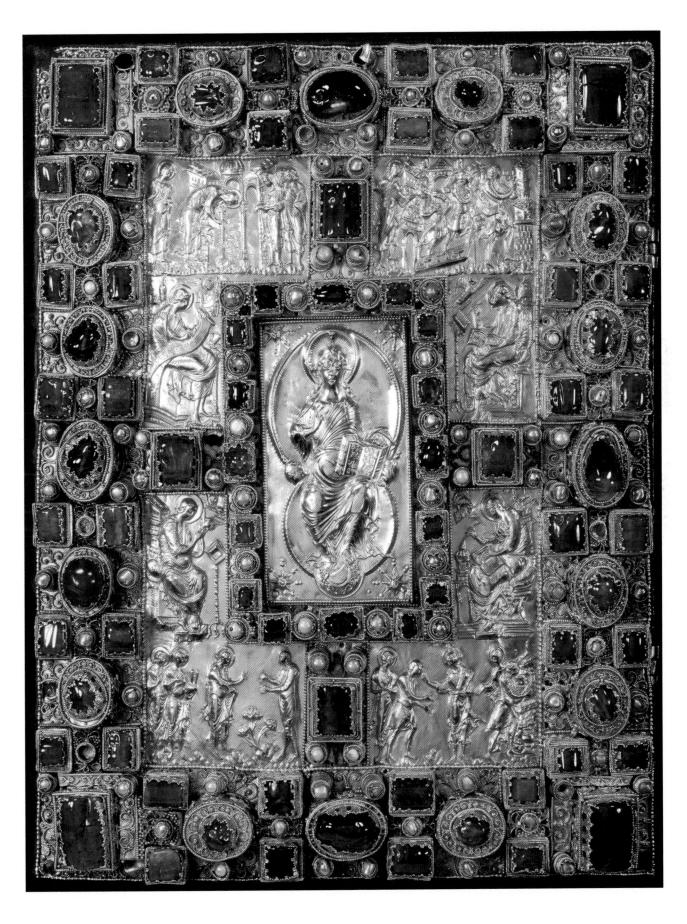

CHAPTER FOUR: ESSENTIAL DATES

- 910 Fatimids (in North Africa) establish themselves as caliphs
- 955 Victory of Otto I over Hungarians at Lechfeld
- 980-1037 Ibn Sina (Avicenna), scholar of medicine and philosophy
 - 988 Conversion of Vladimir, ruler of Rus', to Byzantine Christianity
 - 989 "Peace of God" movement begins
- 1000 (or 1001) Stephen I crowned king of Hungary
 - 1025 Death of Basil II the Bulgar Slayer
 - c.1031 Al-Andalus splits into taifas

NOTES

- I Michael Psellus, Zoe and Theodora, in Reading the Middle Ages: Sources from Europe, Byzantium, and the Islamic World, 3rd ed., ed. Barbara H. Rosenwein (Toronto: University of Toronto Press, 2018), p. 203.
- 2 Epitaph of Basil II, in Reading the Middle Ages, p. 200.
- 3 Romanus I Lecapenus, Novel, in Reading the Middle Ages, p. 178.
- 4 The Russian Primary Chronicle, in Reading the Middle Ages, p. 223.
- 5 Al-Tabari, The Defeat of the Zanj Revolt, in Reading the Middle Ages, p. 176.
- 6 Quoted in Elina Gertsman and Barbara H. Rosenwein, *The Middle Ages in 50 Objects* (Cambridge: Cambridge University Press, 2018), p. 122.
- 7 Ibn 'Abd Rabbihi, Praise Be to Him, in Reading the Middle Ages, p. 180.
- 8 Al-Qabisi, A Treatise Detailing the Circumstances of Students and the Rules Governing Teachers and Students, in Reading the Middle Ages, pp. 211–13.
- 9 Egil's Saga, in Reading the Middle Ages, p. 236.
- 10 The Anglo-Saxon Chronicle, in Reading the Middle Ages, p. 234.
- II Agreement between Count William of the Aquitanians and Hugh IV of Lusignan, in Reading the Middle Ages, p. 192.
- 12 Andrew of Fleury, The Miracles of St. Benedict, in Reading the Middle Ages, p. 196.
- 13 See King Æthelred II, Law Code, in Reading the Middle Ages, p. 228.
- 14 Both ealdormen and sherrifs (shire reeves) were powerful men, and sometimes their functions were the same. Originally the ealdorman was the equivalent of a count or duke who ruled a large region independently of any king. That changed with Alfred and his successors, and by the tenth century the term referred to a local ruler, generally of a shire, who, while certainly a nobleman, acted (or was expected to act) as an agent of the king. Reeves were of more variable status: they were administrators, whether for kings, bishops, towns, or estates. Royal sherrifs were responsible for (among other things) ensuring the peace and meetings of the local court.

- 15 For an image of this runestone, see The Jelling Monument, "Reading through Looking," in Reading the Middle Ages, p. IV.
- 16 Ruotger, Life of Bruno, Archbishop of Cologne, in Reading the Middle Ages, p. 227.
- 17 Ibid., p. 225.
- 18 See Thietmar of Merseburg, Chronicle, in Reading the Middle Ages, p. 220.
- 19 For an image of this coin, see Plate 2, "Reading through Looking," in Reading the Middle Ages, p. III.
- 20 King Stephen, Laws, in Reading the Middle Ages, p. 214.

FURTHER READING

Angold, Michael. The Byzantine Empire, 1025-1204: A Political History, 2nd ed. London, Longman, 1997.

Bagge, Sverre, Michael H. Gelting, and Thomas Lindkvist, eds. Feudalism: New Landscapes of Debate. Turnhout: Brepols, 2011.

Barthélemy, Dominique. "Revisiting the 'Feudal Revolution' of the Year 1000." In The Serf, the Knight, and the Historian, trans. Graham Robert Edwards, 1-11. Ithaca: Cornell University Press.

Berend, Nora, Przemysław Urbańczyk, and Przemysław Wiszewski. Central Europe in the High Middle Ages: Bohemia, Hungary and Poland c. 900-c. 1300. Cambridge: Cambridge University Press, 2013.

Berend, Nora, ed. Christianization and the Rise of Christian Monarchy: Scandinavia, Central Europe, and Rus' c. 900-1200. Cambridge: Cambridge University Press, 2007.

Bolton, Timothy. Cnut the Great. New Haven, CT: Yale University Press, 2017.

Bonfil, Robert, Oded Irshai, Guy G. Stoumsa, et al., eds. Jews in Byzantium: Dialectics of Minority and Majority Cultures. Leiden: Brill, 2012.

Brett, Michael. The Fatimid Empire. Edinburgh: Edinburgh University Press, 2017.

Bruce, Scott G. Cluny and the Muslims of La Garde-Freinet: Hagiography and the Problem of Islam in Medieval Europe. Ithaca, NY: Cornell University Press, 2015.

Cameron, Averil. Byzantine Matters. Princeton, NJ: Princeton University Press, 2014.

Chiarelli, Leonard C. A History of Muslim Sicily. Malta: Santa Venera, 2010.

Clemens, Raymond and Timothy Graham. Introduction to Manuscript Studies. Ithaca: Cornell University Press, 2008.

De Hamel, Christopher. Medieval Craftsmen. Scribes and Illuminators. London: British Museum Press,

Duby, Georges. "The Evolution of Judicial Institutions." In The Chivalrous Society, trans. Cynthia Postan, 15-58. London: Arnold, 1977.

Foot, Sarah. Æthelstan: The First King of England. New Haven, CT: Yale University Press, 2011.

Franklin, Simon, and Jonathan Shepard. The Emergence of Rus, 750-1200. London: Longman, 1996.

Harding, Stephen E., David Griffiths, and Elizabeth Royles, eds. In Search of Vikings: Interdisciplinary Approaches to the Scandinavian Heritage of North-West England. Boca Raton: CRC Press, 2015.

Jaritz, Gerhard. Medieval East Central Europe in a Comparative Perspective: From Frontier Zones to Lands in Focus. London: Routledge, 2016.

- Kaldellis, Anthony. The Byzantine Republic: People and Power in New Rome. Cambridge, MA: Harvard University Press, 2015.
- La Rocca, Cristina, ed. Italy in the Early Middle Ages, 476–1000. Oxford: Oxford University Press, 2002.
- Magdalino, Paul. "Orthodoxy and Byzantine Cultural Identity." In Orthodoxy and Heresy in Byzantium: The Definition and the Notion of Orthodoxy and Some Other Studies on the Heresies and the Non-Christian Religions, ed. Antonio Rigo, 21-46. Rome: Università degli Studi di Roma Tor Vergata, 2010.
- Michałowski, Roman. The Gniezno Summit: The Religious Premises of the Founding of the Archbishopric of Gniezno. Leiden: Brill, 2016.
- Molyneaux, George. The Formation of the English Kingdom in the Tenth Century. Oxford: Oxford University Press, 2015.
- Neville, Leonora. Authority in Byzantine Provincial Society, 950–1100. Cambridge: Cambridge University Press, 2004.
- Raffensperger, Christian. Reimagining Europe: Kievan Rus' in the Medieval World. Cambridge, MA: Harvard University Press, 2012.
- Romane, Julian. Byzantium Triumphant: The Military History of the Byzantines, 959-1025. Barnsley, South Yorkshire: Pen & Sword Military, 2015.
- West, Charles. Reframing the Feudal Revolution: Political and Social Transformation between Marne and Moselle, c. 800-c. 1100. Cambridge: Cambridge University Press, 2013.
- Wilson, Peter H. Heart of Europe: A History of the Holy Roman Empire. Cambridge, MA: Harvard University Press, 2016.
- Winroth, Anders. The Conversion of Scandinavia: Vikings, Merchants, and Missionaries in the Remaking of Northern Europe. New Haven, CT: Yale University Press, 2012.

To test your knowledge of this chapter, please go to www.utphistorymatters.com for Study Questions.

PART II DIVERGING PATHS

FIVE

NEW CONFIGURATIONS (c. 1050-c. 1150)

In the second half of the eleventh century, two powerful groups—Seljuk Turks from the east, Europeans from the west—entered the Byzantine and Islamic empires, changing the political, cultural, and religious configurations everywhere. Byzantium, though seemingly still a force to be reckoned with, lost ground. The Islamic world, tending toward Shiʻsim with the Fatimids, now saw a revival of Sunnism. It elaborated new cultural forms to express its pride in its regained orthodoxy and to proclaim its cosmopolitanism. In Europe, a burgeoning population and vigorous new commercial economy helped fuel new forms of religious life and expand intellectual and territorial horizons.

THE SELJUKS AND THE ALMORAVIDS

In the eleventh century, the Seljuks, a new Turkic group from outside the Islamic world, entered and took over its eastern half. Eventually penetrating deep into Anatolia, they took a great bite out of Byzantium. Soon, however, the Seljuks themselves split apart, and eventually the Islamic world fragmented anew under the rule of dozens of rulers. Meanwhile, Berber tribespeople—the Almoravids—formed a new empire in the Islamic far West.

From Mercenaries to Imperialists

The Seljuk Turks were nomadic warriors from the Kazakh steppe—the extensive Eurasian grasslands of Kazakhstan. Some of them entered the region around the Caspian and Aral Seas at the end of the tenth century as mercenaries serving rival Muslim rulers. During

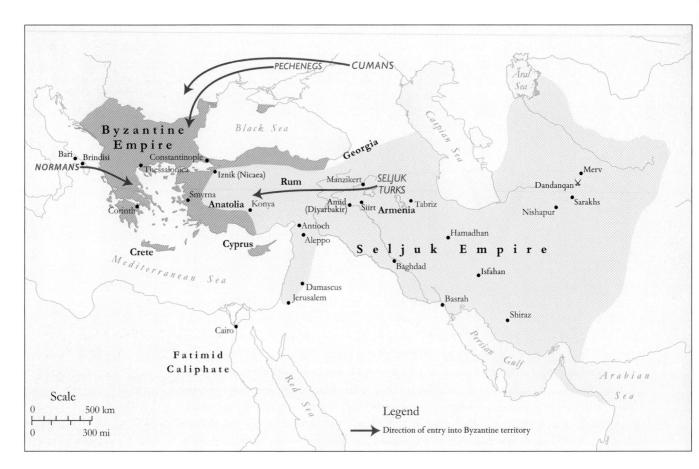

Map 5.1 The Byzantine and Seljuk Empires, *c*.1090

the first half of the eleventh century they began conquests of their own. The Ghaznavids, themselves Turks who had previously displaced the Buyids and Samanids, could perhaps have contained them, but Ghaznavid Sultan Mas'ud I (r.1030–1041) led an ill-prepared and demoralized army against the Seljuks and lost disastrously at the battle of Dandanqan (1040). Abu'l-Fazl Beyhaqi, who served as one of Sultan Mas'ud's secretaries and who witnessed the defeat, described what happened:

The lack of water there [near Dandanqan] worried the [Ghaznavid] troops, and they became dismayed and disorderly. The enemy launched a fierce attack from all four sides.... We made strenuous attacks, and we thought that the compact formations of the right and left wings were still intact. We did not know that a detachment of the palace *gholams* [the elite body guards of the Sultan] mounted on camels had dismounted and were stealing the horses from anyone in sight so that they themselves might ride them into battle. This tussle over horses ... became so intense that [our men] started fighting among themselves.^T

As Beyhaqi dryly observed, "the enemy exploited this opportunity," and the Ghaznavid troops were slaughtered. Thereafter the way to the west was open for the Seljuks, who conquered all the way to Anatolia. (See Map 5.1.)

From about the year 1000 to 1900, the Middle East was dominated by peoples of steppe origin, with the Seljuks among the first to arrive. They eventually formed two separate states. To the east, forming a crescent that embraced the southern halves of the Caspian and Aral Seas, was the Great Seljuk sultanate (c. 1040–1194). It encompassed the region now occupied by Uzbekistan, Turkmenistan, Iraq, and Iran. To the west, like a thumb stuck into what had been Byzantine Anatolia, was the Seljuk sultanate of Rum (c.1081–1308). It took its name from those whom it vanquished: Rum means Rome. Although for the West the Seljuk army's humiliating defeat of the Byzantine emperor at Manzikert (today Malazgirt, in Turkey) in 1071 seemed to mark the conquest of Anatolia—and their occupation of Jerusalem (c. 1075) inspired the First Crusade—their real take-over of former Byzantine regions was effected by quieter methods, as Seljuk families moved in, seeking pastureland for their livestock. Like the Vikings, the Seljuks generally traveled as families.

The Seljuk sultanates were staunchly Sunni. They rolled back the Shi'ite wave that had engulfed the Islamic world since the decline of the Abbasids. Nizam al-Mulk (d. 1092), vizier for Alp Arslan and Malikshah I (see Genealogy 5.1) and in many ways de facto ruler himself for the last twenty years of his life, described Shi'ism as a fraud concocted out of pseudo-philosophy and mumbo-jumbo: "obscure words from the language of the imams, mixed up with sayings of the naturalists and utterances of the philosophers, and consisting largely of mention of The Prophet and the angels, the tablet and pen, and heaven and the throne."2 It was a heresy and its followers were dangerous to the state. To counter its influence, he sponsored the foundation of numerous madrasas. As we have seen (see Chapter 4), the Islamic world had always supported elementary schools. The madrasas, normally attached to mosques, went beyond those schools by serving as centers of advanced scholarship. There young men attended lessons in religion, law, and literature. Sometimes visiting scholars arrived to debate in lively public displays of intellectual brilliance. More regularly, teachers and students carried on a quiet regimen of classes on the Qur'an and other texts. Madrasas had existed before the time of Nizam al-Mulk, but he gave them particular priority, hoping that they would fan new life into political, religious, and cultural Sunnism.

While allowing the Abbasid caliphs in Baghdad to maintain their religious role in a city still splendid in material and intellectual resources, the Seljuks shifted the cultural and political centers of the Islamic world to Iran and Anatolia. The strength and wealth of both the Great Seljuk sultanate (based in Iran) and the Seljuk sultanate of Rum (in Anatolia) were made particularly visible in their architecture. Consider the Friday mosque at Isfahan in Iran. First built in the tenth century, it received a major face-lift under Nizam al-Mulk, who focused his patronage on its courtyard, the heart of its many buildings. Nizam al-Mulk added four iwans—vaulted halls open to the courtyard—one at each wall. (See Plate 5.1.) The most important was the south iwan, for that was in the qibla wall the wall facing Mecca. That iwan led in turn to a large square room housing the mihrab (the niche of the qibla), which was topped by a lofty dome. This, too, was built by Nizam al-Mulk. Competing for Nizam's al-Mulk's power, his rival Taj al-Mulk showed off his own importance by building another square domed room on the very same axis as the

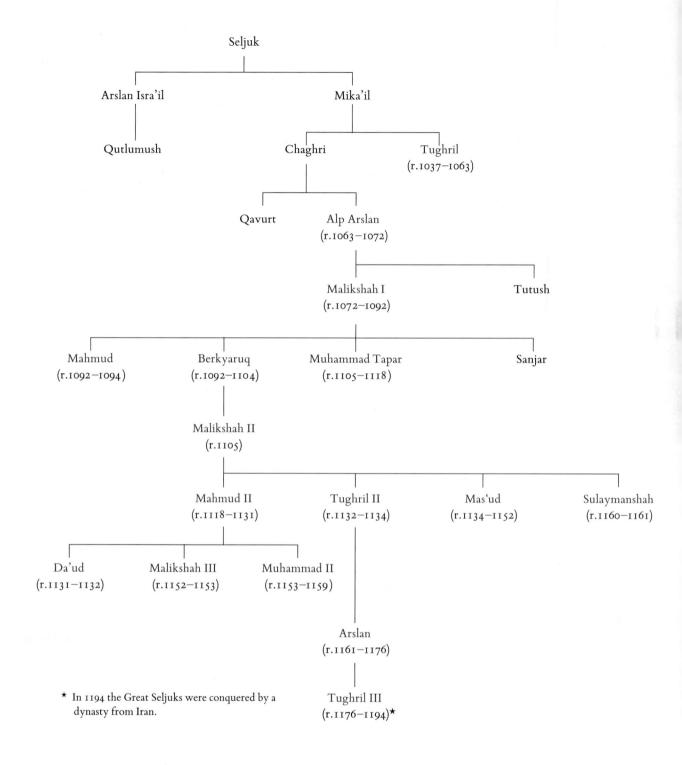

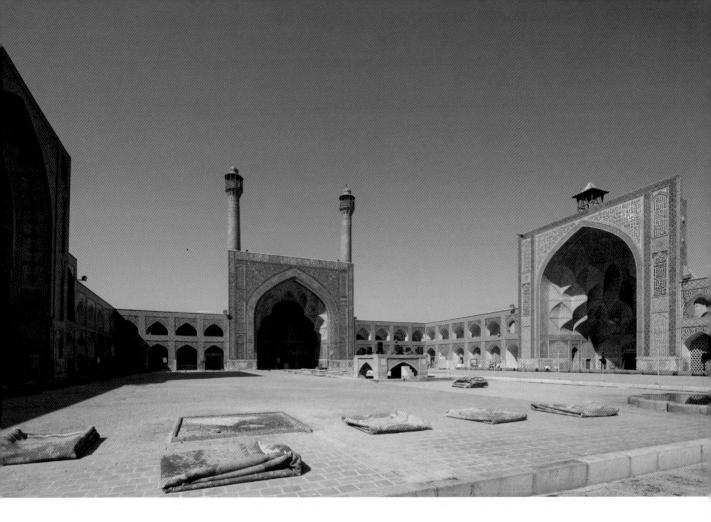

qibla dome, but in his case directly to the north of the courtyard. Less imposing, but more elegant than the southern dome, the northern dome included an inscription dating it to 1088 and named Taj al-Mulk as its donor. (See Plate 5.2.)

There was irony in such lavish expenditure on buildings in a culture originally nomadic. The ruling elite, in particular, was moving away from its roots. Malikshah made Isfahan his capital, far from the original centers of the Seljuk Empire such as Merv. For his part, Nizam al-Mulk cemented his position as virtual ruler by distributing not only money but also land to the army. Even before the time of the Seljuks, rulers had instituted the iqta: something like the European fief, it was a way to pay for military service by giving fighters the right to collect the revenues due from a particular piece of land. Under the Seljuks its use was greatly expanded to pay not only army leaders (emirs), but also bureaucrats and favored members of the dynasty. Like fiefs, *iqtas* were theoretically revocable by the ruler, and, again like fiefs, many iqta holders were able to make them hereditary.

Fortified by their revenues and land grants, the emirs of Iran and Iraq, originally appointed to represent the sultan's power at the local level, broke away from the centralized state. In the course of the twelfth century, in a process of fragmentation similar to the one that undermined the Abbasids, the Great Seljuk Empire fell apart. As under the

Plate 5.1 Isfahan Mosque Courtyard (11th-12th cent.). The courtyard is the heart of this huge and sprawling mosque. In this view to the west, three of the iwans built by Nizam al-Mulk are visible. The bulk of the courtyard is made up of double-decker walls. Each opening leads to an aisle topped by domes.

Genealogy 5.1 (facing page) The Great Seljuk Sultans

Plate 5.2 Isfahan Mosque North Dome (1088). Built according to a precise geometric design, the circular dome sits on a sixteen-sided polygon that rests in turn on an octagon perched on a square base. The design within the dome is equally mathematical, with an oculus in the mid-point of converging triangles. The perfection of this work demonstrates the skill of Seljuk architects.

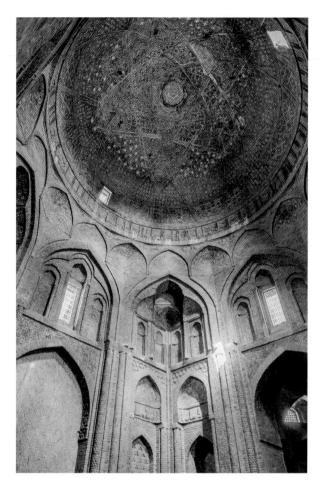

Abbasids, this meant not the end of Seljuk culture and institutions but rather their replication in numerous smaller centers. The decline of the power of the Great Seljuk dynasty did not end the Great Seljuk era.

Meanwhile, the Anatolian branch of the dynasty prospered. It benefitted from the region's silver, copper, iron, and lapis lazuli mines and from the pastureland that supported animal products such as cashmere, highly prized as an export. The Anatolian sultans did not need to give out iqtas; they could pay their soldiers. Even so, Seljuk Anatolia was a sort of "wild west": most houses were made of mud, and the elites did not support the madrasas or the arts and literature as generously as did the rulers of most of the other centers of the Islamic world.

Unlike the Great Seljuk Sultanate, where the main "variety" was to be found in disputing versions of Islam, Anatolia had a significant Christian population. Because the region had been Byzantine before Manzikert, mosques had to be built quickly. (To be sure, the Anatolian Seljuks converted some churches into mosques as well.) At Siirt and elsewhere, the minaret loomed over the landscape (see Plate 5.3). The Shi'ite Fatimids had not built many minarets, but the Seljuks spent lavishly on such towers, asserting in concrete form their adherence to Sunni Islam. However, that adherence did not rule out

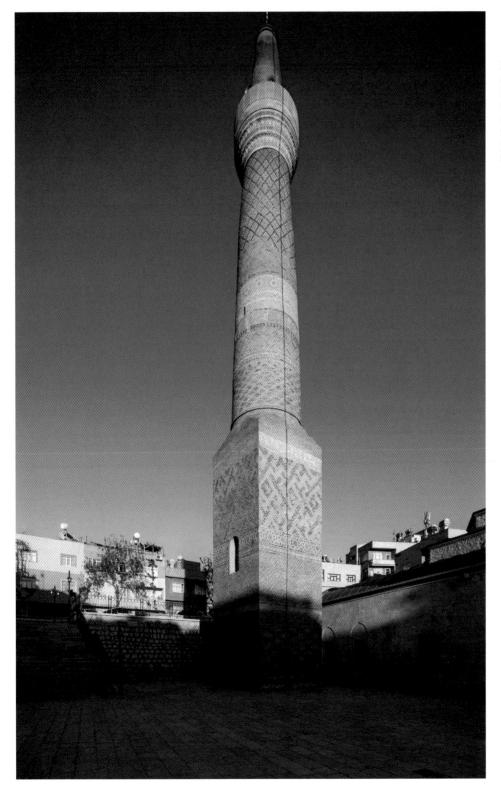

Plate 5.3 Great Mosque Minaret at Siirt (1128/1129?). The minaret has an inscription dating it to 1128/29, but some scholars think it was built a bit later. It is decorated with turquoise tile panels, tiles being a major crafts form of the Seljuks.

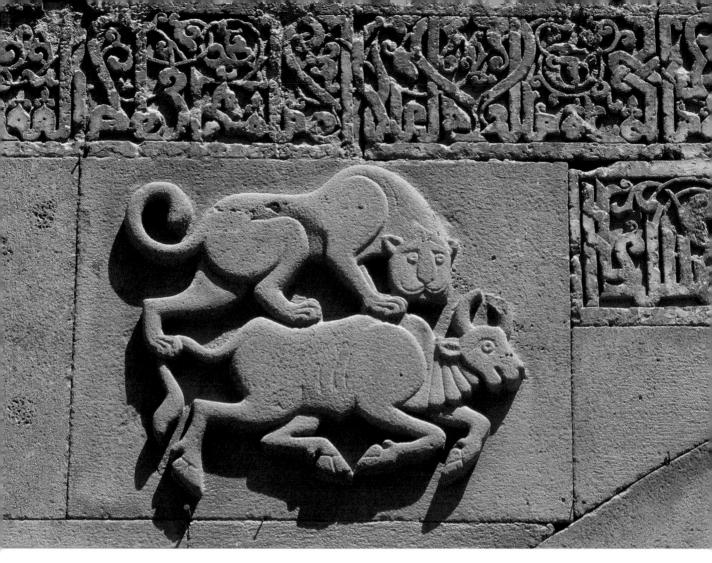

Plate 5.4 Great Mosque at Diyarbakir (1179/1180?). On one of two similar reliefs flanking the portal of the mosque, these fighting animals borrow from Christian church decoration. An inscription near the relief explains that the animals represent the superiority of one local elite dynasty over another.

borrowing from Christian motives. At the Great Mosque in Diyarbakir the unusual portal decoration of a fighting lion and bull betrays the influence of a similar motif on neighboring Georgian and Armenian churches. (See Plate 5.4.)

From Pastoralists to State-Builders

In the western half of the Islamic world, Berber Sanhaja tribesmen from the Sahara Desert forged a state similar to that of the Seljuks. Originally pastoralists who moved from one water source to another with their flocks and tents, they learned Islam from Muslim traders who needed guides and protectors to cross the Sahara. In the 1030s they were inspired by a tribal leader named Yahya ibn Ibrahim and his companions to follow a strict form of Sunni orthodoxy. In addition to adhering rigorously to Qur'anic injunctions, the men (along with the women) wore a veil over the lower part of their faces. Because of this, they were

sometimes called *al-Mulaththamun*—The Veiled Ones. The earliest source for this practice did not connect it with Islam per se, but later sources claimed otherwise. They reported that the Sanhaja had originally lived in Yemen. In order to practice their fledgling monotheism, they were forced to flee to the Sahara with their men disguised as women. Their veils thus demonstrated their devotion to Islam.

Fired with zeal on behalf of their religious beliefs and also seeking economic opportunity, the Sanhaja formed a federation known as the Murabitun (Almoravids) and began conquering the (largely Shiʻite) regions to their north. Making common cause with local Sunni jurists and various tribal notables there, they took over cities bordering on the Sahara in the 1050s and soon had their eyes on the Maghreb. The foundation of their city at Marrakesh c.1070 marked the Almoravid transformation from nomadic tribespeople to settled state. Under their leader, Yusuf ibn Tashfin (d.1106), and members of his

clan, they subdued the Maghreb, taking Tangier in c.1078 and Ceuta in the 1080s.

Because their main goal was to control the African salt and gold trade, the Almoravids were at first not particularly interested in al-Andalus. But the Andalusian taifa rulers kept calling on them to help fight the Christian armies encroaching from the north of Spain. The chief nemesis of these rulers was Christian King Alfonso VI of León and Castile. (He was ruler of León 1065-1109 with a one-year interruption in 1071-72, when his older brother usurped the throne, and was king of Castile 1072-1109.) When Alfonso captured Toledo from its Muslim ruler in 1085, Yusuf ibn Tashfin at last took up the challenge. With Algeciras as the base of their operations, the Almoravids and their allies met Alfonso near Badajoz in 1086 and dealt him a stunning defeat. Dismayed by the taifa leaders' feuding and "lax" form of Islam (in their eyes) the Almoravids

Map 5.2 The Almoravid Empire,

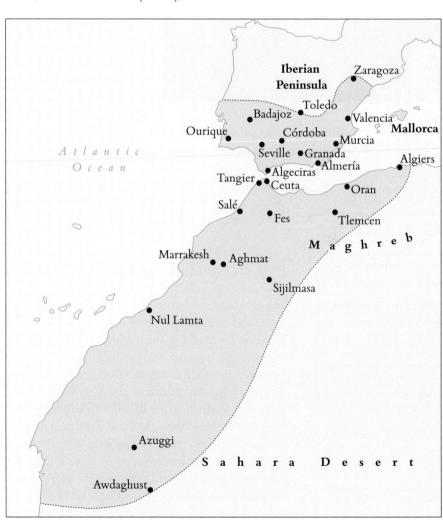

Plate 5.5 Almería Silk (first half of 12th cent.). Although made under the auspices of a Muslim ruler and containing Arabic writing, these silk fragments were used to cover relics of Saint Librada at Sigüenza. They were essential: relics were not ordinarily displayed "naked" but rather were wrapped in costly textiles, preferably made of silk. Every time a relic was moved from one place to another (an event called a "translation"), it had to be covered anew.

soon began to conquer the peninsula on their own behalf. By *c.*1115 all of al-Andalus not yet taken by Christian rulers was under Yusuf ibn Tashfin's control. The gold coin that forms the icon for accessing the Study Questions of this book was one of many gold dinars minted under his rule. The hegemony over the western Islamic world ended only in 1147, with the triumph of the Almohads, a rival Berber group.

The Almoravids thus came to control an empire stretching over 2,000 miles, from today's Ghana to much of Spain. Their wealth and power was mirrored in their crafts. Just as the cashmere of Anatolia had enough cachet to be popular in France, so fine textiles from places like Almoravid al-Andalus were widely distributed. A good example is shown in Plate 5.5. Thickly woven with stunning gold and silk threads, these fragments feature a huge eagle within a roundel interlaced with rosettes. Along the border are lithe catlike animals chasing their curvy tails. Across the eagle's wings are pseudo-Latin inscriptions, while under its talons are blessings in Arabic. The textile's preciousness was appreciated by Alfonso VII of Castile and

León, who seized it when he took Almería in 1147 and held the city for ten years. Carrying it back to his kingdom, he cut it into pieces with which he covered relics that he donated to the cathedral of Sigüenza. Variants on this story could be multiplied. In addition to encasing relics, Christian Europeans used Islamic textiles for elegant garments, dined on Islamic-produced tableware, and decorated their churches with Islamic ceramics.

BYZANTIUM: BLOODIED BUT UNBOWED

The once triumphant empire of Basil II was unable to sustain its successes in the face of Turks and Normans. We have already seen the triumph of the Turks in Anatolia; meanwhile, in the Balkans, the Turkic Pechenegs raided with ease. The Normans, some of whom (as we saw on p. 134) had established themselves in southern Italy, began attacks on Byzantine territory there and conquered its last stronghold, Bari, in 1071. Entering Muslim Sicily in 1060, the Normans conquered it by 1093. Meanwhile, their knights attacked Byzantine territory in the Balkans. (See Map 5.3.) When Norman King Roger II (r.1130–1154) came to the throne, he ruled a realm that ran from southern Italy to Palermo—the Kingdom of Sicily. It was a persistent thorn in Byzantium's side.

Clearly the Byzantine army was no longer very effective. Few themes were still manned with citizen-soldiers, and the emperor's army was also largely composed of mercenaries—Turks and Russians, as had long been the case, and increasingly Normans and Franks as well. But the Byzantines were not entirely dependent on armed force; in

many instances they turned to diplomacy to confront the new invaders. When Emperor Constantine IX (r.1042–1055) was unable to prevent the Pechenegs from entering the Balkans, he shifted policy, welcoming them, administering baptism, conferring titles, and settling them in depopulated regions. Much the same process took place in Anatolia, where the emperors at times welcomed the Turks to help them fight rival *dynatoi*. Here the invaders were occasionally also welcomed by Christians who did not adhere to Byzantine orthodoxy; the Monophysites of Armenia were glad to

have new Turkic overlords. The Byzantine grip on its territories loosened and its frontiers became nebulous, but Byzantium still stood.

There were changes at the imperial court as well. The model of the "public" emperor ruling alone with the aid of a civil service gave way to a less costly, more "familial" model of government. To be sure, for a time competing *dynatoi* families swapped the imperial throne. But Alexius I Comnenus (r.1081–1118), a Dalassenus on his mother's side, managed to bring most of the major families together through a series of marriage alliances. (The Comneni remained on the throne for about a century; see Genealogy 5.2.) Until her death in c.1102, Anna Dalassena, Alexius's mother, held the reins of government while Alexius occupied himself with military matters. At his revamped court, which he moved to the Blachernai palace, at the northwestern tip of the city (see Map 4.1 on p. 114), his relatives held the highest positions. Many of them received *pronoiai* (sing. *pronoia*), temporary grants of imperial lands that they administered and profited from. Just as the Seljuks turned to the *iqta* and the Europeans to the fief, so the Byzantines resorted to land grants rather than salaries.

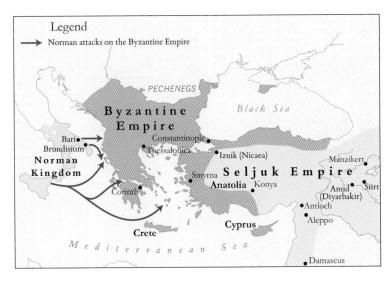

Map 5.3 Byzantium, 12th cent.

Genealogy 5.2 The Comnenian Dynasty

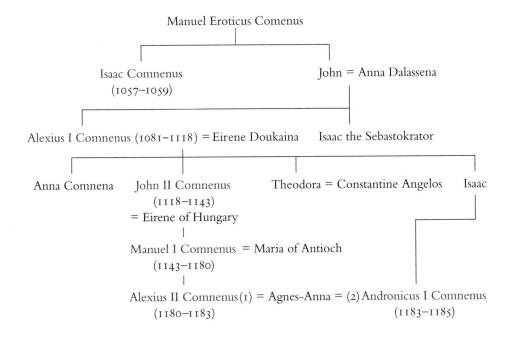

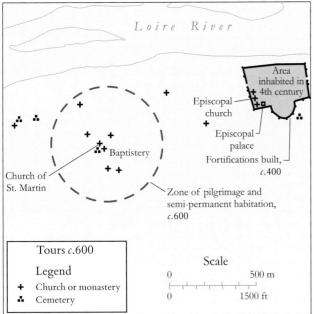

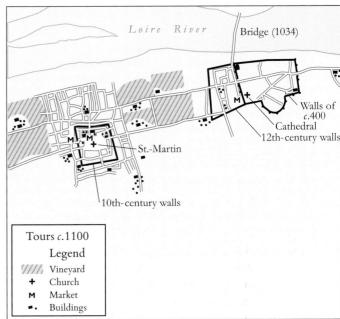

Map 5.4 Tours *c*.600 vs. Tours *c*.1100

In general, Byzantine rulers were becoming more like their European counterparts, holding a relatively small amount of territory, handing some of it out in grants, spending most of their time in battle to secure a stronghold here, a city there. Meanwhile, Western rulers were becoming less regional in focus, encroaching on Byzantine territory and (as we shall see) attacking the Islamic world as well.

THE QUICKENING OF THE EUROPEAN ECONOMY

The Norman take-over of Sicily and attacks on Byzantium were symptoms of European expansion, as were new economic developments. Draining marshes, felling trees, building dikes: this was the backbreaking work that brought new land into cultivation. With their heavy, horse-drawn plows, peasants were able to reap greater harvests; using the three-field system, they raised more varieties of crops. Great landowners, the same "oppressors" against whom the Peace of God fulminated (see p. 139), could also be efficient economic organizers. They set up mills to grind grain, forced their tenants to use them, and then charged a fee for the service. They wanted peasants to produce as much grain as possible. Some landlords gave peasants special privileges to settle on especially inhospitable land: the bishop of Hamburg was generous to those who came from Holland to work soil that was, as he admitted "uncultivated, marshy, and useless."

As the countryside became more productive, people became healthier, their fertility increased, and there were more mouths to feed. Even so, surprising surpluses made possible the growth of old and the creation of new urban centers. Within a generation or two,

city dwellers, intensely conscious of their common goals, elaborated new instruments of commerce, self-regulating organizations, and forms of self-government.

Towns and Cities

Around castles and monasteries in the countryside or at the walls of crumbling ancient towns, merchants came with their wares and artisans set up shop. At Bruges, it was the local lord's castle that served as a magnet. Churches and monasteries were the other centers of town growth. Recall Tours as it had looked in the early seventh century, with its semipermanent settlements around the church of Saint-Martin, out in the cemetery, and its lonely cathedral nestling against one of the ancient walls. By the twelfth century, Saint-Martin was a monastery, the hub of a small town dense enough to boast eleven parish churches, merchant and artisan shops, private houses, and two markets. To the east, the episcopal complex was no longer alone: a market had sprung up outside the old western wall, and private houses lined the street leading to the bridge. Smaller than the town around Saint-Martin, the one at the foot of the old city had only two parish churches, but it was big and rich enough to warrant the construction of a new set of walls to protect it. (See Map 5.4.)

Early cities developed without prior planning, but some later ones were "chartered," that is, declared, surveyed, and plotted out. A marketplace and merchant settlement were already in place at Freiburg im Breisgau when the duke of Zähringen chartered it, promising each new settler there a house lot of 5,000 square feet for a very small yearly rent. The duke had fair hopes that commerce would flourish right at his back door and yield him rich revenues.

The look and feel of medieval cities varied immensely from place to place. Nearly all included a marketplace, a castle, and several churches. Most were ringed by walls. Within the walls lay a network of streets—narrow, dirty, dark, smelly, and winding—made of packed clay or gravel. Most cities were situated near waterways and had bridges; the bridge at Tours was built in the 1030s. Many had to adapt to increasingly crowded conditions. At the end of the eleventh century in Winchester, England, city plots were still large enough to accommodate houses parallel to the street; but soon those houses had to be torn down to make way for narrow ones, built at right angles to the roadway. The houses at Winchester were made of wattle and daub—twigs woven together and covered with clay. If they were like the stone houses built in the late twelfth century (about which we know a good deal), they had two stories: a shop or warehouse on the lower floor and living quarters above. Behind this main building were the kitchen, enclosures for livestock, and a garden. Even city dwellers clung to rural pursuits, raising much of their food themselves.

Although commercial centers developed throughout Western Europe, they grew fastest and most densely in regions along key waterways: the Mediterranean coasts of Italy, France, and Spain; northern Italy along the Po River; the river system of the Rhône-Saône-Meuse; the Rhineland; the English Channel; the shores of the Baltic Sea. During

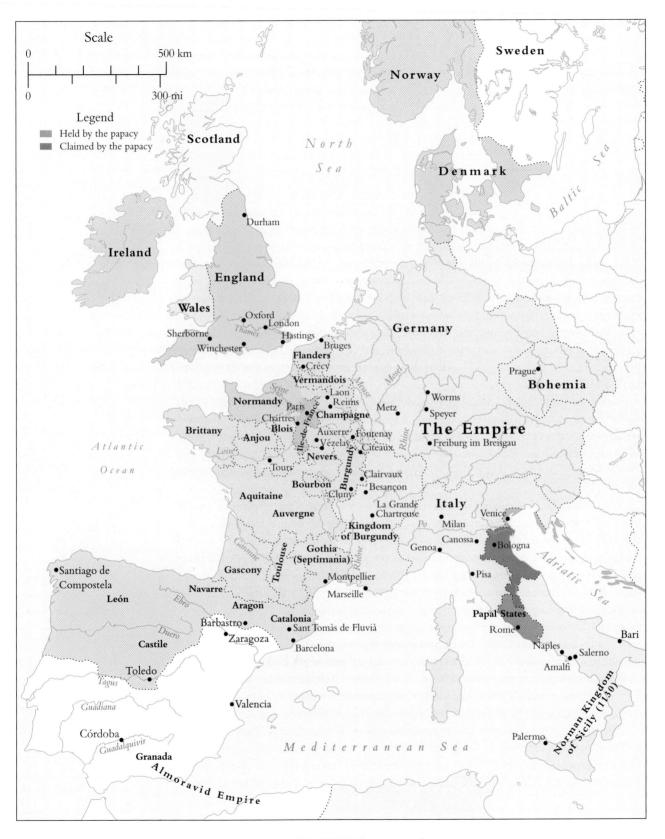

174 FIVE: NEW CONFIGURATIONS (c.1050-c.1150)

Map 5.5 (facing page) Western Europe, c.1100

the eleventh and twelfth centuries, these waterways became part of a single, interdependent economy. At the same time, new roads through the countryside linked urban centers to rural districts and stimulated the growth of fairs (regular, short-term, often lively markets). (See Map 5.5.)

Business Arrangements

The revival of urban life and the expansion of trade, together dubbed the "commercial revolution" by historians, was sustained and invigorated by merchants. They were a varied lot. Some were local traders, such as one monk who supervised a manor twenty miles south of his monastery and sold its surplus horses and grain at a local market. Others—often Jews and Italians—were long-distance traders, much in demand because they supplied fine wines, spices, and fabrics to the aristocracy. Some Jews had long been involved at least part time in long-distance trade as vintners. In the eleventh century, more Jews swelled their ranks when lords reorganized the countryside and drove out the Jewish landowners, forcing them into commerce and urban trades full time.

Other long-distance traders came from Italy. The key players were from Genoa, Pisa, Amalfi, and Venice. Regular merchants at Constantinople, their settlements were strung like pearls along the Golden Horn (see Map 4.1 on p. 114). Italian traders found the Islamic world nearly as lucrative as the Byzantine. Establishing bases at ports such as Tunis, they imported Islamic wares—ceramics, textiles, metalwork—into Europe. In turn, Western traders exported wood, iron, and woolen cloth to the East.

Merchants invented new forms of collective enterprises to pool their resources and finance large undertakings. A cloth industry began, powered by water mills. New deepmining technologies provided Europeans with hitherto untapped sources of metals. Forging techniques improved, and iron was for the first time regularly used for agricultural tools and plows, enhancing food production. Beer, a major source of nutrition in the north of Europe, moved from the domestic hearth and monastic estates to urban centers, where brewers gained special privileges to ply their trade.

Brewers, like other urban artisans, had their own guild. Whether driven by machines or handwork, the new economy was sustained by such guilds, which regulated and protected professionals ranging from merchants and financiers to shoemakers. In these social, religious, and economic associations, members prayed for and buried one another. Craft guilds agreed on quality standards for their products and defined work hours, materials, and prices. Merchant guilds regulated business arrangements, weights and measures, and (like the craft guilds) prices. Guilds guaranteed their members—mostly male, except in a few professions—a place in the market. They represented the social and economic counterpart to urban walls, giving their members protection, shared identity, and recognized status.

The political counterpart of the walls was the "commune"—town self-government. City dwellers—keenly aware of their special identity in a world dominated by knights and peasants—recognized their mutual interest in reliable coinage, laws to facilitate commerce,

freedom from servile dues and services, and independence to buy and sell as the market dictated. They petitioned the political powers that ruled them—bishops, kings, counts, castellans, dukes—for the right to govern themselves.

Collective movements for urban self-government were especially prevalent in Italy, France, and Germany. Already Italy's political life was city-centered; communes there were attempts to substitute the power of one group (the citizens) for another (the nobles and bishops). At Milan in the second half of the eleventh century, for example, popular discontent with the archbishop, who effectively ruled the city, led to numerous armed clashes that ended, in 1097, with the transfer of power from the archbishop to a government of leading men of the city. Outside Italy movements for urban independence—sometimes violent, as at Milan, while at other times peaceful—often took place within a larger political framework. For example, King Henry I of England (r.1100—1135) freed the citizens of London from numerous customary taxes while granting them the right to "appoint as sheriff from themselves whomsoever they may choose, and [they] shall appoint from among themselves as justice whomsoever they choose to look after the pleas of my crown." The king's law still stood, but it was to be carried out by the Londoners' officials.

CHURCH REFORM AND ITS AFTERMATH

Disillusioned citizens at Milan denounced their archbishop not only for his tyranny but also for his impurity; they wanted their pastors to be untainted by sex and money. In this they were supported by a new-style papacy, keen on reform in the church and society. The "Gregorian Reform," as modern historians call this movement, broke up clerical marriages, unleashed civil war in Germany, changed the procedure for episcopal elections, and transformed the papacy into a monarchy. It began as a way to free the church from the world, but in the end the church was deeply involved in the new world it had helped to create.

The Coming of Reform

Free the church from the world: what could that mean? In 910 the duke and duchess of Aquitaine founded the monastery of Cluny with some unusual stipulations. (For all the places involved here, see Map 5.5.) They endowed the monastery with property (normal and essential if it were to survive), but then they gave it and its worldly possessions to Saints Peter and Paul. In this way, they put control of the monastery into the hands of the two most powerful heavenly saints. They designated the pope, as the successor of Saint Peter, to be the monastery's worldly protector if anyone should bother or threaten it. But even the pope had no right to infringe on its freedom: "From this day," the duke wrote,

those same monks there congregated shall be subject neither to our yoke, nor to that of our relatives, nor to the sway of any earthly power. And, through God and all his saints, and by the awful day of judgment, I warn and abjure that no one of the secular princes, no count, no bishop whatever, not the pontiff of the aforesaid Roman see, shall invade the property of these servants of God, or alienate it, or diminish it, or exchange it, or give it as a benefice to any one, or constitute any prelate over them against their will.⁵

Cluny's prestige was great because of the influence of its founders, the status of Saint Peter, and the fame of the monastery's elaborate round of prayers. The Cluniac monks fulfilled the role of "those who pray" in dazzling manner. Through their prayers, they seemed to guarantee the salvation of all Christians. Rulers, bishops, rich landowners, and even serfs (if they could) gave Cluny donations of land, joining their contributions to the land of Saint Peter. Powerful men and women called on the Cluniac abbots to reform new monasteries along the Cluniac model.

The abbots of Cluny came to see themselves as reformers of the world as well as the cloister. They believed in clerical celibacy, preaching against the prevailing norm in which parish priests and even bishops were married. They also thought that the laity could be reformed, become more virtuous, and cease its oppression of the poor. In the eleventh century, the Cluniacs began to link their program to the papacy. When they disputed with bishops or laypeople about lands and rights, they called on the popes to help them out.

The popes were ready to do so. A parallel movement for reform had entered papal circles via a small group of influential monks and clerics. Mining canon (church) law for their ammunition, these churchmen emphasized two abuses: nicolaitism (clerical marriage) and simony (buying church offices). Why were these two singled out? Married clerics were considered less "pure" than those who were celibate; furthermore, their heirs might claim church property. As for simony: the new profit economy sensitized reformers to the crass commercial meanings of gifts; in their eyes, gifts given or received by churchmen for their offices or clerical duties were attempts to purchase the Holy Spirit.

Initially, the reformers got imperial backing. German king and emperor Henry III (r.1039–1056) thought that, as the anointed of God, he was responsible for the well-being of the church in the empire. (For Henry and his dynasty, see Genealogy 5.3.) Henry denounced simony and personally refused to accept money or gifts when he appointed bishops to their posts. He presided over the Synod of Sutri (1046), which deposed three papal rivals and elected another. When that pope and his successor died, Henry appointed Bruno of Toul, a member of the royal family, seasoned courtier, and reforming bishop. Taking the name Leo IX (1049–1054), the new pope surprised his patron: he set out to reform the church under papal, not imperial, control.

Leo revolutionized the papacy. He had himself elected by the "clergy and people" to satisfy the demands of canon law. Unlike earlier popes, he often left Rome to preside over church councils and make the pope's influence felt outside Italy, especially in France and Germany. Leo brought to the papal curia the most zealous church reformers of his

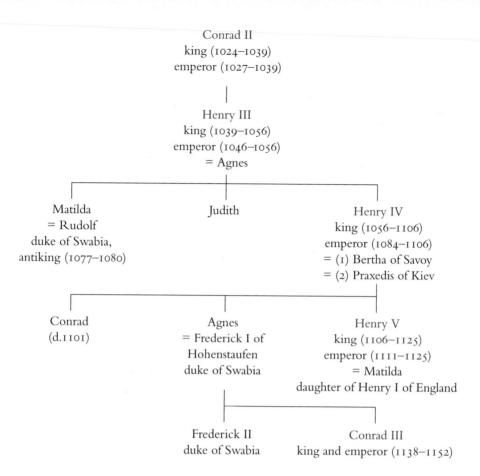

Genealogy 5.3 The Salian Kings and Emperors

day: Peter Damian, Hildebrand of Soana (later Pope Gregory VII), and Humbert of Silva Candida. They put new stress on the passage in Matthew's Gospel (Matt. 16:19) in which Christ tells Peter that he is the "rock" of the church, with the keys to heaven and the power to bind (impose penance) and loose (absolve from sins). As the successor to the special privileges of Saint Peter, the Roman church, headed by the pope, was said to be "head and mother of all churches." What historians call the doctrine of "papal supremacy" was thus announced.

Its impact was soon felt at Byzantium. On a mission at Constantinople in 1054 to forge an alliance with the emperor against the Normans and, at the same time, to "remind" the patriarch of his place in the church hierarchy, Humbert ended by excommunicating the patriarch and his followers. In retaliation, the patriarch excommunicated Humbert and his fellow legates. Clashes between the Roman and Byzantine churches had occurred before and had been patched up, but this one, though not recognized as such at the time, marked a permanent schism. After 1054, the Roman Catholic and Greek Orthodox churches largely went their separate ways.

More generally, the papacy began to wield new forms of power. It waged unsuccessful war against the Normans in southern Italy and then made the best of the situation by

granting them parts of the region—and Sicily as well—as a fief, turning former enemies into vassals. It supported the Christian push into the *taifas* of al-Andalus, transforming the "*reconquista*"—the conquest of Islamic Spain—into a holy war: Pope Alexander II (1061–1073) forgave the sins of the Christians on their way to the battle of Barbastro (see Map 5.5 on p. 174).

The Investiture Conflict and Its Effects

The papal reform movement is associated particularly with Pope Gregory VII (1073–1085), hence the term "Gregorian Reform." A passionate advocate of papal primacy (the theory that the pope is the head of the church), Gregory was not afraid to clash directly with the king of Germany, Henry IV (r.1056–1106), over church leadership. In Gregory's view—an astonishing one at the time, given the religious and spiritual roles associated with rulers—kings and emperors were simple laymen who had no right to meddle in church affairs. Henry, on the other hand, brought up in the traditions of his father, Henry III, considered it part of his duty to appoint bishops and even popes to ensure the well-being of church and empire together.

The pope and the king first collided over the appointment of the archbishop of Milan. Gregory disputed Henry's right to "invest" the archbishop (i.e., put him into his office). In the investiture ritual, the emperor or his representative symbolically gave the church and the land that went with it to the bishop or archbishop chosen for the job. In the case of Milan, two rival candidates for archiepiscopal office (one supported by the pope, the other by the emperor) had been at loggerheads for several years when, in 1075, Henry invested his own candidate. Gregory immediately called on Henry to "give more respectful attention to the master of the Church," namely Peter and his living representative—Gregory himself. In reply, Henry and the German bishops called on Gregory, that "false monk," to resign. This was the beginning of what historians delicately call the "Investiture Conflict" or "Investiture Controversy." In fact it was war. In February 1076, Gregory called a synod that both excommunicated Henry and suspended him from office:

I deprive King Henry [IV], son of the emperor Henry [III], who has rebelled against [God's] Church with unheard-of audacity, of the government over the whole kingdom of Germany and Italy, and I release all Christian men from the allegiance which they have sworn or may swear to him, and I forbid anyone to serve him as king.⁸

The last part of this decree gave it real punch: anyone in Henry's kingdom could rebel against him. The German "princes"—the aristocrats—seized the moment and threatened to elect another king. They were motivated partly by religious sentiments—many had established links with the papacy through their support of reformed monasteries—and partly by political opportunism, as they had chafed under strong German kings

who had tried to keep their power in check. Some bishops, too, joined with Gregory's supporters, a major blow to Henry, who needed the troops that they supplied.

Attacked from all sides, Henry traveled in the winter of 1077 to intercept Gregory, barricaded in a fortress at Canossa, high in the Apennine Mountains. It was a refuge provided by the staunchest of papal supporters, Countess Matilda of Tuscany. In an astute and dramatic gesture, the king stood outside the castle (in cold and snow) for three days, barefoot, as a penitent. Gregory was forced, as a pastor, to lift his excommunication and to receive Henry back into the church, precisely as Henry intended. For his part, the pope had the satisfaction of seeing the king humiliate himself before the papal majesty. Although it made a great impression on contemporaries, the whole episode solved nothing. The princes elected an antiking, the emperor an antipope, and bloody civil war continued intermittently until 1122.

The Investiture Conflict ended with a compromise. The Concordat of Worms (1122) relied on a conceptual distinction between two parts of investiture—the spiritual (in which the bishop-to-be received the symbols of his office) and the secular (in which he received the symbols of the material goods that would allow him to function). Under the terms of the Concordat, the ring and staff, symbols of church office, would be given by a churchman in the first part of the ceremony. Then the emperor or his representative would touch the bishop with a scepter, signifying the land and other possessions that went with his office. Elections of bishops in Germany would take place "in the presence" of the emperor—that is, under his influence. In Italy, the pope would have a comparable role.

In the end, then, secular rulers continued to matter in the appointment of churchmen. But just as the new investiture ceremony broke the ritual into spiritual and secular halves, so too did it imply a new notion of kingship separate from the priesthood. The Investiture Conflict did not produce the modern distinction between church and state—that would develop only very slowly—but it set the wheels in motion. At the time, its most important consequence was to shatter the delicate balance between political and ecclesiastical powers in Germany and Italy. In Germany, the princes consolidated their lands and powers at the expense of the king. In Italy, the communes came closer to their goals: it was no accident that Milan gained its independence in 1097. And everywhere the papacy gained new authority: it had become a "papal monarchy."

Papal influence was felt at every level. At the general level of canon law, papal primacy was enhanced by the publication c.1140 of the Decretum, written by a teacher of canon law named Gratian. Collecting nearly two thousand passages from the decrees of popes and councils as well as the writings of the Church Fathers, Gratian set out to demonstrate their essential agreement. In fact, the book's original title was Harmony of Discordant Canons. If he found any "discord" in his sources, Gratian usually imposed the harmony himself by arguing that the conflicting passages dealt with different situations. A bit later another legal scholar revised and expanded the Decretum, adding Roman law to the mix. At a more local level, papal denunciations of married clergy made inroads on family life. At Verona, for example, "sons of priests" disappeared from the historical record in the twelfth century. At the mundane level of administration, the papal claim to head the church helped turn

the curia at Rome into a kind of monarchy, complete with its own territory, bureaucracy, collection agencies, and law courts. It was the teeming port of call for litigious churchmen disputing appointments and for petitioners of every sort.

The First Crusade

On the military level, the papacy's proclamations of holy wars led to bloody slaughter, tragic loss, and tidy profit. We have already seen how Alexander II encouraged the reconquista in Spain; it was in the wake of his call that the taifa rulers implored the Almoravids for help. An oddly similar chain of events took place at the other end of the Islamic world. Ostensibly responding to a request from the Byzantine emperor Alexius for mercenaries to help retake Anatolia from the Seljuks, Pope Urban II (1088-1099) turned the enterprise into something new: a pious pilgrimage to the Holy Land to be undertaken by an armed militia—one commissioned like those of the Peace of God, but thousands of times larger—under the leadership of the papacy: "Let your quarrels end, let wars cease, and let all dissensions and controversies slumber. Enter upon the road to the Holy Sepulcher; wrest that land from the wicked race, and subject it to yourselves."9

The event that historians call the First Crusade (1096–1099) mobilized a force of some 100,000 people, including warriors, old men, bishops, priests, women, children, and hangers-on. The armies were organized not as one military force but rather as separate militias, each authorized by the pope and commanded by a different leader.

Several motley bands were not authorized by the pope. Though called collectively the "Peasants' (or People's) Crusade," these irregular armies included nobles. They were inspired by popular preachers, especially the eloquent Peter the Hermit, who was described by chroniclers as small, ugly, barefoot, and—partly because of those very characteristics utterly captivating. Starting out before the other armies, the Peasants' Crusade took a route to the Holy Land through the Rhineland in Germany.

This indirect route was no mistake. The crusaders were looking for "wicked races" closer to home: the Jews. Under Henry IV many Jews had gained a stable place within the cities of Germany, particularly along the Rhine River. The Jews received protection from the local bishops (who were imperial appointees) in return for paying a tax. Living in their own neighborhoods, the Jews valued their tightly knit communities focused on the synagogue, which was a school and community center as well as a place of worship. Nevertheless, Jews also participated in the life of the larger Christian community. For example, Archbishop Anno of Cologne made use of the services of the Jewish moneylenders in his city, and other Jews in Cologne were allowed to trade their wares at the fairs there.

Although officials pronounced against the Jews from time to time, and although Jews were occasionally (temporarily) expelled from some Rhineland cities, they were not persecuted systematically until the First Crusade. Then the Peasants' Crusade, joined by some local nobles and militias from the region, threatened the Jews with forced conversion

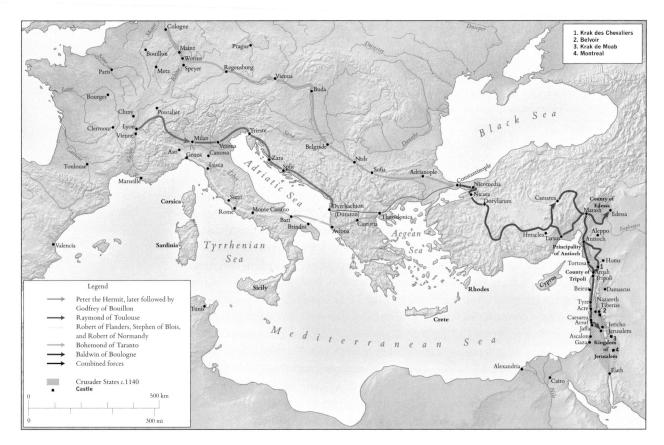

Map 5.6 The First Crusade and Early Crusader States

or death. Some relented when the Jews paid them money; others, however, attacked. Beleaguered Jews occasionally found refuge with bishops or in the houses of Christian friends, but in many cities—Metz, Speyer, Worms, Mainz, and Cologne—they were massacred. Leaving the Rhineland, some of the irregular militias disbanded, while others sought to gain the Holy Land via Hungary, at least one stopping off at Prague to massacre more Jews there. Only a handful of these armies continued on to Anatolia, where most of them were quickly slaughtered.

From the point of view of Emperor Alexius at Constantinople, even the "official" crusaders were problematic. One of the crusade's leaders, the Norman warrior Bohemond, had, a few years before, tried to conquer Byzantium itself. Alexius got most of the leaders to swear that if they conquered any land previously held by the Byzantines, they would restore them; and if they conquered new regions, they would hold them from Alexius as their overlord. Then he shipped the armies across the Bosporus. (For the various armies and their routes, see Map 5.6).

The main objective of the First Crusade—to conquer the Holy Land—was accomplished largely because of the disunity of the Islamic world and its failure to consider the crusade a serious military threat. Spared by the Turks when they first arrived in Anatolia, the crusaders' armies were initially uncoordinated and their food supplies uncertain, but soon they organized themselves, setting up a "council of princes" that included all the great crusade leaders, while the Byzantines supplied food at a nearby port. Surrounding

Iznik (Nicaea) and besieging it with catapults and other war machines, the crusaders, along with a small Byzantine contingent, took the city on June 19, 1097. The city surrendered directly to Alexius, who rewarded the crusaders amply but also insisted that any leader who had not yet taken the oath to him do so.

However, the crusaders soon forgot their promise to the Byzantines. While most went toward Antioch, which stood in the way of their conquest of Jerusalem, one leader went off to Edessa, where he took over the city and its outlying area, creating the first of the Crusader States: the County of Edessa. Meanwhile the other crusaders remained stymied before the thick and heavily fortified walls of Antioch for many months. Then, in a surprise turn-around, they entered the town but found themselves besieged by Muslim armies from the outside. Their mood grim, they rallied when a peasant named Peter Bartholomew reported that he had seen in many visions the Holy Lance that had pierced Christ's body—it was, he said, buried right in the main church in Antioch. (Antioch had a flourishing Christian population even under Muslim rule.) After a night of feverish digging, the crusaders believed that they had discovered the Holy Lance, and, fortified by this miracle, they defeated the besiegers. "[At Antioch,] the number of men, women, and children killed, taken prisoner, and enslaved from its population is beyond computation. About three thousand men fled to the citadel and fortified themselves in it, and some few escaped for whom God had decreed escape," wrote a Muslim chronicler looking back on the event some fifty years later.10

From Antioch, it was only a short march to Jerusalem, though disputes among the leaders delayed that next step for over a year. One leader claimed Antioch. Another eventually took charge—provisionally—of the expedition to Jerusalem. His way was eased by quarrels among Muslim rulers, and an alliance with one of them allowed free passage through what would have been enemy territory. In early June 1099, a large crusading force amassed before the walls of Jerusalem and set to work to build siege engines." In mid-July they attacked, breaching the walls and entering the city. Jerusalem was now in the hands of the crusaders.

RULERS WITH CLOUT

While the papacy was turning into a monarchy, other rulers were beginning to turn their territories into states. They discovered ideologies to justify their hegemony, hired officials to work for them, and found vassals and churchmen to support them. Some of these rulers were women.

The Crusader States

In the Holy Land, the leaders of the crusade set up four tiny states, European colonies in the Levant. Two (Tripoli and Edessa) were counties, Antioch was a principality, Jerusalem a kingdom. (See Map 5.6 again.) The region was habituated to multi-ethnic and multi-religious territories ruled by a military elite; apart from the religion of that elite, the Crusader States were no exception. Yet, however much they engaged with their neighbors, the Europeans in the Levant saw themselves as a world apart, holding on to their western identity through their political institutions and the old vocabulary of homage, fealty, and Christianity.

The states won during the First Crusade lasted—tenuously—until 1291, though many new crusades had to be called in the interval to shore them up. Created by conquest, these states were treated as lordships. The new rulers carved out estates to give as fiefs to their vassals, who, in turn, gave portions of their holdings in fief to their own men. The peasants continued to work the land as before, and commerce boomed as the new rulers encouraged lively trade at their coastal ports. Italian merchants—the Genoese, Pisans, and Venetians—were the most active, but others—Byzantines and Muslim traders—participated as well. Enlightened lordship dictated that the mixed population of the states—Muslims, to be sure, but also Jews, Greek Orthodox Christians, Monophysite Christians, and others—be tolerated for the sake of production and trade. Most Europeans had gone home after the First Crusade; those left behind were obliged to coexist with the inhabitants that remained. Eastern and Western Christians learned to share shrines, priests, and favorite monastic charities, and when they came to blows, the violence tended to be local and sporadic.

The main concerns of the crusader states' rulers were military, and these could be guaranteed as well by a woman as by a man. Thus Melisende (r.1131–1152), oldest daughter of King Baldwin II of Jerusalem, was declared ruler along with her husband, Fulk, formerly count of Anjou, and their infant son. Taking the reins of government into her own hands after Fulk's death, she named a constable to lead her army and made sure that the greatest men in the kingdom sent her their vassals to do military service. Vigorously asserting her position as queen, she found supporters in the church, appointed at least one bishop to his see, and created her own chancery, where her royal acts were drawn up.

But vassals alone, however well commanded, were not sufficient to defend the fragile Crusader States, nor were the stone castles and towers that bristled in the countryside. Knights had to be recruited from Europe from time to time, and a new and militant kind of monasticism developed in the Levant: the Knights Templar. Vowed to poverty and chastity, the Templars devoted themselves to war at the same time. They defended the town garrisons of the Crusader States and ferried money from Europe to the Holy Land. Even so, they could not prevent Zangi, a Seljuk emir, from taking Edessa in 1144. The slow but steady shrinking of the Crusader States began at that moment. The Second Crusade (1147–1149), called in the wake of Zangi's victory, came to a disastrous end. After only four days of besieging the walls of Damascus, the crusaders, whose leaders could not keep the peace among themselves, gave up and went home.

England under Norman Rule

A more long-lasting conquest took place in England. England had been linked to the Continent by the Vikings, who settled in its eastern half, and in the eleventh century it had been further tied to Scandinavia under the rule of Cnut (see above, p. 143). Nevertheless, the country was drawn inextricably into the Continental orbit only with the conquest of Duke William of Normandy (d.1087). (See Map 5.7.)

When William left his duchy with a large army in the autumn of 1066 to dispute the crown of the childless King Edward the Confessor (r.1042–1066), who had died earlier that year, he carried a papal banner, symbol of the pope's support. Opposing his claim were Harald Hardrada, king of Norway, and Harold Godwineson, Edward's brother-in-law, earl of Wessex, and crowned king of England the day after Edward's death. At Stamford Bridge, Harold

defeated the Norwegian king and then wheeled his army around to confront William at Hastings. That one-day battle was decisive, and William was crowned the first Norman king of England. (See Genealogy 5.4.) Treating his conquest like booty (as the crusader leaders would do a few decades later in the Levant), William kept about 20 per cent of the land for himself and divided the rest, distributing it in large but scattered fiefs to a relatively small number of his barons—his elite followers—and family members, lay and ecclesiastical, as well as to some lesser men, such as personal servants and soldiers. In turn, these men maintained their own vassals. They owed the king military service along with the service of a fixed number of their vassals; and they paid him certain dues, such as reliefs (money paid upon inheriting a fief) and aids (payments made on important occasions).

The king also collected land taxes. To know what was owed him, in 1086 William ordered a survey of the land and landholders of England. His officials consulted Anglo-Saxon tax lists and took testimony from local jurors, who were sworn to answer a series of formal questions truthfully. Compilers standardized the materials and organized them by county. Consider, by way of example, the entry for the manor of Diddington:

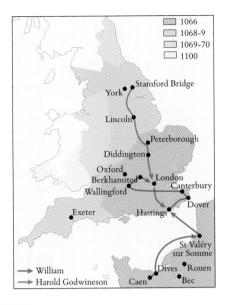

Map 5.7 The Norman Invasion of England, 1066–1100

Genealogy 5.4 The Norman Kings of England

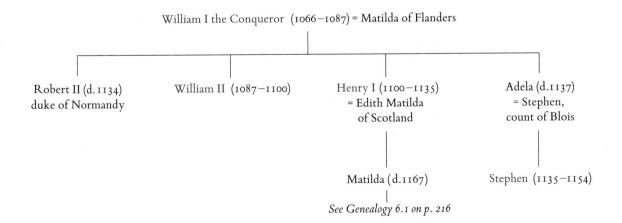

the Bishop of Lincoln had $2\frac{1}{2}$ hides to the geld. [There is] land for 2 ploughs. There are now 2 ploughs in demesne; and 5 villans having 2 ploughs. There is a church, and 18 acres of meadow, [and] woodland pasture half a league long and a half broad. TRE worth 60s; now 70s. William holds it of the bishop. 12

The hides were units of tax assessment; the ploughs and acres were units of area, while the leagues were units of length; the villans were one type of peasant (there were many kinds); and the abbreviation TRE meant "in the time of King Edward." Anyone consulting the survey would know that the manor of Diddington was now worth more than it had been TRE. As for the William mentioned here: he was not William the Conqueror but rather a vassal of the bishop of Lincoln. No wonder the survey was soon dubbed "Domesday Book": like the records of people judged at doomsday, it provided facts that could not be appealed. Domesday was the most extensive inventory of land, livestock, taxes, and people that had as yet been compiled anywhere in medieval Europe.

Communication with the Continent was constant. The Norman barons spoke a brand of French; they talked more easily with the peasants of Normandy (if they bothered) than with those tilling the land in England. They maintained their estates on the Continent and their ties with its politics, institutions, and culture. English wool was sent to Flanders to be turned into cloth. The most brilliant intellect of his day, Saint Anselm of Bec (or Canterbury; 1033–1109), was born in Italy, became abbot of a Norman monastery, and was then appointed archbishop in England. English adolescent boys were sent to Paris and Chartres for schooling. The kings of England often spent more time on the Continent than they did on the island. When, on the death of William's son, King Henry I (r.1100–1135), no male descendent survived to take the throne, two counts from the Continent—Geoffrey of Anjou and Stephen of Blois—disputed it as their right through two rival females of the royal line. (See Genealogy 5.4 again.)

Christian Spain and Portugal

While initially the product of defeat, the Christian strip of northern Iberia in the eleventh and twelfth centuries turned the tables and became, in effect, the successful western counterpart of the Crusader States. The disintegration of al-Andalus into *taifas* opened up immense opportunities for the Spanish princes to the north. Wealth flowed into their coffers not only from plundering raids and the confiscation of lands and cities but also (until the Almoravids put an end to it) from tribute, paid in gold by *taifa* rulers—weak and disunited among themselves—to stave off attacks.

But it was not just the princes who were enriched. When Rodrigo Díaz de Vivar, the Cid (from the Arabic *sidi*, lord), fell out of favor with his lord, Alfonso VI, king of Castile and León, he and a band of followers found employment with al-Mutamin, ruler of Zaragoza. There he defended the city against Christian and Muslim invaders alike. In 1090, he struck out on his own, taking his chances in Valencia, conquering it in 1094 and ruling

there until his death in 1099. He was a Spaniard, but other opportunistic armies sometimes came from elsewhere. Pope Alexander II's call to besiege Barbastro in 1064 appealed to warriors from France.

The French connection was symptomatic of a wider process: the Europeanization of Spain. Initially the Christian kingdoms had been isolated islands of Visigothic culture. But already in the tenth century, pilgrims from France, England, Germany, and Italy were clogging the roads to the shrine of Saint James (Santiago de Compostela); in the eleventh century, monks from Cluny and other reformed monasteries arrived to colonize Spanish cloisters. Alfonso VI actively reached out beyond the Pyrenees, to Cluny—where he doubled the annual gift of 1,000 gold pieces that his father, Fernando I, had given in exchange for

prayers for his soul—and to the papacy. He sought recognition from Pope Gregory VII as "king of Spain," and in return he imposed the Roman liturgy throughout his kingdom, stamping out the traditional Visigothic music and texts.

In 1085 Alfonso made good his claim to be more than the king of Castile and León by conquering Toledo. This was the original reason why the Almoravids came to Spain, as we saw on p. 169. After Alfonso's death, his daughter, Queen Urraca (r.1109–1126), ruled in her own right a realm larger than England. Her strength came from many of the usual sources: control over land, which, though granted out to counts and others, was at least in theory revocable; church appointments; a court of great men to offer advice and give their consent; and an army—everyone was liable to be called up once a year, even armsbearing slaves.

In the wake of Almoravid victories, however, two new Christian states, Aragon-Catalonia and Portugal, began to challenge the supremacy of Castile and León. Aragon had always been a separate entity, but Portugal was the creation of Alfonso VI himself. As king of León, he ruled over the county of Portugal (the name came from Portucalia: land of ports) and in 1095 he granted his rights there to his illegitimate daughter Teresa and her husband, Henry of Burgundy, who then became the first count and countess of Portugal. They remained Alfonso's vassals, but their son, Count Afonso Henriques, rejected the domination of León, took the title of prince of Portugal in 1129, and began to encroach on Islamic territory to his south. In 1139 he defeated the Almoravids at the battle of Ourique and took the title of king of Portugal under the name of Afonso I, though it was not until 1179 that Pope Alexander III (1159–1181) acknowledged Portugal as an independent kingdom.

Reinforced with crusading warriors from France, the Christian half of Iberia vigorously defended its conquests. In the 1140s, they were ready for a new push southward, contributing to the fall of the Almoravid empire.

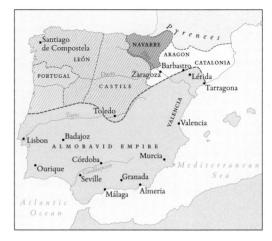

Map 5.8 The Iberian Peninsula,

Genealogy 5.5 (facing page) The Capetian Kings of France

Praising the King of France

Not all rulers had opportunities for grand conquest. How did they maintain themselves? The example of the kings of France reveals the possibilities. Reduced to battling a few castles in the vicinity of the Ile-de-France (see Map 5.5 on p. 174), the Capetian kings nevertheless wielded many of the same instruments of power as their conquering contemporaries: vassals, taxes, commercial revenues, military and religious reputations. Louis VI the Fat (r.1108–1137), so heavy that he had to be hoisted onto his horse by a crane, was nevertheless a tireless defender of royal power. (See Genealogy 5.5.)

Louis's virtues were amplified and broadcast by his biographer, Suger (1081–1151), the abbot of Saint-Denis, a monastery just outside Paris. A close associate of the king, Suger was his chronicler and propagandist. When Louis set himself the task of consolidating his rule in the Ile-de-France, Suger portrayed the king as a righteous hero. He was more than a lord with rights over the French nobles as his vassals; he was a peacekeeper with the God-given duty to fight unruly strongmen. Careful not to claim that Louis was head of the church, which would have scandalized the papacy and its supporters, Suger nevertheless emphasized Louis's role as vigorous protector of the faith and insisted on the sacred importance of the royal dignity. When Louis died in 1137, Suger's notion of the might and right of the king of France reflected reality in an extremely small area. Nevertheless, Louis laid the groundwork for the gradual extension of royal power. As the lord of vassals, the king could call upon his men to aid him in times of war (though the great ones could defy him). As king and landlord, he collected dues and taxes with the help of his officials, called prévôts. Revenues came from Paris as well, a thriving commercial and cultural center. With money and land, Louis could employ civil servants while dispensing the favors and giving the gifts that added to his prestige and power.

NEW FORMS OF LEARNING AND RELIGIOUS EXPRESSION

The commercial revolution and rise of urban centers, the newly reorganized church, close contact with the Islamic world, and the revived polities of the early twelfth century paved the way for the growth of urban schools and new forms of religious expression. Money, learning, and career opportunities attracted many to city schools. At the same time, some people rejected urbanism and the new-fangled scholarship it supported. They retreated from the world to seek poverty and solitude. Yet the new learning and the new money had a way of seeping into the cracks and crannies of even the most resolutely separate institutions.

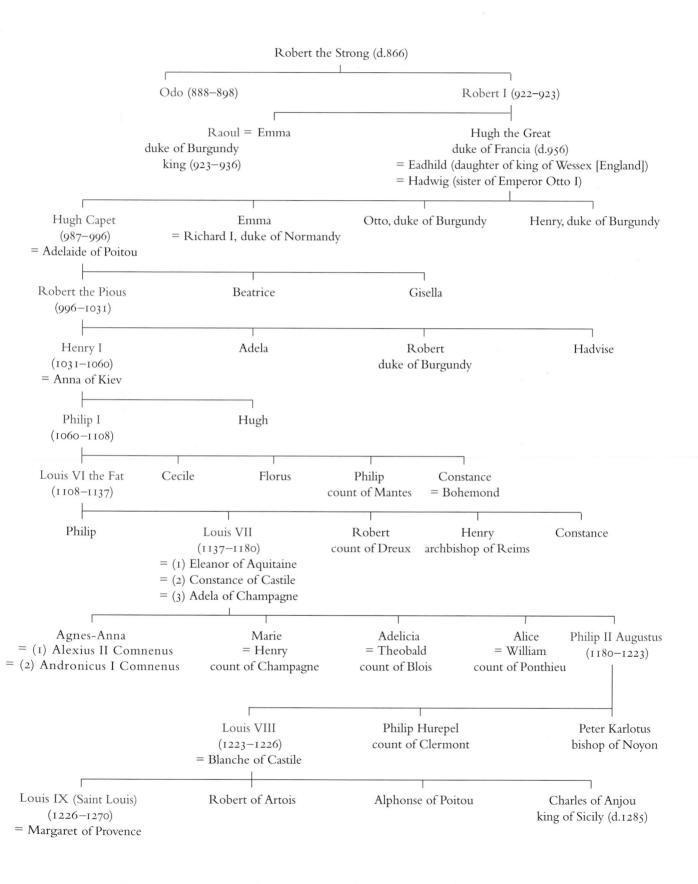

The New Schools and What They Taught

Connected to monasteries and cathedrals since the Carolingian period, traditional schools had trained young men to become monks or priests. Some were better endowed than others with books and teachers; a few developed reputations for particular expertise. By the end of the eleventh century, the best schools were generally connected to cathedrals in the larger cities: Reims, Paris, Bologna, Montpellier. But some teachers (or "masters," as they were called), such as the charismatic and brilliant Peter Abelard (1079–1142), simply set up shop by renting a room. Students flocked to his lectures.

What the students sought, in the first place, was knowledge of the seven liberal arts. Grammar, rhetoric, and logic (or dialectic) belonged to the "beginning" arts, the so-called trivium. Grammar and rhetoric focused on literature and writing. Logic—involving the technical analysis of texts as well as the application and manipulation of arguments—was a transitional subject leading to the second, higher part of the liberal arts, the quadrivium. This comprised four areas of study that would today be called theoretical math and science: arithmetic (number theory), geometry, music (theory rather than practice), and astronomy. Of these arts, logic had pride of place in the new schools, while masters and students who studied the quadrivium generally did so outside of the classroom.

Scholars looked to logic to clarify what they knew and lead them to further knowledge. That God existed, nearly everyone believed. But a scholar like Anselm of Bec (whom we met above, p. 186, as the archbishop of Canterbury) was not satisfied by belief alone. Anselm's faith, as he put it, "sought understanding." He emptied his mind of all concepts except that of God; then, using the tools of logic, he proved God's very existence in his *Monologion*. In Paris a bit later, Peter Abelard declared that "nothing can be believed unless it is first understood." He drew together conflicting authoritative texts on 158 key subjects in his *Sic et non* (*Yes and No*), including "That God is one and the contrary" and "That it is permitted to kill men and the contrary." Leaving the propositions unresolved, Abelard urged his students to discover the reasons behind the disagreements and find ways to reconcile them. Soon Peter Lombard (c.1100–1160) adopted Abelard's method of juxtaposing discordant viewpoints, but he supplied his own reasoned resolutions as well. His *Sententiae* was perhaps the most successful theology textbook of the entire Middle Ages.

One key logical issue for twelfth-century scholars involved the question of "universals": whether a universal—something that can be said of many—is real or simply a linguistic or mental entity. Abelard argued that "things either individually or collectively cannot be called universal, i.e., said to be predicated of many." He was maintaining a position later called "nominalist." The other view was the "realist" position, which claimed that things "predicated of many" were universal and real. For example, when we look at diverse individuals of one kind, say Fluffy and Puffy, we say of each of them that they are members of the same species: cat. Realists argued that "cat" was real. Nominalists thought it a mere word.

Later in the twelfth century, scholars found precise tools in the works of Aristotle to resolve this and other logical questions. During Abelard's lifetime, very little of Aristotle's

work was available in Europe because it had not been translated from Greek into Latin. By the end of the century, however, that lack had been filled by translators who traveled to Islamic or formerly Islamic cities—Toledo in Spain, Palermo in Sicily—where Aristotle had already been translated into Arabic and carefully commented on by Islamic scholars such as Ibn Sina (Avicenna; see p. 128 above) (980–1037) and Ibn Rushd (Averroes) (1126–1198). By the thirteenth century, Aristotle had become the primary philosopher for the scholastics (the scholars of medieval European universities).

The lofty subjects of the schools had down-to-earth, practical consequences in books for preachers, advice for rulers, manuals for priests, textbooks for students, and guides for living addressed to laypeople. Nor was mastery of the liberal arts the end of everyone's education. Many students went on to study theology (for which Paris was the center). Others studied law; at Bologna, for example, where Gratian worked on canon law, other jurists—such as the so-called Four Doctors—achieved fame by teaching and writing about Roman law. By the mid-twelfth century, scholars had made real progress toward a systematic understanding of Justinian's law codes (see above, p. 30). The lawyers who emerged from the school at Bologna went on to serve popes, bishops, kings, princes, or communes. In this way, the learning of the schools was used by the newly powerful twelfth-century states, preached in the churches, and consulted in the courts.

It found a place in the treatment of the ill as well. The greatest schools of medicine were at Salerno (in Italy) and at Montpellier (in France). In the course of the late eleventh and twelfth centuries, these schools' curricula began to draw on classical Greek medical texts, which had been translated into Arabic during the ninth century. Now the Arabic texts were turned into Latin. For example, Constantine the African, who was at Salerno before 1077, translated a key Arabic text based on Galen's *Art of Medicine*. He called it the *Isagoge* ("Introduction"), which indeed it was: "[The principal members of the body are] the brain, the heart, the liver, and the testicles. Other members serve the aforesaid principal members, such as the nerves, which minister to the brain, and the arteries which minister to the heart, and the veins, which minister to the liver, and the spermatic vessels, which convey sperm to the testicles." ¹⁴

Soon the *Isagoge* was gathered together with other texts into the *Articella*, a major training manual for doctors throughout the Middle Ages.

Monastic Splendor and Poverty

To care for ill monks, monasteries had infirmaries—proto-hospitals that were generally built at a short distance from the monastic church and communal buildings (see Figure 5.3 on p. 199). The Benedictine Rule assumed that each religious community would carry out most of its tasks within an enclosed building complex. One Benedictine monastery that has been excavated particularly fully is Saint-Germain at Auxerre. In the twelfth century, it boasted a very large church with an elaborate narthex that served as a grand entranceway for liturgical processions (see Figure 5.1). Toward the east of the church,

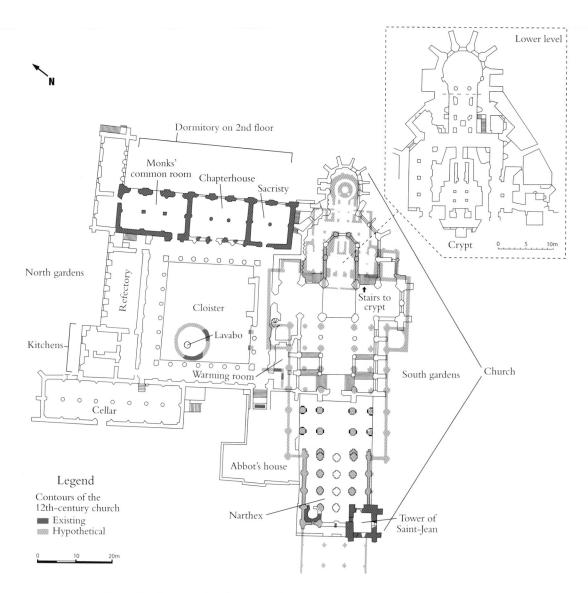

Figure 5.1 Saint-Germain of Auxerre (12th cent.)

Plate 5.6 (facing page) Durham Cathedral, Interior (1093–1133). Huge and imposing, Durham Cathedral is also inviting and welcoming, with its lively piers, warm colors, and harmonious spaces. Built by Norman bishops, it housed the relics of the Anglo-Saxon Saint Cuthbert; in just such ways did the Normans appropriate the power and prestige of English saints' cults.

where the altar stood and the monks sang the Offices, stairs led down to a crypt housing saintly relics constructed during the Carolingian period. To the north and south were the conventual buildings—the sacristy (which stored liturgical vessels and vestments), the "chapter house" (where the Benedictine Rule was read), the common room, dormitory (where the monks slept), refectory (dining hall), kitchens, and cellar. At the center of all was the cloister, entirely enclosed by graceful arcades. Beyond these buildings were undoubtedly others—not yet excavated—for the craftsmen and servants of the monastery, for the ill, for pilgrims and other guests. The whole purpose of this complex was to allow the monks to carry out a life of arduous and nearly continuous prayer. Every detail of their lives was ordered, every object splendid, every space adorned to render due honor to the Lord of heaven.

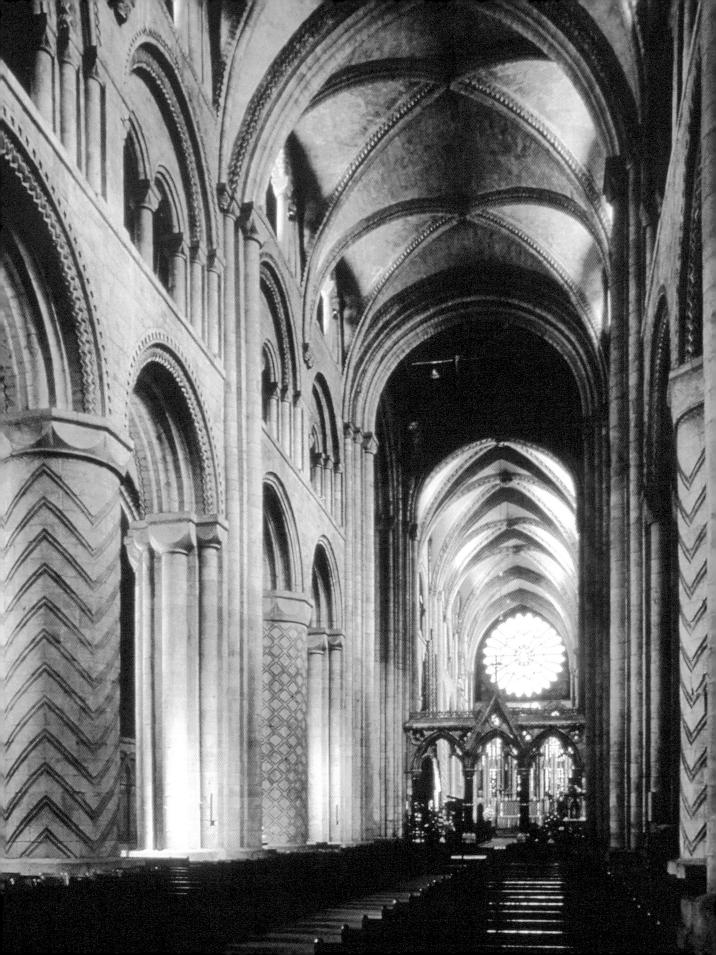

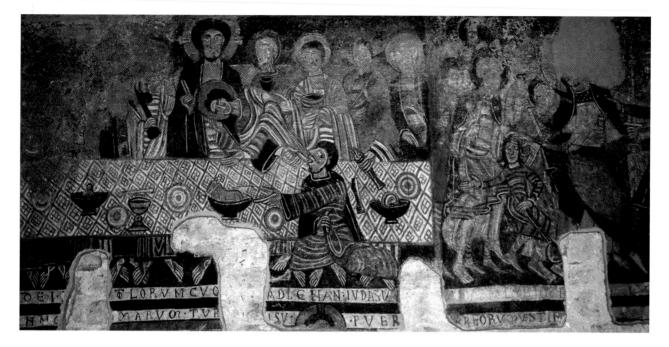

Plate 5.7 Sant Tomàs de Fluvià, The Last Supper, Painted Vault (early 12th cent.). Sant Tomàs was one of many monastic and parish churches in the County of Barcelona richly decorated with paintings in the twelfth century. Here Christ is at the Last Supper with his apostles. The depiction closely follows John 13:23 when Jesus announces that one of his disciples will betray him: "Now there was leaning on Jesus's bosom one of his disciples [John].... [John asked], 'Lord, who is it?' Jesus answered, 'He it is to whom I shall reach bread dipped.' And when he had dipped the bread, he gave it to Judas." To the right of the table a new scene begins: Jesus' disciple Peter cuts off the ear of the servant of the high priest who has come with Judas to betray him. Christ then utters the famous words from Matt. 26:52, "Put your sword back into its place; for all who take the sword will perish by the sword." Then, according to Luke 22:51, Jesus touched the servant's ear and healed him.

The architecture and sculpture of twelfth-century churches like Saint-Germain were suited to showcase both the solemn intoning of the chant and the honor due to God. The style, called Romanesque, represents the first wave of European monumental architecture. Built of stone, Romanesque churches are echo chambers for the sounds of the chant. Massive, weighty, and dignified, they are often enlivened by sculpture, wall paintings, or patterned textures. At Durham Cathedral (built between 1093 and 1133 in the north of England), the stone itself is a warm yellow/pink color, given added zest by piers incised with diamond or zig-zag patterns. (See Plate 5.6.) By contrast, the entire length of the vault of Sant Tomàs de Fluvià, a tiny monastic church in the County of Barcelona, was covered with paintings, a few of which remain today; Plate 5.7 shows the Last Supper. Pisa's famous leaning tower is in fact a Romanesque bell tower; here (Plate 5.8) the decoration is on the exterior, where the bright Italian sun heightens the play of light and shadow.

The church of Saint-Lazare of Autun (1120–1146) may serve as an example of a "typical" Romanesque church, though in fact the most typical aspect of that style is its extreme variety. Striking is the "barrel" or "tunnel" vault whose ribs, springing from the top of the piers, mark the long church into sections called bays. There are three levels. The first is created by the arches that open onto the side aisles of the church. The second is the gallery (or triforium), which consists of a decorative band of columns and arches. The third is the clerestory, where small windows puncture the walls. (See Plate 5.9 on p. 197.)

As at many Romanesque churches, the portals and the capitals (the "top hats" on the columns) at Autun were carved with complex scenes representing sacred stories. The story of the "Raising of Lazarus," patron saint of the church (Saint-Lazare = Lazarus), was once depicted on a tympanum (a half-circle) over the north transept door, the main entrance to the church. (For an Ottonian depiction of the scene, see Plate 4.6 on p. 146.) Other scenes were seemingly more fanciful. Like the fighting lion and bull at Diyarbakir in Seljuk Anatolia (see

Chevet or Apse Tomb Horseman Flight into Egypt -Choir Sleeping Magi Adoration of Magi Resurrection of Lazarus Transept Donation Hanging of Church of Judas Wrath and Avarice Piers Aisle -Aisle Nave Christ's Appearance to Mary Magdalene -St. Steven's Stoning Musicians Cockfight -Flight of Simon Magus St. Peter in Chains -Fall of Simon Magus - St.Vincent's Martyrdom Demon ~ Demon Jacob's Dream David and Goliath Narthex Last Judgment

Figure 5.2 A Model Romanesque Church: Saint-Lazare of Autun

Plate 5.8 Cathedral Complex. Pisa (11th–12th cent.). The tower is part of a large complex that was meant to celebrate Pisa's emergence as a great political, economic, and military power. In this photograph, taken from the upper porch of the hospital (13th cent.), the cathedral (begun in 1064) is just behind and to the left of the tower (which started to lean in 1174, during construction). Behind that, and further to the left, is the baptistery (begun in 1152).

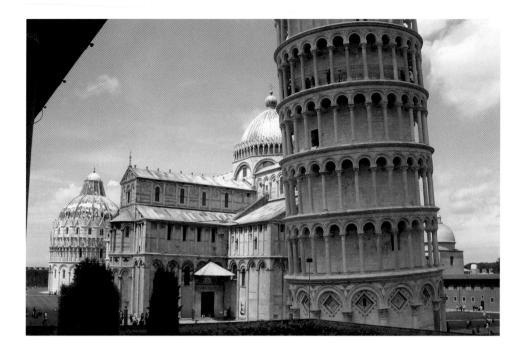

Plate 5.4 on p. 168), a cockfight decorates the capital of a pier right in the center of the nave (see Plate 5.10). But, also like the Seljuk motif, this one had a more profound meaning. The victorious cock is the one who has triumphed over death and symbolizes the hope of resurrection.

The plan of Autun shown in Figure 5.2 on p. 195 indicates the placement of many of the church's carvings, including the cockfight. It also shows that the church was in the form of a basilica (a long straight building) intersected, near the choir, by a transept. The chevet (or apse), the far eastern part of the church, had space for pilgrims to visit the tomb of Lazarus, which held the precious bones of the saint.

Not all medieval people agreed that such extravagant decoration pleased or praised God, however. At the end of the eleventh century, the new commercial economy and the profit motive that fueled it led many to reject wealth and to embrace poverty as a key element of the religious life. The Carthusian order, founded by Bruno of Cologne (d. 1101; not the same person as the archbishop discussed on p. 145), represented one such movement. La Grande Chartreuse, the chief house of the order, was built in an Alpine valley, lonely and inaccessible. Each monk took a vow of silence and lived as a hermit in his own small hut. Only occasionally would the monks join the others for prayer in a common oratory. When not engaged in prayer or meditation, the Carthusians copied manuscripts: for them, scribal work was a way to preach God's word with the hands rather than the mouth. Slowly the Carthusian order grew, but each monastery was limited to only twelve monks, the number of Christ's Apostles.

And yet even the Carthusians dedicated their lives above all to prayer. By now new forms of musical notation had been elaborated to allow monks—and other musicians—to see graphically the melody of their chants. In Plate 5.11 on p. 200, a manuscript from a Carthusian monastery in Lyon, France, the scribe used a red line to show the pitch of F (you can see the letter F at the left of each red line) and a yellow line for the C above that.

The notes, square-headed and precisely placed, can easily be transcribed (by a musicologist who knows their conventions) onto a modern five-line staff.

Another new monastic order, the Cistercian, expanded rapidly. The first Cistercian house was Cîteaux (in Latin, Cistercium), founded in 1098 by Robert of Molesme (c.1027/1028-1111) and a few other monks seeking a more austere way of life. Austerity they found-and also success. With the arrival of Saint Bernard (c.1090–1153), who came to Cîteaux in 1112 along with about thirty friends and relatives, the original center sprouted a small congregation of houses in Burgundy. (Bernard became abbot of one of them, Clairvaux.) The order grew, often by reforming and incorporating existing monasteries. By the mid-twelfth century there were more than 300 monasteries—many in France, but some as well in Italy, Germany, England, Austria, and Spain—following what they took to be the customs of Cîteaux. By the end of the twelfth century, the Cistercians were an order: their member houses adhered to the

Plate 5.9 Saint-Lazare of Autun, Nave (1120-1146). In this view down the nave to the west entrance, a great organ obscures the windows that once allowed in the light of the setting sun.

decisions of a General Chapter; their liturgical practices and internal organization were standardized. Many nuns, too, as eager as monks to live the life of simplicity and poverty that the Apostles had endured and enjoyed, adopted Cîteaux's customs; some convents later became members of the order.

Although the Cistercians claimed the Benedictine Rule as the foundation of their customs, they elaborated a style of life and an aesthetic all their own, largely governed by the goal of simplicity. They even rejected the conceit of dyeing their robes—hence their nickname, the "white monks." White, too, were their houses. Despite regional variations and considerable latitude in interpreting the meaning of "simplicity," Cistercian buildings had a different feel than the great Romanesque churches and Benedictine monasteries of black monks. Foursquare and regular, Cistercian churches and other buildings conformed to a fairly standard plan, typified by a monastery like Fountains (see Figure 5.3 on p. 199). The churches tended to be small, made of smooth-cut, undecorated stone. Wall and vault paintings were eschewed, and any sculpture was modest at best. Indeed, Saint Bernard

Plate 5.10 Autun, Cockfight (12th cent.). This relief, one of many carvings that decorate the capitals at Autun, shows the conclusion of a cockfight. In the twelfth century, cockfighting was among the favorite sports of young boys. At Autun, the cock's victorious trainer grins and throws up his arms as his winning animal puts its foot on the loser's head. The losing cock bows, waiting for the final blow, while his trainer grimaces and clenches his fists in despair. But why depict a youthful sport in the solemn space of a monastic church? In fact, cocks had significance in Christian thought: they recalled the cry that awakened the sleeper, foretelling the Day of Judgment. They were compared to priests, whose better selves did daily battle with their sinful tendencies. The fighting cocks reminded the monks of their own moral battles even as they recalled a frivolous pastime. Note how the sculptor made even this dramatic scene fit the shape of the lintel.

wrote a scathing attack on Romanesque sculpture in which, ironically, he admitted its sensuous allure:

But what can justify that array of grotesques in the cloister where the brothers do their reading...? What place have obscene monkeys, savage lions, unnatural centaurs, manticores, striped tigers, battling knights or hunters sounding their horns? You can see a head with many bodies and a multi-bodied head.... With such a bewildering array of shapes and forms on show, one would sooner read the sculptures than the books.¹⁵

The Cistercians had few such diversions, but the very simplicity of their buildings and of their clothing also had beauty. Illuminated by the pure white light that came through clear glass windows, Cistercian churches were luminous, cool, and serene. Plate 5.12 on p. 201 shows the nave of Sénanque, begun in 1139. There are no wall paintings, carvings, or incised pillars. Yet the very articulation of the pillars and arches and the stone molding that gently breaks the vertical thrust of the vault lend the church a sober charm.

True to their emphasis on purity, the Cistercians simplified their communal liturgy, pruning the many additions that had been tacked on in the houses of the black monks. Only the liturgy as prescribed in the Benedictine Rule and one daily Mass were allowed. Even the music for the chant was modified: the Cistercians rigorously suppressed the

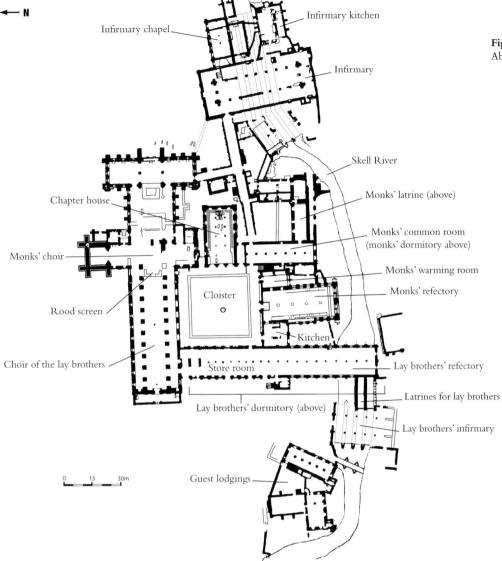

Figure 5.3 Plan of Fountains Abbey (founded 1132)

B flat, even though doing so made the melody discordant, because of their insistence on strict simplicity.

On the other hand, the Benedictine Rule did not prevent the Cistercians from creating a new class of monks—the lay brothers—who were illiterate and unable to participate in the liturgy. These men did the necessary labor—field work, stock raising—to support the community at large. Compare Figure 5.3 with Figure 5.1 on p. 192: the Cistercian monastery was in fact a house divided. The eastern half was for the "choir" monks, the western half for the lay brethren. Each half had its own dining room, latrines, dormitories, and

Plate 5.11 Carthusian Diurnal from Lyon (12th cent.). A Diurnal contains daytime monastic chants. On this page, the scribe has indicated (just beneath each yellow line) the placement of the B natural. Although (or perhaps because) Carthusian monks rarely came together to pray, they, like other sorts of monks, wanted clear guidance for their chants.

infirmaries. The monks were strictly segregated, even in the church, where a rood screen kept them apart.

The choir monks dedicated themselves to private prayer and contemplation and to monastic administration. The Cistercian *Charter of Charity*, in effect a constitution of the order, provided for a closely monitored network of houses, and each year the Cistercian abbots met to hammer out legislation for all of them. Cistercian monasteries held large and highly organized farms and grazing lands called "granges," and the monks spent much of their time managing their estates and flocks of sheep, both of which yielded handsome profits by the end of the twelfth century. Clearly part of the agricultural and commercial revolutions of the Middle Ages, the Cistercian order made managerial expertise a part of the monastic life.

Yet the Cistercians also elaborated a spirituality of intense personal emotion. Their writings were filled with talk of love—love of self, of neighbor, and of God. They were devoted to the humanity of Christ and to his mother, Mary. While pilgrims continued to stream to the tombs and reliquaries of saints, the Cistercians dedicated all their churches to the Virgin Mary (for whom they had no relics) because for them she signified the model of a loving mother. Indeed, the Cistercians regularly used maternal imagery to describe the nurturing care provided to humans by Jesus himself. The Cistercian God was approachable, human, protective, even mothering.

Were women simply metaphors for pious male monks? Or did they too partake in the new religious fervor of the twelfth century? The answer is that women's reformed

monasteries proliferated at the same time as men's. Furthermore, monks and priests undertook to teach and guide religious women far more fully than they had done before. In the Speculum Virginum (Mirror of Virgins), written in the form of a dialogue between a male religious advisor (Peregrinus) and a "virgin of Christ" (Theodora), exhortations to virtue were complemented by images. Some presented, as if in a "mirror," vices that should be avoided. Others gave examples of female heroines to be admired and imitated. In Plate 5.13 on p. 202, three tall and triumphant women stand on dead or defeated enemies. On the left is Jael, who killed the Israelites' enemy leader, and on the right is Judith, who did the same. In the middle, the model for both, is Humility striking Pride in the breast. Clearly the cloistered twelfth-century virgin was justified in considering herself, as Peregrinus said, "an example of disdain for the present life and a model of desire for heavenly things." 16

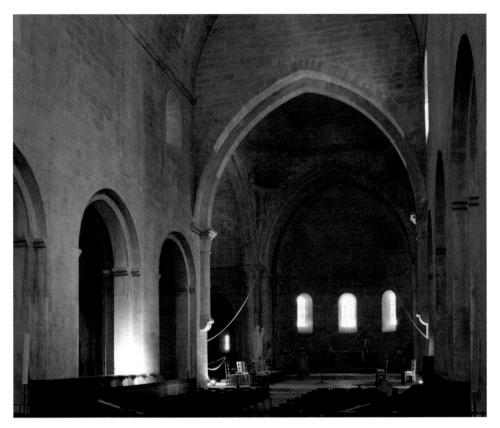

Plate 5.12 Sénanque Monastery Church, Interior (c.1160). Because of the geography of the valley where the monastery was constructed, the church is oriented so that the "north" end takes the usual place of the "east." In this view to the north, the bare walls reveal religious and artistic sensibilities completely different from those of the creators of Sant Tomàs de Fluvià (Plate 5.7).

In the eleventh and twelfth centuries, the Seljuk Turks reconfigured the geography of the Islamic world and put their stamp on religion by affirming Sunnism. Byzantium, badly maimed by the Seljuks on its eastern flank, nevertheless expected to recoup its losses, calling on the papacy to help man its army. The papacy, however, had its own agenda. Invigorated by the Investiture Conflict, it called for an armed pilgrimage to the east that would both ensure peace in Europe and control over regions that suddenly did not seem so far away. For, as the papacy recognized, Europe was burgeoning. Growing population and the profitable organization of the countryside promoted cities, trade, and wealth. Townspeople created new institutions of self-regulation and self-government. Kings and popes found new ways to exert their authority and test its limits. Scholars mastered the knowledge of the past and put it to use in classrooms, royal courts, papal offices, and the homes of the sick. Monks who fled the world ended up in positions of leadership: the great entrepreneurs of the twelfth century were the Cistercians; Saint Bernard was the most effective preacher of the Second Crusade.

Both Seljuk sultans and Byzantine emperors had to recognize the demands of elites. European rulers had, in addition, to reckon with the power of communities. They confronted and sometimes welcomed guilds and communes. The new theology of the time reinforced the importance of community by putting less emphasis on hierarchy and

Plate 5.13 Jael, Humility, and Judith (c.1140). In this early manuscript of the extremely popular Mirror of Virgins, exemplary women triumph over evil. Humility (in Latin, humilitas, a feminine noun) was the key virtue of the monastic life. Before she killed Holofernes, enemy of the Israelites, Judith prayed to God, reminding him that "the prayer of the humble and the meek hath always pleased thee" (Judith 9:16).

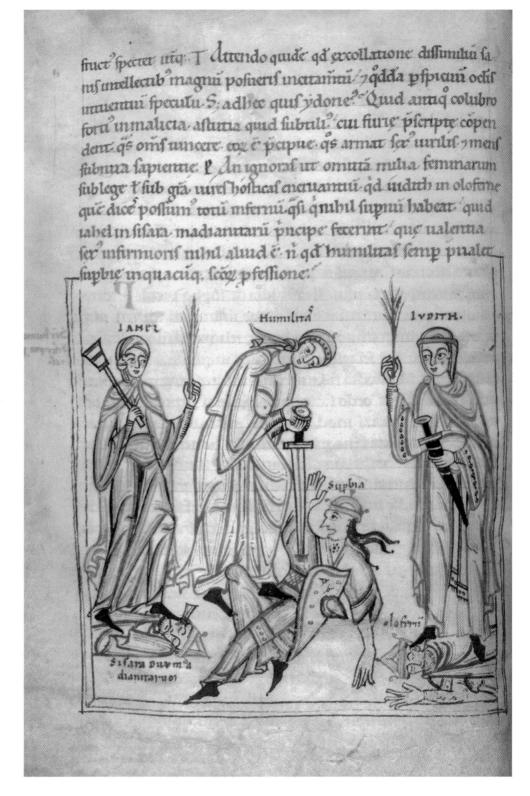

more on the dignity of each human being, the splendor of the natural world, and the nobility of reason. Historians speak of this development as "medieval humanism." In his theological treatise *Why God Became Man*, Anselm of Bec stressed Christ's humanity: Christ's sacrifice was that of one human being for another. The Cistercians spoke of God's mothering. Yet the stress on the loving bonds that tied Christians together also led to the persecution of others, like Jews and Muslims, who lived outside the Christian community. In the next century, Mongols from East Asia would move westward, changing yet again the configuration of the Islamic world, while Europeans moved eastward, taking over Constantinople itself.

CHAPTER FIVE: ESSENTIAL DATES

- 1066 Norman Conquest of England by William of Normandy
- 1071 Battle of Manzikert; Seljuk Turks defeat Byzantines
- 1075-1122 Investiture Conflict
 - 1085 Conquest of Toledo by Alfonso VI
 - 1094 Al-Andalus under Almoravid (Berber) control
- 1096–1099 The First Crusade; establishment of Crusader States
 - 1122 Concordat of Worms; end of the Investiture Conflict
- 1147–1149 The Second Crusade

NOTES

- 1 Abu'l-Fazl Beyhaqi, The Battle of Dandanqan, in Reading the Middle Ages: Sources from Europe, Byzantium, and the Islamic World, 3rd ed., ed. Barbara H. Rosenwein (Toronto: University of Toronto Press, 2018), p. 243.
- 2 Nizam al-Mulk, The Book of Policy, in Reading the Middle Ages, p. 244.
- 3 Frederick of Hamburg's Agreement with Colonists from Holland, in Reading the Middle Ages, p. 246.
- 4 Henry I, Privileges for the Citizens of London, in Reading the Middle Ages, p. 250.
- 5 Cluny's Foundation Charter, in Reading the Middle Ages, p. 186.
- 6 Gregory VII, Admonition to Henry IV, in Reading the Middle Ages, p. 252.
- 7 Henry IV, Letter to Gregory VII, in Reading the Middle Ages, p. 254.
- 8 Roman Lenten Synod, in The Correspondence of Pope Gregory VII: Selected Letters from the Registrum, ed. and trans. Ephraim Emerton (New York: Columbia University Press, 1969), p. 91.
- 9 Robert the Monk, Urban II Preaches the First Crusade, in Reading the Middle Ages, pp. 262-63.
- 10 Ibn al-Qalanisi, The Damascus Chronicle of the Crusades, in Reading the Middle Ages, p. 270.
- II For siege engines, see "Reading through Looking," in Reading the Middle Ages, pp. XII–XIII, esp. Plate 8.

- 12 Domesday Book, in Reading the Middle Ages, p. 277.
- 13 Abelard, Glosses on Porphyry, in Reading the Middle Ages, p. 280.
- 14 Constantine the African's Translation of Johannitius's Isagoge, in Reading the Middle Ages, p. 281.
- 15 St. Bernard, Apologia, in Reading the Middle Ages, p. 288.
- 16 Speculum Virginum, trans. Barbara Newman, in Listen, Daughter: The Speculum Virginum and the Formation of Religious Women in the Middle Ages, ed. Constant J. Mews (New York: Palgrave Macmillan, 2001), p. 270.

FURTHER READING

Andrea, Alfred J., and Andrew Holt, eds. *Seven Myths of the Crusades*. Indianapolis: Hackett, 2015. Barber, Malcolm. *Crusader States*. New Haven, CT: Yale University Press, 2012.

Bell, Nicholas. Music in Medieval Manuscripts. Toronto: University of Toronto Press, 2001.

Bruce, Scott G. Cluny and the Muslims of La Garde-Freinet. Hagiography and the Problem of Islam in Medieval Europe. Ithaca, NY: Cornell University Press, 2015.

Burton, Janet, and Julie Kerr. The Cistercians in the Middle Ages. Woodbridge: Boydell, 2011.

Catlos, Brian A. *Muslims of Medieval Latin Christendom, c. 1050–1614*. Cambridge: Cambridge University Press, 2014.

Christie, Niall. Muslims and Crusaders: Christianity's Wars in the Middle East, 1095–1382, from the Islamic Sources. London: Routledge, 2014.

Cobb, Paul M. The Race for Paradise: An Islamic History of the Crusades. Oxford: Oxford University Press, 2014.

El-Azhari, Taef. Zengi and the Muslim Response to the Crusades: The Politics of Jihad. London: Routledge, 2016.

Fromherz, Allen James. The Near West: Medieval North Africa, Latin Europe and the Mediterranean in the Second Axial Age. Edinburgh: Edinburgh University Press, 2016.

Hamilton, Louis I. A Sacred City: Consecrating Churches and Reforming Society in Eleventh–Century Italy. Manchester: Manchester University Press, 2010.

Harvey, Sally. Domesday: Book of Judgement. Oxford: Oxford University Press, 2014.

Little, Lester K. Religious Poverty and the Profit Economy in Medieval Europe. Ithaca, NY: Cornell University Press, 1978.

Messier, Ronald A. The Almoravids and the Meanings of Jihad. Santa Barbara, CA: Praeger, 2010.

Miller, Maureen C., ed. Power and the Holy in the Age of the Investiture Conflict: A Brief History with Documents. Boston: Bedford, 2005.

Morton, Nicholas Edward. *Encountering Islam on the First Crusade*. Cambridge: Cambridge University Press, 2016.

Peacock, A.C.S. The Great Seljuk Empire. Edinburgh: Edinburgh University Press, 2015.

Robinson, Ian S. Henry IV of Germany. Cambridge: Cambridge University Press, 2000.

Rubenstein, Jay. The First Crusade: A Brief History with Documents. Boston: Bedford/St. Martin's, 2015.

Thibodeaux, Jennifer D. *The Manly Priest: Clerical Celibacy, Masculinity, and Reform in England and Normandy, 1066–1300.* Philadelphia: University of Pennsylvania Press, 2015.

Toman, Rolf, ed. Romanesque: Architecture, Sculpture, Painting. Cologne: Könemann, 2010. Yamroziak, Emilia. The Cistercian Order in Medieval Europe, 1090–1500. Abingdon: Routledge, 2013. Yavari, Neguin. The Future of Iran's Past: Nizam al-Mulk Remembered. Oxford: Oxford University Press, 2018.

Yildiz, Sara Nur. The Seljuk Empire of Anatolia. Edinburgh: Edinburgh University Press, 2016.

To test your knowledge of this chapter, please go to www.utphistorymatters.com for Study Questions.

SIX

INSTITUTIONALIZING ASPIRATIONS

(c.1150-c.1250)

The lively developments of early twelfth-century Europe were institutionalized in the next decades. Fluid associations became corporations. Rulers hired salaried officials to staff their administrations. Churchmen defined the nature and limits of religious practice. While the Islamic world largely went its own way, only minimally affected by European developments, Byzantium was carved up by its Christian neighbors.

THE ISLAMIC AND BYZANTINE WORLDS IN FLUX

Nothing could be more different than the fates of the Islamic world and of Byzantium at the beginning of the thirteenth century. The Muslims remained strong; the Byzantine Empire nearly came to an end.

Islamic Principalities

As the Great Seljuk sultanate lost power, local men of various origins—Kurdish, Arab, Turkmen of different stripes, mamluks (slave soldiers) and Berbers—came to the fore. The Jazira—the upper half of the hourglass formed by the Tigris and Euphrates Rivers—became a hub of activity and a center of wealth. Caravans and armies passed through the region, enriching numerous local strong men. A mixture of cultures flourished, including Christian communities whose brands of Christianity—Nestorian, Armenian, and so on—were considered heretical at Byzantium and in Europe. New monasteries, churches, and mosques were constructed, and old buildings were refurbished. Wealth poured into the creation of fortifications, city walls, and palaces. While books had always been important

in the Islamic world, new to this period was the patronage of lavishly illuminated manuscripts apart from the Qur'an. Visual explanations were offered in scientific treatises and pleasing illustrations were added to works of literature. Plate 6.1 shows the frontispiece of one of the extant volumes of a multi-volume Book of Songs commissioned by a local strongman, the emir of Mosul, Badr al-Din Lu'lu'. But book patrons did not need to be emirs: members of the flourishing middle classes at Mosul, Baghdad, and Damascus eagerly commissioned luxurious manuscripts. Some manuscript workshops may even have produced illuminated books for the open market.

From this heady mix of money and multiple ethnicities emerged Zangi (r.1127–1146). His father had been a mamluk promoted to high rank by the Seljuk sultan. Uniting Aleppo and Mosul under his personal rule, Zangi made the first real dent in the Crusader States, conquering the city of Edessa in 1144 (see above, p. 184). Emboldened by the failure of the Second Crusade, Zangi's son Nur al-Din (r.1146–1174) invaded Antioch. Soon his forces were occupying all the territory east of the Orontes River and absorbing the entire County of Edessa. In 1154 Nur al-Din seized Damascus and began to consolidate his rule over all of Syria. But here he found religious as well as military and political enemies. Much of Syria was controlled by the Shi'ite Fatimids, while along the coast the Christian Crusader States made their own claims. Nur al-Din imposed the Sunni form of Islam where he could. Symbolic of his religious program was the grand madrasa-mosque-mausoleum

complex that he built at Damascus (see Plate 6.2). The combination was meant to associate his name forever with the orthodox teachings of Sunnism.

Nur al-Din's conquests were aided by a Kurdish family of warriors known as the Ayyubids, after Ayyub, the name of its patriarch. Ayyub's brother, Shirkuh, and his son, Saladin (r.1171-1193), played a role in Nur al-Din's activities in Egypt. Called on to resolve a dispute over the Fatimid vizierate in Egypt, Nur al-Din took advantage of the opportunity in 1164 by sending Shirkuh to lead the expedition. Saladin may have accompanied his uncle; at any rate, he was soon involved in Egyptian affairs.

In 1169, without formally deposing the Fatimid caliph, Shirkuh took over the powerful position of Egyptian vizier in the name of Nur al-Din. Shortly thereafter, when Shirkuh died, Saladin succeeded him, and when in 1171 the

Plate 6.1 (facing page)

Frontispiece for the Book of Songs (1217-1219). This multivolume work of some 700 beloved songs and music was first compiled in the tenth century. It included mini-treatises on the poets who wrote the words. the composers who wrote the music, and technical matters of performance. The volumes of the thirteenth-century copy illustrated here boasted lavish frontispieces, of which this is one example. The patron, the emir of Mosul, looms above his much smaller courtiers. He wears a sable fur hat and sits serenely on an imperial-style throne. Above him, angels (or perhaps winged victories) hold a scarf over his head, suggesting a halo. Compare this vision of the emir with the depiction of Emperor Basil II in Plate 4.1 on p. 116. Clearly, Byzantine manuscripts served as models for the artist who painted this frontispiece. But the slanted eyes of all of figures, from emir to courtiers to angels, shows the powerful influence of the Mongols, already a political force and soon to conquer Baghdad (see Chapter 7, p. 251).

Plate 6.2 Funerary Madrasa Complex of Nur al-Din at Damascus (1167-1168). Arranged around a courtyard with a large central pool, the building had four soaring halls (iwans), much like the Isfahan mosque in Plate 5.1 (p. 165). The mausoleum (whose dome tops the elegant iwan on the left) flanked the eastern entryway. Its walls were higher than those of the rest of the complex, marking its importance. The prayer hall was located to the south. On either side of the iwans were small classrooms, which took up two floors.

Map 6.1 (facing page) Saladin's Empire, c.1200

Fatimid caliph died, Saladin had the name of the (more-or-less powerless, but Sunni) Abbasid caliph substituted for that of the Fatimid caliph. Saladin was now the effective ruler of Egypt, though in the name of Nur al-Din. In 1174, after Nur al-Din's death, Saladin marched into Syria. There he contended with three sorts of enemies: the heirs of Nur al-Din, local Syrian strongmen used to independent rule, and the leaders of the Crusader States. During his lifetime, he prevailed, creating a principality that stretched across Egypt and Syria and beyond into Iraq. Like Nur al-Din, Saladin was determined to reform Islam along the Sunni model and to wage *jihad* against the Christian states in his backyard. Above all he wanted to recover Jerusalem. The turning point came in 1187, at the battle of Hattin. "The forces of Islam surrounded the forces of unbelief and impiety [i.e., the Christians] on all sides, loosed volleys of arrows at them and engaged them hand to hand" wrote Ibn Shaddad, who joined Saladin's service a year after the battle. He continued:

One group fled and was pursued by our Muslim heroes. Not one of them survived. Another group took refuge on a hill called the Hill of Hattin.... The Muslims pressed hard upon them on that hill and lit fires around them. Their thirst was killing and their situation became very difficult, so that they began to give themselves up as prisoners for fear of being slain.

The Crusader States were reduced to a few port cities (see Map 6.1). For about a half-century thereafter, the Ayyubids held on to the lands Saladin had conquered, dividing rule over the major cities among family members. But in the end Saladin's empire proved to be a fragile creation. Men from within the Ayyubid army, the *mamluks*, staged a coup in 1250, transforming the principality from a family affair to a military state.

A rather similar development took place in the Maghreb (the western part of North Africa) and the Iberian Peninsula. There, the Almohads (the "al-Muwahiddun," the "upholders of God's unity," 1130–1269), a Berber group espousing a militant form of Sunni Islam, combined conquest with a program to "purify" the morals of their fellow Muslims. In al-Andalus their appearance in 1145 induced some Islamic rulers to seek alliances with the Christian rulers to the north. But other Andalusian rulers joined forces with the Almohads, who replaced the Almoravids as rulers of the whole Islamic far west by 1172, making Seville their capital. (See Map 6.2.)

Where they conquered they built. When he founded Ribat al-Fath (later known as Rabat), the "fortress of victory," to celebrate his win over King Alfonso VIII of Castile (r.II58—1214), Almohad Caliph Abu Yusuf Yaʻqub al-Mansur (r.II84—II99) ordered the construction of what was to be the largest congregational mosque in the western Islamic world. It was to have a huge covered sanctuary (with more than twenty aisles) topped by a towering minaret (Plate 6.3 on p. 213). Planned as a defiant response to the advancing armies of the Christian *reconquista* (see p. 179), Rabat's fate foreshadowed the eventual defeat of the Almohads: at Yaʻqub al-Mansur's death work on the mosque ended and the city was abandoned for the nearby—and more prosperous—Salé.

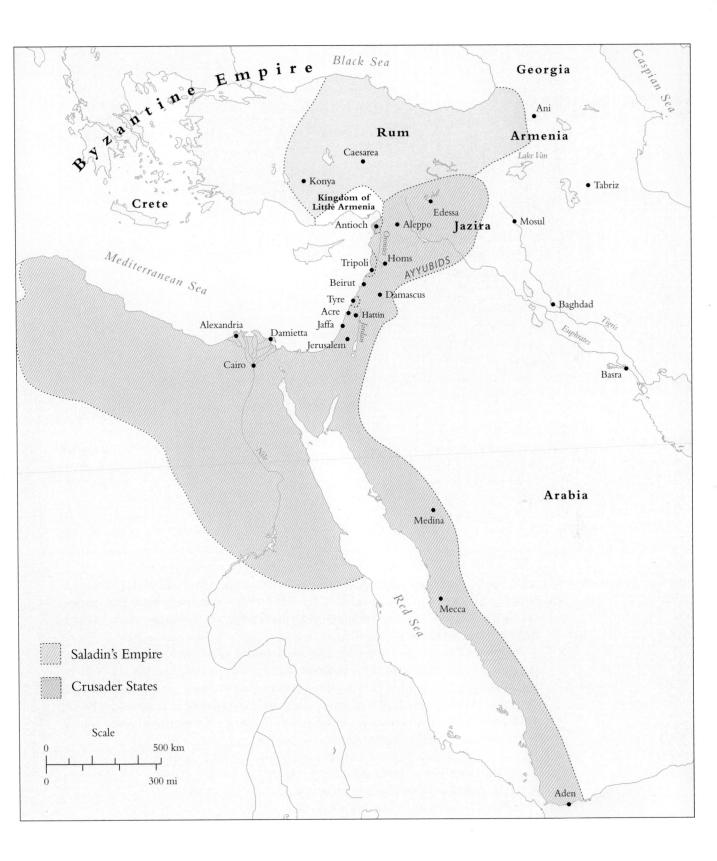

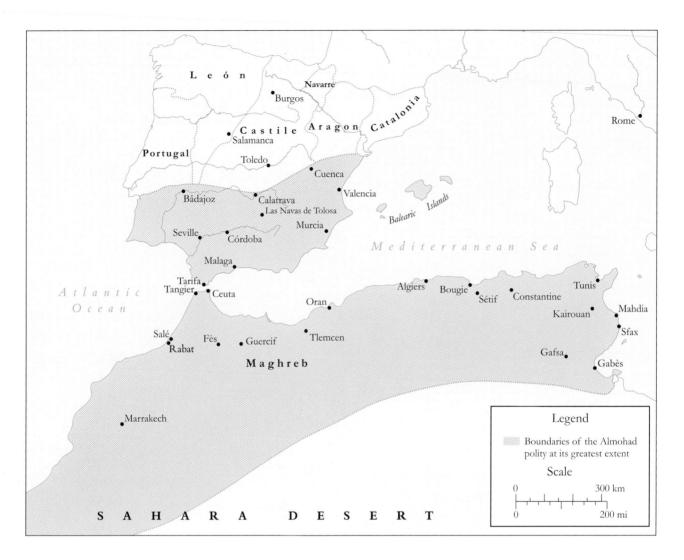

Map 6.2 The Almohad Empire, *c*.1172

At war continuously with Christian Spanish rulers, the Almohads in 1212 suffered a terrible defeat. For the Christian victors, the battle was known simply by its place name, Las Navas de Tolosa; but for the Almohads, it was known as "The Punishment." It was the beginning of the end of Islamic al-Andalus.

Yet even in the midst of war and loss, Almohad cultural life was richly creative. Keeping their distance from the pious rulers at Seville, independent princely courts fostered literature that both inspired and partook in a general interest in love—its pleasures and its dangers—evident (as we shall see) in the Christian world as well. In the story of Bayad and Riyad, two lovers express their feelings (some feigned, some real) in exquisite songs, accompanying themselves on the lute:

Passion called me and I responded, And it gave me to drink from a detestable cup. It placed between my breast and my entrails Sighs and fire, whose flames never go out.²

The Undoing and Persistence of Byzantium

In 1204 the leaders of the Fourth Crusade made a "detour" and conquered Constantinople instead. We shall later explore some of the reasons why they did so. But in the context of Byzantine history, the question is not why the Europeans attacked but rather why the Byzantines lost their capital city and what happened to them thereafter.

Certainly, it would have been hard to predict the fall beforehand. The Byzantines seemed to be recuperating from their eleventhcentury losses. During the twelfth century they had reconquered some of Anatolia, and their court in the capital continued to function normally, with its bureaucracy and machinery of taxation still in place. Powerful men continued to vie to be emperors. In a newly repressive religious atmosphere that insisted on stamping out heresy and creating a new order of preachers to monitor morals, the Byzantine elites thrived. They even found a new way to entertain themselves: with secular Greek romances. Much as at al-Andalus, the Byzantine elites away from court found pleasure in tales of love. But in their case, the stories drew on old models from the Hellenistic past, happily invoking the ancient gods:

[When united with his beloved Drosilla, Charikles says] "Thanks be to you, O son of Zeus, greatest of the gods, who removed the jealous inclination which Kallidemos felt for Drosilla."3

In many ways these were the glory days for the Byzantine elites. The very power of the Comneni was based on alliances with them. They benefited from the pronoiai that the emperors granted to them with increasing frequency in return for military service. They dominated whole regions as dynatoi.

But their power was partly illusory, for the Comneni also depended on outsiders. Manpower was scarce in every area of the economy. Skilled craftsmen, savvy merchants, and seasoned warriors were needed, but where were they to be found? Sometimes Jews were called upon; more often foreigners took up the work. Whole army contingents were made up of foreigners: Cumans, "Franks" (the Byzantine name for all Europeans), Turks. Forced to fight on numerous fronts, the army was not very effective; by the end of the twelfth century the Byzantines had lost much of the Balkans to what historians call the Second Bulgarian Empire.

Foreigners, mainly Italians, dominated Byzantium's long-distance trade. Italian neighborhoods (complete with homes, factories, churches, and monasteries) crowded the major

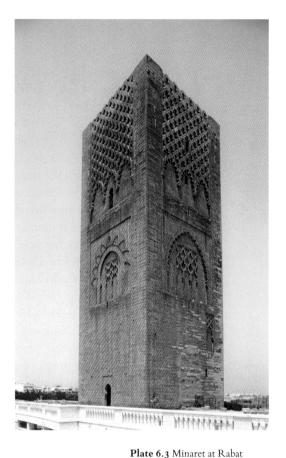

(c.1199). Although unfinished, the minaret shows the great care and detail that the Almohads lavished on their religious architecture. Its exterior, boasting many windows and lattice-work designs, is made of stone, while its interior, which includes six vaulted rooms, is of brick. The unusual shape—square rather than round—was characteristic of Almohad minarets.

cities of the empire. At the capital city itself, stretched along the Golden Horn like pearls on a string, were the Venetian Quarter, the Amalfitan Quarter, the Pisan Quarter, and the Genoese Quarter: these were the neighborhoods of the Italian merchants, exempt from imperial taxes and uniformly wealthy. (See Map 4.1 on p. 114.) They were heartily resented by the rest of Constantinople's restive and impoverished population, which needed little prodding to attack and loot the Italian quarters in 1182 and again in 1203, even when they could see the crusaders camped right outside their city.

To be sure, none of this meant that Europeans had to take over. Yet in 1204, crusader armies breached the walls of Constantinople, encountered relatively little opposition, plundered the city for three days, and finally declared one of their leaders, Baldwin I of Flanders, the new emperor. The Venetians gained the city harbor, Crete, and key Greek cities; other crusader leaders carved out their own states. (See Map 6.3.)

Yet the Byzantines regrouped and persisted. Byzantine leaders formed three new states, the Despotate of Epirus, the Empire of Trebizond, and the Empire of Nicaea. At Nicaea, Emperor Theodore I (r.1205–1221) set up a capital city modeled on Constantinople. He was crowned by a new patriarch, and his court attracted elites exiled from Constantinople. Between that time and 1261, when one of Theodore's successors succeeded in recapturing Constantinople, the Byzantine way of life did not end. At Cyprus, for example, taken over by the "Latins" even before they conquered Constantinople, the hermit Neophytos established a Byzantine-style monastery that thrived under the patronage of both Emperor Theodore and the French king of Cyprus, Hugh of Lusignan (r.1205–1218): "As benefactor, as administrator and as brother," Neophytos wrote, addressing Hugh in his monastic *Rule*, "you shall ... have eternal commemorative services in my holy hermitage. If for a certain most urgent need the brothers [the monks] think fit to send one of them to the emperor [Theodore], co-operate with this and speak up for the brothers." This Byzantine hermit expected the Latin king and the Greek emperor to co-operate to ensure the well-being of his monks.

THE INSTITUTIONALIZATION OF GOVERNMENT IN THE WEST

While the Byzantine government was becoming more like the West—with emperors giving away land grants and *dynatoi* creating regional dynasties—some Western polities were starting to look more Byzantine: more impersonal and bureaucratic. They entered a new phase of self-definition, codification, and institutionalization.

Law, Authority, and the Written Word in England

One good example is England. The king hardly needed to be present: the government functioned by itself, with its own officials to handle administrative matters and record keeping. The very circumstances of the English king favored the growth of an administrative staff:

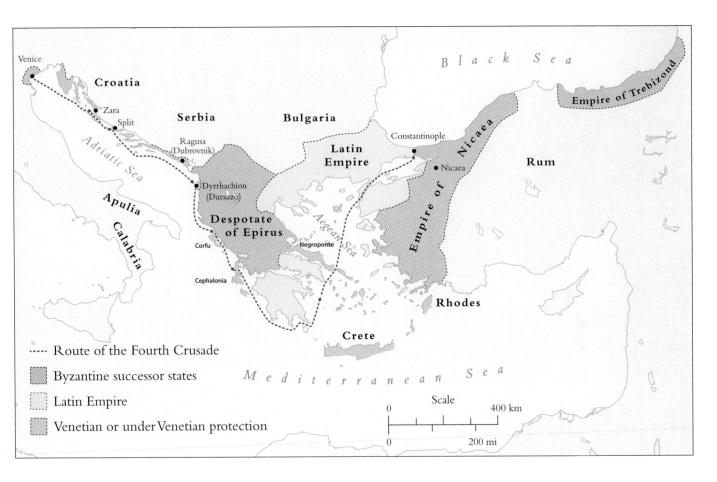

his frequent travels to and from the Continent meant that bureaucrats had to work in his absence, and his enormous wealth meant that he could afford them.

True, a long period of civil war (1135–1154) between the forces of two female heirs to the Norman throne (Matilda, daughter of Henry I, and Adela, Henry's sister) threatened royal power. As in Germany during the Investiture Conflict, so in England the barons and high churchmen consolidated their own local lordships during the war; private castles, symbols of their independence, peppered the countryside. But the war ended when Matilda's son, Henry of Anjou, ascended the throne as the first "Angevin"—or, as he is sometimes called, the first "Plantagenet"—king of England. (See Genealogy 6.1.) Under Henry II (r.1154–1189), the institutions of royal government in England were extended and strengthened.

THE REFORMS OF HENRY II

Henry was count of Anjou, duke of Normandy, and overlord of about half the other counties of northern France. He was also duke of Aquitaine by his marriage to Eleanor, heiress of that vast southern French duchy. As for his power in the British Isles: the princes of Wales swore him homage and fealty; the rulers of Ireland were forced to submit to him; and the king of Scotland was his vassal. Thus Henry exercised sometimes more, sometimes

Map 6.3 The Latin Empire and Byzantine Successor States, 1204–*c*.1250

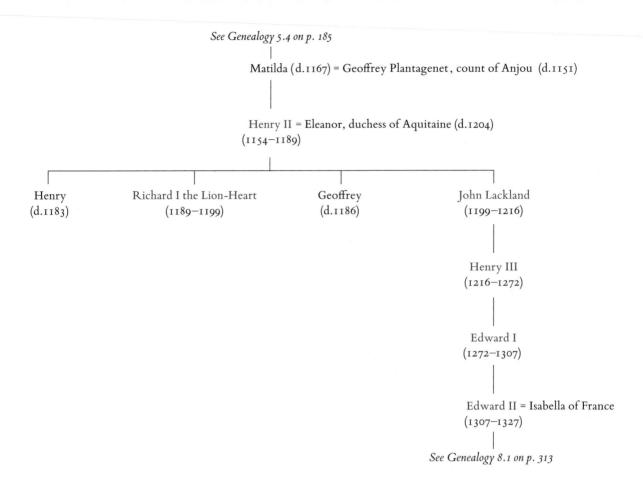

Genealogy 6.1 The Angevin Kings of England

less power over a realm stretching from northern England to the Pyrenees. (See Map 6.4.) For his Continental possessions, he was vassal of the king of France.

Once on the English throne, Henry destroyed or confiscated the private castles built during the civil war and regained the lands that had belonged to the crown. Then he proceeded to extend his power, above all by imposing royal justice. Already the Anglo-Saxon kings had claimed rights in local courts, particularly in capital cases, even though powerful men largely independent of royal authority dominated those courts. The Norman kings added to Anglo-Saxon law in the area of landholding. Henry built on these institutions, regularizing, expanding, and systematizing them. The Assize of Clarendon in 1166 recorded that the king

decreed that inquiry shall be made throughout the several counties and throughout the several hundreds ... whether there be ... any man accused or notoriously suspect of being a robber or murderer or thief.... And let the justices inquire into this among themselves and the sheriffs among themselves.⁵

"Throughout the several counties and throughout the several hundreds": these were the districts into which England had long been divided. Henry aimed to apply a *common* law regarding chief crimes—a law applicable throughout England—to all men and women in the land. Moreover, he meant his new system to be habitual and routine. There had always been justices to enforce the law, but under Henry, there were many more of them; they were trained in the law and required to make regular visitations to each locality, inquiring about crimes and suspected crimes. (They were therefore called "itinerant justices"—from *iter*, Latin for journey. The local hearing that they held was called an "eyre," also from *iter*.) The king required twelve representatives of the local knightly class—the middling aristocracy, later on known as the "gentry"—to meet during each eyre and either give the sheriff the names of those suspected of committing crimes in the vicinity or arrest the suspects themselves and hand them over to the royal justices. While convicted members of the knightly class often got off with only a fine, hanging or mutilation were the normal penalties for criminals. Even if acquitted, people "of ill repute" were exiled from England.

Henry also exercised new control over cases that we would call "civil," requiring all cases of property ownership to be authorized by a royal writ. Unlike the Angevin reforms of criminal law, this requirement affected only the class of free men and women—a minority. While often glad to have the king's protection, they grumbled at the expense and time required to obtain writs. Not only had they to buy the writs, but they had also to pay for "gifts" to numerous officials, line up witnesses, hire a staff (generally made up of clerics) and—because the royal court was itinerant—pay all travel expenses.

The whole system was no doubt originally designed to put things right after the civil war. Although these law-and-order measures were initially expensive for the king—he had to build many new jails, for example—they ultimately served to increase royal income and power. Fines came from condemned criminals and also from knightly representatives who failed to show up at the eyre when summoned; revenues poured in from the purchase of writs. The exchequer, as the financial bureau of England was called, recorded all the fines paid for judgments and the sums collected for writs. The amounts, entered on parchment leaves sewn together and stored as rolls, became the Receipt Rolls and Pipe Rolls, the first of many such records of the English monarchy and an indication that writing had become a tool to institutionalize royal rule in England.

Perhaps the most important outcome of this expanded legal system was the enhancement of royal power and prestige. The king of England touched (not personally but through men acting in his name) nearly every man and woman in the realm. However, the extent of royal jurisdiction should not be exaggerated. Most petty crimes did not end up in royal courts but rather in more local ones under the jurisdiction of a manorial lord—whether a baron, knight, bishop, or monastery. They gained fines from hearing cases, and so they held on tenaciously to their judicial prerogatives.

While peasants came before a local court for a petty crime, clerics were always tried in church courts, even if their crimes were major. Any layperson accused of murder had his hearing in a royal court; but homicidal clerics were brought before church courts, which could be counted on to give them a mild punishment. No churchman wanted to submit

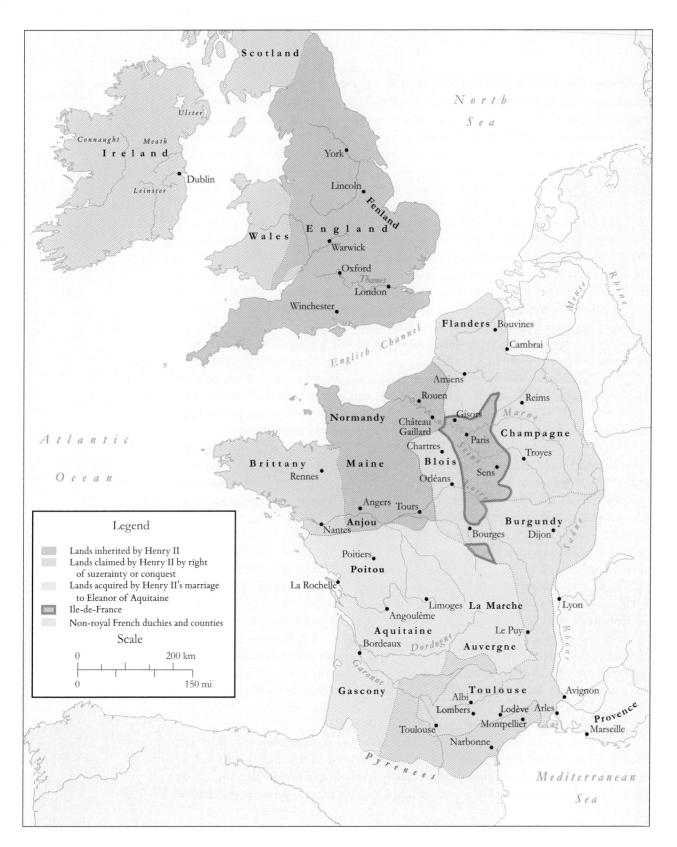

to the jurisdiction of Henry II's courts. But Henry insisted—and not only on that point, but also on the king's right to have ultimate jurisdiction over church appointments and property disputes. The ensuing contest between the king and his appointed archbishop, Thomas Becket (III8—II70), became the greatest battle between the church and the state in the twelfth century. At a meeting held at Clarendon in II64, Becket agreed that clerics might be tried in royal courts, but soon thereafter he clashed with Henry over the rights of the church of Canterbury—Becket's own church—to recover or alienate its own property. The conflict mushroomed to include control over the English church, its property, and its clergy. Soon the papacy joined, with Becket its champion. King and archbishop remained at loggerheads for six years, until Henry's henchmen murdered Thomas, unintentionally turning him into a martyr. Although Henry's role in the murder remained ambiguous, public outcry forced him to do public penance for the deed. In the end, the struggle made both institutions stronger. In particular, both church and royal courts expanded to address the concerns of an increasingly litigious society.

Map 6.4 (facing page) The Angevin and Capetian Realms in the Late 12th cent.

DEFINING THE ROLE OF THE ENGLISH KING

Henry II and his sons Richard I the Lion-Heart (r.1189–1199) and John (r.1199–1216) were English kings with an imperial reach. Richard was rarely in England, since half of France was his to subdue (see Map 6.4, paying attention to the areas in various shades of peach). Responding to Saladin's conquest of Jerusalem, Richard went on the abortive Third Crusade (1189–1192), capturing Cyprus on the way and arranging a three-year truce with Saladin before rushing home to reclaim his territory from his brother, John, and the French king, Philip II (r.1180–1223). (His haste did him no good; he was captured by the duke of Austria and released only upon payment of a huge ransom, painfully squeezed out of the English people.)

When Richard died in battle in 1199, John took over. But if he began with an imperial reach, John must have felt a bit like the Byzantine emperor in 1204, for in that very year the king of France, Philip II, claimed that John had defied his overlordship—and promptly confiscated John's northern French territories. It was a purely military victory, and John set out to win the territories back by gathering money wherever and however he could in order to pay for an abler military force. He forced his barons and many members of the gentry to pay him "scutage"—a tax—in lieu of army service. He extorted money in the form of "aids"—the fees that his barons and other vassals ordinarily paid on rare occasions, such as the knighting of the king's eldest son. He compelled the widows of his barons and other vassals to marry men of his choosing or pay him a hefty fee to remain single. With the wealth pouring in from these effective but unpopular measures, John was able to pay for a navy and hire mercenary troops.

But all was to no avail. Although John masterminded a broad coalition of German and Flemish armies led by Emperor Otto IV of Brunswick, he was soundly defeated at the battle of Bouvines in 1214. It was a defining moment, not so much for English rule on the Continent (which would continue until the fifteenth century) as for England itself,

where the barons—supported by many members of the gentry and the towns—organized, rebelled, and called the king to account. At Runnymede, just south of London, in June 1215, John was forced to agree to the charter of baronial liberties called Magna Carta, or "Great Charter," so named to distinguish it from a smaller charter issued around the same time concerning royal forests.

Magna Carta was intended to be a conservative document defining the "customary" obligations and rights of the nobility and forbidding the king to break from these without consulting his barons. Beyond this, it maintained that all free men in England had certain customs and rights in common that the king was obliged to uphold. "To no one will we sell, to no one will we refuse or delay right or justice." In this way, Magna Carta documented the subordination of the king to written provisions; it implied that the king was not above the law. Copies of the charter were sent to sheriffs and other officials, to be read aloud in public places. Everyone knew what it said, and later kings continued to issue it—and have it read out—in one form or another. Though not a "constitution," Magna Carta was nevertheless an important step in the institutionalization of the English government.

Spain and France in the Making

Two states—Spain and France—started small and beleaguered but slowly grew to embrace the territory we associate with them today. In Spain, the *reconquista* was the engine driving expansion. Like the king of England, the kings from northern Spain came as conquerors. But unlike England, Christian Spain had numerous kings who competed with one another. By the mid-thirteenth century, Spain had the threefold political configuration that would last for centuries (see Map 6.5): to the east was the kingdom of Aragon; in the middle was Castile; and in the southwest was Portugal.

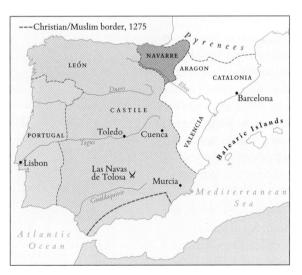

All of the Spanish kings appointed military religious orders similar to the Templars to form permanent garrisons along their ever-moving frontier with al-Andalus. But how were the kings to deal with formerly Muslim-controlled lands? When he conquered Cuenca in 1177, King Alfonso VIII of Castile established a bishopric and gave the city a detailed set of laws (*fueros*) that became the model for other conquests. Confiding enforcement to local officials, the king issued the *fueros* to codify the rights of all groups: clergy, laity, townspeople, peasants, Christians, and Jews. Thus, for example, when a Jew and a Christian litigated something, two judges were assigned, "one of whom should be Christian and the other Jewish."

The kingdom of France was smaller and more fragile than Spain; it was lucky that it did not confront an Islamic frontier or competing royal neighbors (though a glance at Map 6.4 on p. 218 shows that it was surrounded by plenty of independent

counts and dukes). When Philip II (r.1180–1223) came to the throne at the age of fifteen, his kingdom consisted largely of the Ile-de-France, a dwarf surrounded by giants. Philip seemed an easy target for the ambitions of the English king Henry II and the counts of Flanders and Champagne. Philip, however, played them off against one another. Through inheritance he gained a fair portion of the county of Flanders in 1191. Soon his military skills came to the fore as he wrenched Normandy from the king of England in 1204. This was the major conquest of his career, and in its wake he soon forced the lords of Maine, Anjou, and Poitou, once vassals of the king of England, to submit to him. A contemporary chronicler dubbed him Philip Augustus, recalling the expansionist first Roman emperor.

But Philip did more than expand; after he conquered Normandy, he integrated it into his kingdom. Norman nobles promised him homage and fealty, while Philip's royal officers went about their regular business in Normandy—taxing, hearing cases, careful not to tread on local customs, but equally careful to enhance the flow of income into the French king's treasury. Gradually, the Normans were brought into a new "French" orbit just beginning to take shape, constructed partly out of the common language of French and partly out of a new notion of the king as ruler of all the people in his territory.

Although there was never a French "common law" to supersede local ones, the French king, like the Spanish and English, succeeded in extending royal power through governmental bureaucracy. After 1194, Philip had all his decrees written down, establishing permanent repositories in which to keep them. Like the Angevin kings of England, Philip relied on members of the lesser nobility—knights and clerics, most of them educated in the city schools—to do the work of government. They served as officers of his court; as *prévôts*, officials who oversaw the king's estates and collected his taxes; and as *baillis* (or, in some places, seneschals) who not only supervised the *prévôts* but also functioned as judges, presiding over courts that met monthly, making the king's power felt locally as never before.

Of Empires and City-States

Smaller states were the norm. In that sense the empire ruled by the German king—spanning both Germany and Italy—was an oddity. In its embrace of peoples of contrasting traditions, it was more like Byzantium than like England. The location of the papacy made the empire different as well. Every other state was a safe distance away from the pope, but the empire had the pope in its throat. Tradition, prestige, and political self-respect demanded that the German king also be the emperor: Conrad III (r.1138–1152), though never actually crowned at Rome, nevertheless delighted in calling himself "August Emperor of the Romans" (while demeaning the Byzantine emperor as "King of the Greeks"). But being emperor meant controlling Italy and Rome. The difficulty was not only the papacy, defiantly opposed to another major power in Italy, but also the northern Italian communes, independent city-states in their own right.

THE REVIVAL AND DETERIORATION OF THE EMPIRE

Like Henry II of England, Frederick I Barbarossa (r. 1152-1190) came to the throne after a long period of bitter civil war between families. In Frederick's case, the feud, spawned in the wake of the Investiture Conflict, was between the Staufen and the Welfs. Contemporaries hailed Frederick as a reconciler of enemies: he was Staufen on his father's side and Welf on his mother's. (See Genealogy 6.2.) Again like the English king, Frederick held a kingdom and more. But he lacked Henry's wealth. As a result, he was forced to rely on personal loyalties, not salaried civil servants. He could not tear down princely castles as Henry had done. Instead, he conceded the German princes their powers, requiring them in turn to recognize him as the source of those powers and committing them to certain obligations, such as attending him at court and providing him with troops.

Frederick had to deal with more than the princes; he had to confront the papacy. In 1157, at the diet (assembly) of Besançon, Pope Adrian IV sent Frederick a letter that coyly referred to the imperial crown as the pope's beneficium—"benefit" or, more ominously, "fief." "A great tumult and uproar arose from the princes of the realm at so insolent a message," wrote Rahewin, a cleric who had access to many of the documents and people involved at the time. "It is said that one of the [papal] ambassadors, as though adding sword to flame, inquired: 'From whom then does he have the empire, if not from our lord the pope?' Because of this remark, anger reached such a pitch that one of [the princes] ... threatened the ambassador with his sword."8

Frederick calmed his supporters, but in the wake of this incident, he countered the "holy church" by coining an equally charged term for his empire: sacrum imperium—the sacred empire." His idea of "holiness" extended to the emperor as well. In 1165 Frederick exhumed the body of Charlemagne, enclosed the dead emperor's arm in a beautiful reliquary, and set the wheels of canonization in motion. Soon thereafter, Pascal III (1164–1168), Frederick's antipope, declared Charlemagne a saint.

Finally, Frederick had to deal with Italy. As emperor, he had claims on the whole peninsula, but he had no hope—or even interest—in controlling the south. By contrast, northern Italy beckoned: it was near his own inheritance in Swabia (in southwestern Germany), and its rich cities promised to provide him with both a compact power base and the revenues that he needed. (See Map 6.6 on p. 224.)

Taking northern Italy was, however, nothing like, say, Philip's conquest of Normandy, which was used to ducal rule. The communes of Italy were themselves states (autonomous cities, yes, but each also with a good deal of surrounding land, their contado), jealous of their liberties, rivalrous, and fiercely patriotic. Frederick made no concessions to their sensibilities. Emboldened by theories of sovereignty that had been elaborated by the revival of Roman law, he marched into Italy and, at the diet of Roncaglia (1158), demanded imperial rights to taxes and tolls. He brought the Four Doctors (see p. 191) from Bologna to Roncaglia to hear court cases. Insisting that the conquered Italian cities be governed by his own men, Frederick appointed podestà (city managers) who were often German-speaking and heavy-handed. No sooner had the podestà at Milan taken up his post, for example,

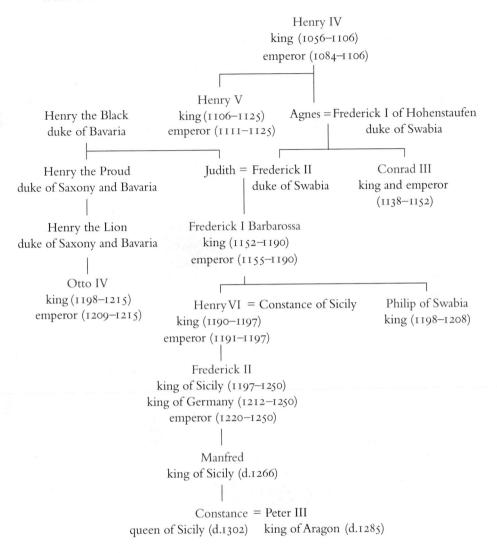

than he immediately ordered an inventory of all taxes due the emperor and levied new and demeaning labor duties on the Milanese. He even demanded that they carry the wood and stones of their plundered city to Pavia, to build new houses there. This was a double humiliation: Milan had been at war with Pavia. Expressing his imperial might in material form, Frederick commissioned a bust of himself in the guise of a Roman emperor; supported by angels, his head towered over a representation of a city, probably Rome. (See Plate 6.4.)

By 1167, most of the cities of northern Italy had joined with Pope Alexander III (1159–1181) to form the Lombard League against Frederick. Defeated at the battle of Legnano in 1176, Frederick agreed to the Peace of Venice the next year and withdrew most of his

Genealogy 6.2 Rulers of Germany and Sicily

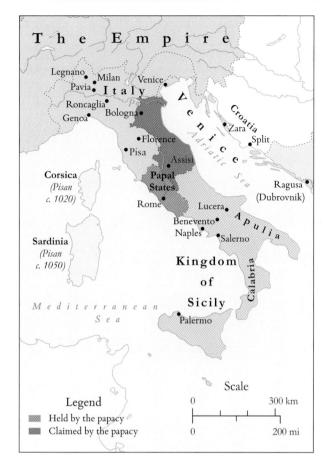

Map 6.6 Italy and Southern Germany in the Age of Frederick Barbarossa

forces from the region. But his failure in the north led him to try a southern strategy. By marrying his son Henry VI (r.1190–1197) to Constance, heiress of the Kingdom of Sicily, Frederick Barbarossa linked the fate of his dynasty to a well-organized monarchy that commanded dazzling wealth.

As we saw (p. 170), the Kingdom of Sicily had been created by Normans. In theory, it was held as a fief from the pope, who, in the treaty of Benevento (1156), recognized Norman sovereignty over a territory that extended from Sicily all the way to the southern edge of the papal states. Both multilingual and multi-religious, the Kingdom of Sicily embraced Jews, Muslims, Greeks, and Italians. Indeed, the Normans saw themselves as heirs to the Byzantines and Muslims and frequently came close to conquering Byzantium and North Africa. Taking over the Byzantine and Islamic administrative apparatuses already in place in their kingdom, they crafted a highly centralized government, with royal justices circuiting the kingdom and salaried civil servants drawn from the level of knights and townsmen.

Frederick II (1194–1250), the son of Henry VI and Constance, tried to unite Sicily, Italy, and Germany into an imperial unit. He failed: the popes, eager to carve out their own well-ordered state in the center of Italy, could not allow a strong monarch to encircle them. Declaring war on

Frederick, the papacy not only excommunicated him several times but also declared him deposed and accused him of heresy, a charge that led to declaring a crusade against him in the 1240s. These were fearsome actions. The king of France urged negotiation and reconciliation, but others saw in Frederick the devil himself. In the words of one chronicler, Frederick was "an evil and accursed man, a schismatic, a heretic, and an epicurean, who 'defiled the whole earth' (Jer. 51:25)."

That was one potent point of view. There were others, more admiring. Frederick was a poet, a patron of the arts, and the founder of the first state-supported university, which he built at Naples. His administrative reforms in Sicily were comparable to Henry II's in England: he took what he found and made it routine. In the *Constitutions of Melfi* (1231) he made sure that his salaried officials worked according to uniform procedures, required nearly all litigation to be heard by royal courts, regularized commercial privileges, and set up a system of royal taxation.

Frederick admired Islamic culture but kept most Muslims themselves a safe distance away. He knew Arabic, sometimes dressed in their garb, and sponsored translations of their writings into Latin, often using Jews as intermediaries. Some Muslims made up part of Frederick's personal bodyguard. At the same time, he gradually relocated many Sicilian Muslims to Lucera in Apulia, in effect creating an Islamic ghetto. They were convenient

for him: they paid taxes but—isolated as they were—could never threaten his rule. Although the Muslims at Lucera could not really harm the papacy either, they constituted an additional thorn in Rome's side.

The struggle with the papacy obliged Frederick to grant enormous concessions to the German princes to give himself a free hand. In effect, he allowed the princes to turn their territories into independent states. Until the nineteenth century, Germany was a mosaic, not of city-states like Italy, but of principalities. Between 1254 and 1273 the princes, split into factions, kept the German throne empty by electing two different foreigners who spent their time fighting each other. Strangely enough, it was during this low point of the German monarchy that the term "Holy Roman Empire" was coined. In 1273, the princes at last united and elected a German, Rudolf I (r.1273–1291), whose family, the Habsburg, was new to imperial power. Rudolf used the imperial title to help him gain Austria for his family. But he did not try to assert his power in Italy. For the first time, the word "emperor" was freed from its association with Rome.

The Kingdom of Sicily was similarly parceled out. The papacy tried to ensure that the Staufen dynasty would never rule there again by calling upon Charles of Anjou, brother of the king of France, to take it over in 1263. Undeterred, Frederick's granddaughter, Constance, married to the king of Aragon (Spain), took the proud title "Queen of Sicily." In 1282, the Sicilians revolted against the Angevins in the uprising known as the "Sicilian Vespers," begging the Aragonese for aid. Bitter war ensued, ending only in 1302, when the Kingdom of Sicily was split: the island became a Spanish outpost, while its mainland portion (southern Italy) remained under Angevin control.

A HUNGARIAN MINI-EMPIRE

Unlike the Kingdom of Sicily, the Kingdom of Hungary reaped the fruits of a period of expansion. In the eleventh century, having solidified their hold along the Danube River (the center of their power), the kings of Hungary moved north and east. In an arc ending at the Carpathian Mountains, they established control over a multi-ethnic population of Germans and Slavs. In the course of the twelfth century, the Hungarian kings turned southward, taking over Croatia and fighting for control over the coastline with the powerful Republic of Venice. They might have dominated the whole eastern Adriatic had not the Kingdom of Serbia re-established itself west of its original site, eager for its own share of seaborne commerce.

Plate 6.4 Bust of Frederick Barbarossa (1165). Made in Aachen, and thus associated with Charlemagne, this bronzegilt bust of Frederick shows him wearing an imperial fillet on his short curly hair. The inscriptions were added later by Frederick's godfather, Otto, who transformed the bust into a reliquary and gave it to a religious house at Cappenberg that he had co-founded and eventually led.

THE TRIUMPH OF THE CITY-STATES

That Venice was strong enough to rival Hungary in the eastern Adriatic was in part due to the confrontations between popes and emperors in Italy, which weakened both sides. The winners of those bitter wars were not the papacy, not the Angevins, not even the Aragonese, and certainly not the emperors. The winners were the Italian city-states. Republics in the sense that a high percentage of their adult male population participated in their government, they were also highly controlling. For example, to feed themselves, the communes prohibited the export of grain while commanding the peasants in the contado—the rural area around the city—to bring a certain amount of grain to the cities by a certain date each year. City governments told the peasants which crops to grow and how many times per year they should plow the land. The state controlled commerce as well. At Venice, exceptional in lacking a contado but controlling a vast maritime empire instead, merchant enterprises were state run, using state ships. When Venetians went off to buy cotton in the Levant, they all had to offer the same price, determined by their government back home.

Italian city-state governments outdid England, Sicily, and France in their bureaucracy and efficiency. While other governments were still taxing by "hearths," the communes devised taxes based on a census (catasto) of property. Already at Pisa in 1162 taxes were being raised in this way; by the middle of the thirteenth century, almost all the communes had such a system in place. But even efficient methods of taxation did not bring in enough money to support the two main needs of the commune: paying their officials and, above all, waging war. To meet their high military expenses, the communes created state loans, some voluntary, others forced. They were the first in Europe to do so.

CULTURE AND INSTITUTIONS IN TOWN AND COUNTRYSIDE

Organization and accounting were the concerns of lords outside Italy as well. But there, few adopted the persona of the business tycoon; the prevailing ideal was the chivalrous knight. Courts were aristocratic centers, organized not only to enhance but also to highlight the power of lord and lady. Meanwhile, in the cities, guilds constituted a different kind of enclave, shutting out some laborers and women but giving high status to masters. Universities, too, were a sort of guild. Artistic creativity, urban pride, and episcopal power were together embodied in Gothic cathedrals.

Inventorying the Countryside

Not only kings and communes but also great lords everywhere hired literate agents to administer their estates, calculate their profits, draw up accounts, and make marketing decisions. Money financed luxuries, to be sure, but even more importantly it enhanced aristocratic honor, so dependent on personal generosity, patronage, and displays of wealth. In the late twelfth century, when some townsmen could boast fortunes that rivaled the riches of the landed nobility, noble extravagance tended to exceed income. Most aristocrats went into debt.

The nobles' need for money coincided with the interests of the peasantry, whose numbers were expanding. The solution was the extension of farmland. By the middle of the century, isolated and sporadic attempts to bring new land into cultivation had become regular and coordinated. Great lords offered special privileges to peasants who would do the backbreaking work of plowing marginal land. In 1154, for example, the bishop of Meissen (in Germany) proclaimed a new village and called for peasants from Flanders to settle there. Experts in drainage, the colonists received rights to the swampland they reclaimed. They owed only light monetary dues to the bishop, who nevertheless expected to reap a profit from their tolls and tithes. Similar encouragement came from lords throughout Europe, especially in northern Italy, England, Flanders, and Germany. In Flanders, where land was regularly inundated by seawater, the great monasteries sponsored drainage projects, and canals linking the cities to the agricultural hinterlands let boats ply the waters to virtually every nook and cranny of the region.

Sometimes free peasants acted on their own to clear land and relieve the pressure of overpopulation, as when the small freeholders in England's Fenland region cooperated to build banks and dikes to reclaim the land that led out to the North Sea. Villages were founded on the drained land, and villagers shared responsibility for repairing and maintaining the dikes even as each peasant family farmed its new holding individually.

On old estates, the rise in population strained to its breaking point the manse organization that had developed in Carolingian Europe, where each household was settled on the land that supported it. Now, in the twelfth century, many peasant families might live on what had been, in the ninth century, the manse of one family. Labor services and dues had to be recalculated, and peasants and their lords often turned services and dues into money rents, payable once a year. With this change, peasant men gained more control over their plots—they could sell them, will them to their sons, or even designate a small portion for their daughters. However, for these privileges they had either to pay extra taxes or, like communes, join together to buy their collective liberty for a high price, paid out over many years to their lord. Peasants, like town citizens, gained a new sense of identity and solidarity as they bargained with a lord keen to increase his income at their expense.

The Culture of the Courts

Great lords needed money to support their courtiers. When they traveled, they did so with a whole retinue of relatives, vassals, officials, priests, knights, probably a doctor, and very likely an entertainer. In the south of France a considerable number of men and women made their way as court troubadours (or, in the case of women, *trobairitz*). They were both poets and musicians, singing in Old Occitan, the vernacular of the region. Duke William IX of Aquitaine (1071–1126) is usually considered the first of the troubadours. But there were certainly people singing his kind of poetry in both Arabic and Hebrew in al-Andalus. One example is the *Tale of Bayad and Riyad* (see above, p. 212). Although Christian and Islamic cultures confronted one another violently at this time, they also seem to have learned from one another, as in this instance. In the south of France, there were many troubadours; they were welcomed at major courts as essential personnel.

Bernart de Ventadorn (fl. c.1147–1170) was among them. Here is one of his verses:

Qan vei la lauzeta mover de joi sas alas contra·l rai, que s'oblid'e·is laissa cazer per la doussor c'al cor li vai, ai! Tant grans enveia m'en ve de cui que veia jauzion, meravillas ai car desse lo cors de desirier no·m fon. When I see the lark beat his wings With joy in the rays of the sun and forget himself and fall In the warmth that fills his heart, Oh, I feel so great an envy Of one I see who's merry I wonder that my heart Does not melt with desire.¹⁰

The rhyme scheme *seems* simple: *mover* goes with *cazer*, *rai* with *vai*. Then comes a new pattern: *ve* rhymes with *desse* and *jauzion* with *fon*. But consider that all seven verses that come after this one have that same *-er*, *-ai*, *-e*, *-on* pattern. Enormous ingenuity is required for such a feat. The poem is extremely complex and subtle, not only in rhyme and meter but also in word puns and allusions, essential skills for a composer whose goal was to dazzle his audience with brilliant originality.

In rhyme and meter, troubadour songs resembled Latin liturgical chants of the same region and period. Clearly, lay and religious cultures overlapped. They overlapped in musical terms as well, in the use, for example, of plucking and percussive instruments. Above all, they overlapped in themes: they spoke of love. The monks (as we have seen with the Cistercians, on p. 200) thought about the love between God and mankind; the troubadours thought about erotic love. Yet the two were deliciously entangled. The verse in which Bernart envies the lark continues:

Oh, I thought I knew so much About love, but how little I know! I cannot stop loving her Though I know she'll never love me. I get no help with my lady From God or mercy or right."

Putting his lady in the same stanza as God elevated her to the status of a religious icon, but at the same time it degraded God: should the Lord really help Bernart with his seduction? Finally, it played with the association of "my lady" with the Virgin Mary, the quintessential "our Lady."

Female troubadours, the *trobairitz*, flirted with the same themes. La Comtessa de Dia (fl. late 12th–early 13th cent.) sang,

I've been in heavy grief
For a knight that once was mine,
And I want it to be forever known
That I loved him too much.
I see now that I'm betrayed
For not giving him my love.
Bemused, I lie in bed awake;
Bemused, I dress and pass the day.¹²

Unlike the Byzantine lovers Drosilla and Charikles or the Andalusian lovers Bayad and Riyad, troubadour lovers rarely ended up happily ever after. But in other ways there were similarities, especially in the authors' appreciation of refinement, feeling, and wit, all summed up, in the case of the troubadours, in the word *cortezia*, "courtliness" or "courtesy."

Ever since the term "courtly love" was popularized by Gaston Paris in 1883, historians and literary critics have used it to talk about medieval romantic literature. For Paris, it meant the poet's adulterous love for a married woman of far higher rank. In the 1960s and 1970s, however, the term was roundly criticized by scholars who judged that medieval authors were ironic when and if they praised profane love. Nowadays critics tend to be more comfortable talking about fin'amor (refined or pure love), a phrase found in some medieval literature itself. But as Linda Paterson has pointed out, the meaning of even that term varied from poet to poet. In fact, the troubadours sang about many sorts of love: some boasted of sexual conquests; others played with the notion of equality between lovers; still others sang of love and desire as the source of virtue.

From southern France, Catalonia, and northern Italy, the lyric love song spread to northern France, England, and Germany. Here Occitan was a foreign language, so other vernaculars were used: the *minnesinger* (literally, "love singer") sang in German; the *trouvère* sang in the Old French of northern France. In northern France another genre of poetry grew up as well, the *fabliau* (pl. *fabliaux*) poking fun at nobles, priests, and pretentiousness and stupidity in general.

Some troubadours, like the poet Bertran de Born (fl. second half of 12th cent.), wrote about war, not love:

Trumpets, drums, standards and pennons And ensigns and horses black and white Soon we shall see, and the world will be good.¹³

But warfare was more often the subject of another kind of poem, the *chanson de geste*, "song of heroic deeds." Long recited orally, these vernacular poems appeared in written form at about the same time as troubadour poetry and, like them, the *chansons de geste* played with aristocratic codes of behavior, in this case on the battlefield rather than at court.

The *chansons de geste* were responding to social and military transformations. By the end of the twelfth century, nobles and knights had begun to merge into one class, threatened from below by newly rich merchants and from above by newly powerful kings. At the same time, the knights' importance in battle—unhorsing one another with lances and long swords and taking prisoners rather than killing their opponents—was waning in the face of mercenary infantrymen who wielded long hooks and knives that ripped easily through chain mail, killing their enemies outright. A knightly ethos and sense of group solidarity emerged within this changed landscape. Like Bertran de Born, the *chansons de geste* celebrated "trumpets, drums, standards and pennons." But they also examined the moral issues that confronted knights, taking up the often contradictory values of their society: love of family vied with fealty to a lord; desire for victory clashed with pressures to compromise.

The *chansons de geste*, later also called "epics," focused on battle; other long poems, later called "romances," explored relationships between men and women. Enormously popular in the late twelfth and early thirteenth centuries, romances took up such themes as the tragic love between Tristan and Isolde and the virtuous knight's search for the Holy Grail. Above all, romances were woven around the many fictional stories of King Arthur and his court. In one of the earliest, Chrétien de Troyes (*fl. c.*1150–1190) wrote about the noble and valiant Lancelot, in love with Queen Guinevere, wife of Arthur. Finding a comb bearing some strands of her radiant hair, Lancelot is overcome:

He gently removed the queen's Hair, not breaking a single Strand. Once a man Has fallen in love with a woman No one in all the world Can lavish such wild adoration Even on the objects she owns, Touching them a hundred thousand Times, caressing with his eyes, His lips, his forehead, his face. And all of it brings him happiness,

Fills him with the richest delight; He presses it into his breast, Slips it between his shirt And his heart—worth more than a wagon-Load of emeralds or diamonds, Holy relics that free him Of disease and infection: no powdered Pearls and ground-up horn And snail shells for him! No prayers To Saints Martin and James: his faith In her hair is complete, he needs No more.14

By making Guinevere's hair an object of adoration, a sort of secular relic, Chrétien here not only conveys the depths of Lancelot's feeling but also pokes a bit of fun at his hero. When Lancelot is on the point of killing an evil opponent, he overhears Guinevere say that she wishes the "final blow be withheld." Then

Nothing in the world could have made him Fight, or even move, No matter if it cost his life. 15

Such perfect obedience and self-restraint even in the middle of a bloody battle was part of the premise of "chivalry." The word, deriving from the French cheval ("horse"), emphasized above all that the knight was a horseman, a warrior of the most prestigious sort. Perched high in the saddle, his heavy lance couched in his right arm, the knight was an imposing and menacing figure. Chivalry made him gentle, gave his battles a higher meaning, whether for love of a lady or of God. The chivalric hero was constrained by courtesy, fair play, piety, and devotion to an ideal. Did real knights live up to these ideals? They knew perfectly well that they could not and that it would be absurd if they tried to do so in every particular. But they loved playing with the idea. They were the poets' audience, and they liked to think of themselves as fitting into the tales. When William the Marshal, advisor of English kings, died in 1219, his biographer wrote of him as a model knight, courteous with the ladies, brave on the battlefield.

Urban Guilds Incorporated

Courtly "codes" were poetic and playful. City codes were drier but no less compelling. In the early thirteenth century, guilds drew up statutes to determine dues, regulate working hours, fix wages, and set standards for materials and products. Sometimes they came into conflict with town government; this happened, for example, to some bread-bakers'

guilds in Italy, where communes considered bread too important a commodity to be left to its producers. At other times, the communes supported guild efforts to control wages, reinforcing guild regulations with statutes of their own. When great lords rather than communes governed a city, they too tried to control and protect the guilds. King Henry II of England, for example, eagerly gave some guilds in his Norman duchy special privileges so that they would depend on him.

There was nothing democratic about guilds. To make cloth, the merchant guild that imported the raw wool was generally the overseer of the other related guilds—the shearers, weavers, fullers (the workers who beat the cloth to shrink it and make it heavier), and dyers. In Florence, professional guilds of notaries and judges ranked in prestige and power above craft guilds. Within each guild was another kind of hierarchy. Apprentices were at the bottom, journeymen and -women in the middle, and masters at the top. Young boys and occasionally girls were the apprentices; they worked for a master for room and board, learning a trade. An apprenticeship in the felt-hat trade in Paris, for example, lasted seven years. After their apprenticeship, men and women often worked many years as day laborers, hired by a master when he needed extra help. Some men, but almost no women, worked their way up to master status. They were the ones who dominated the offices and set guild policies.

The codification of guild practices and membership tended to work against women, who were slowly being ousted from the world of workers during the late twelfth century. In Flanders, for example, as the manufacture of woolen cloth shifted from rural areas to cities, and from light to heavy looms, women were less involved in cloth production than they had been on traditional manors. Similarly, water- and animal-powered mills took the place of female hand labor to grind grain into flour—and most millers were male. Nevertheless, at Paris, guild regulations for the silk fabric makers assumed that the artisans would be women:

No journeywoman maker of silk fabric may be a mistress | the female equivalent of "master"] of the craft until she has practiced it for a year and a day.... No mistress of the craft may weave thread with silk, or foil with silk.... No mistress or journeywoman of the craft may make a false hem or border. 16

By contrast, universities were all-male guilds. (The word *universitas* is Latin for "guild.") Referring at first to organizations of masters and students, the term eventually came to apply to the school itself. At the beginning of the thirteenth century, the universities regulated student discipline, scholastic proficiency, and housing while determining the masters' behavior in equal detail. At the University of Paris, for example, the masters were required to wear long black gowns, follow a particular order in their lectures, and set the standards by which students could become masters themselves. The University of Bologna was unique in having two guilds, one of students and one of masters. At Bologna, the students participated in the appointment, payment, and discipline of the masters.

The University of Bologna was unusual because it was principally a school of law and the students were generally older men well along in their careers (often in imperial service) and used to wielding power. At the University of Paris, by contrast, young students predominated, drawn by its renown in the liberal arts and theology. The universities of Salerno (near Naples) and Montpellier (in southern France) specialized in medicine. Oxford, once a sleepy town where students clustered around one or two masters, became a center of royal administration; its university soon developed a reputation for teaching the liberal arts, theology, science, and mathematics.

The curriculum of each university depended on its specialty and its traditions. At Paris in the early thirteenth century, students spent at least six years studying the liberal arts before gaining the right to teach. If they wanted to specialize in theology, they attended lectures on the subject for at least another five years. With books both expensive and hard to find, lectures were the chief method of communication. These were centered on important texts: the master read an excerpt aloud, delivered his commentary on it, and disputed any contrary commentaries that rival masters might have proposed. Students committed the lectures to memory.

Within the larger association of the university, students found more intimate groups with which to live: "nations," linked to the students' place of origin. At Bologna, for example, students belonged to one of two nations, the Italians and the non-Italians. Each nation protected its members, wrote statutes, and elected officers.

Both masters and students were considered part of another group: clerics. This was an outgrowth of the original, church-related, purposes of the schools, and it had two important consequences. First, there were no university women. And second, university men were subject to church courts rather than the secular jurisdiction of towns or lords. Many universities could also boast generous privileges from popes and kings, who valued the services of scholars. The combination of clerical status and special privileges made universities virtually self-governing corporations within the towns. This sometimes led to friction. When the townsmen of Oxford tried to punish a student suspected of killing his mistress, the masters protested by refusing to teach and leaving the city. Such disputes are called "town against gown" struggles because students and masters wore gowns (the distant ancestors of today's graduation gowns). But since university towns depended on scholars to patronize local taverns, shops, and hostels, town and gown normally learned to negotiate with one another to their mutual advantage.

Gothic Style

Certainly town and gown agreed on building style: by c.1200, "Gothic" (the term itself comes from the sixteenth century) was the architecture of choice. Beginning as a variant of Romanesque in the Ile-de-France, Gothic style quickly took on an identity of its own. Gothic architects tried to eliminate heavy walls by enlivening them with sculpture or piercing them with glass, creating a soaring feel by using pointed arches. Suger, abbot of

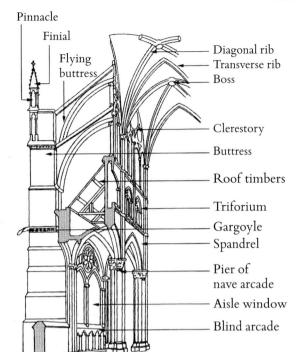

Figure 6.1 Elements of a Gothic Church. This drawing of a section through the nave at Amiens shows the most important features of a Gothic church.

Plate 6.5 (facing page) Notre Dame of Paris, Exterior (begun 1163). To take the weight of the vault off the walls and open them to glass and light, the architects of Gothic churches such as Notre Dame used flying buttresses, which sprang from the top of the exterior wall. In this photograph they look rather like oars jutting out from the church. You can most easily see them on the apse, to the right.

Saint-Denis and the promoter of Capetian royal power (see p. 188), was the style's first sponsor. When he rebuilt portions of his church around 1135, he tried to meld royal and ecclesiastical interests and ideals in stone and glass. At the west end of his church, the point where the faithful entered, Suger decorated the portals with figures of Old Testament kings, queens, and patriarchs, signaling the links between the present king and his illustrious predecessors. Rebuilding the interior of the east end of his church as well, Suger used pointed arches and stained glass to let in light, which Suger believed to be God's own "illumination," capable of transporting the worshiper from the "slime of earth" to the "purity of Heaven."

Gothic was an urban architecture, reflecting—in its grand size, jewel-like windows, and bright ornaments—the aspirations, pride, and confidence of rich and powerful merchants, artisans, and bishops. The Gothic cathedral, which could take centuries to complete, was often the religious, social, and commercial focal point of a city. Funds for these buildings

might come from the bishop himself, from the canons (priests) who served his cathedral, or from townsmen. Notre Dame of Paris (Plate 6.5) was begun in 1163 by Bishop Maurice de Sully, whose episcopal income from estates, forests, taxes, and Parisian properties gave him plenty of money to finance the tallest church of its day. Under his successors, the edifice took shape with three stories, the upper one filled with stained glass. Bristling on the outside with flying buttresses—the characteristic "look" of a French Gothic church—it gave no hint of the light and calm order within (see Plate 6.6). But at Mantes-la-Jolie (about twenty-five miles west of Paris), it was the merchant guild and the Capetian king together—rather than a bishop—who sponsored the building of the new collegiate church.

However financed, Gothic cathedrals were community projects, enlisting the labor and support of a small army of quarrymen, builders, carpenters, and glass cutters. Houses of relics, they attracted pilgrims as well. At Chartres Cathedral, proud home of the Virgin's tunic, crowds thronged the streets, the poor buying small lead figures of the Virgin, the rich purchasing wearable replicas of her tunic.

The technologies that made Gothic churches possible were all known before the twelfth century. The key elements included ribbed vaulting, which could give a sense of precision and order (as at Notre Dame; consider Plate 6.6 again, concentrating on the orderly rhythm of piers and ribs) or of richness and playful inventiveness. Flying buttresses took the weight of the vault off the walls, allowing most of the wall to be cut away and the open spaces filled by glass. (See Figure 6.1.) Pointed arches made the church appear to surge heavenward.

By the mid-thirteenth century, Gothic architecture had spread to most of Europe. Yet the style varied by region, most dramatically in Italy. San Francesco in Assisi is an example of what *Italian* architects meant by a Gothic church. It has high stained glass windows and a

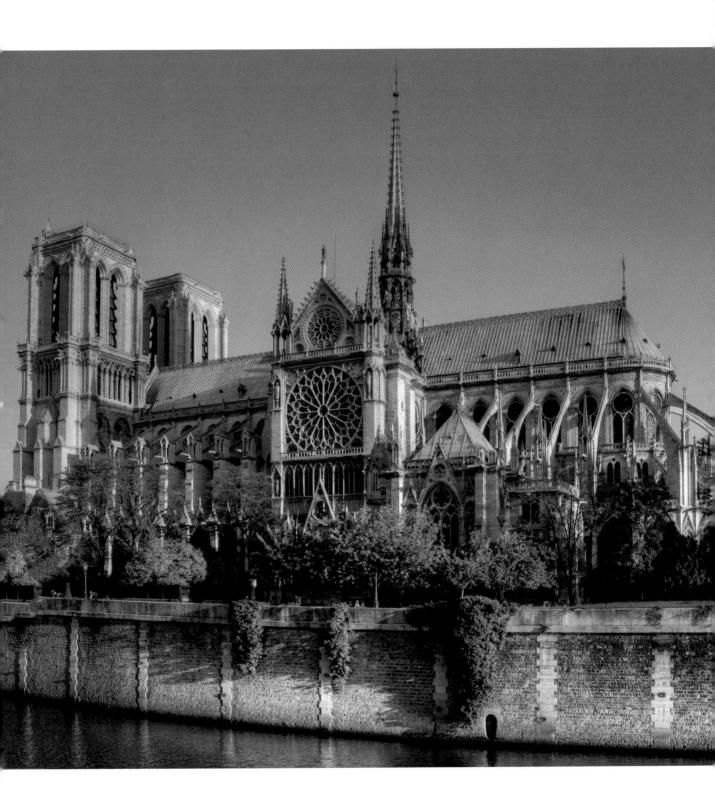

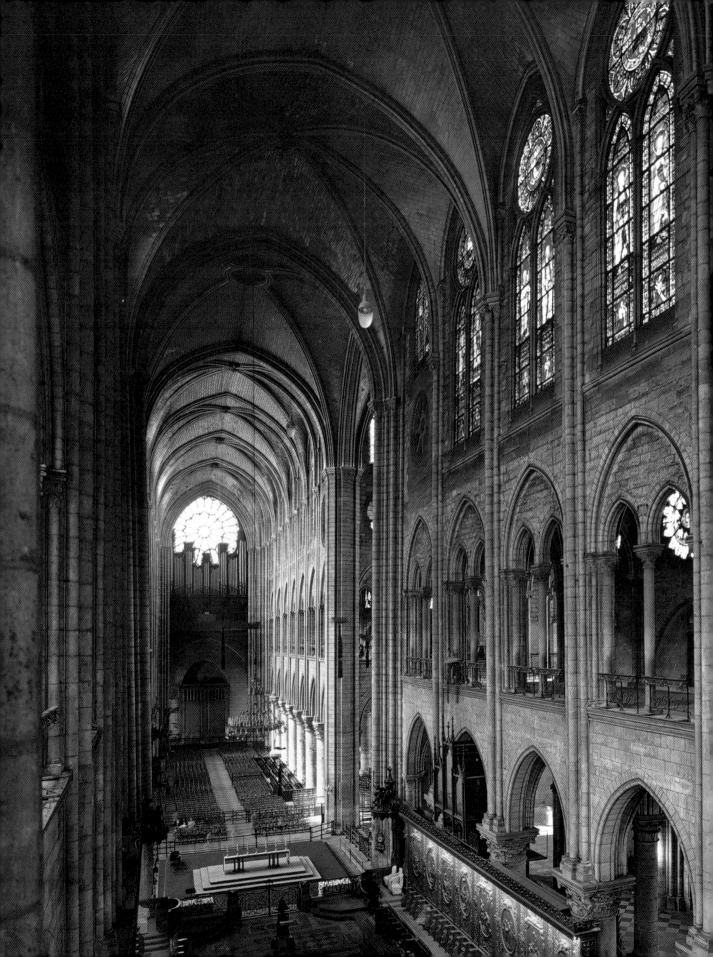

pointed, ribbed vault (see Plate 6.7 on p. 238.) But the focus is not on light and height but on walls, painted decoration, and well-proportioned space. With flying buttresses rare and portal sculpture unobtrusive, Italian Gothic churches convey a spirit of spare and quiet beauty.

Gothic art, both painting and sculpture, echoed and decorated the Gothic church. While Romanesque sculpture played upon a flat surface, Gothic figures were liberated from their background, turning, bending, and interacting. At Bamberg Cathedral in Germany, the figures on the viewer's left on the tympanum above the north portal turn, smile, and hold hands. (See Plate 6.8 on p. 240.) Sculpture like this was meant to be "read" for its meaning. These people are rejoicing because they are among the saved. On the other side of Christ—on his left side—are the damned. With exaggerated gestures, stupid grins, and frivolous dancing, they pay no attention to the little devil pulling them down to Hell.

Plate 6.6 (facing page) Notre Dame of Paris, Interior (begun 1163). Compare this interior with that of Autun in Plate 5.9 (p. 197). Autun, a typical Romanesque church, has a barrel vault (though slightly pointed) and small windows at the top. By contrast, the Gothic cathedral of Notre Dame (shown here) has a pointed ribbed vault that soars above the nave, while light from large stained-glass windows suffuses the interior.

The Church in the World

Just as the church was taking new interest in the human dimension of the saved and the damned, so it concerned itself as never before with the lives of ordinary Christians. Under Innocent III (1198–1216)—the first pope to be trained at the city schools and to study both theology and law—the papacy gained a newly grand sense of itself. Innocent considered himself to rule in the place of Christ the King; secular kings and emperors existed simply to help the pope, who was the real lawmaker—the maker of laws that would lead to moral reformation. In the thirteenth century, the church sought to define Christianity, embracing some doctrines, rejecting others, and turning against Jews and Muslims with new vigor.

The Fourth Lateran Council (1215)

A council was the traditional place to declare church law, and that is what Innocent intended when he convened one at the Lateran Palace at Rome in 1215. Presided over by the pope himself, the Fourth Lateran Council produced a comprehensive set of canons—most of them prepared by the pope's committees beforehand—to reform both clergy and laity and to protect both from the perceived threats of outsiders.

For the lives of ordinary laymen and -women, perhaps the most important canons concerned the sacraments. The Fourth Lateran Council required Christians to take Communion—i.e., receive the Eucharist—at Mass and to confess their sins to a priest at least once a year. Marriage was declared a sacrament, and bishops were assigned jurisdiction over marital disputes. Forbidding secret marriages, the council expected priests to uncover evidence that might impede a marriage. There were many impediments: people were not allowed to marry their cousins, nor anyone related to them by godparentage, nor anyone related to them through a former marriage. Children conceived within clandestine or forbidden marriages were to be considered illegitimate; they could not inherit property from their parents, nor could they become priests.

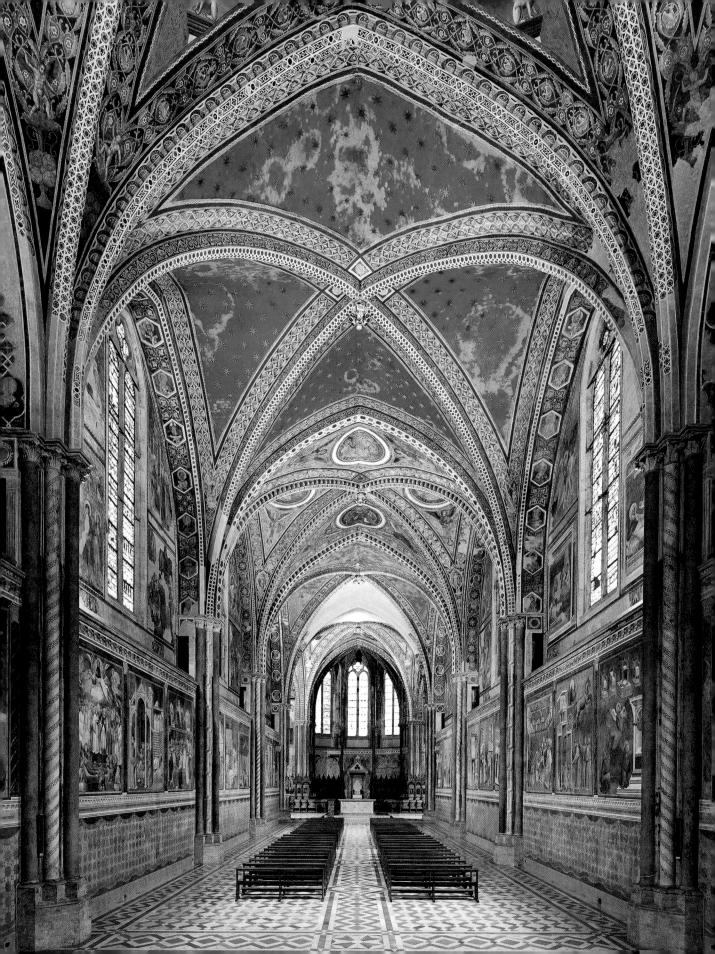

Like the code of chivalry, the rules of the Fourth Lateran Council about marriage worked better on parchment than in life. Well-to-do London fathers included their bastard children in their wills. On English manors, sons conceived out of wedlock regularly took over their parents' land. The prohibition against secret marriages was only partially successful. Even churchmen had to admit that the consent of both parties made a marriage valid.

The most important sacrament was the Mass, the ritual in which the bread and wine of the Eucharist was transformed into the flesh and blood of Christ. In the twelfth century a newly rigorous formulation of this transformation declared that Christ's body and blood were truly present in the bread and wine on the altar. The Fourth Lateran Council not only adopted this as church doctrine but also explained it by using a technical term coined by twelfth-century scholars. The bread and wine were "transubstantiated": although the Eucharist continued to *look* like bread and wine, after the consecration during the Mass the bread became the actual body and the wine the real blood of Christ. The council's emphasis on this potent event strengthened the role of the priest, for only he could celebrate this mystery (the transformation of ordinary bread and wine into the flesh of Christ) through which God's grace was transmitted to the faithful.

The Embraced and the Rejected

As the Fourth Lateran Council provided rules for good Christians, it turned against all others. Some canons singled out Jews and heretics for punitive treatment; others were directed against Byzantines and Muslims. These laws were of a piece with wider movements within the church. With the development of a papal monarchy that confidently declared a single doctrine and the laws pertaining to it, dissidence was perceived as heresy, non-Christians seen as treacherous.

NEW GROUPS WITHIN THE FOLD

The Fourth Lateran Council prohibited the formation of new religious orders. It recognized that the trickle of new religious groups—the Carthusians is one example—of the early twelfth century had become a torrent by 1215. Only a very few of the more recent movements were accepted into the church, among them the Dominicans, the Franciscans, and the Beguines.

Saint Dominic (1170–1221), founder of the Dominican order, had been a priest and regular canon (following the *Rule* of Saint Augustine) in the cathedral church at Osma, Spain. On an official trip to Denmark, while passing through southern France in 1203, Dominic and his companion, Diego, reportedly converted a heretic with whom they lodged. This was a rare success; most anti-heretic preachers were failing miserably around this time because—traveling in finery, riding on horseback, and followed by a retinue—they had no moral standing. Dominic, Diego, and their followers determined to reject

Plate 6.7 (facing page) San Francesco at Assisi (Upper Church: completed by 1253). Influenced by French Gothic, this church of the Franciscan order in Assisi nevertheless asserts a different aesthetic. Compare it with Notre Dame in Plate 6.6 on p. 236, where the piers and ribs mark off units of space (called "bays"). By contrast, San Francesco presents a unified space. Notre Dame celebrated its soaring height; San Francesco balanced its height by its generous width. Unlike French Gothic, Italian Gothic churches gloried in their walls; at San Francesco they were decorated in the 1280s and 1290s with frescoes, the most famous of which illustrated the life and legend of Saint Francis (for whom see below, pp. 240-41).

Plate 6.8 Bamberg Cathedral, Tympanum of "The Princes' Door" (c.1230–1235). While the figures in this sculpture are meant to be symbols of a transcendental reality—the Last Judgment—they also display a new naturalism. Like the people depicted on the ancient Roman Euhodus sarcophagus (see Plate 1.4 on p. 16), the Bamberg figures have weight; they interact; they show their feelings. And via those feelings (some quietly joyful, others boisterous and rowdy) they demonstrate their very different moral characters.

material riches. Gaining a privilege from the pope to preach and teach, they went about on foot, in poor clothes, and begged for their food. They took the name "friars," after the Latin word for "brothers." Because their job was to dispute, teach, and preach, the Dominicans quickly became university men. Even in their convents they established schools requiring their recruits to follow a formal course of studies. Already by 1206 they had established the first of many Dominican female houses. Most of these followed the same *Rule*, but their relationship to the Dominican order was never codified. Married men and women associated themselves with the Dominicans by forming a "Tertiary" order.

Unlike Dominic, Saint Francis (1181/1182–1226) was never a priest. Indeed, he was on his way to a promising career as a cloth merchant at Assisi when he experienced a complete conversion. Clinging to poverty as if, in his words, "she" were his "lady" (thus borrowing the vocabulary of chivalry), he accepted no money, walked without shoes, wore only one coarse tunic, and refused to be confined even in a monastery. He and his followers (who were also called "friars") spent their time preaching, ministering to lepers, and doing manual labor. As Francis recounted in his *Testament*, "And those who came to receive life

gave whatever they had to the poor and were content with one tunic, patched inside and out, with a cord and short trousers. We desired nothing more."17

Normally only bishops had authority to preach and to allow others to preach. But Francis's little group—with the help of the bishop of Assisi—found acceptance at the papal court, and around 1209 Pope Innocent authorized it to preach penance. Thereafter, the Order grew and dispersed. Soon there were Franciscans throughout Italy, France, Spain, the Crusader States, and later Germany, England, Scotland, Poland, and elsewhere. Always they were drawn to the cities. Sleeping in "convents" on the outskirts of the towns, the Franciscans became a regular part of urban community life as they preached to crowds and begged their daily bread. Early converts included women: in 1211 or 1212 Francis converted the young noblewoman Clare. She joined a community of women at San Damiano, a church near Assisi. Clare wanted the Damianites to follow the rule and lifestyle of the friars. But the pope disapproved of the women's worldly activities, and the many sisters following Francis—by 1228 there were at least twenty-four female communities inspired by him in central and northern Italy—were confined to cloisters under the Rule of Saint Benedict. In the course of the thirteenth century, laypeople, many of them married, formed their own Franciscan order, the "Tertiaries." They dedicated themselves to works of charity and to daily church attendance. Eventually the Franciscans, like the Dominicans, added learning and scholarship to their mission, becoming part of the city universities.

The Beguines were even more integral to town life. In the cities of northern France, the Low Countries, and Germany, these women worked as launderers, weavers, and spinners. (Their male counterparts, the "Beghards," were far less numerous.) Choosing to live together in informal communities, taking no vows, and being free to marry if they wished, they dedicated themselves to simplicity and piety. If outwardly ordinary, however, inwardly their religious lives were often emotional and ecstatic. Some were mystics, seeking union with God. Mary of Oignies (1177-1213), for example, imagined herself with the Christ Child, who "nestled between her breasts like a baby.... Sometimes she kissed him as though He were a little child and sometimes she held Him on her lap as if He were a gentle lamb."18

Defining the Other

The heretical groups that Dominic confronted in southern France were derisively called Albigensians or Cathars by the church. But they referred to themselves, among other things, as "good men" and "good women." Particularly numerous in urban, highly commercialized regions such as southern France, Italy, and the Rhineland, the good men were dissatisfied with the reforms achieved by the Gregorians and resented the church's newly centralized organization. Precisely what these dissidents believed may be glimpsed only with difficulty, largely through the reports of those who questioned and persecuted them. At a meeting in Lombers (see Map 6.7 on p. 245) in 1165 to which some of them apparently voluntarily agreed to come, they answered questions put to them by the bishop of Lodève. Asked about the Eucharist, for example, "they answered that whoever consumed it worthily was saved, but the unworthy gained damnation for themselves; and they said that it could be consecrated [that is, transformed into Christ's body and blood] by a good man, whether clerical or lay." When questioned about whether "each person should confess his sins to priests and ministers of the church—or to any layman," they responded that it "would suffice if they confessed to whom they wanted." On this and other questions, then, the good men of Lombers had notions at variance with the doctrines that the post-Gregorian church was proclaiming. Above all, their responses downgraded the authority and prerogatives of the clergy. When the bishop at Lombers declared the good men heretics, "the heretics answered that the bishop who gave the sentence was the heretic and not they, that he was their enemy and a rapacious wolf and a hypocrite...."

By the time that Dominic confronted the southern French dissidents, church leaders were in crisis mode. They dubbed the dissidents "dualists," accusing them of believing that the world was torn between two great forces, one good and the other evil. This was a term and an idea churchmen knew very well from their reading: Saint Augustine had briefly flirted with the dualists of his own day—the Manichees—before decisively breaking with them. (See above, p. 9.) Moreover, Western churchmen were well aware that one of the reasons why the Byzantine church and state had clamped down on heretics in the twelfth century was to counter groups who questioned the sacraments and the institutional church—and who were also reputedly dualists. Classifying heretics as such created a powerful new tool of persecution and coercion that came to be used by both ecclesiastical and secular rulers.

Some of the good men were no doubt dualists. But there were many shades of dualism—many "catharisms"—ranging from the innocuous notion that spiritual things were pure and eternal, while materials things were not, to the radical claim, long ago made by the Manichees, that the devil had created the world and all that was in it, including human beings. The Christianity espoused by the church hierarchy itself had many dualist elements. In some ways, therefore, the issue of the good men's dualism overlooked the most important point for them: that their doctrine was largely a by-product of their determination to pursue poverty and simplicity—to live like the apostles—and to adhere literally to the teachings of Christ as contained in the Gospels.

Other heretical groups were condemned not on doctrinal grounds but because they allowed their lay members to preach without official church authorization. At Lyon (in southeastern France) in the 1170s, for example, a rich merchant named Waldo decided to take literally the Gospel message, "If you wish to be perfect, then go and sell everything you have, and give to the poor" (Matt. 19:21). The same message had inspired countless monks and would worry the church far less several decades later, when Saint Francis established his new order. But when Waldo went into the street and gave away his belongings, announcing, "I am not out of my mind, as you think," 20 he scandalized not only the bystanders but the church as well. Refusing to retire to a monastery, Waldo and his followers, men and women called Waldensians, lived in poverty and went about preaching,

quoting the Gospel in the vernacular so that everyone would understand them. But the papacy rejected Waldo's bid to preach freely; and the Waldensians—denounced, excommunicated, and expelled from Lyon—wandered to Languedoc, Italy, northern Spain, and the Mosel valley, just east of France.

EUROPEAN AGGRESSION WITHIN AND WITHOUT

Jews, heretics, Muslims, Byzantines, and pagans: all felt the heavy hand of Christian Europeans newly organized, powerful, and zealous. Meanwhile, even the undeniable Catholicism of Ireland did not prevent its takeover by England.

The Jews

Prohibited from joining guilds, Jews increasingly were forced to take the one job Christians could not have: lending on credit. Even with Christian moneylenders available (for some existed despite official prohibitions), lords borrowed from Jews. Then, relying on dormant anti-Jewish feeling, they sometimes "righteously" attacked their creditors. This happened in 1190 at York in England, for example, where local nobles orchestrated a brutal attack on the Jews of the city to rid themselves of their debts and the men to whom they owed money. Kings claimed the Jews as their serfs and Jewish property as their own. In England a special royal exchequer of the Jews was created in 1194 to collect unpaid debts due after the death of Jewish creditors. In France, Philip Augustus expelled the Jews from the Ile-de-France in 1182, confiscating their houses, fields, and vineyards for himself. He allowed them to return—minus their property—in 1198.

Attacks against Jews were inspired by more than resentment against Jewish money or desire for power and control. They grew out of the codification of Christian religious doctrine. The newly rigorous definition of the Eucharist as the true body and blood of Christ meant to some that Christ, wounded and bleeding, lay upon the altar. Miracle tales sometimes reported that the Eucharist bled. Reflecting Christian anxieties about real flesh upon the altar, sensational stories, originating in clerical circles but soon widely circulated, told of Jews who secretly sacrificed Christian children in a morbid revisiting of the crucifixion of Jesus. This charge, called "blood libel" by historians, led to massacres of Jews in cities in England, France, Spain, and Germany. In this way, Jews became convenient and vulnerable scapegoats for Christian guilt and anxiety about eating Christ's flesh.

After the Fourth Lateran Council, Jews were easy to spot as well. The council required all Jews to advertise their religion by some outward sign, some special dress. Local rulers enforced this canon with zeal, not so much because they were anxious to humiliate Jews as because they saw the chance to sell exemptions to Jews eager to escape the requirement. Nonetheless, sooner or later Jews almost everywhere had to wear something to advertise

their second-class status: in southern France and Spain they had to wear a round badge; in Vienna they were forced to wear pointed hats.

Crusades

Attacks against Jews coincided with vigorous crusades. A new kind of crusade was launched against the heretics in southern France; along the Baltic, rulers and crusaders redrew Germany's eastern border; and the Fourth Crusade was rerouted and took Constantinople.

Against the Albigensians in southern France, Innocent III demanded that northern princes take up the sword, invade Languedoc, wrest the land from the heretics, and populate it with orthodox Christians. This Albigensian Crusade (1209–1229) marked the first time the pope had offered warriors who were fighting an enemy within Christian Europe all the spiritual and temporal benefits of a crusade to the Holy Land. In the event, the political ramifications were more notable than the religious results. After twenty years of fighting, leadership of the crusade was taken over in 1229 by the Capetian kings. Southern resistance was broken and Languedoc was brought under the control of the French crown. (See Map 6.7.)

Like Spain's southern boundary, so too was Europe's northeast a moving frontier, driven ever farther eastward by crusaders and settlers. By the twelfth century, the peoples living along the Baltic coast—partly pagan, mostly Slavic- or Baltic-speaking—had learned to make a living and even a profit from the inhospitable soil and climate. Through fishing and trading, they supplied the rest of Europe and Rus' with slaves, furs, amber, wax, and dried fish. Like the earlier Vikings, they combined commercial competition with outright raiding, so the Danes and the Saxons (i.e., the Germans in Saxony) both benefited and suffered from their presence. It was Saint Bernard (see p. 197) who, while preaching the Second Crusade in Germany, urged one to the north as well. Thus began the Northern Crusades, which continued intermittently until the early fifteenth century.

In key raids in the 1160s and 1170s, the king of Denmark and Henry the Lion, the duke of Saxony, worked together to bring much of the region between the Elbe and Oder Rivers under their control. They took some of the land outright, leaving the rest in the hands of the Baltic princes, who surrendered, converted, and became their vassals. Churchmen arrived: the Cistercians built their monasteries right up to the banks of the Vistula River, while bishops took over newly declared dioceses. In 1202 the "bishop of Riga"—in fact he had to bring some Christians with him to his lonely outpost amidst the Livs—founded a military/monastic order called the Order of the Brothers of the Sword. The monks soon became a branch of the Teutonic Knights (or Teutonic order), a group originally founded in the Crusader States and vowed to a military and monastic rule like the Templars. The Knights organized crusades, defended newly conquered regions, and launched their own holy wars against the "Northern Saracens." By the end of the thirteenth century, they had brought the lands from Prussia to Estonia under their sway. (See Map 6.8 on p. 246.) Meanwhile German knights, peasants, and townspeople streamed in,

Map 6.7 France, c. 1230

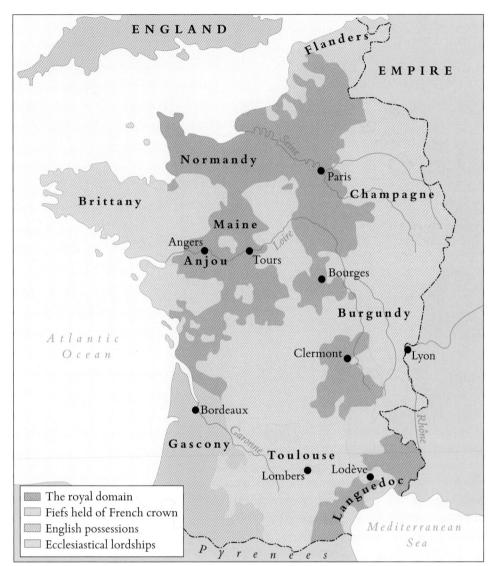

colonists of the new frontier. Although less well known than the crusades to the Levant, the Northern Crusades had more lasting effects, settling the Baltic region with a Germanspeaking population that brought its western institutions—cities, laws, guilds, universities, castles, manors, vassalage—with it.

Colonization was the unanticipated consequence of the Fourth Crusade as well. Called by Innocent III, who intended it to re-establish the Christian presence in the Holy Land, the crusade was diverted when the organizers overestimated the numbers joining the expedition. The small army mustered was unable to pay for the large fleet of ships that had been fitted out for it by the Venetians. Making the best of adversity, the Venetians convinced the crusaders to "pay" for the ships by attacking Zara (today Zadar), one of the coastal cities that Venice disputed with Hungary. Then, taking up the cause of one claimant to the Byzantine throne, the crusaders turned their sights on Constantinople. After taking

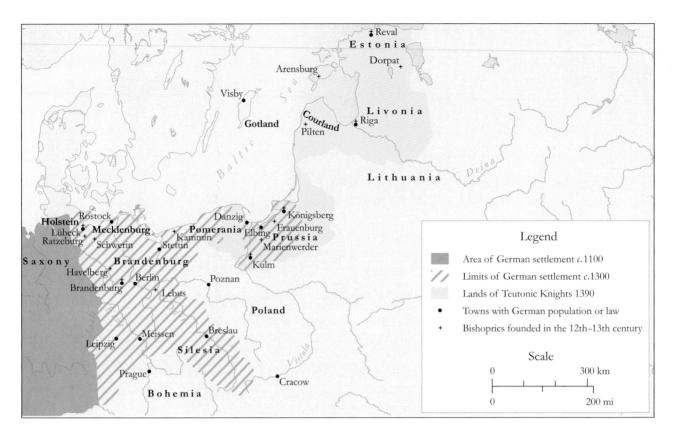

Map 6.8 German Settlement in the Baltic Sea Region, 12th to 14th cent.

and plundering it—hauling off, among other things, precious relics to proudly display in European cities—the crusaders created a number of Latin states. Baldwin I of Flanders became emperor and established himself at Constantinople. The other crusade leaders divided up the rest, by no means theirs to have. Strong resistance from the Byzantines, who founded their own successor states (see p. 214), left the "Latin Empire" very small indeed after around 1235. The real winner was Venice, which had instigated the enterprise in the first place; it won part of Constantinople, crucial territories along the east coast of the Adriatic Sea, Negroponte, and various islands in the Aegean Sea. With its purchase and conquest of Crete, Venice aimed to dominate the region's trade. (See Map 6.3 on p. 215 for Venetian possessions.)

Ireland

In 1169 the Irish king of Leinster, Diarmait Mac Murchada (Dermot MacMurrough), enlisted some lords and knights from England to help him first keep, then expand, his kingdom. The English fighters succeeded all too well; when Diarmait died in 1171, some of the English decided to stay, claiming Leinster for themselves. The king of England, Henry II, reacted swiftly. Gathering an army, he invaded Ireland in 1171. The lords of the 1169 expedition recognized his overlordship almost immediately, keeping their new territories,

but now redefined as fiefs from the king. Most of the native Irish kings submitted in similar manner. The whole of one kingdom, Meath, was given to one of Henry's barons.

The English came to stay, and more. England's laws were instituted; its system of counties and courts was put in place; its notions of lordship (in which the great lords parceled out some of their vast lands to lesser lords and knights) prevailed. Ireland became, effectively, "Anglicized."

* * * * *

In the fifty years before and after 1200, the Islamic world was transformed by two zealous Sunni groups, one led eventually by Saladin, the other known as the Almohads. Both fought not only against the Shi'ites but the Christians. The Ayyubids under Saladin took Jerusalem and prevailed in the region of Egypt and Syria until 1250. The Almohads, rulers of the Maghreb and al-Andalus, were less successful as the crusading Christian armies of the *reconquista* pushed ever southward.

At the other ends of Europe, Christian crusaders poured into the Baltic region and breached the walls of Constantinople. Bruised, but not crushed, the Byzantines founded new states and eventually, in 1261, would retake their capital city. But the peoples of the Baltic region largely succumbed to the Europeans, who imposed their religion and institutions. Ireland, already Catholic, nevertheless was similarly subjected, in its case to England.

In some ways this was the heyday of the elites rather than of central rulers. Aristocrats in Europe—whether Christian or Islamic—and at Byzantium too (before 1204) listened to and read poems and tales of love. Rich townsmen and bishops built soaring Gothic churches. Citizens in Italy ousted the emperor and maintained their communal independence. Enterprising business- and craftsmen created guilds. Lords colluded with peasants as both saw it in their interest to change labor services into monetary payments. The barons of England imposed Magna Carta on the king.

Yet at the same time, centralizing institutions were stronger than ever. The king of England imposed common law in his realm over all free men. The king of France took over Normandy and other regions. The church imposed new rules on all Christians and new penalties on Jews and heretics.

An orderly society would require that these multiple institutions be able to respond to numerous individual and collective goals. But in the next century, while harmony was the ideal and sometimes the reality, discord was an ever-present threat.

CHAPTER SIX: ESSENTIAL DATES

- 1152-1190 Frederick Barbarossa
- 1154-1189 King Henry II of England
- 1171-1193 Saladin's rule in Egypt and (1174) Syria
 - 1187 Battle of Hattin; Saladin's army defeats the Crusaders
- 1189–1192 Third Crusade
- 1194-1250 Frederick II
- 1198-1216 Pope Innocent III
- 1202-1204 Fourth Crusade; Constantinople falls to Crusaders
 - 1212 Battle of Las Navas de Tolosa; Almohads defeated in Spain
 - Battle of Bouvines; French army defeats King John of England
 - Magna Carta defines obligations of the king and rights of English free men
 - 1215 Fourth Lateran Council
 - 1226 Death of Saint Francis
 - 1261 Constantinople again Byzantine

NOTES

- I Ibn Shaddad, The Rare and Excellent History of Saladin, in Reading the Middle Ages: Sources from Europe, Byzantium, and the Islamic World, 3rd ed., ed. Barbara H. Rosenwein (Toronto: University of Toronto Press, 2018), p. 295.
- 2 Anonymous, The Tale of Bayad and Riyad, in Reading the Middle Ages, p. 347.
- 3 Niketas Eugenianos, Drosilla and Charikles, in Reading the Middle Ages, p. 342.
- 4 Neophytos, Testamentary Rule, in Reading the Middle Ages, p. 313.
- 5 The Assize of Clarendon, in Reading the Middle Ages, p. 303.
- 6 Magna Carta, in Reading the Middle Ages, p. 329.
- 7 The Laws of Cuenca, in Reading the Middle Ages, p. 309.
- 8 The Diet of Besançon, in Reading the Middle Ages, p. 329.
- 9 The Chronicle of Salimbene de Adam, ed. and trans. Joseph L. Baird, Giuseppe Baglivi, and John Robert Kane, Medieval & Renaissance Texts & Studies 40 (Binghamton, NY: MRTS, 1986), p. 5.
- 10 Bernart de Ventadorn, "When I see the lark," in Reading the Middle Ages, p. 351.
- 11 Ibid.
- 12 La Comtessa de Dia, "I have been in heavy grief," in Reading the Middle Ages, p. 352.
- 13 Bertran de Born, "Half a sirventés," in Reading the Middle Ages, p. 354.
- 14 Chrétien de Troyes, Lancelot, in Reading the Middle Ages, p. 363.

- 15 Ibid., p. 364.
- 16 Guild Regulations of the Parisian Silk Fabric Makers, in Reading the Middle Ages, pp. 317–18.
- 17 St. Francis, The Testament, in Reading the Middle Ages, p. 377.
- 18 Jacques de Vitry, The Life of Mary of Oignies, in Reading the Middle Ages, p. 375.
- 19 Translation of the text in Pilar Jiménez Sánchez, "L'évolution doctrinale du catharisme, XIIe-XIIIe siècle," 3 vols. (Ph.D. Diss, University of Toulouse II, 2001), Annex 1: Actes de Lombers.
- 20 The Chronicle of Laon, in Reading the Middle Ages, p. 372.

FURTHER READING

Angold, Michael. The Byzantine Empire, 1025-1204. 2nd ed. London: Longman, 1997.

Arlidge, Anthony, and Igor Judge. Magna Carta Uncovered. Oxford: Hart, 2014.

Baldwin, John. The Government of Philip Augustus: Foundations of French Royal Power in the Middle Ages. Berkeley: University of California Press, 1986.

Bartlett, Robert. England under the Norman and Angevin Kings, 1075-1225. Oxford: Oxford University Press, 2000.

-. The Making of Europe: Conquest, Colonization and Cultural Change, 950–1350. Princeton, NJ: Princeton University Press, 1993.

Bennison, Amira K. The Almoravid and Almohad Empires. Edinburgh: University of Edinburgh Press, 2016.

Bruzelius, Caroline. Preaching, Building, and Burying: Friars in the Medieval City. New Haven, CT: Yale University Press, 2014.

Bysted, Ane L., Carsten Selch Jensen, Kurt Villads Jensen, et al. Jerusalem in the North: Denmark and the Baltic Crusades, 1100-1522. Turnhout: Brepols, 2012.

Catlos, Brian A. Muslims of Medieval Latin Christendom, c.1050-1614. Cambridge: Cambridge University Press, 2014.

Christiansen, Eric. The Northern Crusades. 2nd ed. London: Penguin, 1997.

Clanchy, Michael T. From Memory to Written Record, 1066-1307. 3rd ed. Oxford: John Wiley & Sons,

Duggan, Anne. Thomas Becket. London: Arnold, 2004.

El-Azhari, Taef. Zengi and the Muslim Response to the Crusades: The Politics of Jihad. New York: Routledge, 2016.

Evergates, Theodore. Henry the Liberal: Count of Champagne, 1127-1181. Philadelphia: University of Pennsylvania Press, 2016.

Frame, Robin. Colonial Ireland, 1169–1369. Dublin: Four Courts Press, 2012.

France, John. Hattin. Oxford: Oxford University Press, 2015.

Freed, John B. Frederick Barbarossa: The Prince and the Myth. New Haven, CT: Yale University Press,

Kaeuper, Richard W. Medieval Chivalry. Cambridge: Cambridge University Press, 2016.

Madden, Thomas F. The Concise History of the Crusades. Plymouth: Rowman & Littlefield, 2013.

Man, John. Saladin: The Sultan Who Vanquished the Crusaders and Built an Islamic Empire. Boston: Da Capo, 2016.

Mooney, Catherine M. Clare of Assisi and the Thirteenth-Century Church: Religious Women, Rules, and Resistance. Philadelphia: University of Pennsylvania Press, 2016.

Moore, R.I. The War on Heresy. Cambridge, MA: Belknap Press, 2012.

Mayr-Harting, Henry. Religion, Politics and Society in Britain 1066-1272. Harlow, UK: Pearson, 2011.

Newman, Barbara. Making Love in the Twelfth Century: "Letters of Two Lovers" in Context. Philadelphia: University of Pennsylvania Press, 2016.

Paterson, Linda. "Fin'amor and the Development of the Courtly Canso." In The Troubadours: An Introduction, ed. Simon Gaunt and Sarah Kay, 28-46. Cambridge: Cambridge University Press,

Pegg, Mark Gregory. The Corruption of Angels: The Great Inquisition of 1245-1246. Princeton, NJ: Princeton University Press, 2001.

Robson, Michael. The Franciscans in the Middle Ages. Woodbridge: Boydell Press, 2006.

Şenocak, Neslihan. The Poor and the Perfect: The Rise of Learning in the Franciscan Order, 1209–1310. Ithaca, NY: Cornell University Press, 2012.

To test your knowledge of this chapter, please go to www.utphistorymatters.com for Study Questions.

SEVEN

TENSIONS AND RECONCILIATIONS

(c.1250-c.1350)

In the shadow of a great Mongol Empire that, for about a century, stretched from the East China Sea to the Black Sea and from Moscow to the Himalayas, Europeans were bit players in a great Eurasian system tied together by a combination of sheer force and open trade routes. Taking advantage of the new opportunities for commerce and evangelization offered by the mammoth new empire, Europeans ventured with equal verve into experiments in their own backyards: in government, thought, and expression. Above all, they sought to harmonize disparate groups, ideas, and artistic modes. At the same time, unable to force everything into unified and harmonious wholes and often confronted instead with discord and strife, the directing classes—both secular and ecclesiastical—tried to purge their society of deviants of every sort.

THE ISLAMIC WORLD TRANSFORMED

Around 1250 the Islamic world was divided in two. In the east, the Mongols—pastoralists who occupied the eastern edge of the great steppes that stretch west to the Hungarian plains—took Baghdad. Their empire, in its heyday stretching about 4,000 miles from east to west, was the last to be created by the nomads from the steppes. In the west, the Mamluks—warriors originally of slave status—quietly and decisively ousted Saladin's dynasty, the Ayyubids, and became rulers of the Mamluk sultanate. Their empire included Libya, Egypt, and Syria.

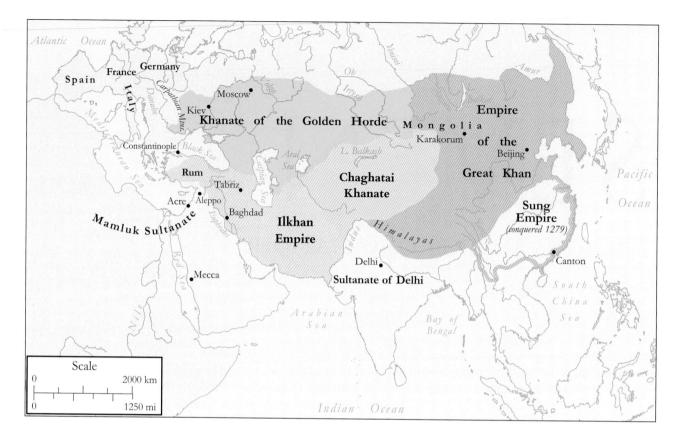

Map 7.1 The Mongol Empire, *c*.1260–1350

The Contours of the Mongol Empire

The Mongols formed under the leadership of Chinghis (or Genghis) Khan (c.1162–1227). Fusing together various tribes of mixed ethnic origins and traditions, Chinghis created a highly disciplined, orderly, and sophisticated army. Impelled out of Mongolia in part by new climatic conditions that threatened their grasslands, the Mongols were equally inspired by Chinghis's vision of world conquest. All of China came under their rule by 1279, and they tried (unsuccessfully, as it turned out) to conquer Japan as well. Meanwhile, they made forays to the west. They took Rus' in the 1230s, invaded Poland and Hungary in 1241, and might well have continued into the rest of Europe, had not unexpected dynastic disputes and insufficient pasturage for their horses drawn them back east. In the end, the borders of their European dominion rolled back east of the Carpathian Mountains.

Something rather similar happened in the Islamic world. Mongols took Seljuk Rum, the major power in the region, by 1243. They then moved on to Baghdad, putting an end to the caliphate there in 1258 (though a shadow caliph continued at Cairo until 1517). The next year, the Mongols took Syria (1259–1260), threatening the fragile Crusader States a few miles away.

In spite of these victories, a few months later the Mongols withdrew their troops from Syria, probably (as in the case of Europe) because of inadequate grasslands and dynastic problems. The Mamluks of Egypt took advantage of the moment to conquer Syria. This

Genealogy 7.1 (facing page) The Mongol Khans

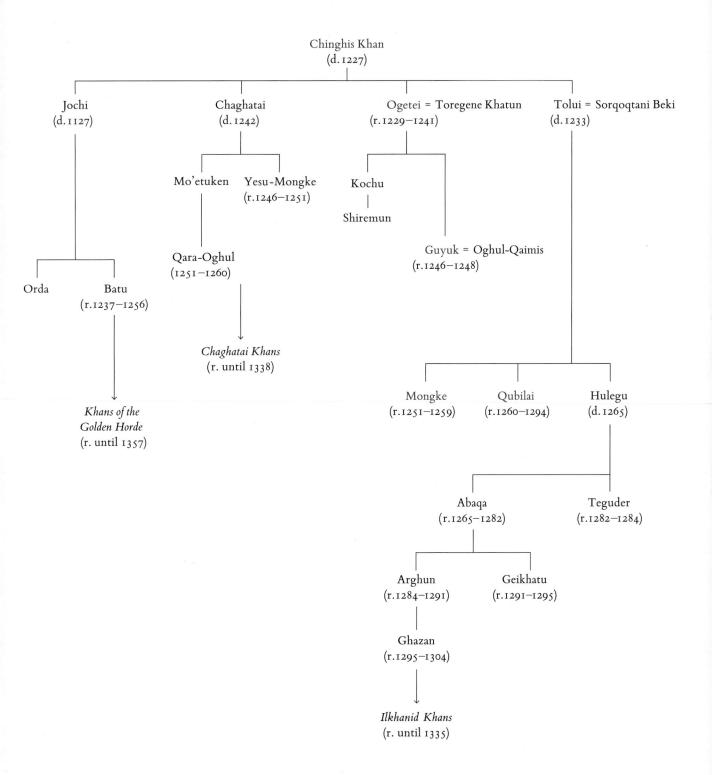

Plate 7.1 (facing page) Great Mongol Shahnama, "The Death of Alexander" (1330s). Counting the conqueror Alexander the Great among the "kings of Persia," the Great Mongol Shahnama illustrated his life and death in great detail. Here the dead Alexander lies in a richly ornamented coffin. In front, his mother throws herself over his body, her back to the viewer, her arms raised as if to envelop him. Behind her (nearest the viewer), women tear at their hair in grief. On the other side of the coffin, Aristotle weeps into a handkerchief. Compare this scene with the Lamentation of Giotto (Plate 7.12 on pp. 290-91), which also drew upon Byzantine models.

effectively ended the Mongol push across the Islamic world. It was the Mamluks, not the Mongols, who took Acre in 1291, snuffing out the last bit of the original Crusader States.

By the middle of the thirteenth century, the Mongol Empire had taken on the contours of a settled state. (See Map 7.1.) It was divided into four regions, each under the rule of various progeny of Chinghis. (See Genealogy 7.1.) The westernmost quadrant was dominated by the rulers of Rus', the so-called Golden Horde ("horde" derived from the Turkic word for "the Khan's residence"). Settled along the lower Volga River valley, the Mongols of the Golden Horde combined traditional pastoralism with more settled activities. They founded cities, fostered trade, and gradually gave up their polytheism in favor of Islam. While demanding regular and exactly calculated tribute, troops, and recognition of their overlordship from the indigenous Rus rulers, they nevertheless allowed the princes of Rus' considerable autonomy. Their policy of religious toleration allowed the Orthodox church to flourish, untaxed, and willing in turn to offer up prayers for the soul of the Mongol khan. Kiev-based Rus', largely displaced by the Mongols, gave way to the hegemony of northern Rus princes centered in the area around Moscow. As Mongol rule fragmented, in the course of the fifteenth century, Moscow-based Russia emerged.

Meanwhile, the Ilkhan Empire was born. Centered in Iran, it began with blood and violence, but once the new rulers established themselves, they created a flourishing state in which Mongol shamanism coexisted in peace with various forms of Christianity, Islam, Buddhism, and Judaism. After flirting for a time with Christianity, the Ilkhanids under Ghazan Khan (r.1295–1304) broke with the Mongols of China and converted to Islam (1295). The career of Rashid al-Din (c.1247–1318), while not quite "typical," illustrates the social, political, intellectual, and religious possibilities that existed under Ilkhan rule. Born into a Jewish family, Rashid trained as a physician and came to serve the Mongol court under Ilkhan Abaga (r.1265–1282). During that time he converted to Islam, and when Ghazan came to power, Rashid was appointed to the high political office of co-vizier. He remained a key player in Ilkhanid government, credited with important reforms—setting tax rates, regulating weights and measures, specifying the jobs of judges and other authorities. He also wrote numerous books, including a history commissioned by Ghazan in which he recounted—mainly with praise—stories of the Mongol rulers. "And he commanded that of the Tazik armies in Persia two out of every ten men should set out and reduce the rebellious territories, beginning with the Heretics," he wrote of the Great Khan Guyuk (r.1246-1248), emphasizing the Khan's war against the Isma'ilis, or Assassins, a move welcomed by mainstream Muslims.1

As the newcomers integrated with the old Islamic civilizations of Persia and Anatolia, they adopted some of their practices and styles. The Mongol version of the *Shahnama* (*Book of Kings*)—a Persian classic—is a good example: its artists drew not only on Persian and Mongol traditions but also the gestures of Byzantine art (see Plate 7.1).

Thus the Mongols assimilated into the older civilizations of the regions that they conquered. At the same time, they greatly extended the global vision of Europeans and Muslims, opening up routes to China. Muslim, Jewish, and European craftsmen, merchants and (in the case of Europeans) missionaries not only traveled to China but also settled

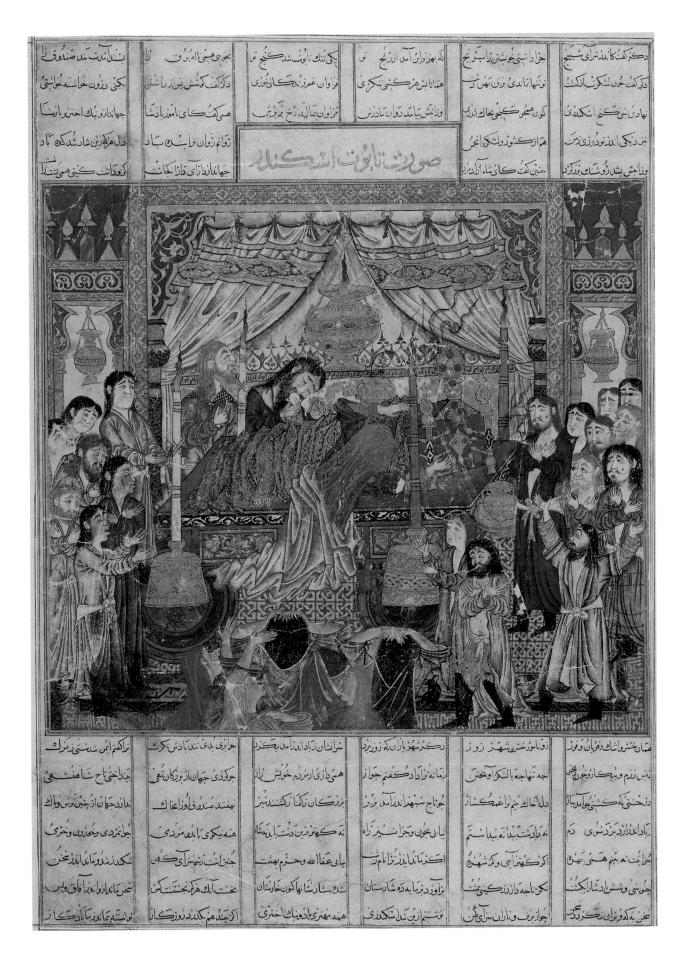

Map 7.2 The Mamluk Sultanate

Plate 7.2 (facing page) Funerary Complex of Mamluk Emirs Salar and Sanjar al-Jawli, Cairo (1302-1304). The two emirs served the same master and were both very powerful for a time, though they ended up starving in a prison. They built their mausoleum in happier days: it contained not only their tombs but also, probably, a madrasa for teaching Islamic law and a hospice for Sufis. Often called a mystical branch of Islam, Sufism might better be considered a set of traditions about authoritative texts,

people (saints), and practices.

there, living in their own quarters in cities like Hangchow. The most famous of these travelers was Marco Polo (1254–1324), whose descriptions of the fabulous wealth of the orient fired up still other adventurers. In a sense, the Mongols initiated the search for exotic goods and missionary opportunities that culminated in the European "discovery" of a new world, the Americas.

An Enduring Sultanate: The Mamluks

When Saladin died in 1193, his state was parceled out to his heirs, the Ayyubids. Theoretically, they formed a cooperative "confederation," but it never worked well and fell apart entirely in 1238. When the last Ayyubid in Egypt, al-Saleh Ayyub (r.1240–1249), took the reins of power, he turned to Mamluks—men (mainly Turks) taken as slaves, trained, converted to Islam, then freed—to help him govern and serve in his army. In 1250, six months after he died, the Mamluks took over Egypt, and when the Mongols ousted the Ayyubids in Syria, the Mamluks defeated them and extended their rule over Syria as well, creating an empire that lasted until 1517 (see Map 7.2).

The Mamluks presented themselves as the Middle Eastern bulwark against the Mongols. Superficially, they were like the rulers the Islamic world had known since the time of the Seljuks: they were Turks, like the Seljuks and Ayyubids; they upheld Sunni Islam; and they protected the last (symbolically important though utterly powerless) caliphs, who, since ousted by the Mongols, now lived at Cairo. Nevertheless, the Mamluks were also something new. They rarely formed a hereditary dynasty: rather, they created a military state ruled by army units fiercely loyal to their leaders. Since sons of Mamluks could not inherit their father's property or titles (at least theoretically), the army had constantly to be replenished by new Mamluks from the steppes. Living in garrisons, the Mamluks followed a military code, their lives dominated by constant drilling and military exercises. They formed a society largely separate from the general population.

Yet the Mamluks also made use of the society and institutions that they found in place. Thus Abu'l-Fida (d.1331), an Ayyubid whose family professed loyalty to the Mamluks, was allowed to rule as lord of Hama in Syria under the Mamluk sultans. Well educated, Abu'l-Fida wrote A Short History of Mankind that took the story up to his own day. As he reports, he himself was present as the leader of an army contingent fighting on behalf of the Mamluks at the siege of Acre (1291), the death knell of the Crusader States: "We were beside the sea, with the sea on our right as we faced Acre. Ships with timber vaulting covered with ox-hides came to us firing arrows and quarrels [crossbow bolts]. There was fighting in front of us from the direction of the city, and on our right from the sea." The fighting was fierce "until God Most High" allowed the Mamluk armies to win.²

While largely a closed society, the Mamluks nevertheless allowed many different religions—Islam, of course, Judaism, Coptic Christianity—to flourish. They fostered the arts, architecture, and scholarship just as the caliphs and emirs of old had done. Obsessed with rank and status, their buildings celebrated their importance, with grand funerary

Map 7.3a, b European and Eurasian Trade Routes, c.1300

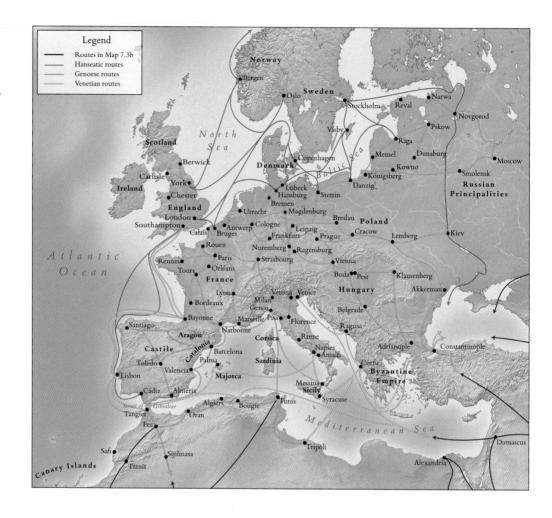

complexes that employed family members, in that way ensuring them a hereditary job. The stately funerary monument illustrated in Plate 7.2 had several mausoleums, a three-story minaret, and numerous rooms and corridors.

A GLOBAL ECONOMY

The Mongol conquests, stretching from China into Europe and the Middle East, brought new economic and (for churchmen) missionary opportunities. At the same time, Atlantic Ocean travel became possible with crucial developments in naval technology. Within Europe, roads and bridges made land trade faster and more profitable. Burgeoning trade called for large-scale payments, necessitating the introduction of gold coinage. Europeans now had access to material goods of every sort, but wealth also heightened social tensions, especially in the cities.

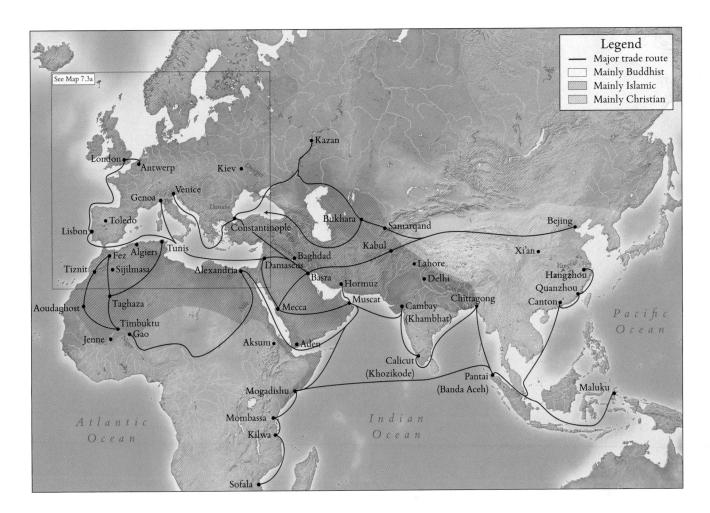

New Routes

The Mongols opened up trade routes to China. Already in the mid-fourteenth century, the Florentine merchant Francesco Balducci Pegolotti well knew the perils and the possibilities:

[On the way to China] it will be well for anyone travelling with merchandise to go to Urgench [today in Uzbekistan], for in that city there is a ready market for goods. From Urgench to Otrar [in Kazakhstan] is thirty-five to forty days in camelwagons.... From Otrar to Yining [in western China] is forty-five days' journey with pack-asses, and every day you find Moccols [bandits].... And then you can go down the river to Hangzhou, and there you can dispose of the [ingots] of silver that you have with you, for that is a most active place of business.3

Once in Hangzhou, you were at China's eastern seaboard.

After the Byzantines reconquered Constantinople in 1261, some Byzantine entrepreneurs made a profit by serving as local intermediaries on behalf of such Italian merchants. They were aptly dubbed the *mesoi*—middlemen. But the Byzantine state itself benefited little from the global economy. Venice and Genoa retained special privileges in Byzantine cities, and they monopolized most of the trade that passed through their ports.

On the other—the western—coast of Europe, the first ships to ply the Atlantic's waters in regular trips were the galleys of Genoese entrepreneurs. By the 1270s they were leaving the Mediterranean via the Strait of Gibraltar, stopping to trade at various ports along the Spanish coast, and then making their way north to England and northern France. (See Map 7.3a on p. 258.) In the western Mediterranean, Majorca, recently conquered by the king of Aragon, sent its own ships to join the Atlantic trade at about the same time. Soon the Venetians began state-sponsored Atlantic expeditions using new-style "great galleys" that held more cargo yet required fewer oarsmen. Eventually, as sailing ships—far more efficient than any sort of galley—were developed by the Genoese and others, the Atlantic passage replaced older overland and river routes between the Mediterranean and Europe's north.

Equally important for commerce were new initiatives in North Africa. As the Almohad Empire collapsed, weak successor states allowed Europeans new elbow room. Genoa had outposts in the major Mediterranean ports of the Maghreb and new ones down the Atlantic coast, as far south as Safi (today in Morocco). Pisa, Genoa's traditional trade rival, was entrenched at Tunis. Catalonia and Majorca, now ruled by the king of Aragon, found their commercial stars rising fast. Catalonia established its own settlements in the port cities of the Maghreb; Majorcans went off to the Canary Islands. Profits were enormous. Besides acting as middlemen, trading goods or commodities from northern Europe, the Italian cities had their own products to sell (Venice had salt and glass, Pisa had iron) in exchange for African cotton, linen, spices, and, above all, gold.

At the same time as Genoa, Pisa, Venice, Majorca, and Catalonia were forging trade networks in the south, some cities in the north of Europe were creating their own market-place in the Baltic Sea region. Built on the back of the Northern Crusades, the Hanseatic League was created by German merchants, who, following in the wake of Christian knights, hoped to prosper in cities such as Danzig (today Gdansk, in Poland), Riga, and Reval (today Tallinn, in Estonia). Lübeck, founded by the duke of Saxony, formed the Hansa's center. Formalized through legislation, the association of cities agreed that

Each city shall ... keep the sea clear of pirates.... Whoever is expelled from one city because of a crime shall not be received in another.... If a lord besieges a city, no one shall aid him in any way to the detriment of the besieged city.⁴

There were no mercantile rivalries here, unlike the competition between Genoa and Pisa in the south. But there was also little glamor. Pitch, tar, lumber, furs, herring: these were the stuff of northern commerce.

The opening of the Atlantic and the commercial unification of the Baltic were dramatic developments. Elsewhere the pace of commercial life quickened more subtly. By 1200 almost all the cities of pre-industrial Europe were in existence. By 1300 they were connected by a spider's web of roads that brought even small towns of a few thousand inhabitants into wider

networks of trade. To be sure, some old trading centers declined: the towns of Champagne, for example, had been centers of major fairs—periodic but intense commercial activity. By the mid-thirteenth century the fairs' chief functions were as financial markets and clearing houses. On the whole, however, urban centers grew and prospered. As the burgeoning population of the countryside fed the cities with immigrants, the population of many cities reached their medieval maximum: in 1300, Venice and London each had perhaps 100,000 inhabitants, Paris an extraordinary 200,000. Many of these people became part of the urban labor force, working as apprentices or servants; but others could not find jobs or became disabled and could not keep them. The indigent and sick posed new challenges for urban communities. Rich townspeople and princes alike supported the building of new charitable institutions: hospices for the poor, hospitals for the sick, orphanages, refuges for penitent prostitutes. But in big cities the numbers that these could serve were woefully inadequate. Beggars (there were perhaps 20,000 in Paris alone) became a familiar sight, and not all prostitutes could afford to be penitent.

New Money

Workers were paid in silver pennies; mines were discovered and exploited. At just one city, Freiburg, in northern Germany, the number of mints increased from nine in 1130 to twenty-five in 1197. Small workshop mints, typical before the thirteenth century, gave way to mint factories run by profit-minded entrepreneurs. Princes added to their power by making sure that the coins of one mint under their control would prevail in their region. Thus, the bishops of Maguelonne, who also were the counts of Melgueil, issued coins that supplanted most of the others in southern France.

But large-scale transactions required coins larger than pennies. Between the early thirteenth and mid-fourteenth centuries, new, heavier silver coins were struck. Under Doge Enrico Dandolo (r.1192–1205), Venice began to strike great silver coins, grossi ("big ones" in Italian), in order to make convenient payments for the Fourth Crusade, even as Venice's little silver coins, the piccoli, continued to be minted. Soon Venice's commercial rival Genoa produced similarly large coins, and the practice quickly spread to other cities in northern Italy, Tuscany, and southern France. In 1253, Rome doubled the size of the grossi, a coinage model that was followed in Naples and Sicily. The practice of minting these heavy silver coins spread northward.

Heavy silver was one answer to the problem of paying for large transactions. Gold coins were another. They were already common in the Islamic world. In Europe before the mid-thirteenth century, though, they were limited to the regions that bordered on that world, like Sicily and Spain. Gold panned on the upper Niger River in Africa and wrested from mines in Hungary helped infuse Europe with the precious metal. In 1252 Genoa and Florence struck gold coins for the first time (they got the gold from panning on the upper Niger River). The practice spread, profiting above all Italy and East Central Europe. In fact, the kings of Hungary and Bohemia formed an alliance to control the flow of gold, enhance their purchasing power, and increase trade.

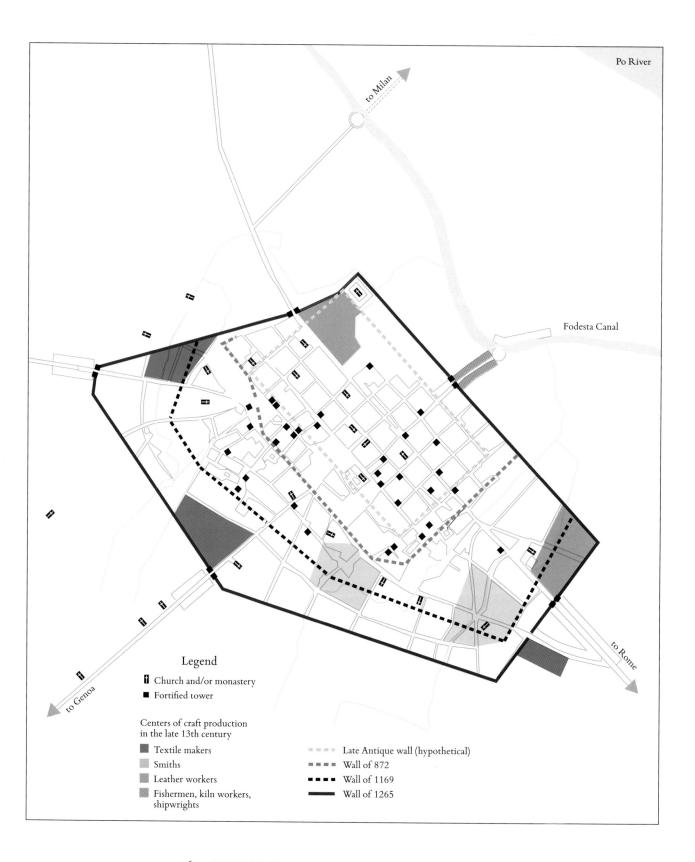

The most commercialized regions were the most restive. Consider Flanders, where the urban population had grown enormously since the twelfth century. Flemish cities depended on England for wool to supply their looms and on the rest of Europe to buy their finished textiles. But Flemish workers were unhappy with their town governments, run by wealthy merchants, the "patricians," whose families had held their positions for generations. When, in the early 1270s, England slapped a trade embargo on Flanders, discontented laborers, now out of work, struck, demanding a role in town government. While most of these rebellions resulted in few political changes, workers had better luck early in the next century, when the king of France and the count of Flanders went to war. The workers (who supported the count) defeated the French forces at the battle of Courtrai in 1302. Thereafter the patricians, who had sided with the king, were at least partly replaced by artisans in the apparatus of Flemish town governments. In the early fourteenth century, Flemish cities had perhaps the most inclusive governments of Europe.

Similar population growth and urban rebellions beset the northern Italian cities. The swelling population of Piacenza is easily illustrated by its ballooning walls (see Map 7.4). The city replaced the wall of 872 by another that covered former suburbs in 1169; then that one had to be torn down for a wall embracing still more area.

Italian cities were torn into factions that defined themselves not by loyalties to a king or a count (as in Flanders) but rather by adherence to either the pope or the emperor. City factions often fought under the party banners of the Guelfs (papal supporters) or the Ghibellines (imperial supporters), even though for the most part they were waging very local battles. As in the Flemish cities, the late thirteenth century saw a movement by the Italian urban lower classes to participate in city government. The *popolo* ("people") who demanded the changes were in fact made up of many different groups, including crafts and merchant guildsmen, fellow parishioners, and even members of the commune. The *popolo* acted as a sort of alternative commune within the city, a sworn association dedicated to upholding the interests of its members. Armed and militant, the *popolo* demanded a say in matters of government, particularly taxation.

While no city is "typical," the case of Piacenza may serve as an example. Originally dominated by nobles, the commune of Piacenza granted the *popolo*—led by a charismatic nobleman from the Landi family—a measure of power in 1222, allowing the *popolo* to take over half the governmental offices. A year later the *popolo* and the nobles worked out a plan to share the election of their city's *podestà*, or governing official. Even so, conflict flared up periodically: in 1224, 1231, and again in 1250, when a grain shortage provoked protest:

In 1250 the common people of Piacenza saw that they were being badly treated regarding foodstuffs: first, because all the corn [grain] that had been sent from Milan, as well as other corn in Piacenza, was being taken to Parma ... [and] second because the Parmesans were touring Piacentine territory buying corn from the

Plate 7.3 Jews in an English Exchequer Tax Receipt Roll (1233). The three-faced man in the middle is Issac. To the viewer's left is a devil tweaking the long hooked noses of a man named Mosse and of a woman labeled Avegaye. Behind her are little demons. Clearly the doodler was critical of the Jews. But he was also lampooning the government, which profited from taxing the Jews. The little man on the far left is probably an exchequer official charged with weighing the coins; the doodler has made him nearly as ugly as he portrayed the Jews.

threshing floors and fields.... The Parmesans could do this in safety because Matteo da Correggio, a citizen of Parma, was podestà of Piacenza.⁵

In this case, too, members of noble families took the lead in the uprising, but this time the *popolo* of Piacenza divided into factions, each supporting a different competing leader. Eventually one came to the fore—Alberto Scotti, from a family deeply immersed in both commerce and landholding. In 1290, he took over the city, gaining the grand title of "defender and rector of the commune and the society of merchants and craft guilds and of all the *popolo*." He was, in short, a lord, a *signore* (pl. *signori*). Map 7.4 shows some of the features of Piacenza in his day: concentrated centers of craft production, a new wall built in 1265 to enclose most of the population, an impressive number of churches and monasteries, and a generous sprinkling of private towers put up by proud and often warring members of the nobility.

A similar evolution—from commune to the rule of the *popolo* and then to the rule of a *signore*—took place in cities throughout northern Italy and in much of Tuscany as well.

It was as if the end of imperial rule in Italy, marked by the fall of Frederick II, ironically brought in its train the creation of local monarchs—the *signori*, who maintained order at the price of repression. By 1300 the commune had almost everywhere given way to the *signoria* (a state ruled by a *signore*), with one family dominating the government.

XENOPHOBIA

Urban discord was fairly successfully defused in Flanders, fairly well silenced in Italy. In neither instance was pluralism valued. Europeans had no interest in hearing multiple voices; rather, they were eager to purge and purify themselves of the pollutants in their midst.

Driving the Jews from the Île-de-France in the twelfth century (see p. 243) was a dress rehearsal for the expulsions of the thirteenth. In England during the 1230s and 1250s, some local municipal governments expelled the Jews from their cities. By then, they thought

Genealogy 7.2 Henry III and His Progeny

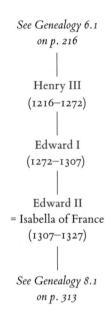

of Jews not only as the religiously hateful but ugly as well. In an English tax receipt roll of 1233, someone doodled an image of the very exchequer building topped by a three-faced man labeled "Isaac of Norwich." (See Plate 7.3 on pp. 264–65.) Beneath Isaac (on the viewer's left) is a devil and, still further left, a man labeled Mosse Mokke. Both Isaac and Mosse were well-known Jewish financiers. Showing Isaac as triple-faced gave him the attribute of the Antichrist, while Mosse's long nose, tweaked by the devil, was coming to be associated with Jewish physiognomy.

Little wonder, then, that King Henry III (r.1216–1272) thought fit to impose unusually harsh taxes on the Jews. (See Genealogy 7.2.) By the end of Henry's reign, the Jews were impoverished and their numbers depleted. There were perhaps 3,000 Jews in all of England when King Edward I (r.1272–1307) drew up the *Statute of the Jewry* in 1275, stipulating that they end the one occupation that had been left open to them: moneylending. They were henceforth expected to "live by lawful trade and by their labor." But, as the Jews responded in turn, they would be forced to buy and sell at higher prices than Christians, and thus would sell nothing. Fifteen years later, in 1290, Edward expelled them from England entirely.

The story was similar in France. King Louis IX (r.1226–1270; see Genealogy 7.3) later canonized as Saint Louis, reportedly could not bear to look at a Jew and worried that their "poison" might infect his kingdom. In 1242, he presided over the burning of two dozen cartloads of the ancient rabbinic Bible commentaries known as the Talmud. Actively promoting the conversion and baptism of Jews, Louis offered converts pensions, new names, and an end to special restrictions. His grandson, Philip IV the Fair (r.1285–1314), gave up on conversion and expelled the Jews from France in 1306. By contrast with England, the French Jewish population had been large; after 1306, perhaps 125,000 French men, women, and children became refugees in the Holy Roman Empire, Spain, and Italy. The few who were later allowed to return to France were wiped out in popular uprisings in the early 1320s.

One anti-Jewish episode started with an attack on lepers. In 1321, in the south of France, lepers were said to be plotting to poison the kingdom's wells, fountains, and rivers. Seized by local vigilantes or hauled in by local officials, the lepers were tortured, made to confess, and burned. Soon Jews and Muslims were associated with their nefarious plans. Historians used to consider this incident typical, emphasizing the leper's status as an outcast. Saul Brody, for example, highlighted the association between leprosy—a skin disease often leading to disfigurement—and sin. Other scholars spoke of the fear of contagion that lepers inspired. Thus lepers carried clappers to warn others to flee, and leprosaries (hospitals for lepers) were located outside of town walls to quarantine their disease.

But Elma Brenner and other historians have more recently reconsidered the place of the leper in medieval society. While the persecution of 1321 was a fact, so was the reign of King Baldwin IV of Jerusalem (r.1174–1185), who developed leprosy as a child and yet remained on the throne until his death at the age of twenty-three. Fears of contagion were not important until the early thirteenth century, and the lepers' clapper, far from scaring people away, called them to approach and offer alms. Leprosaries were located near town

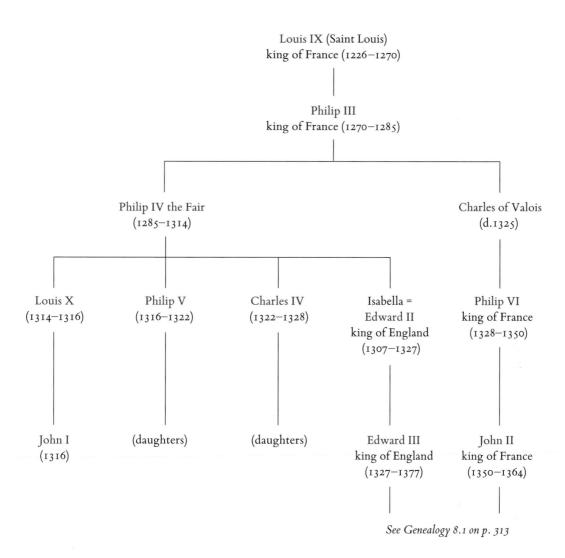

gates in order to attract the charity of pilgrims and other travelers. Saint Francis ministered to lepers and kissed them on their hands and mouths.

Genealogy 7.3 Louis IX and His Progeny

Thus both reviled and beloved, lepers held a particularly ambivalent place in medieval society. In that, they were similar to beggars. Certainly, the mendicants like the Franciscans and Dominicans, who went about begging, were understood to be exercising the highest vocation. And even involuntary beggars were thought (and expected) to pray for the souls of those who gave them alms. Nevertheless, the sheer and unprecedented number of idle beggars in the towns led to calls for their expulsion.

No group, however, suffered social purging more than heretics. Beginning in the thirteenth century, church inquisitors, aided by secular authorities, worked to find and extirpate heretics from Christendom. The Inquisition was a continuation (and expansion) of the Albigensian Crusade by other means. Working in the south of France, the mid-Rhineland, and Italy, the inquisitors began their scrutiny in each district by giving a

sermon and calling upon heretics to confess. Then the inquisitors granted a grace period for heretics to come forward. Finally, they called suspected heretics and witnesses to inquests, where they were interrogated:

Asked if she had seen Guillaume [who was accused of being a heretic] take communion [at Mass] or doing the other things which good and faithful Christians are accustomed to do, [one of Guillaume's neighbors] responded that for the past twelve years she had lived in the village of Ornolac and she had never seen Guillaume take communion.⁷

Often imprisonment, along with both physical and mental torture, was used to extract a confession. Then penalties were assigned. Bernard Gui, an inquisitor in Languedoc from 1308 to 1323, gave out 633 punishments. Nearly half involved imprisonment, a few required penitential pilgrimages, and forty-one people (6.5 per cent of those punished by Bernard) were burned alive. Many former heretics were forced to wear crosses sewn to their clothing, rather like Jews, but shamed by a different marker.

STRENGTHENED MONARCHS AND THEIR ADAPTATIONS

The impulse behind "purification" was less hatred than the exercise of power. Expelling the Jews meant confiscating their property and calling in their loans while polishing an image of zealous religiosity. Burning lepers was one way to gain access to the assets of *leprosaria* and claim new forms of hegemony. Imprisonment and burning put heretics' property into the hands of secular authorities. As kings and other great lords manipulated the institutions and rhetoric of piety and purity for political ends, they learned how to adapt to, mollify, and use—rather than stamp out—new and up-and-coming classes. As their power increased, they came to welcome the broad-based support that representative institutions afforded them.

All across Europe, from Spain to Poland, from England to Hungary, rulers summoned parliaments. (See Map 7.5.) Growing out of ad hoc advisory sessions that kings and other rulers held with the most powerful people in their realms, parliaments became solemn and formal assemblies in the thirteenth century, moments when rulers celebrated their power and where the "orders"—clergy, nobles, and commons—assented to their wishes. Eventually parliaments became organs through which groups not ordinarily at court could articulate their interests.

The orders (or "estates") were based on the traditional division of society into those who pray, those who fight, and those who work. Unlike modern classes, defined largely by economic status, medieval orders cut across economic boundaries. The clerics, for example, included humble parish priests as well as archbishops; the commons included wealthy merchants as well as impoverished peasants. That, at least, was the theory. In

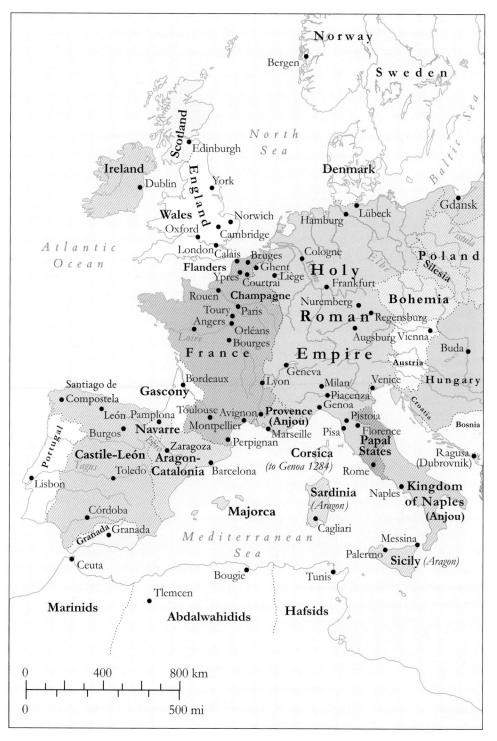

practice, rulers did not so much command representatives of the orders to come to court as they summoned the most powerful members of their realm, whether clerics, nobles, or important townsmen. Above all they wanted support for their policies and tax demands.

Spanish Cortes

The cortes of the Spanish kingdoms were among the earliest representative assemblies called to the king's court. Townsmen were included in 1188, evidence of their new social and economic position. As the reconquista pushed southward across the Iberian Peninsula, Christian kings called for settlers to occupy the new frontiers. Enriched by plunder, fledgling villages soon burgeoned into major commercial centers. Like the cities of Italy, Spanish towns dominated the countryside. Their leaders—called caballeros villanos, or "city horsemen," because they were rich enough to fight on horseback—monopolized municipal offices. Thus in 1258, when Alfonso X (r.1252–1284), king of Castile and León, called for a meeting of the cortes at Valladolid he convened the counsel with "the archbishops and with the bishops and the magnates of Castile and León and with the good men of the towns." In fact, the representatives of the towns were in the majority. Alfonso's ambitious plans included invading Africa, taking the title Holy Roman Emperor, and dominating the other Iberian kingdoms. For this he needed money, and he regularly called meetings of the cortes to consent to new taxes.

Local Solutions in the Empire

In 1356 the so-called Golden Bull freed imperial rule from the papacy but at the same time made it dependent on the German princes. The princes had always participated in ratifying the king and emperor; now seven of them were given the role and title of "electors." When a new emperor was to be chosen, each prince knew in which order his vote would be called, and a majority of votes was needed for election.

After the promulgation of the Golden Bull, the royal and imperial level of administration was less important than the local. Yet every local ruler had to deal with the same two classes on the rise: the townsmen (as in Castile and elsewhere) and a group particularly important in Germany, the ministerials. The ministerials were legally serfs whose services—collecting taxes, administering justice, and fighting wars—were so honorable as to garner them both high status and wealth. By 1300 they had become "nobles" in every way but one: they needed their lord's permission to marry. Apart from this indignity (which itself was not always imposed), the ministerials, like other nobles, profited from German colonization to become enormously wealthy landowners. Some held castles, and many controlled towns. They became counterweights to the territorial princes who, in the wake of the downfall of the Staufen, had expected to rule unopposed. In Lower Bavaria in 1311, for example, when the local duke was strapped for money, the nobles, in tandem

with the clergy and the townsmen, granted him his tax but demanded in return recognition of their collective rights. The privilege granted by the duke was a sort of Bavarian Magna Carta. By the middle of the fourteenth century, princes throughout the Holy Roman Empire found themselves negotiating periodically with various noble and urban leagues.

English Parliament

In England, the consultative role of the barons at court had been formalized by the guarantees of Magna Carta. When Henry III (r.1216–1272) was crowned at the age of nine, a council consisting of a few barons, professional administrators, and a papal legate governed in his name. Although not quite "rule by parliament," this council set a precedent for baronial participation in government. Once grown up and firmly in the royal saddle, Henry so alienated barons and commoners alike by his wars, debts, favoritism, and lax attitude toward reform that the barons threatened rebellion. At Oxford in 1258, they forced Henry to dismiss his foreign advisers (he had favored the Lusignans, from France). Henceforth, he was to rule with the advice of a Council of Fifteen, chosen jointly by the barons and the king, and to limit the terms of his chief officers. Yet even this government was riven by strife, and civil war erupted in 1264. At the battle of Lewes in the same year, the leader of the baronial opposition, Simon de Montfort (c.1208–1265), routed the king's forces, captured the king, and became England's de facto ruler.

By Simon's time the distribution of wealth and power in England had changed from the days of Magna Carta. Well-to-do merchants in the cities could potentially buy out most knights and even some barons many times over. Meanwhile, in the rural areas, the "knights of the shire" as well as some landholders below them were rising in wealth and standing. These ancestors of the English gentry were politically active: the knights of the shire attended local courts and served as coroners, sheriffs, and justices of the peace, a new office that gradually replaced the sheriff's. The importance of the knights of the shire was clear to Simon de Montfort, who called a parliament in 1264 that included them; when he summoned another parliament in 1265, he added, for the first time ever, representatives of the towns—the "commons." Even though Simon's brief rule ended that very year and Henry's son Edward I (r.1272-1307) became a rallying point for royalists, the idea of representative government in England had emerged, born of the interplay between royal initiatives and baronial revolts. Under Edward, parliament met fairly regularly, a by-product of the king's urgent need to finance his wars against France, Wales, and Scotland. "We strictly require you," he wrote in one of his summonses to the sheriff of Northamptonshire, "to cause two knights from [Northamptonshire], two citizens from each city in the same county, and two burgesses from each borough, of those who are especially discreet and capable of laboring, to be elected without delay, and to cause them to come to us [at Westminster]."9

Map 7.6 (facing page) East Central Europe, *c*.1300

French Monarchs and the "Estates"

French King Louis IX, unlike Henry III, was a born reformer. He approached his kingdom as he did himself: with zealous discipline. As an individual, he was (by all accounts) pious, dignified, and courageous. He attended church each day, diluted his wine with water, and cared for the poor and sick (we have already seen his devotion to lepers). Hatred of Jews and heretics followed as a matter of course. Twice Louis went on crusade, dying on the second expedition.

Generalized and applied to the kingdom as a whole, Louis's discipline meant doling out proper justice to all. As the upholder of right in his realm, Louis pronounced judgment on some disputes himself—most famously under an oak tree in the Vincennes forest, near his palace. This personal touch polished Louis's image, but his wide-ranging administrative reforms were more fundamentally important for his rule. Most cases that came before the king were not, in fact, heard by him personally but rather by professional judges in the *Parlement*, a newly specialized branch of the royal court (and therefore nothing like the English "Parliament," which was a representative institution). Louis also created a new sort of official, the *enquêteurs*, who traveled to the provinces to hear complaints about the abuses of royal administrators. At the same time, Louis made the seneschals and *baillis*, local officials created by Philip Augustus, more accountable to the king by choosing them directly. They called up the royal vassals for military duty, collected the revenues from the royal estates, and acted as local judges. For the administration of the city, Louis instituted joint rule by royal officials and citizens.

There were discordant voices in France, but they were largely muted and unrecognized. At the royal court, no regular institution spoke for the different orders. This began to change only under Louis's grandson, Philip IV the Fair (r.1285–1314). When Philip challenged the reigning pope, Boniface VIII (1294–1303), over rights and jurisdictions (see below for the issues), he felt the need to explain, justify, and propagandize his position. Summoning representatives of the French estates—clergy, nobles, and townspeople—to Paris in 1302, Philip presented his case in a successful bid for support. In 1308 he called another representative assembly, this time at Tours, to ratify his actions against the Templars—the crusading order that had served as *de facto* bankers for the Holy Land. Philip had accused the Templars of heresy, arrested their members, and confiscated their wealth. He wanted the estates to applaud him, and he was not disappointed. These assemblies, ancestors of the French Estates General, were convened sporadically until the Revolution of 1789 overturned the monarchy. Yet representative institutions were never fully or regularly integrated into the pre-revolutionary French body politic.

New Formations in East Central Europe

Like a kaleidoscope—the shards shuffling before falling into place—East Central Europe was shaken by the Mongol invasions and then stabilized in a new pattern. (See Map 7.6.)

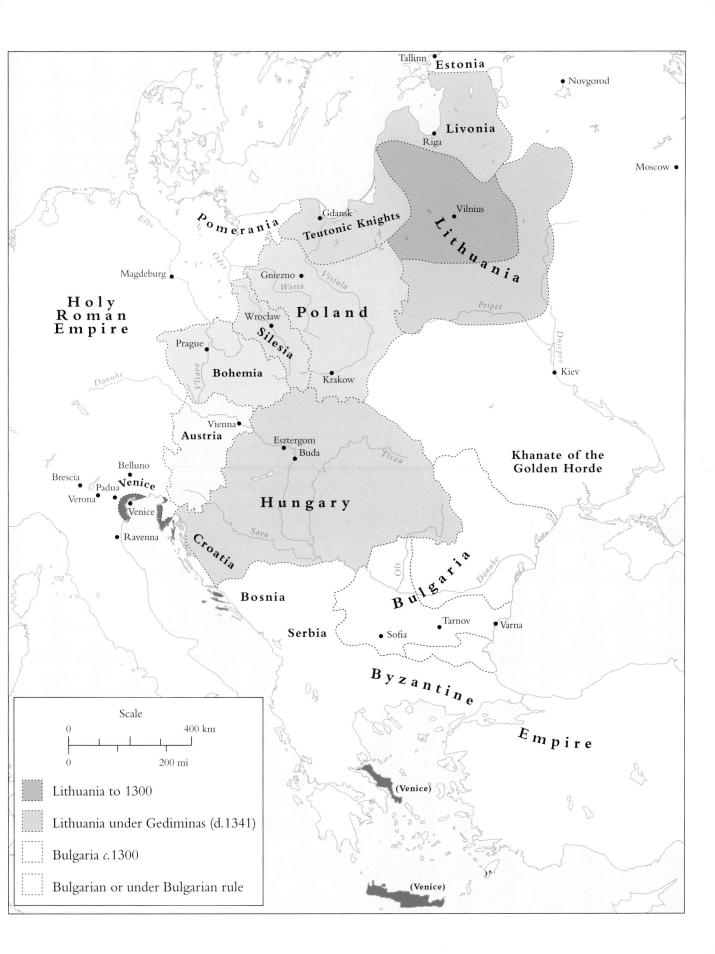

In Hungary, King Béla IV (r.1235–1270) complained that the invaders had destroyed his kingdom: "most of the kingdom of Hungary has been reduced to a desert by the scourge of the Tartars," he wrote, begging the pope for help. Described But the greatest danger to his power came not from the outside but from the Hungarian nobles, who began to build castles for themselves—in a move reminiscent of tenth-century French castellans. The nobles eventually elected an Angevin—Charles Robert, better known as Carobert (r.1308–1342)—to be their king. Under Carobert, Hungary was very large, even though the region controlled by the king was quite small.

Bulgaria and Poland experienced similar fragmentation in the wake of the Mongols. At the end of the twelfth century, Bulgaria had revolted against Byzantine rule and established the Second Bulgarian Empire. Its ruler, no longer harking back to the khans, took the title tsar, Slavic for "emperor." He wanted his state to rival the Byzantines in other ways as well. In the early thirteenth century, for example, when crusaders had taken Constantinople and Byzantine power was at a low ebb, Tsar Ivan Asen II (r.1218–1241) expanded his hegemony over neighboring regions. Making a bid for enhanced prestige, he seized the relics of the popular Byzantine saint Paraskeve and brought them to his capital city. She became the patron saint of Bulgaria, where she was known as Saint Petka: "The great Tsar Ivan Asen," wrote Petka's admiring biographer, "heard about the miracles of the saint and strongly desired to transport the body of the saint to his land.... He ... wanted neither silver nor precious stones, but set off with diligence and carried the saintly body to his glorious [imperial city of] Tarnov." It was a great triumph. But the Mongol invasions hit Bulgaria hard, and soon its neighbors were gnawing away at its borders. Meanwhile, its nobles—the boyars—began to carve out independent regional enclaves for themselves. Nevertheless, by the early fourteenth century agreements with the Byzantines and Mongols brought territories both north and south back under Bulgarian control.

In Poland, as one author put it, "as soon as the pagans [the Mongols] entered this land, and did much in it that was worthy of lament, and after the celebrated Duke [Henry II] was killed, this land was dominated by knights, each of whom seized whatever pleased him from the duke's inheritances." The author was abbot of a monastery in Silesia, which in his day—the mid-thirteenth century—was ruled by a branch of the Piast ducal dynasty, as were other Polish territories. He looked back with nostalgia to the days of Henry II, when one Piast duke ruled over all. In fact, a centralized Poland was gradually reconstructed, not least by Casimir III the Great (r.1333–1370), but this time it looked eastward to Rus' and Lithuania rather than westward to Silesia and Bohemia.

It made sense to veer in Lithuania's direction: there Duke Gediminas (r.c.1315/1316–1341), while not formally converted to Christianity, nevertheless favored Christian missionaries and encouraged merchants from Germany and Rus' to settle in his duchy and build churches representing both Roman Catholic and Byzantine forms of worship. Declaring war against the Teutonic Knights, Gediminas took Riga and pressed yet farther eastward and southward. By the time of his death, Lithuania was the major player in Eastern Europe. Gediminas's heirs (known as the Jagiellon dynasty) expanded still further into Rus'.

On the other, western edge of East Central Europe, Bohemia, too, became a powerhouse. Taking advantage of the weak position of the German emperors, Bohemia's rulers now styled themselves "king." Ottokar II (r.1253–1278) and his son Vaclav II (r.1283–1305) welcomed settlers from Germany and Flanders and took advantage of newly discovered silver mines to consolidate their rule. Charles IV (r.1347–1378) even became Holy Roman Emperor. At the same time, however, Czech nobles, who had initially worked as retainers for the dukes and depended on ducal largesse, now became independent lords who could bequeath both castles and estates to their children.

Despite their differences, the polities of East Central Europe c.1300 were all starting to resemble Western European states. They had begun to rely on written laws and administrative documents; their nobles were becoming landlords and castellans; their economies were increasingly urban and market-oriented; their constitutions were defined by charters reminiscent of Magna Carta; and their kings generally ruled with the help of representative institutions of one sort or another. All—except for Lithuania until Gediminas's death—were officially Christian, and even Lithuania under Gediminas supported Christian institutions like monasteries, churches, and friaries. Universities, the symbolic centers of Western European culture, were transplanted eastward in quick succession: one was founded at Prague in 1348, another at Krakow in 1364, and a third at Vienna in 1365.

THE CHURCH MILITANT, HUMILIATED, AND REVAMPED

On the surface, the clash between Philip the Fair and Boniface VIII seemed yet one more episode in the ongoing struggle between medieval popes and rulers for power and authority. But by the end of the thirteenth century the tables had turned: the kings had more power than the popes, and the confrontation between Boniface and Philip was one sign of the dawning new principle of national sovereignty.

The Road to Avignon

The issue that first set Philip and Boniface at loggerheads involved the English king Edward I as well: taxation of the clergy. Eager to finance new wars, chiefly against one another, both monarchs needed money. When the kings financed their wars by taxing the clergy along with everyone else (as if they were going on crusade), Boniface reacted, threatening to excommunicate both clergymen who paid taxes to the king and kings who demanded such taxes.

Reacting swiftly, the kings soon forced Boniface to back down. But in 1301, testing his jurisdiction in southern France by arresting Bernard Saisset, the bishop of Pamiers, on a charge of treason, Philip precipitated another crisis. Boniface responded to the arrest by issuing the bull *Unam sanctam* (1302), which declared that "it is altogether necessary to

salvation for every human being to be subject to the Roman Pontiff." As we have seen, (above p. 272), Philip adroitly rallied public opinion in his favor by calling the Estates together. Philip's agents also invaded Boniface's palace at Anagni (southeast of Rome) to capture the pope, bring him to France, and try him for heresy. Although the citizens of Anagni drove the agents out of town, Philip's power could not be denied. A month later, Boniface died, and the next two popes quickly pardoned Philip and his agents.

The papacy was never quite the same thereafter. In 1309, forced from Rome by civil strife, the popes settled at Avignon, a Provençal city administered by the Angevins of Naples but very much under the influence of the French crown. There the popes remained until 1377. The Avignon papacy, largely French, established a sober and efficient organization that took in regular revenues and gave the papacy more say than ever before in the appointment of churchmen and the distribution of church benefices and revenues.

In some ways, papal authority grew during this time, becoming the unchallenged judge of sainthood. Moreover, the Dominicans and Franciscans became its foot soldiers in the evangelization of the world and the purification of Christendom. These were tasks that required realistic men. When a group of Franciscans objected to their fellows building convents and churches within the cities, the popes condemned them. The Spirituals, as they were called, cultivated a piety of poverty and apocalypticism, believing that Saint Francis had ushered in a new Age of the Holy Spirit. But the popes interpreted the Franciscan rule differently. They advocated the repression of the Spirituals and even had a few burned at the stake.

Even so, the Avignon papacy was mocked and vilified by contemporaries, especially Italians, whose revenues suffered from the popes' exile from Rome. Petrarch (Francesco Petrarca, 1304–1374), one of the great literary figures of the day, called the Avignon papacy the "Babylonian Captivity," referring to 2 Kings 25:11, when the ancient Hebrews were exiled and held captive in Babylonia. Pliant and accommodating to the rulers of Europe, especially the kings of France, the popes were slowly abandoning the idea of leading all of Christendom and were coming to recognize the right of secular states to regulate their internal affairs.

Lay Religiosity

Secular states, yes; but their populations took religion very seriously. With the doctrine of transubstantiation (see p. 239), Christianity became a religion of the body: the body of the wafer of the Mass, the body of the communicant who ate it, and equally the body of the believers who celebrated together in the feast of Corpus Christi (the Body of Christ). Eucharistic piety was already widespread in the most urbanized regions of Europe when Juliana of Mont Cornillon (1193–1258), prioress of a convent in the Low Countries, announced that Christ himself wanted a special day set aside to celebrate his Body and Blood. Taken up by the papacy and promulgated as a universal feast, Corpus Christi was adopted throughout Western Europe. Cities created new processions for the day. Fraternities dedicated themselves to the Body of Christ, holding their meetings on the

feast day, focusing their regular charity on bringing the *viaticum* (or final Eucharist) to the dying. Dramas were elaborated on the theme. Artists decorated the chalices used in the Mass with symbols that made the connection between the wine and the very blood that Christ had shed on the cross. (See Plate 7.4.)

Along with new devotion to the flesh of Christ came devotion to his mother. Like other Shrine Madonnas, the one in Plate 7.5 on pp. 278–79 displays her body as twofold: one external, the other within. Closed, she is a nursing mother; open she reveals a seated God the Father holding a cross. The original would have included (where there are now only holes) the figure of the crucified Christ on the Cross, above whom was once a dove signifying the Holy Spirit. Framing this Holy Trinity are scenes of Jesus' infancy.

Books of Hours—small prayer books aimed especially at laywomen—almost always included all the prayers for the Hours of the Virgin. These were eight short devotional texts to be said at the eight canonical times of the day. Often illustrated, they attest to the important place of Mary in the lives of the devout. Plate 7.6 on p. 280 from one such Book of Hours gives the text for Vespers, which took as its theme the Flight into Egypt. Within the initial D of *Deus*, the first letter of the first word of the biblical text for this hour, "God [Deus] incline unto my aid," is a depiction of the Holy Family in flight.

That worship could be a private matter was part of larger changes in the ways in which people negotiated the afterlife while here on earth. The doctrine of Purgatory, informally believed long before it was declared dogma in 1274, held that Masses and prayers said by the living could shorten the purgative torments that had to be suffered by the souls of the dead. Soon families were endowing special chapels for themselves, special spaces for offering private Masses on behalf of their own members. High churchmen and wealthy laymen and -women insisted that they and members of their family be buried within the walls of the church rather than outside of it, reminding the living—via their effigies—to pray for them. Typical is the tomb of Robert d'Artois (d.1317), commissioned by his mother, Countess Mahaut d'Artois (in northern France). (See Plate 7.7 on p. 281.)

THE SCHOLASTIC SYNTHESIS AND ITS FRAYING

Widespread religiosity went hand-in-hand with increasing literacy. In some rural areas, schools for children were attached to monasteries or established in villages. In the south of France, where the church still feared heresy, preachers made sure that they taught children how to read along with the tenets of the faith. In the cities, all merchants and most artisans had some functional literacy: they had to read and write to keep accounts, and, increasingly, they owned religious books for their private devotions. In France, Books of Hours were most fashionable; Psalters were favored in England.

The broad popularity of the friars fed the institutions of higher education. Franciscans and Dominicans now established convents and churches within cities; their members

Plate 7.4 Chalice (c. 1300). This gilded silver chalice, one of a pair made in the Rhineland, graphically shows the connection between the wine of the Eucharist and Christ's blood. On a large knob just below the cup, the goldsmith has placed medallions stamped with Christ's head alternating with rosettes that represent the five wounds of Christ. Each rosette sprouts a vine tendril that spreads its leaves on the base of the chalice, reminding communicants of the grapes that were pressed into the wine.

Following pages:

Plate 7.5 A Shrine Madonna from the Rhineland (c.1300). This painted wooden sculpture of the Virgin would have been used for private contemplation, perhaps by a nun at a convent in Cologne. The statue embodies an idea that was echoed in contemporary prayers, hymns, and poetry: that Mary was not just the mother of Christ but the bearer of the entire Trinity.

Plate 7.6 Page from a Book of Hours, Northern France or Flanders (early 14th cent.). While contemplating the text and its illustration, the reader of this book was also pleasantly diverted by small, playful drawings: a woman winding yarn, a lion with a curling tail, the head of a man peeking out of the letter D.

attended the universities as students, and many went on to become masters. The friars—men like Thomas Aquinas (c.1225–1274) and Bonaventure (c.1217–1274)—were the greatest of the scholastics, mastering the use of logic to summarize and reconcile all knowledge and use it in the service of contemporary society.

The Dominican Thomas Aquinas's *summae* (sing. *summa*)—long, systematic treatises that attempted to sum up all knowledge—were written to harmonize matters both human and divine. Using the technique of juxtaposing contrary positions, as Abelard had done in his *Sic et non*, Aquinas (unlike Abelard) carefully explained away or reconciled contradictions, using Aristotelian logic as his tool for analysis and exposition. Aquinas wanted to reconcile faith with reason, to demonstrate the harmony of belief and understanding

even though (in his view) faith ultimately surpassed reason in knowing higher truths. In his massive Summa Theologiae, written as a sort of textbook for budding theologians, Thomas summed up the natures of man and God and the relations between them. His theme was salvation: how human beings heirs to the original sin of Adam and Eve, who disobeyed God and were condemned to a life of pain and toil until they diednevertheless had been offered a way back to God. That way back entailed belief, virtue, and—crucially—the human capacity to love. People loved many things, all of which they considered good. That was right, according to Thomas, because "the proper object of love is the good."14 But often people chose as the good the wrong things—impermanent things or even bad things. Nevertheless, they could also learn to love the right good, the highest good, God. And as they did so, they returned to God.

In the writings of Albertus Magnus (c.1200–1280), Aquinas's teacher, the topics ranged from biology and physics to theology. In the *summae* of the Franciscan Saint Bonaventure, for whom Augustine was more important than Aristotle, the topics as such were secondary to an overall vision of the human mind as the recipient of God's beneficent illumination. For Bonaventure, minister general of the Franciscan order, spirituality

was the font of theology. Yet it was the Spiritual Franciscan Peter Olivi (1248-1298) who first defined the very practical word "capital": wealth with the potential to generate more wealth. With this concept, he hoped to reassure merchants when they consulted churchmen in the confessional.

The scholastics' teachings were preached to townsmen by the friars, who turned the Latin of the universities into the vernacular of the streets. Far from the streets, however, were the reclusive contemplatives in the cities of Italy, the Netherlands, and the Rhineland; some absorbed the new learning from their confessors. But the Dominican Meister Eckhart (d.1327/1328) was himself a contemplative: a mystic who saw union with God as the goal of human life. He studied at Paris before beginning a career of teaching and preaching in Germany, and he enriched the German language with new words for the abstract ideas of the schools.

Plate 7.7 Tomb and Effigy of Robert d'Artois (1317). Although Robert was only seventeen years old when he died, the sculptor of his tomb effigy, Jean Pépin de Huy, gave him a sword and buckler (the accoutrements of a knight) and placed a tame lion at his feet (the symbol of his power). At the same time, his prayerful pose and the lion alert his viewers to think of the life to come. Robert's uplifted hands signify his piety, while the lion (mother lions were believed to waken their stillborn cubs to life by their roars) recalls the hope of resurrection.

These thirteenth-century scholastics united the secular realm with the sacred in apparent harmony. But at the end of the century, fissures began to appear. In the writings of the Franciscan John Duns Scotus (1265/1266–1308), for example, the world and God were less compatible. As with Bonaventure, so too with Duns Scotus: human reason could know truth only by divine illumination. But Duns Scotus argued that this illumination came not as a matter of course but only when God chose to intervene. He saw God as willful rather than reasonable; the divine will alone determined whether human reason could soar to knowledge. Further unraveling the knot tying reason and faith together was William of Ockham (d.1347/1350), another Franciscan who nevertheless disputed Duns Scotus vigorously. For Ockham, reason was unable to prove the truths of faith; it was apt only for things human and worldly, where, in turn, faith was of no use. Ockham himself turned his attention to the nature of government, arguing the importance of the state for human society. But several of his contemporaries looked at the physical world: Nicole Oresme (c.1320–1382), for example, following Ockham's view that the simplest explanation was the best, proposed that the sun, not the earth, was the center of the heavens.

HARMONY AND DISSONANCE IN WRITING, MUSIC, AND ART

On the whole, writers, musicians, architects, and artists, like scholastics, presented complicated ideas and feelings in harmony. Writers explored the relations between this world and the next; musicians found ways to bridge sacred and secular genres of music; artists used fleshy, natural forms to evoke the divine.

Vernacular Literature

In the hands of Dante Alighieri (1265–1321), vernacular poetry expressed the order of the scholastic universe, the ecstatic union of the mystic's quest, and the erotic and emotional life of the troubadour. His Commedia—later known as the Divine Comedy—presents Dante (writing in the first person) as a traveler who passes through Hell, Purgatory, and Paradise, and yet the poem is fixed on locations in this world. For example, when Dante asks a soul in Hell to introduce herself, she begins with her hometown: "The city where I was born lies on that shore where the Po descends." Dante himself was a child of the Arno, the river that flows through Florence. An ardent Florentine patriot and member of the "Whites" party, the faction that opposed papal intervention in Tuscany, he was condemned to death and expelled from the city by the "Blacks" after their victory in 1301. The Commedia was written during Dante's bitter exile. It was peopled with his friends, lovers, enemies, and the living and dead whom he admired and reviled.

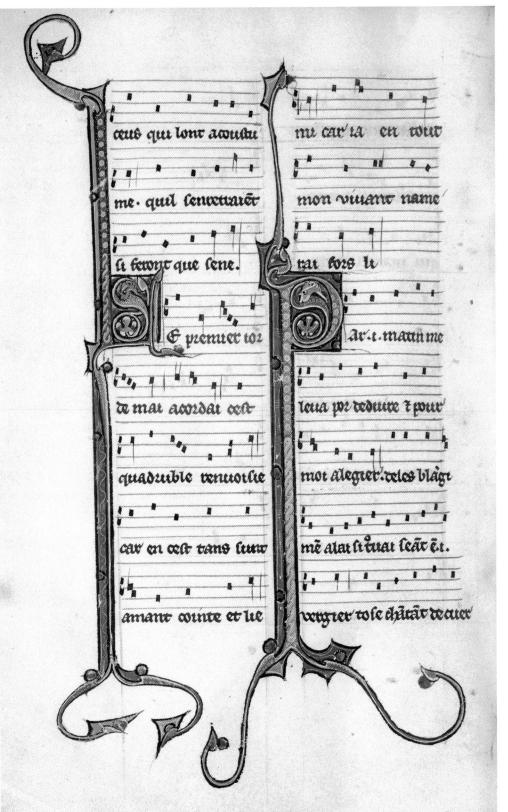

Plate 7.8 The Motet Le premier jor de mai (c.1280). The motet begins in the middle of the page (the decorated initial is the L of Le), and two voices are shown here. While the voice on the left sings "On the first day of May..." the one on the right, who begins on exactly the same note, sings something quite different: "One morning I got up ... I found a girl sitting in an orchard." As it turns out, the girl rejects her would-be lover. The third voice (whose music and words begin on the next page), also sings at the same time as the other two. That voice starts on a lower note with the words, "I can no longer endure without you ..." Accompanying all three voices is the lowest one, which intones simply the word Justus (meaning "the just man"), the first word of an antiphon from church liturgy that continues "the just man will sprout like the lily and flower in eternity."

At the same time, it was a parable about the soul seeking and finding God in the blinding light of love. Just as Thomas Aquinas used Aristotle's logic to lead him to important truths, Dante used the pagan poet Virgil as his guide through Hell and Purgatory. And just as Aquinas believed that faith went beyond reason to even higher truths, Dante found a new guide, Beatrice, representing earthly love, to lead him through most of Paradise. But only faith, in the form of the divine love of the Virgin Mary, could bring Dante to the culmination of his journey, the inexpressible and ravishing vision of God.

In other writers, the harmony of heaven and earth was equally sought, if differently expressed. In the anonymous prose *Quest of the Holy Grail* (c.1225), the adventures of the knights of King Arthur's Round Table were turned into a fable to teach the doctrine of transubstantiation and the wonder of the vision of God. In *The Romance of the Rose*, begun by one author (Guillaume de Lorris, a poet in the romantic tradition) and finished by another (Jean de Meun, a poet in the scholastic tradition), a lover seeks the rose, his true love, but is continually thwarted by personifications of love, shame, reason, abstinence, and so on. They present him with arguments for and against love, but in the end, erotic love is embraced in the divine scheme—and the lover plucks the rose.

The Motet

Already by the tenth century, the chant in unison had been joined by a chant of many voices: polyphony. Initially voice met voice in improvised harmony, but in the twelfth century polyphony was increasingly composed as well. In the thirteenth century, its most characteristic form was the motet. Created at Paris, probably in the milieus of the university and the royal court, the motet harmonized the sacred with the worldly, the Latin language with the vernacular.

Two to four voices joined together in a motet. The lowest voice, singing a chant taken from church liturgy, generally consisted of one or two words. Perhaps it was played on an

Figure 7.1 Single Notes and Values of Franconian Notation

Name and shape of note	Value (in beats)	Modern equivalent
Duplex long	6	٥.
Perfect long	3	d.
Imperfect long	2	
Breve	1	J
Semibreve		
Minor + major ◆ ◆	1/3 + 2/3	ار پر ع
Three minor • • •	1/3 + 1/3 + 1/3	ĬŢ,
Inree minor • • •	/3 + /3 + /3	3

instrument (such as a vielle or lute) rather than sung. The other voices had different texts and melodies, sung simultaneously. The form allowed for the mingling of religious and secular motives. Very likely motets were performed by the clerics who formed the entourages of bishops or abbots—or by university students—for their entertainment and pleasure. In the motet *Le premier jor de mai*, whose opening music is pictured in Plate 7.8 on p. 283, the top voice begins (in French): "On the first day of May I composed this cheerful quadruplum [a four-part song]." But it goes on to lament, "But I find myself disconsolate on account of love."

Complementing the motet's complexity was the development of new schemes to indicate rhythm. The most important, that of Franco of Cologne in his *Art of Measurable Song* (c.1260), used different shapes to mark the number of beats for which each note should be held. (See Figure 7.1; the music in Plate 7.8 uses a similar rhythmic system.) Allowing for great flexibility and inventiveness in composition, Franco's scheme became the basis of modern musical notation.

New Currents in Art

Flexibility and inventiveness describe the art of Franco's time as well. Artists had new patrons to serve: the urban elite. In the Paris of Saint Louis's day, for example, wealthy merchants coveted illuminated law books and romances; rich students prized illustrated Bibles as essential fashion accessories; churchmen wanted beautiful service books; the royal family craved lavishly illustrated Bibles, Psalters, and Books of Hours; and the nobility aspired to owning the same books as their sovereigns. The old-fashioned scriptoria that had previously produced books, with scribes and artists working in the same place, gave way to specialized workshops, often staffed by laypeople. Some workshops produced the raw materials: the ink, gold leaf, or parchment; others employed scribes to copy the texts; a third kind was set up for the illuminators; and a fourth did nothing but bind the finished books. (See Material Culture: The Making of an Illuminated Manuscript on pp. 152-55.) At Bologna, where the university specialized in law, students, professors, and lawyers wanted books that covered the most up-to-date legal thinking. The text of the folio in Plate 7.9 was written by a famous professor of canon law at Bologna, Giovanni d'Andrea, and illuminated by an artist there, Nerio, active between 1310 and 1320. The page illustrates a delicate issue: consanguinity. The church had long banned "incestuous marriages" among members of a kin group, and the Tree of Consanguinity was a convenient way to diagram degrees of separation.

Giovanni d'Andrea was so revered that he and his classroom were portrayed in marble after his death. While some of his students pore over their books, one of them (on the left) sleeps, and another (on the right) blows at something in his hand. (See Plate 7.10.)

At the same time, painters began to adopt—even on flat surfaces—the weighty, natural forms already evident in the Bamberg tympanum (Plate 6.8 on p. 240). This was especially true of Italian painters, who lived in a world still permeated by ancient Roman art

Following pages:

Plate 7.9 Page from Giovanni d'Andrea, Summa on Engagements and Marriages and Lecture on the Tree of Consanguinity and Affinity (c.1315). The bearded male figure signifies the family forefather. Screening most of his body is the Tree of Consanguinity. The black circle at the center is the Ego, "I." All the other circles radiate out from it and indicate their relationship to Ego. For example, just beneath Ego is the number I (the degree of relation) and the words filio/ filia—son/daughter. The tree follows the prohibition of marriages within four degrees of consanguinity declared at the Fourth Lateran Council (1215). Giovanni's lecture surrounds the illumination, and one or more diligent readers added notes in the margins.

Plate 7.10 Sepulcher of Giovanni d'Andrea, Bologna (1348). This is a new sort of tomb sculpture, neither allegorical, like the Euhodus sarcophagus (Plate I.4 on p. 16) nor chivalric, like the tomb of Robert d'Artois (see above, Plate 7.7 on p. 281).

the tectaria article out to other outstand most tendents, p. or too stamus post those tectars them articles nomin maxim assume post the entrans require nomin medianum appur fine nuste a particle noting articles of the procum sendents and the second medianum and the second tendents of the second medianum and the second second medianum and the second tendents of the second medianum and the second second tendents of the second seco un ucarini aritone (cco finife ur binito mariam ofangamunai raffinitani i importam, nocibindo notum, excallegiu infracti nonlima ficieramajmosimi finipati rendum opini erretori recitioi opiniam.

Dinnio finime abinimo artorica ad do finici mi uno aginote.

Litco antica autorica.

Certica ad quiti in notumi tretini of olim fucari micerio.

Dannio quaditori erretini of olim fucari micerio.

Dannio quaditori erretini ofinimi primi ofinimi cario accipimi a tam unica indivigiti ca agnatuoto. Evil, quante aliquia reconsiliumi ariellare pripummi gi ellomor, evivona-

rozummefilo fat m ansariquit r aplan quinicum no anni ficionale fracuen-infri-Lapa leccura puorine lii nehgano anmli fic ungo appar pofin hi anarta terngio finicing utali mpe

anticacionecommaco ff-cefei-laper house pupaleGanfinenere it fle termin falles florin ole arror in tennea è spiparete emonibor flori et alextrique i grant uit. Labranmon quartie reconfan.
4.16. ranufnulefo
17.16. arboren ponecrozurockenub en uactatus-cuam m becuolimineunic furiepen ercoman monbumo ans a

malicum fatiga fa molum ornicuta lenoplaticaemen moluma greeco ornicum anticum dicamatiam ilam multü erant cozro haynteceptores funt enterentation in the control of the erpanno grqualit outerinations (fo

formeturet quenc formet quare fic pacter

bounces par materia puncion de comunicación de parte para a comens qua parte p

quountrum mmanmou trabigussine neceset aum miumfitac copapueter mnorum è amoneuris mip opterul micrationep menacomo Pochoc rofa trumqruis gunasfemo plonavonta fone peams pagonem g ounabouat Autodusir cosfinitios monolebac magaam regu laning aften TENTHUM CE'OC form bentunn quot furt p groputatis intincono cuma dempra, totiunt go interes. Or un fanc quid Sifter abaum April umoq3 oputate 7inf meduan fue for bemasy fiam-quatuo कारक का का का का

Plate of figuration of the state of the stat

Alangarancy

maps gla

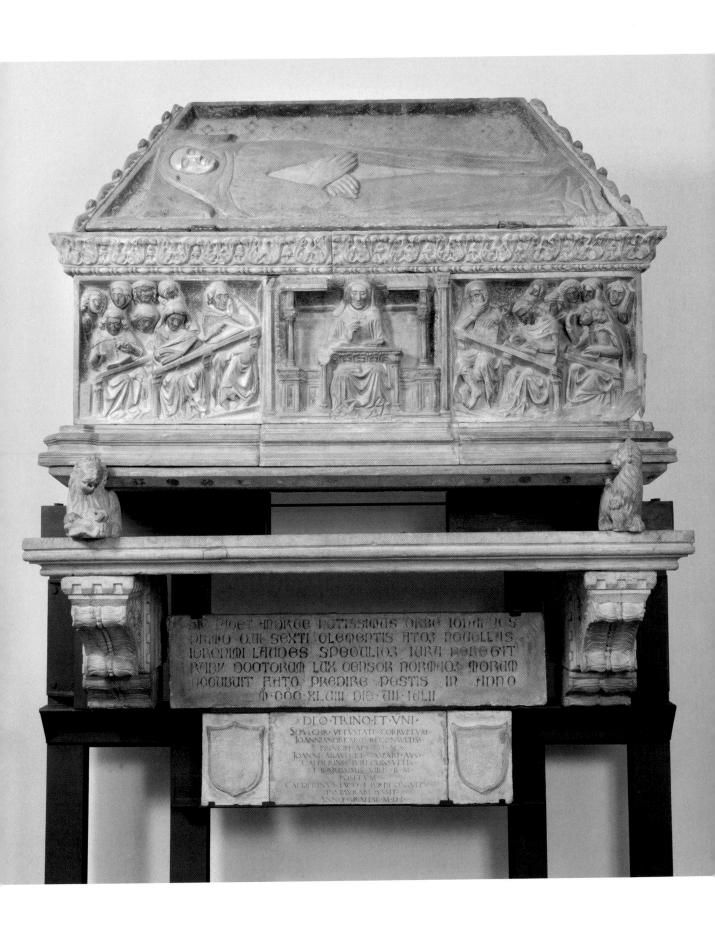

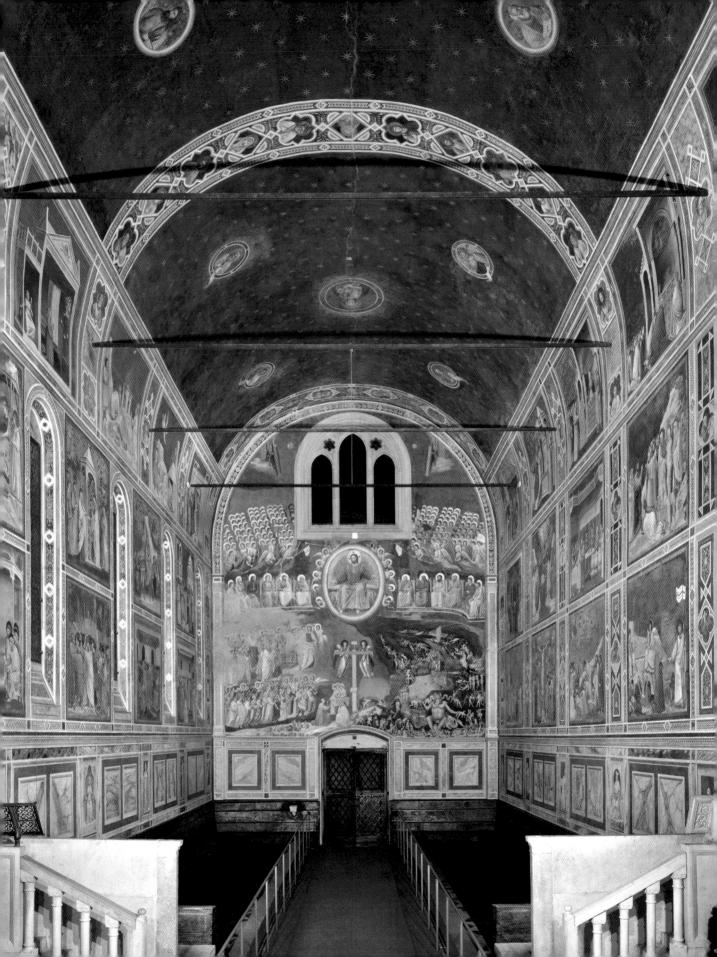

(such as that in Plate 1.1 on p. 12) and models from Byzantium. But it was the case everywhere now that the body—both human and godly—was newly appreciated. When Giotto (1266/1267–1337) decorated the private chapel of the richest man in Padua he filled the walls with frescoes narrating humanity's redemption through Christ, culminating in the Final Judgment. (See Plate 7.11.) Throughout, Giotto experimented with the illusion of depth, weight, and volume, his figures expressing unparalleled emotional intensity as they reacted to events in the world-space created by painted frames. In the *Lamentation of Christ* (see Plate 7.12 on pp. 290–91), Giotto gives a key role to Mary, who cradles her son's head while Mary Magdalene holds his feet. Others stand or kneel with gestures of grief, while the angels above mirror their anguish.

Plate 7.11 (facing page) Giotto, Scrovegni Chapel, Padua (1304–1306). Giotto organized the Scrovegni Chapel paintings like scenes in a modern comic book, to be read from left to right, with the Last Judgment over the entryway.

AN AGE OF SCARCITY?

Giotto's Lamentation was created not long before the horrific event that historians call the Great Famine (1315–1322), one of many waves of food shortages that shook the medieval world on either side of the year 1300. The chief causes of this calamity have traditionally been sought in demographics and declining food production. But newer research, summed up in a book edited by John Drendel, points out that the Mediterranean region did not suffer the Great Famine and that everywhere human action and inaction were as much to blame for food scarcity as natural factors.

Overpopulation, Undersupply

There is certainly much to be said for the demographic argument, particularly for the north of Europe. While around the year 1300 farms were producing more food than ever before, population growth meant that families had more hungry mouths to feed. Consider the village of Toury, about forty-five miles south of Paris (Map 7.7 on p. 292). It originally consisted of a few peasant habitations (their houses and gardens) clustered around a central enclosure belonging to the lord, in this case the monastery of Saint-Denis. Nearby, across the main route that led from Paris to Orléans, was a parish church. In 1110 Suger, then a monk at Saint-Denis and provost of Toury, constructed a well-fortified castle on the site of the enclosure. In the course of the thirteenth century, encouraged both by Saint-Denis's policy of giving out lots in return for rents and by a market granted by the king, the village grew rapidly, expanding to the east, then to the west, and finally (by the fourteenth century) to the north. Meanwhile the lands cultivated by the villagers—once called upon to support only a small number of householders—were divided into more than 5,000 parcels.

In general, population growth seems to have leveled off by the mid-thirteenth century, but climate change wrought its own havoc. A mini ice age took hold in the north of

Following pages:

Plate 7.12 Giotto, Lamentation of Christ, Scrovegni Chapel (1304–1306). Compare this depiction of collective grieving over the body of Christ with the painting of mourning Alexander the Great in the Shahnama produced in Mongol Iran (Plate 7.1 on p. 255). Both are influenced by themes and portrayals in Byzantine art of the time. In both, people react with dramatic gestures. In both, mothers play a significant role in setting the tone.

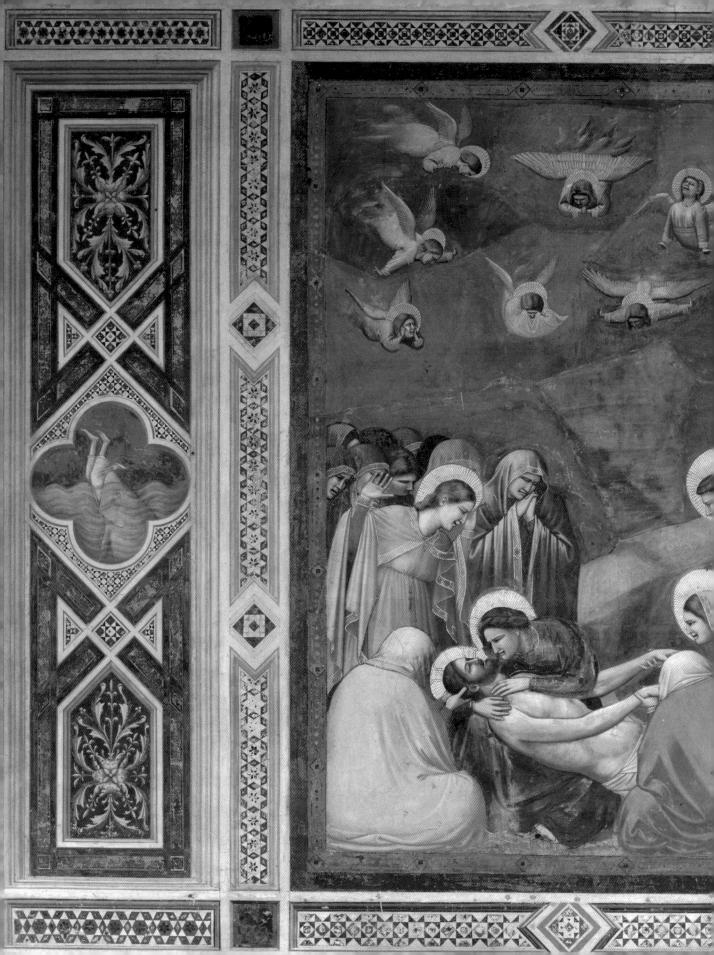

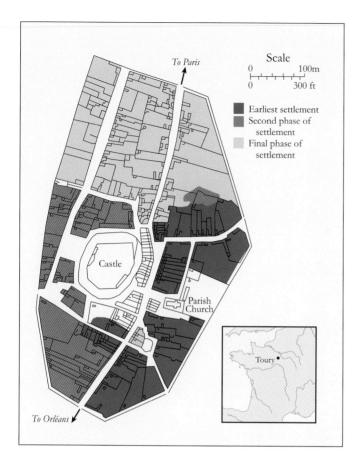

Map 7.7 The Village of Toury, 14th and 15th cent.

Europe (though not in the south), leading to wheat shortages. In 1309 the cold weather was joined by an extremely wet growing season that ruined the harvest in southern and western Germany; the towns, to which food had to be imported, were hit especially hard. And yet the towns were themselves overpopulated, swollen by immigrants from the overcrowded countryside.

Human Manipulation of Supply and Demand

Yet scarcity and famine were hardly inevitable, and in some places they were not evident at all. Often human actions were responsible for aggravating food shortages across Europe. Warfare, for example, took a major toll on economic life. As states grew in power, rulers hired soldiers—mercenaries—and depended less on knights. But these troops were paid such poor wages that they plundered the countryside even when they were not fighting. Warring armies had always disrupted farms, ruining the fields as they ran through them, but in the thirteenth century burning crops became a battle tactic,

used both to devastate enemy territory and to teach the inhabitants a lesson. Towns were as vulnerable as the countryside. They could defend their walls against roving troops, but they could not easily stop the flow of refugees who sought safety. Lille's population, for example, nearly doubled as a result of the wars between Flanders and France during the first two decades of the thirteenth century. Like other Flemish cities, Lille was obliged to impose new taxes on its population to pay for its huge war debts.

Pressured by such debts as well as the desire for gain, landlords and town officials alike strove to get more money. Everywhere, customary and other dues were deemed inadequate. In 1315 the king of France offered liberty to all his serfs, mainly to assess a new war tax on all free men. In other parts of France, lords imposed a *taille*, an annual money payment, and many peasants had to go into debt to pay it. Some lost their land entirely. To enforce their new taxes, great lords, both lay and ecclesiastical, installed local agents. Living near villages in fortified houses, these officials kept account books and carefully computed their profits and their costs.

But great lords, rulers, and merchants did not simply keep records of agricultural production; they planned ahead and manipulated the markets. The global economy meant that Italian cities no longer fed themselves from nearby farms: they relied on imports. Florentines got their grain from Sicily, Genoa from as far away as the Black Sea. Controlling these imports were the cities themselves, which functioned like mini-states.

Great merchants worked in collusion with the political powers in place. In England, major landowners were now as much agri-businessmen as they were feudal lords.

Anticipating food shortages, middlemen hoarded food stocks until prices rose steeply. Rulers were torn by their desire to make money and their duty to the common good. The kings of Aragon (in Spain) prohibited the export of wheat in times of scarcity, but they also sold special licenses to individuals, allowing them to ignore the law. City governments found themselves in a balancing act: they could store food in reserve to sell at below-market cost to the needy, but they also wanted to please their merchants.

Peasants were not passive in the face of the new conditions. They too were involved in markets—not in the grand long-distance networks of Venetian and Genoese traders, but in small-scale exchanges among local hamlets and villages. The countryside had its own sort of commerce, petty but active. The little Provençal village of Reillane, for example, with a population of 2,400, supported thirteen cloth makers. Such shopkeepers might also extend credit, on the side, to the local peasantry. The Mediterranean region—Italy, Spain, southern France, and Provence—boasted more diversified crops than the north: this meant that, when wheat harvests were poor, peasants could survive on chestnuts and millet. Or they could relocate to regions better suited to their needs. When peasants in Navarre found that they could not afford to pay their lord his dues, they moved to the Ebro valley, where they found a place in the flourishing commercial economy there. All was not bleak in the age of the Great Famine; much depended on who and where you were—and on how fair the markets were.

The Mongol invasions brought fear, war, and dislocation to both the Christian and Islamic worlds. Yet soon there was a stalemate, with the Mamluks serving as one western bulwark against the invaders, and East-Central Europe as another. There was even reconciliation, as a new global order emerged. The Ilkhanids and Khans of the Golden Horde converted to Islam; the Chinese Mongols—the Great Khans—welcomed traders and European missionaries. In many ways, this was a prosperous era across all of Europe, Eurasia, and North Africa.

Medieval Europe reached the zenith of its prosperity. Its population grew and its cities became centers of culture and wealth. Universities took wing, producing scholasticism, a "scientific revolution" in logical and systematic thought. The friars, among the most prominent of the scholastics, and ministering to an attentive, prosperous, increasingly literate laity, installed themselves right in the center of towns.

Harmonies were achieved even among clashing cultures. The Ilkhanids adopted the Persian Shahnama; the Mamluks welcomed diverse religious groups. European scholastic summae brought together a vast body of often contradictory knowledge. Kings sought new taxes by calling upon the disparate orders of nobles, clergy, and townspeople. The great artistic innovations of the day reconciled classical styles with Christian themes. Motets combined liturgical chants with songs of disappointed love.

MATERIAL CULTURE: THE DEVELOPMENT OF ISLAMIC CERAMICS

Everywhere in the medieval world people used pottery for storage, tableware, and cooking pots. For the most part, these items were workaday. Made of clay—brown, gray, red, or yellow—they were sometimes covered with slip (clay suspension) or green lead glaze and, again sometimes, were further decorated, with a geometric design or a stamped or incised pattern. Always they were fired at very high heat to make them durable.

In the Islamic world, starting under the Abbasids in the tenth century, pottery became an art form so much in demand that it sparked a mass-production industry. The original impetus came from China. By the early ninth century, traders were bringing Chinese wares made with fine white kaolin clay into the wealthy centers of the caliphate in Iraq. Islamic potters were compelled to compete. They had no kaolin clay, but they refined an Egyptian technique that blended tin-oxide and clear lead to produce a fine white opaque glazed surface that could then be decorated. The most spectacular sort of decoration derived from traditions of glass painting combined with the use of silver or copper oxides applied on opaque-glazed ceramics, which were then refired. The result was "lusterware" white opaque pottery painted with an overglaze that glowed with a brilliant iridescence, shimmering like gold. So beautiful was the effect that the technique was sometimes used in place of mosaic. An example is the arch and surrounding wall of the

mihrab (the niche pointing to Mecca) of the Great Mosque of Kairouan in Tunisia (Plate 7.13).

Lusterware was hugely popular across the entire Islamic world and was exported to Byzantium and Europe. But soon Islamic potters found a way to improve the very clay body by adding to it crushed quartz or glass or other silicate (frit). This produced a type of ceramic known as "fritware," "stone-paste," or "faience." The resulting object, already white in color, could be fired at a lower temperature than clay alone. Then it was decorated in a wide variety of colors and designs, and fired again. By the twelfth century, Fatimid Egypt was an important center of fritware manufacture, and the technique continued under Saladin (r.1171-1193) as well as traveling to workshops in Iran and elsewhere. An example is the rooster-shaped pitcher in Plate 7.14 on p. 296, which was made of two "shells" of fritware. The inner shell was solid; the outer one decorated with openwork cuttings. It is likely that metalwork pitchers inspired the form of this one in ceramic. More delicate than metal, it survived the centuries because its owner packed it carefully and buried it—and many other vessels in Jurjan (in northeast Iran) when that city was threatened by invading Mongols.

Even though the owner of the rooster pitcher feared the Mongols, those same invaders also contributed to the rich mix that made up Islamic ceramics. When the Mongols got to China, they

Plate 7.13 (facing page) Great Mosque mihrab, Kairouan, Tunisia (862–863). Reflecting the polychrome tastes of ninth-century potters, these ornamental tiles are luster-painted in green and yellow tones. Here, as in much early lusterware, the decorations are geometric and floral. Later lusterware simplified the decoration to just one color, but at the same time they complicated the designs, which included stylized animals (often birds) and human figures.

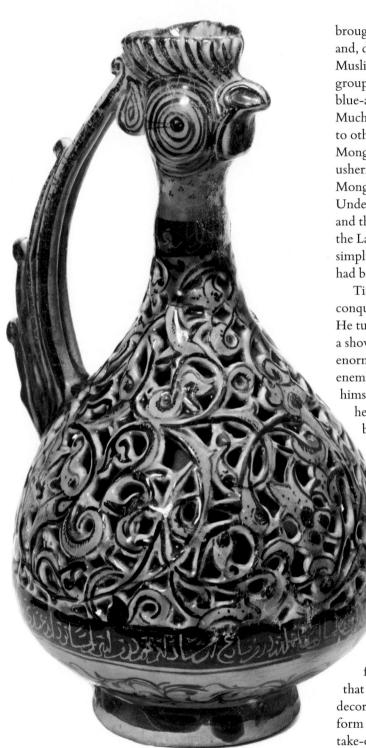

brought with them Muslim traders and craftsmen, and, distrusting the Chinese, they also used Muslims as high government officials. This new group transformed Chinese porcelains, favoring blue-and-white designs and new decorative motifs. Much of this pottery was produced for export to other parts of the Islamic world. While the Mongols in China were defeated in around 1350, ushering in the Ming dynasty, Iran remained under Mongol rulers until the early sixteenth century. Under those rulers—the Ilkhanids (1256–1353) and the Timurids (1370–1505), named after Timur the Lame, or Tamerlane—potters in Iran copied, simplified, and reinterpreted the new styles that had been created in China.

Timur, while destroying much in his quest to conquer the Mongol world, patronized the arts. He turned Samarqand (today in Uzbekistan) into a showplace—fitted out with a grand treasury, an enormous mosque, a major prison for all of Timur's enemies, and countryside garden-palaces—to prove himself the "restorer" of Mongol greatness. When he went to Syria in the hopes of conquest, he

brought back master potters from Damascus to work in Samarqand, which became the main production center for the finest pottery. It exported its wares widely. Other centers produced lesser-quality ceramics for local distribution. The bowl in Plate 7.15 is an example of the fine-quality tableware produced at Samarqand.

Islamic ceramics were much appreciated by Byzantine and Christian European elites. Byzantine potters long clung to Roman glazed wares, but beginning in the ninth century and increasingly in the tenth and eleventh,

factories near Constantinople produced vessels that imitated Islamic designs and even employed decorations that echoed Kufic—a very stylized form of Arabic script. In the twelfth century, their take-over of much of Anatolia gave the Seljuks an

important role as intermediaries between Islamic and Byzantine production centers.

Similarly, Christian Europe shared borders—in Iberia, in southern Italy—with the western half of the Islamic world. As early as the eleventh century, the facades of many Italian churches were decorated with bowls imported from North Africa. Called bacini, they gleamed in the bright Italian sun and yet cost far less than mosaics. Local workshops began to produce imitations of Islamic pottery, adopting both their manufacturing techniques and decorative motifs. By the late fourteenth century, Italian and Spanish/Islamic potters were successfully competing with lusterware imports from elsewhere in the Islamic world. Most famously,

as the kingdom of Aragon moved into the former al-Andalus, its pottery was shipped, either directly or via the island of Majorca, throughout Europe. This "majolica" inspired Italian workshops at Deruta, Gubbio, Urbino, Venice, and Faenza, and from there potters elsewhere. From Faenza comes the French word *faience*. Delftware is another term for these tin-glazed ceramics, which continue to be popular today.

FURTHER READING

Jenkins, Marilyn. "Islamic Pottery: A Brief History."

Metropolitan Museum of Art Bulletin 40, no. 4 (1983).

Watson, Oliver. Ceramics from Islamic Lands. New York:
Thames and Hudson, 2004.

Plate 7.14 (facing page) Rooster Ewer, Kashan, Iran (1200–1220). The solid inner shell, which held the liquid, was given a turquoise glaze and fired. Then the outer shell was constructed, cut to form flower motifs, and decorated in black. Inscriptions were incised on the black bands above and below the openwork. Finally, the outer shell was covered with turquoise glaze before the whole piece was fired again. Above its "double shell" body, the mouth of the pitcher was formed into a rooster's head, while its handle became the bird's tail feathers.

Plate 7.15 Bowl, Samarqand, Uzbekistan (c.1420–1450). Clearly imitating Chinese porcelain is this white and blue fritware bowl. Its decoration features stylized blossoms alternating with large, fleshy leaf forms. The motif was inspired by Mongol-dominated Chinese patterns, but here it was repurposed from the bowl's interior to its exterior.

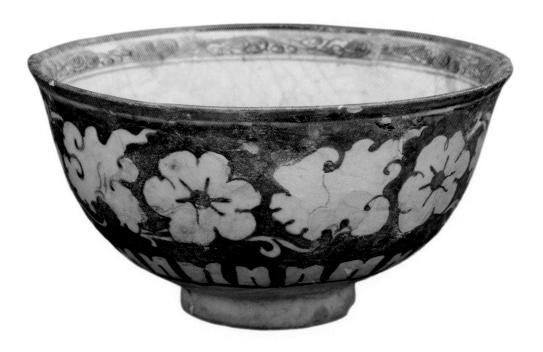

The harmonies were not always sweet, but sweetness need not be a value, in music or in life. More ominous were the attempts to sound single notes: the Mamluks considered their victory over Acre to be God's will; Europeans suppressed the voices of the Jews and heretics and silenced the bells of the lepers. In the next century, terrible calamities would construct new arenas for discord and creativity.

CHAPTER SEVEN: ESSENTIAL DATES

- 1188 First time townsmen were summoned to the Spanish cortes
- c.1225-1274 Thomas Aquinas (author of the Summa Theologiae)
 - 1226-1270 King Louis IX (Saint Louis) of France
 - 1230s Mongols conquer Rus'
 - 1250-1517 Mamluk Sultanate
 - 1265 Commons included in English Parliament
 - 1290 Jews expelled from England
 - 1291 Mamluk siege of Acre; end of the Crusader States
 - 1295 Ilkhanids convert to Islam
 - 1309–1377 Avignon papacy (so-called Babylonian Captivity)
 - 1315-1322 Great Famine
 - 1321 Death of Dante
 - 1356 Golden Bull frees imperial rule from the papacy

NOTES

- I Rashid al-Din, Universal History, in Reading the Middle Ages: Sources from Europe, Byzantium, and the Islamic World, 3rd ed., ed. Barbara H. Rosenwein (Toronto: University of Toronto Press, 2018), p. 385.
- 2 Abu'l-Fida, A Short History of Mankind, in Reading the Middle Ages, p. 391.
- 3 See Francesco Balducci Pegolotti, *The Practice of Trade* and its accompanying map, in *Reading the Middle Ages*, p. 400.
- 4 Decrees of the League, in Reading the Middle Ages, p. 415.
- 5 Ghibelline Annals of Piacenza, in Reading the Middle Ages, p. 413.
- 6 Statute of the Jewry, in Reading the Middle Ages, p. 426.
- 7 Jacques Fournier, Episcopal Register, in Reading the Middle Ages, p. 419.
- 8 Alfonso X, Cortes of Valladolid, in Reading the Middle Ages, p. 428.
- 9 Summons of Representatives of Shires and Towns to Parliament, in Reading the Middle Ages, p. 432.

- 10 Béla IV, Letter to Pope Innocent IV, in Reading the Middle Ages, p. 388.
- II The Short Life of St. Petka (Paraskeve) of Tarnov, in Reading the Middle Ages, p. 412.
- 12 The Henryków Book, in Reading the Middle Ages, p. 403.
- 13 Boniface VIII, Unam sanctam, in Reading the Middle Ages, p. 439.
- 14 Thomas Aquinas, On Love, in Reading the Middle Ages, p. 441.
- 15 Dante, Inferno, in Reading the Middle Ages, p. 443.

FURTHER READING

- Abulafia, David, ed. Italy in the Central Middle Ages. Short Oxford History of Italy. Oxford: Oxford University Press, 2004.
- Ames, Christine Caldwell. Righteous Persecution: Inquisition, Dominicans, and Christianity in the Middle Ages. Philadelphia: University of Pennsylvania Press, 2009.
- Brenner, Elma. "Recent Perspectives on Leprosy in Medieval Western Europe." History Compass 8, no. 5 (2010): 388-406.
- Brody, Saul Nathaniel. The Disease of the Soul: Leprosy in Medieval Literature. Ithaca: Cornell University Press, 1974.
- Drendel, John, ed. Crisis in the Later Middle Ages: Beyond the Postan-Duby Paradigm. Turnhout: Brepols, 2015.
- Farmer, Sharon. The Silk Industries of Medieval Paris: Artisanal Migration, Technological Innovation, and Gendered Experience. Philadelphia: University of Pennsylvania Press, 2016.
- Harreld, Donald J., ed. A Companion to the Hanseatic League. Leiden: Brill, 2015.
- Jackson, Peter. The Mongols and the Islamic World: From Conquest to Conversion. New Haven, CT: Yale University Press, 2017.
- Jobson, Adrian. The First English Revolution: Simon de Montfort, Henry III and the Barons' War. London: Bloomsbury, 2012.
- Jones, P.J. The Italian City-State: From Commune to Signoria. Oxford: Oxford University Press, 1997.
- Jordan, William Chester. The French Monarchy and the Jews: From Philip Augustus to the Last Capetians. Philadelphia: University of Pennsylvania Press, 1989.
- Kitsikopoulos, Harry, ed. Agrarian Change and Crisis in Europe, 1200-1500. New York: Routledge, 2012.
- Klápště, Jan. The Czech Lands in Medieval Transformation. Ed. Philadelphia Ricketts. Trans. Sean Mark Miller and Kateřina Millerová. Leiden: Brill, 2012.
- Lipton, Sara. Dark Mirror: The Medieval Origins of Anti-Jewish Iconography. New York: Henry Holt, 2014.
- Martin, Janet. Medieval Russia, 980–1584. Cambridge: Cambridge University Press, 1995.
- Mundill, Robin R. England's Jewish Solution: Experiment and Expulsion, 1262-1290. Cambridge: Cambridge University Press, 1998.
- Nirenberg, David. Communities of Violence: Persecution of Minorities in the Middle Ages. Princeton, NJ: Princeton University Press, 1996.
- O'Callaghan, Joseph F. The Cortes of Castile-León, 1188–1350. Philadelphia: University of Pennsylvania Press, 1989.

Pegg, Mark Gregory. *The Corruption of Angels: The Great Inquisition of 1245–1246*. Princeton, NJ: Princeton University Press, 2001.

Rubin, Miri. Corpus Christi: The Eucharist in Late Medieval Culture. Cambridge: Cambridge University Press, 1991.

Santagata, Marco. Dante: The Story of His Life. Cambridge, MA: Harvard University Press, 2016.

Strayer, Joseph R. The Reign of Philip the Fair. Princeton, NJ: Princeton University Press, 1980.

Vallerani, Massimo. *Medieval Public Justice*. Trans. Sarah Rubin Blanshei. Washington, DC: Catholic University of America Press, 2012.

Ward, Jennifer C. Women in Medieval Europe, 1200-1500. 2nd ed. New York: Routledge, 2016.

Watts, John. The Making of Polities: Europe, 1300–1500. Cambridge: Cambridge University Press, 2009.

White, John. Art and Architecture in Italy, 1250–1400. 3rd ed. New Haven, CT: Yale University Press, 1003.

Wing, Patrick. The Jalayirids: Dynastic State Formation in the Mongol Middle East. Edinburgh: Edinburgh University Press, 2016.

Zorzi, Andrea. "The Popolo." In *Italy in the Age of Renaissance, 1300–1550*, ed. John M. Najemy, 145–64. Oxford: Oxford University Press, 2004.

To test your knowledge of this chapter, please go to www.utphistorymatters.com for Study Questions.

EIGHT

CATASTROPHE AND CREATIVITY

(c.1350-c.1500)

The Ottoman Turks emerged in Anatolia in the thirteenth century and conquered Byzantium in 1453. They became a major player in the Islamic world and made inroads into Europe as well. Meanwhile, unimpeded by borders, a plague pandemic struck the Eurasian land mass, bringing death and social dislocation in its wake. The Hundred Years' War broke out, involving mainly France and England but nevertheless sweeping much of the rest of Western Europe into its vortex. All events were both catastrophic and creative. The Ottomans ultimately established a stable political order that did not end until 1924. Europeans survived their wars and diseases to enjoy a higher standard of living than ever before. Fifteenth-century rulers exercised new powers, and intellectuals and artists found original ways to approach old issues. In Europe, new-rigged sailing ships, manned by hopeful adventurers and financed by rich patrons, plied the seas east- and westwards. By 1500, Europe was poised to conquer the Americas.

CRISES AND CONSOLIDATIONS

In 1281, the first Ottoman dynasty established itself on the western fringes of the disintegrating Ilkhanid Khanate. In less than two centuries, they toppled Constantinople and moved into Europe. While the Ottomans flexed their muscles, the first pandemic since the sixth-century Plague of Justinian hit. At the same time, France and England waged a long and debilitating Hundred Years' War, and popular revolts and insurrections—the bitter harvest of war and economic contraction—rocked both town and countryside. In general, these upheavals resulted in the ascendency of new and powerful princes. Almost everywhere in the medieval world, the multiple lordships and political fragmentation of the past came to an end.

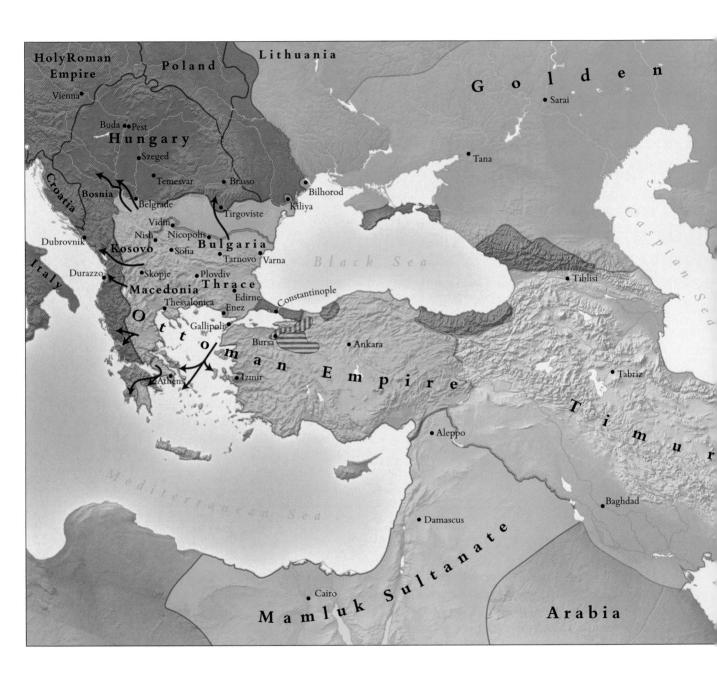

Map 8.1 Eurasia, *c*.1400

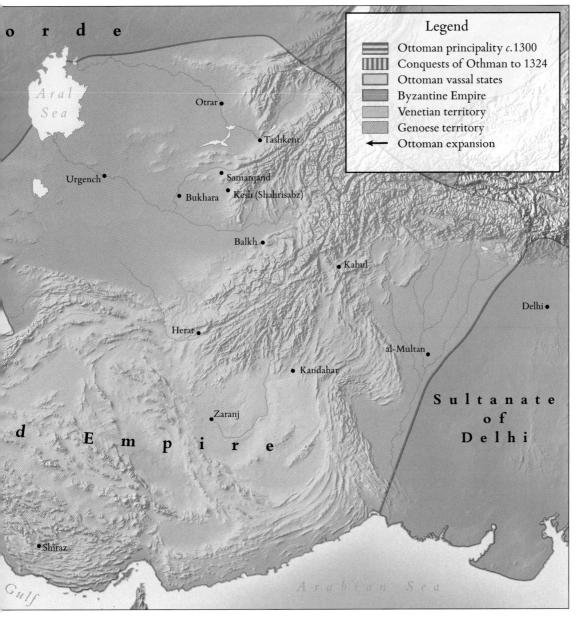

The Ottomans

The Mongol Empire fell apart around 1350. The Ming dynasty took control in China; Tamerlane (Timur the Lame, 1336–1405), a warlord with Mongol connections from Transoxiana, conquered much of the Islamic world west of China. (See Map 8.1.) Timur's armies were exceptionally violent. But he spared craftspeople and, from the first, made dazzling artistic, architectural, and literary achievements a centerpiece of his rule. With major centers at Kesh (today Shahrisabz, near his birthplace), Samarqand, Bukhara, and Herat, Timur established a political order centered on himself as the lynchpin of justice and patronage. He surrounded himself with ceremonial pomp and the éclat of cultural brilliance, bringing—sometimes forcibly—the talent of his entire empire to serve his ambitions. His accomplishments became mythic, inspiring the glittering courts of Ottoman and European Renaissance princes. Yet soon after Timur's death, his empire—held together largely by his political and military successes and personal charisma—began to disintegrate.

By contrast, the Ottomans began modestly but grew to govern a powerful and longlived state. At the beginning of the fourteenth century, Othman (d.1324/1326), after whom the Ottomans were named, was one of a number of tribal leaders busily carving out small principalities for themselves in the interstices between Mongol-ruled Rum and the Byzantine Empire. As his later biographer, Ashikpashazade, wrote, Othman "feigned friendship" with some of the nearby leaders, while starting feuds (always with some excuse) with others: "he began hostilities with the emir of Germiyan [a neighboring region] because the latter was constantly harassing the populace." Soon Othman controlled a small state right in Byzantium's backyard. Rather than unite in the face of these developments, rival factions within Byzantium tried to make use of the Ottomans. Thus, Ottoman troops arrived in Gallipoli in 1354 at the request of one claimant to the Byzantine throne. Religious quarrels among the Catholics and Orthodox in the Balkan states—Byzantium, Bulgaria, and Serbia—made alliances with the Ottomans seem preferable to joining forces with one another. Anatolian settlers moved into the region, and Ottoman armies and other Turkish raiders came to conquer and convert it to Islam. In the course of the fourteenth century, the Ottoman empire embraced Thrace, Macedonia, and Bulgaria. Their hold on the region was only enhanced by their stunning victory at the battle of Nicopolis in 1396 of a crusading army sent to crush them. (See Map 8.1.)

To the east, the Ottoman advance was set back by a major defeat at the hands of Timur in 1402 at Ankara. But Timur's death soon thereafter allowed them to regroup. They re-centered their power in Europe and established a capital at Edirne (the former Adrianople). Ottoman hegemony depended not only on the disunity of their enemies but also the superiority of their military power. They adopted the new hardware of the west: cannons and harquebuses (heavy matchlock guns). And they deployed elite troops, the Janissaries. These were Christian boys from the conquered regions who were enslaved, converted to Islam, and trained not only for military service but also for the highest positions in government. Under Mehmed II the Conqueror (r.1444–1446 and 1451–1481),

Ottoman cannons accomplished what former sieges had never done, breaching the thick walls of Constantinople in 1453 and bringing the Byzantine Empire to an end.2

And yet, if officially "fallen," Byzantium nevertheless lived on culturally. The sultan himself recognized the need for a Christian religious leader right in Istanbul, and he re-established the patriarch, who still had a church organization to run and a flock of Orthodox believers to serve. The Greeks who fled Byzantium kept their customs, language, and religion. In Venice, a large group of Greek immigrants—perhaps 4000 in a city of around 100,000 people—made a home for themselves. They were allowed one church, San Biagio, where the Greek rite could be practiced, and they were granted the right to establish a confraternity (a Scuola—a kind of guild common in Venice), for, as they pointed out, "the greatest good will result from it, especially through giving maintenance to sick and feeble persons, through giving burial to those who from time to time die in great poverty, and through helping widows and orphans who have lost their husbands and fathers." Members of the Greek community in Venice served as sailors, soldiers, shipyard workers, tailors, barbers: a whole miscellany of occupations. At the beginning of the sixteenth century, some of them successfully petitioned the Venetian government to establish yet another church. While Venice attracted the largest number of Greek immigrants, some settled in other Italian cities. A few became university

professors, teaching Greek and translating important Greek texts into Latin.

Byzantium lived on within the new Ottoman regime as well. Although in popular speech Constantinople became Istanbul (meaning "the city"), its official name remained "Qustantiniyya"—the City of Constantine. The Ottoman sultans saw themselves as the successors of the Roman emperors—but better, truebelieving successors. Mehmed commissioned an edition of Homer's Iliad, negotiated with Genoese and Venetian traders, and "borrowed" Gentile Bellini (c. 1429–1507) from Venice to be his court artist. He knew about the new fashion of portrait medallions just taking off in Italy and commissioned several artists to make medallions for him. Among the finest is that of Costanzo da Ferrara, who spent several years in Istanbul. (See Plate 8.1.) Such medallions were hallmarks of the Renaissance underway in Italy—and also, it must be said, in Istanbul. They celebrated individual identity with a recognizable portrait on the obverse and a "personal statement"—a visual motto—on the reverse.

On the walls of his splendid Topkapi palace, Mehmed displayed tapestries from Burgundy portraying the deeds of Alexander the Great, probably much like the one in Plate 8.10 on pp. 334-35. The comparison between Alexander and Mehmed was deliberate. The tapestries were themselves trophies of war, wrested from the failed crusade that ended at the battle of Nicopolis. The Burgundian Duke John the Fearless was captured there; his ransom was the Alexander tapestries.

But if these were "western" influences in the Ottoman court, Islamic traditions reigned there as well. Mehmed and his successors staffed their cities with men schooled in Islamic

Plate 8.1 Costanzo da Ferrara, Portrait Medallion of Mehmed II (1470s). On the obverse, the sultan's face is presented as he had looked in his younger days. He wears a many-folded turban, which soon became the rage in Europe as well. On the reverse, he sits astride a horse, riding through a rocky, wintry landscape. The writing around the edges (the "legend") of the medal is in Latin, not Turkish. The legend on the obverse says: "Sultan Mehmed of the house of Osman, emperor of the Turks." The legend on the reverse alludes to Mehmed's many victories, proclaiming: "This man, the thunderbolt of war, has laid low peoples and cities."

administration and culture and set up *madrasas* to teach the young. At workshops built by the sultan in Istanbul, artists and craftsmen produced books, ceramics, and textiles decorated in styles drawn from Mamluk and Timurid models. New buildings—both religious and secular—needed furnishings: tiles, lamps, candelabra, wall hangings, ceramics, and carpets. The designs were controlled and to some extent standardized by court workshops under the sultan's patronage. In the fifteenth century for the first time, carpets from Anatolia were sold on the European market (they show up in numerous paintings from Italy and northern Europe). With the ruler's support, similar carpets were produced in larger sizes and more elaborate designs exclusively for the Ottoman court. (See Plate 8.2.)

The new Ottoman state had come to stay. Its rise was due to its military power and the weakness of its neighbors. But its longevity—it did not begin to decline until the

Plate 8.2 Ushak Medallion Carpet, Anatolia (third quarter of 15th cent.). Made of knotted wool, this type of carpet, first commissioned by the sultan, broke away from earlier Anatolian examples both in design and size (this one is nearly twenty-four feet long). Earlier carpets relied on geometric, angular forms. By contrast, the decoration here employs curves, arabesques, and tendrils.

late seventeenth century—was due to more complicated factors. Building on a theory of absolutism that echoed similar ideas beginning to take shape in the Christian West, the Ottoman rulers acted as the sole guarantors of law and order. Taking the title of caliphs in 1517, they considered even the leaders of the mosques to be their functionaries, soldiers without arms. The Ottoman rulers dominated everything, even architecture, where the domed square became their signature feature. (See Plate 8.3.)

Prospering from taxes pouring in from its conquered lands and its relatively well-todo peasantry, the new rulers spent their money on roads to ease troop transport and a navy powerful enough to oust the Italians from their eastern Mediterranean outposts. Eliminating all signs of rebellion (which meant, for example, brutally putting down Serb and Albanian revolts), the Ottomans created a new world power.

Plate 8.3 Building Complex, Edirne (1484–1488). Edirne, in Thrace, was the Ottoman gateway to Europe. There Bayezid II (r.1481–1512) built an enormous architectural complex: centered on a mosque, it includes an insane asylum, a medical school, four madrasas, a kitchen, toilets, dining halls, baths, two mausolea, a hospital, and a hospice for wandering dervishes (Sufi mendicants). All, even the courtyard arcades, are covered with domes.

The Ottoman state eventually changed Europe's orientation. Europeans could—and did—continue to trade in the Mediterranean. But, on the whole, they preferred to treat the Ottomans as a barrier to the Orient. Not long after the fall of Constantinople, as we shall see, the first transatlantic voyages began as a new route to the East.

The Black Death

The Black Death (1346–1353), so named by later historians looking back on the disease, was caused by *Yersinia pestis*, the bacterium of the plague. As Giovanni Boccaccio (d.1375), a famous keen-eyed Florentine author, reported, "it began both in men and women with certain swellings in the groin or under the armpit. They grew to the size of a small apple or an egg.... Soon after this the symptoms changed and black or purple spots appeared on the arms or thighs or any other part of the body."⁴

New research on the DNA of the microbe suggests that the disease began on the Tibetan-Ouinghai Plateau, now claimed by China. It arrived in the West along wellworn routes of trade with the Mongols. Caffa, the Genoese trading post on the northern shore of the Black Sea, was hit in 1347. From there the plague traveled to Europe and the Middle East, immediately striking Constantinople and Cairo and soon leaving the port cities for the hinterlands. In early 1348, the citizens of Pisa and Genoa, fierce rivals on the seas, were being felled without distinction by the disease. Early spring of the same year saw the Black Death at Florence; two months later it had hit Dorset in England. Dormant during the winter, it revived the next spring to infect French ports and countryside, moving on swiftly to Germany. By 1351 it was at Moscow, where it stopped for a time, only to recur in ten- to twelve-year cycles throughout the fourteenth century. (Only the attack of 1346–1353 is called the Black Death.) The disease continued to strike, though at longer intervals, until the eighteenth century.

We know most about its effect in Europe, where it wiped out on average 50 per cent of the population. In eastern Normandy, perhaps 70 to 80 per cent of the population succumbed. At Bologna, even the most robust—men able to bear arms—were reduced by 35 per cent in the course of 1348. Demographic recovery across Europe began only in the second half of the fifteenth century.

Deaths, especially among the poor, led to acute labor shortages in both town and country. In 1351, King Edward III of England (r.1327-1377) issued the Statute of Laborers, forbidding workers to take pay higher than pre-plague wages and fining employers who offered more. Similar laws were promulgated—and flouted—elsewhere. In the countryside, landlords needed to keep their profits up even as their workforce was decimated. They were obliged to strike bargains with enterprising peasants, furnishing them, for example, with oxen and seed; or they turned their land to new uses, such as pasturage. In the cities, the guilds and other professions recruited new men, survivors of the plague. Able to marry and set up households at younger ages, these nouveaux riches helped reconstitute the population. Although many widows were now potentially the heads of households, deeply rooted customs tended to push them either into new marriages (in northern Europe) or (in southern Europe) into the house of some male relative, whether brother, son, or son-in-law.

The plague affected both desires and sentiments. Upward mobility in town and country meant changes in consumption patterns, as formerly impoverished groups found new wealth. They chose silk clothing over wool, beer over water. In Italy, where a certain theoretical equality within the communes had restrained consumer spending, cities passed newly toughened laws to restrict finery. In Florence in 1349, for example, a year after the plague first struck there, the town crier roamed the city shouting out new or renewed prohibitions: clothes could not be adorned with gold or silver; capes could not be lined with fur; the wicks of funeral candles had to be made of cotton; women could wear no more than two rings, only one of which could be set with a precious stone; and so on. As always, such sumptuary legislation affected women more than men.

Small wonder that eventually death became an obsession and a cult. A newly intense interest in the macabre led to original artistic themes. Plate 8.4 shows one side of a

manuscript folio that depicted the various people whom death would visit sooner or later. In each of the four frames Death, personified by a corpse (outlined by its coffin and covered with the lizards, snakes, worms, maggots, and frogs that were consuming its flesh), confronts a living person. A pope is in the first box, an emperor in the next, below left is a knight, below right a burgher. On the other side of the folio page (not shown here) the corpses meet a young woman, a young man, an astrologer, and a shepherd.

Similarly, in the artistic and literary genre known as the Dance of Death, life itself became a dance with death, as men and women from every class were escorted—sooner or later—to the grave by ghastly skeletons. Blaming their own sins for the plague, penitent pilgrims, occasionally bearing whips to flagellate themselves, crowded the roads. Rumors flew, accusing the Jews of causing the plague by poisoning the wells. The idea spread from southern France and northern Spain (where, as we have seen [p. 266], similar charges had already been leveled in the 1320s) to Switzerland, Strasbourg, and throughout Germany. At Strasbourg, more than 900 Jews were burned in 1349, right in their own cemetery.

The Hundred Years' War

While disease felled half the population of much of Europe, the Hundred Years' War took its own grim toll. The immediate cause of the conflict, fought sporadically over more than a century, from 1337 to 1453, was the English king's bid to become ruler of France. Beyond that dynastic dispute were England's long-standing claims to Continental lands, many of which had been confiscated by Philip II of France and the rest by Philip VI in 1337. (See Map 8.2 on the next page, paying particular attention to English possessions in 1337.) Fundamental as well were Flemish-English economic relations, to which English prosperity and taxes were tied. Ultimately, the war was not so much between England and France as between two conceptions of France: one, a centralized monarchy, the other, an association of territories ruled by counts and dukes. The centralized model won.

As son of Isabella, the last living child of French king Philip the Fair, Edward III of England was in line for the French throne when Charles IV died in 1328. The French nobles awarded it, instead, to Philip VI, the first Valois king of France. (See Genealogy 8.1 on p. 313.) Edward's claims led to the first phase of the Hundred Years' War. Looking back on it, the chronicler Froissart tried to depict its knightly fighters as gallant protagonists:

As soon as Lord Walter de Manny discovered ... that a formal declaration of war had been made ... he gathered together 40 lances [each lance being a knight, a servant, and two horses], good companions from Hainaut and England,... [because he] had vowed in England in the hearing of ladies and lords that, "If war breaks out between my lord the king of England and Philip of Valois who calls himself king of France, I will be the first to arm himself and capture a castle or town in the kingdom of France."5

Plate 8.4 (facing page)

Corpses Confront the Living (c.1441). This unusual illustration shows not only the physical confrontations between the dead and the living but also their verbal exchanges, which are written on scrolls in front of each protagonist. For example, the king (top right), proudly faces the viewer and boasts, "I am the king and the emperor and a lover of delights." But the corpse calls his bluff: "Once you ruled over nations: now you are conquered by worms."

Following pages:

Map 8.2 The First Phase of the Hundred Years' War, 1337-1360

Genealogy 8.1 Kings of France and England and the Dukes of Burgundy during the Hundred Years' War

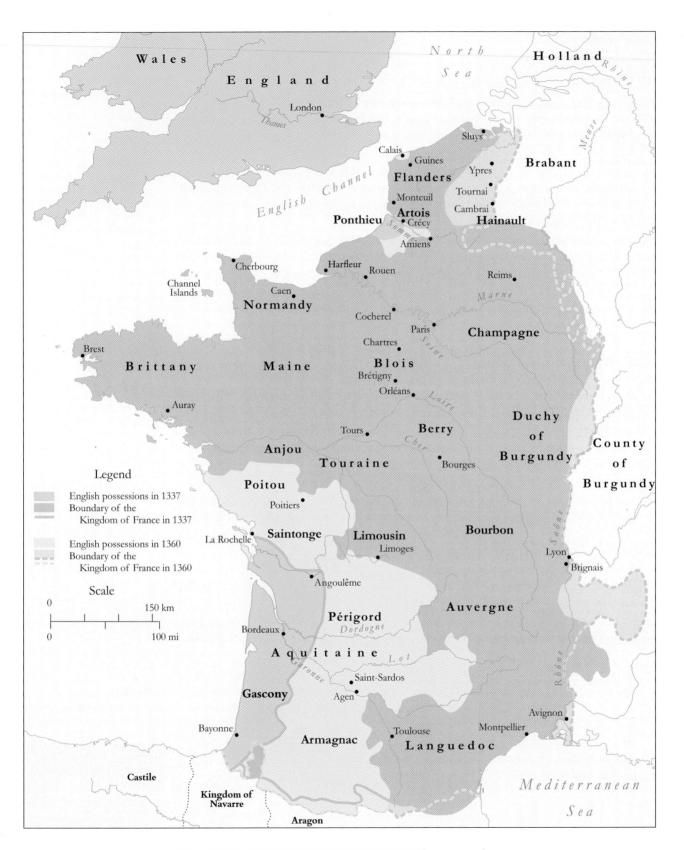

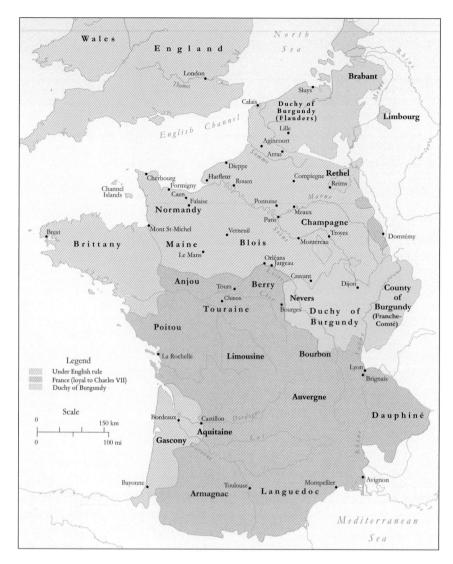

Map 8.3 English and Burgundian Hegemony in France, *c*.1430

In fact, in this war English knights like Walter de Manny and his men depended on non-knightly long-bowmen. Well-trained, coordinated, and massive in number, longbowmen gave the English army a distinct advantage over the French.⁶ By 1360, the size of English possessions in southern France was approximately what it had been in the twelfth century. (Look at Map 8.2 again, this time considering "English Possessions in 1360," and compare it with Map 6.4 on p. 218.)

English successes were nevertheless short-lived. Harrying the border of Aquitaine, French forces chipped away at it in the course of the 1380s. Meanwhile, sentiments for peace were gaining strength in both England and France; a treaty to put an end to the fighting for a generation was drawn up in 1396. Yet the "generation" had hardly reached adulthood when Henry V (r.1413–1422) came to the throne and revived England's Continental claims. Demanding nearly all of the land that the Angevins had held in

the twelfth century, he struck France in 1415 in a concerted effort to conquer both cities and countryside. Soon Normandy was Henry's, and, determined to keep it, he forced all who refused him loyalty into exile, confiscating their lands and handing the property over to his own followers. (See Map 8.3.)

Henry's plans were aided by a new regional power: Burgundy. A marvel of shrewd marriage alliances, canny purchases, and outright military conquests, the Duchy of Burgundy forged by Philip the Bold (r.1364–1404) was a cluster of principalities with one center at Dijon (the traditional Burgundy) and another at Lille, in the north (the traditional Flanders). The only unity in these disparate regions was provided by the dukes themselves, who traveled tirelessly from one end of their duchy to the other, participating in elaborate ceremonies—lavish entry processions into cities, wedding and birth festivities, funerals—and commissioning art and music that both celebrated and justified their power. (See Map 8.4.)

Like the kings of France, Philip the Bold was a Valois, but his grandson, Philip the Good (r.1419–1467), decided to link his destiny with England, long the major trading partner of Flanders. Thus, with the support of the Burgundians, the English easily marched into Paris, inadvertently helped by the French king, Charles VI (r.1380–1422), whose frequent bouts of insanity created a vacuum at the top of France's leadership. The Treaty of Troyes (1420) made Henry V the heir to the throne of France.

Had Henry lived, he might have made good his claim. But he died in 1422, leaving behind an infant son to take the crown of France under the regency of the duke of Bedford. Meanwhile, with Charles VI dead the same year, Charles VII, the French "dauphin," or crown prince, was disheartened by defeats. Only in 1429 did his mood change: Jeanne d'Arc (Joan of Arc), a sixteen-year-old peasant girl from Domrémy (part of a small enclave in northern France still loyal to the dauphin), arrived at Chinon, where Charles was holed up, to convince him and his theologians that she had been divinely sent to defeat the English. As she wrote in an audacious letter to the English commanders, "The Maid [as she called herself] has come on behalf of God to reclaim the blood royal. She is ready to make peace, if you [the English] are willing to settle with her by evacuating France."7

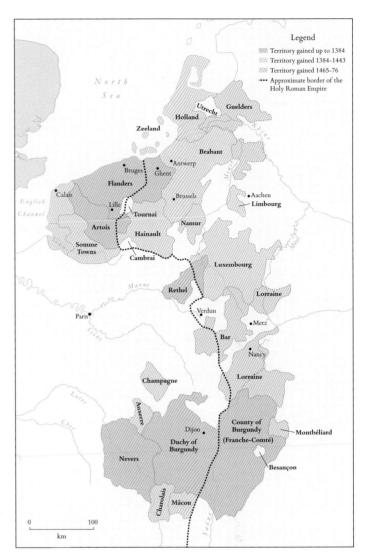

Map 8.4 The Duchy of Burgundy, 1363–1477

In effect, Jeanne inherited the moral capital that had been earned by the Beguines and other women mystics. When the English forces laid siege to Orléans (the prelude to their moving into southern France—see Map 8.3), Jeanne not only wrote the letter to the English quoted above but was allowed to join the French army. Its "miraculous" defeat of the English at Orléans (1429) turned the tide. Soon thereafter Jeanne led Charles to Reims, deep in English territory, where he was anointed king. Captured by Burgundians in league with the English in 1430, Jeanne was ransomed by the English and tried as a heretic the following year. Found guilty, she was burned, eventually becoming a symbol of martyrdom as well as of triumphant French resistance.

It took many more years, indeed until 1453, for the French to win the war. One reason for the French victory was their systematic use of gunpowder-fired artillery: in one fifteenmonth period around 1450, the French relied heavily on siege guns such as cannons to capture more than seventy English strongholds. Diplomatic relations helped the French as

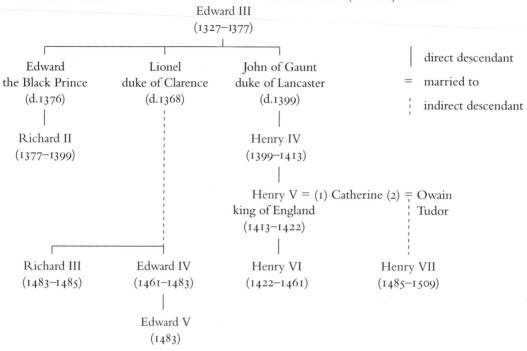

Genealogy 8.2 Yorkist and Lancastrian (Tudor) Kings well: after 1435, the duke of Burgundy abandoned the English and supported the French, at least in lukewarm fashion.

The Hundred Years' War devastated France in the short run. During battles, armies destroyed cities and harried the countryside, breaking the morale of the population. Even when not officially "at war," bands of soldiers—"Free Companies" of mercenaries that hired themselves out to the highest bidder, whether in France, Spain, or Italy—roved the countryside, living off the gains of pillage. Nevertheless, soon after 1453, France began a long and steady recovery. Merchants invested in commerce, peasants tilled the soil, and the king exercised more power than ever before. A standing army was created, trained, billeted, and supplied with weapons, including the new "fiery" artillery, all under royal command.

Burgundy, so brilliantly created a century earlier, fell apart even more quickly: Charles the Bold's expansionist policies led to the formation of a coalition against him, and he died in battle in 1477. His daughter Mary, his only heir, tried to stave off French control by quickly marrying Maximilian of Habsburg. This was only partly successful: while she brought the County of Burgundy and most of the Low Countries to the Holy Roman Empire, the French kings were able to absorb the southern portions of the duchy of Burgundy as well as the Somme Towns in the north. Soon (in 1494) France was leading an expedition into Italy, claiming the crown of Naples.

In England, the Hundred Years' War brought about a similar political transformation. Initially France's victory affected mainly the topmost rank of the royal house itself. The progeny of Edward III formed two rival camps, York and Lancaster (named after some of their lands in northern England). (See Genealogy 8.2.) Already in 1399, unhappy with

Richard II, who had dared to disinherit him, the Lancastrian Henry had engineered the king's deposition and taken the royal scepter himself as Henry IV. But when his grandson Henry VI lost the war to France, the Yorkists quickly took advantage of the fact. A series of dynastic wars—later dubbed the "Wars of the Roses" after the white rose badge of the Yorkists and the red of the Lancastrians—was fought from 1455 to 1487. In 1461, Edward of York deposed Henry, becoming Edward IV. Upon his death in 1483 there was further intrigue as his brother, Richard III, seized the eleven-year-old Edward V and his brother, packing them off to the Tower of London, where they were soon murdered. Two years later, Richard himself was dead on the fields of Bosworth, and Henry VII, the first Tudor king, was on the throne.

All of this would later be grist for Shakespeare's historical dramas, but at the time it was more the stuff of tragedy, as whole noble lines were killed off, Yorkist lands were confiscated for the crown, and people caught in the middle longed for a strong king who would keep the peace. When the dust settled, the Tudors were far more powerful than previous English kings had ever been.

Princes, Knights, and Citizens

The Hundred Years' War, the Wars of the Roses, and other, more local wars of the fifteenth century brought to the fore a kind of super-prince: mighty kings (as in England, Scotland, and France), dukes (as in Burgundy), and signori (in Italy). All were supported by mercenary troops and up-to-date weaponry, putting knights and nobles in the shade.

Yet the end of chivalry was paradoxically the height of the chivalric fantasy. We have already seen how delighted Froissart was by Walter de Manny's chivalric vow. Heraldry, a system of symbols that distinguished each knight by the sign on his shield, came into full flower around the same time. Originally meant to advertise the fighter and his heroic deeds on the battlefield, it soon came to symbolize his family, decorating both homes and tombs. Kings and other great lords founded and promoted chivalric orders with fantastic names—the Order of the Garter, the Order of the Golden Buckle, the Order of the Golden Fleece. All had mainly social and honorific functions, sponsoring knightly tournaments and convivial feasts precisely when knightly jousts and communal occasions were no longer useful for war.

While super-princes were the norm, there were some exceptions. In the mountainous terrain of the alpine passes, a coalition of members of the urban and rural communes along with some lesser nobles promised to aid one another against the Habsburg emperors. Taking advantage of rivalries within the Holy Roman Empire, the Swiss Confederation created c.1500 a militant state of its own. Structured as a league, the Confederation put power into the hands of urban citizenry and members of peasant communes. The nobility gradually disappeared as new elites from town and countryside took over. Unlike the great European powers in its "republican" organization, Switzerland nevertheless conveniently served as a reservoir of mercenary troops for its princely neighbors.

Map 8.5 (facing page) Western Europe, c.1450

Venice maintained its own republicanism via a different set of compromises. It was dominated by a Great Council from whose membership many of the officers of the state were elected, including the "doge," a life-long position. Between 1297 and 1324 the size of the Council grew dramatically: in 1296 it had 210 members, but by 1340 its membership was over one thousand. At the same time, however, the Council was gradually closed off to all but certain families, which were in this way turned into a hereditary aristocracy. Accepting this fact constituted the compromise of the lower classes. Its counterpart by the ruling families was to suppress (in large measure) their private interests in favor of the general welfare of the city. That welfare depended mainly on the sea for both necessities and wealth. Only at the end of the fourteenth century did the Venetians begin to expand within Italy itself, becoming a major land power in the region. But as it gobbled up Bergamo and Verona, Venice collided with the interests of Milan. Wars between the two city-states ended only with the Peace of Lodi in 1454. Soon the other major Italian powers—Florence, the papacy, and Naples—joined Venice and Milan in the Italic League. (See Map 8.5.) The situation in Naples eventually brought this status quo to an end. Already in 1442 Alfonso V of Aragon had entered Naples as Alfonso I, ending Angevin rule there. A half century later, the Valois king of France's desire to reinstate French rule over Naples helped fuel his invasion of Italy in 1494.

Revolts in Town and Country

While power at the top consolidated, discontent seethed from below. Throughout the fourteenth century popular uprisings across Europe gave vent to discontent. The "popular" component of these revolts should not be exaggerated, as many were led by petty knights or wealthy burghers. But they also involved large masses of people, some of whom were very poor indeed. Although at times articulating universal principles, these revolts were nevertheless deeply rooted in local grievances.

Long accustomed to a measure of self-government in periodic assemblies that reaffirmed the customs of the region, the peasants of Flanders reacted boldly when the count's officials began to try to collect new taxes. Between 1323 and 1328, Flemish peasants drove out the officials and their noble allies, redistributing the lands that they confiscated. The peasants set up an army, established courts, collected taxes, and effectively governed themselves. The cities of Flanders, initially small, independent pockets outside of the peasants' jurisdiction, soon followed suit, with the less wealthy citizens taking over city government. It took the combined forces of the rulers of France and Navarre plus a papal declaration of crusade to crush the peasants at the battle of Cassel in 1328.

Anti-French and anti-tax activities soon resumed in Flanders, however, this time at Ghent, where the weavers had been excluded from city government since 1320. When England prepared for the opening of the Hundred Years' War, it cut off wool exports to Flanders, putting the weavers (who depended on English wool) out of work. At Ghent, the weavers took the hint and rallied to the English cause. Led by Jacob van Artevelde,

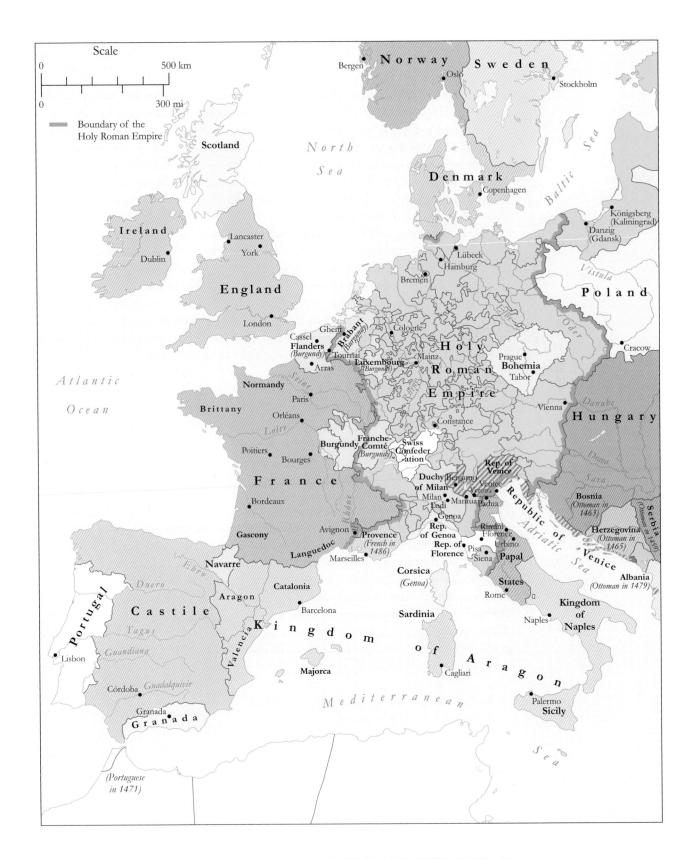

himself a landowner but now spokesman for the rebels, the weavers overturned the city government. By 1339, Artevelde's supporters dominated not only Ghent but also much of northern Flanders. A year later, he was welcoming the English king Edward III to Flanders as king of France. Although Artevelde was assassinated in 1345 by weavers who thought he had betrayed their cause, the tensions that brought him to the fore continued. The local issues that pitted weavers against the other classes in the city were exacerbated by the ongoing hostility between England and France. Like a world war, the Hundred Years' War engulfed its bystanders.

In France, uprisings in the mid-fourteenth century signaled further strains of the war. At the disastrous battle of Poitiers (1356), King John II of France was captured and taken prisoner. The Estates General, which prior to the battle had agreed to heavy taxes to counter the English, met in the wake of Poitiers to allot blame and reform the government. When the new regent (the ruler in John's absence) stalled in instituting the reforms, Étienne Marcel, head of the merchants of Paris, led a plot to murder some royal councilors and take control of Paris. But the presence of some Free Company (mercenary) troops in Paris led to disorder there, and some of Marcel's erstwhile supporters blamed him for the riots, assassinating him in 1358.

Meanwhile, outside Paris, the Free Companies harassed rural communities. In 1358, a peasant movement formed to resist them. Called the Jacquerie by dismissive chroniclers (probably after their derisive name for its leader, Jacques Bonhomme—Jack Goodfellow), it soon turned into an uprising against the members of the nobility, whom peasants considered failures because of their loss at Poitiers and their inability to keep the peace in the countryside. The revolt was brutal and was quickly put down with equal viciousness.

More permanent in their consequences were peasant movements in England; Wat Tyler's Rebellion of 1381 is the most famous. During this revolt, groups of "commons" (in this case mainly country folk from southeast England) converged on London to demand an end to serfdom: "And they required that for the future no man should be in serfdom, nor make any manner of homage or suit to any lord, but should give a rent of 4 [pennies] an acre for his land." Most immediately, the revolt was a response to a poll tax of one shilling per person, the third fiscal imposition in four years passed by Parliament to recoup the expenses of war. More profoundly, it was a clash between new expectations of freedom (in the wake of the Black Death, labor was worth much more than before) and old obligations of servitude. The egalitarian chant of the rebels signaled a growing sense of their own power:

When Adam delved [dug] and Eve span [spun], Who then was the gentleman?

Although Tyler, the leader of the revolt, was soon killed and the rest of the commons dispersed, the death knell of serfdom in England had in fact been sounded, as the rebels went home to bargain with their landlords for new-style leases.

In the decades just before this in a number of Italian cities, cloth workers chafed under regimes that gave them no say in government. The revolt by the woolworkers (the ciompi) at Siena was typical. In 1355, they rose up against their employers, the wool guild, overturned the existing government of the city—until then the most stable city-state regime in Italy—and briefly established their own rule. In 1371, "demanding to be paid according to the ordinance of the Sienese commune and not that of the [Wool] Guild,"10 they again took up arms and, joined by the popolo minuto—literally the "little people," but in reality a mix of salaried workers, artisans, merchants, and even some nobles who took on the role of "consorts" of the people—they clashed with the elites of the city and again set up a short-lived government. A similar set of events took place in Florence in 1378 when the ciompi there briefly established a government. In both instances, the old elites were soon back in power. But, while they largely remained so in Siena, in the fifteenth century the Florentine republic gave way to rule by one powerful banking family, the Medici.

Economic Contraction

While the Black Death was good for the silk trade, and the Hundred Years' War stimulated the manufacture of arms and armor, in other spheres economic contraction was the norm. After 1340, with the disintegration of the Mongol Empire and the Ming dynasty in control of China, easy trade relations between Europe and the Far East were destroyed. Within Europe, rulers' war machines were fueled by new taxes and loans—some of them forced. At times, rulers paid back the loans; often they did not. The great import-export houses, which loaned money as part of their banking activities, found themselves advancing too much to rulers all too willing to default. In the 1340s the four largest firms went bankrupt, producing, in domino effect, the bankruptcies of hundreds more.

War did more than gobble up capital. Where armies raged, production stopped. Even in intervals of peace, Free Companies attacked not only the countryside but also merchants on the roads. To ensure its grain supply, Florence was obliged to provide guards all along the route from Bologna. Merchants began investing in insurance policies, not only against losses due to weather but also against robbers and pirates.

Meanwhile, the plague dislocated normal economic patterns. Urban rents fell as houses went begging for tenants, while wages rose as employers sought to attract scarce labor. In rural areas, whole swathes of land lay uncultivated. The monastery of Saint-Denis, so rich and powerful under Abbot Suger in the twelfth century, lost more than half its income from land between 1340 and 1403. As the population fell and the demand for grain decreased, the Baltic region—chief supplier of rye to the rest of Europe—suffered badly; by the fifteenth century, some villages had disappeared.

Yet, as always, the bad luck of some meant the prosperity of others. While Tuscany lost its economic edge, cities in northern Italy and southern Germany gained new muscle, manufacturing armor and fustian (a popular textile made of cotton and flax) and distributing their products across Europe. The center of economic growth was in fact shifting northwards, from the Mediterranean to the European heartlands. There was one unfortunate exception: the fourteenth century saw the burgeoning of the slave trade in southern Europe. Girls, mainly from the Mongol world but also sometimes Greeks or Slavs (and therefore Christians), were herded onto ships; those who survived the harrowing trip across the Mediterranean were sold on the open market in cities such as Genoa, Florence, and Pisa. They were high-prestige purchases, domestic "servants" with the allure of the Orient.

THE CHURCH DIVIDED

The fourteenth and fifteenth centuries saw deep divisions within the church. A schism—setting first two, then three popes against one another—shattered all illusions of harmony within Christendom. Popes fought over who had the right to the papacy, and ordinary Catholics disputed about that as well as the very nature of the church itself.

The Great Western Schism

Between 1378 and 1409, rival popes—one line based in Avignon, the other in Rome—claimed to rule as vicar of Christ; from 1409 to 1417, a third line based in Bologna joined them. The popes at each place excommunicated one another, surrounded themselves with their own colleges of cardinals, and commanded loyal followers. The Great Western Schism (1378–1417)—as this period of popes and antipopes is called—was both a spiritual and a political crisis.

Exacerbating political tensions, the schism fed the Hundred Years' War: France supported the pope at Avignon, England the pope at Rome. In some regions, the schism polarized a single community: for example, around 1400 at Tournai, on the border of France and Flanders, two rival bishops, each representing a different pope, fought over the diocese. Portugal, more adaptable and farther from the fray, changed its allegiance four times.

The crisis began with the best of intentions. Stung by criticism of the Avignon papacy, Pope Gregory XI (1370–1378) left Avignon to return to Rome in 1377. When he died a year later, the cardinals elected an Italian as Urban VI (1378–1389). Finding Urban high-handed, however, the French cardinals quickly thought better of what they had done. At Anagni, declaring Urban's election invalid and calling on him to resign, they elected Clement VII, who installed himself at Avignon. The papal monarchy was now split. The group that went to Avignon depended largely on French resources to support it; the group at Rome survived by establishing a *signoria*, complete with mercenary troops to collect its taxes and fight its wars. Urban's successor, Boniface IX (1389–1404), reconquered the papal states and set up governors (many of them his family members) to rule over them. Desperate for more revenues, the popes at Rome turned all their prerogatives

into sources of income. Boniface, for example, put church benefices on the open market. He also commercialized penance, a move that was made possible by the development of the doctrine of Purgatory, the place where the souls of the dead were "purged" of their sins. In the thirteenth century, the church taught that certain pious acts here and now (such as viewing a relic or attending a special church feast) could reduce time in Purgatory. Such reductions were called "indulgences." Now, in the time of the schism, money payments were declared equivalent to performing the acts. Many people willingly purchased indulgences; others were outraged that Heaven was for sale.

Solutions to end the schism eventually coalesced around the idea of a council. The "conciliarists"—those who advocated the convening of a council that would have authority over even the pope—included both university men and princes anxious to flex their muscles over the church. At the Council of Pisa (1409), which neither of the popes attended, the delegates deposed them both and elected a new man. But the two deposed popes refused to budge: there were now three popes, one at Avignon, one at Rome, and a third at Bologna. The successor of the newest one, John XXIII, turned to the emperor to arrange for another council. This one, the Council of Constance (1414-1418), met to resolve the papal crisis as well as to institute church reforms. In the first task it succeeded, deposing the three rivals and electing Martin V as pope. In the second, it was less successful, for it did not end the fragmentation of the church. National, even nationalist, churches had begun to form, independent of and sometimes in opposition to papal leadership.

The major exception to this fragmentation was the decree in the name of Pope Eugenius IV (1431–1447) and Byzantine Emperor John VIII Palaeologus (r. 1425–1448) at the Council of Florence in 1439 that they had healed the rift between their churches. There was considerable opposition to this at Constantinople, however, and the Ottoman conquest put an end to the discussion. Meanwhile the conciliar movement continued, developing an influential theory that held that church authority in the final instance resided in a corporate body (whether representing prelates or more broadly the community of the faithful) rather than the pope.

Popular Religious Movements in England and Bohemia

While the conciliarists worried about the structure of the church, others began to rethink the church's role. In England, the radical Oxford-trained theologian John Wyclif (c.1330– 1384), influenced in part by William of Ockham (see p. 282), argued for a very small sphere of action for the church. In his view, the state alone should concern itself with temporal things, the pope's decrees should be limited to what was already in the Gospels, the laity should be allowed to read and interpret the Bible for itself, and the church should stop promulgating the absurd notion of transubstantiation. At first the darling of the king and other powerful men in England (who were glad to hear arguments on behalf of an expanded place for secular rule), Wyclif appealed as well (and more enduringly) to the gentry and literate urban classes. Derisively called "lollards" (idlers) by the church and persecuted as heretics, the followers of Wyclif were largely, though not completely, suppressed in the course of the fifteenth century.

Considerably more successful were the Bohemian disciples of Wyclif. In Bohemia, part of the Holy Roman Empire but long used to its own monarchy (see above, p. 150), the disparities between rich and poor helped create conditions for a new vision of society in which religious and national feeling played equal parts. There were at least three inequities in Bohemia: the Germans held a disproportionate share of its wealth and power, even though Czechs constituted the majority of the population; the church owned almost a third of the land; and the nobility dominated the countryside and considered itself the upholder of the common good. In the hands of Jan Hus (1369/71-1415), the writings of Wyclif were transformed into a call for a reformed church and laity. All were to live in accordance with the laws of God, and the laity could disobey clerics who were more interested in pomp than the salvation of souls. Hus translated parts of the Bible into Czech while encouraging German translations as well. Furthering their vision of equality within the church, Hus's followers demanded that all the faithful be offered not just the bread but also the consecrated wine at Mass. (This was later called Utraquism, from the Latin sub utraque specie—communion "in both kinds.") In these ways, the Hussites gave shape to their vision of the church as the community of believers—women and the poor included. Hus's friend Jerome of Prague identified the whole reform movement with the good of the Bohemian nation itself, appropriating the traditional claim of the nobility.

Burned as a heretic at the Council of Constance, Hus nevertheless inspired a movement that transformed the Bohemian church. The Hussites soon disagreed about demands and methods (the most radical, the Taborites, set up a sort of government in exile in southern Bohemia, pooling their resources while awaiting the Second Coming of Christ), but most found willing protectors among the Bohemian nobility. In the struggle between these groups and imperial troops—backed by a papal declaration of crusade in Bohemia—a peculiarly Bohemian church was created, with its own special liturgy for the Mass.

Churches under Royal Leadership: France and Spain

"National" churches did not need popular revolts to spark them. Indeed, in France and Spain they were forged in the crucible of growing royal power. In the Pragmatic Sanction of Bourges (1438), Charles VII surveyed the various failings of the church in France and declared himself the guarantor of its reform. Popes were no longer to appoint French prelates nor grant benefices to churchmen; these matters now came under the jurisdiction of the king.

The crown in Spain claimed similar rights about a half-century later, when the marriage of Ferdinand (r.1479–1516) and Isabella (r.1474–1504)—dubbed the "Catholic Monarchs" by the pope—united Aragon and Castile. In their hands, Catholicism became an instrument of militant royal sovereignty. King and queen launched an offensive against the Muslims in Granada (conquering the last bit in 1492). In 1502, the remaining Muslims were required

to convert to Christianity or leave Spain. Many chose to convert (coming to be known as *moriscos*), but they were never integrated into the mainstream and were expelled from the kingdom in the early seventeenth century.

The Jews suffered a similar fate even earlier—in fact, right after the 1492 conquest of Granada. Their persecution had deep roots. Historians have traditionally spoken of the relatively peaceful co-existence (convivencia) of Christians, Muslims, and Jews in the Iberian Peninsula from the time of the Muslim invasion (711) until the fourteenth century. Others, however—Darío Fernández-Morera is a good example—have argued that both Jews and Christians were persecuted or at least suffered discrimination under Islamic rule. More recent studies, summed up in a recent book edited by Connie L. Scarborough, suggest that grand generalizations must give way to particular cases. It is clear, nevertheless, that the fourteenth century wrought a major change in the position of many Jews, as virulent anti-Jewish pogroms in 1391 led many to convert to Christianity (gaining the name conversos). But the subsequent successes of the conversos—some of whom obtained civil and church offices or married into the nobility—stirred resentment among the "Old Christians." Harnessing popular hostility, the Catholic Monarchs received a papal privilege to set up their own version of the Inquisition in 1478. Under the friar-inquisitor Tomás de Torquemada (1420–1498), wholesale torture and public executions became the norm for disposing of "crypto-Jews." After they conquered Granada, the monarchs demanded that all remaining Jews convert or leave the country. Many chose exile over conversos status. Soon the newly "purified" church of Spain was extended to the New World as well, where papal concessions gave the kings control over church benefices and appointments.

DEFINING STYLES

Everywhere, kings and other rulers were intervening in church affairs, wresting military force from the nobility, and imposing lucrative taxes to be gathered by their zealous and efficient salaried agents. All of this was largely masked, however, by brilliant courts that employed every possible means to burnish the image of the prince.

Renaissance Italy

In 1416, taking a break from their jobs at the Council of Constance, three young Italians went off on a "rescue mission." One of them, Cincius Romanus (d.1445) described the escapade to one of his Latin teachers back in Italy:

In Germany there are many monasteries with libraries full of Latin books. This aroused the hope in me that some of the works of Cicero, Varro, Livy, and other great men of learning, which seem to have completely vanished, might come to

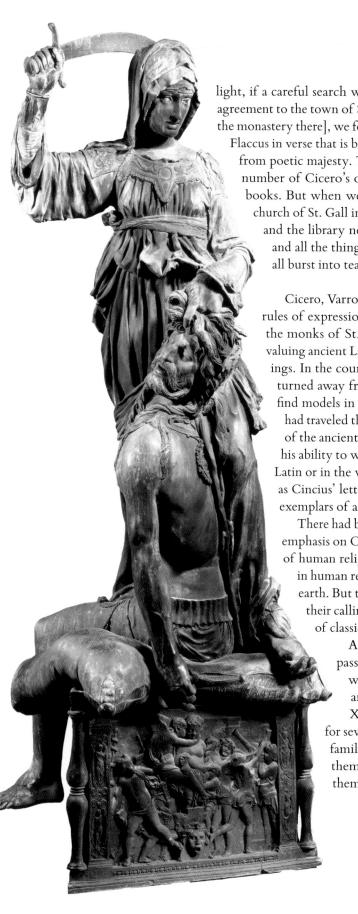

light, if a careful search were instituted. A few days ago, [we] went by agreement to the town of St. Gall. As soon as we went into the library [of the monastery there], we found *Jason's Argonauticon*, written by C. Valerius

Flaccus in verse that is both splendid and dignified and not far removed from poetic majesty. Then we found some discussions in prose of a number of Cicero's orations.... In fact we have copies of all these books. But when we carefully inspected the nearby tower of the church of St. Gall in which countless books were kept like captives and the library neglected and infested with dust, worms, soot, and all the things associated with the destruction of books, we all burst into tears."

Cicero, Varro, Livy: these provided the models of Latin and the rules of expression that Cincius and his friends admired. To them the monks of St. Gall were "barbarians" for not wholeheartedly valuing ancient Latin rhetoric, prose, and poetry over all other writings. In the course of the fourteenth century, Italian intellectuals turned away from the evolved Latin of their contemporaries to find models in the ancients. Already in 1333, the young Petrarch had traveled through the Low Countries looking for manuscripts of the ancient authors. Petrarch's taste for ancient eloquence and his ability to write in a new, elegant, "classical" style (whether in Latin or in the vernacular) made him a star. But he was not alone, as Cincius' letter proves; he was simply one of the more famous exemplars of a new group calling themselves "humanists."

There had been humanists before: we have seen Saint Anselm's emphasis on Christ's saving humanity, Saint Bernard's evocation of human religious emotion, and Thomas Aquinas's confidence in human reason to arrive at key truths about both heaven and earth. But the new humanists were more self-conscious about their calling, and they tied their humanism to the cultivation of classical literature.

As Cincius's case also shows, if the humanists' passion was antiquity, their services were demanded with equal ardor by contemporary ecclesiastical and secular princes. Cincius worked for Pope John XXIII. Petrarch was similarly employed by princes: for several years, for example, he worked for the Visconti family, the rulers of Milan. As Italian artists associated themselves with humanists, working in tandem with them, they too became part of the movement.

Historians have come to give the name Renaissance to this era of artists and humanists. But the Renaissance was not so much a period as a program. It made the language and art of the ancient past the model for the present; it privileged classical books as "must" reading for an eager and literate elite; and it promoted old, sometimes crumbling, and formerly little-appreciated classical art, sculpture, and architecture as inspiring models for Italian artists and builders. Meanwhile, it downgraded the immediate past—the last thousand years!—as a barbarous "Middle" Age. Above all, the Renaissance gave city communes and wealthy princes alike a new repertory of vocabulary, symbols, and styles, drawn from a resonant and heroic past, with which to associate their present power.

At Florence, for example, where the Medici family held sway in the fifteenth century behind a façade of communal republicanism, the sculptor Donatello (1386–1466) cast a gilded bronze figure of Judith beheading the tyrant Holofernes (Plate 8.5). Commissioned, probably in the 1420s, for the private garden of the Medici Palace, the heroic woman paired with the drunk and groggy Holofernes was meant to present the Medici as glorious defenders of liberty. The unabashed fleshiness and dramatic gestures of the figures were reminiscent of ancient Roman art.

The Medici were not the only Florentines who commissioned the new-style art. So did other wealthy merchants and aristocrats, rivalrous neighborhood churches, and confraternities. The painting of *Venus*, *Cupid*, *and Mars* by Piero di Cosimo (1462–1522) in Plate 8.6 was probably made as a wedding gift for a wealthy client. It echoed not only a popular theme of ancient art (see Plate 1.1 on p. 12) but also key elements of the classical style: figures with substance and volume, a recognizable natural world in which the figures move (or, in this case, rest), and hints of a private world into which the viewer is intruding.

Renaissance artists did not just imitate ancient models; they also strove to surpass them. Consider the new dome for the cathedral at Florence (see Plate 8.7 on p. 330). The Florentine Opera del Duomo, which was responsible for the upkeep of Florence's cathedral, held a competition to decide who would be commissioned to span the huge octagonal opening above the church. The winner was Filippo Brunelleschi (1377–1446). Later one of his many admirers, Leon Battista Alberti, himself an architect, dedicated his book *On Painting* to Brunelleschi, praising the dome as "an enormous structure towering over the skies, and wide enough to cast its shadow all over the Tuscan people, made as it is without any beam or abundance of wooden supports, surely hard to believe as an artifice that it was done at this time when nothing of the kind was ever to have been seen in antiquity." 12

The Renaissance flourished in many Italian cities besides Florence, among them Rome, Urbino, Mantua, Venice, Milan, and Perugia. At Milan, Duke Ludovico il Moro (r.1494–1499) gave Leonardo da Vinci (1452–1519) numerous commissions, including painting *The Last Supper* (see Plate 8.8 on p. 331) on one of the walls of the dining hall of a Dominican convent. Here Leonardo demonstrated his mastery of the relatively new science of linear perspective: the hall sheltering Christ and his disciples seems to recede as its walls approach a vanishing point. On the opposite side of the hall, Leonardo added a fresco (now nearly obliterated) of his patron: Ludovico, his wife, and their two children kneeling before an image of the Crucifixion.

Plate 8.5 (facing page) Donatello, Judith and Holofernes (c.1420-1430). The dense symbolism of this sculpture allowed it to be used for many purposes. Taken literally, it illustrated the moment in the biblical Book of Judith (13:4-10) when "Holofernes lay on his bed, fast asleep, being exceedingly drunk," while Judith, strengthened by prayer, grabbed his sword and "took him by the hair of his head ... struck twice upon his neck, and cut off his head." The Medici took it to justify their extraordinary role in Florence's political life. But in 1494, when the Medici were expelled (temporarily, as it turned out) from the city, and the sculpture was transferred from the private space of the Medici garden to the publically accessible Piazza della Signoria, it came to signify the triumph of the citizens.

Following pages:

Plate 8.6 Piero di Cosimo, Venus, Cupid, and Mars (c.1495-1505). For Florentines steeped in Neo-Platonic ideas, Venus and Mars represented not just ancient mythological lovers but an allegory of the marriage of opposites—in this case peace and war—that brought apparent conflict into one harmonious form. Here the wakeful Venus's seduction of Mars has put war to sleep. At the same time, Piero's painting spoke to more earthly concerns: women were said to conceive more beautiful children if they gazed at beautiful forms, and so Venus raises her head to peer at her lover.

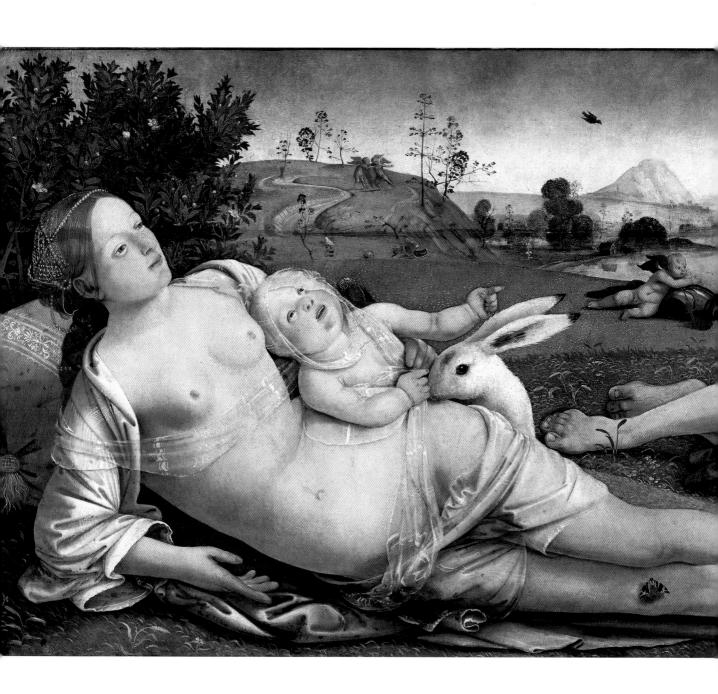

Plate 8.7 Filippo Brunelleschi, Florence Cathedral Dome (1418–1436). The dome spans the enormous 42-meter (46-yard) octagonal space over the cathedral. Brunelleschi accomplished this major engineering feat by designing a light inner shell atop of which the workers could then construct the upper dome—heavier and impervious to winds—with an ingenious use of ribs, rings, and bricks. He also designed the hoisting equipment for the building materials. No wonder that Brunelleschi became a "star"—the first celebrity architect.

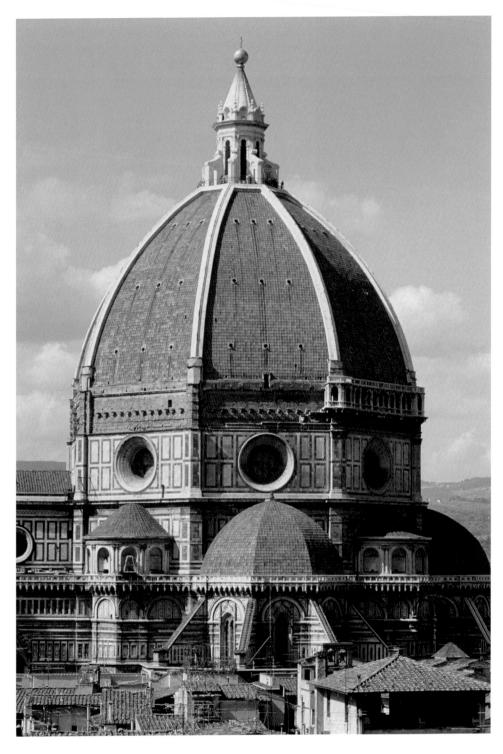

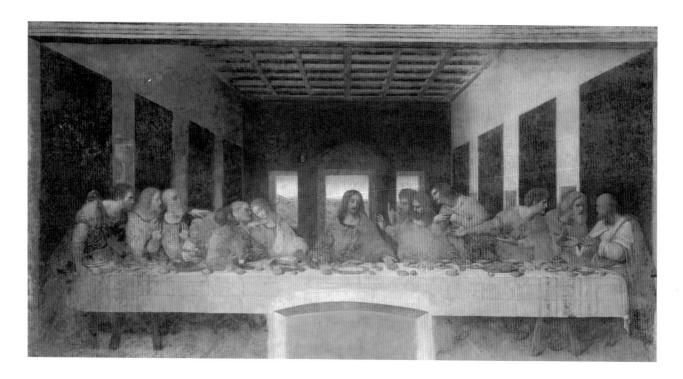

The new interest in perspective changed the way people looked at the world. Venetian artist Jacopo de' Barbari (c. 1460/70-before 1516), pictured his city with remarkable accuracy from an imaginary point above it. (See Plate 8.9.) This was one of the very first maps to accomplish anything like this. Given its enormous size (and cost), it was hardly meant to be a handy practical guide to the city. Rather, it had metaphorical significance, presenting an ideal city in the form of Venice. Just as Christ was increasingly depicted in naturalistic detail in both literature and art at this time, so patrons of city plans wanted their objects of contemplation to be true to life. Augustine had written about the City of God. In the Renaissance, the human city—a symbol of wealth, community, and power—became a sacred institution.

The Northern Renaissance

Toward the end of his life, Jacopo de' Barbari moved to northern Europe to work in Germany and the Netherlands. The move should not surprise: Italy was not the only place where the Renaissance took hold. Although Gothic style persisted in northern Europe, especially in architecture, the Greco-Roman world also beckoned. Ancient themes—especially the deeds of heroes, whether real or mythical—were depicted on tapestries that provided lustrous backdrops for rulers of every stripe. Burgundy—that ephemeral creation of the Hundred Years' War—embraced nearly all the possibilities of Renaissance culture: Plate 8.8 Leonardo da Vinci, The Last Supper (1494-1497). Leonardo first made his reputation with this painting, which evokes the precise moment when Christ said to his feasting apostles, "One of you is about to betray me." All the apostles react with horror and surprise, but the guilty Judas recoils, his face in shadows.

Following pages:

Plate 8.9 Jacopo de' Barbari, Bird's-Eye View of Venice (1500). This enormous woodcut measuring about 41/2 x 9 feet, represents Venice, complete with its churches, palaces, and small neighboring islands. While the top of the woodcut is framed by the alps, the bottom opens up toward the viewer, as if the scene were just a small part of a far vaster whole. And, indeed, Columbus's trip across the Atlantic made that perspective utterly realistic.

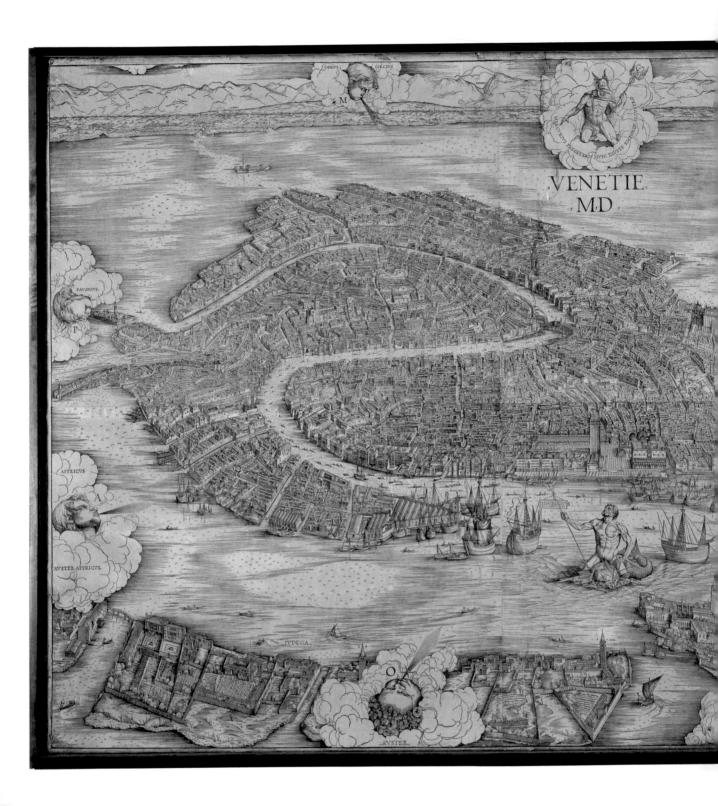

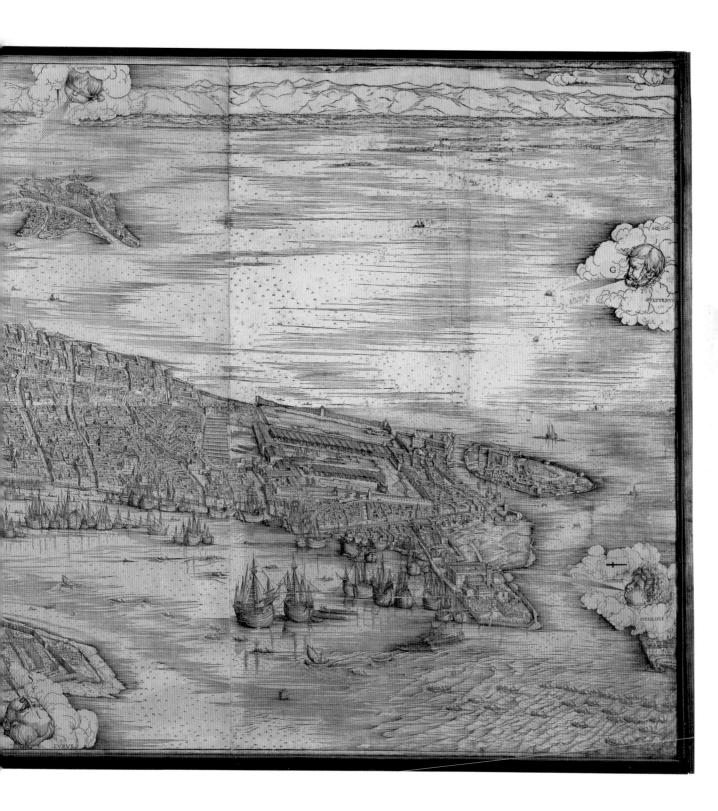

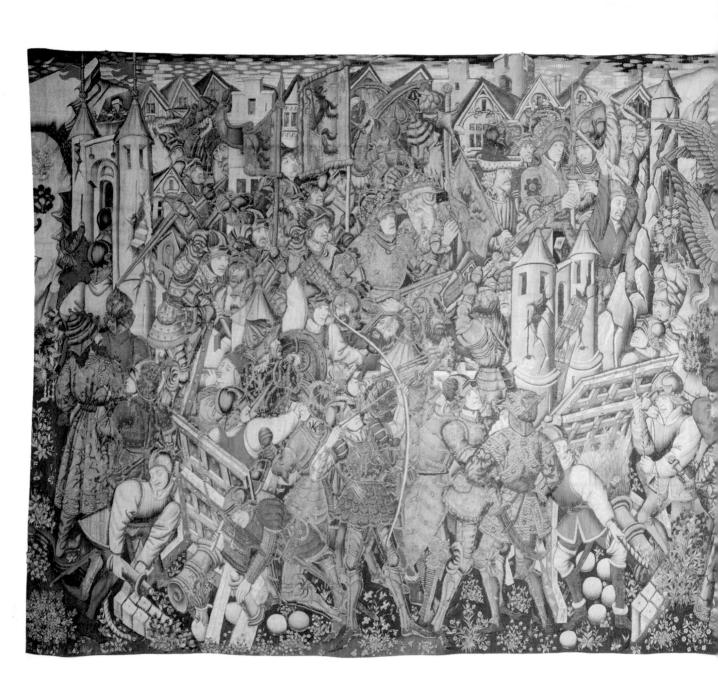

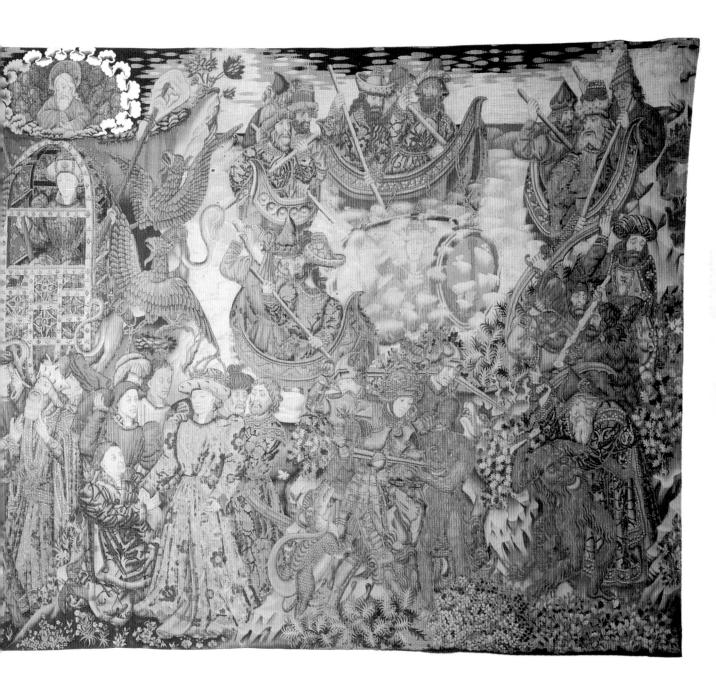

Previous pages:

Plate 8.10 History of Alexander the Great, Tapestry (c.1459). To the right of the depiction of his ascent into the air, Alexander appears surrounded by his courtiers. Next, he explores the underwater world: seated in a glass bell, he is encircled by sea creatures. Below, now returned to land, Alexander and his men fight dragons and monsters, one of whom is pierced by the hero's sword. The tapestry was commissioned by Philip the Good for 500 gold pieces and created by the master weaver of Tournai in silk, wool, and real gold thread. Alexander's adventures were recounted in vernacular romances; the text that probably directly inspired this tapestry was The Book of the Conquests and Deeds of Alexander the Great by Jean Wauquelin (d.1452), a copy of which was owned by the duke of Burgundy. music, art, literature, and pageantry. Its dukes traveled from one end of their dominions to the other with gorgeous tapestries in tow. Weavings lined their tents during war and their boats during voyages. In 1459 Philip the Good bought a series of fine tapestries woven in silk spiced with gold and silver threads—depicting the History of Alexander the Great (see Plate 8.10). Reading this tapestry from left to right, we see a city besieged, the trumpeters, archers, artillerymen, and soldiers reflecting the realities of fifteenth-century warfare. At the center, Alexander rises to the sky in a decorated metal cage lifted by four winged griffons. The weaving was the perfect stage setting for the performance of ducal power. No wonder European rulers—from English kings to Italian signori (and on to Ottoman sultans)—all wanted tapestries from Burgundy for their palaces.

At the same time, dukes and other northern European patrons favored a new style of art that emphasized devotion, sentiment, and immediacy. Painted in oil-based pigments, capable of showing the finest details and the subtlest shading, Netherlandish art was valued above all for its true-to-life expressivity. In the Columba Altarpiece (Plate 8.11) by Rogier van der Weyden—likely commissioned by Johann Dasse, a wealthy merchant from Cologne (Germany)—the donor himself is depicted, hat in hand (to the left in the central panel), humbly witnessing the visit of the Magi. Time itself is compressed in this picture, as the immediacy of the painting—its here-and-now presence—defies historical reality: no one from the fifteenth century could possibly have been at the scene.

The emphasis on natural details was equally striking in secular paintings from the Netherlands. In Portrait of Jan de Leeuw (see Plate 8.12) by Jan van Eyck (c.1390-1441), a

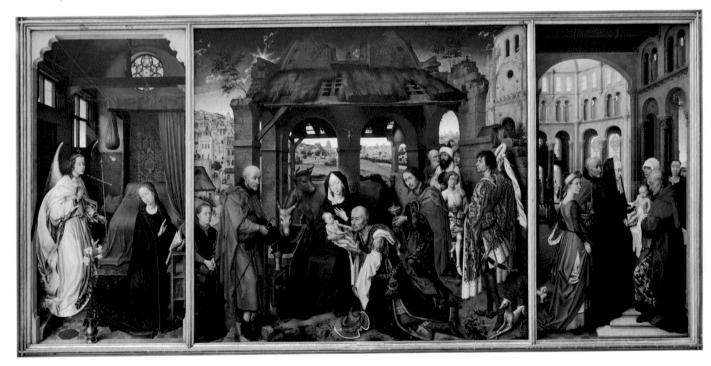

young man gazes directly at the viewer, serious and dignified. The gold ring he holds up announces his profession: a goldsmith. Yet this entirely secular theme is infused with a quiet inner light that endows its subject with a kind of otherworldliness.

Both the Italian and Northern Renaissances cultivated music and musicians, above all for the aura that they gave rulers, princes, and great churchmen. In Italy, Isabella d'Este (1474–1539), marchioness of Mantua, employed her own musicians—singers, woodwind and string players, percussionists, and keyboard players—while her husband had

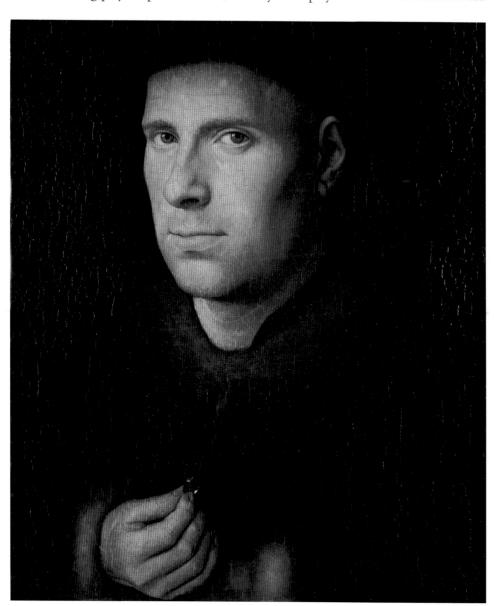

Plate 8.11 (facing page)

Rogier van der Weyden, Columba Altarpiece (1450s). Depicting three standard scenes from Christ's childhood—the Annunciation, the Adoration of the Magi, and the Presentation in the Temple—the Columba Altarpiece subtly introduces new themes alongside the old. For example, Christ's death is suggested by the crucifix above Mary in the central panel, while the present era (the fifteenth century) is suggested by the cityscape in the background, which probably represents Cologne, the native city of the man who commissioned the altar and the proud home of the relics of the Magi.

Plate 8.12 Jan van Eyck, Portrait of Jan de Leeuw (1436). Compare this portrait with the idealized Mars of Imperial Rome (see Plate 1.1 on p. 12), the gesturing Saint John of the Carolingians (Plate 3.9 on p. 110), the jovial figures at the Gothic cathedral at Bamberg (Plate 6.8 on p. 240), and the beautiful young Mars of the Italian Renaissance (Plate 8.6 on pp. 328-29). Only van Eyck painted his subject without idealizing, symbolizing, or beautifying him. He is an individual, with his own powerful—if reserved—personality.

his own band. In Burgundy, the duke had a fine private chapel and musicians, singers, and composers to staff it. In England, wealthy patrons founded colleges—Eton (founded by King Henry VI in 1440–1441) was one—where choirs offered up prayers in honor of the Virgin. Motets continued to be composed and sung, but now polyphonic music for larger groups became common as well. In the hands of a composer such as John Dunstable (d.1453), who probably worked for the duke of Bedford, regent for Henry VI in France during the Hundred Years' War, dissonance was smoothed out. In the compositions of Dunstable and his followers, harmonious chords that moved together even as they changed replaced the old juxtapositions of independent lines. Working within the old modal categories, composers made their mark with music newly sonorous and smooth.

NEW HORIZONS

Experiment and play within old traditions were thus major trends of the period. They can be seen in explorations of interiority, in creative inventions, even in the conquest of the globe. Yet their consequences may fairly be said to herald a new era.

Interiority

Donatello's Judith, intent on her single-minded task, and van Eyck's portrait, glowing from within, are similar in their self-involved interiority. Judith's self-centeredness is that of a hero; Jan de Leeuw's is that of any human being, the artist's statement about the dignity of mankind.

These two styles of interiority were mirrored in religious life and expression. Saint Catherine of Siena (1347–1380) was a woman in Judith's heroic mold. A reformer with a message, she was one of the first in a long line of women (Jeanne d'Arc is another example) to intervene on the public stage because of her private agonies. Writing (or rather dictating) nearly 400 letters to the great leaders of the day, she worked ceaselessly to bring the pope back to Rome and urged crusade as the best way to purge and revivify the church. Others found their purpose in their interior experiences alone.

In the Low Countries, northern Germany, and the Rhineland, the *devotio moderna* (the "new devotion") movement found purgation and renewal in individual reading and contemplation rather than in public action. Founded c.1380 by Gerhard Groote (1340–1384), the Brethren of the Common Life lived in male or female communities that focused on education, the copying of manuscripts, material simplicity, and individual faith. The Brethren were not quite humanists and not quite mystics, but they drew from both for a religious program that depended very little on the hierarchy or ceremonies of the church. Their style of piety would later be associated with Protestant groups.

Inventions

The enormous demand for books—whether by ordinary lay people, adherents of the devotio moderna, or humanists eager for the classics—made printed books a welcome addition to the repertory of available texts, though manuscripts were neither quickly nor easily displaced. The printing press, however obvious in thought, marked a great practical breakthrough: it depended on a new technique to mold metal type. This was first achieved by Johann Gutenberg at Mainz (in Germany) around 1450. The next step was getting the raw materials that were needed to ensure ongoing production. Paper required water mills and a steady supply of rag (pulp made of cloth); the metal for the type had to be mined and shaped; ink had to be found that would adhere to metal letters as well as spread evenly on paper.

By 1500 many European cities had publishing houses, with access to the materials that they needed and sufficient clientele to earn a profit. Highly competitive, the presses advertised their wares. They turned out not only religious and classical books but whatever the public demanded. Martin Luther (1483–1546) did not in fact nail his Ninety-five Theses to the door of the church at Wittenberg in 1517, but he certainly allowed them to be printed and distributed in both Latin and German. Challenging prevailing church teachings and practice, the Theses ushered in the Protestant Reformation. The printing press was a powerful instrument of mass communication.

More specialized, yet no less decisive for the future, were new developments in navigation. Portolan maps charted the shape of the Mediterranean coastline through accurate measurements from point to point. Compasses, long known in China but newly adopted in the West, provided readings that were noted down in nautical charts; sailors used them alongside maps and written information about such matters as harbors, political turmoil, and anchorage. But navigating the Atlantic also depended on methods for exploiting the powerful ocean wind systems. New ship designs—the light caravel, the heavy galleon featured the rigging and sails needed to harness the breezes.

Voyages

Already in the thirteenth century merchants and missionaries from Genoa and Majorca were making forays into the Atlantic. In the fifteenth century, the initiative that would eventually take Europeans around the Cape of Good Hope in one direction and to the Americas in the other came from the Portuguese royal house. The enticements were gold and slaves as well as honor and glory. Under King João I (r. 1385–1433) and his successors, Portugal extended its rule to the Muslim port of Ceuta and a few other nearby cities. (See Map 8.6.) More importantly, João's son Prince Henry "the Navigator" (1394–1460) sponsored expeditions—mainly by Genoese sailors—to explore the African coast: in the mid-1450s they reached the Cape Verde Islands and penetrated inland via the Senegal and Gambia Rivers. A generation later, Portuguese explorers were working their way far past

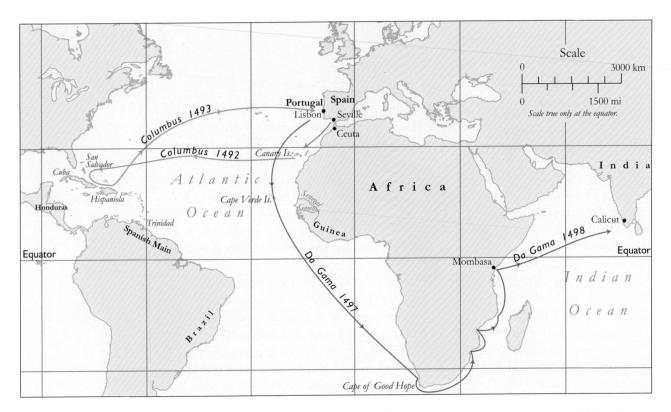

Map 8.6 Long-Distance Sea Voyages of the 15th cent.

the equator; in 1487 Bartolomeu Dias (d.1500) rounded the southern tip of Africa (soon thereafter named the Cape of Good Hope), opening a new route that Vasco da Gama sailed about ten years later all the way to Calicut (today Kozhikode) in India.

Such voyages were for more than trade and adventure. They were the prelude to colonialism. Already in the 1440s, Henry was portioning out the uninhabited islands of Madeira and the Azores to those of his followers who promised to find peasants to settle them. The Azores remained a grain producer, but, with financing by the Genoese, Madeira began to grow cane sugar. The product took Europe by storm. Demand was so high that some decades later, when few European settlers could be found to work sugar plantations on the Cape Verde Islands, the Genoese Antonio da Noli, discoverer and governor of the islands, brought in African slaves instead. Cape Verde was a microcosm of later European colonialism, which depended on just such slave labor.

Portugal's successes and pretensions roused the hostility and rivalry of Castile. Ferdinand and Isabella's determination to conquer the Canary Islands was in part their "answer" to Portugal's Cape Verde. When, in 1492, they half-heartedly sponsored the Genoese Christopher Columbus (1451–1506) on a westward voyage across the Atlantic, they were trying to best Portugal at its own game.

Although the conquistadores confronted a New World, they did so with the expectations and categories of the Old. When the Spaniard Hernán Cortés (1485–1547) began his conquest of Mexico, he boasted in a letter home that he had reprimanded one of the native chiefs for thinking that Mutezuma, the Aztec emperor who ruled much of Mexico at the time, was worthy of allegiance:

I replied by telling him of the great power of Your Majesty [Emperor Charles V, who was king of Spain] and of the many other princes, greater than Mutezuma, who were Your Highness's vassals and considered it no small favor to be so; Mutezuma also would become one, as would all the natives of these lands. I therefore asked him to become one, for if he did it would be greatly to his honor and advantage, but if, on the other hand, he refused to obey, he would be punished.¹³

The old values lived on.

* * * * *

Between the years 1350 and 1500, much of the Islamic world came under the control of the Ottomans, who also gobbled up the Byzantine empire and made inroads even further west. The Black Death hit the Eurasian continent in all directions; as much as half the population of Western Europe perished. The Hundred Years' War wreaked havoc in Europe when archers shot and cannons roared, and it loosed armies of freebooters in both town and country during its interstices of peace. The Roman church splintered as first the Great Schism and then national churches tore at the loyalties of churchmen and laity alike. These events were transformative in ways both bad and good. Much of the Islamic world found stability under the Ottomans, and although Byzantines suffered much, many found homes elsewhere—or lived on under Ottoman rule. The Black Death allowed the peasants in England to loosen the bonds of serfdom. It helped, too, to excite new interest in the body—in death but also in pleasure, in mystical experiences, and in the arts. New inventions allowed sea-faring adventurers to discover gold and land via the high seas; and everywhere bibliophiles and artists found wisdom and beauty in the classical past. Princes east and west flexed the muscles of sovereignty. History books normally divide this period into two parts, the "crises" going into a chapter on the Middle Ages, the creativity saved for a chapter on the Renaissance. But the two happened together, and, as they demonstrate, a crisis for one group was a creative moment for another.

EPILOGUE

By general common agreement, the "Middle Ages" ends in about 1500, with the European conquests of the Americas and, in the course of the sixteenth century, the Protestant Reformation, which shattered whatever was left of a united Christendom. Nevertheless, we may wish to challenge the date—and even the idea of an "end." Certainly, much of the Middle Ages remains today in recognizable bits and pieces. This is easy to see when we consider the persistence of universities, parliaments, ideas about God and human nature, the papacy, and Gothic churches. It is less easy to see, but certainly arguable, when we ask about less palpable things: our loves and hates, our pleasures and pains. For convenience,

historians carve their subject into "periods," but it is very hard to say when one of those periods ends and another begins. Many things live on, others fall by the wayside, and still others are revived—yet never exactly as they once had been. The fascination of history is to understand how everything around us—including ourselves—partakes of both old and new.

CHAPTER EIGHT: ESSENTIAL DATES

1337-1453	Hundred Years' War
1346-1353	Black Death
1358	Jacquerie in France
1371	Ciompi revolt in Siena
1378-1417	Great Schism of the papacy
1381	Wat Tyler's Rebellion
1414-1418	Council of Constance ends Great Schism
1429	Jeanne d'Arc leads French army to victory at Orléans
1444 ⁻ 1446, 1451 ⁻ 1481	Rule of Mehmed II the Conqueror, Ottoman sultan
c.1450	Gutenberg invents the printing press
1453	Ottoman conquest of Constantinople; end of Byzantine Empire
1492	Spanish conquest of Granada; expulsion of Jews from Spain; first

NOTES

- I Ashikpashazade, Othman Comes to Power, in Reading the Middle Ages: Sources from Europe, Byzantium, and the Islamic World, 3rd ed., ed. Barbara H. Rosenwein (Toronto: University of Toronto Press, 2018), p. 455.
- 2 For cannons, see "Reading through Looking," in Reading the Middle Ages, pp. XX-XXIII.
- 3 Petitions from the Greek Community at Venice, in Reading the Middle Ages, p. 466.

trans-Atlantic voyage of Columbus

- 4 Giovanni Boccaccio, The Decameron, in Reading the Middle Ages, p. 448.
- 5 Froissart, Chronicles, in Reading the Middle Ages, p. 468.
- 6 For longbowmen, see "Reading through Looking," in Reading the Middle Ages, pp. XVIII-XIX.
- 7 Jeanne d'Arc, Letter to the English, in Reading the Middle Ages, p. 473.
- 8 For siege guns and cannons, see "Reading through Looking," in *Reading the Middle Ages*, pp. XX–XXIII.
- 9 Wat Tyler's Rebellion, in Reading the Middle Ages, p. 483.
- 10 Chronicle of Siena, in Reading the Middle Ages, p. 475.

- II Cincius Romanus, Letter to His Most Learned Teacher Franciscus de Fiana, in Reading the Middle Ages,
- 12 Leon Battista Alberti, On Painting, in Reading the Middle Ages, p. 492.
- 13 Hernán Cortés, The Second Letter, in Reading the Middle Ages, p. 498.

FURTHER READING

- Bachrach, Bernard S., and David S. Bachrach. Warfare in Medieval Europe, c.400-c.1453. London: Routledge, 2017.
- Barton, Simon. Conquerors, Brides, and Concubines: Interfaith Relations and Social Power in Medieval Iberia. Philadelphia: University of Pennsylvania Press, 2015.
- Belozerskaya, Marina. Rethinking the Renaissance: Burgundian Arts across Europe. Cambridge: Cambridge University Press, 2002.
- Blumenfeld-Kosinski, Renate. The Strange Case of Ermine de Reims: A Medieval Woman between Demons and Saints. Philadelphia: University of Pennsylvania Press, 2015.
- Cerman, Markus. Villages and Lords in Eastern Europe, 1300–1800. New York: Palgrave Macmillan, 2012.
- Curry, Ann. The Hundred Years' War, 1337-1453. Oxford: Osprey, 2002.
- Fernández-Armesto, Felipe. Pathfinders: A Global History of Exploration. New York: Norton, 2006.
- Fernández-Morera, Darío. The Myth of the Andalusian Paradise: Muslims, Christians, and Jews under Islamic Rule in Medieval Spain. Wilmington, DE: ISI Books, 2016.
- Fudge, Thomas A. Jerome of Prague and the Foundations of the Hussite Movement. Oxford: Oxford University Press, 2016.
- Goffman, Daniel. The Ottoman Empire and Early Modern Europe. Cambridge: Cambridge University Press, 2002.
- Green, Monica H., ed. Pandemic Disease in the Medieval World: Rethinking the Black Death. Kalamazoo: Arc Medieval Press, 2015.
- Hudson, Anne. The Premature Reformation: Wycliffite Texts and Lollard History. Oxford: Oxford University Press, 1988.
- Imber, Colin. The Ottoman Empire, 1300-1650: The Structure of Power. 2nd ed. New York: Palgrave Macmillan, 2009.
- Jardine, Lisa, and Jerry Brotton. Global Interests: Renaissance Art between East and West. Ithaca, NY: Cornell University Press, 2000.
- Johnson, Geraldine A. Renaissance Art: A Very Short Introduction. Oxford: Oxford University Press, 2005.
- Karras, Ruth Mazo. Unmarriages: Women, Men, and Sexual Unions in the Middle Ages. Philadelphia: University of Pennsylvania Press, 2012.
- McKitterick, David. Print, Manuscript and the Search for Order, 1450-1830. Cambridge: Cambridge University Press, 2003.
- Parker, Geoffrey, ed. The Cambridge History of Warfare. Cambridge: Cambridge University Press, 2005.
- Patton, Pamela A. Art of Estrangement: Redefining Jews in Reconquest Spain. University Park: Penn State Press, 2012.

Scarborough, Connie L., ed. Revisiting Convivencia in Medieval and Early Modern Iberia. Newark, Delaware: Juan de la Cuesta, 2014.

Small, Graeme. Late Medieval France. New York: Palgrave Macmillan, 2009.

Smail, Daniel Lord. Legal Plunder: Households and Debt Collection in Late Medieval Europe. Cambridge, MA: Harvard University Press, 2016.

Sumption, Jonathan. Cursed Kings. Vol. 4 of The Hundred Years War. Philadelphia: University of Pennsylvania Press, 2015.

Vale, M.G.A. Henry V: The Conscience of a King. New Haven, CT: Yale University Press, 2016. Watts, John. The Making of Polities: Europe, 1300–1500. Cambridge: Cambridge University Press, 2009. Wheeler, Bonnie, and Charles Wood, eds. Fresh Verdicts on Joan of Arc. New York: Routledge, 1996.

To test your knowledge of this chapter, please go to www.utphistorymatters.com for Study Questions.

SOURCES

PLATES

- 1.1 Scala/Art Resource, NY.
- 1.2 Jebulon/CCo 1.0.
- 1.3 Scala/Art Resource, NY.
- 1.4 © Vanni Archive/Art Resource, NY.
- 1.5 © Tyne & Wear Archives & Museums/ Bridgeman Images.
- I.6 Limestone stela with flat top and relief; Ghorfa; Carthage. © The Trustees of the British Museum. All rights reserved.
- 1.7 Scala/Art Resource, NY.
- 1.8 SEF/Art Resource, NY.
- 1.9 "Orant" Fresco, SS. Giovanni e Paolo, Rome, view of confessio (late 4th cent.). Reprinted by permission of the Ministero dell'Interno-Dipartimento per le Libertà civili e l'Immigrazione-Direzione Centrale per l'Amministrazione del Fondo Edifici di Culto.
- 1.10 Scala/Art Resource, NY.
- 1.11 Erich Lessing/Art Resource, NY.
- 1.12 Mihai Barbat/Alamy Stock Photo.
- 2.1 Cross from South Tympanum, Hagia Sophia. The Courtauld Institute of Art, London. Photograph by Ernest Hawkins. Reproduced by permission.
- 2.2 Islamic Arabic 1572a fol. 2r. Cadbury Research Library: Special Collections, University of Birmingham. Reproduced by permission.
- 2.3 © Andrea Jemolo: www.jemolo.
- 2.4 Square-headed brooch, Early Anglo-Saxon, Chessell Down. © The Trustees of the British Museum. All rights reserved.
- 2.5 Cotton Nero D.IV fol. 137v. Copyright © The British Library Board. All Rights Reserved.

- 2.6 Cotton Nero D.IV fol. 138v. Copyright © The British Library Board. All Rights Reserved.
- 2.7 Cotton Nero D.IV fol. 139. Copyright
 © The British Library Board. All Rights Reserved.
- 2.8 Scala/Art Resource, NY.
- 2.9 Cameraphoto Arte, Venice/Art Resource, NY.
- 2.10 Janzig/Europe/Alamy Stock Photo.
- 2.11 Spatha (FG2187). Photograph ©
 Germanisches Nationalmuseum.
 Reproduced by permission.
- 2.12 MS 32, fol. 35v. Courtesy of Utrecht University Library.
- Werner Forman Archive/Bridgeman Images.
- 3.2 MS gr. 510, fol. 78r. Reproduced by permission of the Bibliothèque nationale de France.
- 3.3 180 AH/796-797 Aquamanile in the Form of an Eagle; The State Hermitage Museum, St. Petersburg. Photograph © The State Hermitage Museum/photo by Vladimir Terebenin, Leonard Kheifets, Yuri Molodkovets.
- 3.4 Panel (lid from a chest?), second half 8th century, wood (fig); mosaic with bone and four different types of wood, Samuel D. Lee Fund, 1937. Image courtesy of the Metropolitan Museum of Art/CCo 1.0.
- 3.5 Scala/Art Resource, NY.
- 3.6 MS lat. 2291, fol. 14v. Reproduced by permission of the Bibliothèque nationale de France.
- 3.7 MS Voss. lat. Q. 79, fol. 30v. Leiden University Library. Reproduced by permission.

- 3.8 bpk, Berlin/Staatsbibliothek zu Berlin/Art Resource, NY.
- 3.9 MS lat. 257, fol. 147v. Reproduced by permission of the Bibliothèque nationale de France
- 4.1 Erich Lessing/Art Resource, NY.
- 4.2 Jug, 900s. Iran or Iraq, Baghdad, Buyid
 Period, reign of Samsam al-Dawla (985–998
 AD). Gold with repoussé and chased and
 engraved decoration; overall: 12.5 x 10.2
 cm (4 1/8 x 4 in.); diameter of base: w. 7 cm
 (2 3/4 in.). The Cleveland Museum of Art,
 purchase from the J.H. Wade Fund 1966.22.
 © The Cleveland Museum of Art.
- 4.3 travelpixs/Alamy Stock Photo.
- 4.4 Ivan Vdovin/Alamy Stock Photo.
- 4.5 akg-images/De Agostini Picture Library.
- 4.6 MS 24, fol. 52v. Photograph by Anja Runkel. Reproduced by permission of Stadtbibliothek/Stadtarchiv Trier.
- 4.7 MS 1640, fol. 117r. Hessische Landesund Hochschulbibliothek Darmstadt. Reproduced by permission of Universitätsund Landesbibliothek Darmstadt.
- 4.8 Bayerische Staatsbibliothek München, Clm 4453, fol. 139v. CC-BY-NC-SA 4.0.
- 4.9 By permission of Det Kongelige Bibliotek.
- 4.10 Royal MS 10 A XIII, f. 2v. British Library/ Granger, NYC—All Rights Reserved.
- 4.11 Bayerische Staatsbibliothek München, Clm 14000. CC-BY-NC-SA 4.0.
- 5.1 B. O'Kane/Alamy Stock Photo.
- 5.2 JTB Photo/Universal Images Group/Getty Images.
- 5.3 B. O'Kane/Alamy Stock Photo.
- 5.4 akg-images/Gerard Degeorge.
- 5.5 Inv. no. 9/2001, The David Collection. Photograph by Pernille Klemp. Reproduced by permission.
- 5.6 Anthony Scibilia/Art Resource, NY.

- 5.7 Sant Tomàs de Fluvià (Toroella).
 Photograph by Heinz Hebeisen.
 Reproduced by permission of Iberimage.
- 5.8 Photograph by Barbara H. Rosenwein.
- 5.9 © Emmanuel PIERRE/Romanes.com. Reproduced by permission.
- 5.10 Allie_Caulfield/CC-BY-SA 2.0.
- 5.11 Add 17302, fol. 52r. British Library/ Granger, NYC—All Rights Reserved.
- 5.12 Reproduced by permission of Stan Parry.
- 5.13 Arundel 44, fol. 34v. British Library/ Granger, NYC—All Rights Reserved.
- 6.1 Paul Fearn/Alamy Stock Photo.
- 6.2 akg-images/Gerard Degeorge.
- 6.3 B. O'Kane/Alamy Stock Photo.
- 6.4 Church of St. Johannes, Cappenberg, Germany/Bridgeman Images.
- 6.5 Reproduced by permission of Stan Parry.
- 6.6 Scala/Art Resource, NY.
- 6.7 Alinari/Art Resource, NY.
- 6.8 akg-images/Erich Lessing.
- 7.1 Freer Gallery of Art and Arthur M. Sackler Gallery, Smithsonian Institution, Washington, DC: Purchase—Charles Lang Freer Endowment, F1938.3. Reproduced by permission.
- 7.2 B. O'Kane/Alamy Stock Photo.
- 7.3 E 401/1565, "Caricature of Norwich Jews on 13th Century Roll." Courtesy of the National Archives (UK).
- 7.4 Copyright © Rheinisches Bildarchiv Koln, rba_c007428. Rhineland, in 1300, silver, gold, H 15.7 cm, Inv. No. G 12.
- 7.5 Shrine of the Virgin. Ca. 1300. German, made in Rhine Valley. Oak, linen covering, polychromy, gilding, gesso. Overall: 14 ½ x 13 58 x 5 18 in. Closed: w. 5 in. Gift of J. Pierpont Morgan, 1917 (17.190.185). Image copyright © The Metropolitan Museum of Art. Image source: Art Resource, NY.

- 7.6 Initial D: Flight into Egypt: Leaf from a Book of Hours (2 of 2 Excised Leaves), early 1300s. Northern France or Flanders, early 14th century. Ink, tempera, and gold on vellum; leaf: 13 x 9.7 cm (5 1/16 x 3 13/16 in.). The Cleveland Museum of Art, The Jeanne Miles Blackburn Collection 2011.56. © The Cleveland Museum of Art.
- 7.7 Basilique Saint-Denis, France/Bridgeman Images.
- 7.8 Chansons anciennes (en latin et en français) avec la musique. MS H196, fol. 49v. Copyright BIU Montpellier/DIAMM, University of Oxford. Reproduced by permission of the Bibliothèque interuniversitaire de Montpellier, Bibliothèque universitaire historique de médecine.
- 7.9 The Morgan Library & Museum/Art Resource, NY.
- 7.10 Reproduced by permission of the Museo Civico Medievale. Bologna, Italy.
- 7.11 Reprinted by permission of Comune di Padova–Assessorato alla Cultura.
- 7.12 Cameraphoto Arte, Venice/Art Resource, NY.
- 7.13 akg/Bildarchiv Steffens.
- 7.14 V&A Images, London/Art Resource, NY.
- 7.15 Bowl with Chinoiserie design, ceramic (stonepaste, thrown), with cobalt-blue paint under colourless alkali glaze, Timurid

- Period, c. 1420–1450 AD, Samarqand, Uzbekistan, Central Asia, 10 x 21 cm; ROM2006_8439_1. With permission of the Royal Ontario Museum © ROM.
- 8.1 The Sultan Riding [reverse]. Samuel H. Kress Collection, 1957.14.695.b. Photograph courtesy of the National Gallery of Art, Washington.
- 8.2 Image LNS 26 R. Copyright © The al-Sabah Collection, Dar al-Athar al-Islamiyyah, Kuwait. Reproduced by permission.
- 8.3 Bayezid II Complex at Edirne. Alexander Calderon, 1983, courtesy of Aga Khan Documentation Center at MIT.
- 8.4 Sign. XVIII B 18, fol. 542r: Alexander de Villa Dei, Hieronymus Stridonensis, Pseudo-Augustinus. Reproduced by permission of the National Museum, Prague, Czech Republic.
- 8.5 Scala/Art Resource, NY.
- 8.6 bpk, Berlin/Gemaeldegalerie, Staatliche Museen, Berlin/Jörg P. Anders/Art Resource, NY.
- 8.7 Scala/Art Resource, NY.
- 8.8 Alinari/Art Resource, NY.
- 8.9 Cameraphoto Arte, Venice/Art Resource, NY.
- 8.10 Alinari/Art Resource, NY.
- 8.11 Reproduced by permission of SuperStock.
- 8.12 Erich Lessing/Art Resource, NY.

FIGURES

- 1.1 From Deborah Mauskopf Deliyannis,
 Ravenna in Late Antiquity (Cambridge:
 Cambridge University Press, 2010), Fig. 78,
 p. 227. Courtesy of Cambridge University
 Press.
- 2.1 Adapted from Stefan Karwiese, Gros is die Artemis von Ephesos (Vienna: Phoibos Verlag, 1995), Maps 5 and 6. Courtesy of Österreichisches Archäologisches Institut.

- 2.2 Reconstruction drawing of Saxon Yeavering AD 627, by Peter Dunn (English Heritage Graphics Team). Historic England/Mary Evans. Reproduced by permission.
- 3.1 Adapted from J.J. Norwich, ed., *Great Architecture of the World* (DeCapo, 2001), p. 133.
- 5.1 Adapted from Christian Sapin (dir.), Archéologie et architecture d'un site monastique: 10 ans de recherche à l'abbaye Saint-Germain d'Auxerre (Auxerre: Centre d'etudes medievales; Paris: CTHS, 2000), Figs. 3 and 371.
- 5.2 Adapted from Linda Seidel, Legends in Limestone: Lazarus, Gislebertus, and the Cathedral of Autun (Chicago: University of Chicago Press, 1999), p. 120, original drawing attributed to Anthony Titus.
- 5.3 Adapted from Wolfgang Braunfels, Monasteries of Western Europe: The Architecture of the Orders (Princeton: Princeton University Press, 1972), p. 84.
- 7.1 From Richard Hoppin, ed., *Anthology of Medieval Music* (New York: W.W. Norton, 1978).

MAPS

- 1.7 © Henri Galinie.
- 3.1 "Imperial Territory and the Themes, c. 917," from Mark Whittow, The Making of Orthodox Byzantium, 600–1025 (Berkeley: University of California Press, 1996), p. 166. Reproduced with permission of Palgrave Macmillan.
- 4.1 Adapted from Linda Safran, Heaven on Earth: Art and the Church in Byzantium (University Park, PA: Penn State UP, 1998), Images 1.7 and 1.9.
- 5.1 "Byzantium and the Islamic World, c. 1090," from Christophe Picard, Le monde musulman du XIe du XVe au siecle. Copyright © Armand Colin, 2000. Reproduced by permission.
- 6.8 From Atlas of Medieval Europe (Routledge, 2007). Reproduced by permission of Robert Bartlett.
- 7.7 © Samuel Leturcq. Reproduced by permission.
- 8.4 From Atlas of Medieval Europe (Routledge, 2007). Reproduced by permission of Michael C.E. Jones.

INDEX

Page numbers for illustrations appear in italics.

Aachen, 100, 108, 225 Abaga, khan (r.1265-1318), 254 Abbasids, 81, 88-94, 104, 111, 121-22, 128, 129, 147, 163, 165-66, 294 Abbo of Saint-Germain-des-Prés, 103, 105 'Abd al-Malik, caliph (r.685-705), 53, 54 Abd al-Rahman I, emir, 94-95 Abd al-Rahman III, caliph (r.912–961), 94, 125 Abelard. See Peter Abelard Abu Huraira, 93-94. See also hadith Abu Tammam, 92 Abu-Bakr, caliph, 54 Abu'l-Fazl Beyhaqi, 162 Abu'l-Fida (d.1331), lord of Hama, 256 Acre, siege of (1291), 254, 256, 298 Adalbert, saint, 150 Adela, sister of Henry I of England, 215 Adrian IV, pope, 222 Adrianople, 304 battle of (378), 23, 37 See also Edirne Adriatic, 100, 118, 225-26, 246 Aegean Sea, 47, 246 Æthelred II the Unready, king of England (r.978-Æthelstan, king of England (r.924-939), 130, 142-43 Afghanistan, 121 Afonso I Henriques, king of Portugal, 187 Africa, 129, 261, 270, 340 sub-Saharan, 122, 129 See also North Africa Agaune. See Saint-Maurice d'Agaune agriculture. See economy, rural Agrippa, 16 Aix-en-Provence, 104 al-Akhtal (c.640-710), 53, 54 Alaric (d.410), Visigothic leader, 23 Alba. See Scotland Alberti, Leon Battista, 327 Albertus Magnus (c. 1200–1280), saint, 280 Albigensians, 241, 244. See also Crusade Alcuin (d.804), 99, 107 Aleppo, 209 Alexander II, pope (1061-1073), 179, 181, 187 Alexander III, pope (1159-1181), 187, 223

Alexander the Great, 254, 289, 305, 334-35, 336 Alexandria, 6, 7, 8, 11, 42, 52 Alexius I Comnenus, Byzantine emp. (r.1081-1118), 171, 181, 182-83 Alfonso I, king of Asturias (r.739-757), 95-96 Alfonso I, king of Naples (r.1442-1458), 318 Alfonso V, king of Aragon. See Alfonso I, king of **Naples** Alfonso VI, king of Castile and León (r. 1065–1109), 169, 186-87, 203 Alfonso VII, king of Castile and León, 170 Alfonso VIII, king of Castile (r.1158-1214), 210, 220 Alfonso X, king of Castile and León (r.1252-1284), Alfred the Great, king of Wessex (r.871-899), 134, 140, 142-43, 147, 156 Algeciras, 169 Ali (d.661), caliph, 54, 88, 123, 129 Alighieri, Dante (1265-1321), 282, 284, 298 al-khurs. See warfare Almería, 170 Almohads, 170, 210, 212, 213, 247, 248 Almoravids, 161, 169-70, 181, 186-87, 210 Alp Arslan, sultan (r. 1063-1072), 163 Altar of Ratchis, 71-72, 72 Amalfi, 175 Ambrose (339–397), saint, bishop of Milan, 11, 21, Americas, 256, 301, 339, 341. See also New World Amiens, 234 Amorium, 92 Anagni, 276, 322 Anatolia, 23, 46, 82, 83, 117, 118, 119, 161-63, 166, 170-71, 181-82, 194, 213, 254, 296, 301, 306, al-Andalus (Andalusia), 94-96, 98, 99, 122, 125, 129, 140, 156, 169-70, 179, 186, 203, 210, 212, 213, 220, 228, 247, 297. See also Spain Angevin (dynasty), 215-16, 221, 225, 226, 314 of Hungary, 274 of Naples, 276, 318 Anglo-Saxon (Old English) (language), 66, 140 Anglo-Saxons, 24, 58, 65-66, 71, 142 Angold, Michael, 118 Anjou, 184, 186, 215, 221 Ankara, 304

Byzantine, 86, 88, 86-87 Anno, archbishop of Cologne, 181 Carolingian, 107-10, 108-10 anointment of kings, 70, 98-99, 150, 177, 315 ceramics, Islamic, 294, 296, 295-97 Anselm of Bec (or Canterbury) (1033-1109), saint, Gothic, 237, 240 186, 190, 203, 326 Images of Death, 309, 310, 311 Ansgar (d.865), 143 Jaziran, 207, 208, 209 Antioch, 6, 7, 52, 117, 119, 183, 209 Lombard, 71, 72 Principality of, 184 Mongol, 254, 255 Antonio da Noli, 340 Ottonian, 146-47, 146, 148-49 Antony (250-356), saint, 10-11, 27 Renaissance (Italy), 327, 328-29, 331, 331-33 Apulia, 224 Renaissance (northern), 331, 334-37, 336-37 Aguinas. See Thomas Aguinas Aquitaine, 61, 137, 176, 215, 228, 314 Roman classical, 11, 12, 13, 13-16, 16 Roman provincial, 15-16, 20, 17-20 Arabia, 43, 49, 52, 78, 122-23, 125 Roman, renaissance (4th-5th cent.), 20-21, 22 Arabian Peninsula. See Arabia Romanesque, 194, 194-98 Arabic numerals, 93 urban, 285, 289, 286-88, 290-91 Arabic script. See Kufic script See also architecture Arabs, 41, 43, 49, 70, 78, 83, 88, 95-96, 118, 119 Artevelde, Jacob van (d.1345), 318, 320 Aragon, 187, 220, 225, 260, 293, 297, 318, 324 Articella, 191 Aragonese (dynasty), 225, 226 Asella, Roman virgin, 10-11 Aral Sea, 161, 163 Ashikpashazade, 304 Aratos (fl. 3rd cent. BCE), 108 architecture Asia, 23, 128, 129, 203 Almohad, 210, 213 Assisi, 234, 239, 240-41 Asturias, 70, 96 Andalusian (al-Andalus), 95, 97 Byzantine, 29, 31, 32-33, 44-46, 45 Aswan, 125, 126-27 Athanasius (c.295-373), saint, bishop of Alexandria, Carolingian, 100 Fatimid, 124, 125, 126-27 Gothic, 233-34, 235-36, 238 Atlantic, 130, 258, 260, 331, 339-40, 342 Attila (d.453), Hunnic leader, 24 Lombard, 71-72, 73 Augustine, archbishop of Canterbury, 65 Mamluk, 209, 209, 257-58, 258 Augustine (354-430), saint, bishop of Hippo, 9, 23, Ottoman, 307, 308 73, 239, 242, 280, 331 Renaissance (Italian), 327, 330 Austrasia, 61, 98. See also Francia Romanesque, 194, 196-98, 195-99 Austria, 119, 197, 219, 225 Seljuk, 163, 165, 165-68 Autun, 194-98, 237 Umayyad, 54, 55 See also art; names of individual architectural Auxerre, 191-92 monuments Avars, 42-43, 84, 99, 120 Averroes. See Ibn Rushd Arianism. See Christianity Avicenna. See Ibn Sina Aristotle, 93, 128, 190-91, 254, 280, 284 Arius, Alexandrian priest (250-336), 8 Avignon, 275-76, 322-23 papacy, 275, 298, 322 Armenia, 42, 83, 118, 129, 171 Avitus, bishop of Vienne, 25 Arno River, 282 Arnulf, king of the East Franks (r.887–899), 135 Ayyub, governor of Damascus, 209 Ayyubids, 209-10, 247, 251, 256. See also Saladin Art of Measurable Song (Franco of Cologne), 285 al-Azhar Mosque, 124, 125 Art of Medicine (Galen), 191 Azores, 340 art and sculpture Abbasid, 91-92, 91-93 Badajoz, 169 Almoravid, 170, 170 Badr al-Din Lu'lu', emir of Mosul, 209 Anglo-Saxon, 65-66, 66-69

Badr, battle of (624), 52, 79 Bergamo, 318 Bernard Gui, 268 Baghdad, 53, 89, 90, 91, 94, 96, 111, 121, 122, 125, 128, 129, 147, 163, 209, 251, 252 Bernard (c. 1090–1153), saint, abbot of Clairvaux, baillis. See officials 197, 201, 244, 326 Bernart de Ventadorn (fl. c.1147-1170), 228-29 Balducci Pegolotti, Francesco, 259 Baldwin I of Flanders, emp. (Latin Empire), 214, Bernicia, 58 Bertran de Born (fl. 2nd half of 12th cent.), 230 Baldwin II, king of Jerusalem (r.1118-1131), 184 Besançon, diet of (1157), 222 Baldwin IV, king of Jerusalem (r.1174-1185), 266 Balkans, 1, 23, 30, 43, 82, 118, 170, 171, 213 and the laity, 323 Balthild, Merovingian queen (d.680), 61 for taking oaths, 136 Baltic, 60, 66, 84, 100, 104, 173, 244-47, 260, 321 New Testament, 66 Bamberg, 237, 240, 285, 337 Old Testament, 70, 142 bannum (ban), 99, 138 rabbinic commentaries, 266 barbarians, 1, 4, 18, 21-25, 36. See also names of translated, 8, 324 individual Germanic peoples Black Death (1346-1353), 308-11, 320, 321, 341, 342 Barbastro, battle of (1064), 179, 187 Black Sea, 23, 46, 119, 251, 292 Barcelona, 140 Boccaccio, Giovanni (d. 1375), 308 County of, 194 Boethius (d. 524/526), 26 Bohemia, 130, 150-51, 261, 274-75, 323-24 Bari, 170 Barthélemy, Dominique, 136 Bohemond of Taranto, 182 Basil I, Byzantine emp., 88 Boleslaw I the Brave, duke and king of Poland Basil II, Byzantine emp. (r.976-1025), 115, 116, (r.992-1025), 150-51 117-19, 121, 143, 151, 156, 170, 209 Bologna, 190, 191, 222, 285, 309, 321, 322-23 Bavaria, 135 University of, 232-33, 285 Lower, 270 Bonaventure (c.1217-1274), saint, 280-81, 282 Bayezid II, sultan (r.1481–1512), 308 Boniface VIII, pope (1294-1303), 272, 275-76 Bec, monastery, 186 Boniface IX, pope (1389–1404), 322–23 Boniface (672/675-754), saint, 65, 78, 98 Becket, Thomas (1118-1170), archbishop of Canterbury, 219 Book of Songs, 208, 209 Bede (the Venerable), 64-65, 66 Book of the Conquests and Deeds of Alexander the Great Bedford, duke of, 315, 338 (Wauquelin), 336 Books of Hours, 277, 285. See also liturgy Bedouins, 49 beggars, 261, 267 Boris-Michael, khan of Bulgaria (r.852-889), 85, Beghards, 241 111, 143 Beguines, 239, 241, 315 Bosporus, 182 Béla IV, king of Hungary (r.1235–1270), 274 Bosworth, battle of (1485), 317 Belgium, 1, 61, 103 Bourges, 139, 324 Bellini, Gentile (c.1429–1507), 305 Bouvines, battle of (1214), 219, 248 Benedict Biscop, 58, 65 Brenner, Elma, 266 Benedict of Aniane (d.821), 102 Brescia, 71, 72 Benedict (d.c.550/560), saint, 28, 241 Brethren of the Common Life, 338 Benedictine Rule, 28, 102, 154, 191, 192, 197, Bretislav I (d. 1055), prince of Bohemia, 150-51 198-99, 241 Britain, 9, 16, 17, 24, 64, 143 Benevento, 36, 71 British Isles, 58, 64-66, 108-9, 142, 215. See also Treaty of (1156), 224 Britain; England; Ireland; Scotland; Wales Benghazi, 121 Brody, Saul, 266 Berbers, 70, 91, 123, 207. See also Almohads; Brown, Peter, 1 Almoravids Brubaker, Leslie, 47

Carobert, king of Hungary (r.1308-1342), 274 Bruges, 173 Carolingian Empire, 103, 111, 129, 140 Brunelleschi, Filippo (1377–1446), 327, 330 Carolingians, 28, 74, 81, 96, 98-111, 113, 135-36, 138, Bruno of Cologne (d. 1101), 196 Bruno of Toul. See Leo IX 144, 147 Carpathian Mountains, 225, 252 Bruno (d.965), archbishop of Cologne, 145-46 Carthage, 6, 16, 18, 20, 52. See also Tunis Buddhism, 254 Carthusian Diurnal, 200 Bukhara, 128, 304 Carthusian order, 196, 239 al-Bukhari (810-870), 93 Casimir III the Great, king of Poland (r.1333-1370), Bulgaria, 5, 43, 82, 84-85, 118, 143, 150, 274, 304 Bulgarian Empire, 83, 117-18 Caspian Sea, 104, 119, 122, 161, 163 Second, 213, 274 Cassel, battle of (1328), 318 Bulgarians, 82, 117, 118, 119 Cassiodorus (490-583), 26 Bulgars, 43, 82, 85, 121, 135 Burchard, bishop of Worms, 146. See also canon law castellans, 138, 150, 176, 274, 275 Castile, 169, 170, 186-87, 210, 220, 270, 324, 340 Burgundian Code, 26 Catalonia, 138, 140, 187, 229, 260 Burgundians, 24, 26 Cathars, 241-42. See also Albigensians Burgundofara, 63 Catherine of Siena (1347-1380), saint, 338 Burgundy, 25, 61, 64, 187, 197, 305, 311, 314-16, 317, Celtic kingdoms, 64. See also British Isles 331, 336, 338 Celtic peoples, 58, 64-65 burhs. See warfare Ceuta, 169, 339 Buyids, 122-23, 162 Byzantine Empire (Byzantium), 24, 41-48, 49, Chalcedon, council of (451), 9 Champagne, 221, 261 51, 52, 53, 55, 60, 66, 71-72, 73, 79, 81-88, chansons de geste. See literature 113-121, 170-72, 178, 182, 213-14, 304-5, 342 charitable institutions, 261 and the papacy, 78, 98 Byzantium (city), 4, 7, 41. See also Constantinople; Charlemagne, king and emp. (r.768–814), 96, 99–102, 103, 107, 108, 111, 144, 150, 154, 222, 225 Istanbul Charles IV, emp. (r.1347-1378), 275 Charles IV, king of France (r.1322-1328), 311 caballeros villanos (city horsemen), 270 Charles V, emp., 341 Caesarea, 119 Charles VI, king of France (r.1380-1422), 315 Caesarius, bishop of Arles (r.502-542), 28 Charles VII, king of France, 315, 324 Caffa, 309 Charles Martel, mayor of palace (r.714-741), 98-99 Cairo, 53, 90, 92, 95, 124, 125, 127, 128, 129, 252, Charles of Anjou, 225 256, 309 Charles Robert. See Carobert Calicut, 340 Charles the Bald, king and emp. (r.843-877), 103, Cameron, Averil, 115 Canary Islands, 260, 340 canon law, 7, 78, 139, 146, 177, 180–81, 191, 217–18, Charles the Bold (d.1477), duke of Burgundy, 316 Charles the Fat (d.888), emp., 103 237-39, 243, 285 Charles the Great. See Charlemagne against Jews and heretics, 239 Charles the Simple, king, 134 Canossa, 180 Charter of Charity, 200. See also Cistercian order Canterbury, 65, 142, 154, 186, 190, 219 Chartres, 186, 234 Canute. See Cnut Chelles, monastery, 107 Cape of Good Hope, 339-40 China, 54, 91, 123, 129, 251-52, 254, 258-59, 294, Cape Verde Islands, 339-40 296, 304, 309, 321, 339 Capetians, 147, 150, 151, 188, 234, 244 Chinghis Khan (c.1162–1227), Mongol ruler, 252, 254 Cappadocia, 88 Chinon, 315 Cappenberg, monastery, 225 chivalry, 231, 239-40, 317. See also knights Carmathians. See Qaramita

```
Chosroes II, Persian king (r.590-628), 42
                                                         Columbanus (543-615), saint, 63, 108
Chrétien de Troyes (fl. c.1150–1190), 230–31
                                                         Columbus, Christopher (1451–1506), 331, 340, 342
Christ Church (Canterbury), 154
                                                         Commedia (Alighieri), 282
Christianity (forms of), 7-8, 11, 242, 254
                                                         Commentary on the Rule of Saint Benedict (Smaragdus),
   Arian, 8, 25, 70
                                                                154
   Donatist, 8
                                                         commercial revolution, 175-76. See also economy,
   Greek Orthodox (Byzantine), 84-85, 115, 121,
                                                                urban
          156, 171, 178, 184, 254, 274, 304
                                                         commons. See social orders
   Manichaean, 8-10, 242
                                                         communes (urban and rural), 9, 175-76, 180, 191,
   Monophysite (Armenia, Egypt, Ethiopia, Syria),
                                                                201, 221-22, 226-27, 232, 263-65, 309, 317,
          8-9, 52, 92, 171, 184, 207, 256
                                                                321, 327
   Nestorian, 207
                                                         Communion. See Eucharist
   Roman Catholic, 8, 65, 70-71, 79, 84, 121, 178,
                                                         Comneni (dynasty), 171, 213
          243, 274, 304, 324
                                                         Comtessa de Dia (fl. late 12th-early 13th cent.), 229
church, definition of, 6
                                                         conciliarists, 323
Church Fathers, 8, 73, 85, 105, 107, 180
                                                         confessio, 18-19, 21
church law. See canon law
                                                         Conrad III, king and emp. (r.1138-1152), 221
Cicero, 146, 325-26
                                                         Consolation of Philosophy (Boethius), 26
Cid. See Díaz de Vivar, Rodrigo
                                                         Constance I, queen of Sicily and empress, 224
Cináed mac Ailpín. See Kenneth I MacAlpin
                                                         Constance II (d. 1302), queen of Sicily, 225
Cincius Romanus (d.1445), 325-26
                                                         Constance, council of (1414-1418), 323, 324, 325, 342
ciompi (woolworkers), 321, 342
                                                         Constantine I, Roman emp. (r.306-337), 5-7, 8, 10,
Cistercian order, 197-200, 201, 203, 228, 244
                                                                37, 71, 99, 113, 305
Cîteaux, monastery, 197
                                                            Donation of, 98
City of God (Augustine), 9, 23, 331
                                                         Constantine V, Byzantine emp. (r.741-775), 48, 82
city-states. See Italy. See also communes; signorie
                                                         Constantine VI, Byzantine emp., 81
Cividale del Friuli, 71-73
                                                         Constantine VIII, Byzantine emp., 115
Clairvaux, monastery, 197
                                                         Constantine IX, Byzantine emp. (r.1042-1055), 171
Clare of Assisi, saint, 241
                                                         Constantine the African, 191
Clarendon, 219
                                                         Constantine-Cyril, saint, 84, 86
   Assize of (1166), 216
                                                         Constantinople, 4, 7, 16, 18, 20, 29-30, 41, 42, 46,
Clement VII, antipope, 322
                                                                53, 82, 84, 85, 88, 92, 96, 99, 113, 115, 119, 175,
clergy, 6, 11, 27, 100, 113, 145, 220, 242, 268, 270,
                                                                182, 203, 259, 296, 301, 323
      272, 285
                                                            Black Death at, 309
   and celibacy, 78, 177
                                                            crusaders conquest of, 213-14, 244-46, 247, 248,
   English, 217, 219
                                                                   274
   in papal election, 177
                                                            Ottoman conquest of, 305, 308, 342
   married, 177, 180
                                                            patriarch of, 48, 86, 178
   reformed, 237
                                                            Quinisext Council of (691/692), 47, 48, 78
   taxed, 275, 293
                                                            Synod of (754), 48
Clovis I, king of the Franks (r.481/482-511), 24-26,
                                                            See also Istanbul
                                                        constitutions, 30, 275
Clovis II (d.657), king of the Franks, 61
                                                         Constitutions of Melfi (Frederick II), 224
Cluniac order, 177
                                                        contado (rural area), 139-40, 222, 226
Cluny, monastery, 135, 176-77, 187
                                                        conversion, 7, 9, 25, 49, 52, 54, 64-65, 70-71, 84-85,
Cnut, king of England (r.1016-1035), 143-44, 185
                                                                88, 99, 111, 119-21, 122, 134, 142, 143-44, 156,
Codex Justinianus (Justinian I), 30
                                                               181, 239-41, 244, 254, 256, 266, 274, 293, 298,
Cologne, 145-47, 181-82, 196, 277, 285, 336, 337
                                                               304, 325
colonialism, 340
                                                        conversos, 325
```

Damianite order, 241 Córdoba, 94-95, 96, 125, 128, 140 Dandangan, battle of (1040), 162 cortes (Spanish). See courts Dandolo, Enrico, Venetian doge (r.1192-1205), 261 Cortés, Hernán (1485-1547), 340 Danelaw, 134 cortezia, 229 Costanzo da Ferrara, 305 Danes, 142, 143-44, 244 Dante. See Alighieri, Dante council. See names of individual councils (by city) Danube River, 1, 4, 113, 117, 135, 225 Courtrai, battle of (1302), 263 Danzig, 260 courts Abbasid, 88, 92-93 Dara, 42 Dasse, Johann, 336 Almohad, 212 al-Dawla, Samsam, emir (r.985–998), 122 Anglo-Saxon, 140-43 Decretum (Burchard), 146. See also canon law aristocratic, 63, 228-31 Decretum (Gratian), 180. See also canon law Byzantine, 31, 88, 113-15, 171, 213-14 Denmark, 130, 140, 143, 144, 239, 244 Carolingian, 100, 107 Dermot MacMurrough (d. 1171), king of Leinster, 246 English, 271 Deruta, 297 episcopal (bishops), 146-47 devotio moderna, 338-39 French royal, 221, 272, 284 Merovingian, 61-62 Dhuoda, 107 Diarmait Mac Murchada. See Dermot Mongol, 254 MacMurrough Ottoman, 305-7 Dias, Bartolomeu (d.1500), 340 Ottonian, 145-46 Spanish cortes, 270 Díaz de Vivar, Rodrigo (the Cid), 186 Diddington, manor of, 185-86 taifa (al-Andalus), 128 Digest (Justinian I), 30 Umayyad, 53 See also law courts Dijon, 314 Diocletian, Roman emp. (r.284-305), 1, 5, 6, 18 Crete, 117, 214, 246 Divine Comedy. See Commedia Croatia, 5, 225 Diyarbakir, 168, 194 Crusade, 224, 244-46, 272, 275, 305, 318, 324, 338 Domesday Book, 186 Albigensian (1209-1229), 244, 267 Dominic (1170-1221), saint, 239-40, 241-42 First (1096-1099), 163, 181-84, 203 Dominican order, 239-40, 241, 267, 276, 277 Fourth (1202–1204), 213, 244, 245, 248, 261 Northern, 244-45, 260 Domrémy, 315 Donatello (1386-1466), 327, 338 Peasants' (or People's), 181 Dorestad, 58, 104 Second (1147-1149), 184, 201, 203, 209, 244 Dorset, 309 Third (1189-1192), 219, 248 Drendel, John, 289 Crusader States, 184, 186, 203, 209-10, 241, 244, 252, dualism, 9, 242 254, 256, 298 Duby, Georges, 136 Ctesiphon, 42, 52 Duero River, 95 Cuenca, 220 Duns Scotus, John (1265/1266-1308), 282 curiales (town councilors), 26, 46 Dunstable, John (d. 1453), 338 Cuthbert, saint, 192 Dunstan (d.988), saint, archbishop of Canterbury, Cyprus, 117, 214, 219 Cyril. See Constantine-Cyril 154 Durham Cathedral, 192, 193, 194 dynatoi (Byzantine powerful men), 117, 119, 143, 151, Dalassa, 119 Dalassena, Anna (d.c. 1102), 171 171, 213, 214 Dalasseni (family), 119, 171 East China Sea, 251 Dalmatia, 5 Ebbo, archbishop of Reims, 109 Damascus, 42, 52, 53, 54-55, 72, 88, 128, 184, 209, 296

```
Ebro, 99, 293
                                                             fin'amor, 229
Ecclesiastical History (Bede), 66
                                                             love, 13, 49, 93, 200, 212, 213, 228-31, 247, 280,
Ecclesius, bishop of Ravenna, 30-31
                                                                    284, 293
Eckhart (d.1327/1328), 281
                                                         empire. See names of individual empires
economy
                                                         England, 1, 58, 60, 61, 64, 66, 70, 73, 79, 107, 129,
   barbarian, 21-22
                                                                 130, 137, 140, 142-43, 173, 176, 187, 194, 221,
   Byzantine, 29, 46
                                                                 222, 227, 229, 232, 243, 246-47, 260, 263, 277,
   money, 22, 54, 60, 104, 140, 151, 170, 175, 258,
                                                                 293, 322, 338
           261, 264
                                                             Anglo-Saxon, 58, 64, 66, 134
   gift, 60-61
                                                             Black Death in, 309
   pre-Islamic Arabia, 49
                                                             Cistercians in, 197
   Roman (3rd century), 4-5
                                                             conquest of, 143, 203
   rural, 27, 46, 58-61, 103-5, 165, 172-73, 227,
                                                             diocesan division of, 65
           289-93, 307, 309, 320
                                                             Franciscans in, 241
   urban/trade, 26-27, 71, 91, 123-24, 128-29,
                                                             in the Hundred Years' War, 301, 311-17, 318, 320
           139-40, 173-75, 213-14, 226, 231-32, 241,
                                                             institutionalization of, 214-20, 224, 226
           254-56, 258-65, 292-93, 318-22, 339-41
                                                             Jews in, 243, 265-66, 298
   See also Black Death; communes; Great Famine;
                                                             Parliament in, 268, 271
                                                             peasant movements in, 320, 341
          taxation
Edessa, county of, 183-84, 209
                                                             popular religious movements in, 323-24
Edirne, 304, 308
                                                             taxation system in, 134
education
                                                             under Norman rule, 185-86
   madrasas, 163, 166, 209, 256, 306, 308
                                                             unification of, 134
   schools, 9, 28, 55, 65, 85, 107, 128, 146, 181, 186,
                                                             See also Britain; British Isles
           188, 190-91, 221, 232-33, 237, 240, 277,
                                                         English Channel, 58, 173
                                                         enquêteurs. See officials
   students, 163, 190-91, 232-33, 280, 285, 287
                                                         Ephesus, 44-46, 45
   teachers (masters), 85, 107, 115, 128, 146, 163,
                                                         Epirus, despotate of, 214
           190, 232, 287
                                                         estates. See social orders
   universities, 191, 226, 232-33, 241, 245, 275,
                                                         Estates General (French), 272, 320
           280-81, 293, 341
                                                         Estonia, 244, 260
Edward I, king of England (r.1272-1307), 266, 271,
                                                         Ethelbert (d.616), king of Kent, 65
                                                         Eton College, 338
Edward III, king of England (r.1327-1377), 309, 311,
                                                         Etymologies (Isidore of Seville), 70
                                                         Eucharist, 10, 31, 36, 51, 237, 239, 242, 243, 268,
       316, 320
Edward IV, king of England, 317
                                                                 276-77, 324. See also transubstantiation
Edward V, king of England, 317
                                                         Euclid, 93
Edward the Confessor, saint, king of England
                                                         Eugenius IV, pope (1431-1447), 323
       (r.1042-1066), 185-86
                                                         Euhodus (sarcophagus), 16, 17, 18, 20, 21, 22, 240,
Egbert, archbishop of Trier (r.977-993), 147
Egbert Codex, 146, 147
                                                         eunuchs, 115
Egil's Saga, 130
                                                         Euphrates River, 113, 117, 207
Egypt, 1, 18, 42, 46, 52-53, 86, 89, 91, 92, 123, 125,
                                                         Eyck, Jan van (c. 1390-1441), 336-38
       128, 129, 209-10, 247, 248, 251, 252, 256, 277,
       294
                                                         fabliau. See literature
Einhard (d.840), 99, 100
                                                         Faenza, 297
Elbe River, 144, 244
                                                         family, 46-47, 51, 63, 138, 180, 230
Eleanor, duchess of Aquitaine, 215
                                                         farming, 61, 105
emotions, 17, 200, 326
                                                         farms, 4, 46, 58, 289, 292
```

Cistercian (granges), 200	Franco of Cologne, 285
See also manors	Franks, 21, 23, 24, 25, 55, 71, 73, 78, 84, 100, 119, 135
Farnesina (Villa), 13, 14–15, 16, 55	170, 213
fasting, 9, 10, 51, 64, 78, 79, 93	Frederick I Barbarossa, king and emp. (r.1152–1190),
Fatimah, 54, 123	222-24, 225, 248
Fatimids, 122, 123, 125, 128, 129, 134–35, 151, 156,	Frederick II, king and emp. (r.1197–1250), 224–25,
161, 166, 209	248, 265
fealty, 136-37, 150, 184, 215, 221, 230. See also	Free Companies. See warfare
vassalage	Freiburg im Breisgau, 173, 261
Fenland, 227	friars, 240-41, 267, 277, 280-81, 293. See also names
feodum. See fief	of individual mendicant orders
Ferdinand the Catholic, king of Spain (r.1479–1516),	Frisia, 98
324, 340	Froissart, Jean, 311, 317
Fernández-Morera, Darío, 325	fueros. See laws
Fernando I, king of Castile, 187	Fulk, count of Anjou, 184
feudalism, 136. See also fief; vassalage	Fustat, 92, 197
fief, 125, 136, 138, 165, 171, 179, 184–85, 222, 224,	
247. See also vassalage	Galen, 191
Flaccus, C. Valerius, 326	Gallienus, Roman emp. (r.253–268), 5
Flanders, 186, 214, 221, 227, 232, 246, 263, 265, 275,	Gallipoli, 304
280, 292, 314–15, 318, 320, 322	Gama, Vasco da, 340
Florence, 232, 261, 282, 309, 318, 321, 322, 327, 330	Gambia River, 339
Council of (1439), 323	Gaul, 23–24, 26, 55, 61. See also France; Francia
Fountains, monastery, 197, 199	Gauls, 21
Four Doctors (of law), 191, 222	Gdansk. See Danzig
Fourth Lateran Council (1215), 237, 239, 243, 248,	Gediminas, duke of Lithuania (r.c.1315/1316–1341),
285	274-75
France, 1, 61, 103, 105, 109, 129–30, 135, 137–39,	Geneva, 28
147, 170, 173, 176, 177, 187, 191, 196, 215, 220,	Genghis Khan. See Chinghis Khan
226, 228–29, 239, 241, 242, 260, 261, 271, 272,	Genoa, 26, 175, 260, 261, 292, 309, 322, 339
275-76, 277, 280, 293	gentry, 217, 219, 220, 271, 323
Cistercians in, 197	Geoffrey of Anjou, 186
	Georgia, 118, 129
Franciscans in, 241	Gepids, 24
heretics in, 244, 267, 277	Germani, 21. See also barbarians; Germanic peoples;
Ile-de-France, 150, 188, 221, 233, 243, 265 in the Hundred Years' War, 301, 311–17, 320,	names of individual Germanic peoples
	Germania, 4. See also Germany
322, 338	Germanic
Jacquerie in, 320, 342	
Jews in, 243–44, 265–66	languages, 21 peoples, 4, 21–22, 58, 64
king of, 188, 216, 219, 224, 225, 247, 263, 276,	warriors, 4, 36
292, 298, 318, 320	Germanicus Caesar (fl. 1st cent. CE), 108
national church in, 324	Germany, 61, 74, 76, 98, 103, 129, 135, 140, 143,
versus Flanders, 292	
See also Francia; Gaul	144–47, 150, 176–77, 179–80, 187, 215,
Francia, 55, 58, 60, 61, 63, 81, 96, 98, 99, 100, 102,	221–25, 227, 229, 237, 241, 244, 261, 274–75,
105. See also France; Gaul	281, 292, 321, 325, 331, 336, 339
Francis of Assisi (1181/1182-1226), saint, 240-41,	Black Death in, 309
242, 267, 276	Cistercians in, 197
Franciscan order, 239, 241, 267, 276, 277, 280–81	devotio moderna in, 338

free peasants in, 137 Guelfs (papal supporters), 263 Jews in, 181, 243, 311 guilds, 175, 201, 226, 231-33, 234, 243, 245, 247, 263-64, 305, 309, 321. See also economy, ministerials in, 270 urban Gervasius, saint, 11 Géza, prince of Hungary (r.972-997), 151 Guillaume de Lorris, 284 Gutenberg, Johann, 339, 342 Ghana, 170 Ghazan, khan (r. 1295-1304), 254 Gutones. See Goths Guyuk, khan (r.1246.1248), 254 Ghent, 318, 320 Ghibellines (imperial supporters), 263 Gibbon, Edward, 1 Habsburgs (dynasty), 225, 317 Gibraltar (Strait of), 260 hadith, 54, 93-94, 146. See also Muhammad the Giotto (1266/1267-1337), 254, 289 Prophet Giovanni d'Andrea, 285, 287 Hagia Sophia (Constantinople), 29, 48 hairesis. See heresy Gisela, abbess of Chelles, 107 Gniezno, 150-51 Haithabu, 104, 140 Goffart, Walter, 25 Hama, 256 Golden Bull (1356), 270, 298 Hamburg, 153, 172 Handbook for Her Son (Dhuoda), 107 Golden Horde. See Mongols Hangzhou, 259 Golden Horn, 119, 175, 214 Hansa (or Hanseatic League), 260 Gothic (language), 8 Harald Bluetooth, king of Denmark (r.c.958-c.986), Gothic. See architecture; art Goths, 8, 21, 23, 25. See also Ostrogoths; Visigoths 143, 150 Harald Fairhair, king of Norway, 130 Granada, 324-25, 342 Grande Chartreuse, monastery, 196 Harald Hardrada, king of Norway, 185 Harmony of Discordant Canons. See Decretum (Gratian) granges. See farms Gratian (canon lawyer), 180, 191. See also canon law Harold Godwineson, king of England (r.1066), 185 Great Famine (1315-1322), 289, 293, 298 Hastings, battle of (1066), 185 Great Mosque (Córdoba), 95, 96, 97, 128 Hattin, battle of (1187), 210, 248 Great Mosque (Damascus), 55 Hellespont, 1 Great Mosque (Diyarbakir), 168 Henry I, king of England (r.1100-1135), 176, 186, 215 Great Mosque (Kairouan), 294, 295 Henry I, king of Germany (r.919-936), 144 Henry II, duke of Poland, 274 Great Mosque (Siirt), 167 Henry II, king and emp. (r.1002-1024), 144-45 Great Palace (Constantinople), 113, 115 Great Western Schism. See papacy Henry II, king of England (r.1154-1189), 215-17, 219, 221-22, 224, 232, 246-47, 248 Greece, 1, 41, 82 Greek Fire. See warfare Henry III, king and emp. (r.1039–1056), 150, 177, 179 Greenland, 130 Henry III, king of England (r.1216-1272), 266, 271, Gregorian chant. See liturgy 272 Gregorian Reform, 176-79. See also Investiture Henry IV, king and emp. (r.1056-1106), 179-80, 181 Conflict Henry IV, king of England (r. 1399-1413), 317 Gregory, bishop of Tours (r.573-594), 26-27 Henry V, king of England (r.1413-1422), 314-15 Henry VI, emp. (r.1190-1197), 224 Gregory I the Great, pope (590-604), 28, 30, 37, 65, 73, 78, 107 Henry VI, king of England (r.1422-1461), 317, 338 Henry VII, king of England (r.1485-1509), 317 Gregory II, pope (715-731), 65, 78 Henry of Anjou. See Henry II, king of England Gregory VII, pope (1073-1085), 178, 179-80, 187 Gregory XI, pope (1370-1378), 322 Henry of Burgundy, count of Portugal, 187 Gregory of Nazianzus, 87, 88 Henry the Lion, duke of Saxony, 244 Henry "the Navigator" (1394-1460), Portuguese Groote, Gerhard (1340-1384), 338 Gubbio, 297 prince, 339-40

Heraclius, Byzantine emp. (r.610-641), 42-43 Ile-de-France. See France heraldry, 317 Iliad (Homer), 305 Herat, 304 Ilkhan Empire (Khanate), 254, 301 heresy, 8, 119, 163, 213, 224, 239, 276, 277 Ilkhanids, 254, 293, 296, 298 Templars accused of, 272 Ilmen (lake), 119 imam. See Islam heretical, 7, 207, 241 heretics, 239, 242-44, 247, 254, 267-68, 272, 298, India, 52, 91, 123, 129, 340 indulgences, 323 315, 324 High Rochester, 17 Indus River, 42 Innes, Matthew, 25 Hijra (622), 51, 79. See also Muhammad the Prophet Hildebrand of Soana. See Gregory VII Innocent III, pope (1198-1216), 237, 241, 244, 245, Hildesheim, 146 248 Himalavas, 251 Inquisition, 267-68 Hitda, abbess of Meschede, 147 Abbasid (Mihna), 94 Hitda Gospels, 147, 148 Spanish, 325 Holland, 172 Investiture Conflict (or Controversy), 179-81, 201, Holy Land, 181-82, 184, 244, 245, 272. See also 203, 215, 222. See also Gregorian Reform Crusader States; Levant; names of individual igta, 125, 165-66, 171 Crusader States Iran, 88, 122, 128, 129, 163, 164, 165, 254, 289, 294, Holy Roman Empire, 225, 266, 271, 316, 317, 324 296, 297 Holy Sepulcher (Jerusalem), 181 Iraq, 88-89, 91, 119, 122, 129, 163, 165, 210, 294 homage, 136-37, 150, 184, 215, 221, 320. See also Ireland, 64, 130, 134, 142, 215, 243, 246-47 Irene, Byzantine empress, 81-82, 99, 100 vassalage Isaac of Norwich, 266 Homer, 305 Homilies (Gregory of Nazianzus), 87, 88 Isabella d'Este (1474-1539), marchioness of Mantua, Horace, 146 Hugh I, king of Cyprus (r.1205-1218), 214 Isabella the Catholic, queen of Spain (r.1474-1504), Hugh IV of Lusignan, 137, 139 324, 340 Isagoge (trans. Constantine the African), 191 Hugh Capet, king of France (r.987-996), 147, 150 Humbert of Silva Candida, 178 Isfahan, 128, 163, 165 Hundred Years' War (1337-1453), 301, 311-17, 318, Mosque, 165, 166, 209 320, 321, 322, 331, 338, 341, 342 Isidore of Seville (c. 560–636), 70 Hungarians, 103, 130, 135, 144, 150, 151, 156 Islam, 41, 49-55, 70, 88, 121-22, 129, 166, 168-69, Hungary, 130, 135, 150, 151, 156, 182, 225, 226, 245, 254, 256, 293, 298, 304 five pillars of, 51, 79 252, 261, 268, 274 imam, 54, 88-89, 123, 163 Huns, 23-24 Hus, Jan (1369/71-1415), 324 mahdi, 123 Hussites, 324 Qur'an, 49-51, 52, 54, 88, 94 Shi'ism, 123, 129, 161, 163 Hylestad, 74 Sufism, 256 Iberia (or Iberian Peninsula). See al-Andalus; Spain Sunnism, 94, 129, 161, 163, 166, 168, 201, 209-10, Ibn Rushd (Averroes) (1126–1198), 191 Ibn Shaddad, 210 ulama, 84 Ibn Sina (Avicenna) (980–1037), 128, 156, 191 ummah, 51-52 Ibn Tulum Mosque, 95 Islamic era. See Hijra Islamic Spain. See al-Andalus Iceland, 130 Israel, 1, 99 iconoclasm, 47-48, 53, 78, 79, 81-82, 85, 86, 94, Istanbul, 305-6. See also Constantinople 108, 111 Italic League, 318 Ifriqiya, 91, 135

Italy, 1, 5, 16, 26, 28, 41, 55, 58, 63, 66, 73, 78, 83, 98, persecution, 119, 181-82, 243-44, 247, 265-66, 103, 108, 118, 129, 134, 135, 146, 173, 175, 177, 268, 272, 298, 311, 325, 342 179-80, 186, 187, 191, 227, 229, 234, 243, 261, Talmud, 266 267, 270, 281, 293, 297, 306, 309, 316, 318 taxation, 53, 94, 266 Byzantine, 71, 118-19 See also economy, rural; economy, urban Byzantine war in, 36 jihad (striving), 52, 210 Carolingian conquest of, 99-100 Joan of Arc. See Jeanne d'Arc Cistercians in, 197 João I, king of Portugal (r.1385-1433), 339 city-states in, 226, 247, 321 John, king of England (r.1199-1216), 219-220, 248 Franciscans in, 241 John, saint, 20, 72, 109, 110, 337 imperial power in, 221-25 John I Tzimisces, Byzantine emp. (r.969–976), 117 Jews in, 266 John II, king of France, 320 Lombard, 71-72 John VIII Palaeologus, Byzantine emp. (r. 1425– Normans in, 170, 178 1448), 323 Ostrogoths in, 24, 31 John XXIII, antipope, 323, 326 Ottonians in, 144 John of Damascus (d.749), saint, 53 peasants in, 60, 137 John the Fearless, duke of Burgundy, 305 Renaissance, 305, 325-31, 337 Judaism, 120, 121, 254, 256 urban life in, 139-40, 176, 232 Julian the Apostate, Roman emp., 7 Visigoths in, 23 Juliana of Mont Cornillon (1193-1258), 276 Ivan Asen II, tsar of Bulgaria (r. 1218-1241), 257 Junius Bassus, sarcophagus of, 20-21, 22 Justinian I, Byzantine emp. (r.527-565), 29-31, 32, Iznik. See Nicaea 36, 41, 42, 71, 86, 100, 191 Jacopo de' Barbari (c.1460/1470-bef. 1516), 331 Plague of, 29-30, 44, 81, 301 Jacquerie, 320, 342 Justinian II, Byzantine emp. (r.685–695; 705–711), Jacques Bonhomme (Jack Goodfellow), 320 78 Jael, Humility, and Judith, 202 Jagiellon (dynasty), 274 Ka'ba (Mecca), 49, 51 James, saint, 187, 231 Kabul, 52, 121 Janissaries. See warfare Kaldellis, Anthony, 115 Japan, 252 Kashan, 207 Jarrow, monastery, 65 Kazakhstan, 161, 259 al-Jawli, Salar, emir, 256 Kenneth I MacAlpin (d.858), king, 134 al-Jawli, Sanjar, emir, 256 Kent, 65 Jazira, 207 Kesh, 304 Jean de Meun, 284 Khazar Empire, 91 Jeanne d'Arc (Joan of Arc), 315, 338, 342 Khazars, 119-21 Jerome, saint, 10-11, 153 Khurasan, 88-89, 91 Jerome of Prague, 324 al-Khwarizmi (d.c.850), 93 Jerusalem, 6, 21, 22, 42, 54, 163, 183, 210, 219, 247, Kiev, 120-21, 254 266 Kievan Rus'. See Rus' Kingdom of, 184 knights, 136, 138-39, 150, 175, 184, 198, 221, 224, Jews, 5-6, 51, 54, 64, 70, 95, 129, 147, 175, 184, 203, 228, 230-31, 247, 260, 271, 292, 317-18 213, 220, 237 King Arthur's, 284 at Genoa, 26 See also names of individual knightly orders; canon law against, 239 warfare depictions of, 264-65 Kozhikode. See Calicut in Persia, 52 Krakov, university of, 275 in the Kingdom of Sicily, 224 Krum, Bulgarian khan (r.803-814), 82

Kufic script, 122, 296	Leovigild, Visigothic king (r.569–586), 66
	lepers, 240, 266-67, 268, 272, 298
La Garde-Freinet, 135	leprosaries, 266, 268
Ladoga (lake), 119	leprosy, 266
laity, 8, 27, 78, 100, 139, 220, 293, 323, 341	Levant, 184, 185, 226, 245. See also Crusader States;
reformed, 177, 237, 324	Holy Land; names of individual Crusader
Lancastrian (Tudor) (dynasty), 316–17	States
Landi (family), 263	Lewes, battle of (1264), 271
Languedoc, 243, 244, 268	liberal arts, 190-91, 233. See also education
Las Navas de Tolosa, battle of (1212), 212, 248	Librada, saint, 170
Lateran Palace. See Rome	Libya, 42, 121, 123, 251
Latin Empire, 246	Licinius, Roman emp., 6
law courts	Liège, 146
aristocratic, 138	Life of Charlemagne (Einhard), 99
English (local), 217	Lille, 292, 314
English (royal), 216–17, 219	Lincoln, 186
Flemish (peasant), 318	Lindisfarne, monastery, 66
French (royal), 272	Lindisfarne Gospels, 66, 67, 68, 69, 70, 133
German (imperial), 222, 224	literature
papal, 73, 181	Abbasid, 92–94
laws, 7–8, 26, 37, 46, 70, 71, 102, 237, 245, 260, 275	adab, 93
barbarian, 26	Almohad, 212
Byzantine, 117	Andalusian (al-Andalus), 128
Carolingian (capitularies), 100, 139	Byzantine, 85–86, 213
English, 142-43, 176, 214-19, 220, 247, 309	chansons de geste, 230
of commerce, 175	epic poetry, 74
Hungarian, 151	fabliau, 229
Lombard, 71	Renaissance (Italy), 325–27
Roman, 30, 180, 191, 222	romances, 230–31
Spanish (fueros), 220	troubadour, 228–30
sumptuary, 309	Umayyad, 54
Viking, 134	vernacular, 282–83
See also canon law; names of individual	See also names of individual works of literature
constitutions, law codes, and statutes	Lithuania, 84, 274–75
Lebanon, 1	liturgy, 28, 84, 283, 284
Lechfeld, battle of (955), 135, 144, 147, 156	Bohemian, 324
Lecture on the Tree of Consanguinity and Affinity	books, 84, 86, 105, 106, 107
(Giovanni d'Andrea), 285	Cistercian, 197–99
Leeuw, Jan de, 336, <i>337</i> , 338	Gregorian chant, 105
Legnano, battle of (1176), 223	in the Benedictine Rule, 198
Leinster, 246	Latin chants, 228, 293
Leo III, Byzantine emp. (r.717–741), 47–48, 78, 94	Mass, 10
Leo III, pope (795–816), 100	processions, 31, 191
Leo IV (d.780), Byzantine emp., 81	Roman, 187
Leo VI, Byzantine emp. (r.886–912), 83, 86, 135	vessels, 192
Leo IX, pope (1049–1054), 177	vestments, 65, 192
Leo the Mathematician, 85	Lives of the Caesars (Suetonius), 99
León, 169, 170, 186–87, 270	Livy, 325–26
Leonardo da Vinci (1452–1519), 327, 331	Lodève, 242

Lodi, peace of (1454), 318 Manichees, 9, 242 Mannheim, 76 lollards, 323 manors, 105, 138, 232, 245 Lombard League, 223 Lombards, 36, 55, 71, 78, 98, 100, 119 Carolingian (villae), 104-5 Lombers, 241-42 English, 239 London, 176, 220, 239, 261, 320 al-Mansur, Abu Yusuf Ya'qub, caliph (r.1184-1199), Tower of, 317 lords, 136-38, 227-28, 232-33, 292-93. See also al-Mansur, caliph (r.754-775), 89 signori Mantes-la-Jolie, 234 Lothar, emp. (r.840-855), 102-3 Mantua, 327, 337 Lotharingia, 145, 146 manuscripts, 86, 105, 107, 109, 128 Louis VI the Fat, king of France (r.1108-1137), 188 illuminated, 86, 108, 209 Louis IX, saint, king of France (r.1226-1270), 266, making of, 152-55, 285 See also art 267, 272, 285, 298 Louis the Child (d.911), king, 144 Manzikert, battle of (1071), 163, 166, 203 Louis the German, king (r.843-876), 101-2, 109 Marcel, Étienne, 320 Marrakesh, 169 Louis the Pious, emp. (r.814-840), 102-3 marriage, 63, 121, 138 Low Countries, 140, 241, 276, 316, 326, 338. See also Netherlands alliances, 144, 171, 314 Lübeck, 260 as a church sacrament, 237, 239, 285 Lucera, 224-25 clerical (nicolaitism), 176-77 Ludovico il Moro, duke of Milan (r. 1494–1499), 327 Marseille, 104 Luke, saint, 66, 67, 70, 147, 149 Martin, saint, bishop of Tours, 26-27, 28, 29, 231 Luther, Martin (1483-1546), 339 Martin V, pope, 323. See also Great Western Schism Marwan II, caliph, 89 Luxembourg, 61, 103 Mary of Burgundy, 316 Lyon, 196, 200, 242-43 Mary of Oignies (1177-1213), 241 Mass. See liturgy Madeira, 340 madrasas. See education Mas'ud I, sultan (r.1030–1041), 162 Magdalino, Paul, 115 Matilda, daughter of Henry I of England, 215 Matilda of Tuscany, countess, 180 Magdeburg, 146 Maghreb, 123, 169, 210, 247, 260. See also North Matteo da Correggio, podestà of Piacenza, 264 Maurice, Byzantine emp., 42 Africa Magna Carta (Great Charter), 220, 247, 248, 271, 275 Maurice, saint, 29 Magnus the Good, king of Norway (r.1035-1047), 144 Maurice de Sully, bishop of Paris, 234 Maguelonne, 261 Maxentius, Roman emp., 7 Magyars. See Hungarians Maximian, Roman emp. (r.286-305), 4 Maximianus, archbishop of Ravenna, 30-31 Mahaut, countess of Artois, 277 Maine, 221 Maximilian of Habsburg, emp., 295 Mainz, 182, 339 McKitterick, Rosamond, 98 Majolus (c.906-994), abbot of Cluny, 135 Meath, 247 Mecca, 49, 51-52, 79, 125, 163, 294 Majorca, 260, 297, 339 Medici (family), 321, 327 Malazgirt. See Manzikert Malikshah I, sultan (r.1072-1092), 163, 165 medicine, 85, 128, 156 Mamluk sultanate, 251, 256, 298 schools of, 191, 233 Mamluks, 207, 210, 251, 252, 254, 256, 293, 298 Medina, 51, 52, 54, 79 al-Ma'mun, caliph (r.813-833), 91, 92, 94 Mediterranean, 1, 24, 27, 29, 42, 46, 52, 53, 60, 64, Mani, 9 91, 123, 134, 173, 260, 289, 293, 307-8, 322, Manichaeism, 9, 10 339

Meerssen, treaty of (870), 102, 103 moriscos, 325 Mehmed II the Conqueror, sultan (r.1444-1446, Morocco, 260 1451-1481), 304-5, 305, 342 Moscow, 251, 254, 309 Meissen, 227 Mosel, 59, 243 Meister Eckhart. See Eckhart Mosse Mokke, 264, 266 Melgueil, 261 Mosul, 200 motet. See music Melisende, queen of Jerusalem (r.1131-1152), 184 mendicants. See friars Mozarabs, 95-96 mercenaries. See warfare al-Mufid (d. 1022), caliph, 129 merchants. See economy, urban Muhammad the Prophet (c.570-632), 49-52, 54-57, Mérida, 66, 95 79, 89, 93-94, 123, 125 al-Mulk, Nizam (d.1092), vizier, 163, 165 Merovingians, 61-63, 70, 78, 81, 98 al-Mulk, Taj, 163, 165 Mesopotamia, 83 music, 105, 107, 190, 198, 209, 228, 282–83, 298, 314 Methodius, saint, 84 Metilia Acte, 16. See also Euhodus (sarcophagus) canticles, 109 Metz, 108, 182 in Burgundy, 336-38 Prior Annals, 107 motet, 284-85, 293 Mexico, 340 notation, 65, 105, 196-97, 284, 285 Michael III, Byzantine emp. (r.842-867), 85 polyphonic, 338, 284-85 Mieszko I, duke of Poland (r.c.960-992), 150 troubadour songs, 228 Mihna. See Inquisition Visigothic, 187 Muslims, 36, 43, 49, 51–54, 55, 78, 92, 95, 103, 125, mihrab, 124, 125, 163, 294, 295 Milan, 4, 11, 28, 140, 176, 179, 180, 222-23, 263, 318, 128-30, 134-35, 184, 207, 254, 296 326, 327 at Hattin, 210 Edict of (313), 6, 37 in Constantinople, 119 Milvian Bridge, battle of (312), 7 persecution of, 203, 237, 239, 243, 266, 324-25 Ming (dynasty), 296, 304, 321 Sicilian, 224-25 minnesinger, 229 al-Mustansir, caliph (r.1036-1094), 125 Mirror of Virgins (Speculum Virginum), 200, 202 al-Mutamin, ruler of Zaragoza, 186 missi dominici. See officials al-Mu'tasim, caliph (r.833-842), 89, 91, 92 Moesia, 5 al-Mutawakkil, caliph (r.847-861), 94 Molyneaux, George, 134 Mutezuma, Aztec emp., 340-41 monasticism, 63, 184, 191-201. See also individual mystics, 241, 281, 338 monasteries, orders, and rules women, 315 Monegundis, 26-27, 28-29 money. See economy Naples, 233, 261, 276, 316, 318 Mongol Empire, 251-52, 254, 304, 321 University of, 224 Mongolia, 252 Navarre, 293, 318 Mongols, 203, 209, 251-52, 254, 256, 259, 274, 293, navy. See warfare 294, 296, 298, 309 Negroponte, 246 Neophytos, 214 Golden Horde, 254 Monologion (Anselm of Bec), 190 Nerio, 285 Monophysite Christians. See Christianity Netherlands, 21, 61, 98, 103, 281, 331, 336. See also Monte Cassino, monastery, 28 Low Countries Neustria, 61. See also Francia Montmartre (Paris), 58 Montpellier, 178 New World, 325, 340. See also Americas Nicaea, 183, 214 University of, 179, 233 Council of (325), 7-8, 37 Moralia in Job (Gregory I the Great), 73 Moravia, 84, 150 Council of (787), 81

```
Empire of, 214
                                                        Order of the Brothers of the Sword, 244
                                                        Order of the Garter, 317
Nicephorus I, Byzantine emp. (r.802-811), 82
                                                        Order of the Golden Buckle, 317
Nicephorus II Phocas, Byzantine emp. (r.963-969),
                                                        Order of the Golden Fleece, 317
                                                        Orléans, 280
Nicole Oresme (c. 1320–1382), 282
                                                            siege of (1429), 315, 342
Nicomedia, 4
                                                        Orontes River, 209
Nicopolis, battle of (1396), 304, 305
                                                        Osma, 239
Niger River, 261
                                                        Ostia, 16
Nishapur, 52
                                                        Ostrogoths, 23, 24, 31
nobility, 220, 264, 285, 317, 320, 325
   Bavarian, 102
                                                         Oswy, king of Northumbria, 65
                                                         Othman (d.1324/1326), sultan, 304
   Bohemian, 324
                                                         Otto I, king and emp. (r.936-973), 135, 144-45, 146,
   landed, 227
   lesser, 221
                                                                156
   Saxon, 102
                                                         Otto II, king and emp. (r.961-983), 144, 147
                                                         Otto III, king and emp. (r.983-1002), 144, 147
Normandy, 119, 134, 185-86, 203, 215, 221, 222, 247,
                                                         Otto IV of Brunswick, emp., 219
       309, 314
                                                         Otto of Cappenberg, 225
Normans, 119, 134, 170, 178, 192, 221, 224. See also
                                                         Ottokar II, king of Bohemia (r.1253-1278), 275
       England; France; Sicily
                                                         Ottoman Turks, 301, 304-8, 323, 336, 341
North Africa, 8, 24, 31, 41, 53, 70, 91, 123, 125, 156,
                                                         Ottonians, 130, 144-47
       210, 224, 260, 293, 297
                                                         Ourique, battle of (1139), 187
North Sea, 21, 60, 66, 104, 130, 227
                                                         Oxford, 271, 323
Northamptonshire, 271
Northumberland, 17, 60
                                                            University of, 233
Norway, 74, 75, 130, 143-44, 185
                                                         Padua, 289
Notre Dame (Paris), 234, 235, 236, 237, 239
                                                         paganism, 6-8, 64-65, 85, 92, 143, 243, 244, 274
Novel (Romanus I Lecapenus), 117
Novgorod, 120-21, 130
                                                         Palermo, 170, 191
Nur al-Din, emir (r.1146-1174), 209-10
                                                         Palestine, 5, 46, 52, 53
                                                         Pamiers, 275
                                                         Pamplona, 70
Oakeshott, Ewart, 74
                                                         papacy, 28, 70-71, 73, 140, 181, 183, 187, 188, 201,
oblation, 63
                                                                219, 237, 243, 318
Oder River, 144, 244
Odoacer (433-493), king of Italy, 24
                                                            Avignon, 276, 298, 322
                                                            and Byzantium, 78, 98
officials, 42, 54, 58, 65, 85, 115, 129, 142, 176, 185,
                                                            Great Western Schism (1378-1417), 322-23, 341,
       292
    Abbasid, 92
                                                                   342
                                                            reformed, 176-80
    Carolingian missi dominici, 100, 102
                                                            versus German emperors, 221-26, 270
    Egyptian pagarchs, 53
                                                         paper, 128-29, 152, 339
    English sheriffs, 142-43, 176, 216, 220, 271
    Flemish, 318
                                                         Paraskeve. See Petka
    French prévôts, baillis, enquêteurs, seneschals, 188,
                                                         Paris, 58-59, 63, 103, 107, 150, 154, 186, 188, 190,
           221, 272
                                                                191, 232, 234, 237, 261, 272, 281, 284-85, 289,
    salaried, 92, 96, 135, 207, 224, 226
                                                                315, 320
                                                             University of, 232-33
Olav Haraldsson, king of Norway, 144
Old Cairo. See Fustat
                                                         Paris, Gaston, 229
                                                         parliaments. See courts; Estates General; law courts
Old Church Slavonic (language), 84
                                                         Parma, 263-64
On Painting (Alberti), 327
                                                         Pascal III, antipope (1164-1168), 222
Oplontis, 13, 109
```

Pastoral Care (Gregory I the Great), 78 Pippin III, king of the Franks (r.751-768), 78, 98, Paterson, Linda, 229 Patrick, saint, 64 Donation of (756), 98 Paul (d.c.67), saint, 5, 20, 22, 147, 176 Pisa, 175, 194, 196, 226, 260, 309, 322 Pavia, 71, 223 Council of (1409), 323 Peace of God (movement), 139, 156, 172, 181 Plague of Justinian. See Justinian I peasantry, 113, 145, 227, 293, 307 plague. See Black Death peasants, 137-39. See also economy, rural Pliska, 82, 85 Po River, 173, 282 Pechenegs, 118, 170-71 Pelagius (d. after 418), 9 podestà, 222, 263-64 Penitential of Finnian, 64 Poitiers Pépin de Huy, Jean, 281 battle of (732), 98 Pera, 119 battle of (1356), 320 Persepolis, 52 Poitou, 221 Persia, 34, 36, 41-43, 49, 52, 88, 254. See also Iran Poland, 23, 130, 150-51, 241, 252, 260, 268, 274 Persian Gulf, 129 Polo, Marco (1254-1324), 256 Persians, 4, 36, 41-43 polyptyques, 104 Perugia, 327 Pompeii, 13 Peter, saint, bishop of Rome, 10, 22, 65, 98, 150, popes. See names of individual popes 176-78, 179, 194 popolo (urban lower classes in Italy), 263-64 Peter Abelard (1079-1142), 190, 280 minuto, 321 Peter Bartholomew, 183 portolan maps, 339 Peter Damian, 178 Portugal, 186-87, 220, 322, 339-40 Peter Lombard (c.1100-1160), 190 poverty (religious), 184, 188, 191, 196-97, 240, 242, Peter Olivi (1248-1298), 281 276 Peter the Hermit, 181 Pragmatic Sanction (1438), 324 Petka, saint, 274 Prague, 182, 324 Petrarch, Francis (1304-1374), 276, 326 University of, 275 Phainomena (Aratos), 108 prévôts. See officials Philip II Augustus, king of France (r.1180–1223), primogeniture, 138 printing press (c.1450), 339, 342 219, 221, 222, 243, 311 Philip IV the Fair, king of France (r.1285-1314), Protasius, saint, 11 Protestant Reformation, 339, 341 266, 272, 275-76, 311 Philip VI, king of France, 311 Provence, 135, 293 Philip the Bold, duke of Burgundy (r.1364-1404), Prussia, 264 Psellus, Michael, 115 Philip the Good, duke of Burgundy (r.1419–1467), Pyrenees, 140, 187, 216 315, 336 Phocas, Byzantine emp., 42 al-Qabisi (d.1012), 128 Photius, patriarch of Constantinople (r.858–867; Qaramita, 122-23, 129 877-886), 85 Quentovic, 58, 104 Piacenza, 263-64 Quest of the Holy Grail, 284 Piast (ducal dynasty), 274 Qur'an. See Islam Piero di Cosimo (1462–1522), 327 Quraysh (tribe), 49, 51, 54. See also Umayyads pilgrimage, 64, 268 to Holy Land, 181, 201 Rabat, 210, 213 to Mecca, 79 Raffensperger, Christian, 121 pilgrims, 26, 49, 58, 187, 192, 196, 200, 234, 267, 311 Rahewin, 222 al-Rashid, Harun, caliph, 92

Pippin (d.838), son of Louis the Pious, 102-3

Rule of Saint Augustine, 239 Rashid al-Din (c.1247–1282), co-vizier, 254 Rule of Saint Benedict. See Benedictine Rule Ratchis, king of the Lombards (r.744-749), 71-72 Ratislav, duke in Moravia (r.846-870), 84 Rum (Seljuk sultanate), 163, 252 Mongol-ruled, 304 Ravenna, 4, 10, 30-31, 36, 71, 100, 108. See also San See also Seljuk Turks Vitale (Ravenna) Reccared, Visigothic king (r. 586-601), 70 Runnymede, 220 reconquista. See Spain Ruotger, 145-46 Reillane, 293 Rus (people), 117, 119-20. See also Vikings Reims, 109, 190, 315 Rus' (polity), 117, 119-21, 151, 156, 244, 252, 254, relics, 11, 47, 136, 234 274, 298. See also Russia reliquaries, 29, 47, 225 Russia, 85, 121, 129, 254 Russian Primary Chronicle, 121 Renaissance Carolingian, 105-10 al-Saffah, caliph, 89 Italian, 325-31 Macedonian, 86 Safi, 260 Northern, 331-38 Sahara Desert, 168-69 Ottoman, 304-8 Saint Mary of Marseille, 104 Saint Omer, monastery, 109 Roman (4th-5th cent.), 20-21, 147 Reval, 260 Saint-Amand, monastery, 105, 109 Rhine River, 4, 21, 24, 65, 74, 76, 181 Saint-Denis, monastery, 154, 188, 234, 289, 321 Rhineland, 173, 181-82, 241, 267, 277, 281, 338 Saint-Germain (Auxerre), monastery, 191, 192, 194 Ribat al-Fath. See Rabat Saint-Germain-des-Prés (Paris), monastery, 105, 107 Richard I the Lion-Heart, king of England (r. 1189-Saint-Laurent (Paris), 58 1199), 219 Saint-Lazare of Autun, 194, 195, 197 Richard II, king of England, 317 Saint-Martin of Tours, monastery, 107, 173 Richard III, king of England, 317 Saint-Martin-des-Champs (Paris), 58 Saint-Maurice d'Agaune, monastery, 27, 28 Riga, 244, 260, 274 Saint-Mihiel, monastery, 154 Robert, count of Artois (d. 1317), 277, 281, 285 Saisset, Bernard, bishop of Pamiers, 275 Robert of Molesme (c.1027/1028-1111), 197 Saladin, sultan (r.1171-1193), 209-10, 219, 247, 248, Roger II, king of Sicily (r.1130–1154), 170 Rollo, duke of Normandy, 134 251, 256, 294 Romance of the Rose (Guillaume de Lorris; Jean de Salé, 210 al-Saleh Ayyub, sultan (r.1240-1249), 256 Meun), 284 Romanesque. See architecture; art Salerno, 191 University of, 233 Romania, 23 Romanus I Lecapenus, Byzantine emp. (r.920-944), Samarqand, 52, 296, 297, 304 Samarra, 89, 121 Rome, 1, 4, 6-7, 10, 13, 16, 18, 20, 24, 28, 36, 41, 48, San Biagio (Venice), 305 58, 65-66, 70, 71, 73, 78, 84, 98-100, 105, 108, San Damiano (Assisi), 241 130, 139-40, 163, 177, 181, 223, 225, 261, 276, San Francesco (Assisi), 234, 238, 239 San Giovanni (Cividale del Friuli), 71, 73 322-23, 327, 338 imperial coronation at, 107, 221 San Salvatore (Brescia), monastery, 72 San Vitale (Ravenna), 10, 30-33, 100, 115 Lateran Palace, 237 Sanhaja (Berber tribe), 168-69 Visigothic sack of (410), 21, 23, 30, 37 Sant Tomàs de Fluvià, monastery, 194, 201 Romulus Augustulus, Roman emp. (r.475-476), Santa Maria in Valle. See Tempietto 24, 37 Santiago de Compostela, 187 Roncaglia, diet of (1158), 222 Sardica, 4, 82 Rudolf I, emp. (r.1273-1291), 225 Sasanid Empire. See Persia Rugi, 24

Saudi Arabia. See Arabia	Simon de Montfort (c.1208–1265), 271
Saxons, 64, 99, 244	slaves, 23, 26, 58, 59, 61, 63, 64, 74, 91, 99, 113, 119,
Saxony, 130, 137, 144, 146, 244, 260	120, 122, 125, 129, 140, 187, 244, 256, 339, 340
Scandinavia, 60, 119, 121, 142, 143, 151, 185	Slavs, 30, 42-43, 82, 84, 86, 118, 225, 322
Scandinavians, 130	Smaragdus, abbot of Saint-Mihiel, 154
Scarborough, Connie L., 325	social orders (estates), 268, 270, 272, 293
scholasticism, 293. See also education, universities;	Sofia. See Sardica
summae	Somme Towns, 316
scholastics, 191, 281-82. See also friars; Thomas	Song of Roland, 99
Aquinas	Spain, 1, 23–24, 31, 52, 53, 55, 58, 91, 99, 125, 169,
schools. See education	173, 191, 225, 239, 243, 261, 268, 270, 293,
science, 190, 233	297, 316, 341
Scotland, 17, 64, 130, 134, 215, 241, 271, 317	Christian reconquista of, 179, 181, 186–87, 210,
Scotti, Alberto, signore of Piacenza, 264	220, 247–48, 270
scriptorium, 105, 153, 285. See also manuscripts	Cistercians in, 197
Scrovegni Chapel (Padua), 288, 289, 290–91	Franciscans in, 241
sculpture. See art and sculpture	Islamic, 79, 94–95, 170, 179
Seljuk Turks, 161–68, 171, 181, 201, 203, 256, 296.	Jews in, 243–44, 266, 311, 342
See also Rum	national church in, 324–25
Sénanque, monastery, 198, 201	Visigothic, 66, 70
Senegal River, 339	See also al-Andalus
Sententiae (Peter Lombard), 190	Spanish March, 99
Serbia, 5, 85, 225, 304	Speculum Virginum. See Mirror of Virgins
serfdom, 151, 320, 341	Speyer, 182
serfs, 137	Spoleto, 36, 71
freed, 292	St. Gall, monastery, 326
Jews as, 243	Stalsberg, Anne, 74
	Stamford Bridge, battle of (1066), 185
See also Germany, ministerials in	Statute of Laborers (Edward III), 309
Sergius I, pope (687–701), 78	Statute of the Jewry (Edward II), 309 Statute of the Jewry (Edward I), 266
Seville, 70, 210, 212	
Shakespeare, William, 317	statutes, 231–33
Shahnama (Book of Kings), 254, 255, 289, 293 Shahrisabz. See Kesh	Staufen (dynasty), 222–23, 225, 270
sheriffs. See officials	Stephen I, prince and king of Hungary (r.997–
	1038), 151, 156
Shirkuh, vizier, 209	Stephen II, pope (752–757), 78, 98
Short History of Mankind (Abu'l-Fida), 256	Stephen of Blois, 186
Sic et non (Yes and No) (Peter Abelard), 190, 280	Strasbourg, 311
Sicilian Vespers (1282), 225	students. See education
Sicily, 72, 83, 91, 123, 134–35, 170, 172, 179, 191, 223,	Suetonius, 99
224–25, 226, 261, 292	Sueves, 24
Siena, 321, 338, 342	Suger (1081–1151), abbot of Saint-Denis, 188,
Sigismund, king of the Burgundians (r.516–524),	233-34, 289, 321
26, 28	Summa on Engagements and Marriages (Giovanni
signori, 264–65, 317, 336	d'Andrea), 285
signorie, 265, 322	Summa Theologiae (Thomas Aquinas), 280, 298
Sigüenza, 170	summae, 280, 293
Sigurd, 74-75	Sutri, synod of (1046), 177
Siirt, 166–67	Swabia, 76, 222
Silesia, 274	Sweden, 143–44

Swiss Confederation, 317 Theodore I, Byzantine emp. (r.1205-1221), 214 Theodoric the Great, king of the Ostrogoths Switzerland, 24, 103, 311, 317 Sylvester, pope, 99 (r.493-526), 24, 26 Theodosian Code (Theodosius I), 26 30 Symeon Stylites (c.390-459), saint, 10 Syria, 1, 46, 52, 53, 88, 91, 118, 123, 125, 209-10, 247, Theodosiopolis, 42 Theodosius I, Roman emp. (r.379-395), 8, 36, 102 248, 251, 252, 256, 296 Theodosius II, Roman emp. (r.408-450), 30 Theophanes the Confessor, 82 tagmata. See warfare taifas, 125, 156, 179, 186. See also courts Theophanu, Byzantine princess, 147 Tale of Bayad and Riyad, 212, 228, 229 Theophilus, Byzantine emp. (r.829-842), 85, 88 Tallinn. See Reval Thessalonica, 84, 86 Tamerlane. See Timur the Lame Edict of (380), 7, 37 Thomas Aquinas (c.1225-1274), saint, 280, 284, 298, Tangier, 169 Tarnov, 274 Tarsus, 83 Thrace, 304, 308 taxation Tiber River, 16 barbarian, 29 Tigris River, 207 based on census, 226-27 Timur the Lame (Tamerlane) (1336-1405), 296, 304 Byzantine, 42, 82, 118, 213 titulus (community church), 21. See also confessio Carolingian, 100, 104 Toledo, 169, 187, 191, 203 communes, 263-64 Third Council of (589), 70 Torquemada, Tomás de (1420-1498), 325 Egyptian, 52-53 English, 134, 176, 185-86, 320 Tournai, 322, 336 Tours, 26-27, 28, 107, 172, 173, 272 English scutage, 219 Flemish, 292, 318 Toury, 289, 292 French, 188, 221, 320 trade. See economy French taille, 292 transubstantiation, 239, 276, 284, 323. See also imperial, 214, 222-25, 270 Eucharist Islamic, 52-53, 88-89, 91, 94, 96, 121-22, 254 Trebizond Empire, 214 Islamic zakat, 79 Trier, 4, 146, 147 of Jews, 181, 266 Tripoli, county of, 184 of papal property, 78 troubadours, 228-30 of the clergy, 275 Troyes, treaty of (1420), 315 Ottoman, 307 Truce of God, 139. See also Peace of God rights, 138 Tudmir. See Theodemir Roman, 4, 25-26, 42 Tudor. See Lancastrian (Tudor) (dynasty) Spanish, 270 Tunis, 16, 175, 260. See also Carthage teachers. See education Tunisia, 16, 91, 123, 294. See also Ifriqiya Tempietto (Cividale), 71-72, 73 Turkey, 1, 23, 41, 163 Templar order, 184, 220, 244, 272 Turkmenistan, 163 Tuscany, 180, 261, 264, 282, 321 Teresa, countess of Portugal, 187 Tertiary order, 240, 241 Tyler, Wat, 320, 342 Tertry, battle of (687), 98 Testament (Francis), 240 Ukraine, 23 Testamentary Rule (Neophytos), 214 Ulfila (311-c.382), Gothic bishop, 8, 25 Teutonic order, 244, 274 Umar, caliph, 54 themata. See warfare Umayyads, 54, 56, 72, 79, 81, 88-89, 121 Theodemir, Visigothic leader, 52 rulers of al-Andalus, 94-96, 125, 128 Theodora, Byzantine empress, 31, 33 Umayyah, Quraysh leader, 54

artillery, 76, 315-16 ummah. See Islam Byzantine navy, 42, 53, 91 Unam sanctam (Boniface VIII), 275 Byzantine strategoi/strategiai, 42, 81-83 universities. See education. See also names of individual universities (by city) Byzantine tagmata, 82-83, 99 Byzantine themata, 82-83, 118, 170 Urban II, pope (1088–1099), 181 Carolingian, 99 Urban VI, pope (1378-1389), 322 cavalry, 82, 138 Urbino, 297, 327 English burhs, 134, 140 Urraca, queen of Castile and León (r.1109–1126), 187 English longbowmen, 314 Uthman, caliph (r.644-656), 51, 54 Utraquism, 324. See also Eucharist English navy, 134, 140, 219 Free Companies, 316, 320, 321 Uzbekistan, 163, 259, 296, 297 French, 316 Greek Fire, 42 Vaclav II, king of Bohemia (r. 1283–1305), 275 in literature, 230-31 Valencia, 186 Valens, Roman emp. (r.364-378), 23, 37 Islamic, 52, 134 Janissaries, 304 Valladolid, 270 Valois (dynasty), 311, 313, 318 al-khurs (silent ones), 94 Mamluk, 256 Vandals, 24, 31 mercenaries, 23, 118-19, 122, 135, 161, 170, 181, Varangian Guard. See warfare 219, 230, 292, 317, 322 Varro, 325-26 Ottoman, 304-5, 307 vassalage, 136, 150, 151, 245. See also fealty; fief; homage Roman, 4-5, 23 siege, 183, 256, 260, 305, 315, 336 vassals, 99, 125, 135-38, 143, 150, 179, 183-85, 187-88, 219, 221, 228, 244, 272, 341 skirmish, 83, 91 Venice, 175, 225-26, 245-46, 260-61, 297, 305, 318, Varangian Guard, 117-19, 143 See also names of individual battles; Truce of 327, 331, 332-33 God Peace of (1177), 223 Wars of the Roses, 316 Verdun, treaty of (843), 102, 103, 111 Verona, 71, 180, 318 Wauquelin, Jean (d. 1452), 336 Wearmouth, monastery, 65 viaticum. See Eucharist Welf (dynasty), 102, 222, 223 Vienna, 244 Wenceslas, prince of Bohemia, 150 University of, 275 Wessex, 134, 185 Vikings, 103, 119, 130, 134, 142-43, 163, 185, 244 Vincennes, 272 Westminster, 271 Weyden, Rogier van der, 336, 337 Visigothic Code, 26 Whitby, synod of (664), 65, 79 Visigoths, 21, 23-24, 30, 37, 55, 71, 95 Vistula River, 244 Why God Became Man (Anselm of Bec), 203 Vitalis, saint, 31. See also San Vitale (Ravenna) Wijster, 21-22, 58 William I the Conqueror, king of England (r. 1066– Vladimir, ruler of Rus' (r.980-1015), 119-21, 156 1087), 185, 186, 203 Volga River, 104, 121, 254 William V, duke of Aquitaine, 137 Volsunga Saga, 74 William IX (1071–1126), duke of Aquitaine, 228 William of Ockham (d.1347/1350), 282, 323 Waldensians, 242-43 William the Marshal (d.1219), 231 Waldo, 242-43 Winchester, 173 Wales, 1, 64, 215, 271 Wittenberg, 339 al-Walid I, caliph (r.705-715), 54 Worms, 146, 182 Walter de Manny, 311, 314, 317 Concordat of (1122), 180, 203 Ward-Perkins, Bryan, 1 Wyclif, John (c.1330–1384), 323–24 warfare

Wynfrith. See Boniface, saint

Yahya ibn Ibrahim, 168

Yaroslav the Wise, ruler of Rus' (r.1019–1054), 121

Yeavering, 58, 60 Yemen, 169 York, 243, 317

Yorkist (dynasty), 316–17

Yusuf ibn Tashfin (d.1106), Almoravid ruler, 169–70

Zacharias, pope (741-752), 98

Zadar. See Zara Zähringen, 173

Zangi, emir (r.1127–1146), 184, 209

Zanj, 122 Zara, 245 Zaragoza, 186

Zeno, Roman emp. (r.474–491), 24

Zirids, 122, 123

Zoe (d.1050), Byzantine empress, 115, 118